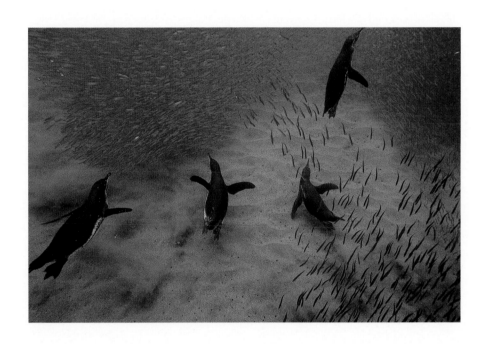

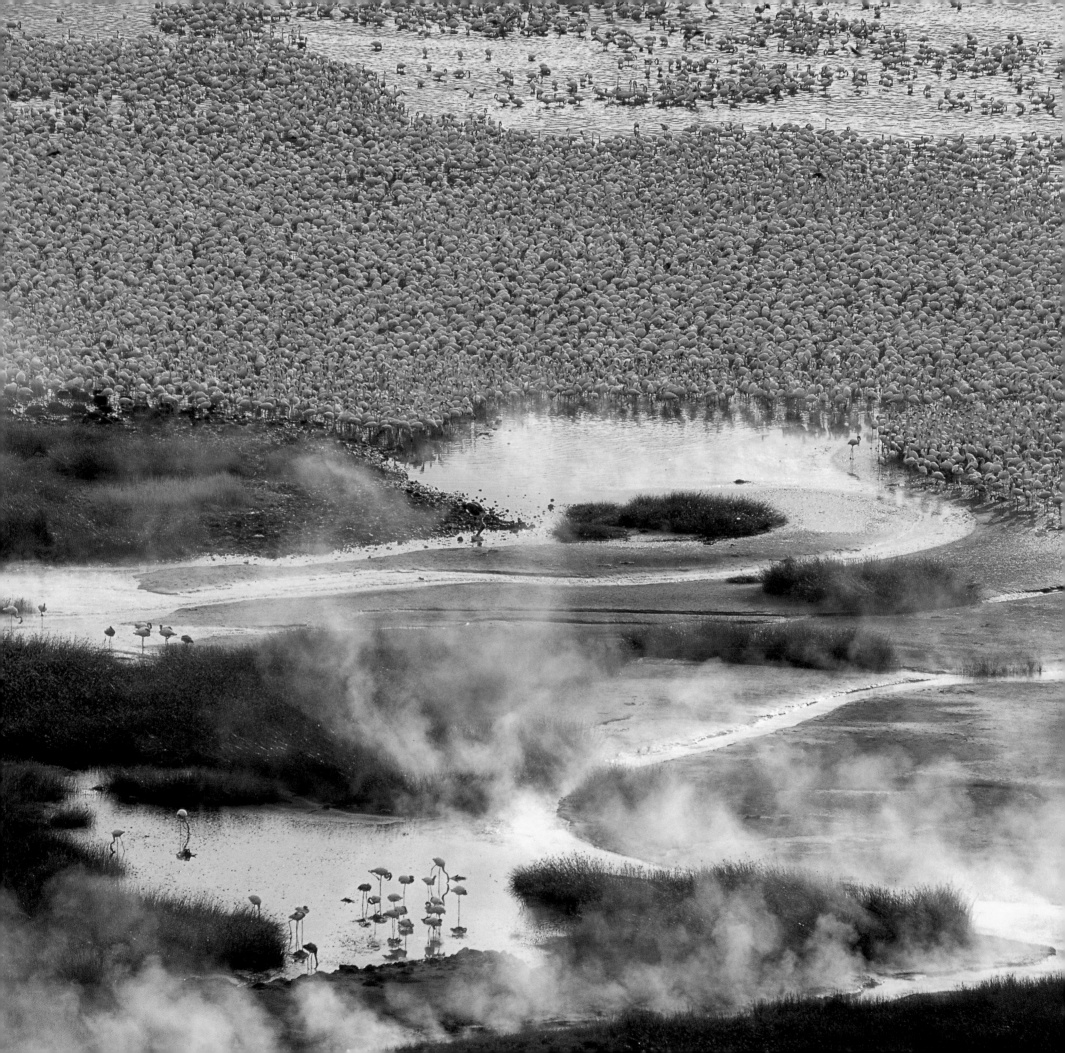

WILDLIFE SPECTACLES

SERIES PRODUCER
CEMEX BOOKS ON NATURE
PATRICIO ROBLES GIL

RUSSELL A. MITTERMEIER • PATRICIO ROBLES GIL
CRISTINA G. MITTERMEIER • THOMAS BROOKS • MICHAEL HOFFMANN
WILLIAM R. KONSTANT • GUSTAVO A.B. DA FONSECA • RODERIC B. MAST

PREFACE BY
PETER A. SELIGMANN

FOREWORD BY
WILLIAM G. CONWAY

CEMEX

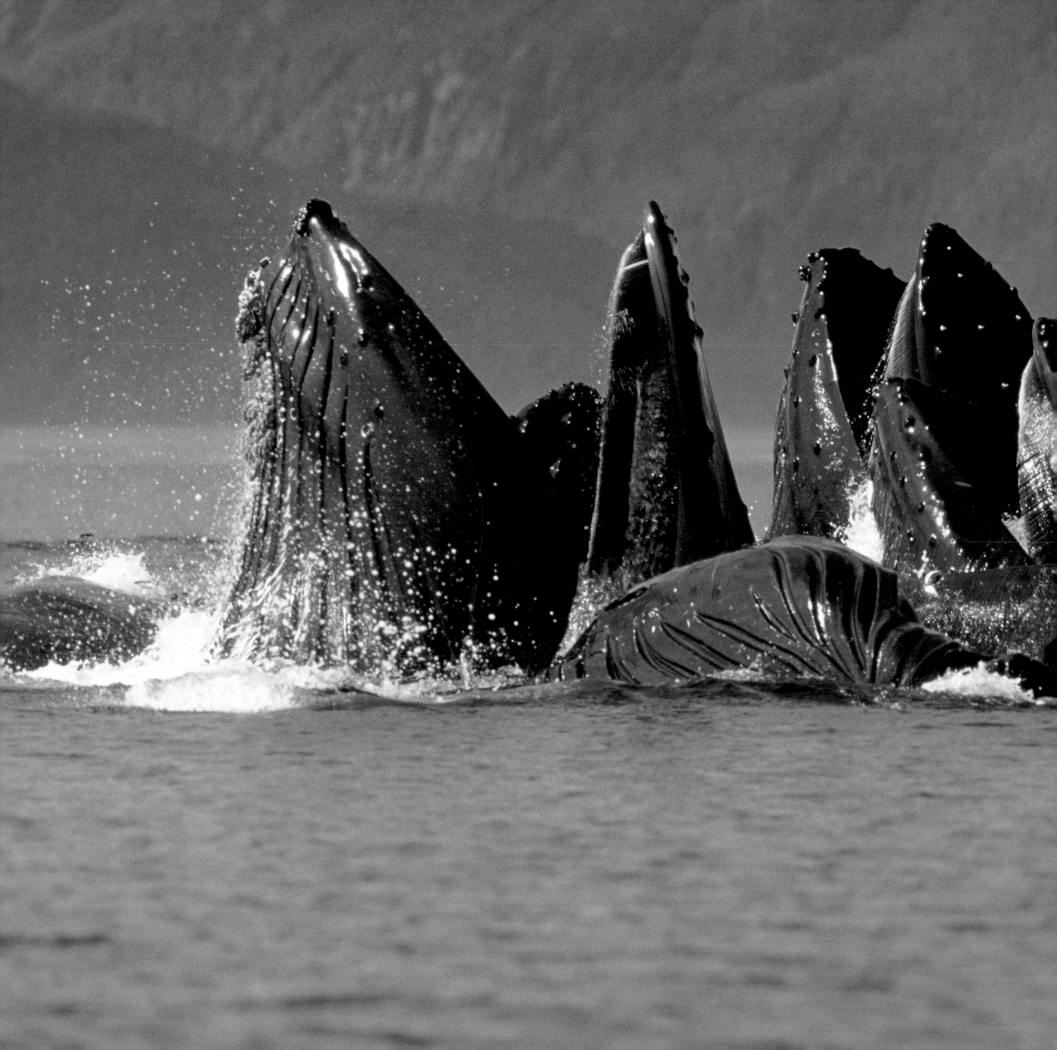

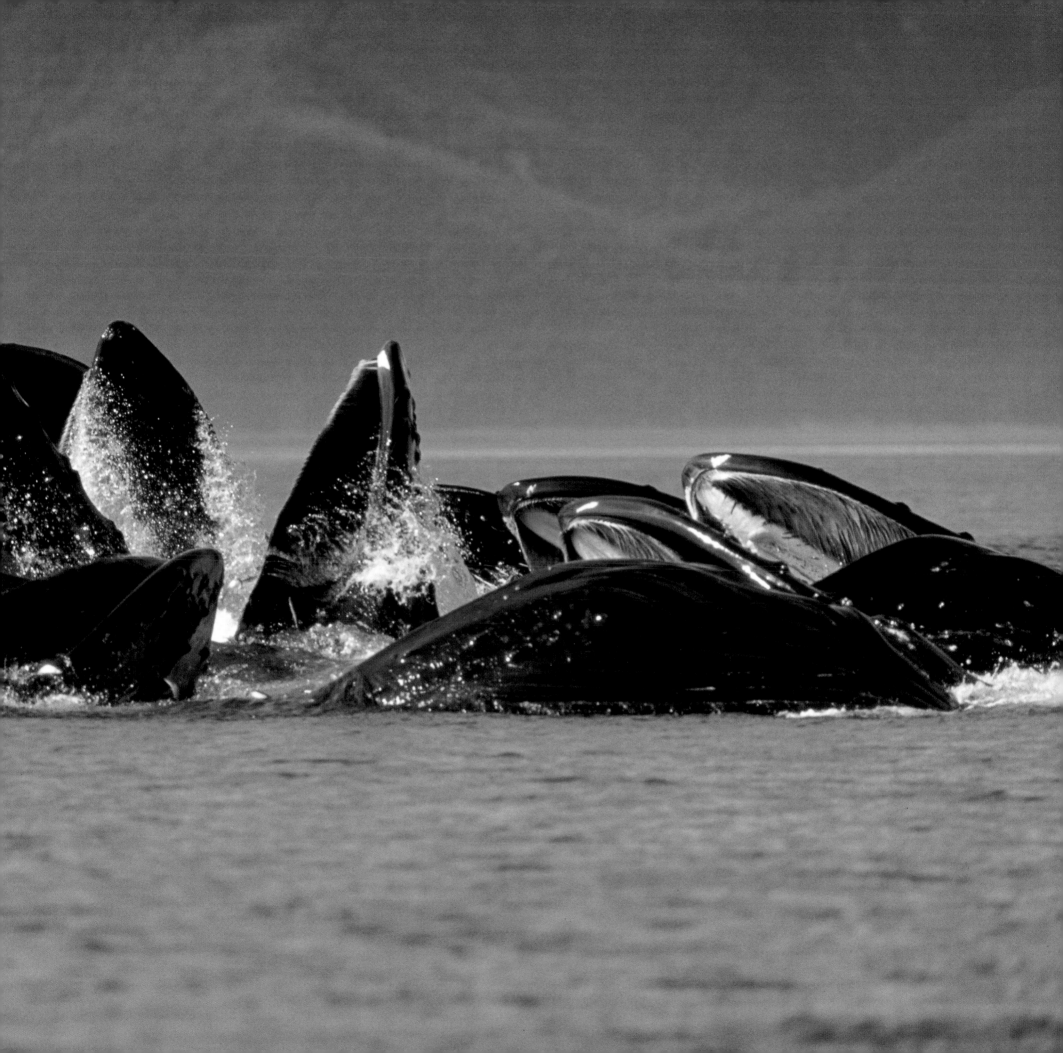

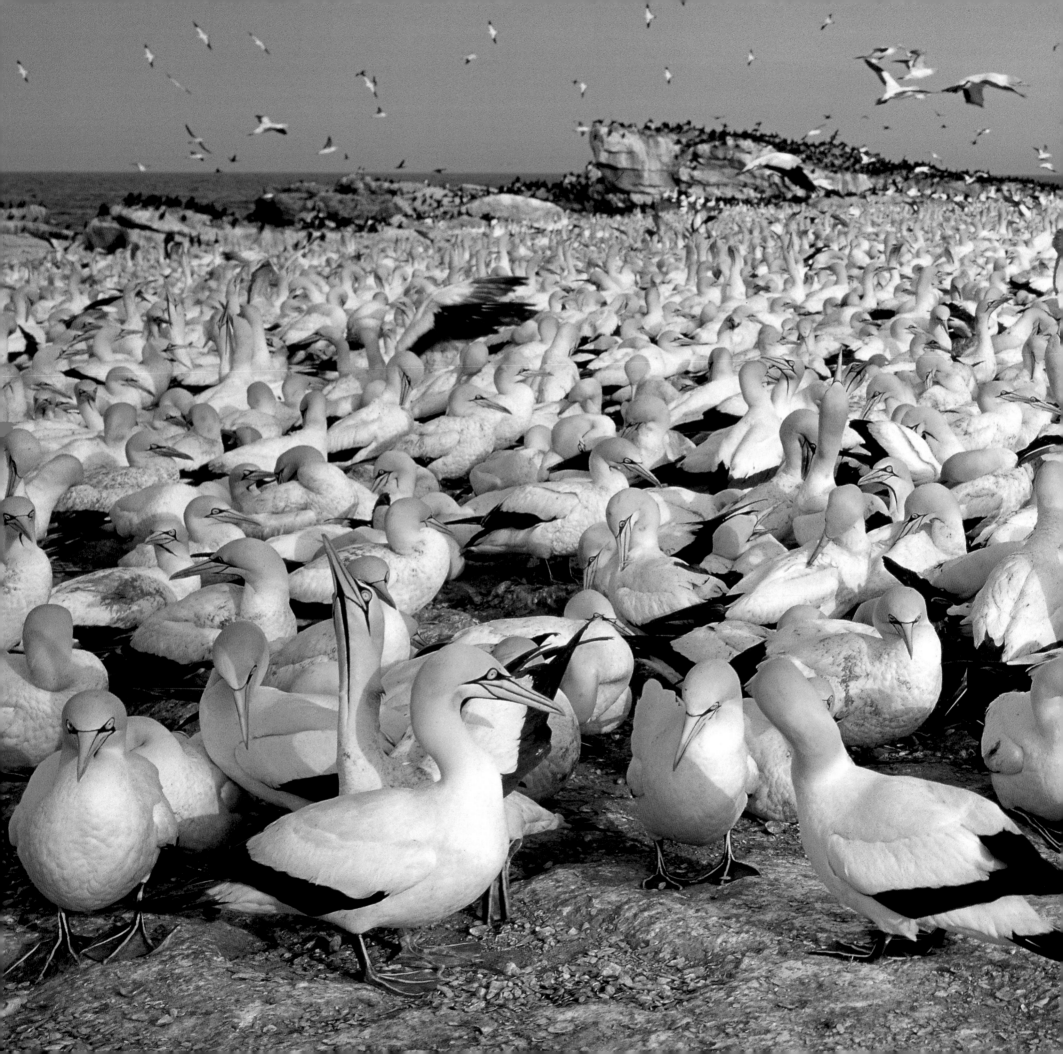

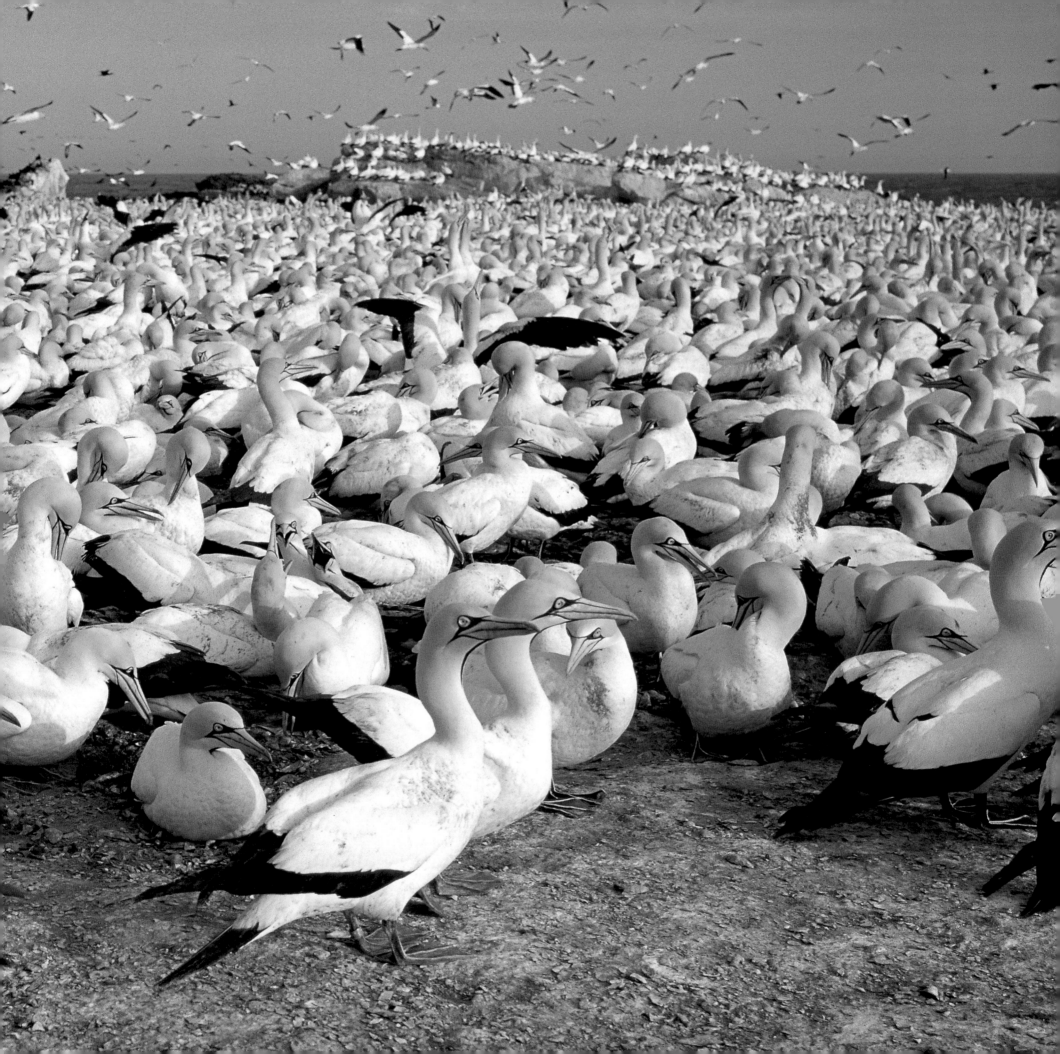

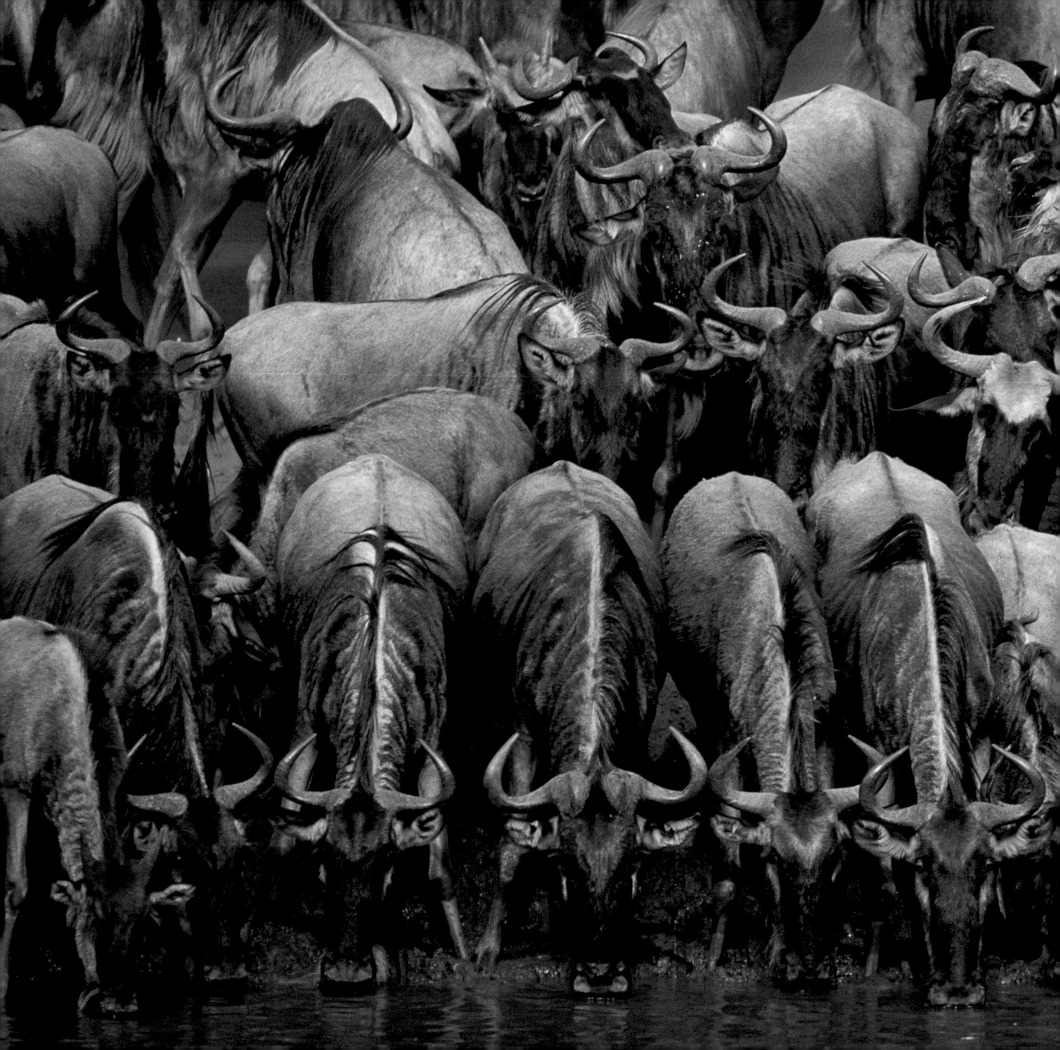

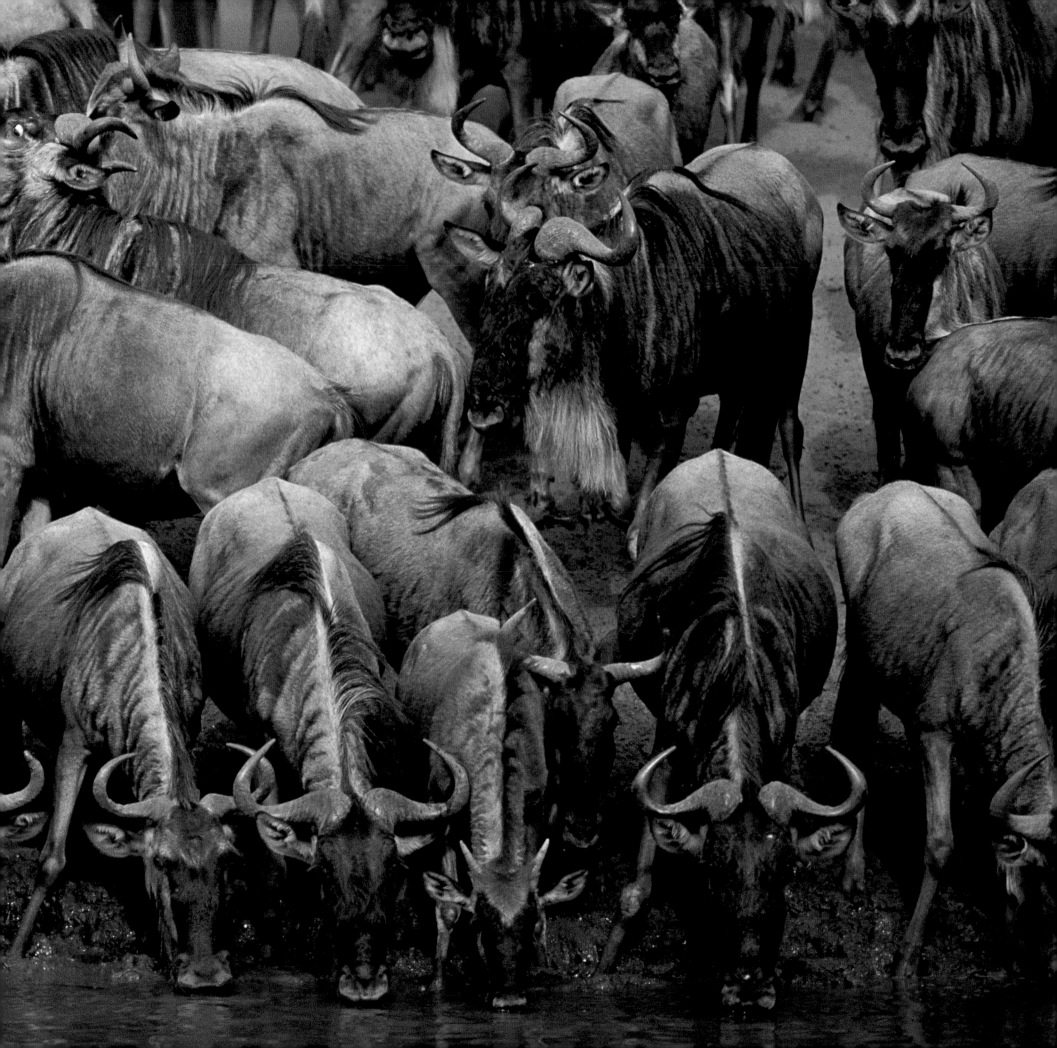

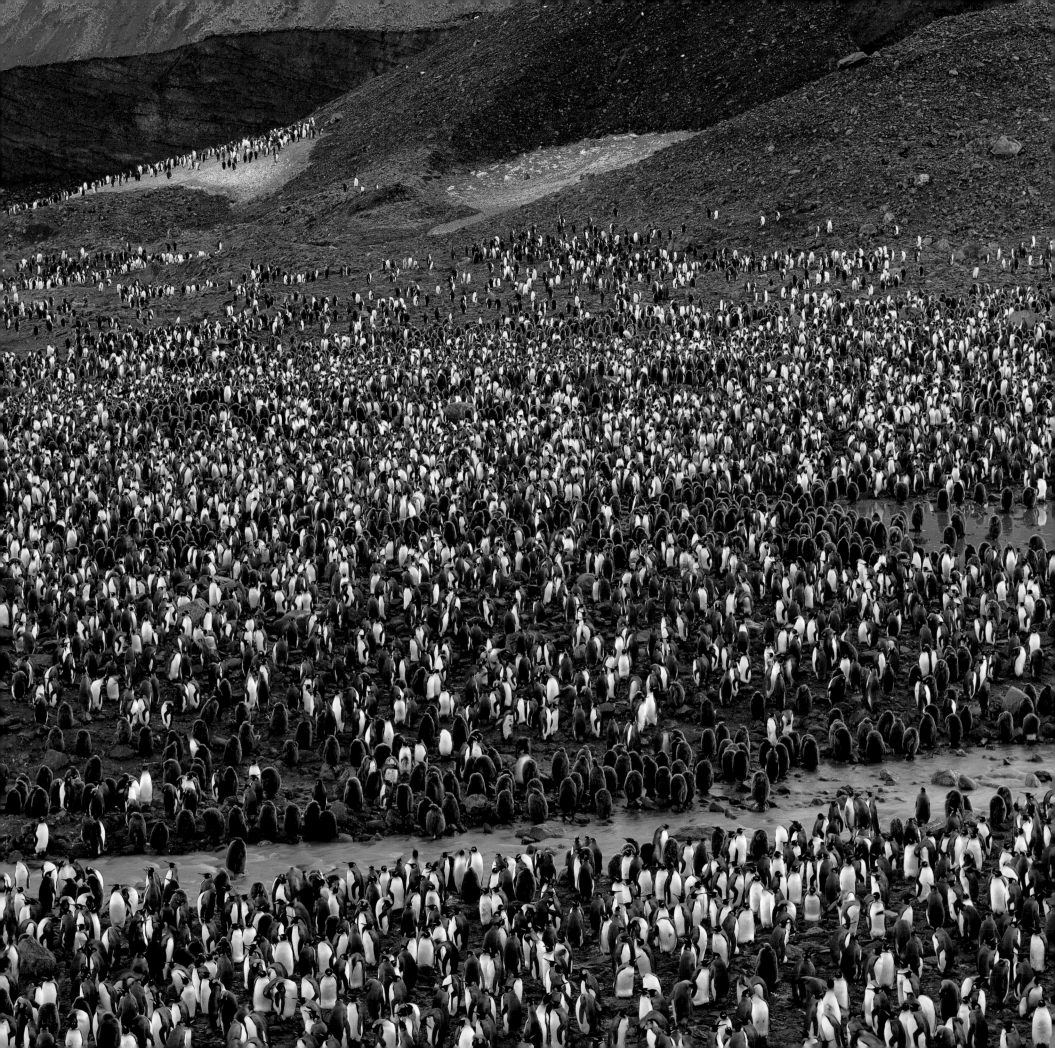

There are few experiences as thrilling as to feel the trembling of the earth by hundreds of thousands of galloping zebras and wildebeest in their annual migration over the African plains, to hear the chorus of thousands of king penguins calling to their mates with trumpet-like voices in the subantarctic islands, or to see the sky turn bright orange with the wings of millions of monarch butterflies in the forests of central Mexico.

The great concentrations of the Animal Kingdom are one of the most impressive natural phenomena. Witnessing them is a unique experience that transports us beyond our wildest dreams. It entails coming into contact with age-old instincts of entire populations that are in constant movement; in their dances, courting displays, and battles we encounter the secret of survival.

The many causes of these magical concentrations and their movements have been molded by millions of years of evolution, whether they be to find refuge and food or to ensure reproduction. Their fragility stems from the fact that they are unique and irreplaceable since at times over 90% of the world population of a particular species is concentrated at a single site, and this greatly increases their vulnerability.

Although these spectacular phenomena have been the subject of numerous studies, unfortunately their protection has not been evaluated and discussed as an integral part of global conservation strategies. Various organizations are working on phenomena involving specific species. However, only in the case of birds, as a group, thanks to the efforts of BirdLife International, have these great concentrations been considered as a criterion for defining policies related to the establishment of conservation areas.

As a multinational corporation, in CEMEX we believe in sustainable development. We continue with the commitment of balancing industrial development with environmental and safety concerns. For that reason, in 2002 we received the World Environment Center Gold Medal for International Corporate Achievement in Sustainable Development. Now, as part of our effort to help define and highlight the most urgent strategies for biodiversity conservation, we present *Wildlife Spectacles*, the eleventh title in our series of books on the natural world.

In collaboration with Agrupación Sierra Madre and Conservation International, who structured, defined, and subjected to scientific analysis the criteria for major concentrations of animals, we invited outstanding specialists and photographers to participate in this book, which reveals to us these marvelous natural phenomena, their relationship with other species, the threats they are facing, and the actions to be taken to conserve them.

With this book, we hope to contribute to the establishment of new protected areas that include breeding and feeding sites, as well as the protection of corridors these species use in their migrations. Based on well-defined conservation criteria, we trust that it will be possible to ensure the survival of annual cycles of millions of creatures, of forces that transcend time and link us to the spirit of life on this planet.

CEMEX

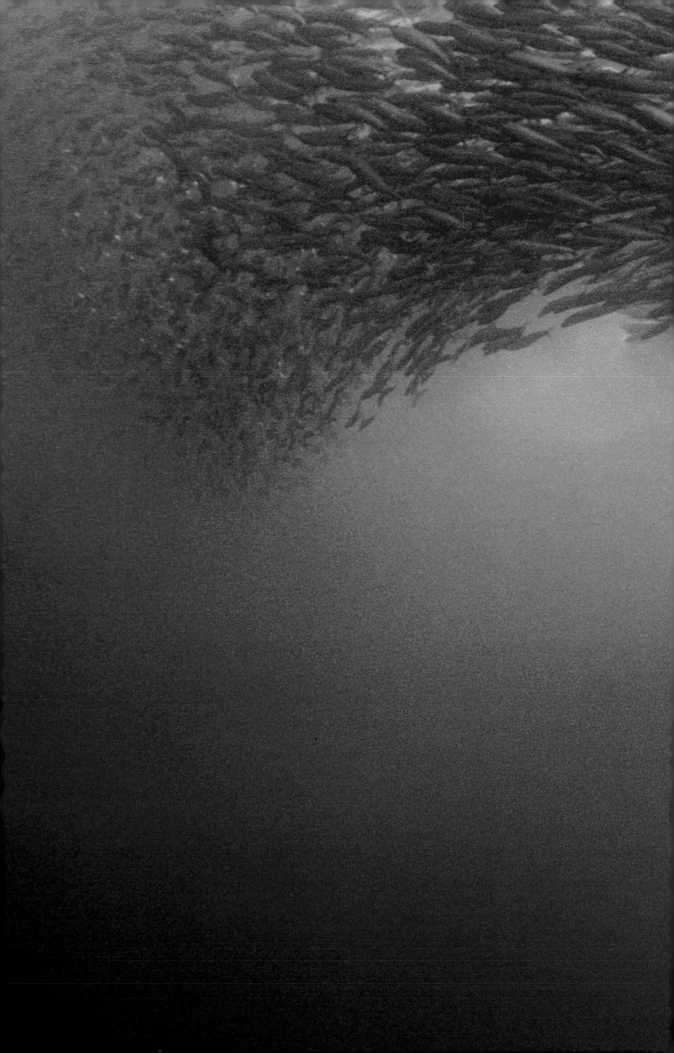

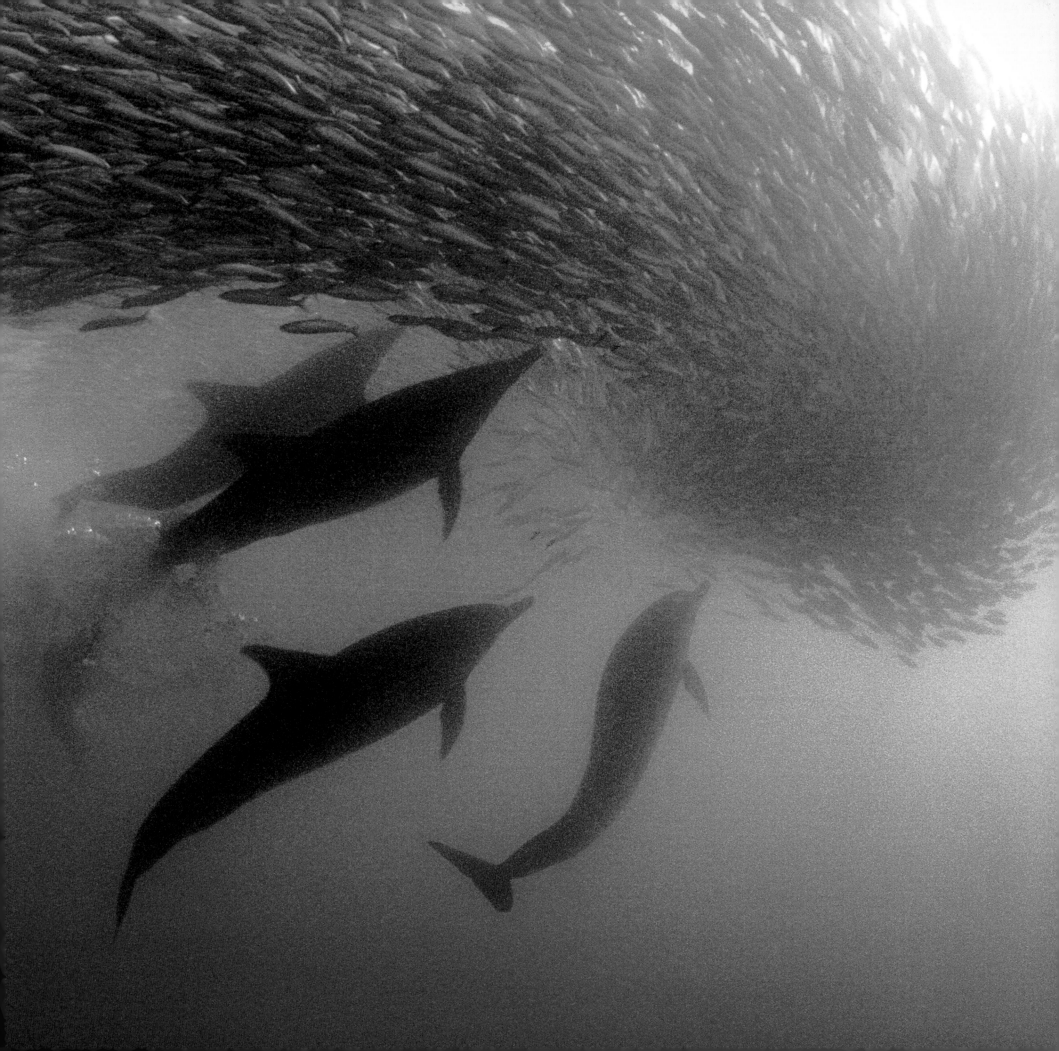

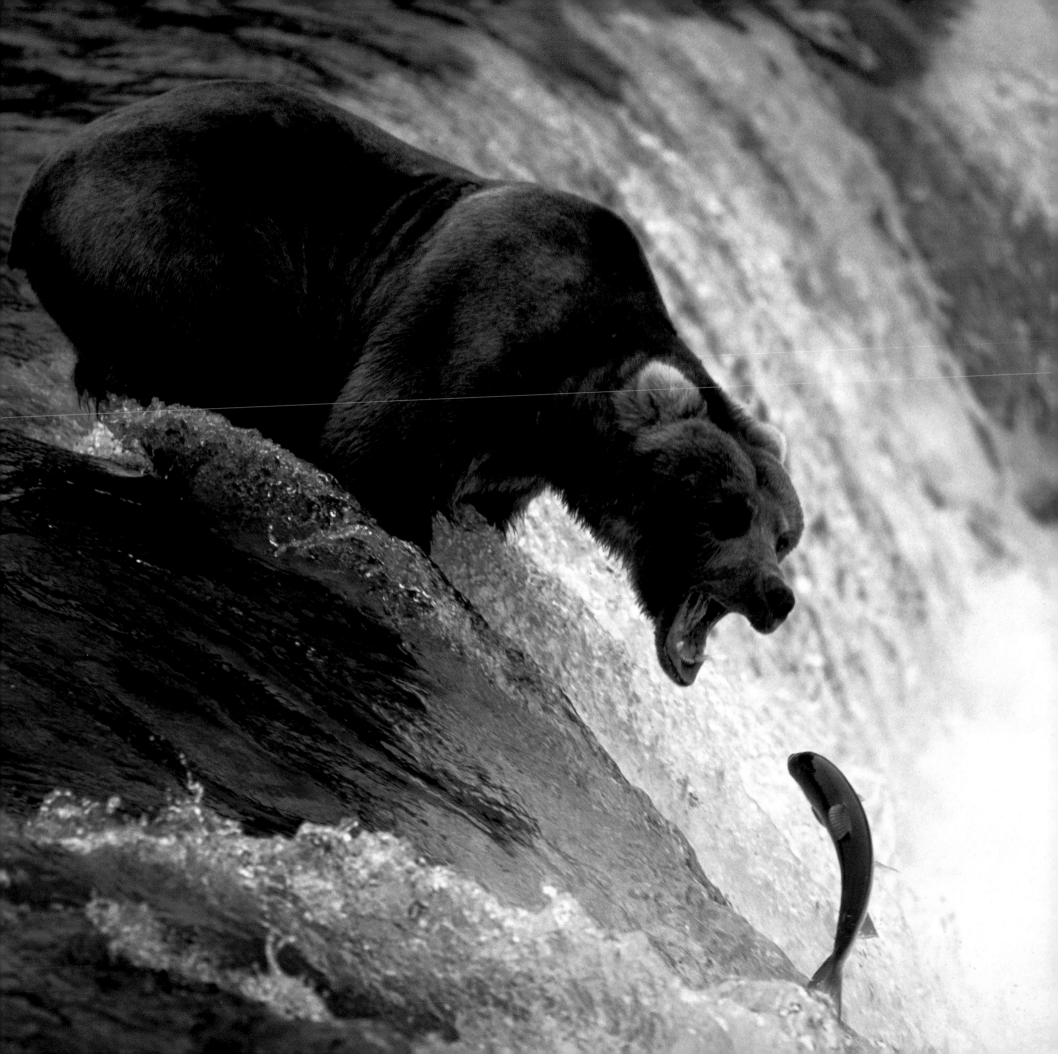

The pulsations of life, splendid and powerful, remind us that we humans have not always been the star of the ballad of nature. Since the beginning of time, every day, every season, there have been extraordinary displays of the beautiful choreography of nature. From the colorful and driven search by salmon for their spawning beds to the thunderous charge of wildebeest across the savannas of southern Africa, these wildlife spectacles have endured history. Survival is at their core: food, safety, reproduction, health.

As a fisherman, I have stood by many rivers, watching salmon work their way home. Their blind determination is never as clear as when they charge amid cascades of white, rushing, foaming waters —into the mouth of an awaiting Alaskan brown bear. While I admire the raw skills of this noble predator, I am truly overwhelmed by the spectacle presented by its prey, thousands upon thousands of single-minded fish that will brave the rapids and run a gauntlet of bloodthirsty bruins en route to their natal stream. Those lucky enough to avoid the bear claws will spawn farther upstream, produce the next salmon generation, and perish within a matter of days.

Migration is a surprisingly common phenomenon within the Animal Kingdom, best known to us perhaps through the mass movements of butterflies, songbirds, raptors, and large hooved mammals of the open plains. But animals assemble in large herds and colonies for a variety of reasons. Such congregations, often of enormous proportions, provide living evidence of a much wilder period in humankind's early history and draw us to some of Earth's most pristine landscapes. Regrettably, the present array of wildlife spectacles also points to species and areas of the planet that will require increasingly serious attention from the international conservation community, since the more impressive animal congregations are undeniably declining in magnitude across the globe. Some, in fact, exemplified by the American bison and the passenger pigeon, remain today only in historical texts and museum exhibits.

Where they still occur, these large natural assemblages attract people from all corners of the globe. Tourists will travel thousands of kilometers to witness tens of thousands of wildebeests migrating across Africa's Serengeti Plains, scores of sea turtles hauling themselves ashore on Costa Rican beaches, or millions of seabirds congregating along rocky coasts in Arctic rookeries.

These performances, however, are not conducted for the tourists. They are a reflection of evolving survival needs. Each of these spectacles is essential for species survival. And each of these spectacles exposes these species to severe human-caused dangers: wildebeest migrations are blocked by fences, salmon are stopped by dams, turtles are frustrated by hotels, lights, and egg collectors.

While this book celebrates these wildlife spectacles through the camera lens and the written word, let us not forget that species survival depends upon all of us. Our obligation is to ensure that we protect the species featured here from being destroyed by shortsighted human interference. We at Conservation International, Agrupación Sierra Madre, and CEMEX are proud to offer you our perspective on both the beauty and importance of Earth's most spectacular wildlife assemblages.

PETER A. SELIGMANN
Chairman and CEO
Conservation International

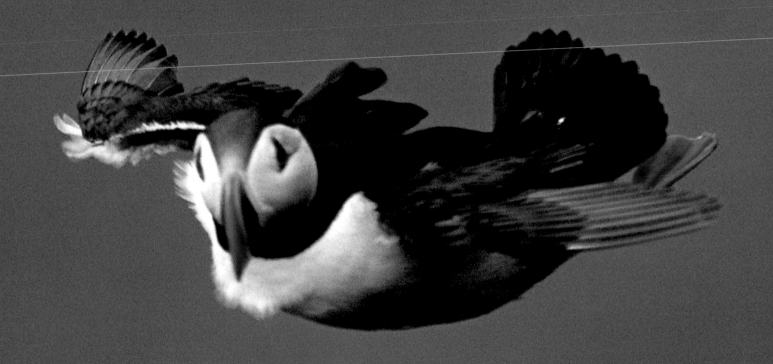

It is impossible not to be captivated by the magic and beauty of major concentrations of animals —and one's addiction increases with every encounter. My work as a photographer and conservationist has enabled me to witness different spectacles which have left an indelible mark on me.

There are simply no words to describe the sensation of sitting at the edge of a cliff facing the North Sea in Iceland, watching the comings and goings of tens of thousands of Atlantic puffins. Sometimes the wind is so fierce that when it hits the cliff, it creates rising currents of air that make it extremely difficult for these little birds to land, leaving them suspended in space a few meters away from me. It is the breeding season, a time of hard work for two to three months a year, which often makes them travel as much as 100 km to find the food they bring their chicks. I never fail to be amazed by the tenacity with which they confront such extreme conditions, but it is their charming form, way of walking, and, above all, their gaze, that most enthralls me.

Throughout our planet we still find major concentrations of animals, from imposing whales to tiny insects. Diverse species form groups, which come together, move, migrate, feed, and reproduce. These are the most marvelous spectacles of the Animal Kingdom.

To admire the fleeting rainbow created by the flight of hundreds of parrots and macaws that come together at the *collpas* of an Amazonian river; to walk in the cool waters of a shallow river literally crawling with salmon; to contemplate the infinite silhouettes of zebras and antelopes sketched against the sun of an African horizon; to touch a gray whale and its calf in the coastal lagoons of Baja California —where thousands of these cetaceans return year after year to reproduce— these are some of the spectacles I have had the privilege to see.

If I had to choose one, without a doubt I would go back to Ranthambhore, a national park in Rajasthan, India. In this oasis of life, what most impresses me are not the great concentrations of a particular species, but rather the groups of many species which, as a whole, make Ranthambhore a great spectacle.

Before the monsoons, everything there is so dry and the heat is so intense that there are only a few small waterholes left. There, dozens of sambar and chital refuse to leave the fresh waters of these pools. When the sun is going down, the wild boars descend en masse to drink. Close by, in the trees, groups of langur monkeys wait their turn. This spectacle is also auditory; flocks of different birds come and go: parrots, drongos, paradise flycatchers; and oustanding is the call of the Indian peafowl, which takes us to a pristine world. But, undoubtedly, it is the presence of the tiger that frames all this biological wealth. As he advances, there arises a concert of voices announcing his presence. There is nothing like it in this world. Ranthambhore is a true paradise.

This is a complete world, it is the story we want to hear, one which gives us peace and confidence in the future. Nevertheless, Ranthambhore and many other refuges are threatened. Around the park live thousands of people in devastated natural surroundings. The peasants want to invade the park so that their livestock can graze in these pastures and they can obtain firewood for their domestic needs. It is a constant threat that polarizes the needs of humans with the conservation of this piece of paradise. Yet, if we invade this or other places, within a few years they will have been stripped of their natural riches. Then what will we have gained? Do we want this to be the fate of many other wild areas and their wildlife populations? That is the challenge facing conservationists, societies, and governments: to find sustainable alternatives.

For over a decade, in Unidos para la Conservación and in Agrupación Sierra Madre, we have worked towards the conservation of Mexico's extraordinary biodiversity, in many cases placing emphasis on flagship species and large concentrations of animals whose biological, economic, and cultural value is of great importance to our country and to the world as a whole. We have insisted on alliances between different groups comprising our society: companies, governmental institutions, and conservation organizations. We support, for example, projects underlining the importance of caves housing great concentrations of bats. These small mammals are natural predators of the moths that attack corn, and thus make a significant contribution to agriculture. Similarly, we support studies on the concentrations of seabirds in the Gulf of California, as an indicator of the status of fish populations sustaining fisheries in this important sea. We have also helped finance reforestation of the fir forests where the monarch butterfly overwinters, and have designed campaigns for stressing the importance of wetlands which are home to concentrations of shorebirds, geese, and ducks, as well as the last forests which protect the nesting sites of thick-billed parrots, all of this coordinated with government agencies, universities, and NGOs (Pronatura, Conservation International, World Wildlife Fund) and with the great support of companies such as CEMEX, Kimberly Clark, Coca-Cola, and many others.

Our interest in major wildlife concentrations has grown as a matter of course with each project we have supported. But the idea of this book arose specifically during a trip to see one of the most spectacular *arribadas* of marine turtles on the coasts of Oaxaca, Mexico. Rod Mast, a good friend from Conservation International, had invited me on this trip to do the photographs. One night, Rod proposed the topic of major wildlife concentrations as a theme to be included in CEMEX's series of books on nature. And here it is, with Rod as one of the contributors.

During twenty years as a photographer, coordinator, and designer of books on the riches of the natural world, I have become familiar with many works presenting a testimony, a documentation, sometimes romantic, of our natural history. For that reason, in the last few years we have tried to ensure that the books we produce support advances in conservation, that they become tools helping international conservation organizations to launch their strategies, and that these strategies have a real bearing on our efforts to safeguard this planet's biodiversity.

Wildlife Spectacles is the eleventh title in the CEMEX series that I have had the privilege to produce since 1993. This topic had already been dealt with by the photographer Art Wolfe in his magnificent book *Migrations: Wildlife in Motion*, published in 1994. There, Wolfe presents a pictorial vision, creating surprising textures with groups of animals in movement. Almost ten years later there appeared the book *Glimpses of Paradise: The Marvel of Massed Animals*, by photographer Fred Bruemmer, whose images of different groups, with descriptive texts, highlight the marvel of these spectacles. In both cases, the essence of the work is the personal efforts of a single photographer who stamps his own particular style, stressing his vision of one of the most extraordinary themes of life on this planet. Inspired by these two books, we have attempted in our book, to invite a large group of photographers and researchers to collaborate, so as to enrich this work with their distinct visions.

With the idea that this book would go beyond the concept of an art book to become a conservation proposal, I approached the well-known researcher and conservationist George Schaller. We discussed the possibilities of the project and he suggested I propose it to William Conway, senior conservationist of the Wildlife Conservation Society, whom we knew had a great interest and passion for this topic and who later would write the Prologue for this book.

In a meeting with him, he insisted on the need to define major concentrations with scientific criteria that would highlight the relationship between these phenomena and the rest of the ecosystem and that would stress their threats. That would make the book a true contribution, as had been *Hotspots: Earth's Biologically Richest and Most Endangered Terrestrial Ecoregions*, which has had great influence in determining environmental policies. The success of that book and of the other two that were published in conjunction with Conservation International is due to the importance and clarity of their concepts —which make it possible to achieve an efficient allocation of funds, always so scarce—, and most of all to the amazing vision and communication skills of its President, Russell A. Mittermeier.

As a result, I presented to Russ the idea of producing this book on major wildlife concentrations, once again as a collaboration between CEMEX, Conservation International, and Agrupación Sierra Madre. He was immediately enthusiastic, and saw its importance as an opportunity to transform these criteria into a conservation strategy, since no other organization had embraced the concept in all its magnitude. We discussed and structured the way of approaching this book, in conjunction with Cristina G. Mittermeier and Thomas Brooks. We agreed to utilize the formula we had already used of an art book that would be attractive for the general public, but grounded in solid science.

These wildlife spectacles include additional criteria for defining conservation priorities and, at the same time, represent tools for designing biological corridors and new natural protected areas.

I hope that *Wildlife Spectacles* helps set a path for biodiversity conservation and that major wildlife concentrations continue to roam along the countless arteries that breathe life into this marvelous planet.

PATRICIO ROBLES GIL
President
Agrupación Sierra Madre

I would like to dedicate this book to my mother.

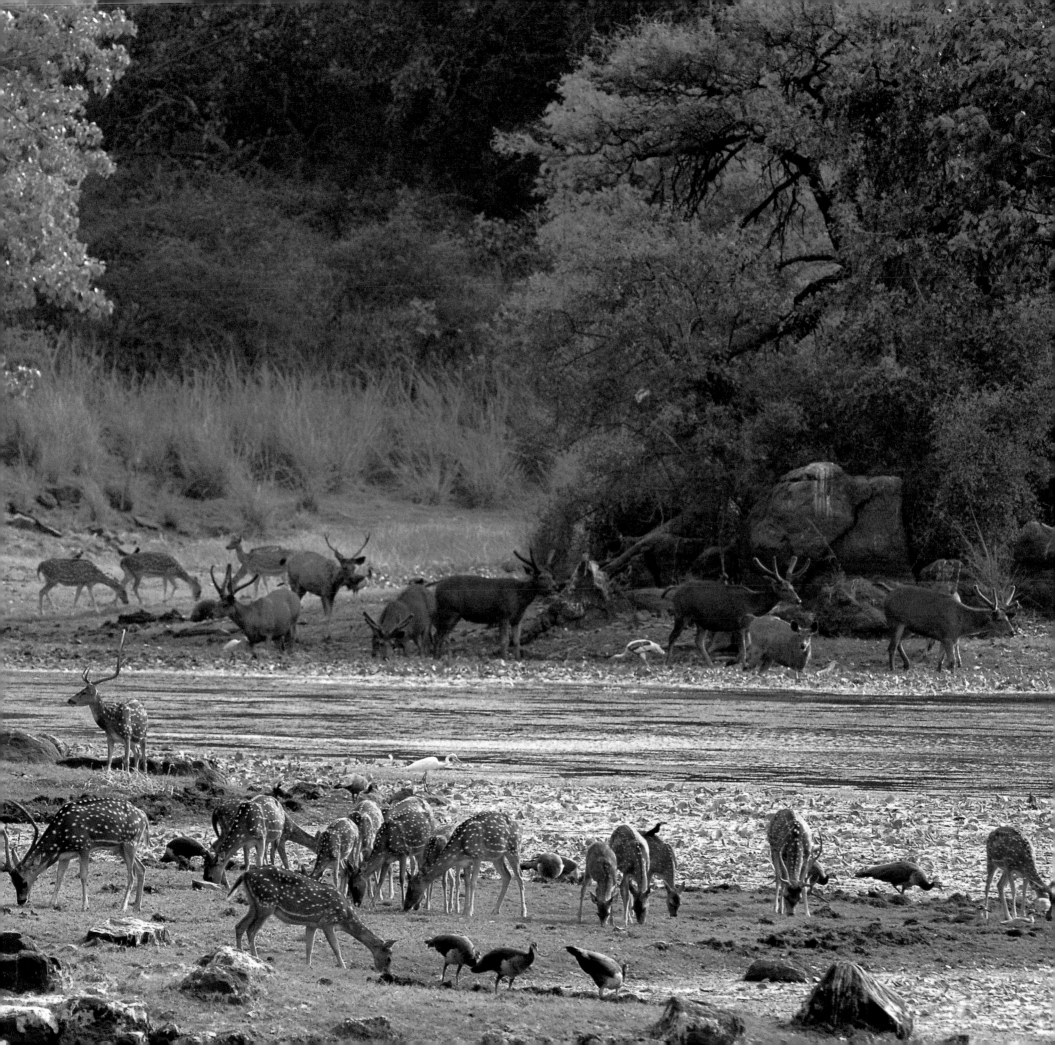

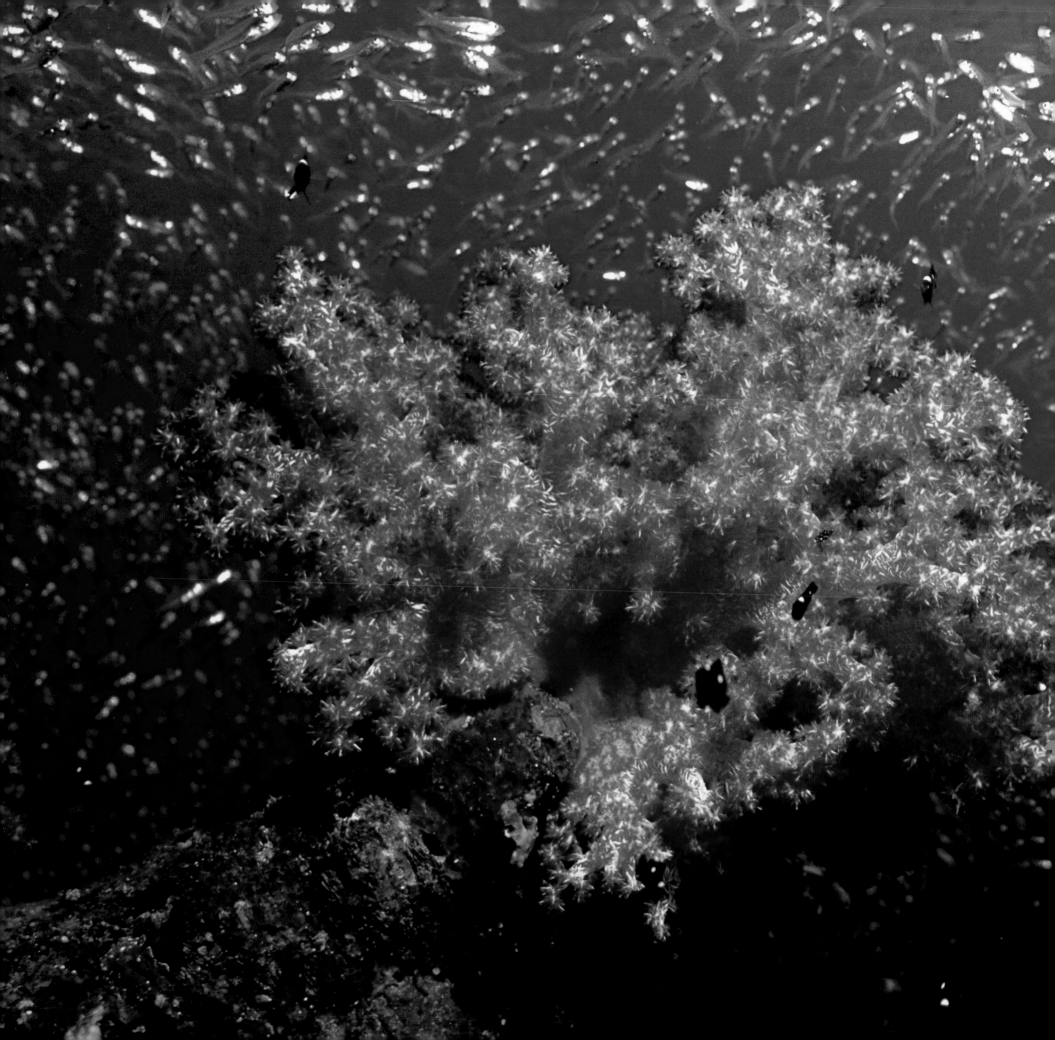

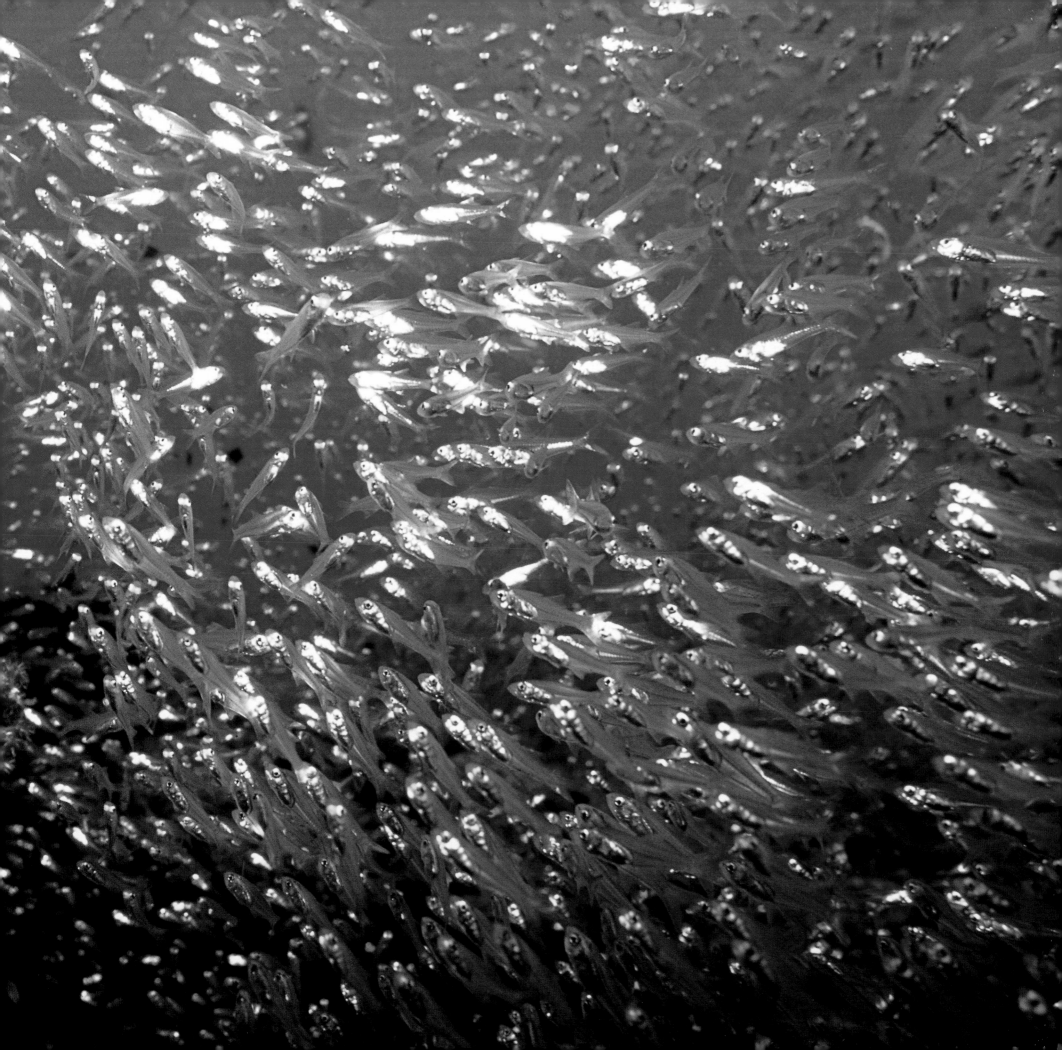

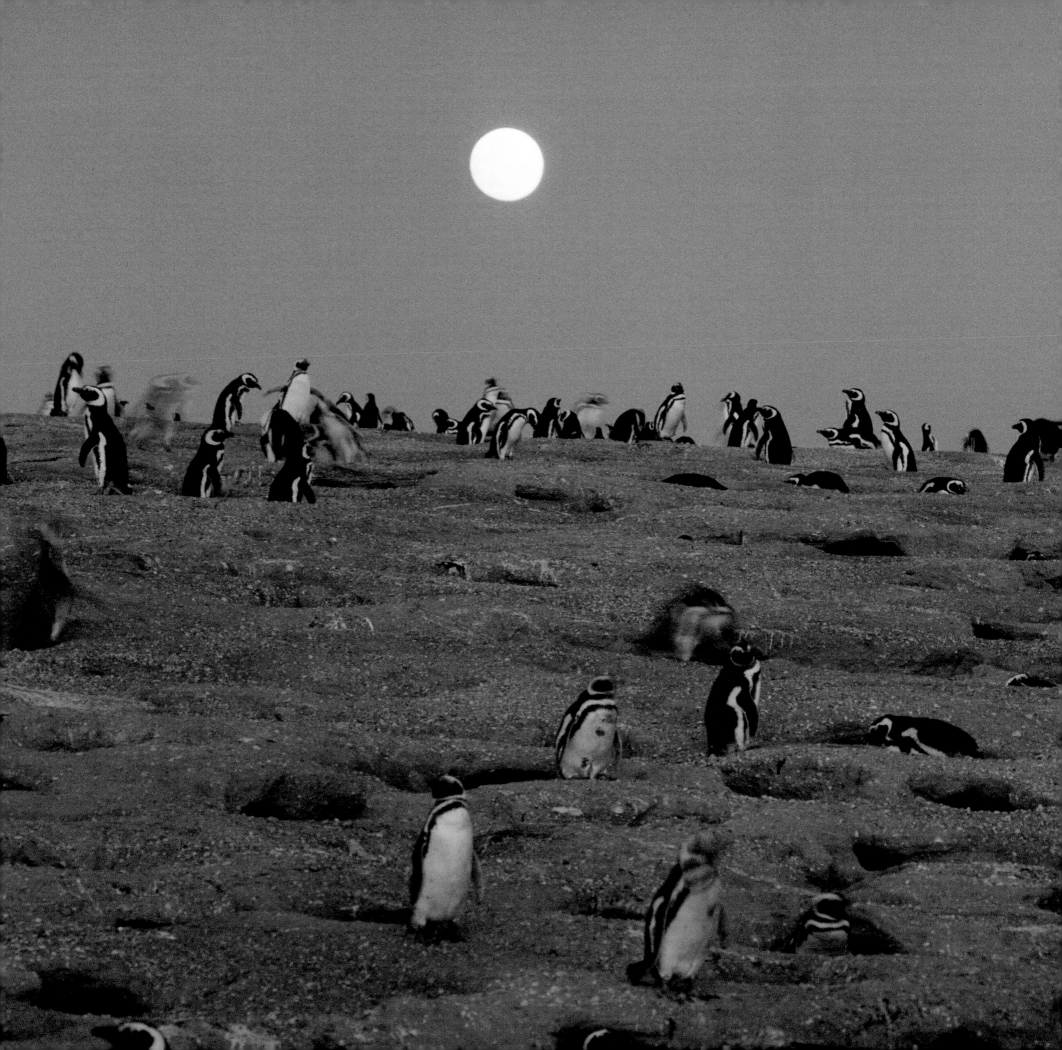

At 5:30 a.m. the moon was pale and small, and the wind was cold and sharp. It rustled the *humi* and *zampa* thickets behind me, but lacked enough energy to make a problem of the ever-present dust, the infamous Patagonian "polvo." Magellanic penguins sang hoarsely nearby. There were more than 400 000.

Folding my legs between those of my tripod, I scrunched down and tried not to sit on thorns or pointed stones. It was still too dark for photography but I was okay for a long wait, warm in an old down jacket and tattered scarf. It was also low tide and the nearby Atlantic was unusually quiet. A penguin was brooding two chicks seven meters away, according to the scale on my camera lens. I had marked the nest last evening with a handkerchief tied atop a nearby bush so I could find it in the dark, then slipped out of a bunk in the ranger station early to be here at first light.

Gradually, sunrise brought life to a vast spectacle silhouetting thousands of birds against gray-green bushes and wind-thinned clouds in a straw-colored sky. There was a huge colony of 4.5-kg birds, each assiduously attending to the business of being a penguin. I wanted to know more about them. They did not really care to know about me. I was ignored —no address, credit card or driver's license needed. I felt as though I had been specially permitted to view the world of the South Atlantic at its very beginning.

The female penguin, her slightly smaller size and more slender beak distinguishing her sex, was warming the two chicks her mate had been brooding yesterday. She held them close to her body —one under each flipper-like wing. My hope was to see what kind of sea creatures she would regurgitate to feed them and to photograph her doing it. She had been foraging at sea 100 km from the coast for two days; food-hunting trips were taking at least that long, but she looked heavy and full. Now, her mate was out there, bobbing in the new dawn's dark waves waiting for enough light to fish on behalf of their chicks in his turn —an exacting partnership. The chicks begged again and again, squeaking incessantly and pushing their soft little beaks at her hard sharp one.

I was 240 km south of Argentina's Península Valdés on the edge of the South Atlantic at Punta Tombo. It is an isolated, sand-covered lava rock strewn peninsula jutting four kilometers into the sea at the same latitude as Tasmania. Twenty-six species of terrestrial birds, mostly small, spend some part of the year there, but it is the grand congregation of penguins, perhaps 10% of all Magellanic penguins, which makes Punta Tombo special and qualifies it as one of Earth's great wildlife spectacles.

Twenty-one hundred meters higher than Tombo, in the foothills of the Chilean Andes, is a far less-known spectacle. A formidable "salt pan" called Salar de Atacama is the sometime home of the biggest remaining colony of the magnificent black-winged, magenta-necked, yellow-legged, Andean flamingo, the "parina grande." The Salar, a plantless, glaring white, dried lakebed of 4 000 km² appears, in places, to be made of broken glass. It is about as close to Hell as can be reached in a four-wheel drive. By day, its temperature commonly exceeds 49°C. By night, it is cold and windy. Its painfully bright, salty mud is relieved by less than 15.5 km² of open watery brine, but this is where the world's rarest, least-known flamingo feeds and breeds, spectacularly. The Andean is not only the grandest of the world's six kinds of flamingos, it is also the most threatened although its numbers here sometimes exceed twelve thousand.

Trudging through the heat and mud on my first visit to the Salar, with the birds but a shimmering mirage in the distance, a Chilean colleague suddenly pointed upwards. We stopped, spellbound, as a flock of shockingly brilliant flamingos drifted lightly down from high in the desert sky, as if from the Lascar Volcano belching smoke behind them, slipping and gliding through the hot air into the hellish Salar —and landing as bright and delicately as if fiery ashes from the volcano itself.

Hellish the Salar may be, but it has long protected one of the greatest of flamingo spectacles. Now, mining of the pan for its lithium, nitrates, potassium, boron, and molybdenum is under way and the pan is criss-crossed by oil exploration roads admitting both predatory foxes and egg-stealing people.

How can a species with several thousand individuals be considered Threatened? After all, there are about 35 000 Andean flamingos. That is nearly thirty-five times the estimated population of the grizzly bear in the contiguous U.S., or the giant panda in China, and fifty-three times that of mountain gorillas in Africa, 205 times that of the California condor, 230 times that of the U.S. whooping crane, and who knows how many times the population of the Mediterranean monk seal. It comes down to the basic understanding necessary to preserving all intensely colonial birds and mammals, that the *number of effectively breeding colonies is nearly as important as the number of individual animals* —to say nothing of the importance of feeding and migratory congregations. Ninety percent of all lesser flamingos breed at one Tanzanian lake, and 85% of all James' flamingos breed at one Bolivian lake. Ninety-eight percent of all seabirds breed in colonies.

We don't know the lower limits of successful colony size, the essential interchange between populations, or even the necessary number of colonies. Genetically, demographically, ecologically, a viable population of Magellanic penguins or Andean flamingos probably requires at least a dozen sizable colonies with several thousand birds each to survive the normal gauntlet of environmental catastrophes, now so enlarged by humans.

Virtually all congregating creatures are ecological superpowers if they are big enough or numerous enough (E.O. Wilson calculates that ants comprise 20% of terrestrial animal biomass). Their very life-style influences their ecosystems in ways that less-synchronized creatures can not. Hence, they have a special importance to conservation efforts, anywhere. If they can survive, so will their worlds. Consequently, it seems curious that no major conservation effort has focused its energies upon the safety of great animal aggregations. Perhaps the numbers of animals apparent in colonies misleads us. The traditional wisdom, that the probability of a population's extinction is a function of its size, is inappropriate to animals that gather in large groups to breed, to feed or to travel. For them, it is the number of successful congregations rather than the number of successful individuals or pairs that is the unit of security —hence the unusual importance of this Conservation International–Agrupación Sierra Madre–CEMEX publication of *Wildlife Spectacles* and the deliberately analytical approach which it takes.

Although most of the great wildlife spectacles are gone, some are recovering. The sea lions of Patagonia's Punta Norte are a case in point, but when I first saw the Punta in 1964, I was appalled. Once a spectacular congregation of life, of living sea lions and elephant seals, the beauty of this striking shore was eclipsed by hectares of bones and mummified carcasses. It called to mind a battlefield where the fallen had been stripped of their uniforms and their bodies left to rot. There were thousands of skeletons and piles of bone fragments. The remaining bits of skin and flesh were black and brittle and the skeletons dry and bleached, remains of the grand, almost regal, southern sea lion and a few southern elephant seals —so much slaughter for such trivial purposes.

Between 1935 and 1962, 500 000 southern sea lions were clubbed to death for their skins on the coast of Argentina —a minimum estimate. Over 140 000 were clubbed at Punta Norte, where they are now protected but, even after forty years, less than one thousand can be counted.

There is a majesty in great wildlife spectacles that creates a sense of life's significance apart from humanity's more temporal concerns. Their multitudes have astonished and inspired our own species since we were capable of inspiration. Observing a Serengeti wildebeest migration, a great elephant seal, albatross or flamingo colony can bring forth not only a feeling of awe, but also one of kinship, of common rhythms and destinations. Perhaps it is the feeling a soldier knows as the earth vibrates with the trampling of thousands of his own army or, perhaps, that thrilling communion that can come from a rousing Stravinsky finale —or a game-clinching Yankee home run.

To surmount a high Andean pass in Bolivia and come upon the vast unpeopled valley and scarlet waters of Laguna Colorada, its skies filled with overwhelmingly beautiful flights of exquisite James and Andean flamingos, their carmine wings flashing against the forbidding blue-gray of surrounding volcanoes, is an esthetic adventure that can not be approached by anything human-made. And so it is with the green meadows and pink granite panoramas of Tanzania's savannas and Gol Kopjes with their elegant processions of gazelles, wildebeests, and zebras on the Serengeti; the LaRue Valley of Yellowstone with its gatherings of dark bison and elk; the raw, misty majesty of Steeple Jason Island's 5-km long colony of huge, black-browed albatrosses in the Falklands or, the wildlife spectacle I know and love best, the grand Magellanic penguin rookery at Punta Tombo in Patagonia. How can one not be moved and humbled, one's selfish concerns forgotten, by such grandeur? But, more to the point, how can one move others?

I suppose that it is relatively easy to gather up a gang of unemployed "bully boys," tramp down the beach and club sea lions to death (or penguins or albatrosses or sea turtles); dirty, disgusting, but easy. It takes no thinking, no skill, to kill them until there aren't any more. Suppose, however, that you wish to save a great sea lion spectacle? That is hard. It will take intelligence and layer after layer of training, of preparation, of planning. It can not be done in a day or a week or a year. It will take countless hours of observation, comparison, analysis, presentations, and arguments with those who simply wish to kill them, or use their rookery area for something else. Thoughtful justifications, inspiration in lieu of income —hard. And it will take ongoing response to critics, and teaching, and even begging... and the finding of money to do all these things, and keep doing them. To make arguments for tomorrow, not just today —hard. It will take the development of a constituency for sea lions, a following, and the maintenance of it. It will take monitoring, educating, and putting in place ways to sustain these commitments in perpetuity, when you are not able to be there —hard.

Wildlife Spectacles, with its powerful pageant of mesmerizing pictures, is an inspiring inauguration for the hard work that lies ahead, an effort that deserves the support of everyone who cares about nature. Conservation International, Agrupación Sierra Madre and CEMEX are to be profoundly thanked as well as congratulated.

WILLIAM G. CONWAY
Senior Conservationist
Wildlife Conservation Society

26

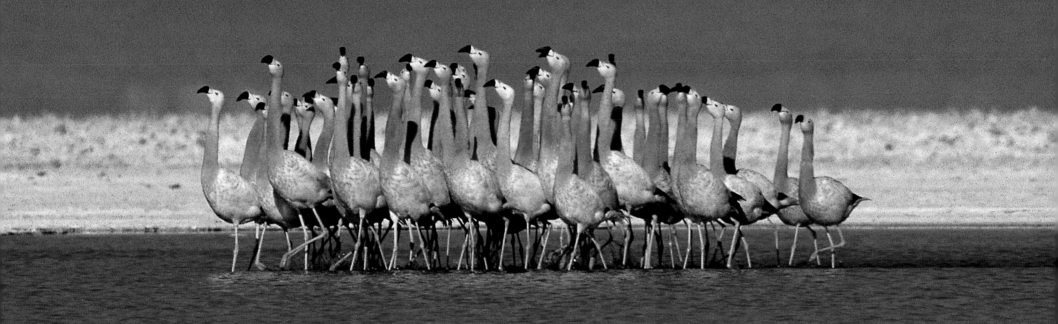

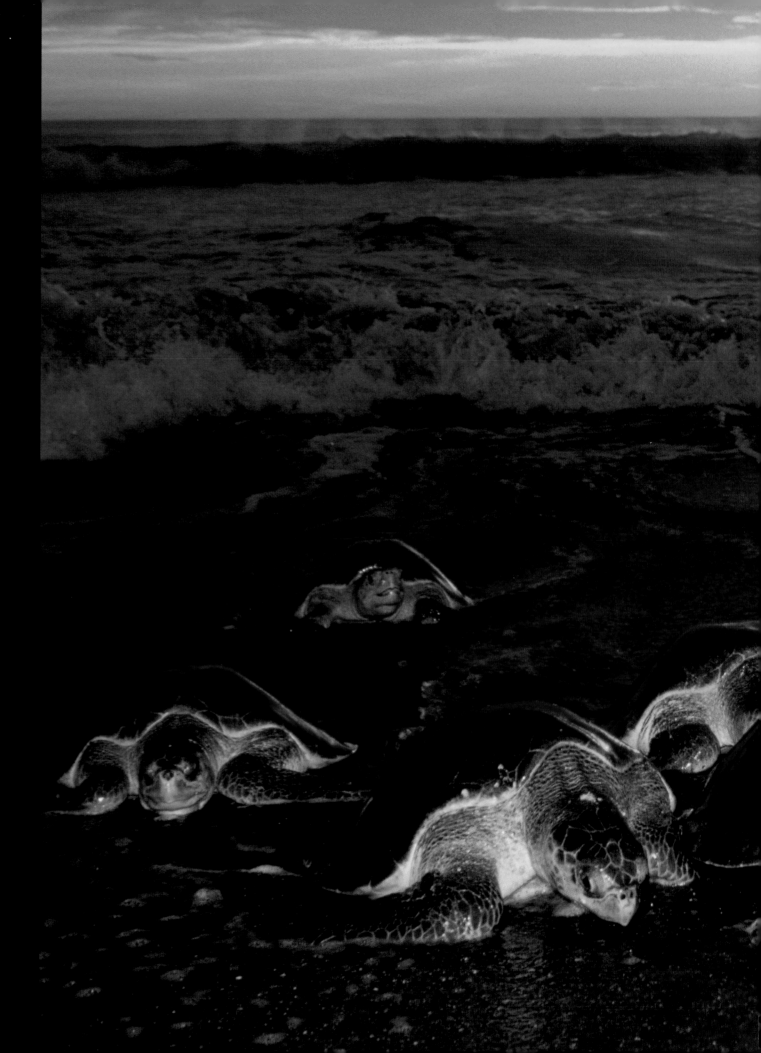

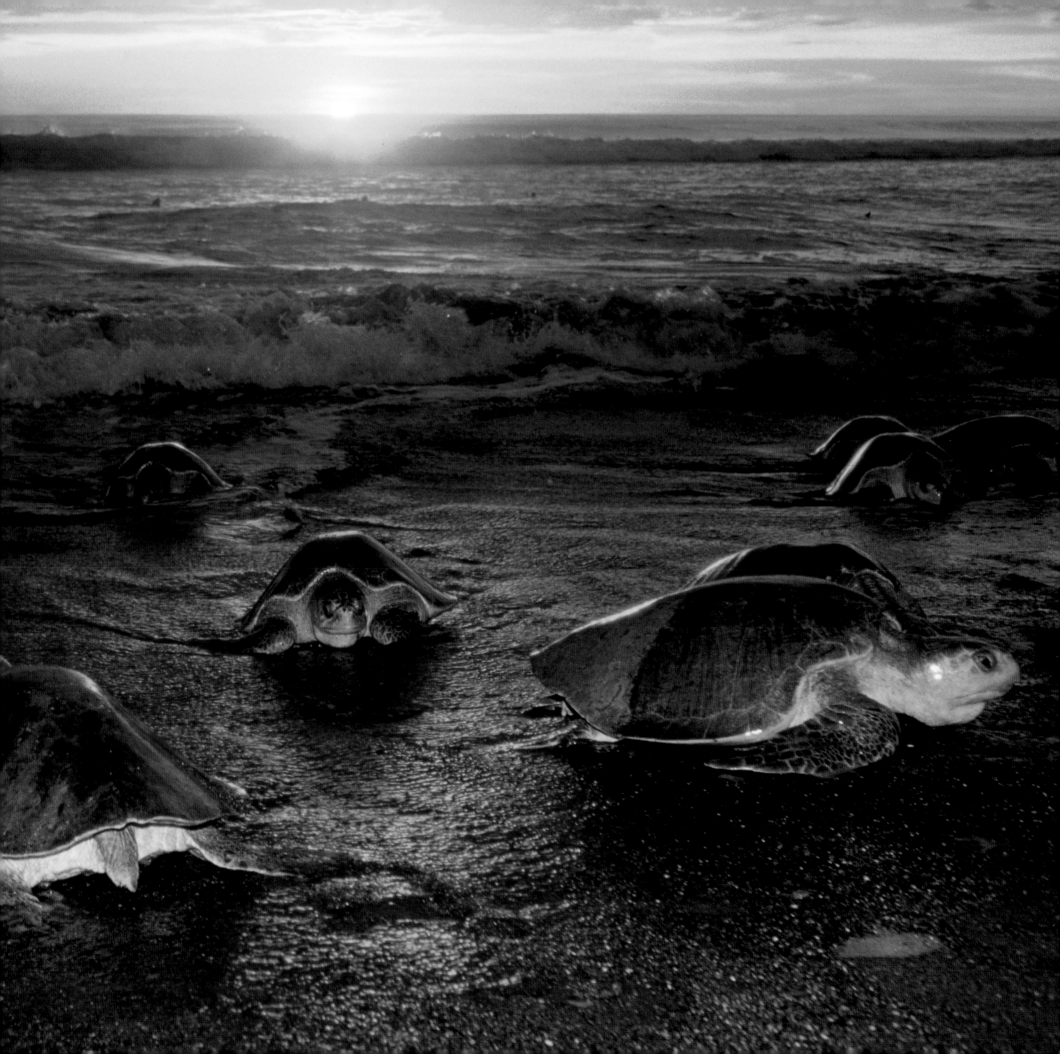

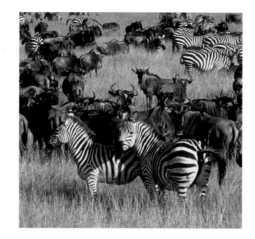

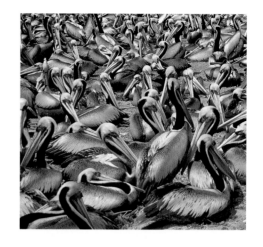

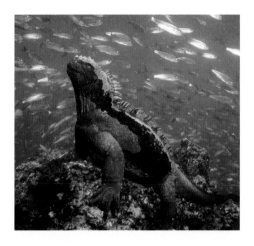

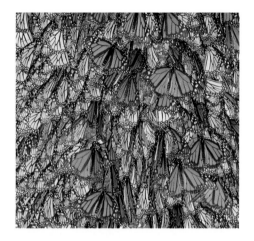

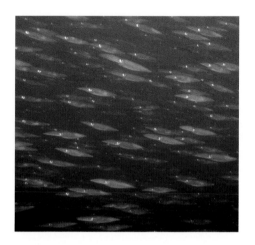

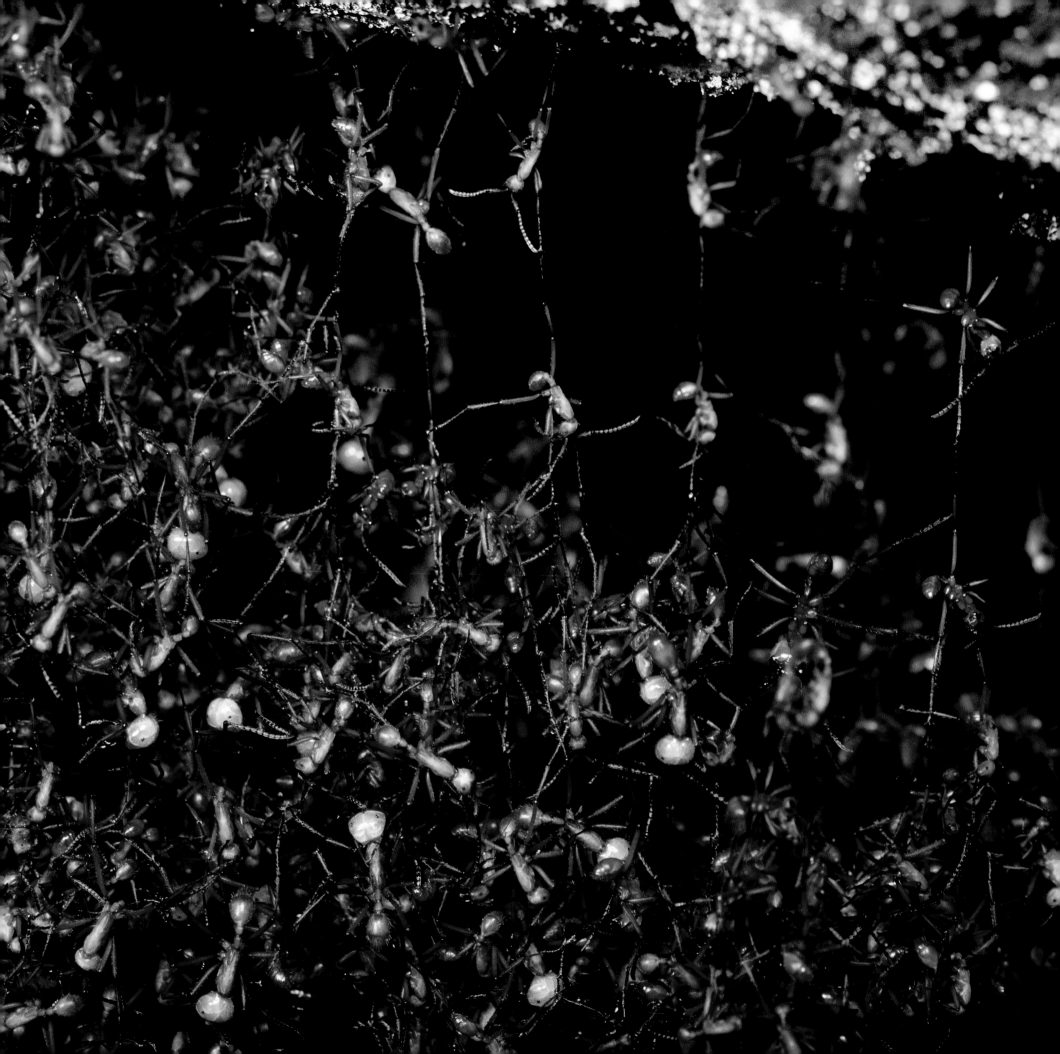

What on Earth was it? In this part of the Tilemsi Valley of northeast Mali everything is desert-brown, billiard-table flat, and virtually featureless in every direction, where distance merges into distance. At least, it normally is. This afternoon was different; in front of us was an unbroken line of indistinct black and white shapes that stretched away on both sides of the track, as far as the heat haze allowed us to see. We switched off the engine of the Land Rover, got out and watched, fascinated. The line was getting larger —whatever it was was coming our way. All we had to do was wait. After a few minutes the line had come close enough for us to resolve it into its constituent parts. It was a large flock of Abdim's storks (Ciconia abdimii), and soon thereafter we could see —and hear from their bill clatter— what they were doing. Walking line abreast into the wind, they were feeding intently on a loose swarm of grasshoppers (Aiolopus simulatrix) which was moving steadily down the valley on the wind. The storks, nearing our vehicle, divided their line with almost military precision, passed either side of us at a distance of about 50 m, snapping up grasshoppers all the while, reunited into their single row behind us, and continued their march up the valley. Jaw-dropping, simply jaw-dropping.

That this flock of several hundred, perhaps over a thousand, birds was largely unperturbed by our presence is due to the fact that they are revered by the human population in this part of Africa. Abdim's storks are inter-African migrants and arrive in the Sahelian zone of western Africa shortly before the onset of the rainy season in May-June. Their reappearance in these latitudes, from their non-breeding quarters south of the equator, is therefore taken as propitious, auguring the return of the rains and, with them, the planting of the year's millet and sorghum crops. Indeed, here they are almost commensal with man, breeding in the center of villages because this is where the largest trees now stand.

Whether we have observed them personally or only vicariously through *National Geographic* or the Discovery Channel, some of our most vivid and enduring images of the natural world are of spectacular congregations of animals. Imagine vast flocks of migratory birds so enormous that they block out the sun, schools of herrings or anchovies so large and dense that the ocean appears to be more fish than water, wildebeest migrations on the plains of Africa that stretch to the horizon, monarch butterflies that cover trees in Mexico as if they were gaily colored leaves, free-tailed bats exploding out of caves in Texas in vast, almost incalculable numbers. The innate appeal of such amazing wildlife spectacles has stimulated the production of a host of books and films over the past century, and has done much to keep inhabitants of an increasingly urban world in touch with nature. However, despite the profound impact that such spectacles have on human consciousness, remarkably little has been done to highlight the conservation importance of these congregations. This book is a contribution towards filling that gap and starting to incorporate congregatory species into conservation planning.

Conservation planning requires two key sets of information: knowledge of the "irreplaceability" of biodiversity —which is generally expressed in terms of uniqueness— and knowledge of threats to this biodiversity and costs of conserving it. Over the last decade, a number of analyses have applied such a framework at a global level. CEMEX, in collaboration with Agrupación Sierra Madre, has produced three books focused on such analyses, with the research being carried out by Conservation International: *Megadiversity*, a geopolitical assessment identifying the 17 nations holding more than 2% of the planet's plants as endemic species; *Hotspots*, focused on those ecoregions that both hold unusually high levels of endemism (more than 0.5% of the global flora) and have already lost at least 70% of their original habitat; and *Wilderness*, which assessed those areas of the planet that are still relatively intact (at least 70% of original natural habitat still remaining) and inhabited by relatively small numbers of people (population densities less than 5 people/km^2). Other global scale analyses have focused on specific taxa, for example by defining *Endemic Bird Areas of the World* and *Centers of Plant Diversity* or by assessing the *Global 200* ecoregions.

As high-quality biodiversity data become increasingly available, the same framework can be applied, at much finer scales, to identify priority sites for conservation actions on the ground. An excellent example of such analysis is that undertaken by the global BirdLife partnership of conservation organizations to identify *Important Bird Areas*. This approach is currently being expanded in collaboration with many organizations to incorporate data on taxa beyond birds in order to identify *Key Biodiversity Areas*. The framework for this approach again builds on the concepts of threat and irreplaceability. The first of these, threat, is derived directly from the *IUCN Red List of Threatened Species*. The second, irreplaceability or biodiversity value, is largely derived from the concepts of endemism developed in the assessment of global conservation strategies. However, this notion of irreplaceability has a further, special dimension: the concentration of very high proportions of the global population of particular species in particular places at particular times. Gómez de Silva Garza has neatly labeled such species "semi-endemics." Sites holding such congregations are of conservation importance for at least three reasons: 1] they are of disproportionate value for the survival of the species in question; 2] species may be particularly vulnerable when pres-

On the opposite page, army ants (Eciton hamatum) on Barro Colorado Island, Panama, in the process of building their nest. The ants hook their legs with each other, creating a thin curtain, which quickly thickens to create a solid wall of interlocked ants. This is a colony of perhaps some 300 000 ants.
© Christian Ziegler

On pp. 34-35, Steller's sea lion (Eumetopias jubatus) hauled out on land on Brothers Island, Alaska.
© Tim Fitzharris/Minden Pictures

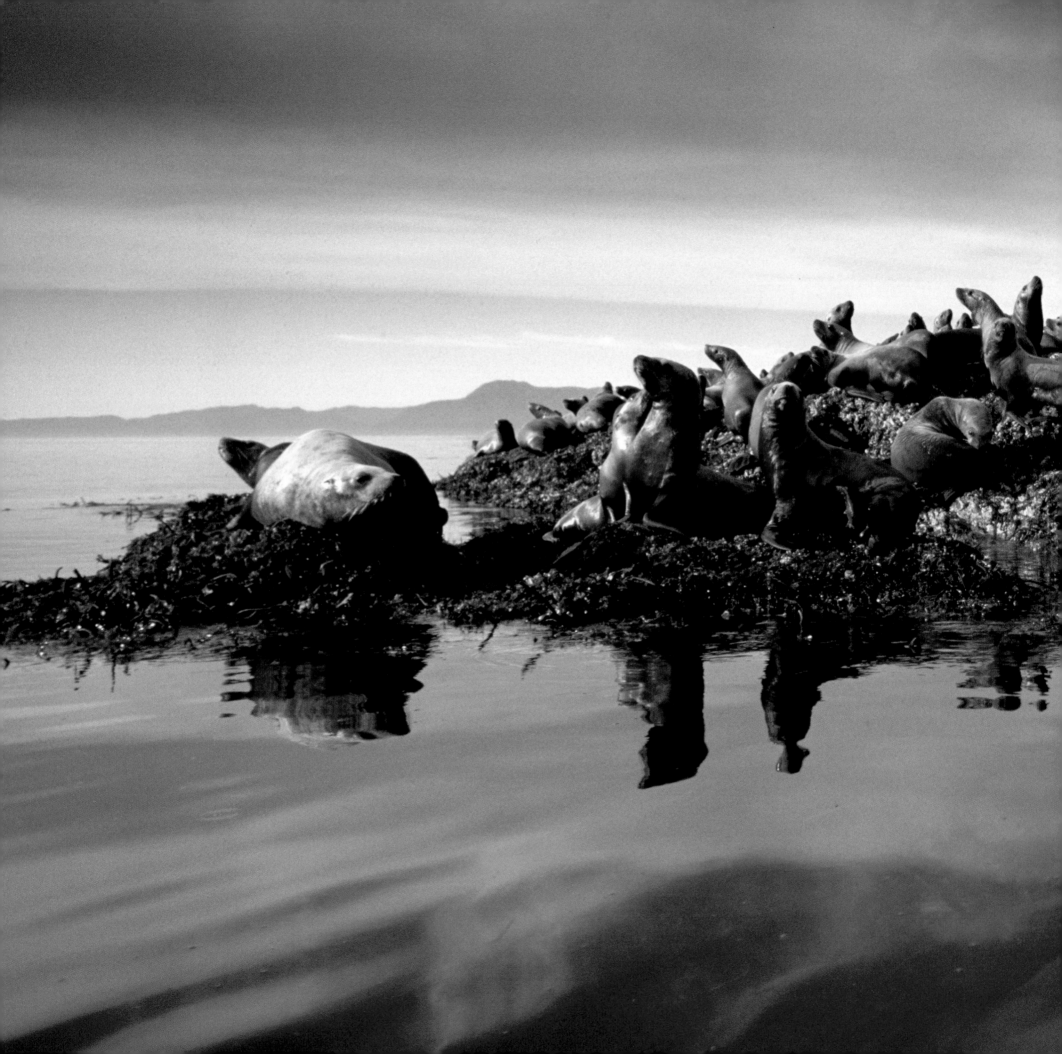

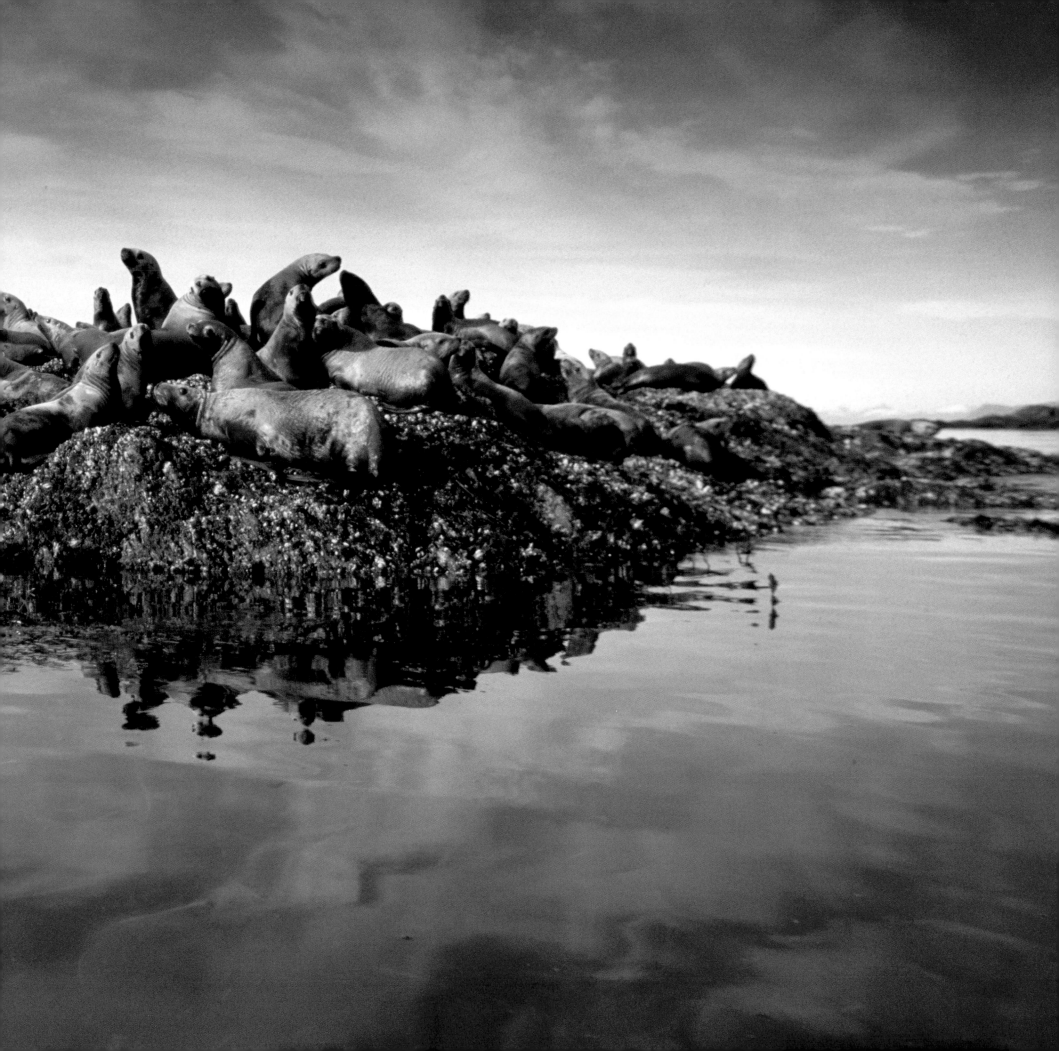

ent in such congregations (for example, due to exhaustion from breeding or migration); and 3] such congregations have biodiversity value in their own right, over and above that of the species comprising them. These remarkable concentrations, although perhaps well studied by field biologists and popular with nature photographers, have been much overlooked in the discussion of global conservation strategies. The only examples of explicit incorporation of species congregations into conservation planning come from bird conservation organizations; for example, BirdLife International includes species congregations as a criterion for defining *Important Bird Areas*.

In this book, we take this congregatory species approach beyond birds by surveying nature for conspicuous congregations of species, which we refer to as *Wildlife Spectacles*. Consideration of these must be an integral part of global conservation strategies, particularly since some widespread and normally non-threatened "common" species —which may consequently be ignored by conservation strategies— face significant extinction threats during times when a large proportion of their population congregates in a few sites. Conservation of congregatory species first requires cataloguing these species, and then identifying the sites at which their congregations occur. This book aims to initiate this analysis, and to stimulate further research into threats to these congregatory species, and critical thresholds for numbers of individuals that trigger sites of importance for them.

We do not suggest that all animal congregations of unusually large size are threatened, or that all species in which such assemblages occur should be considered high-conservation priorities. Rather, they are conservation targets, "outcomes" for conservation at the site scale. We also believe that these wonderful wildlife spectacles are of particular importance to our own species, and serve to bring home to us —perhaps more than anything else— the sheer wonder and magnificence of the natural world.

The definition of wildlife spectacles

In order to move from a purely qualitative celebration of vast animal concentrations towards a science-driven analysis of the irreplaceability of such congregation sites, and hence their importance for conservation, it is first necessary to provide guidelines on what we consider to be a "wildlife spectacle." This is complicated for numerous reasons. Large-bodied species often appear more "spectacular" to the human eye, and hence there may be publicity reasons to consider even small groups of such species as spectacles. Conversely, small-bodied species are often

extremely numerous, and so the compilation of quantitative data on their populations may be perceived as impossible.

Despite these complications, there is considerable precedent for identifying sites known to be important "meeting points" for congregations of animals, mainly from BirdLife International's *Important Bird Area* program. According to criteria identified by BirdLife, the site may qualify on any one or more of the following: 1] if the site is known or thought to hold, on a regular basis, 1% or more of a population of a congregatory waterbird species that is restricted to a particular zoogeographic region (e.g., the Afrotropical region); 2] if the site is known or thought to hold, on a regular basis, 1% or more of the global population of a congregatory seabird or terrestrial species; 3] if the site is known or thought to hold, on a regular basis, at least 20 000 waterbirds, or at least 10 000 pairs of a seabird, of one or more species; or 4] if the site is known or thought to be a "bottleneck site," where at least 20 000 pelicans (Pelecanidae), storks (Ciconiidae), raptors (Accipitriformes and Falconiformes), or cranes (Gruidae) pass regularly during spring or autumn migration. These criteria apply to those bird species that are thought to be vulnerable, at the population level, to the destruction or degradation of sites, by virtue of their congregatory behavior at any stage in their life cycles. Importantly, the first and third criteria have direct parallels with two of the criteria used for site identification under the Ramsar Convention on Wetlands. In addition, the American Bird Conservancy has used a similar criterion in its identification of *Important Bird Areas* for the U.S., namely "sites that contain large congregations of migratory birds."

Of course, central to the correct application of these criteria is a clear understanding of what represents a site, and how to go about defining the boundaries of such a site. Here again, Birdlife has identified certain criteria that define such sites with relevance to birds. According to these guidelines, a site should, as far as possible: 1] be different in character or habitat or ornithological importance from the surrounding area; 2] exist as an actual or potential protected area, with or without buffer zones, or as an area which can be managed in some way for nature conservation; and 3] exist, alone or with other sites, as a self-sufficient area which provides all the requirements of the birds, when present, and for which it is important.

So far, more than 2 000 *Important Bird Areas* have been identified based on the criterion for congregations, across Africa, the Middle East, and Europe. As the *Important Bird Areas* program develops across the Americas and Asia, doubtless several thousand more such sites will be identified. Indeed, for several of the bird groups addressed here, particularly shorebirds and waterfowl, but also flamingos and penguins, some preliminary assess-

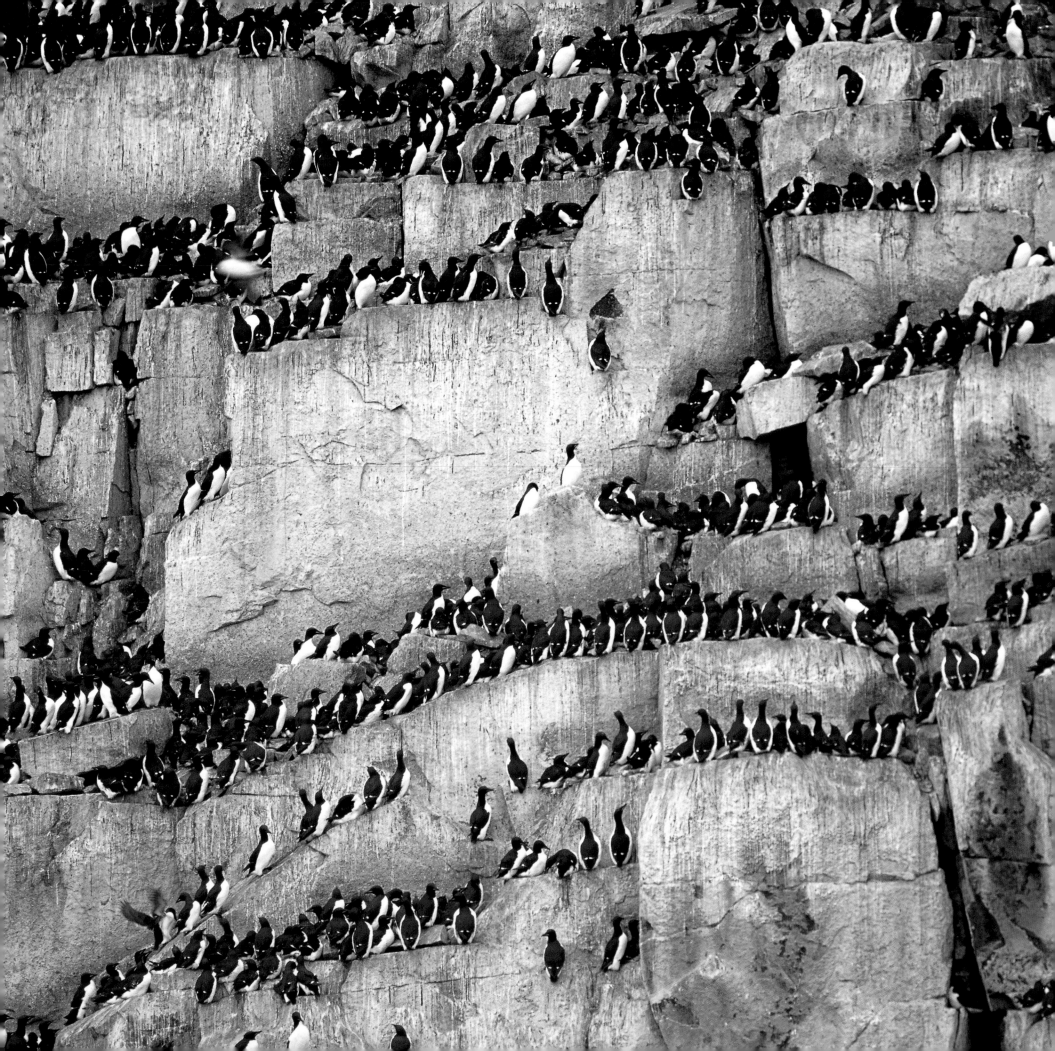

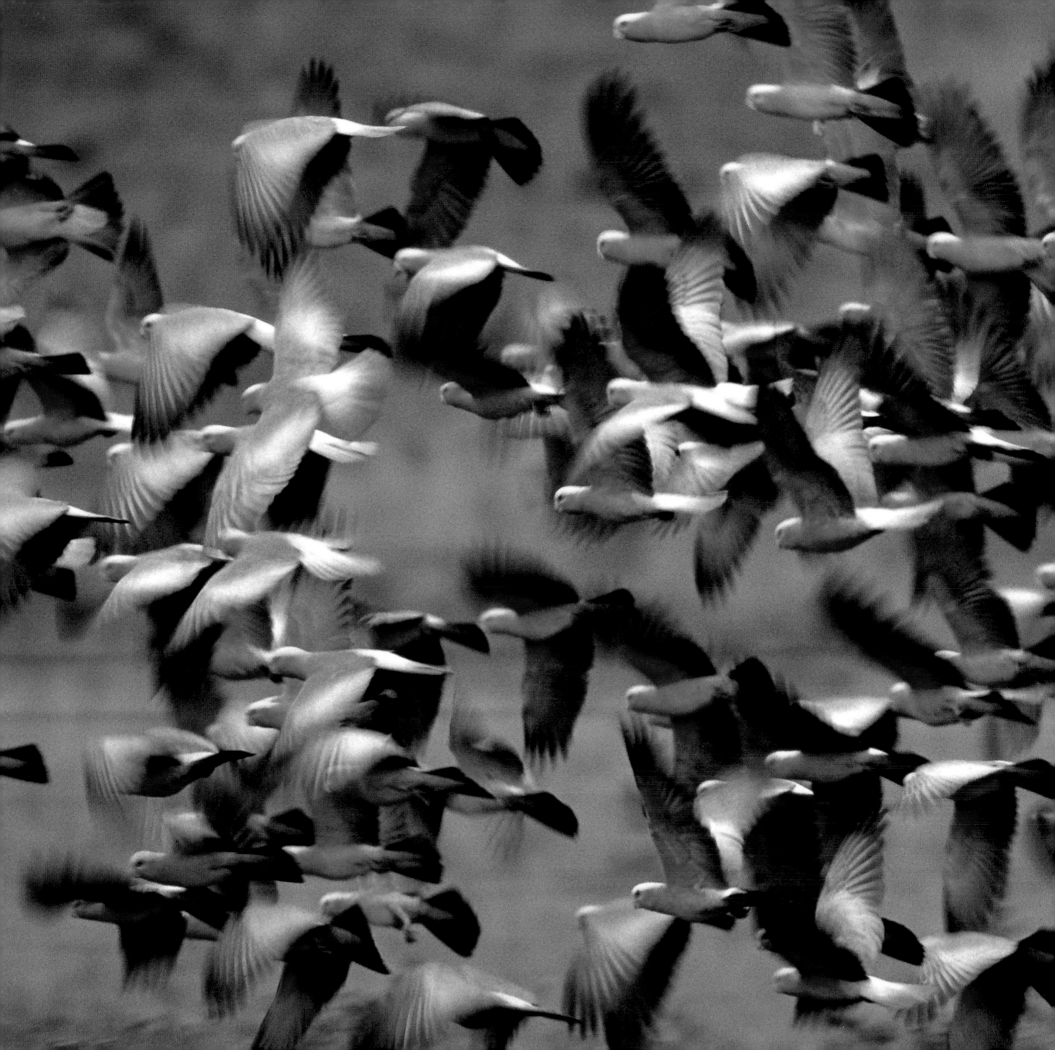

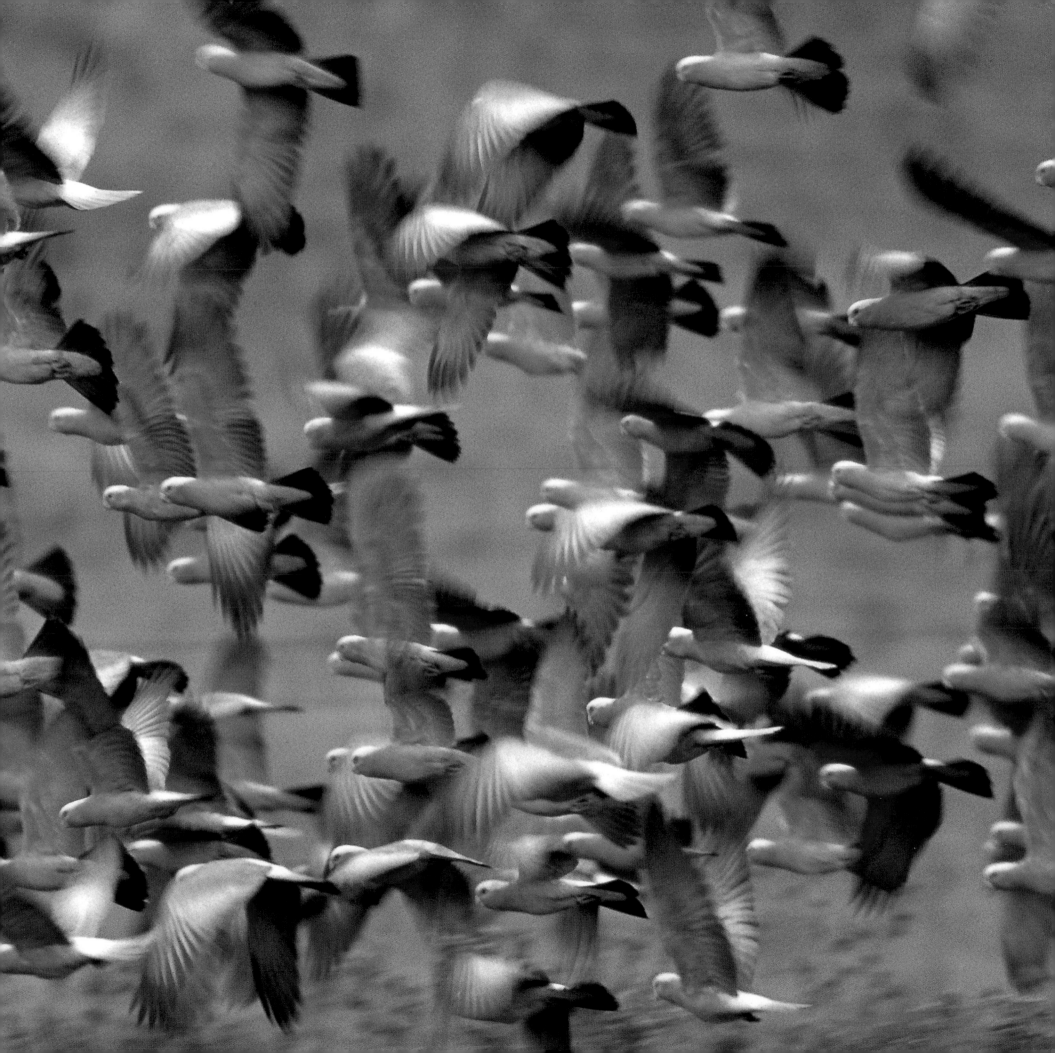

ment by the authors has enabled us to start identifying those sites triggering the *Important Bird Area* criterion for congregatory species in the Americas and Asia.

However, while the BirdLife criteria represent a reasonable and widely accepted methodology for identifying important concentrations of birds, they have not been extensively tested outside this arena. To assess the suitability of the approach for other taxa, and to define appropriate criteria and thresholds, much more information is needed —particularly on global population sizes. Recognizing this paucity of information, we attempt to highlight an array of unusually large wildlife congregations that are obvious phenomena that can be studied and compared; wherever possible, we take this to the level of individual sites holding >1% of a particular species' global population in a particular place at a particular time.

For those species for which site-scale congregation data were available, we provide a detailed map highlighting these sites. Not surprisingly, such detailed data were only available for birds, and readers with further questions regarding these datasets should contact the relevant chapter authors directly. For most other species, data at the site scale were simply not available, and so instead maps have been compiled showing the extent of occurrence distributions of the species in question (e.g., saiga and oilbirds). In all cases where maps are provided, effort has been made to interpret these data by including the locations and directions of flyways and migration routes. In a few cases (e.g., amphibians, jellyfish, and ants and termites), even extent of occurrence data could not be usefully mapped. Thus, for these latter species, this current work highlights targets for future research more generally than it does conservation priorities.

We should point out that this book deliberately omits one set of species that could arguably be described as "congregatory": none of our chapters address plants (or, indeed, fungi). It could be argued that mono-dominant plant communities —such as the quaking aspen (*Populus tremuloides*), which boasts the world's largest living organism, an 800-hectare grove— are congregations over evolutionary or even ecological time. However, there is a substantive difference between plant congregations and the animal congregations examined here. All of the animal congregations are *ephemerata*, which means that they only occur at particular places at particular points in time (whether over the course of many years, annually, seasonally, or even daily).

One final caveat with regard to determining which species we consider as wildlife spectacles is that species with restricted ranges often appear congregatory when they are actually just clumped in space due to a factor such as habitat preferences or geographical isolation. Many of these species have tiny ranges and tiny population sizes, and so groups of just a handful of individuals could easily meet the criterion of 1% of the global population. To define these as "spectacles," however, would be stretching credibility and, in any case, such species are already well covered by numerous other conservation approaches. For some restricted-range species, the situation is even less clear; for example, Galápagos tortoises, Christmas Island crabs, and gelada baboons, all clearly have restricted ranges, but the first two also have obvious temporal concentrations, and the latter species is highly gregarious within its small range. To draw attention to these species, they have been included in this book.

The scope and causes of wildlife spectacles

The factors that bring together large numbers of animals fall into four broad categories: climate, food, defense, and reproduction. Changing seasons tend to usher some species in and out of torpor, during which times unusually large concentrations of individuals may form, or the same changes may trigger mass migrations to more suitable climes. The quest for food can also cause spectacular wildlife groupings and movements, whether the events are unique and irruptive in nature, or of more predictable and periodic occurrence. Likewise, congregations can form to provide increased vigilance and response against predators —the axiom "safety in numbers" has a solid basis in fact. Lastly, among sexually reproductive organisms, the need to procreate is often the primary stimulus behind large aggregations of the two sexes.

Beyond these four distinct categories, however, we must recognize that multiple causal factors are the general rule in describing unusually prolific congregations. For example, the coordinated mass movements of animals from higher to lower latitudes in advance of severe winter weather represent innate responses to changing climatic conditions, but these movements are also likely to yield more abundant or nutritious food resources. The return migrations, by comparison, may be driven by the same nutritional needs —the temporal availability of food resources that are critical to the survival of the impending generation— while being equally essential to overall reproductive success. Thus we can not cleanly categorize large associations of animals according to a single behavioral or ecological purpose. We can, however, make some general observations about the conditions under which congregations tend to occur and how these phenomena differ from one group of organisms to the next.

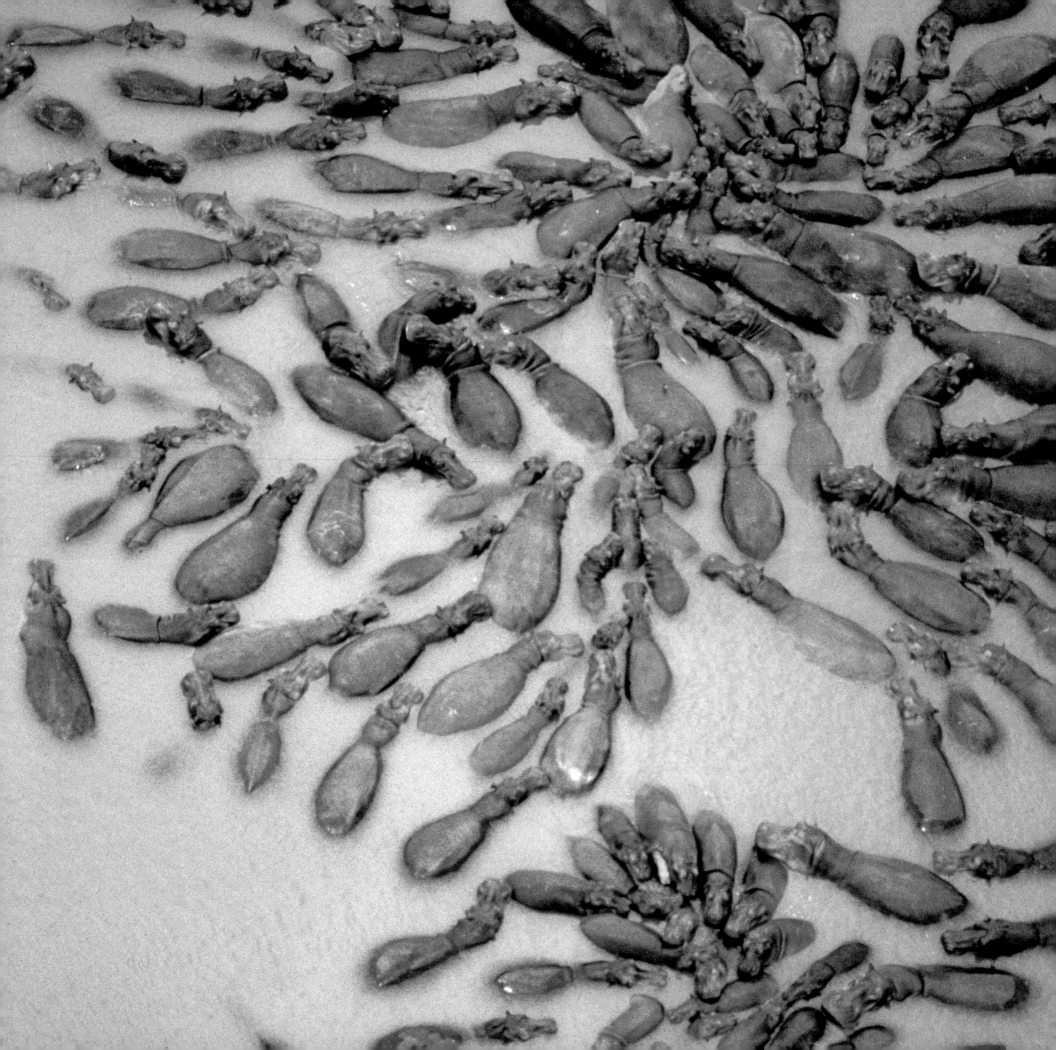

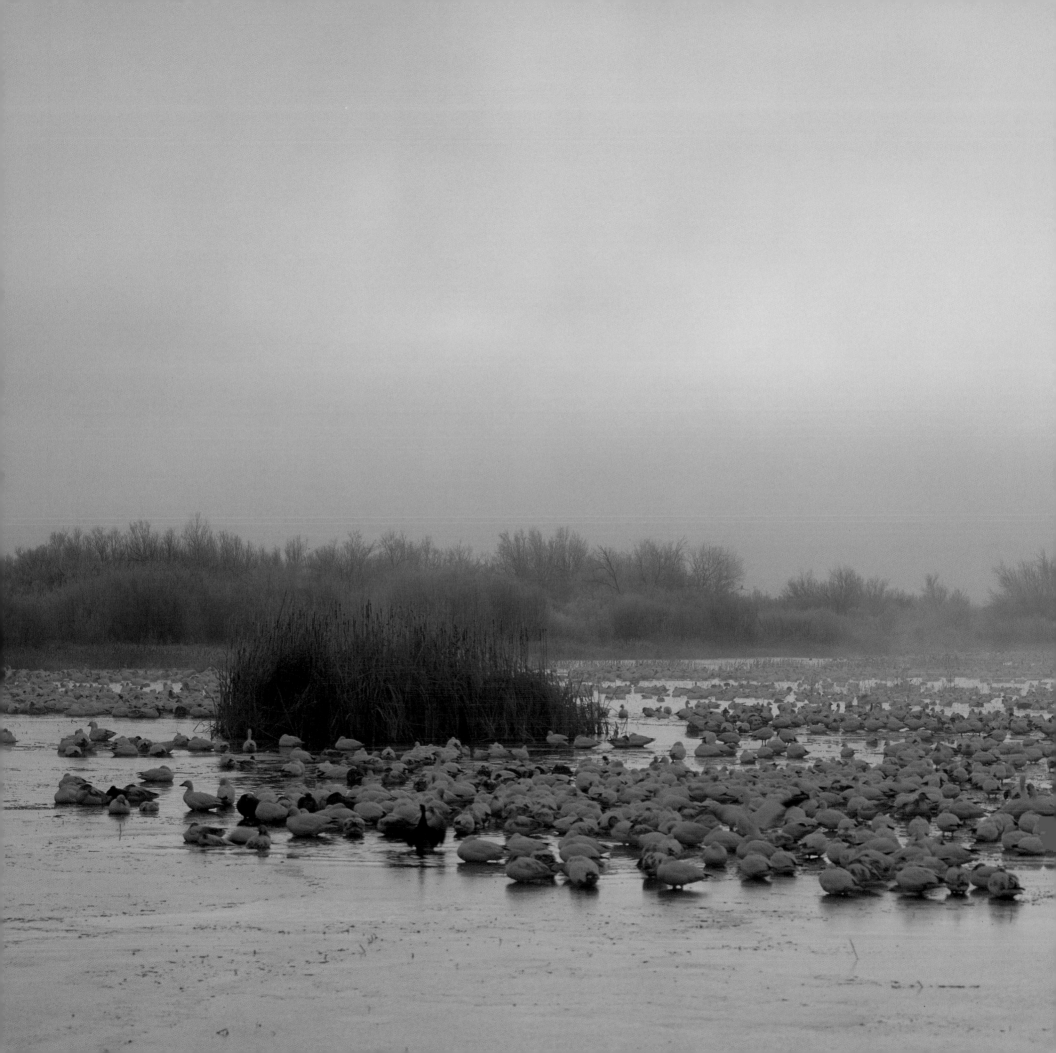

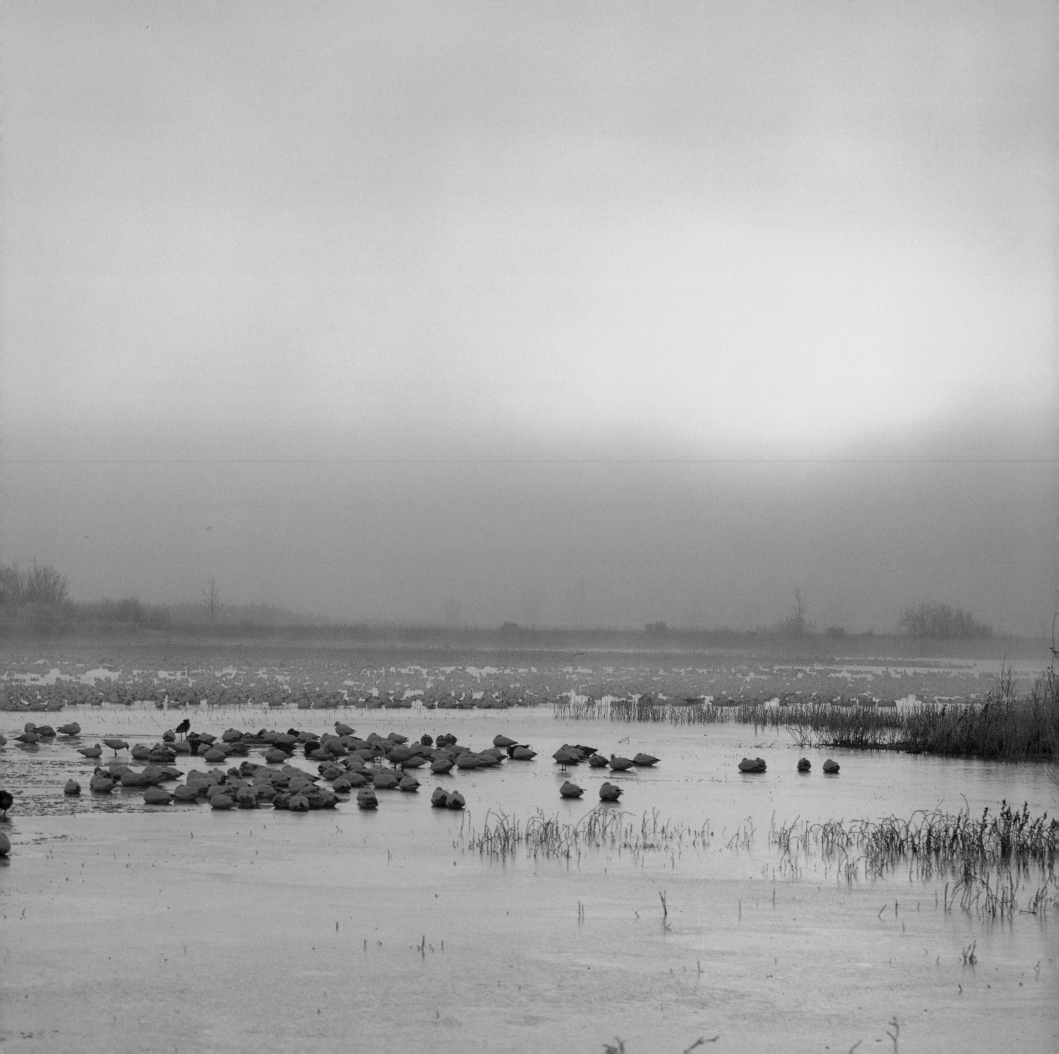

Many large wildlife assemblages occur as part of migratory processes. According to Orr, migration is "the movement of populations." The movement may be toward suitable breeding areas at the proper time of the year or at the appropriate period in the life of the individual. It may be governed by seasonal climatic conditions. It may also take populations into regions where there is suitable food and habitat available at certain seasons of the year. Migrations tend to be round trips. They also tend to be periodic. Some are completed in the course of a day. Others are annual. A few span lifetimes. As you would expect, migrations factor prominently in our survey of wildlife spectacles. They are phenomena that occur across the Animal Kingdom, but remain peculiar to relatively few species' groups.

The huge datasets compiled to date by the BirdLife partnership, Wetlands International, the American Bird Conservancy, and other organizations, enable wildlife spectacles to be evaluated systematically across the Class Aves. Very many of the bird species that congregate are waterbirds. These include many of those that favor marine environments such as penguins (Spheniscidae) and albatrosses, shearwaters, and petrels (Procellariiformes), tropicbirds (Phaethontidae), boobies and gannets (Sulidae), many cormorants (Phalacrocoracidae), frigatebirds (Fregatidae), some ducks (Anatidae), skuas (Stercorariidae), some gulls (Laridae), terns (Sternidae), and auks (Alcidae). Also included are birds that occur in freshwater environments comprising most pelicans (Pelecanidae), the majority of herons and egrets (Ardeidae), some coots and gallinules (Rallidae), many ducks, geese and swans (Anatidae); many other storks (Ciconiidae) and some cranes (Gruidae); and many of the shorebirds, waders, plovers, stilts, and similar birds (Charadriiformes). The flamingos (Phoenicopteridae) specialize in wetlands that the other species mostly avoid —soda lakes and other hypersaline water bodies.

Proportionately, fewer "landbirds" congregate to the same degree as "waterbirds." Nevertheless, they comprise a heterogeneous group: sandgrouse (Pteroclidae), pigeons such as the eared dove (Zenaida auriculata), many diurnal birds of prey (Accipitridae and Falconidae), the curious oilbird (Steatornis caripensis) that is the sole member of the Family Steatornithidae, some parrots and macaws, many swifts (Apodidae) and bee-eaters (Meropidae), plus a few species from among the many families of perching or passerine birds (Passeriformes). Those species from this group that do congregate include some swallows (Hirundinidae) and wagtails (Motacillidae), a number of the weaver birds (Ploceidae) —most spectacularly the red-billed quelea (Quelea quelea) which, congregating in flocks of millions, becomes the scourge of farmers across much of Africa—, the bobolink (Dolichonyx oryzivorus),

dickcissels (Spiza americana) wintering in the Venezuelan Llanos and, one of the most familiar of all, in northern urban environments at least, the European starling (Sturnus vulgaris).

A feature of many of these bird species is that, like the Abdim's storks described earlier, they are migratory. They are migratory because they need to be able to avoid places that undergo periods of food scarcity and severe weather, but are then able to move back again to exploit those same places, often in a relative absence of competition, when conditions ameliorate (e.g., waterfowl). Of course, many passerines are also migratory but do not migrate in large flocks in the way that many larger birds do. This is at least partly a consequence of physics —the energy saving in flight costs that accrues to large-bodied species from slipstreaming behind each other is considerable. Further, large birds of prey and others such as storks and cranes gain much benefit from using the thermal air currents that develop over land during the day, obliging them to funnel through well-defined bottlenecks in order that they minimize the time spent in energetically expensive flight above the ocean.

Other species are congregatory because their specialized nesting requirements mean the places available to them are narrowly circumscribed, such as caves (e.g., for oilbirds), and often remote from their feeding grounds. Thus, many pelagic seabirds nest in huge colonies on small offshore or oceanic islands. This is because safety from predators is inherent in the isolation of these islands. Avoidance of predation is itself a further reason why birds congregate; proverbially, there is safety in numbers. Sheer numbers of birds, often moving as one, can confuse, disorient and, often, frustrate a potential predator, as well as provide a stunning display to the human observer, as anyone who has watched the aerobatics of a flock of shorebirds in response to the threat of a peregrine falcon (Falco peregrinus) can attest. Other reasons for congregatory behavior may be more specific. They include dietary supplements at localized sources, even the attraction of patches of exposed clay deposits for macaws and of desert waterholes for sandgrouse.

Penguins, specifically the male emperor penguin (Aptenodytes forsteri), also provide the best example of an animal aggregating for warmth. The female emperor lays her single egg in May, at the end of the austral autumn, passes it to her mate and then promptly trundles back to the sea, leaving the male to face the raw edge of winter and parenting alone. The male carries the egg for the full 64-day incubation period, enduring blizzard after blizzard in continuous polar darkness, fasting for 15 weeks or more and losing half of his body weight. Male emperors meet this challenge by huddling together on the exposed surface of the sea ice. By packing in tight groups, about 10 birds per square

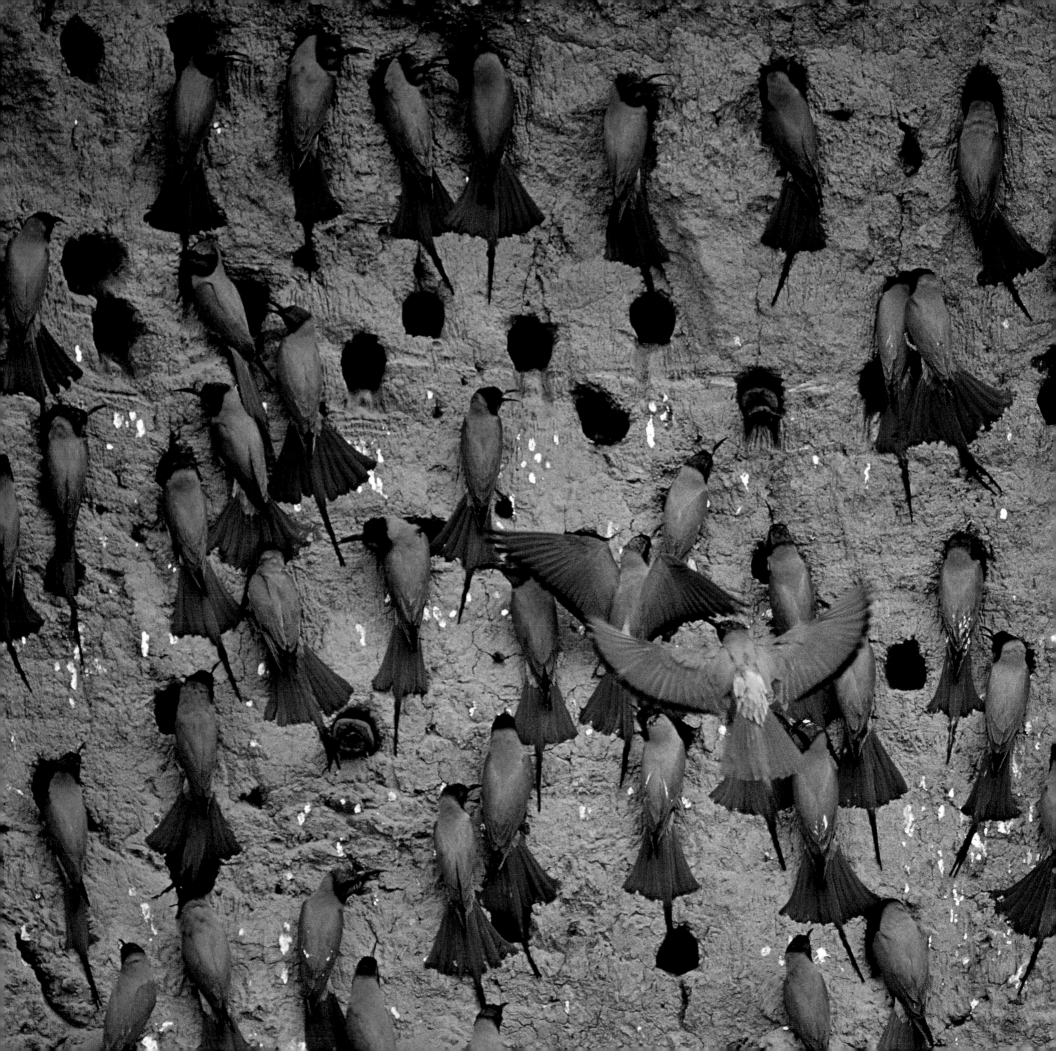

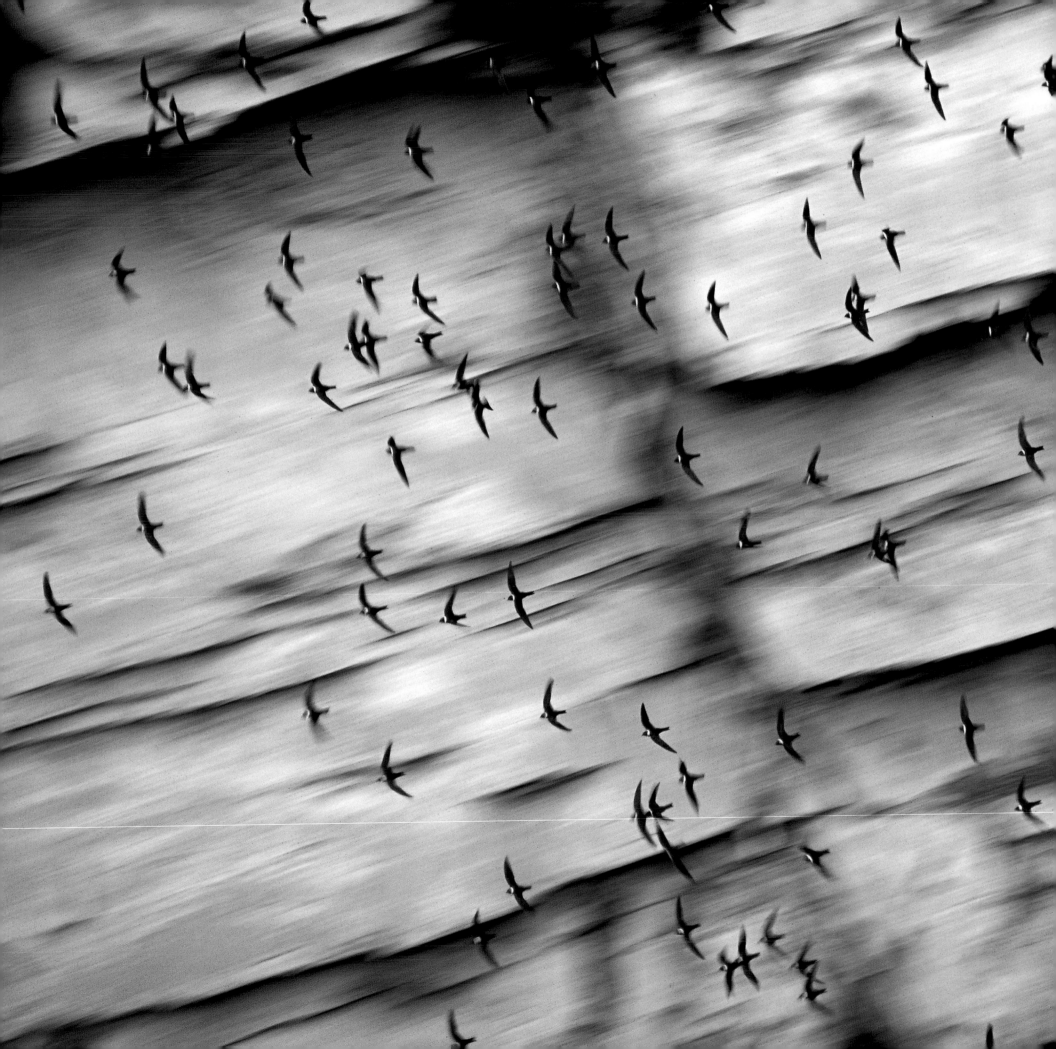

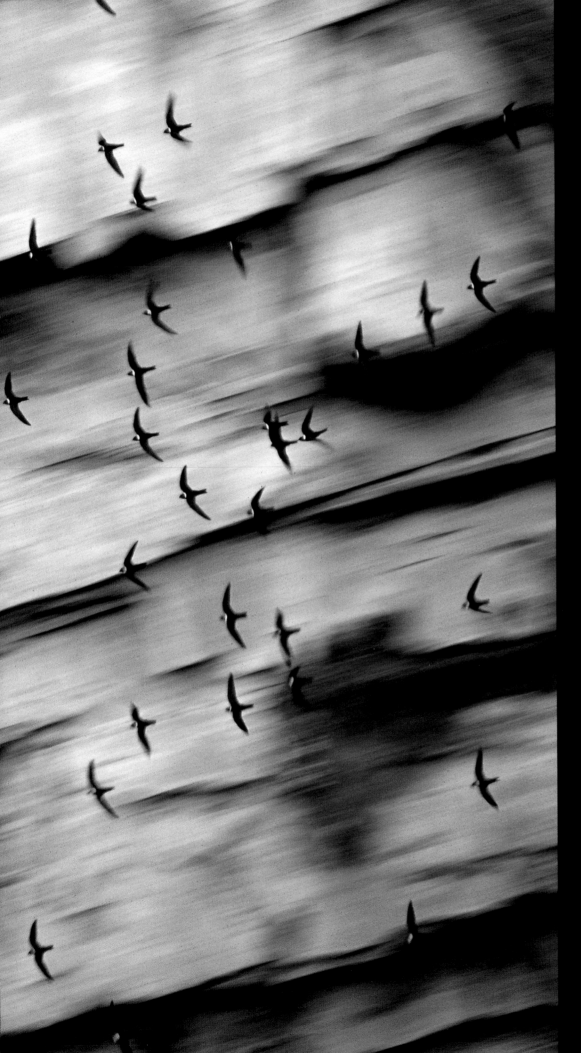

*White-collared swifts (Streptoprocne zonaris)
coming out of a sinkhole at Huasteca
Potosina, Mexico. Within their large range
in the Neotropics,
white-collared swifts often occur in montane
or hilly areas, up to almost 4 400 m
in the Andes.*
© Patricio Robles Gil/Sierra Madre

47

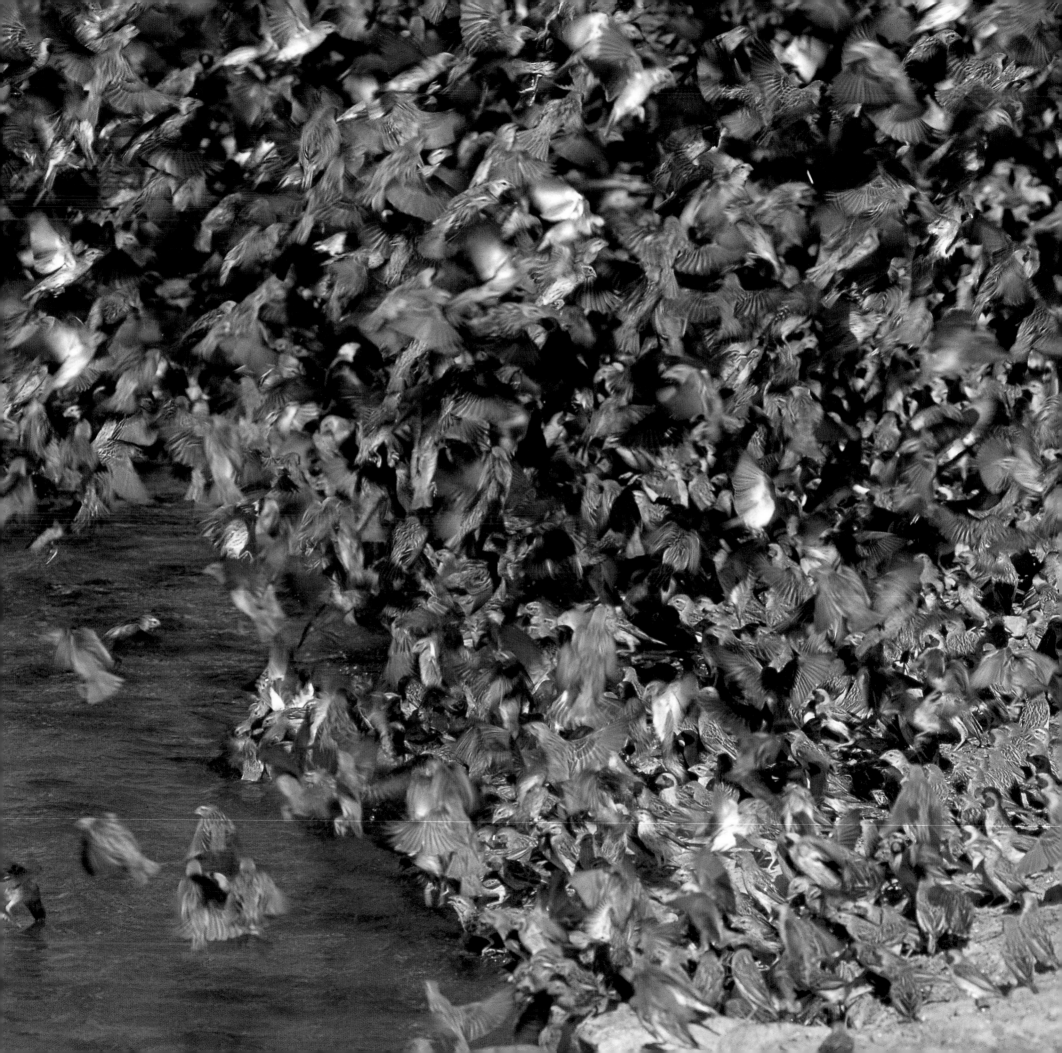

meter, an individual emperor reduces the surface area of its body that is exposed to the heat-stealing wind and cold. This translates into an energy saving of 150 per cent! As many as 5 000 male emperors may cluster together like this in a single group. Without this clustering behavior, the birds could never endure their lengthy winter fasts.

Moving beyond birds, there is no doubt that a broad, open landscape overflowing with huge herds of large mammals can provide vistas resembling those of the Pleistocene Era. Many congregatory species of mammals are large-bodied, and occur in disproportionately large numbers in Africa, which is perhaps a product of the co-evolution of humans with large mammals there. The congregatory behavior of most large African mammals is largely determined by prevailing climatic conditions. For example, the largest herds of African elephants (*Loxodonta africana*) —approaching 1 000 animals— tend to come from East Africa, and appear to represent temporary associations of smaller herds brought together by drought or human-caused disruptions of normal social behavior. East Africa is also home to the world's best known mammalian migration, that of the blue wildebeest or brindled gnu (*Connochaetes taurinus*). Throughout much of the arid year, this species occurs in small herds. When the rains come, however, many hundreds of thousands of animals migrate together with herds of Thomson's gazelle (*Gazella thomsonii*) and Plains zebra (*Equus burchellii*) across the Serengeti in search of green pasture and their calving grounds.

East of the Gregory Rift Valley, in the Tarangire ecosystem, a smaller-scale situation occurs as about 45 000 wildebeest of a separate subspecies concentrate in the 2 600-km^2 Tarangire National Park during the dry season. During the wet season, they range widely over the huge and poorly protected Masai steppe. Further south, the massive Selous ecosystem is home to more than 70 000 Nyassa wildebeest while in Zambia the Liuwa Plains National Park in the west holds a migratory population of at least 25 000 of another wildebeest subspecies. Besides these important wildebeest populations, various factors have conspired to confine wildlife populations to particular locations, many of them outside of protected areas. For example, the Kilombero Game Controlled Area in the Selous ecosystem holds more than 70% of the world's 75 000-odd puku (*Kobus vardonii*), while a number of sites in Zambia and northern Botswana hold important populations of lechwe (*Kobus leche*), namely the Kafue Flats (between 50 000 and 70 000 Kafue lechwe), the Bangweulu Swamps (around 30 000 black lechwe), and the Okavango Delta (perhaps 70 000 red lechwe).

Asian and North American landscapes are also home to some impressive congregations of large hooved mammals. The blackbuck (*Antilope cervicapra*) of southern Asia once moved in herds several thousands strong, the Tibetan antelope (*Pantholops hodgsoni*) in numbers perhaps an order of magnitude greater, and the saiga (*Saiga tatarica*) of northern Asia in migrations ten times greater still. Today, sadly, none of these creatures assemble in congregations anywhere near their former sizes. However, the eastern steppe of Mongolia is still home to more than a million Mongolian gazelles (*Procapra gutturosa*), which exhibit their own migratory movements during the summer and fall, with herds some 30 000 strong. But these examples pale in significance when compared to the caribou, or reindeer (*Rangifer tarandus*), an inhabitant of the Holarctic tundra and boreal forest: each year, herds numbering as many as half a million animals migrate seasonally between the two biomes. The species has been domesticated throughout much of Scandinavia and western Russia, where human herders migrate along with their reindeer.

Among other land mammals, hooved ones aside, congregatory tendencies are restricted to a few primate species and a handful of rodents such as prairie dogs and lemmings. As with birds, however, marine mammal species are disproportionately congregatory. The range of conditions and behaviors associated with large congregations of pinnipeds is truly diverse. For example, the two-ton elephant seals (*Mirounga* spp.), with one species inhabiting the northern Pacific and one the southern oceans, assemble in breeding colonies of a thousand individuals or more. The same is true for the walrus (*Odobenus rosmarus*), a similar-sized creature of Arctic coastal regions. Winters are literally spent on thin ice to facilitate feeding in the sea. The females tend to remain on the ice in summer as well, where they raise their young, while males may assemble on rocky coasts. Outside the breeding season, dense, sexually segregated colonies of several thousand individuals may assemble; breeding colonies tend to be more dispersed. In a few special places of the planet even some of the great whales congregate. For instance, gray whales (*Eschrichtius robustus*) of the eastern Pacific pass very close to the coast in early winter on their long migration south to Baja California's Scammon Lagoon, where they calve about every second year, and where whalers used to harpoon them by the thousands each season. This pattern of wintering, calving, and fasting in subtropical waters, while feeding at the higher latitudes, is common among cetacean populations worldwide: humpback whales (*Megaptera novaeangliae*) in coastal waters off Brazil and Hawaii; killer whales (*Orcinus orca*) in Alaska's Kenai Fjords; blue whales (*Balaenoptera musculus*) around California's Channel Islands; right whales (*Eubalaena glacialis*) off the coast of Georgia in the southeastern U.S.; bottlenose dolphins (*Tursiops truncatus*)

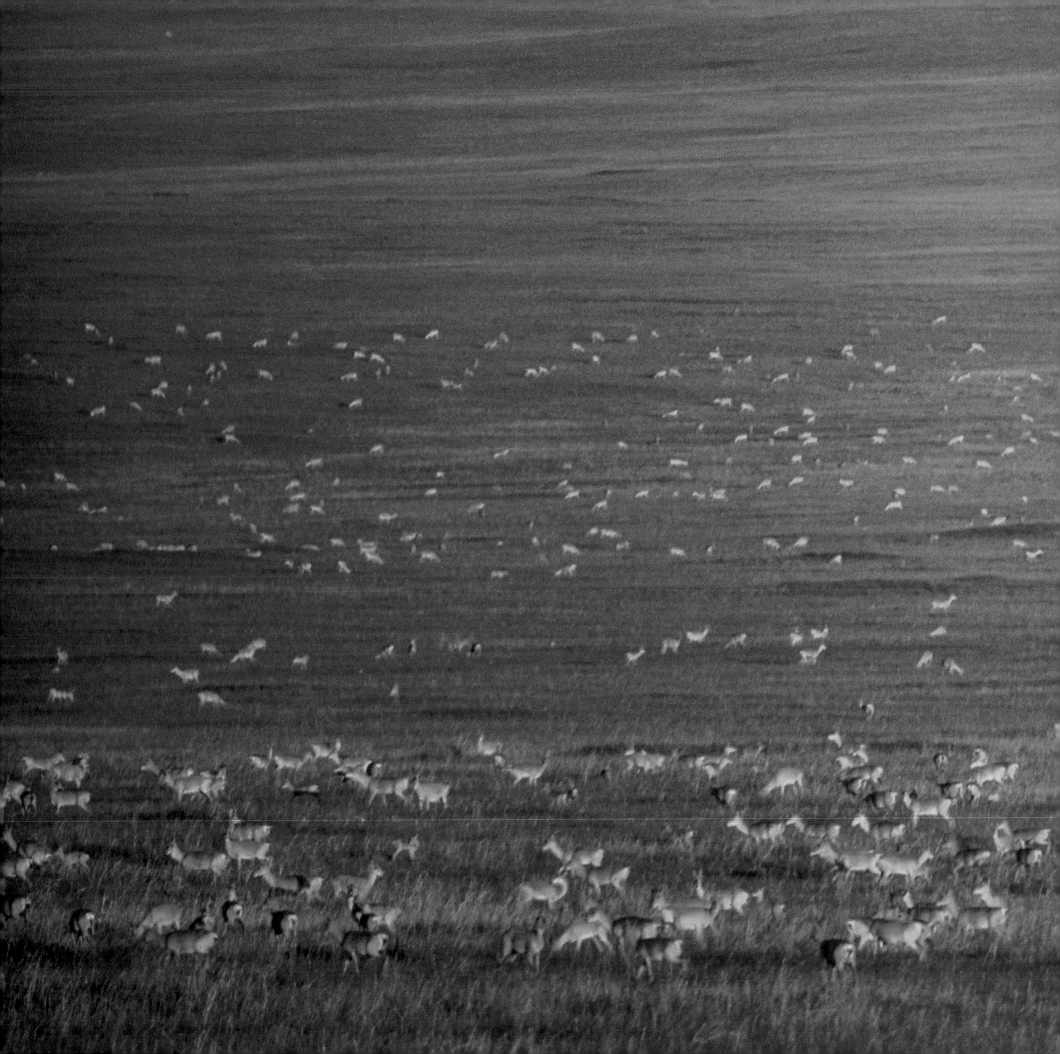

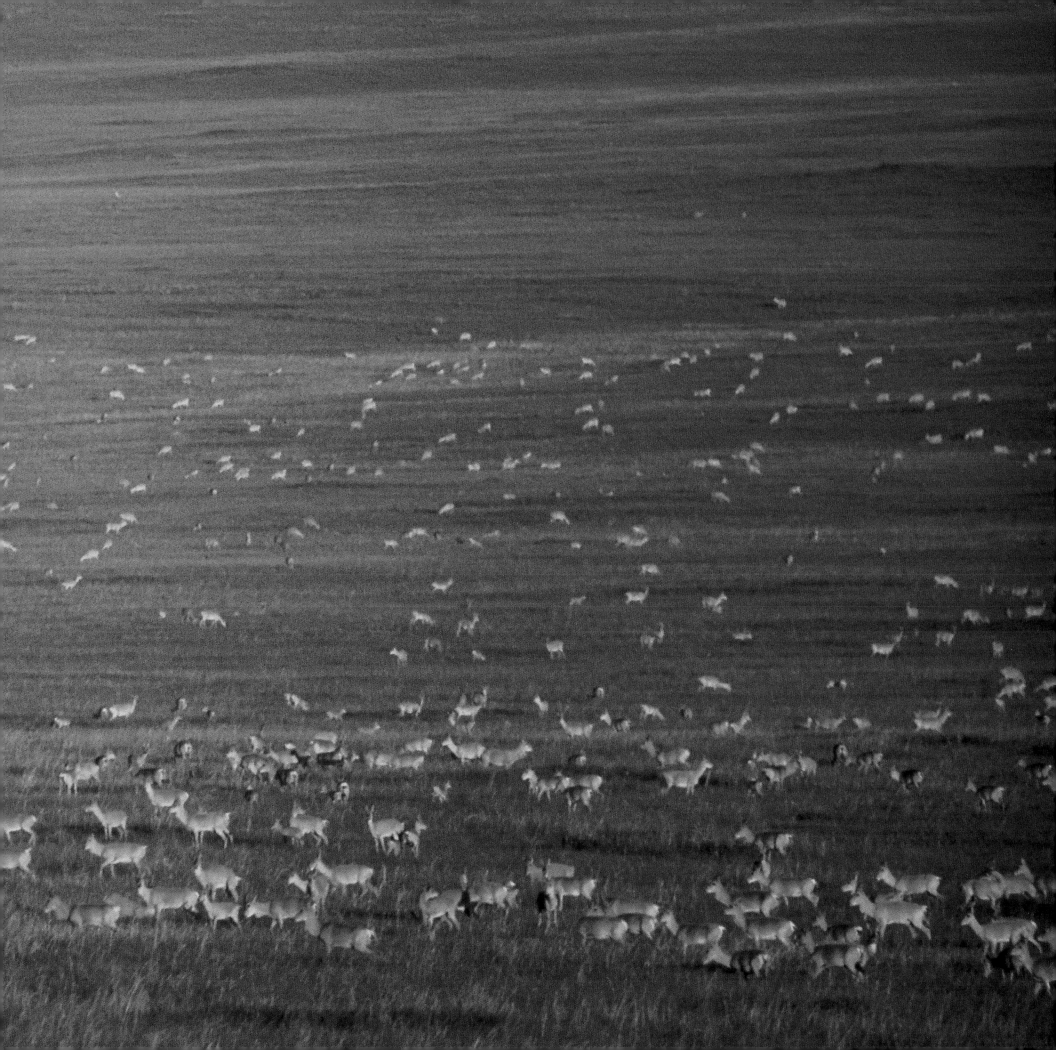

off the coasts of Florida; and long-beaked common dolphins (*Delphinus capensis*) off the southern African coast.

However, the record for the largest concentration of individual mammals —numbering in the millions crammed into tiny spaces— is held by the bats. Many bats migrate seasonally over considerable distances between roosts and hibernation caves, but it is the nightly foraging flights that draw the many thousands of visitors each year to Carlsbad Caverns National Park, New Mexico, where they may witness bats emerging from their summer maternity roosts at rates that sometimes climb to 5 000 individuals a minute or produce an exodus that lasts more than an hour. The Mexican free-tailed bat (*Tadarida brasiliensis*) is one of 17 bat species that inhabit the caves at Carlsbad, numbering in the hundreds of thousands and representing perhaps half the resident bat population. This, incredibly enough, turns out to be a comparatively "small" colony, as the number of free-tailed bats that occupy Bracken Cave near San Antonio, Texas, is estimated at 20 million individuals.

Compared with mammals and birds, amphibians tend to be sedentary creatures, most often inconspicuous, except to those who tend to explore nature on more of a nocturnal schedule, and for whom the almost deafening chorus of peeps and croaks emitted by breeding frogs and toads constitutes a full blown aural wildlife spectacle. A significant number of reclusive amphibian species, in fact, are regarded as "explosive breeders," unseen for much of the year until the first rains bring an abrupt end to the dry season and lure large numbers of animals to precious, ephemeral water sources. Other species remain more obvious throughout the year, but come breeding time still assemble in unusually large numbers in marshes, ponds, and lakes, putting their vocal repertoires to the test.

Reptiles, by comparison, are relatively quiet creatures, especially the turtles and tortoises, several species of which assemble in significant numbers at certain times of the year. Of these, the Galápagos giant tortoise (*Geochelone nigra*) may be the most dramatic. These creatures once inhabited 11 separate islands in the Galápagos, but occur today only on six, having been slaughtered for food and extirpated on the other islands. The need for fresh water apparently influences the movements of surviving island races, individuals migrating along altitudinal gradients through periods of drought and rain, and gathering in large groups. On the opposite side of the world, more than 100 000 Aldabra giant tortoises (*G. gigantea*) inhabit the island of Grand Terre in the Aldabra Atoll, forming congregations that are both spectacular and stark. In search of meager shade from a broiling tropical sun, aged giants maneuver for favored positions

with one another amid the bleached remains of former competitors.

Sea turtles are among only a handful of reptiles that have evolved to survive in marine environments, but they remain tied to the land to reproduce. Latin Americans have given the name *arribada* to the amphibious "invasions" of sea turtles during the breeding season —a time when huge numbers of females haul themselves ashore and up the beach, dig their nests, lay their eggs, and then return to the sea. Large Amazonian river turtles (*Podocnemis* spp.) are also social nesters that historically reached incredible densities along the river's sandy beaches. British naturalist Henry Walter Bates wrote about the spectacular appearance of river turtles at the approach of the dry season during his exploration of the Amazon from 1848 to 1859, and likened it to the annual migration of unusually large concentrations of black caiman (*Melanosuchus niger*) along the Lower Amazon at the same time of year, when water levels are at their lowest and beaches at their broadest. The spectacle of the *Podocnemis* turtles still exists today, although in greatly reduced form. The spectacular black caiman concentrations of the kind reported by Bates are now largely a thing of the past although, amazingly, they seem to be starting to reappear in parts of this species' range (e.g., the Rio Madeira in Brazil). Yet another reptile species still exists in primeval densities, and that is the Paraguayan caimans (*Caiman yacare*) of the Pantanal region of Brazil, Bolivia, and Paraguay —the world's largest contiguous wetland. Tens of millions of these animals still thrive and assemblages several thousand strong remain readily observable.

Most lizards are not gregarious, one exception being the Galápagos marine iguana (*Amblyrhynchus cristatus*). This iguana species, the only saurian in the world that feeds regularly in the sea, has been estimated to occur in densities of up to 3 000 animals per kilometer of coastline and, at places such as Punta Espinosa (Fernandina Island), they can be seen in vast hordes of as many as 2 000 or more adults. Snakes, on the other hand, are known to congregate in hibernacula during the winter months. This phenomenon is particularly common in garter snakes (*Thamnophis* spp.) and rattlesnakes (*Crotalus* spp.). In southern British Columbia, 400 Pacific rattlesnakes (*Crotalus oreganus*) may den together on a single talus slope. Elsewhere, in southern Manitoba, the large aggregations of overwintering red-sided garter snakes (*Thamnophis sirtalis parietalis*) are legendary. These aggregations are partially thermal, but in garter snakes are primarily a reproductive strategy, while in rattlesnakes the animals are forced together because of a limited number of overwintering sites where they can find refuge below the frost line.

On the opposite page, large male Galápagos tortoises (Geochelone nigra vandenburghi) *vie for space in a rainy-season wallow on the caldera rim of Volcán Alcedo on Isabela Island. Isabela is the largest island in the Galápagos and Volcán Alcedo is home to the largest remaining populations of these tortoises.*
© Tui De Roy

On pp. 54-55, most of the toothed whales, or odontocetes, which include the dolphins and porpoises, live in social groups of different sizes that may last for generations. Size varies, but some dolphins are known to form groups of hundreds or even thousands of individuals, as is the case with these striped dolphins (Stenella coeruleoalba) *in the Gulf of California, Mexico.*
© Patricio Robles Gil/Sierra Madre

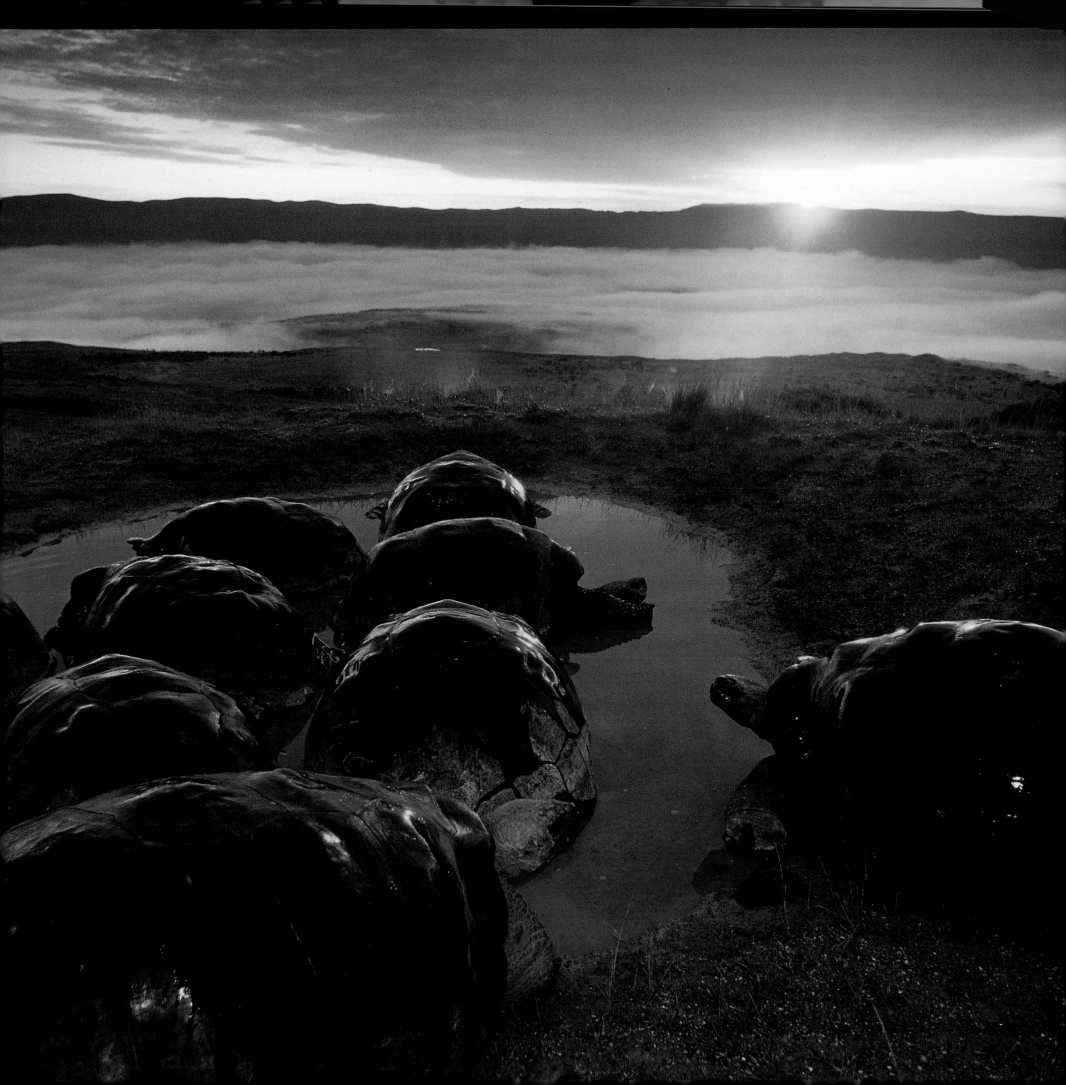

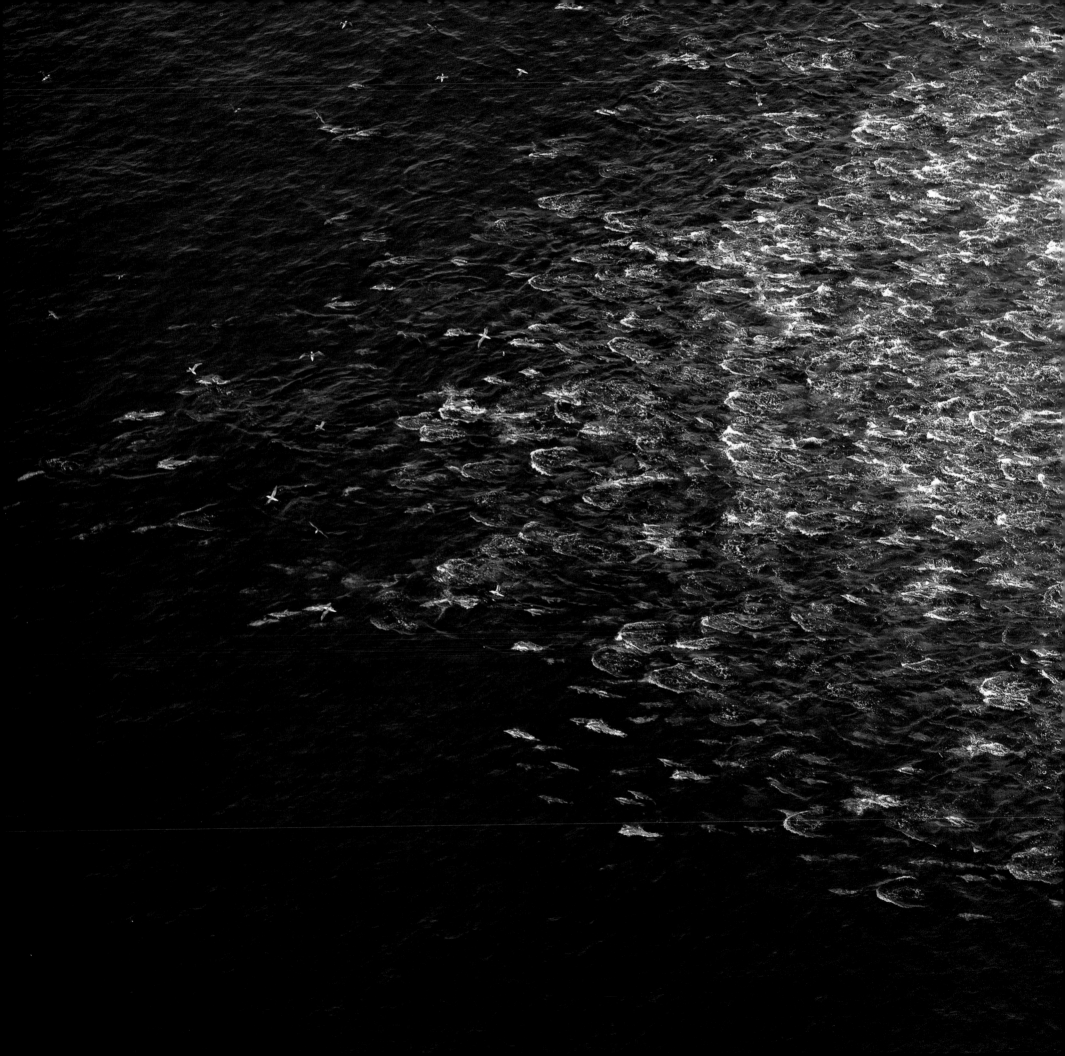

Another extraordinary example concerns water pythons occurring in the floodplains of Northern Australia, where densities have been estimated at about 6 000 pythons in an area measuring 1.3×2 km (equivalent to a biomass of 300 kg/km^2). The pythons are supported by very high densities of dusky rats (*Rattus colletti*), which themselves are estimated to number some 150 individuals/ha (or 1 ton of rats/km^2).

Schooling is an innate behavior among fish and a natural contributor to large congregations of individuals. However, the reproductive phenomenon known as spawning creates the most conspicuous spectacles within this group of animals, perhaps best exemplified by the Pacific salmon (*Oncorhynchus* spp.). Except for a handful of landlocked populations, Pacific salmon hatch in fresh water (streams, rivers, and lakes), move to the sea to feed and grow, and then, literally starving themselves, "smell" their way back to the precise waters of their birth, where they spawn and die in large numbers. The management and survival of migrating salmon populations is a major topic of debate that pits commercial fishermen, sports fishermen, hydroelectric engineers, and government agencies against one another. Other congregatory fish also tend to be migrants, either over long distances —such as herrings spawning in Alaska, and some sharks— or among reef systems.

Hundreds of popular books enthrall us with vivid descriptions of wildebeest migrations or spectacular journeys of birds across seas and continents. But even more stunning wildlife spectacles are happening around us on scales equally grand and at the same time infinitesimally smaller, spectacles we often entirely overlook. The chapters in this book that deal with invertebrate congregations can barely scratch the surface of the wealth of biological phenomena that involve inconceivable numbers of individuals within certain species of invertebrates. We have selected a few that best represent the primary reasons for mass gatherings or migrations among these animals. With ants and termites the benefits of communal behavior allow for the creation of finely structured societies that are equipped with climate-controlled colonies, carefully tended gardens, and a precise division of labor. Such societies are among the most successful of all life forms on the planet, allowing these insects to colonize nearly every terrestrial habitat. Their efficiency in molding the surrounding environment to suit the needs of the colony also results in the creation of new niches for other organisms, and the ecological services that social insects provide, such as soil production or pollination, affect entire ecosystems.

The small size of most invertebrates makes them particularly vulnerable to predation. In fact, most of the world's predators feed on invertebrates, many exclusively. One way of coping with the problem of being devoured by something bigger is to become a part of a huge assemblage of similar individuals, thus reducing the chance of becoming the one picked by the predator. And if an organism temporarily saturates the environment with a seemingly endless supply of edible members of its own species, sooner or later the predators will have to stop gorging and rest. This will allow the prey species to complete the activities it gathered for, be it courtship, egg laying, or seasonal migration. We see this behavior, known as predator satiation, in periodical cicadas that appear in the millions only once in more than a decade to prevent not only the predators from building up their ranks, but also to make it exceedingly difficult for parasitic organisms to synchronize their life cycles with such an unusual periodicity. The same kind of escape from predation is used by many marine organisms, such as jellyfish, horseshoe crabs (Merostomata), and Christmas Island crabs (*Gecarcoidea natalis*) that breed explosively, for a fleeting moment filling the sea with billions of eggs and larvae. Synchronized breeding also greatly increases the chances of finding a mate in organisms that normally lead solitary or sedentary lives.

Extinct wildlife spectacles

No treatment of wildlife spectacles would be complete without reference to natural congregations that were recorded within historic times, but upon which human eyes will never gaze again. In some cases, the species themselves have disappeared from the face of the Earth, largely driven to extinction by our own species. In other instances, the populations in question have been so drastically reduced in size that they can no longer overwhelm our senses as they did those of our ancestors. We might, in either case, wish to call these incredible animal congregations of long ago "extinct spectacles," and reflect on examples of both as we contemplate the future of today's threatened congregations.

The two remaining giant tortoise species are the sole survivors of a once speciose lineage. The memoirs of François Leguat, a Huguenot castaway on the island of Rodrigues during the seventeenth century, contain vivid accounts of the island's tortoise populations. "There are such plenty of Land-Turtles on this Isle, that sometimes you see 2 000-3 000 of them in a Flock; so that you can go above a hundred paces on their backs without setting foot on the ground. They meet together in the evening in shady places, and lie so close, that one would think those spots were paved with them." It's unclear whether Leguat was writing

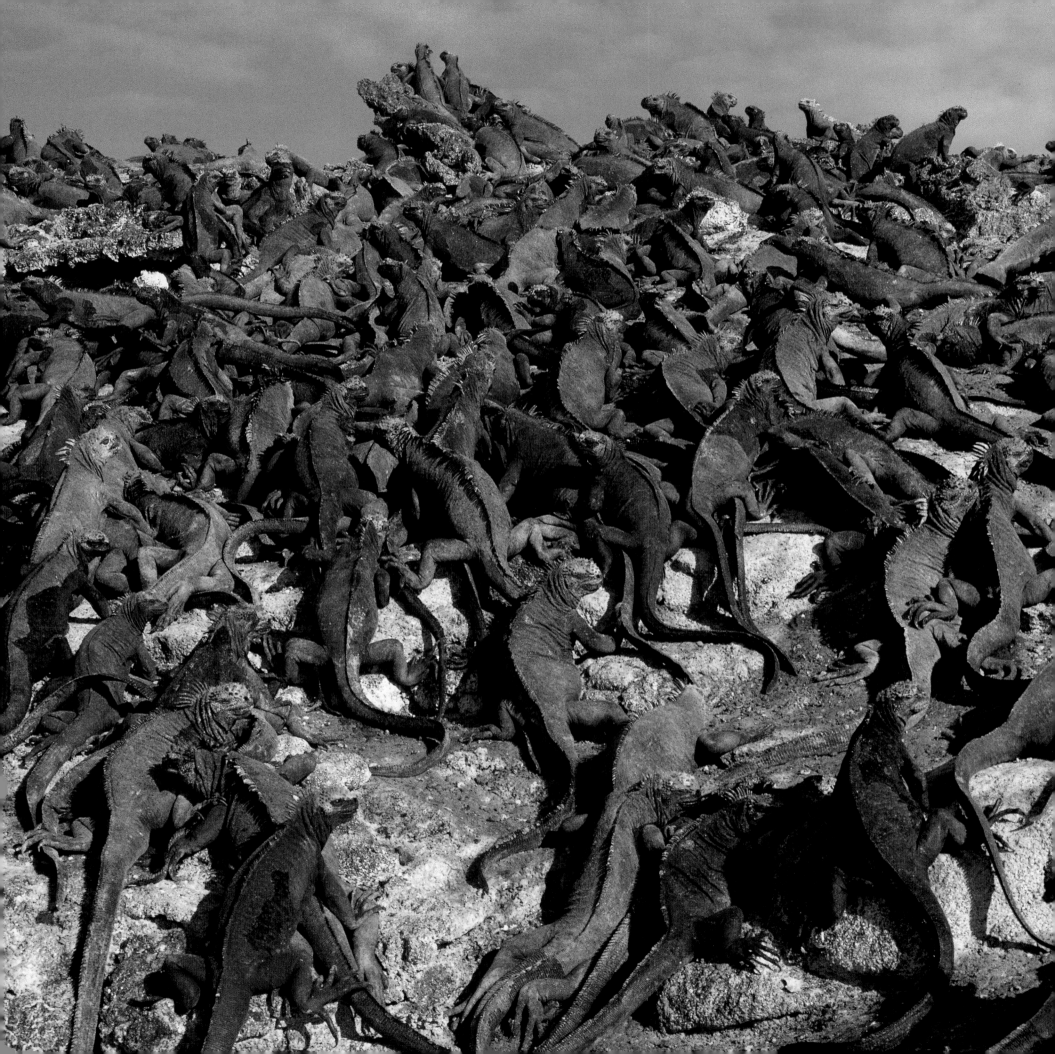

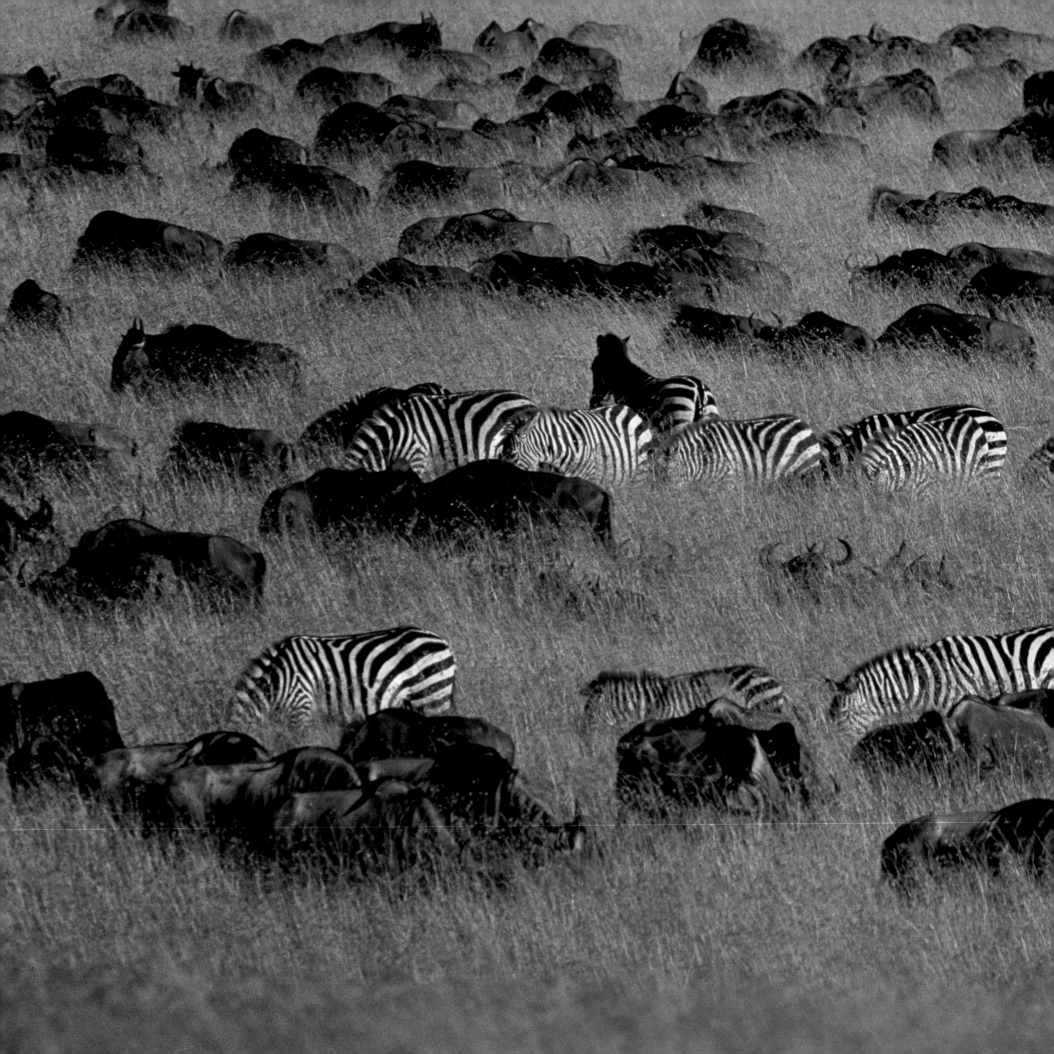

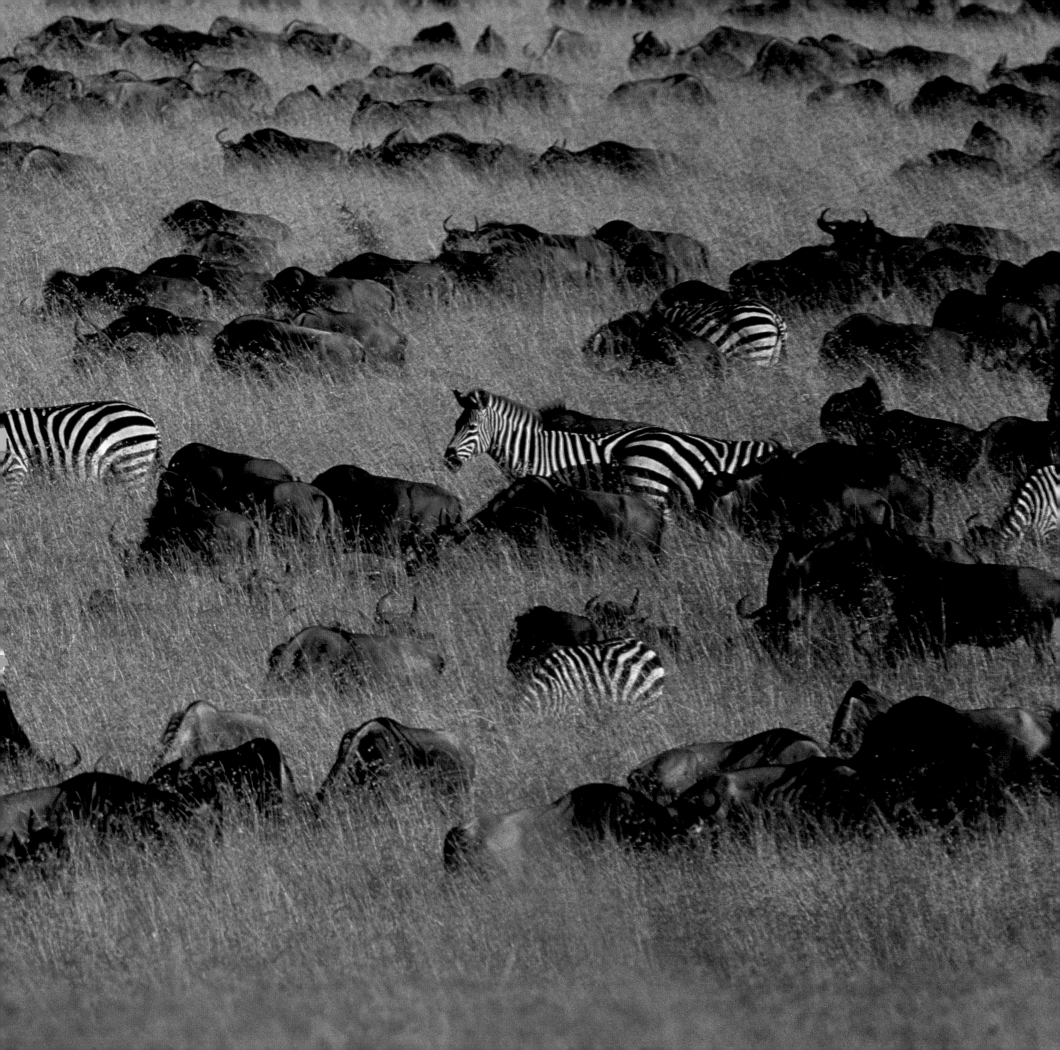

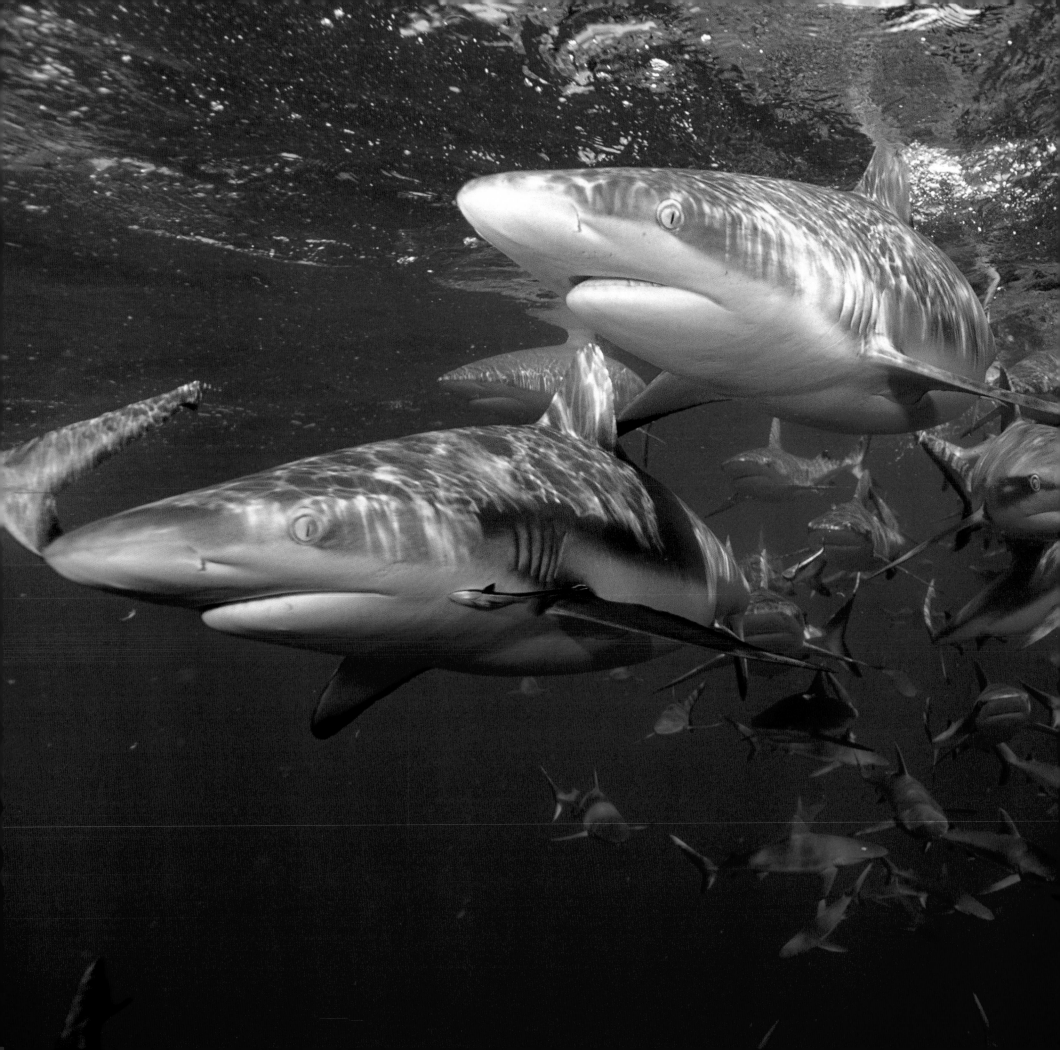

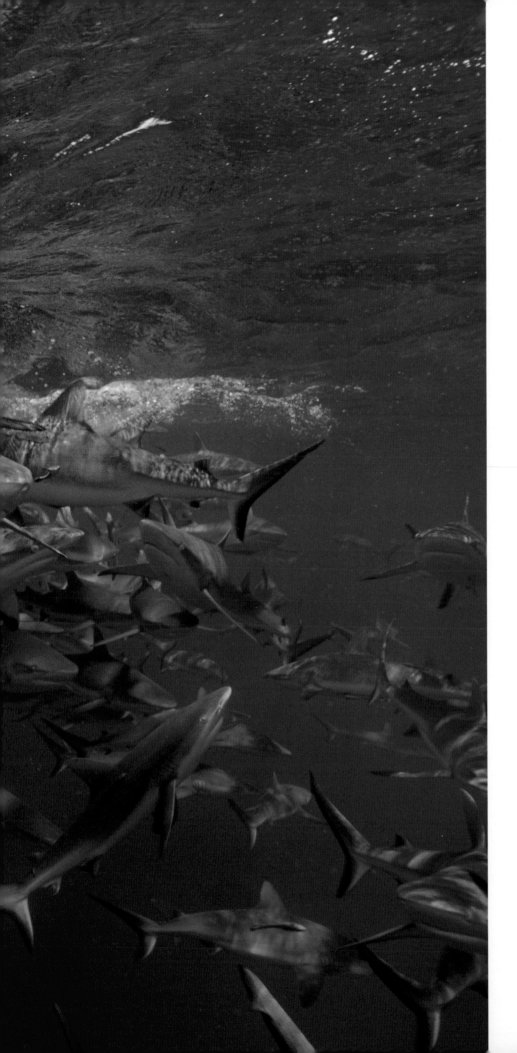

Gray reef sharks
(Carcharhinus amblyrhynchos)
schooling at Bikini Atoll, Marshall Islands,
Micronesia.
© Doug Perrine/Seapics.com

about *Geochelone vosmaeri* or *G. peltastes*, the two species of tortoise believed to have inhabited Rodrigues based on the analysis of sub-fossil remains. The former was a true giant, the latter just a large tortoise. No matter to sailors of the Dutch, English or French navies, nor to occasional pirates who came ashore on Rodrigues, as all saw fit to haul away shiploads of tortoises —living larders for long sea voyages.

The last of the island's huge reptiles were gone by the end of the 1700s. The demise of Madagascar's giant tortoises apparently had occurred millennia before and we know virtually nothing about the natural history of *G. grandidieri* and *G. abrupta* or their final days. However, events similar to those on Rodrigues had already unfolded on Mauritius, where populations of *G. inepta* and *G. trisserata* were probably extirpated by the turn of the nineteenth century. On nearby Réunion, the *coup de grâce* for *G. indica* and *G. borbonica* came a bit later in the century, largely from French colonists, who had developed an insatiable appetite for tortoise flesh, and from their introduced swine, which relished both eggs and hatchlings. Less is known about the history of more distant Indian Ocean tortoise populations. At least one species, *G. semeirei*, a former inhabitant of the Seychelles and Amirante islands, became extinct in 1918 when the last known individual died after an incredible 152 years in captivity!

Consider also the stories of two formerly prolific, but now extinct bird species. The last great auks (*Alca impennis*) were reportedly taken on Eldey Rock off the coast of Iceland on June 3, 1844. A century before, the species' numbers were inestimable. The great auk was the largest of its kind and is survived today by 13 genera and almost two dozen species of the Family Alcidae —auklets, dovekies, guillemots, murrelets, and puffins. Colored black-and-white with a large, conspicuous white oval spot before the eye, the great auk stood almost one meter tall. Known also as penguin, garefowl, and wobble, this flightless diving bird of the North Atlantic chose barren rocky coastlines, distant from human habitations of its day, along which to breed. The Vikings apparently hunted it routinely during long sea voyages, but they and later pursuers stood little hope of catching these torpedo-like birds in open water. Flightless birds on land, however, were a different story entirely. The great auk's breeding season probably extended from late spring through early summer, during which time thousands —perhaps tens of thousands— of breeding pairs crowded together along the shore. Perhaps the largest colonies were those found on islands of Newfoundland's Grand Banks. Funk Island, in particular, was among the most notorious killing grounds, and actually received its name from the stench generated by the slaughter and rendering of countless auks. The natural spectacles

On the opposite page, silky sharks (Carcharhinus falciformus) *attacking a "baitball" of young jacks* (Caranx caballus), *Cocos Island, Costa Rica.* © Bob Cranston/Seapics.com

provided by vast, thriving colonies of great auks were not, however, recorded by renaissance men. Instead, all that lies in testimony to this species are bones found in ancient middens and gruesome tales of the hunt left behind by rapacious mariners.

Only a handful of human beings laid eyes upon the great auk's teeming colonies. By comparison, a large percentage of eighteenth- and nineteenth-century Americans living east of the Mississippi River witnessed what may be described as the most incredible wildlife spectacle of all time, the migration of the passenger pigeon (*Ectopistes migratorius*). Many ornithologists believe that there has never been a bird species so numerous. From the time it was first reported by European explorers in the early sixteenth century, the passenger pigeon was described as roosting in "countless numbers" and feeding in "infinite multitudes." Even on the island of Manhattan, following settlement by the Dutch, these birds were said to be "so numerous that they shut out the sunshine," much more so even than skyscrapers do today. Having acknowledged the passenger pigeon's prominence, it's also quite impossible to offer a reliable estimate of the total population during its heyday. The passenger pigeon's range covered the eastern half of North America. It relished beechnuts, acorns, chestnuts, a variety of berries and earthworms above all other foods, but was also known to consume grains from a few cultivated crops. When it roosted in woodlands and swamps, the ground was said to be covered centimeters deep in pigeon droppings. Colonial nesting areas were reported to cover several thousands of hectares, or even hundreds of square kilometers, with each tree holding as many as 100 nests.

Yet migrating flocks of passenger pigeons were more impressive still. Various observers estimated them at 1.6 km or greater in breadth and hundreds of kilometers in length. Based on an average flight speed of 1.6 km per minute and a density of two individuals per square meter, naturalists Audubon and Wilson estimated flocks upwards of a billion birds. One such flock darkened the skies over Fort Mississauga, Ontario, Canada in 1866 for almost 10 hours and "fizzled out" for perhaps another four. Calculations put its size at an incomprehensible 3.7 billion birds, a figure that probably represented the bulk of the North American population. A flock seen five years later in Wisconsin Dells was described as "creating an almost bewildering effect on the senses" and producing a sound of "condensed terror" equivalent to that of "a thousand threshing machines ... as many steamboats" and an "equal quota of railroad trains." By the turn of the next century, however, the sounds of passenger pigeons in flight were no more than a memory. The massive destruction of the eastern deciduous forests over the nineteenth century, com-

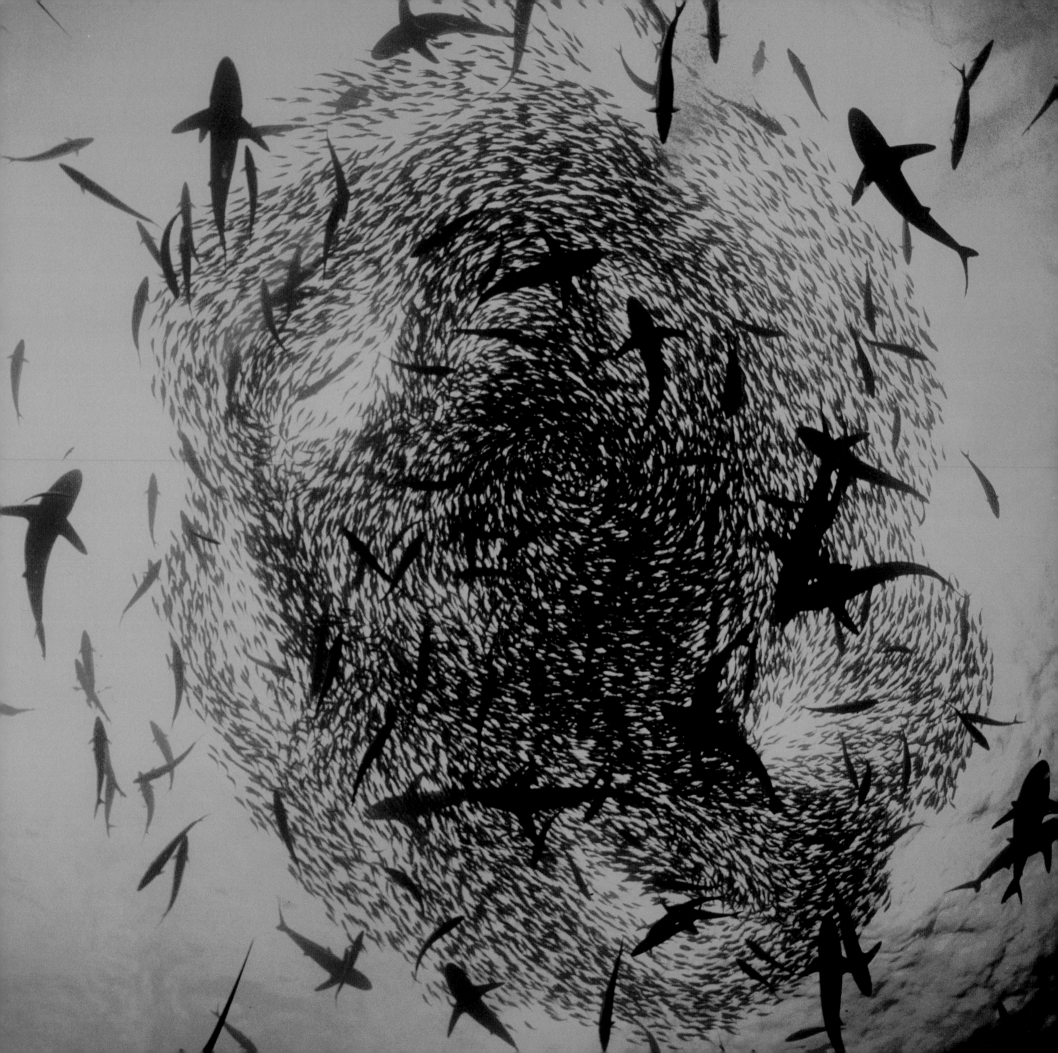

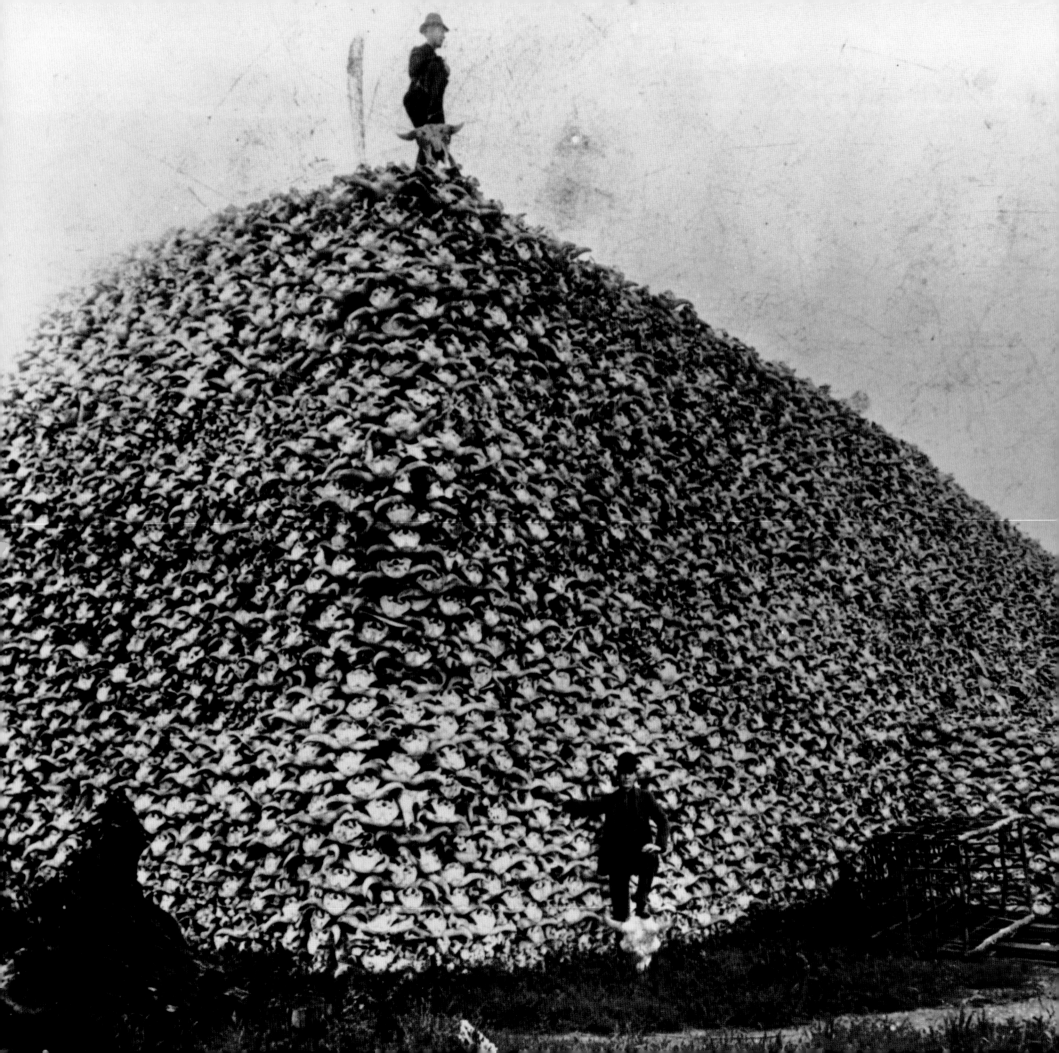

bined with heavy hunting and probably disease, and a loss of social facilitation, resulted in the collapse of the population to such an extent that it fell below some unknown minimum threshold —a situation from which the species never recovered. The last bird died in captivity in 1914.

In the realm of historical animal spectacles, little can compare with the vast herds of American bison (*Bison bison*) —also commonly known as buffalo— that formerly roamed North America's Great Plains. According to naturalist William T. Hornaday, "It would have been as easy to count or to estimate the number of leaves in a forest as to calculate the number of buffaloes living at any given time during the history of the species previous to 1870." Such estimates do exist, in fact, ranging from a low of 30 million to a high of 200 million animals. With bison cows reaching close to half a ton and bulls tipping the scales at nearly twice that weight, the biomass once represented by this species truly boggles the mind. Just as passenger pigeons congregated in immense migratory flocks, relatively small bands of bison, numbering perhaps a few dozen animals, would eventually coalesce into tremendous herds and move en masse across seemingly endless prairies. In *Plains of the Great West*, Colonel R.I. Dodge remarked, "The whole country appeared one great mass of buffalo...mad with fright, and as irresistible as an avalanche. The great herd of the Arkansas through which I passed...was not less than 25 miles wide...or not less than 50 miles deep.... That was the last of the great herds." Calculations based on Colonel Dodge's description put the number of animals at four million or more.

Several Native American tribes —the Sioux, Cheyenne, Apache, and Comanche being among the best known— followed the herds as the seasons would allow. They rode horses brought to the New World by Spanish explorers. They lived off the animal's meat, and fashioned their clothes, utensils, and shelters from its hide, internal organs, and bones. Tales of hunts by the Plains Indians are portrayed in oil on canvas by nineteenth-century historian and painter George Catlin, who would argue that this hunter-prey relationship was sustainable. However, the prolific herds ultimately had to contend with throngs of settlers moving westward along the Oregon and California trails, people who had no history with, dependence upon, or concern for the bison. Then came hordes of soldiers and commercial hunters who extracted a great toll to obtain the animals' meat, tongues, and hides. Construction of the western railroads divided the bison's range into northern and southern herds, both of which were then systematically slaughtered. And, while protective legislation was introduced to the U.S. Congress in the early 1870s, it came too late to save the bison in its former splendor. By 1880

the southern herd had been annihilated, and by the turn of the twentieth century only a thousand or so animals survived, enough to save the species from extinction, but too late to save the spectacle of the bison herds.

The African continent once played host to a wildlife spectacle that even today would compare with those of the wildebeest migrations in the Serengeti. The springbok (*Antidorcas marsupialis*) is a small, highly gregarious, gazelle-like antelope native to the open savannas and grasslands of southern Africa, and is the sole extant member of its genus. Many decades ago, springbok herds of more than a million individuals were reported; it would take days for the entourage to pass a stationary observer. These treks were triggered in response to a lack of suitable grazing, with animals moving from arid to more mesic environments. Those days are long gone, however. The species was ruthlessly hunted for its skin and meat, it was considered a threat to agricultural crops and, later, it suffered the arrival of the rinderpest epidemic in the Cape region of South Africa in 1896 that likely contributed to its disappearance from most of its former range. Today, large concentrations of springbok still occur when the animals congregate on patches of greenery stimulated by rainfall, but at nowhere near the spectacular size of the treks of old. Recent estimates of the species' total population are 600 000 or more, although the profitability of the game farming industry has seen numbers on both private and protected land increase, and the species has been reintroduced to many areas in its former range. Sadly, rapid population declines such as those experienced by the springbok more than a century ago, are even now unfolding for other wildlife species across the globe; one typical example concerns the saiga of central Asia (*Saiga tatarica*).

Similar catastrophic collapses of spectacles have occurred in the marine environment. Large vertebrates like sea turtles, whales, manatees, monk seals, cod, jewfish, swordfish, sharks, and rays have been extirpated over the bulk of their historical ranges, leading to dramatic and maybe irreversible changes in entire offshore ecosystems. Even marine invertebrates such as oysters and conches have in many places been decimated, leaving only garbage heaps of empty shells as a reminder of what was once astounding abundance.

The future of wildlife spectacles

Wildlife Spectacles provides many examples of normally widespread species that concentrate in large numbers at some point in their life cycle, where they are at considerably greater extinc-

On the opposite page, this mountain of American bison skulls (Bison bison) *is sickening testimony to the wholesale destruction and near-complete extermination of what was once an incredibly abundant and dominant North American species.*
© Courtesy of the Burton Historical Collection, Detroit Public Library

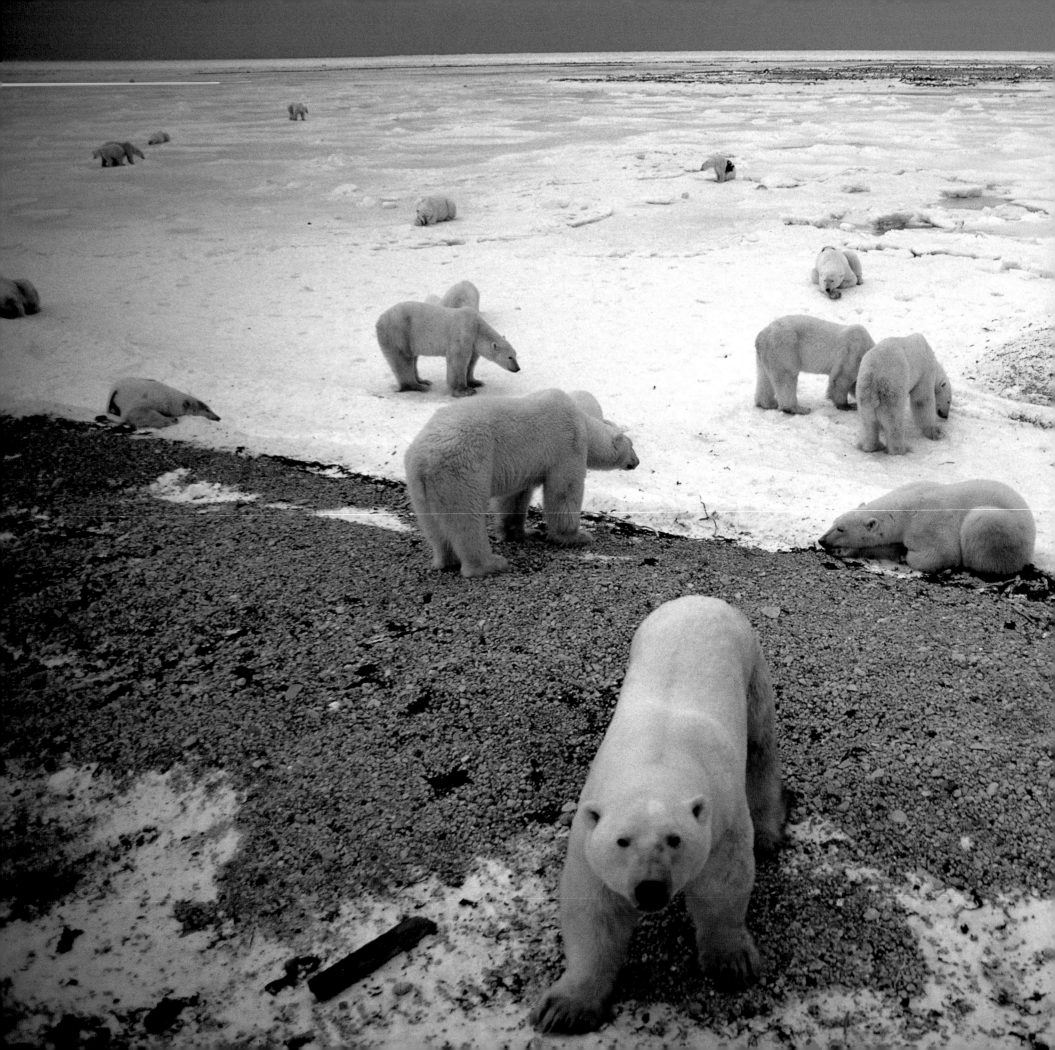

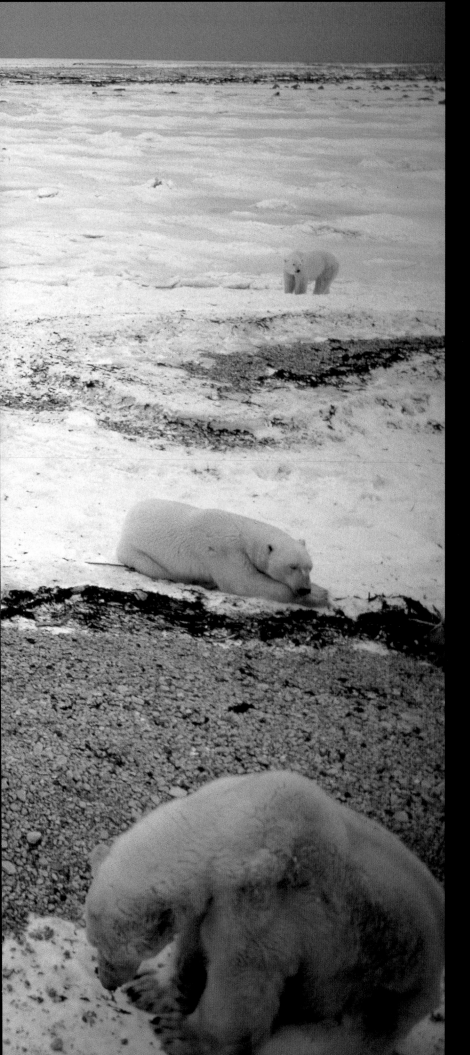

A concentration of some 20 polar bears
(Ursus maritimus) *waiting for the sea to freeze over,*
Cape Churchill, Manitoba, Canada.
© Fred Bruemmer/DRK PHOTO

tion risk from threats that normally would not be of significance to their survival. Such threats are familiar ones such as habitat destruction (e.g., for monarchs) and invasive species (e.g., for Christmas Island crabs). However, two other threats appear to be particularly pertinent to congregatory species. As suffered by species like the great auk and the American bison, one of these is direct human exploitation. The other appears to be that of large development projects. These threats may not extinguish all individuals of a species immediately but, as with the passenger pigeon, may reduce populations below some unknown critical threshold for survival of the species.

The congregatory behavior of species represents a concentrated food resource which our ancestors long ago learned to exploit, and which their descendants have been doing ever since. But there are now additional, more insidious, anthropogenic threats at work. These may be direct, such as habitat degradation and loss, the draining of wetlands for agriculture, or the creation of flood defenses, all of which translate into fewer and smaller places in which these species have to find their living. For many long-distance migrants, there was not a lot of choice of suitable habitat available along their migratory routes, even before the human hand got to work. Now they are more constrained than ever. Even where habitat remains, increased levels of disturbance, eutrophication as a result of runoff from agricultural chemicals, and other forms of pollution, such as oil spills, all mean that the quality of the environment needed by these species may be deteriorating.

Furthermore, remote and isolated oceanic islands are no longer so far removed from human actions. Human visits to and settlement of such islands, as well as the addition of new species to the list of our culinary repertoire, have also resulted in the introduction, both deliberate and accidental, of exotic plants and animals. The most serious and pervasive of these are rats, which take birds' eggs, young, and even, in some cases, adults. World-wide, the destructive effect of rats on nesting seabirds is enormous and has eliminated many bird species from islands and other places where they used to breed.

Examining the full range of migratory, explosive breeding, colonial nesting, and otherwise congregatory species that are described in this volume, we find the full spectrum of conservation status assessments to be represented. Some groups, in sharp contrast to being threatened, appear to be expanding their ranges and increasing in numbers to the point of becoming serious concerns or even pests. Jellyfish, for example, respond to some forms of environmental pollution by multiplying rapidly and becoming seriously destructive to marine-based industries, while marauding ants and killer bees seem to be taking advantage of global warming by extending their tropical ranges incrementally away from the equator each year, harassing humans and other species along the way, and swarms of locusts seem destined to irrupt for millennia in response to periodically greening landscapes and shifting food supplies.

Many species depicted in this volume are relatively common, well studied, and not considered threatened at present. This is largely the case for social insects, most migratory raptors, antelopes of the African plains, caribou, and others. There are also groups of species, such as the land-breeding seals, that suffered huge declines during prolonged periods of hunting in the nineteenth and twentieth centuries, but have subsequently recovered, and are once again abundant. At the other end of the spectrum are vertebrate families and orders with unusually high representation on the IUCN Red List of Threatened Species, among them the bats, cranes, primates, elephants, great whales, and sea turtles.

The world's sea turtles offer a unique perspective on global populations, distribution, and the assessment of conservation status. Six of the eight recognized species are listed either as Endangered or Critically Endangered. While most animal and plant species to which these categories of threat are assigned tend to be endemic to a certain region or a single country, the sea turtles, as a group, are geographically widespread and reported to nest in many different countries —35 for the olive ridley (*Lepidochelys olivacea*), more than 50 for the loggerhead (*Caretta caretta*), close to 60 for the leatherback (*Dermochelys coriacea*), almost 80 for the hawksbill (*Eretmochelys imbricata*), and at least 90 countries for green turtle (*Chelonia mydas*). The "odd turtle out" is the Atlantic ridley (*Lepidochelys kempi*), known to nest only on beaches in the United States and Mexico. It probably seems curious to the reader that the other sea turtle species, so widespread and presumably so numerous, could be considered so threatened. In fact, debate continues about the conservation assessment of this group of animals. With such charismatic creatures that are sought for a variety of products —in this case meat, shells, and eggs—, it is difficult to disregard the potentially devastating effects of overexploitation even though current populations seem robust.

Considerable efforts are being made in different parts of the world to identify, protect, and indeed restore places of vital significance to congregatory species. At the local and national levels many such sites have been known and appreciated for many years. Large numbers of them are now conserved as nature reserves of one sort or another, while efforts are being made on behalf of others yet to be protected. The most famous example

On the opposite page, golden cowrays (Rhinoptera steindachneri) *in Turtle Cove, Santa Cruz Island, Galápagos, Ecuador. Some schools may exceed 10 000 individuals.*
© M. Harvey/DRK PHOTO

On pp. 70-71, large herds of African elephants (Loxodonta africana) *coming together to bathe and drink in the Hluhluwe River, Hluhluwe-Umfolozi Game Reserve, KwaZulu-Natal, South Africa.*
© Jean-Paul Ferrero/Auscape

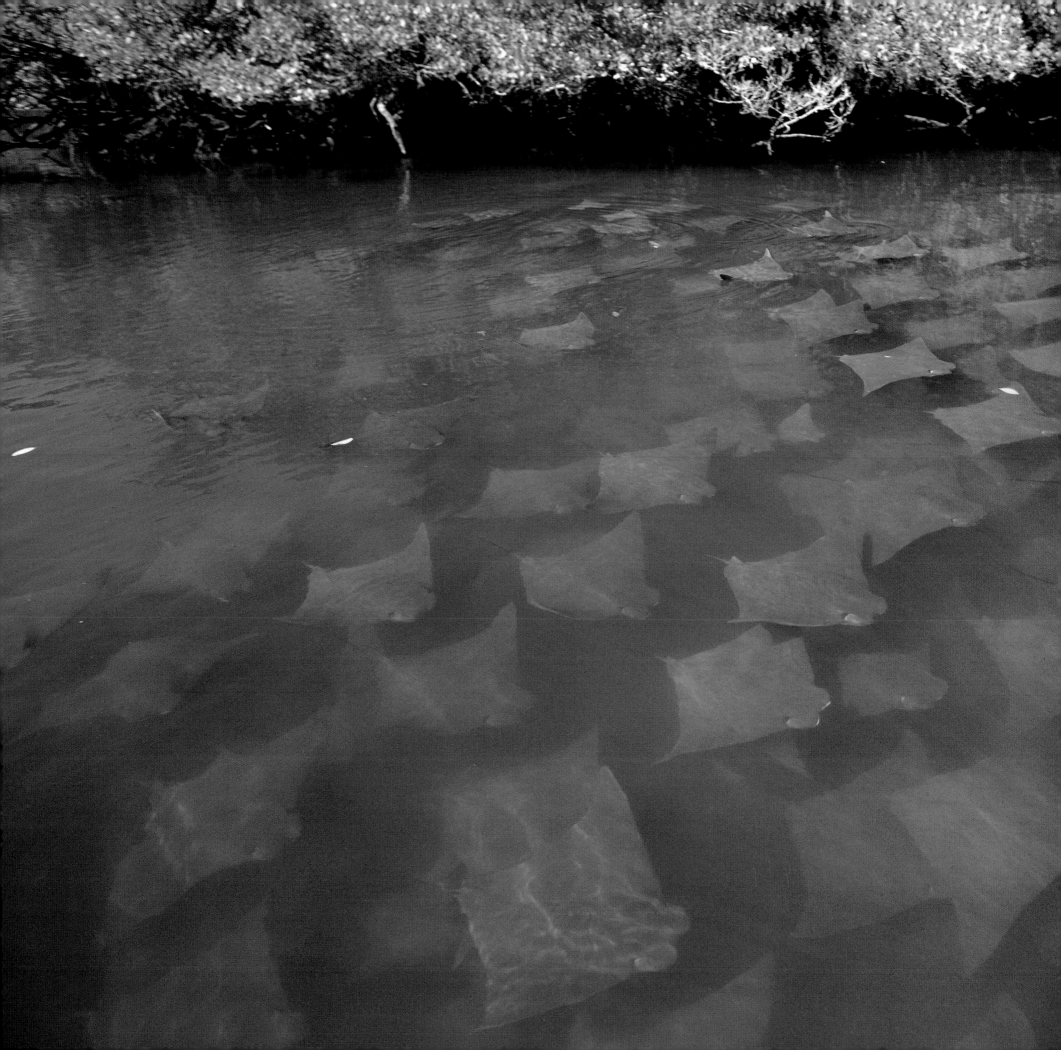

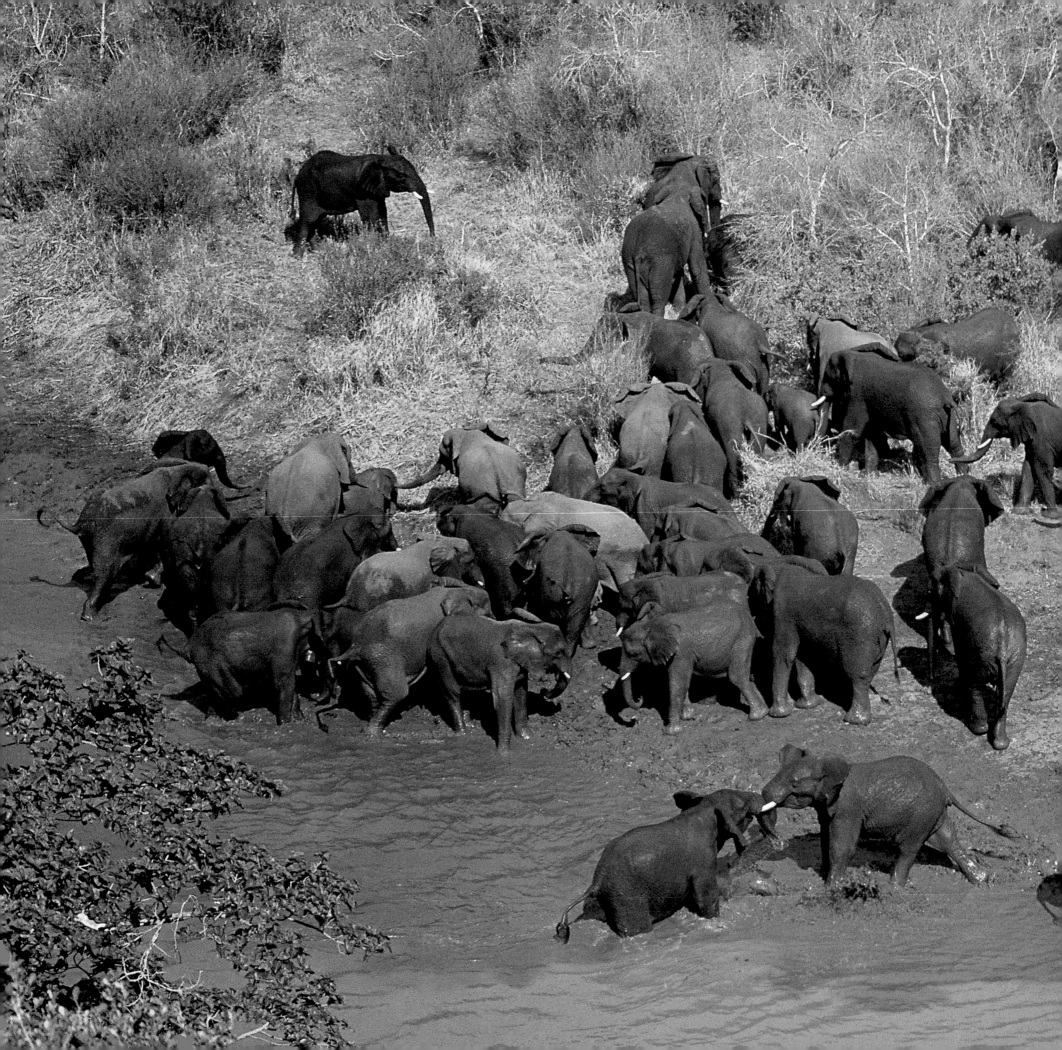

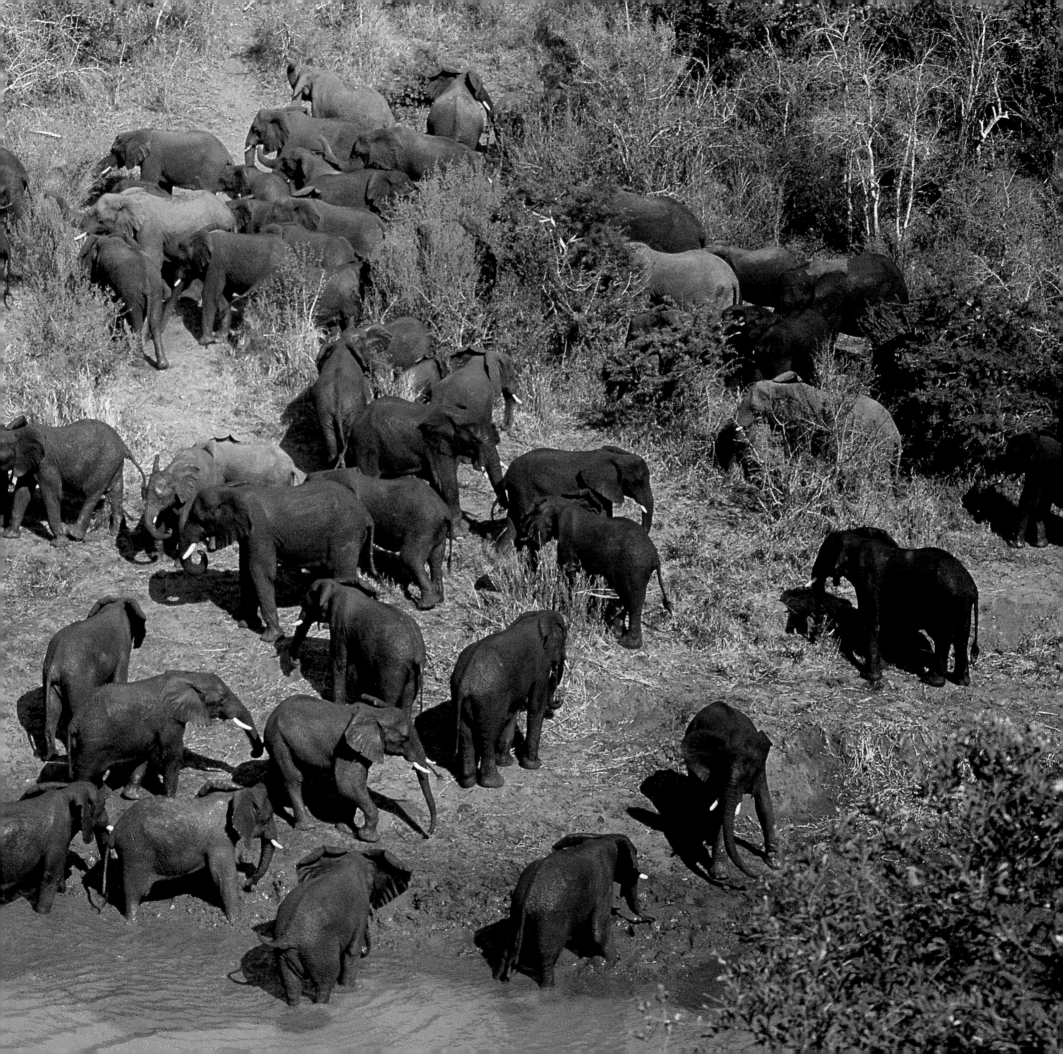

may be Hawk Mountain in eastern Pennsylvania, part of the Appalachian's Kittatinny Ridge, a bottleneck over which seasonal flights of raptors migrate, and where thousands of birds were once ruthlessly shot each year. That was until 1934, when local conservationists were successful in establishing the Hawk Mountain Sanctuary, the world's first protected area created especially for birds of prey. Other such places are, as a result of the efforts of the ever-increasing numbers of birders, field naturalists, and explorers, only now becoming known.

Uncontrolled hunting and trapping have adversely affected sea turtles and many other species, and for some, these threats remain significant. International agreements are sometimes the last hope. An international moratorium can be credited with saving a number of the world's great whales, while a ban on ivory exports seriously curtailed the poaching of African elephants. Habitat protection, however, is the best means of protecting gregarious species and ensuring that wildlife spectacles will continue to be seen by future generations. Many countries have seen fit to establish sanctuaries for animals that congregate in large numbers. Islands and coastal areas that harbor large colonies of pelagic seabirds, giant tortoises, nesting sea turtles, or marine mammal rookeries have been set aside as national parks, nature reserves, and wildlife refuges. Offshore areas are being targeted as marine sanctuaries. Staging grounds along the routes of migratory raptors, waterfowl, songbirds, and shorebirds are incorporated into national protected-area systems. Corridors are being developed along the migratory routes of large land animals that allow safe passage through otherwise unprotected landscapes. Unsurprisingly, tourists tend to flock to many of these areas, lending further support to conservation efforts. Nonetheless, in spite of these successes many hunting issues remain unresolved and very difficult to combat, two of the most notable being the uncontrolled and growing bushmeat trade in Central and West Africa, and the trade in a wide variety of species in Asia for both food and medical purposes (e.g., primates and river turtles).

Large-scale conservation initiatives are also beginning to put together pieces of the global biodiversity protection jigsaw. This is particularly important for migratory species, since conservation efforts in one country are ultimately only going to be successful if similar initiatives are undertaken in other countries within each species' range. For example, since 1967, the International Waterfowl Census, organized by Wetlands International, has been collecting data on waterbird numbers, the places where waterfowl concentrate, and the threats to them. Originally a northwestern European initiative, this effort now extends to all parts of the world, and is one source of information by which

countries identify and designate *Wetlands of International Importance* under the Ramsar Convention. In the U.S., a number of other initiatives to protect congregatory birds have been developed, including the North American Bird Conservation Initiative, the North American Waterbird Conservation Plan, the North American Waterfowl Conservation Plan, the U.S. Shorebird Conservation Plan, and Partners in Flight.

Most of the species and spectacles presented in this book are found within wilderness regions distant from abnormally large congregations of our planet's six billion *Homo sapiens*. Those that are most remote will enjoy some degree of protection for that fact alone. Those that are most accessible will easily "pay their own way" well into the future by attracting us to them. Those that lie in between may only survive if we make a major effort to find conservation solutions to the threats they face.

We, as a species, have the final word regarding the future of wildlife spectacles. The future of these spectacles depends on our ability to afford protection for the special places and conditions on which the wildlife gatherings depend. Wildlife spectacles enable creatures to gather in fulfillment of ancient survival strategies. They are a legacy to nature's prowess and stir the emotions of people young and old. By highlighting the uniqueness and vulnerability of these wildlife marvels, we hope that this book will stimulate special recognition and protection for the spectacles herein described.

RUSSELL A. MITTERMEIER
WILLIAM R. KONSTANT
CRISTINA G. MITTERMEIER
PATRICIO ROBLES GIL
MICHAEL HOFFMANN
THOMAS BROOKS
GUSTAVO A.B. DA FONSECA
LINCOLN FISHPOOL
JOHN PILGRIM
CARLY VYNNE
PENNY LANGHAMMER
MATT FOSTER
RODERIC B. MAST
WAYNE LYNCH
MICHAEL J. PARR

On the opposite page, an aggregation of blue whales (Balaenoptera musculus) *off the coast of the Gulf of California, Mexico. The largest living animal on the planet, these magnificent giants sometimes gather in temporary associations of 20 or more individuals.*
© Flip Nicklin/Minden Pinctures

On pp. 74-75, belugas (Delphinapterus leucas) *form enormous migratory processions that may spread out over several kilometers at any one time. Here, a group in freshwater shallows off the coast of Northern Canada in October.*
© Flip Nicklin/Minden Pictures

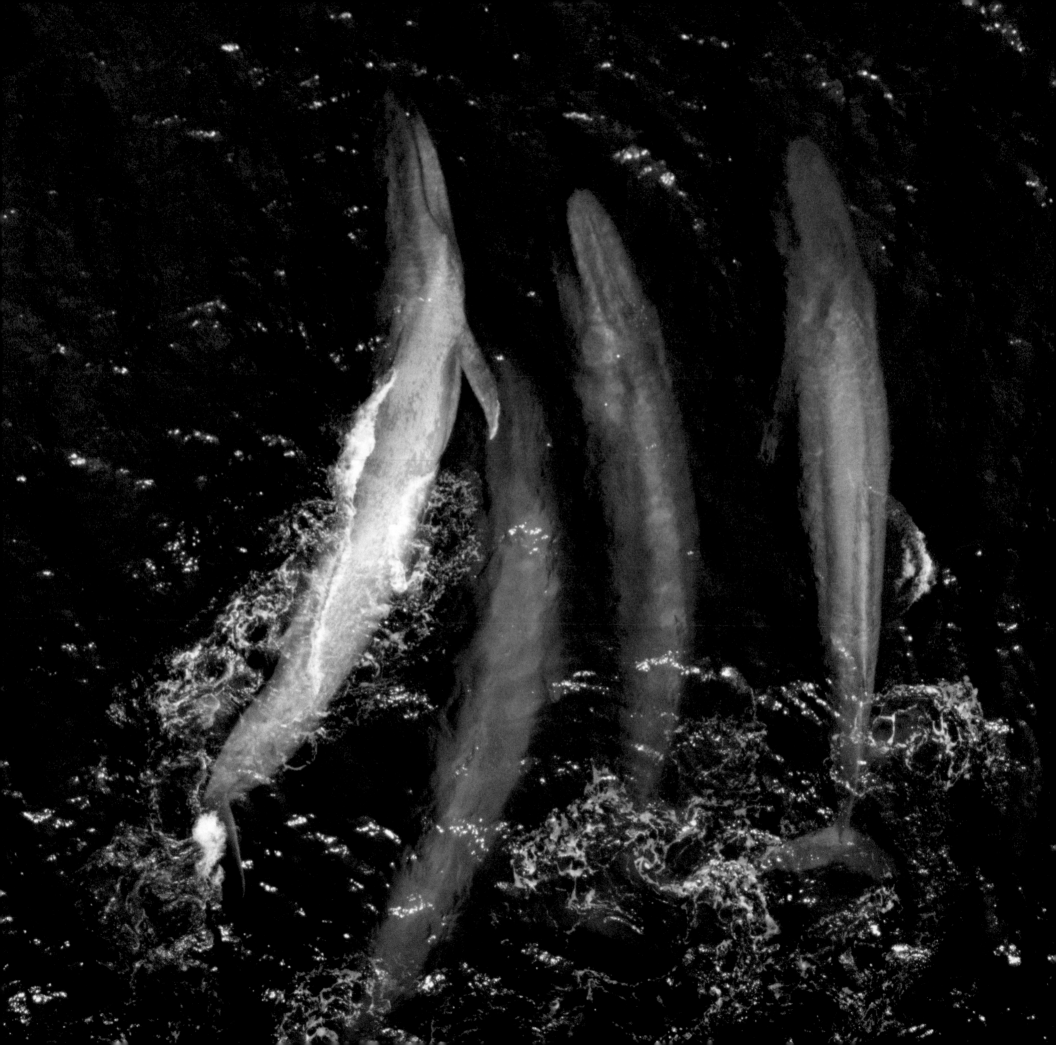

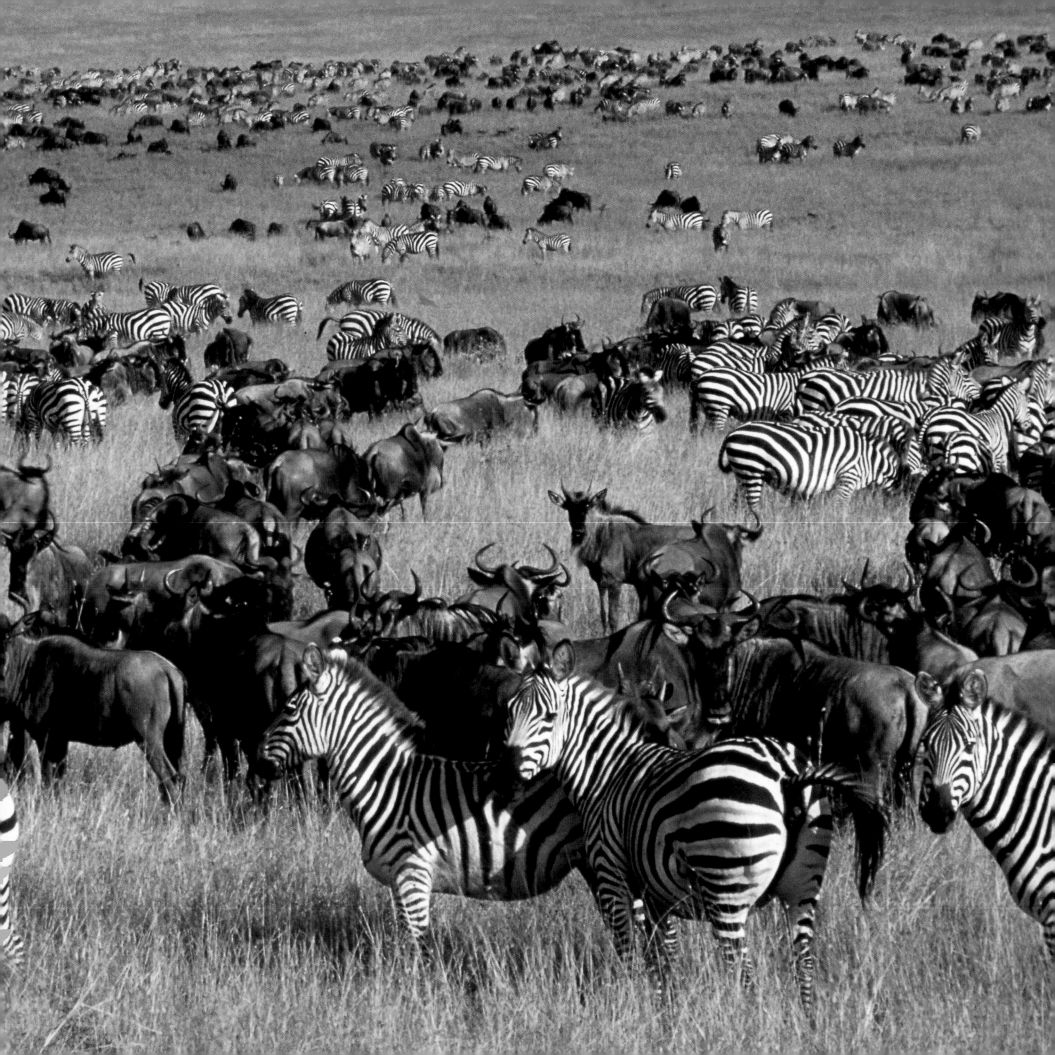

M A M M A L S

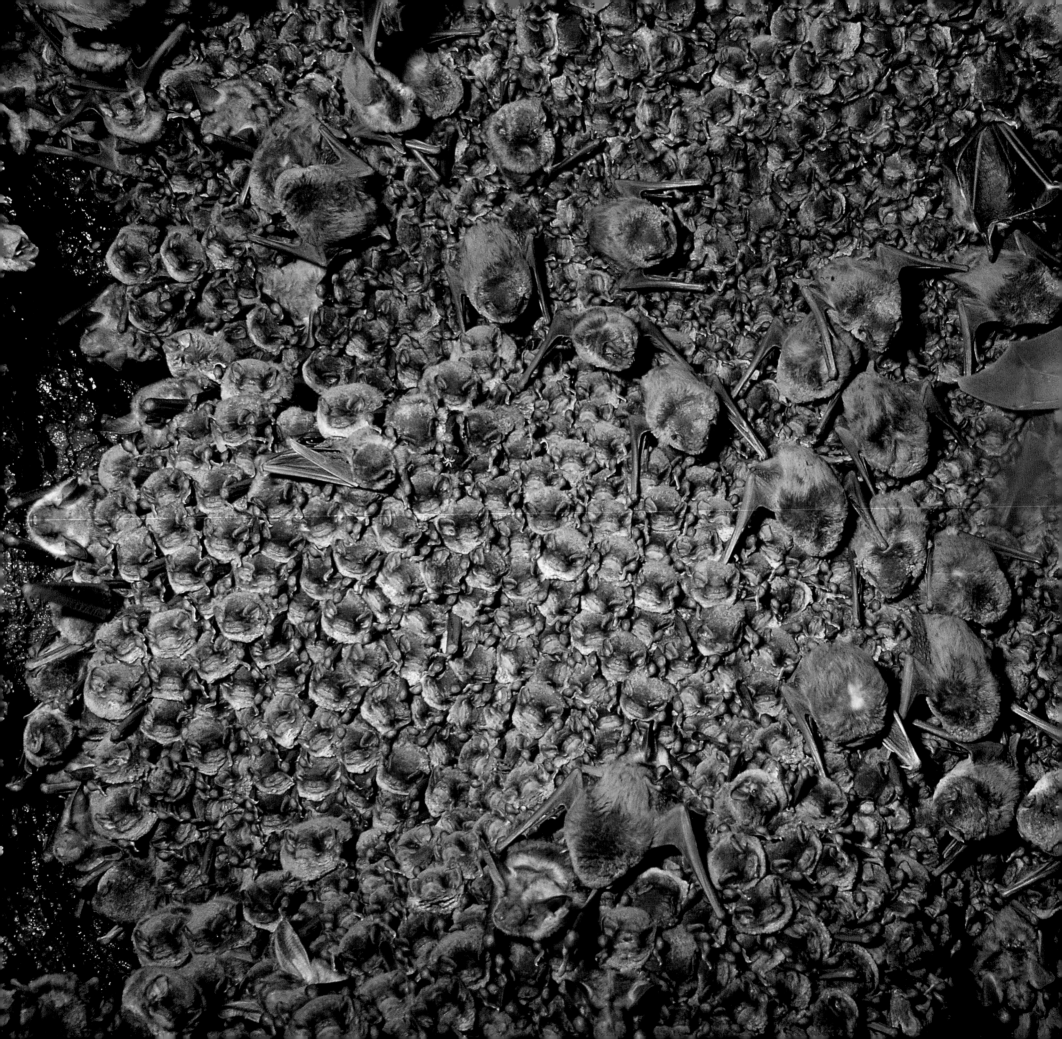

BATS

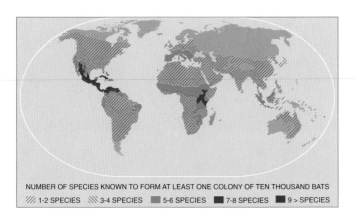

NUMBER OF SPECIES KNOWN TO FORM AT LEAST ONE COLONY OF TEN THOUSAND BATS
/// 1-2 SPECIES \\\ 3-4 SPECIES ▨ 5-6 SPECIES ■ 7-8 SPECIES ■ 9 > SPECIES

Next time you are anywhere on land where it's hot, look up at the night sky. Chances are, within a few minutes, you will catch a glimpse of a bat or two. These nocturnal flying mammals are virtually ubiquitous. Many species roost in caves, and at least 30 of these form concentrations of more than 10 000 bats in a single cave. Bats living in large numbers in caves can be found almost everywhere in the tropical and temperate regions of the world.

North America hosts some of the largest groupings of bats in the world. Bracken Cave, near San Antonio, Texas, contains the largest concentration of individual warm-blooded mammals in the world (except for the largest metropolises such as Mexico City or Tokyo), with an estimated 20 million bats during the summer. In northern Mexico and southern United States, Mexican free-tailed bats (*Tadarida brasiliensis*) join in colonies of several million, for a total population of well over 150 million. The spectacle of millions of bats emerging from a karstic cave in a whirlwind of wings and bodies leaves an indelible mark in every human lucky enough to witness this nightly event. Over 50 000 bats per minute (close to 1 000 per second) leave the cave for several hours starting well before sunset. Clicks and chirps can be heard as the bats navigate their way through the chaotic, yet organized column. They are headed to their feeding grounds, agricultural fields in this highly productive region. Every million bats consume about 10 metric tons of insects, mostly agricultural pests, every night. A single colony of five million, of which there are several in northern Mexico and southern United States, will destroy an astounding 1 500 tons of insects in a single month. Their contribution as agricultural allies is fundamental for sustainable production practices; without them, insect pests would destroy a much greater proportion of crops than they currently do, and we would have to apply far larger amounts of harmful pesticides. Snakes, falcons, hawks, owls, raccoons, skunks, and other predators visit these caves every evening, reinforced by the sheer probability that one bat might come close enough to become their prey.

Most bats in the largest colonies are pregnant females that arrive in spring to give birth. They rely on large numbers and the "heat-trapping" features of these caves (an upper chamber where warm air is trapped) to successfully raise their young, which are not capable of regulating their body temperature at birth. Fe-

On the opposite page, Schreiber's long-fingered bats (Miniopterus schreibersii) *in a cave in Spain.*
© Francisco Márquez

Above, tent bats (Ectophylla alba) *roosting in a tent made from a* Heliconia *leaf in rain forest in Costa Rica. These delicate, beautiful little bats are common in the forests of Central America.*
© Michael & Patricia Fogden

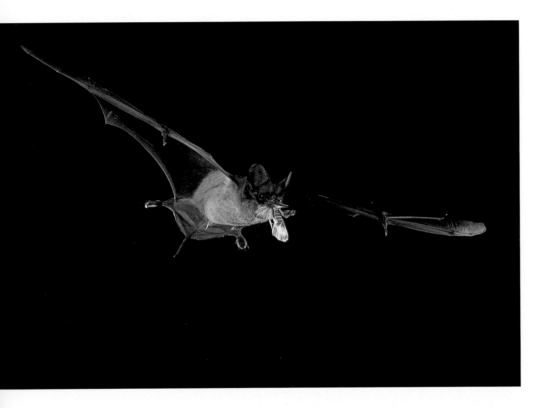

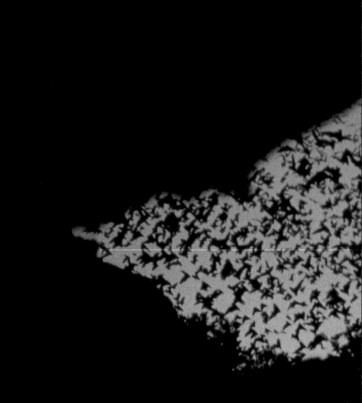

Above, Mexican free-tailed bat (Tadarida brasiliensis) *with a moth.
This species is important in controlling insect pests.*

*On the opposite page, Mexican free-tailed bats emerging from Bracken Cave near
San Antonio, Texas. This cave is home to the largest concentration of individuals
of a single mammal species anywhere in the world.
Both photos,* © Merlin Tuttle/Bat Conservation International

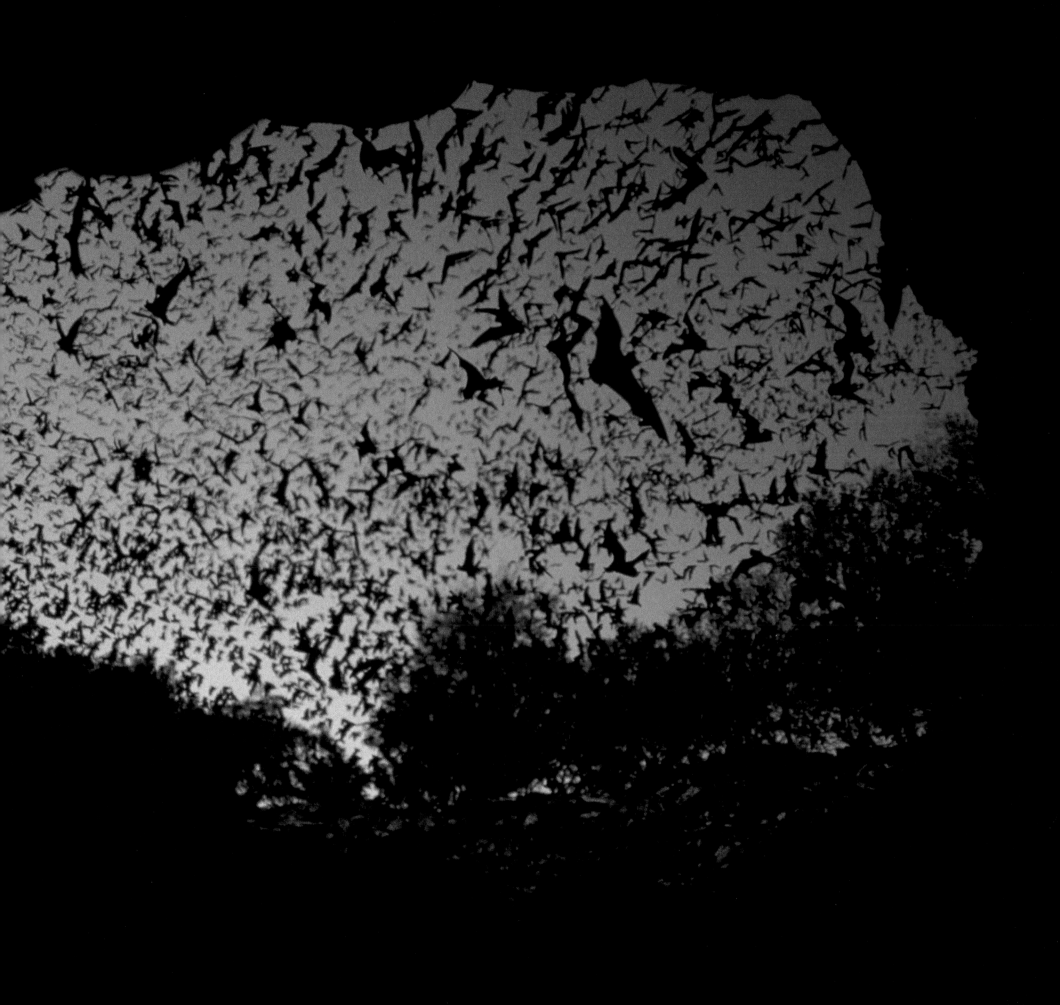

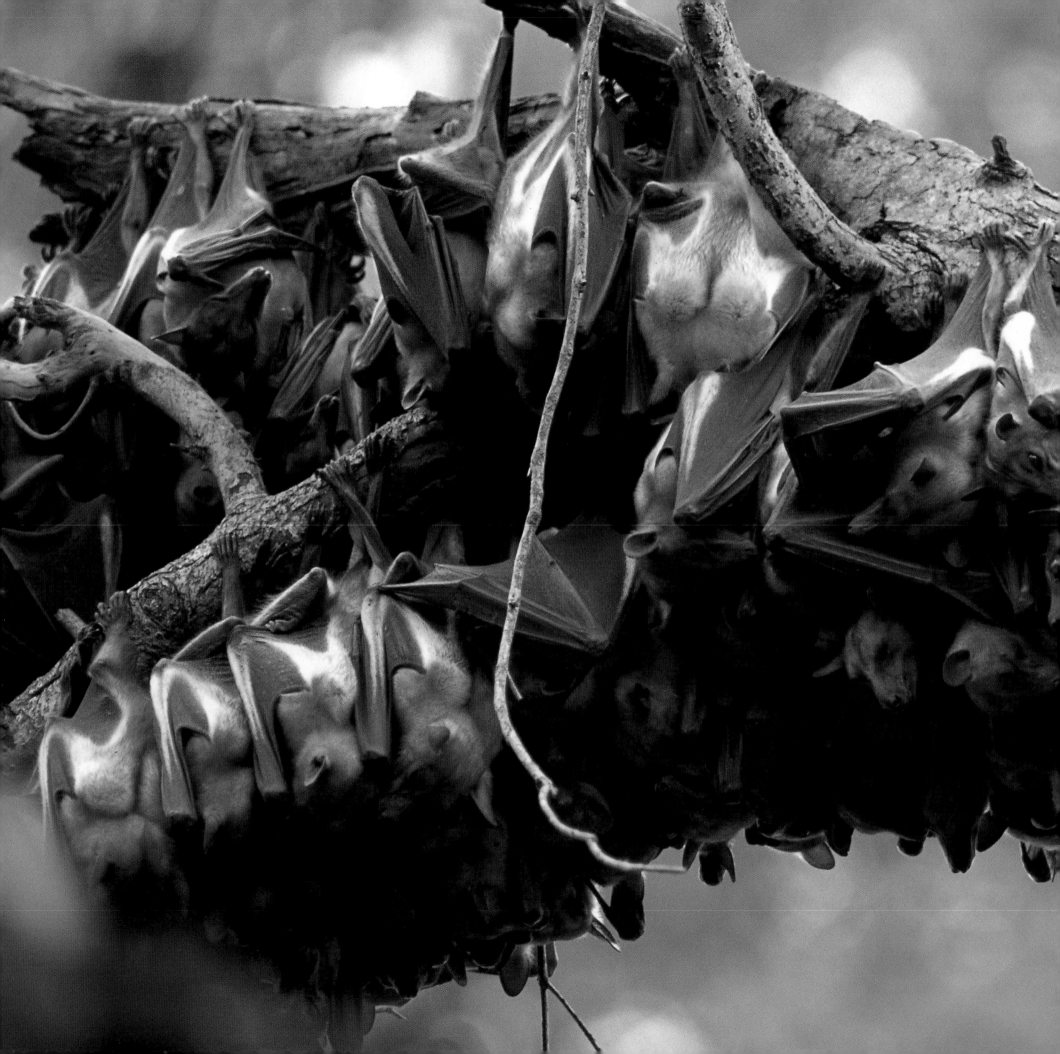

Straw-colored fruit bats
(Eidolon helvum)*, Kasanka National Park,*
northeastern Zambia.
© Chris & Tilde Stuart

males gather in particularly productive sites where food is seasonally plentiful, and the caves provide the temperatures appropriate for breeding (close to 40ºC). In order to cope with the physiological stress of producing enough milk for their babies, lactating mothers may increase their food intake as much as two or even threefold. Another important hurdle is how females recognize their own babies amidst literally millions of other young. This species, like most other bat species, gives birth to a single young. These young are gathered in large patches in the cave roof, and each female locates her own by a combination of hearing and smell.

Sadly, because of the very large concentrations and fixed locations of these caves, these bats are particularly sensitive to several threats. Vandalism and disturbance of colonies severely impact populations, while the continued use of pesticides remains a very real threat to populations. Of perhaps greater concern are the misguided efforts of humans to kill and control bats in caves around the world through the use of explosives, cyanide gas, fire, and the sealing up of entrances.

But bats do not roost only in caves. Another stunning but dramatically different spectacle is provided by some bat species of the Old World tropics. For example, an estimated 1.5 million straw-colored fruit bats (*Eidolon helvum*) gather in one hectare of forest in Kasanka National Park, Zambia, in November and December, probably to take advantage of the great abundance of the musuku (*Uapaca kirkiana*) fruit, as there is no reproduction in those months. So great are their roosting numbers that branches of large trees break from the weight. Deer Cave in Gunung Mulu National Park, which is located in the middle of the rain forest on Sarawak, Malaysia, is inhabited by about two million insectivorous wrinkle-lipped free-tailed bats (*Chaerephon plicata*) and 11 other bat species. The National Museum in Phnom Penh, Cambodia, also used to have a colony of two million *C. plicata*, but they were evicted due to the smell and the guano. The spectacle was beyond breathtaking, as the bats left the impressive Khmer-style building by the thousands a minute in the warm evening. In Queensland, Australia, about a million flying foxes gather in Tooan Tooan Creek, but then almost everywhere in Oceania there are impressive flying fox colonies. The Indooroopilly golf course in urban Brisbane, Australia, is home to up to 100 000 flying foxes gathering to breed. The spectacle of these large bats hanging from tree branches like huge, elongated dark fruits and fanning their wings to cool off and protect their young is truly remarkable, all the more so when they begin to leave towards their feeding roosts in the late afternoon. And many other large colonies of bats are known throughout the world.

Because of their great importance as insect pest controllers, seed dispersers, pollinators of hundreds of plant species, many useful to humans, and because of their undeserved bad reputation, bats require urgent, widespread, and effective conservation efforts worldwide. If humans left them alone they would continue fulfilling their important ecological and economic roles. Considering their obvious benefits to humans and our productive processes, it is relatively easy to convince people of how important it is to protect bats and leave their caves alone. Actions such as those by the Program for the Conservation of Mexican Bats, a collaboration between the National Autonomous University of Mexico and Bat Conservation International, using a combination of research projects, environmental education modules, and conservation efforts, have shown their positive and effective consequences in the conservation of bats; so far, over 20 caves that are being monitored have either remained stable or increased in colony size. Concerned readers can join conservation efforts by contacting local, national, or international conservation organizations, erecting bat houses, protecting bat roosts, and spreading the word of their great importance and the key roles that bats play for our welfare and that of virtually every land ecosystem on Earth.

RODRIGO A. MEDELLÍN
MERLIN D. TUTTLE

PRIMATES

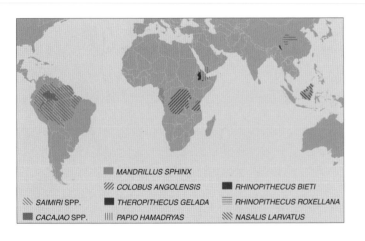

MANDRILLUS SPHINX
COLOBUS ANGOLENSIS
RHINOPITHECUS BIETI
SAIMIRI SPP.
THEROPITHECUS GELADA
RHINOPITHECUS ROXELLANA
CACAJAO SPP.
PAPIO HAMADRYAS
NASALIS LARVATUS

We stood in the rain and dense fog at nearly 3 000 m, with the temperature barely above 0°C, craning our necks and scanning the steep pine-covered slopes, waiting anxiously for the appearance of the Yunnan snub-nosed monkey (*Rhinopithecus bieti*). A mystery animal until the early 1990s, when it was finally studied in the wild, this monkey ranks among the top 25 most threatened primates on Earth and numbers no more than 1 500 individuals in about 13 scattered populations in northwestern Yunnan Province and an adjacent corner of Tibet. After nearly two hours of waiting, we spied movement at the very top of the hill, the pines swaying back and forth with the arrival of these monkeys that can weigh close to 20 kg. And then it began —a cascade of monkeys climbing, walking, and leaping down the slope, in what seemed to be endless numbers, an immense group of some 150. As impressive as our sighting was, the Yunnan snub-nosed monkey is known to travel in even larger groups of up to 300 individuals. Its close relation, the Sichuan snub-nosed monkey (*R. roxellana*), another Chinese endemic, forms similarly large groups, but they tend to divide up to forage in smaller groups when food is scarce and patchy. The Yunnan snub-nosed monkey, the more terrestrial of the two, exploits lichens that are consistently available and widespread, and its enormous groups can be observed year-round.

Most of the world's 640 different kinds of primates live in family groups, extended families, or multi-male, multi-female groups of as many as several dozen individuals. Fewer than a dozen, though, are documented to live in very large groups numbering in the hundreds. These include the baboons (*Papio* spp.) of the woodland savannas of sub-Saharan Africa, and the gelada (*Theropithecus gelada*) of the grass-covered highlands of Ethiopia. Four of the five species of savanna baboons at times live in groups of between 100 and 200 individuals. However, the hamadryas baboon (*P. hamadryas*) of the Horn of Africa and Arabia stands out among its congeners in forming groups that can exceed 700. Similarly, the gelada, an Ethiopian endemic that feeds largely on grass seeds at altitudes reaching 4 400 m, forms groups of up to 600 individuals at certain times of the year. It also sometimes joins with olive baboon (*P. anubis*) groups to form mixed-species associations. Another largely terrestrial primate, but one of the forested regions, is the brilliantly colored mandrill (*Mandrillus sphinx*) of western Central Africa. This species clearly is the congregations record-holder among the non-human primates, with groups in Gabon's Lopé Reserve regularly in the several hundreds, and sometimes in excess of 1 300 individuals. And, in Southeast Asia, routine evening congregations of up to 80 proboscis monkeys (*Nasalis larvatus*), with the large males

On the opposite page, the Yunnan snub-nosed monkey (Rhinopithecus bieti) *is endemic to China and lives in high-altitude temperate forests in northwestern Yunnan Province and adjacent portions of Tibet. As with other* Rhinopithecus *species, it can occur in huge groups of several hundred individuals.*
© Patricio Robles Gil/Sierra Madre

Above, mandrills (Mandrillus sphinx) *live in the forests of Central Africa and form larger groups than any other non-human primate species. More than 1 300 individuals have been recorded in a single group in Gabon's Lopé Reserve.*
© Cyril Ruoso/BIOS

87

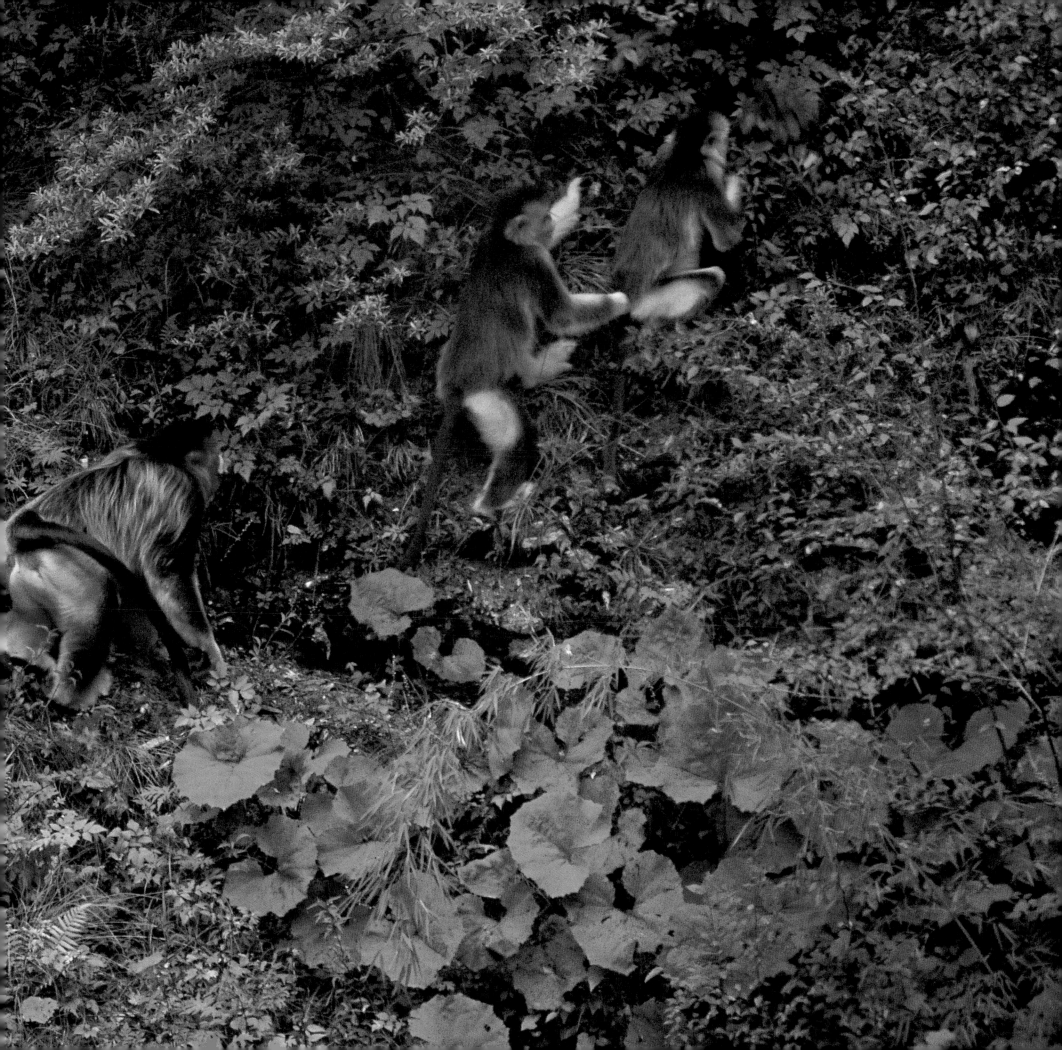

reaching some 20 kg, provide a unique spectacle for travelers along the river-edge and mangrove forests of coastal Borneo.

Groups tend to be larger for terrestrial primates than for arboreal primates, but there are exceptions. For example, the Angolan black-and-white colobus (*Colobus angolensis*) typically lives in groups of over 100 animals, with groups in the Nyungwe Forest, Rwanda, known to comprise 300 or even 400 animals. Amazonia may hold the single-species group size record for arboreal monkeys. Troops of 120 to 300 squirrel monkeys (*Saimiri* spp.) have been reported from Colombia, and there is an early twentieth-century account from Guyana of as many as 550 monkeys in a single group. Groups of 100 or more uakaris (*Cacajao* spp.) may be less spectacular in terms of sheer numbers, but provide an amazing spectacle as they move rapidly through the Amazon rain-forest canopy, stopping only to rip open seeds and husks.

In the rain forests of West, Central, and East Africa, mixed-species associations of guenons, mangabeys, and colobus are also remarkable. These associations often include a few hundred animals represented by three to four species, although associations of as many as six species have been observed. Typical members of such associations among the guenons include the crowned monkey (*Cercopithecus pogonias*), putty-nosed monkey (*C. nictitans*), cephus monkey (*C. cephus*), mona monkey (*C. mona*), Wolf's monkey (*C. wolfi*), blue monkey (*C. mitis*), and red-tailed monkey (*C. ascanius*). Two or more species of guenon often travel and forage with groups of gray-cheeked mangabeys (*Lophocebus albigena*), black mangabeys (*L. aterrimus*), guereza colobus (*Colobus guereza*), red colobus (*Procolobus badius*), and Angolan colobus (*Colobus angolensis*). Some mixed-species associations are stable from day to day and from year to year, while others tend to disband after less than one hour together. Some African rain-forest primates are more likely to be seen in association with other species than by themselves. Furthermore, they frequently can be found in association with other non-primate species, and it is not uncommon to find antelope species, like duikers (Cephalophini) and bushbuck (*Tragelaphus scriptus*), and birds, such as hornbills (Bucerotidae) and guineafowl (Numididae), associating with primate groups.

Why do some primates live in large groups? Why do some primates, especially in Africa, frequently participate in large, multi-species associations? There are numerous explanations, but key aspects for both phenomena center on foraging efficiency, food availability, and defense from predators. The more terrestrial primates, notably the baboons and geladas, face fearsome predators such as leopards (*Panthera pardus*), and their large size, ferocious nature, and large numbers are one solution to defending themselves in the open. In the case of associations of guenons and colobus monkeys, improved predator detection has been shown to be important, as well as improved foraging success due to reduced need for vigilance. The distribution and abundance of food resources in both space and time are also vital in allowing such large numbers to travel together. In the case of the snub-nosed monkeys, which live at high altitudes where it can snow for months at a time, group formation also enables these primates to huddle and keep warm.

The threats to these remarkable primate spectacles are both numerous and serious. Habitat destruction is the principal concern, but hunting for bushmeat, especially in West and Central Africa, is also severe. Not surprisingly, living in multi-species associations increases vulnerability to such hunting because these large, noisy associations are quite easy to locate and follow. In terms of conservation, the principal need for primates is protection in parks and reserves. Large and spectacular megagroups and mega-associations can persist only where there are enormous areas of suitable habitat and where the animals are protected from unsustainable levels of hunting. The forest-dwellers are now largely restricted to the relatively intact wildernesses of Amazonia and the Congo Forests of Central Africa, but a handful persist in some of the better-protected parks in West Africa as well. There is a particular need for very large protected areas. Fortunately, several of these already exist (e.g., Odzala National Park in the People's Republic of Congo, Salonga National Park in the Democratic Republic of Congo, the National Parks of Jaú, Pico da Neblina, and Tumucumaque in Brazil, Pacaya-Samiria National Park in Peru, and the Central Suriname Nature Reserve in Suriname), but many more will be needed if the magnificent spectacle of large groups and associations of primates is still to exist at the end of this century.

RUSSELL A. MITTERMEIER
WILLIAM R. KONSTANT
ANTHONY B. RYLANDS
CRISTINA G. MITTERMEIER
THOMAS BUTYNSKI

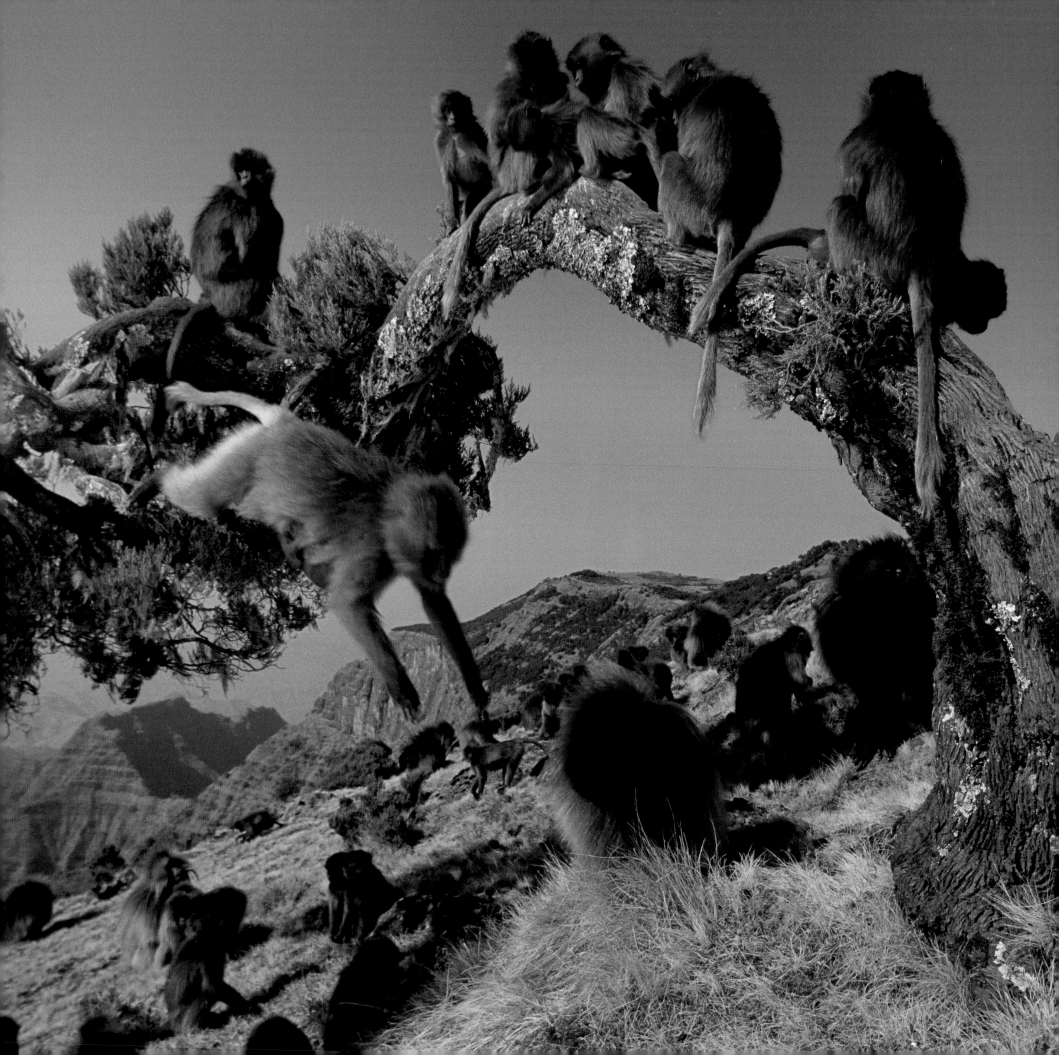

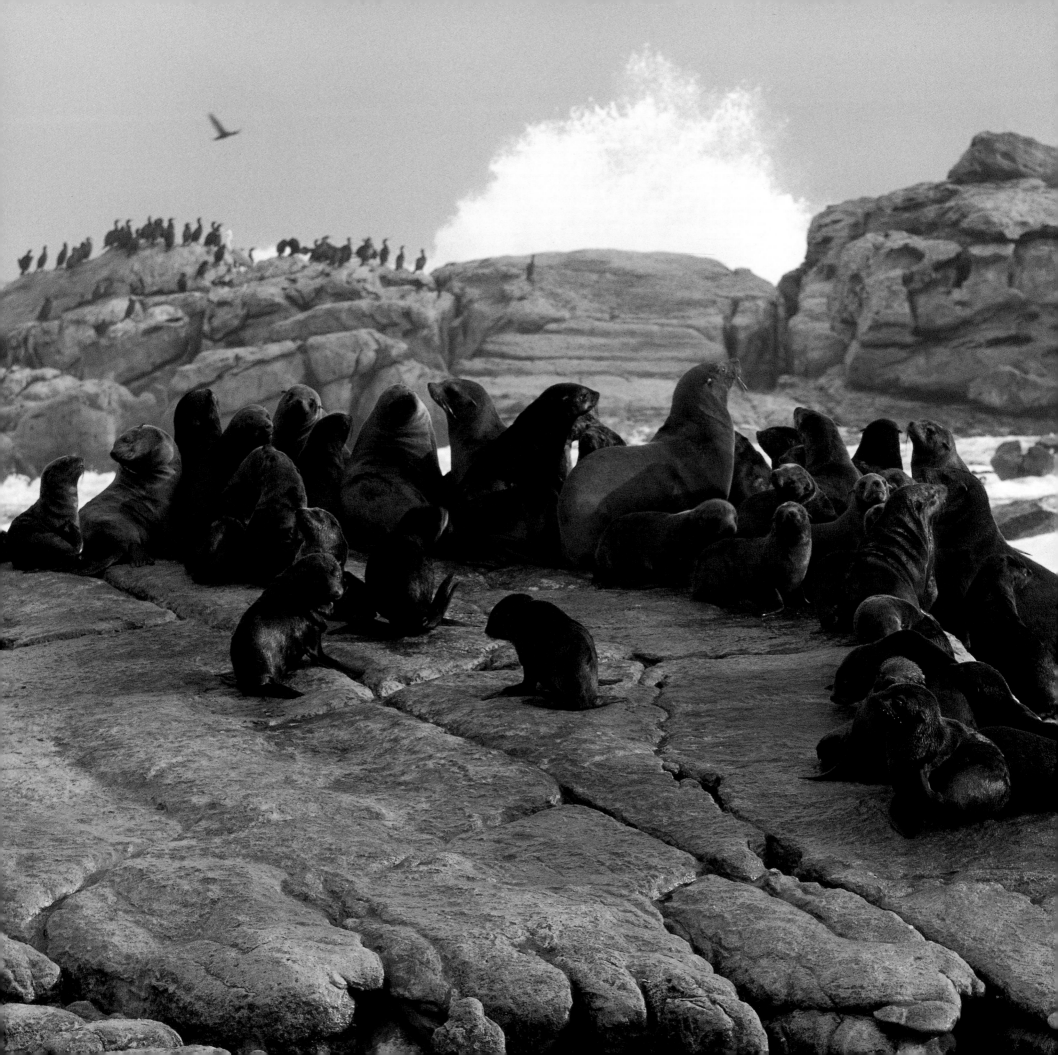

There are 33 different species of pinnipeds (true seals, sea lions, fur seals, and walruses) throughout the world today, including 18 phocids, 14 otariids, and one odobenid (walrus). In terms of actual populations, there are many more phocids than otariids, mainly because there are almost 15 million crabeater seals (*Lobodon carcinophagus*) in the Antarctic (crabeater seals are the most abundant large mammal species in the world after humans), 6-7 million ringed seals (*Phoca hispida*), and hundreds of thousands of all the other ice-breeding species. However, even though they are so abundant, most of these tend to be widely scattered in pairs, triads or very small groups.

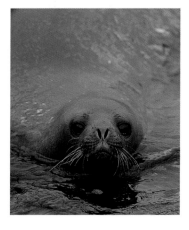

The only ice-breeding pinnipeds forming large-sized groups are the walruses and harp seals (*P. groenlandica*). Female walruses form dense groups around islands and large floes, with males displaying in the waters around them. Almost 80% of the estimated world population (250 000) of walruses is found in the Bering and Chukchi Seas and on Wrangel Island in the north Pacific. In the Eastern Canadian Arctic, walruses occur in northern Foxe Basin, and in Hudson Bay, near Coats Island and southern Southampton Island. There are almost 2.5 million harp seals in the White Sea, near Jan Mayen Island east of Greenland, and around Newfoundland in January and February, when females gather in "whelping patches" of several thousands on floes of one-winter ice with males circulating among them. Unlike walruses, which tend to travel with their young and suckle them for months, harp seals may wean their pups in less than 10 days. This short lactation is a response to breeding in a highly unstable substrate —the faster they can wean the pup, the more likely it is to survive if the ice breaks and mother and pup are separated from each other.

Land-breeding seals, on the other hand, gather in very large groups. The northern and southern elephant seals (*Mirounga angustirostris* and *M. leonina*) form very large colonies, thousands of animals coming together during the breeding and molting seasons. The main northern elephant seal colonies, on islands off Central Baja California, and those of southern elephant seals, off Península Valdez in Argentinian Patagonia, are subjects of intense tourism. These species show the most extreme sexual dimorphism in any mammal and, accordingly, the most extreme cases of polygyny, with a single male mating with several hundreds of females.

For the pinnipeds, the separation between foraging and mating environments and anatomical adaptations for diving likely have been the most important factors leading to the evolution of some of the most extreme levels of polygyny and sexual dimorphism in the world. With limited terrestrial mobility, present-day

SEALS, SEA LIONS, AND WALRUSES

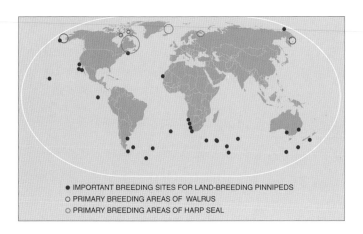

● IMPORTANT BREEDING SITES FOR LAND-BREEDING PINNIPEDS
○ PRIMARY BREEDING AREAS OF WALRUS
○ PRIMARY BREEDING AREAS OF HARP SEAL

On the opposite page, Cape fur seal (Arctocephalus pusillus), *Cape of Good Hope, South Africa. This species occurs in the southern hemisphere in areas of upwelling. The warm waters of the Agulhas Current meet the near-freezing water of Antarctica at the Cape of Good Hope, making it an ideal place for fur seals to congregate.*
© Art Wolfe

Above, crabeater seal (Lobodon carcinophagus) *in the Antarctic Peninsula. This species is by far the most abundant pinniped and the most abundant large mammal species in the world after humans, its total population being estimated at 15 million individuals.*
© Patricio Robles Gil/Sierra Madre

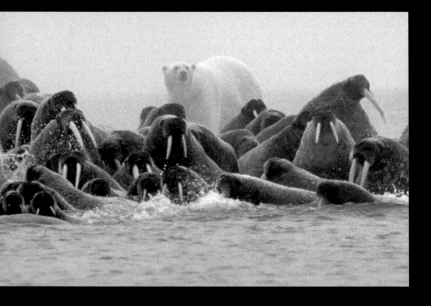

Above,
polar bear (Ursus maritimus)
approaching a group of walruses
(Odobenus rosmarus).
© Norbert Rosing

On the opposite page,
thousands of bull walruses
crowd the beach at Togiak National
Wildlife Refuge in Alaska.
© Joel Sartore

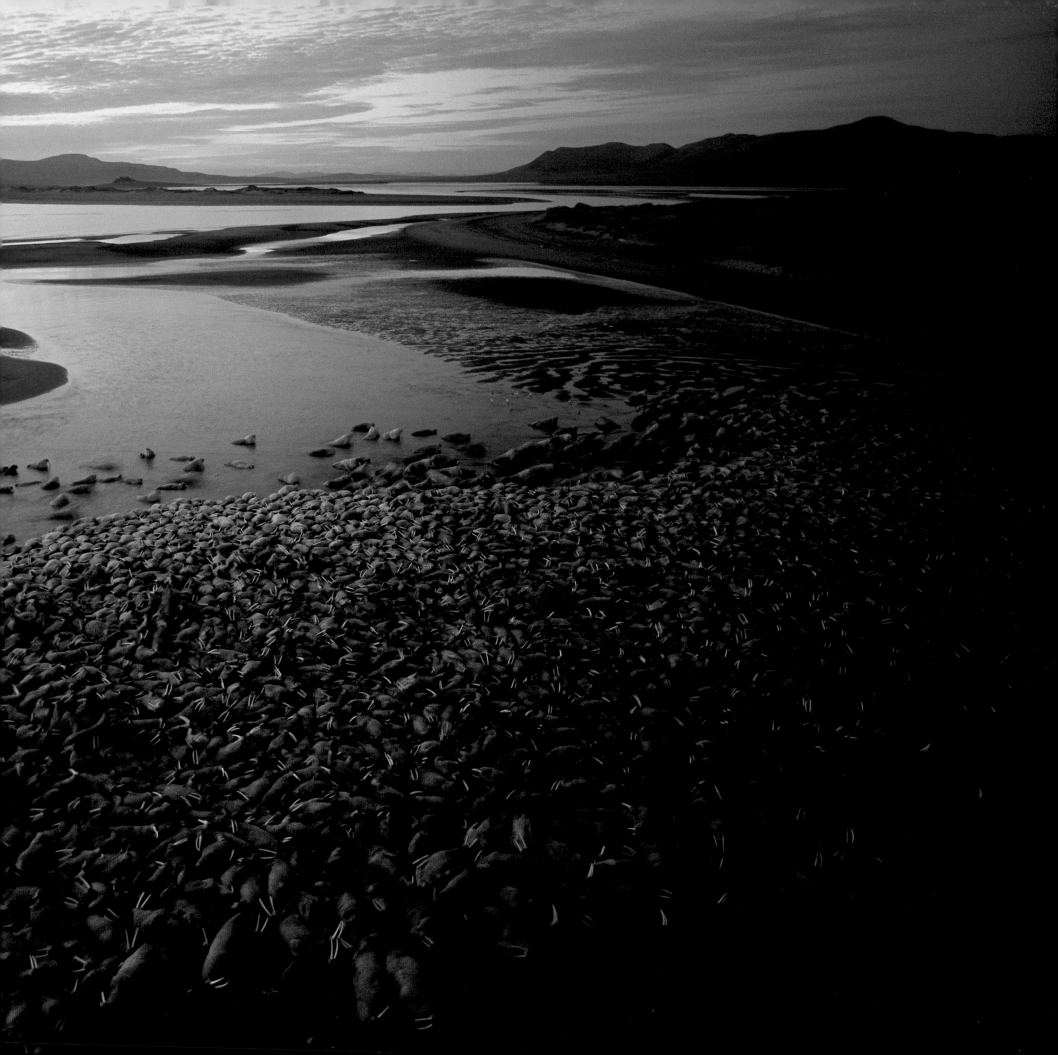

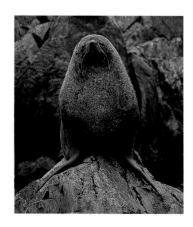

Above, Antarctic fur seal
(Arctocephalus gazella)
on South Georgia Island.
© Patricio Robles Gil/Sierra Madre

On the opposite page,
northern elephant seal bulls
(Mirounga angustirostris)
fighting on a breeding beach off
the coast of California.
© Tim Fitzharris/Minden Pictures

On pp. 98-99, a huge
congregation of California sea
lions (Zalophus californianus)
on the coast of California.
© Frans Lanting

pinnipeds are constrained by predators and humans to breeding in remote or difficult-to-access areas. At these sites, females gather annually to give birth and mate, and males fight for access to females. Furthermore, because all foraging takes place away from the mating grounds, the size and stability of breeding colonies are not limited by food supply. In the few suitable breeding sites, females may form very large and dense aggregations that provide the opportunity for a few males to mate with many females.

Adaptations for foraging at sea such as large body mass, blubber, and fur, allow pinnipeds to fast and remain ashore for extended periods of time. These same adaptations may result in heat stress while ashore; thus, most species live in cold or temperate areas, which allow them to avoid overheating, and also are usually surrounded by very productive seas. The walruses (*Odobenus rosmarus*) and almost all phocids (true seals) live in northern circumpolar waters. The only phocids found closer to the tropics are the Endangered Hawaiian monk seal (*Monachus schauinslandi*) and the Critically Endangered Mediterranean monk seal (*M. monachus*), of which less than 1 500 and 400 seals, respectively, are left in the world today. The otariids (sea lions and fur seals) are also found in temperate to cold areas, but have a much wider distribution. Those few that range close to the equator, including the Galápagos fur seal (*Arctocephalus galapagoensis*), South American fur seal (*A. australis*), and South African fur seal (*A. pusillus*), live in upwelling areas, where cold, nutrient-rich waters occur. All fur seals, except for the Guadalupe fur seal (*A. townsendi*) and Northern fur seal (*Callorhinus ursinus*), live in the Southern Hemisphere, whereas the sea lions are common in both hemispheres.

Most land-breeding seals have gone through periods when they were intensively hunted and brought close to extinction throughout the nineteenth century and the first half of the twentieth. The majority of these have shown significant recoveries since then, but the most remarkable is the case of the Antarctic fur seal (*Arctocephalus gazella*). This species was thought to be extinct in the 1930s, and was rediscovered in the 1950s. By 1990 there were close to 1.5 million, and by now there may be close to four million scattered around the Antarctic islands. No less than 95% of them are on South Georgia Island in the South Atlantic.

Today, all pinniped species are legally protected throughout the world. This protection, however, is effective mainly while ashore. At sea they are vulnerable to entanglement in fishing nets, and are often directly killed by fishermen who see them mostly as pests. However, the greatest threat to pinnipeds today is the development of industrial fisheries over the last 50 years

that has led to the depletion of most commercial fish stocks. Pinnipeds have evolved very efficient foraging strategies, but these depend on the availability of large schools of fish. Overfishing has depleted many of these large schools of fish, and seals have had to switch to either less energy-rich species or to species that are more difficult to catch. To complicate this matter further, global warming trends may be affecting the distribution patterns and availability of traditional prey species, and causing El Niño or El Niño-like events to happen more frequently and more intensely, thereby resulting in high levels of pinniped mortality due to food shortages. Although some pinniped populations are still very large, they could easily be threatened if the growth of the fisheries industry continues and manages to exterminate the few remaining abundant fish stocks.

Efforts to reduce fishing pressure will take a while to have an effect and fish stocks may have been depleted to a level that may not allow recovery in the short term. The most promising solution seems to be the establishment of fully protected marine reserves. These marine reserves may not only provide protection to pinniped species subject to disturbances or poaching while on land, but may also allow faster recovery of fish stocks. Even if we can not prevent El Niño-like events from happening, by allowing undisturbed breeding and faster fish stock recoveries, threatened pinniped species may have a better chance of survival. Conservation efforts have managed to bring many seals back from the brink of extinction —the task ahead is much more difficult as it entails not only those causes directly affecting the populations, but complex food chains and long-term climate changes. With adequate protection and abundant food supplies, pinnipeds may recover amazingly fast as evidenced by the Antarctic fur seal of South Georgia. Many other species that depend on commercial fish stocks are not so lucky and are presently threatened. It remains to be seen whether anything can be done in time to save some of the most remarkable wildlife spectacles in the world.

PATRICIA MAJLUF

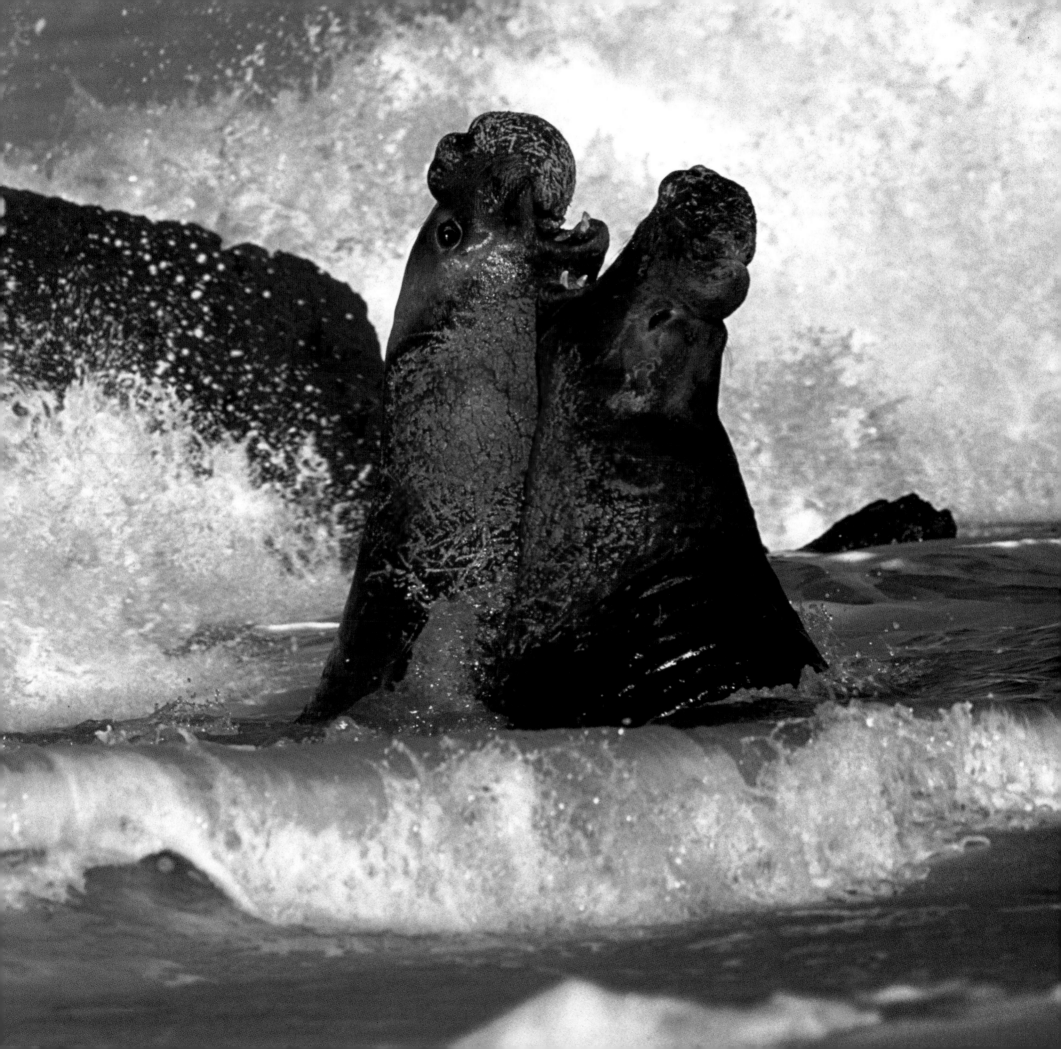

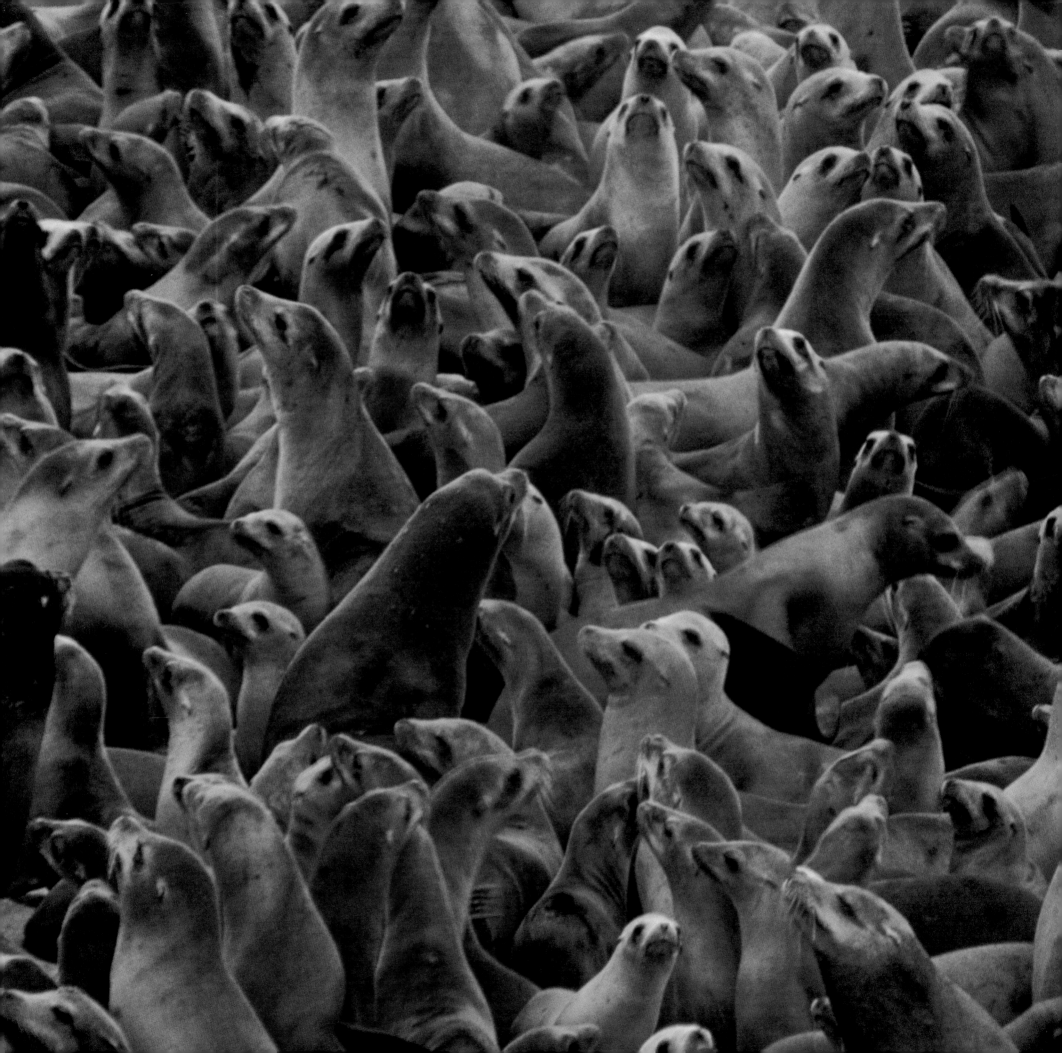

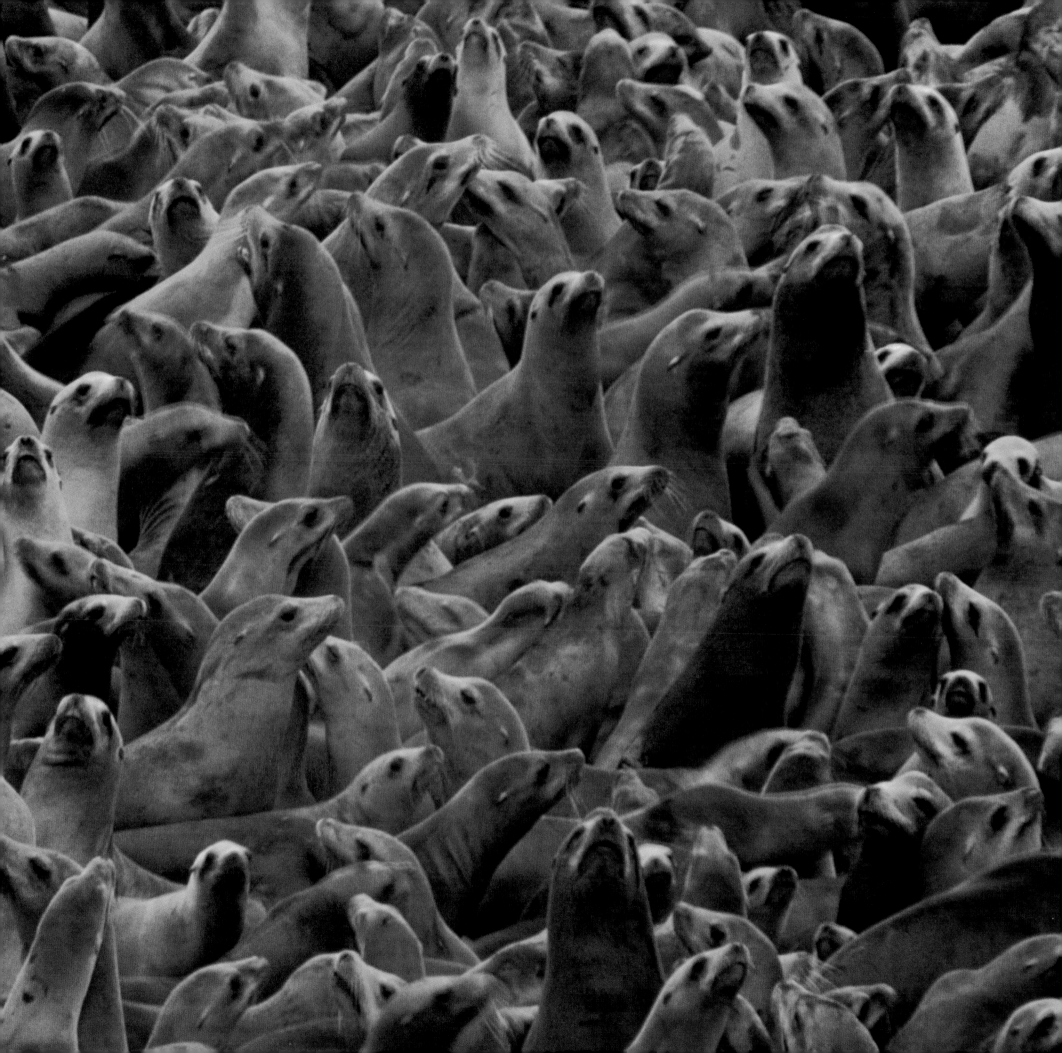

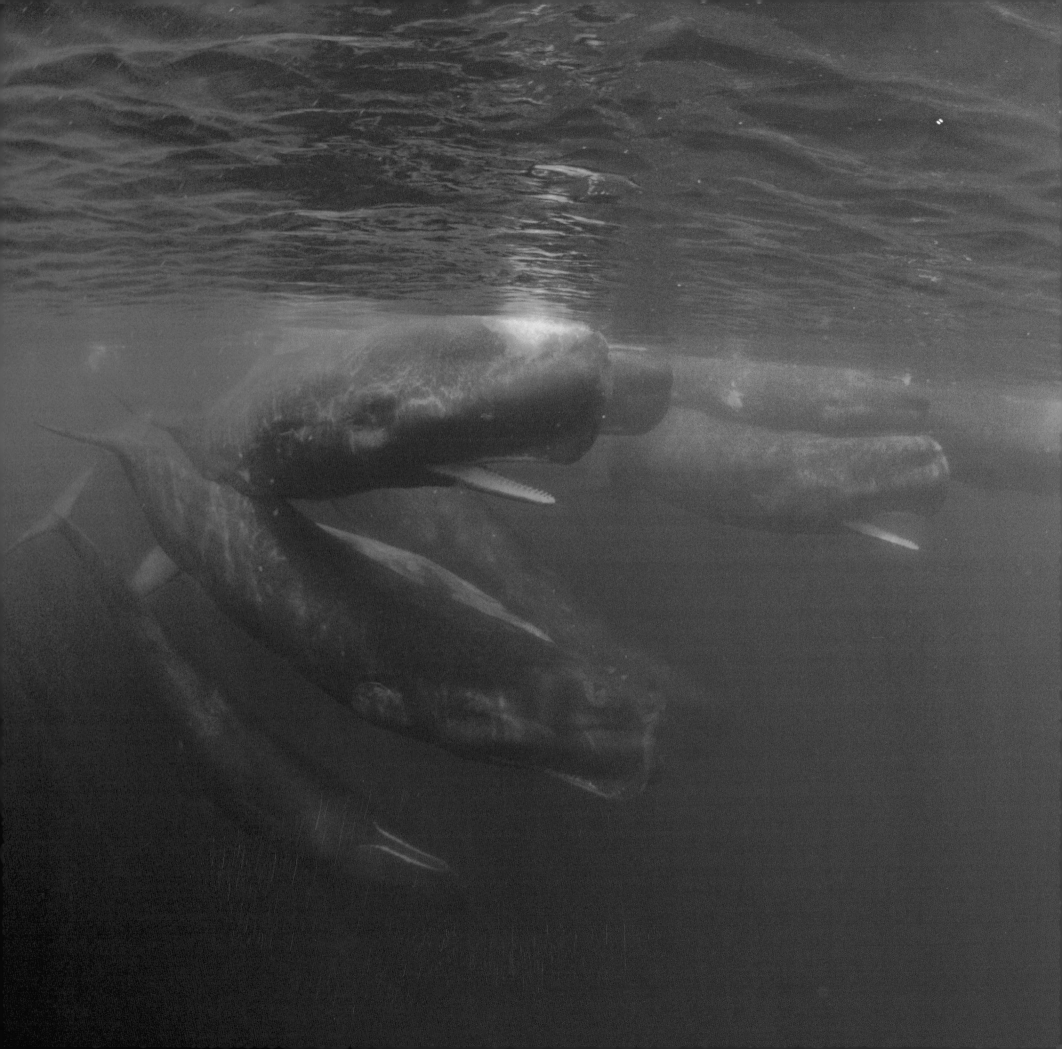

WHALES, DOLPHINS, AND PORPOISES

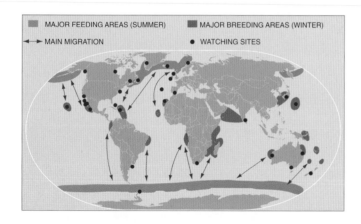

MAJOR FEEDING AREAS (SUMMER) MAJOR BREEDING AREAS (WINTER)

→← MAIN MIGRATION ● WATCHING SITES

As the early morning mist lifts from the calm waters of sheltered lagoons in the Gulf of California, the spray from the blowholes of numerous gray whales becomes visible. Here and in a few other select places around the world, whales and other cetaceans still gather to form some of nature's most magnificent and unique spectacles. How, what, and why would these mystical creatures form such aggregations or groups?

Whales, dolphins, and porpoises make up the more than 80 species of cetaceans that can be found in every part of the ocean, venturing from shallow tropical waters to dark abyssal depths, and in rivers and estuaries. Generally, scientists agree that most cetaceans spend at least part of their life cycle in aggregations or groups. Aggregations can be defined as non-mutualistic relationships where the members do not derive benefits from being together. In contrast, groups are mutualistic in that individuals live close together so they can benefit from one another and also benefit the whole group. Although rarely witnessed by humans, some species of cetaceans congregate in large groups for numerous reasons. These include to breed, to calve, and to feed in areas where food availability is high.

Cetaceans are divided into two major categories: the baleen (or mysticete) whales, and the toothed (or odontocete) whales, which include dolphins and porpoises. Baleen whales usually do not form groups, schools or pods. However, most of the toothed whales do live in social groups of different sizes that may last for generations. The size of the groups varies with the species. This is particularly true among the dolphins, where groups can consist of hundreds to thousands of individuals, as is the case with the long-beaked common dolphin (*Delphinus capensis*) in the Gulf of California. There is no denying the amazing wildlife spectacle of several hundred to thousands of dolphins frolicking close to the surface of the water. Even in smaller numbers of around 170 individuals, sperm whales (*Physeter macrocephalus*), the largest odontocete, are also known to occasionally form impressive groups.

Some whales, like the beautiful white whales or belugas (*Delphinapterus leucas*), form enormous migratory processions that may spread out over several kilometers at any one time. Beluga pods generally include only 10 to 12 animals, but when the time comes to migrate, several pods may travel together to form herds of several hundred whales. Belugas range widely across the

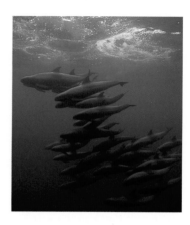

On the opposite page, sperm whales (Physeter macrocephalus) like these, sometimes occur together in groups of up to 170 individuals.
© Stuart Westmorland

Above, a group of melon-headed whales (Peponocephala electra) off the Big Island of Hawaii.
© Mark Conlin/Seapics.com.

One of the most amazing wildlife spectacles is that of gray whales
(Eschrichtius robustus) in their breeding lagoons, such as that shown
here in Bahía Almejas, Baja California, Mexico. During peak season,
it is possible to count as many as 700 per day in a single bay.
© Marilyn Kazmers/Seapics.com

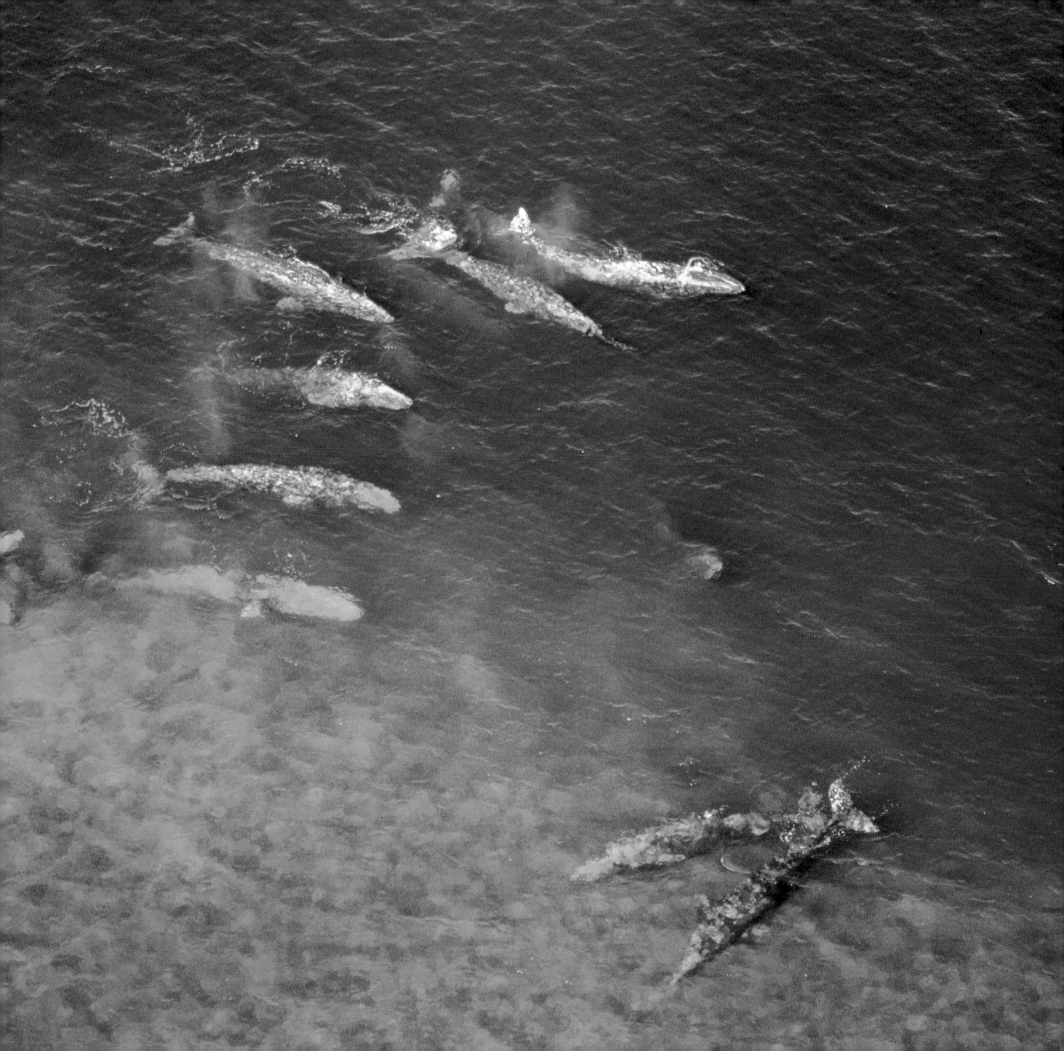

Arctic Ocean and adjacent seas, divided into several populations that together number well over 100 000 individuals. The most impressive densities of belugas, however, occur during the spring, when they migrate to warmer coastal estuaries and bays such as that of St. Lawrence in North America, where animals can molt, rear young, and find food in relatively sheltered conditions.

Ocean predators such as belugas are themselves hunted by one of the most popularly known odontocetes, the killer whale (*Orcinus orca*). Herds of this whale can number over 250 individuals, although such aggregations are not commonly seen. Hunting cooperatively like a pack of wolves, pods of killer whales roam all the oceans of the planet; in fact, they are among the most widely distributed mammals on Earth, making their total abundance difficult to assess.

Although baleen whales do not form groups, their aggregations can be nonetheless impressive, mainly because these are often massive animals coming together in relatively small or enclosed areas compared to the vast and open ocean. Of particular note is our planet's largest living animal, the mighty blue whale (*Balaenoptera musculus*), which aggregates off the Baja California Peninsula, an area considered to be a nursing, feeding, and probably calving region for the species. The number of blue whales found there is estimated to be no larger than 600 animals. Typically, blue whales are encountered alone or in pairs of mother and calf. To see just 20 of these majestic animals congregating in a common area for feeding in a single day is definitely a wildlife spectacle. The second largest baleen whale in the world, the fin whale (*B. physalus*), is also found in the Gulf of California forming large groups of around 70 individuals. Although this may be considered a small number for other taxa, any gathering of these animals is still extraordinary due to their sheer size.

Perhaps the most amazing wildlife spectacle of any large mammal is that of gray whales (*Eschrichtius robustus*) in their breeding lagoons. Like other baleen whales, the gray whale migrates between feeding grounds at high latitudes to warmer waters at lower latitudes for breeding and calving. The gray whale follows this behavior, logging a remarkably long round trip migration of between 16 000-22 500 km each year. In October, the Eastern Pacific population of this species begins to leave their feeding grounds in the Bering and Chukchi Seas. The southern destination for this population is the warm, shallow lagoons of Baja California, Mexico, where they mate and give birth to their young. By early December this population of gray whale begins to assemble in areas like Laguna Ojo de Liebre, a lagoon that is adjacent to Laguna San Ignacio, Laguna Guerrero Negro, and Magdalena Bay. At the peak of the season it is possible to count in a single day as many as 700 animals or even more at Laguna Ojo de Liebre. Though not swimming in close proximity, the sheer number of blowholes blasting water from the glistening backs of these gray whales that span across the lagoon into the ocean as far as the eye can see is truly awe-inspiring.

Cetaceans also are known to congregate in the Atlantic. The West Indies, for example, draws humpback whales (*Megaptera novaeangliae*) from across the whole North Atlantic, into one relatively small breeding area off the coast of the Dominican Republic. Remarkably, yearly concentrations total between 6% and 10% of the global population. When they converge in their breeding grounds, male humpback whales often form competitive groups around single females. A group of up to 12 animals swimming packed together is an amazing sight.

Many of us have been fortunate to witness such wonders, though for the most part large-scale whaling and other human practices have drastically reduced the abundance of many cetacean populations. In too many cases, our own species has caused the loss of entire populations, and possibly also, of species of whales, including the North Atlantic gray whale, and we have pushed others to the brink of extinction. With surviving populations, we will need to draw on the huge amount of public interest placed on cetacean conservation to ensure that large groups of whales and dolphins will fill the ocean for generations to come.

LORENZO ROJAS
CRISTINA G. MITTERMEIER
SHEILA A. MCKENNA

On the opposite page,
the 80 or so species of whales,
dolphins, and porpoises currently
recognized can be found in every
part of the ocean, from shallow
tropical waters to dark abyssal
depths, and even in some rivers
and estuaries, too. Most
cetaceans, such as this group
of spinner dolphins (Stenella
longirostris) off the Big Island
of Hawaii, spend at least part
of their life cycle
in aggregations or groups.
© Masa Ushioda/Seapics.com

On pp. 106-107, a super pod
of 20 killer whales or orcas
(Orcinus orca). *This magnificent*
marine mammal hunts
in groups, and preys on other
whales and seals.
© François Gohier

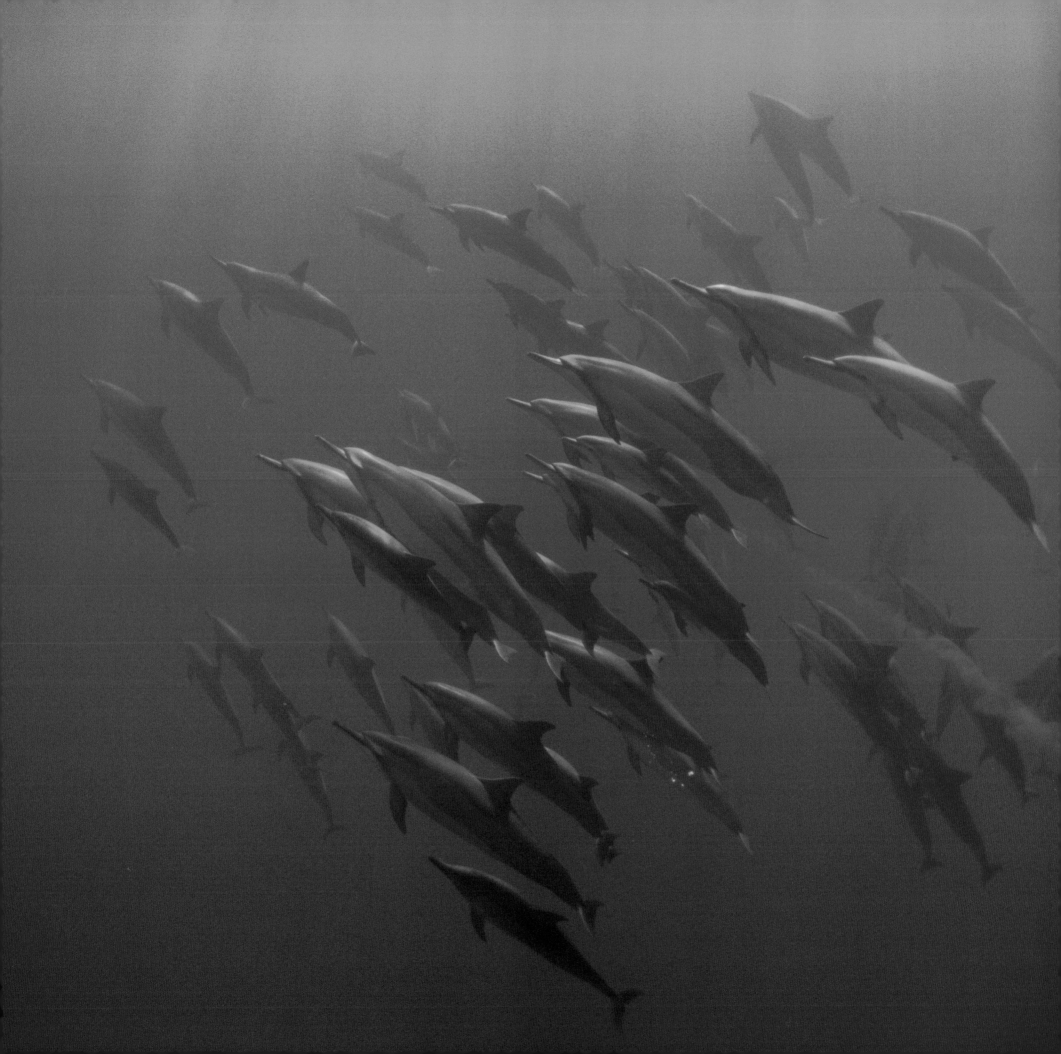

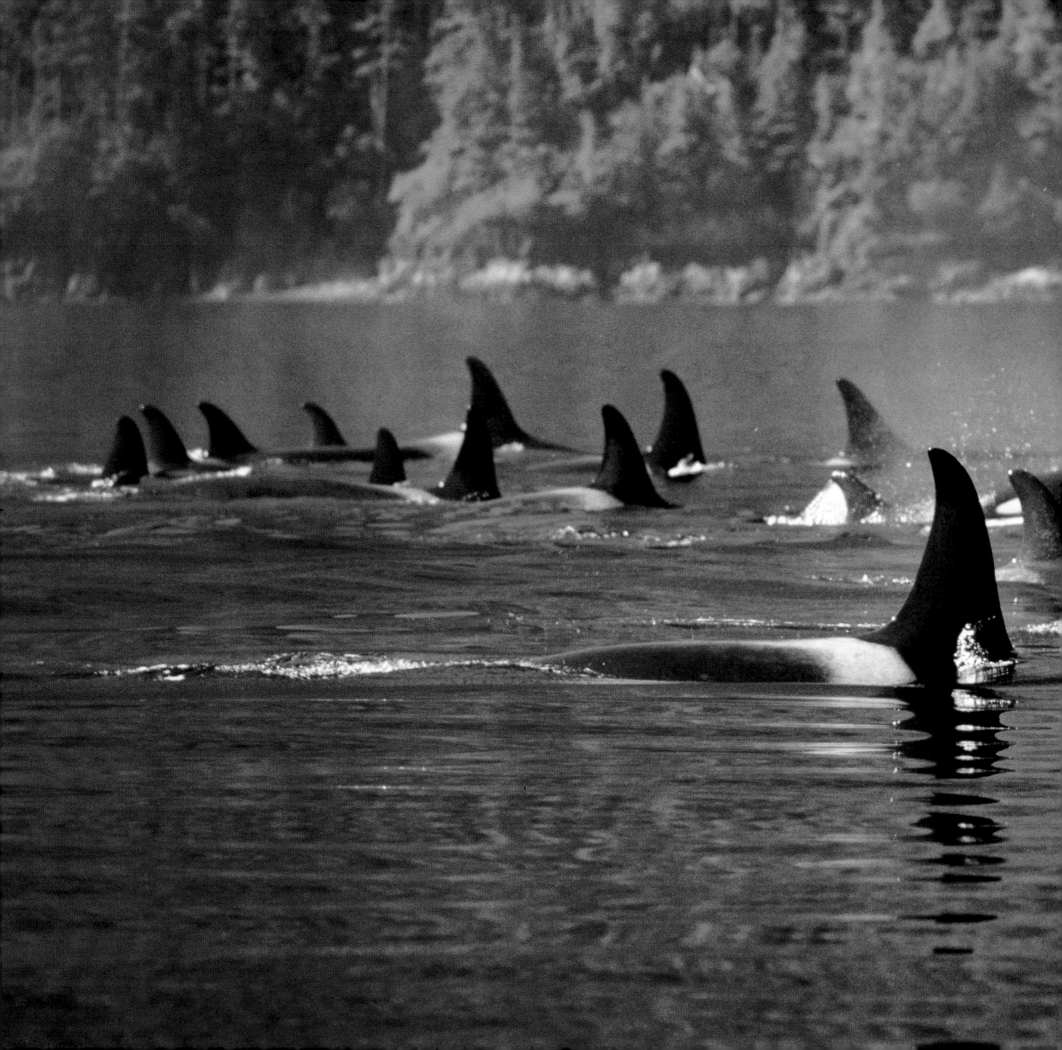

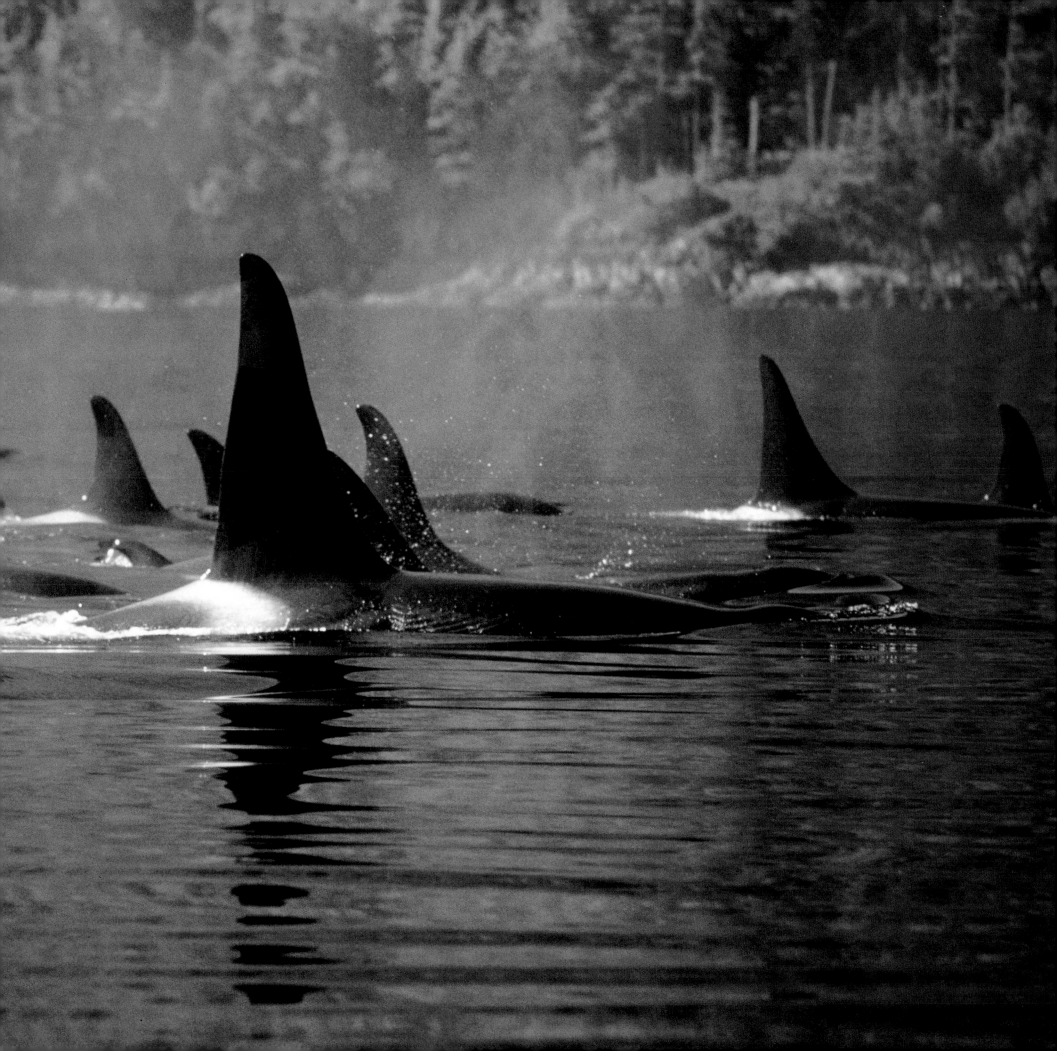

These striking belugas or white whales (Delphinapterus leucas) form enormous migratory processions that may spread over several kilometers. Beluga pods generally include only 10-12 animals, but in the spring, when the time comes to migrate to warmer coastal estuaries and bays, various pods come together to form herds of several hundred individuals. Northwest Territories, Canada. Both photos, © Günter Ziesler

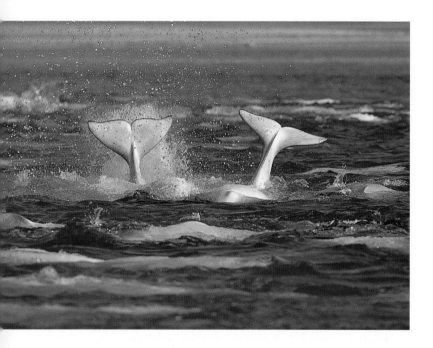

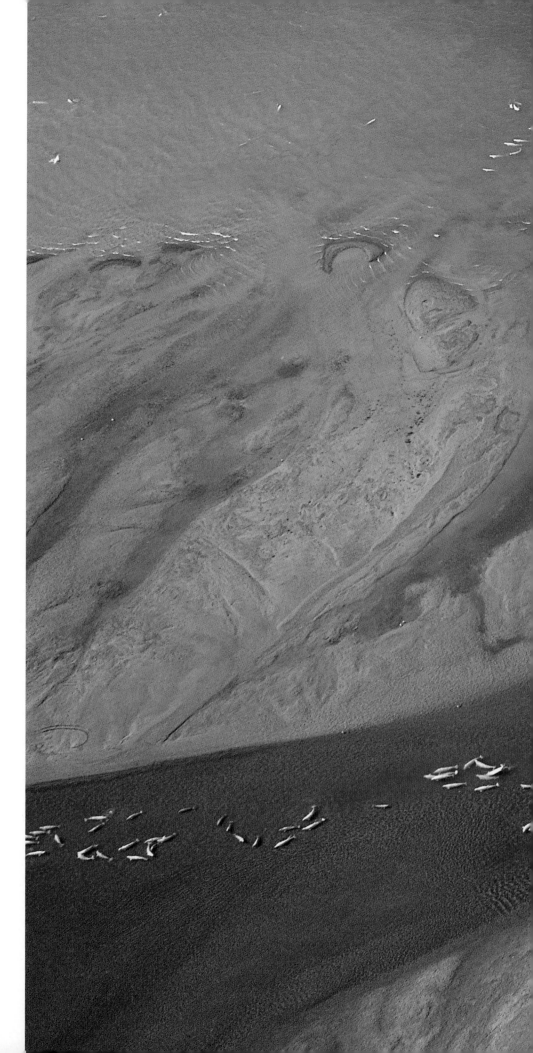

108

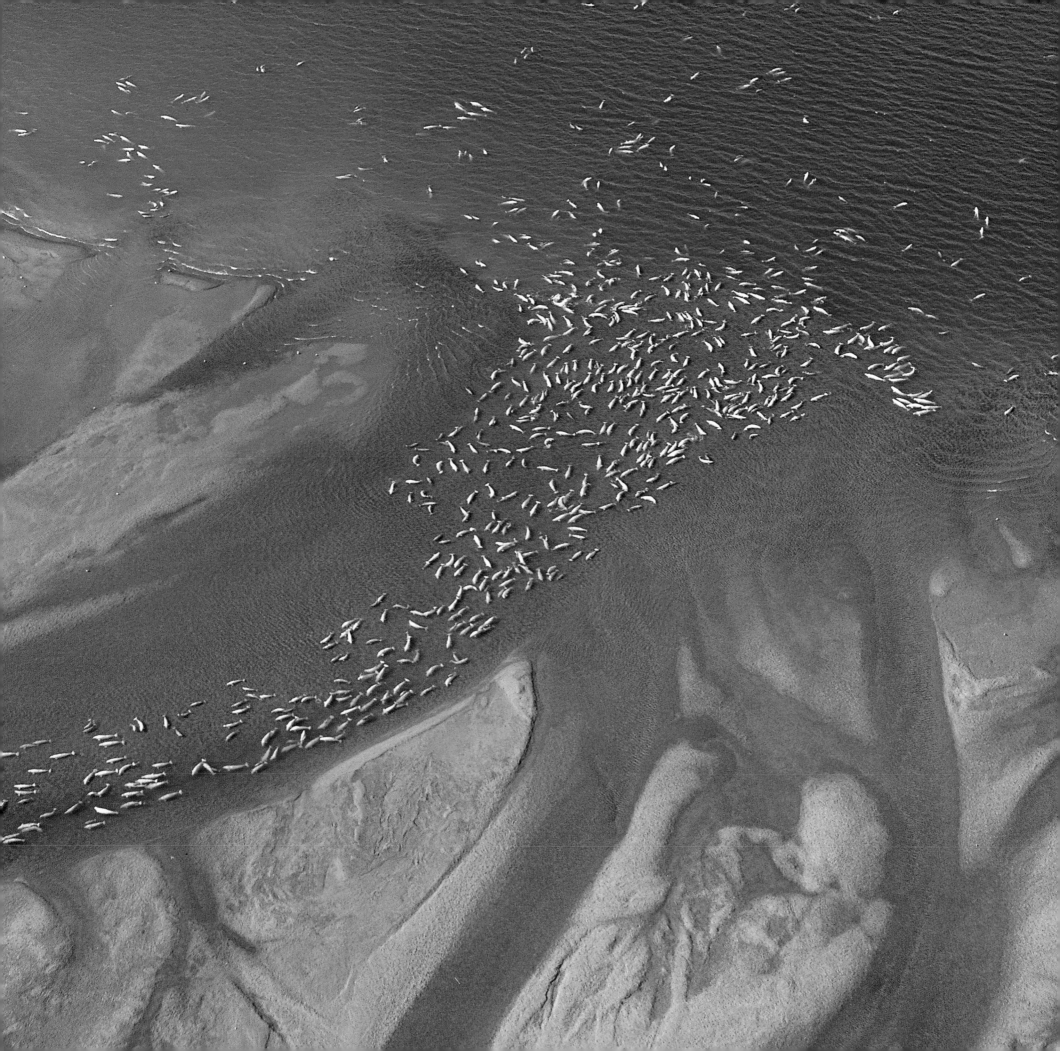

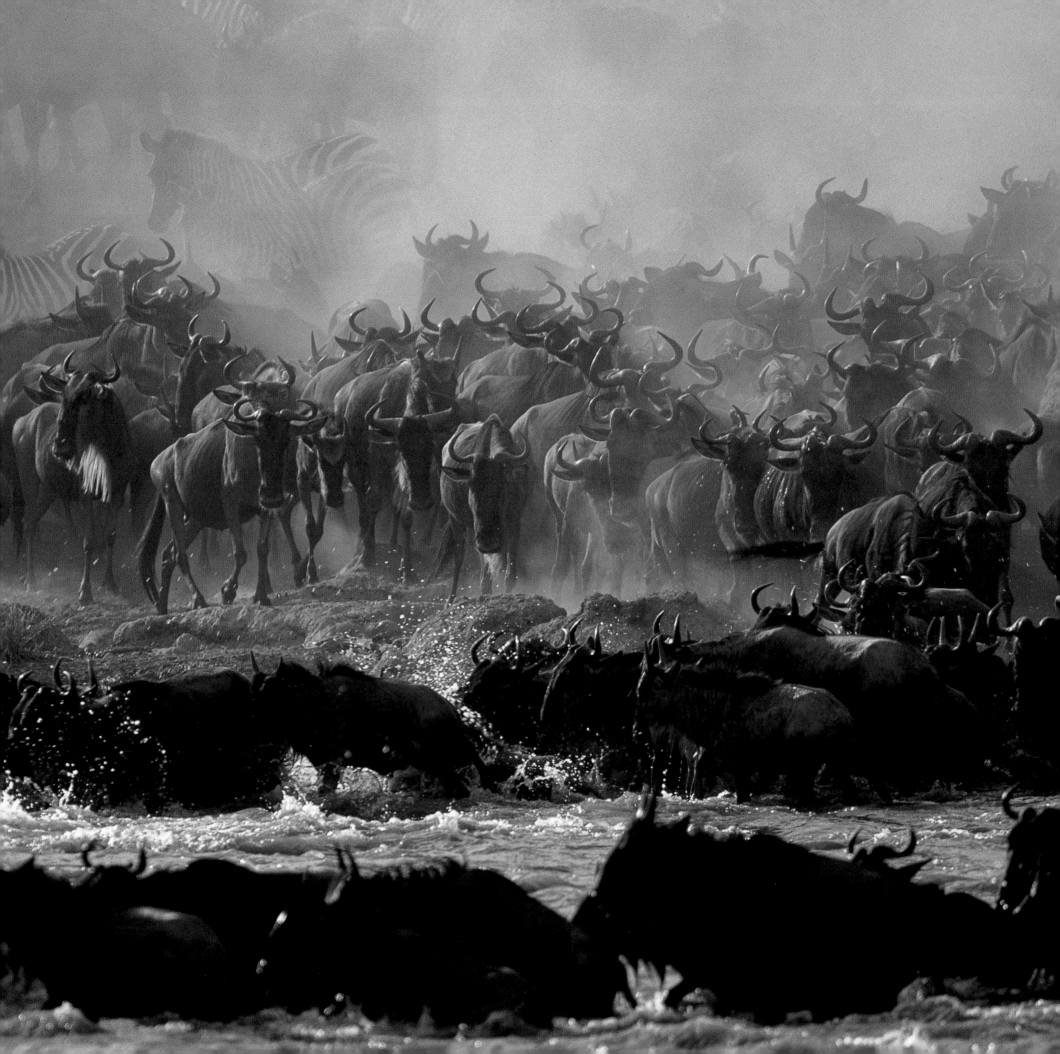

AFRICAN PLAINS GAME

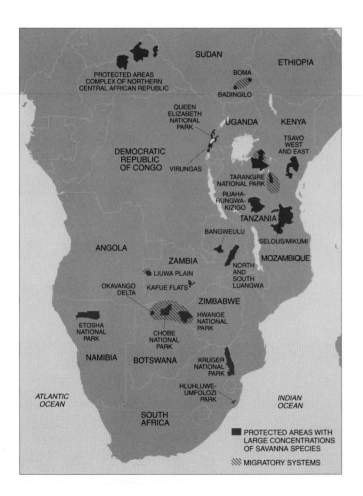

The last of the season's grass has gone on the *seringet*, the "endless plains" of the Masai. The countless herds of grazing animals are on the move with their new calves. At the Grumeti River crossing on the Tanzania/Kenya border, it is bedlam. The huge columns come to a temporary standstill from their trek, milling about in confusion. Great columns of dust rise in the shimmering heat. Animals slide down the bank and leap into the water, those in front pushed from the back. Many are trampled and fall, but the momentum is relentless. The muddy water is a swirling cauldron of thrashing beasts trying to escape snapping crocodile jaws. Panicked calves bleat for their mothers and injured animals drop from exhaustion. Thousands are in the water already, swimming purposefully, their eyes crazed. Behind them, in the shade of flat-topped thorn trees lurk predators, already gorged on plentiful prey, and the vultures circle overhead. On the distant horizon, storm clouds amass and far away thunder rumbles. This is the Serengeti migration —probably the greatest wildlife spectacle on Earth, which has lost none of its fascination since it was so brilliantly portrayed in Bernard Grzimek's classic *Serengeti Shall Not Die* over 40 years ago.

The Serengeti plains of Tanzania, 4 763 km^2 in extent, are estimated to contain three million large animals. Triggered by the rains each year, 1.3 million blue wildebeest (*Connochaetes taurinus*), 200 000 plains zebra (*Equus burchellii*), and 300 000 Thomson's gazelle (*Gazella thomsonii*) come together to undertake the long 800-km triangular trek to new grazing lands in the Masai Mara in Kenya, returning two months later.

In southeastern Sudan, a similar phenomenon occurs. In 1985, white-eared kob (*Kobus kob leucotis*) numbered 840 000. Although no recent count is available due to ongoing civil war, the numbers are likely to have been maintained in some areas because of the remoteness of the region and the low human population. This vast aggregation, with densities of up to 1 000 animals per km^2, converges on the grassland at the base of the Boma Escarpment. The kob move away from the floodplains with the onset of the rains and return in the dry months, covering some 1 500 km during the migration. Up to 500 000 tiang (*Damaliscus lunatus*) join them on their wet-season pastures.

While white-eared kob still show migratory tendencies, Uganda kob (*Kobus kob kob*) exhibit a different form of congregatory behavior. Leks are territories held and defended by males during the breeding season and in which they exhibit various displays as a means of luring estrous females into the lek for mating. Lekking is a relatively well-studied phenomenon in birds, for example birds of paradise, but is only just becoming better understood in mammals. Besides Uganda kob, Kafue lech-

On the opposite page, a swirling cauldron of thrashing wildebeest (Connochaetes taurinus) trying to escape the snapping jaws of huge Nile crocodiles (Crocodylus niloticus) with panicked calves bleating for their mothers and injured animals collapsing from exhaustion.
© Anup Shah/DRK PHOTO

Above, waiting patiently are other predators and scavengers, such as this white-headed vulture (Trigonoceps occipitalis), which also come together in large numbers to feast on the bodies of those that don't make it. Together, these creatures create one of the greatest wildlife spectacles on Earth.
© Ferrero-Labat/Auscape

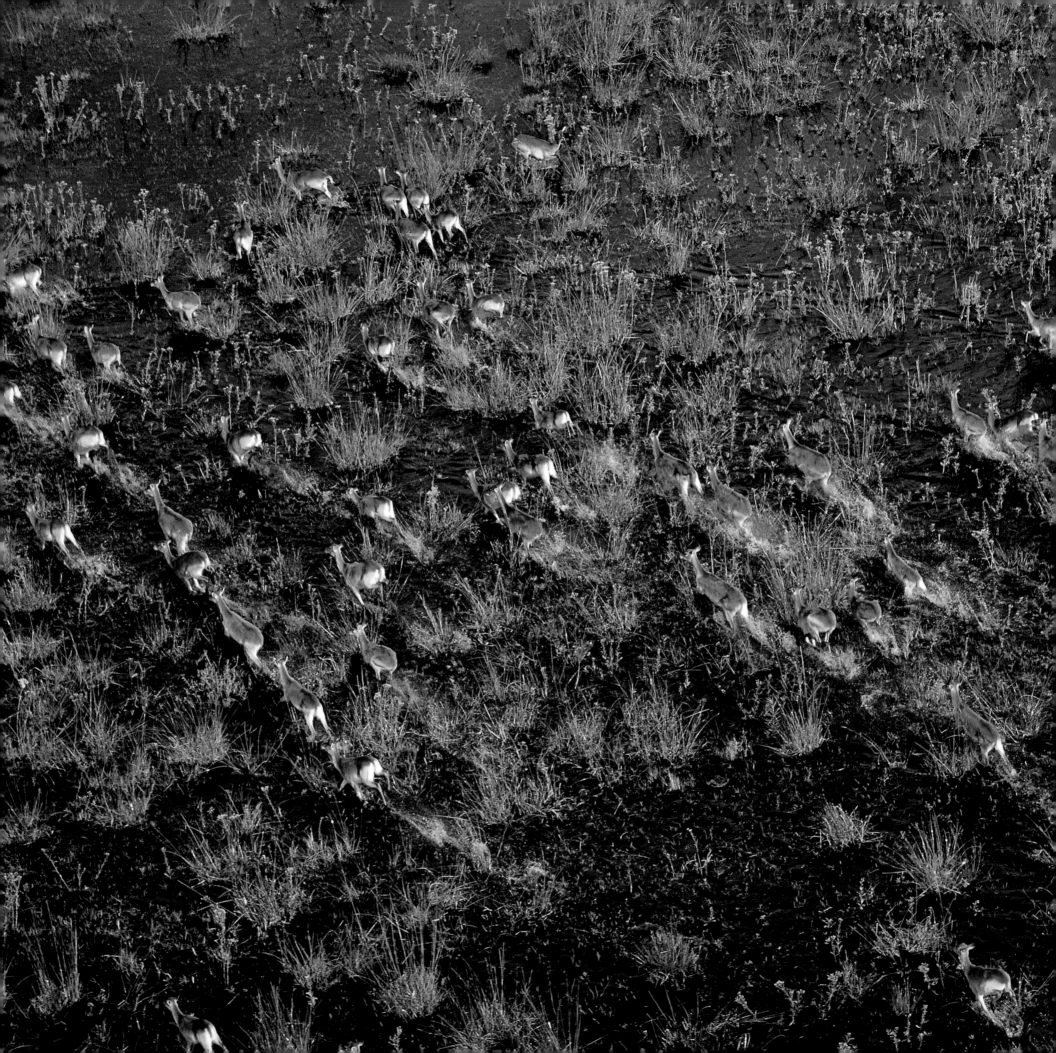

On the opposite page, large herd of red lechwe (Kobus leche)
on the floodplain of the Okavango Delta, Botswana.
© M. Harvey/DRK PHOTO

Above, red lechwe males fighting.
© Patricio Robles Gil/Sierra Madre

On pp. 114-115, a large herd of African buffalo (Syncerus caffer)
in the Okavango Delta, Botswana.
© Chris Johns/National Geographic Image Collection

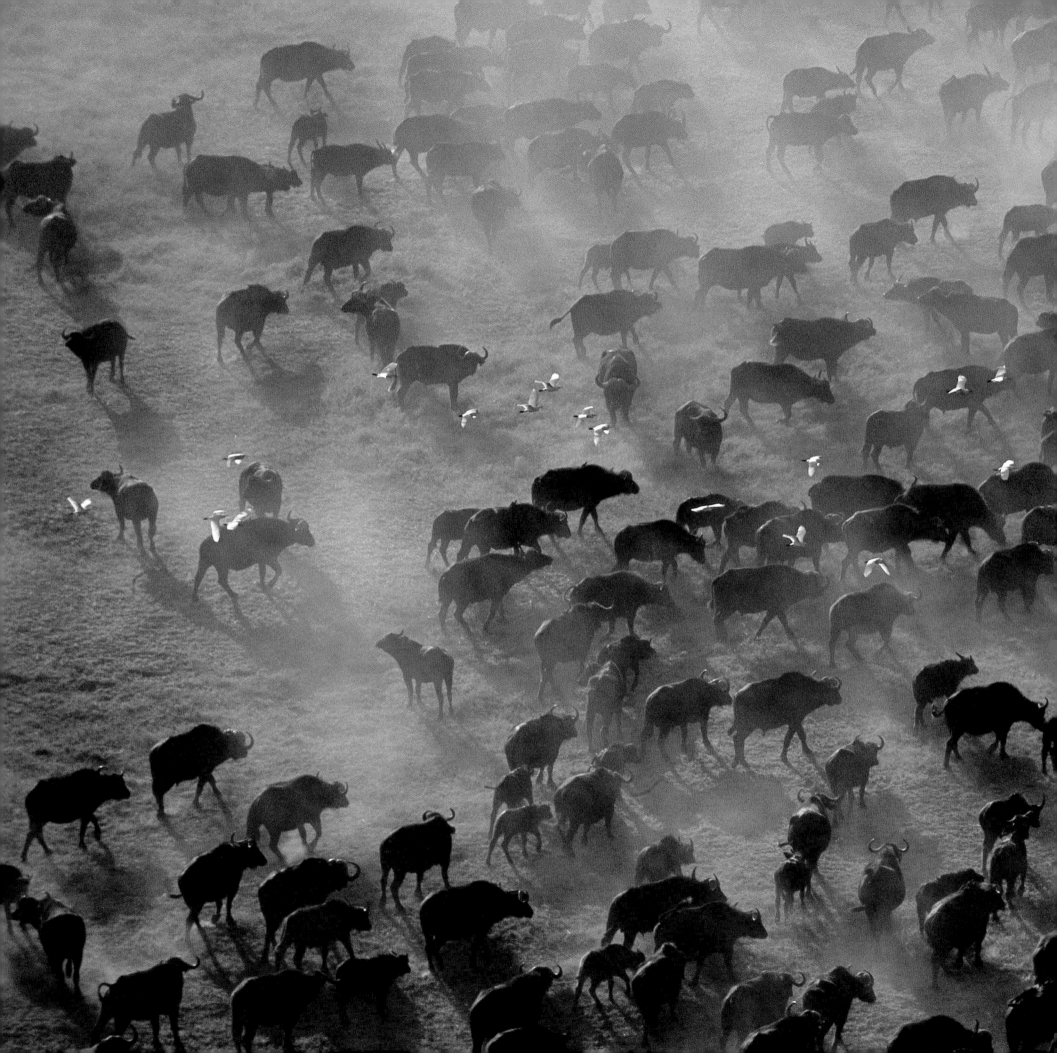

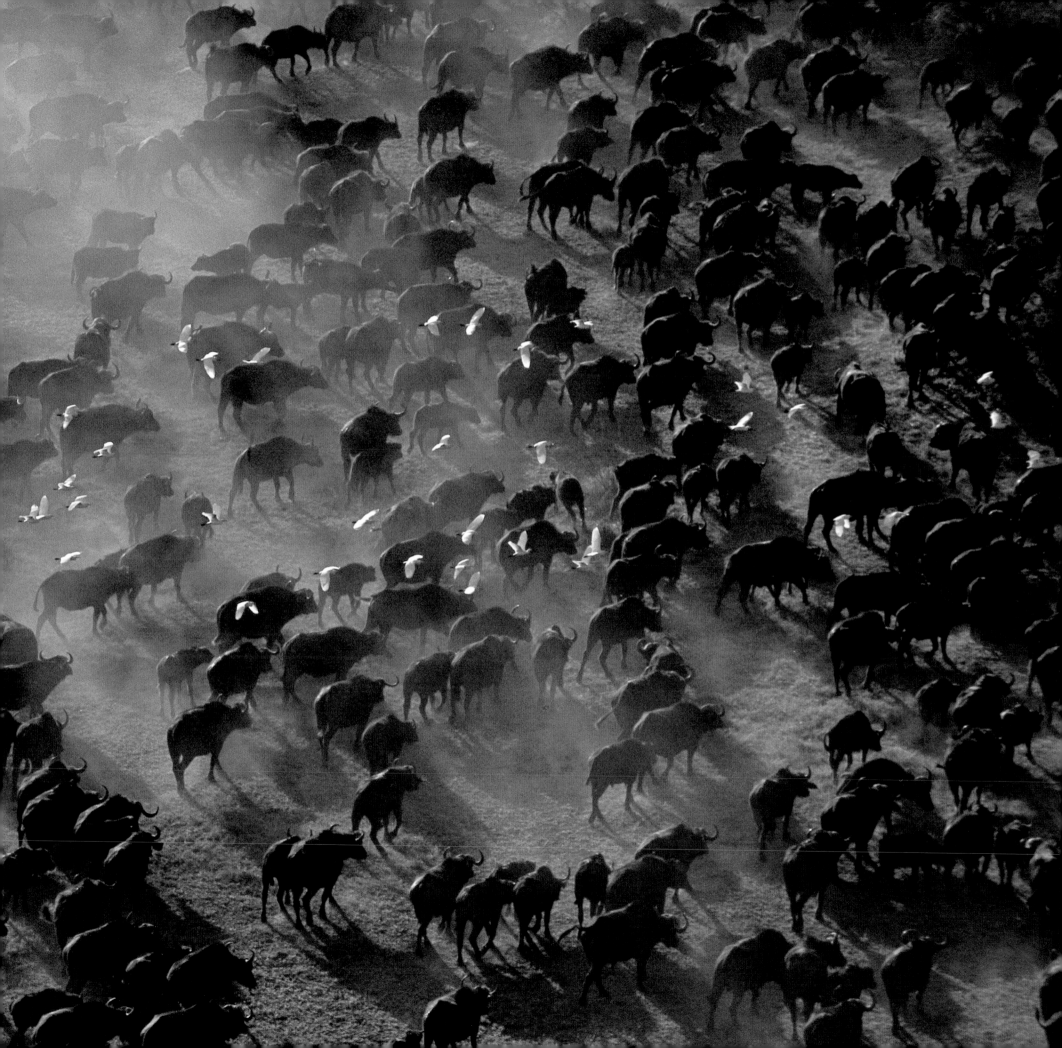

we (*Kobus leche kafuensis*) have also been found to use leks, and up to 100 males can be seen defending very small, exclusive territories within a limited area. Where such lekking behavior occurs, the females have access to any leks within their home range, moving freely in and out of the leks, mating with males whose displays they find the most attractive. Most frequently, they choose the large, prime males whose leks are located more centrally, and research has shown that estrous females make use of olfactory cues in the soil of the lek territories to choose the most suitable males.

While the common denominator for lek-breeding antelope is sex, the common imperative for the migration of large mammals is seasonal rainfall. The African savannas are characterized by one or sometimes two rainy seasons a year, with precipitation during the summer months from the Intertropical Convergence Zone, the tropical storm belt which itself migrates between the Tropics of Cancer and Capricorn. Grasses, such as the red oat grass (*Themeda triandra*) of the East African plains, quickly rejuvenate providing rich pasture for the grazing herds. Once the rainy season has passed, moisture evaporates in the heat, the grasses and woodlands become desiccated, and both nutrient and ground cover is lost. The great herds follow the rains to new pastures, many of them breeding at the same time to maximize the flush of new growth, allowing the overgrazed dust bowls left behind to recuperate.

Dizzying though these numbers are, they have dwindled considerably. In 1936, travelers to Chad observed a single herd of 10 000 scimitar-horned oryx (*Oryx dammah*), while early settlers in South Africa reported that the springbok (*Antidorcas marsupialis*) migration in the Cape took eight days to pass, with animals several kilometers abreast. The decline in numbers is largely due to habitat transformation by humans, a combination of subsistence farming, fencing and overgrazing, escalating urbanization, and charcoal burning. More recently, increased poaching, a burgeoning "bush-meat" trade, the isolation of protected areas, and containment of migratory animals in areas too small for them, have added to this downward pressure on numbers.

The plight of one of the continent's most charismatic species, the African elephant (*Loxodonta africana*), encapsulates this combination of threats, but at the same time brings a message of hope for the future. Africa's elephants have always been prized trophies, but with the growth of conservation awareness early in the last century, numbers started to build up. All this changed in the 1960s when an orgy of renewed poaching for ivory swept through East, Central, and West Africa, decimating populations. Although poaching has abated somewhat, a new threat has emerged in parts of southern Africa, namely that of overconcentration in small areas. Botswana's Chobe National Park is a case in point. It hosts the largest single population of elephant in Africa, over 100 000 individuals, unable to disperse because of human settlements, fences, and pressures from an increase in elephant/human conflicts. The elephants have wreaked havoc on the riverine vegetation of the Chobe area, transforming lush vegetation into a stark lunar landscape. Kruger National Park in South Africa has had a similar problem for over 30 years, and has had no option but to cull its elephant population if the park is to halt the loss of biodiversity and stop an elephant population crash.

The exciting vision embraced by the Transfrontier Conservation Areas (TFCAs) initiative has the potential to provide a new solution to conserving Africa's magnificent wildlife. Where nature's ecoregions straddle international boundaries, but are separated by fences, those countries are looking to break down the barriers, link the protected areas, and manage them as one united system. This will bring huge areas under one conservation umbrella, allowing animals to migrate over larger areas and making it possible to mitigate drought, rehabilitate vegetation loss, widen gene pools, lessen the spread of disease, improve tourism, enhance development potential with concomitant social upliftment, unlock international funding for better management, and stabilize borders through regional cooperation.

The concept is gathering momentum, and fortunately has been welcomed by local and national political leaders. The Kgalagadi Transfrontier Park between South Africa and Botswana is already in operation, and the Greater Limpopo TFCA, a joint initiative between South Africa, Mozambique, and Zimbabwe, will open in 2003. The Three-Nations Namib Desert TFCA, which will join the Richtersveld in South Africa, the Namib Desert and the Skeleton Coast National Parks in Namibia, and the Iona National Park in Angola, is at an advanced stage of planning, while the Four Corners TFCA (spanning Botswana, Namibia, Zambia, and Zimbabwe) is making progress. If these initiatives are given the support that they deserve, Africa's spectacular migrations will persist for centuries to come.

JOHN HANKS
SHANNON CHARLTON

Above, African elephants (Loxodonta africana) eating the bark of a tree; at high densities, elephants can do considerable damage to an ecosystem.
© Joe McDonald/Auscape

On the opposite page, this species has suffered from poaching in many parts of its range and has even been eliminated from some African countries. However, it still reaches incredible numbers in some parts of Africa, as in Chobe National Park, Botswana, shown here.
© Patricio Robles Gil/Sierra Madre

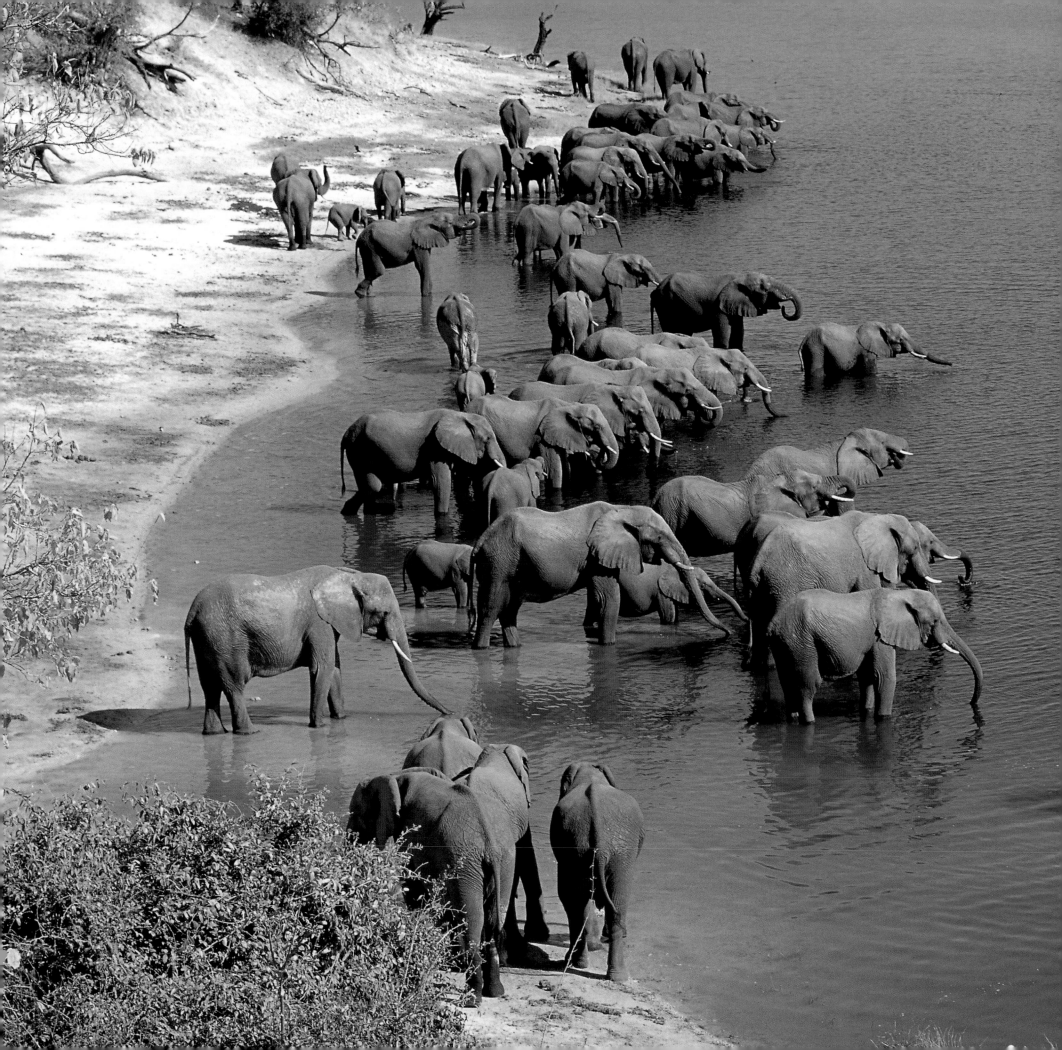

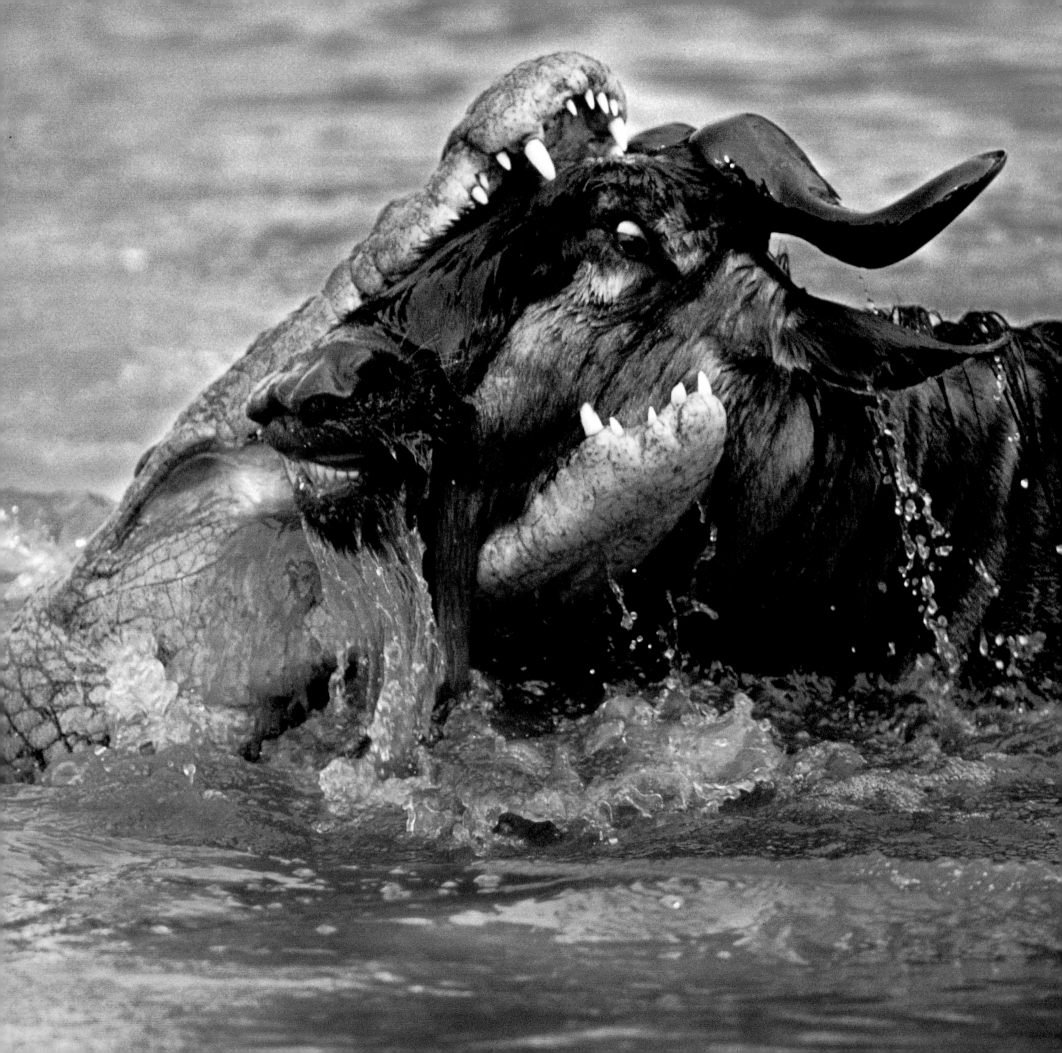

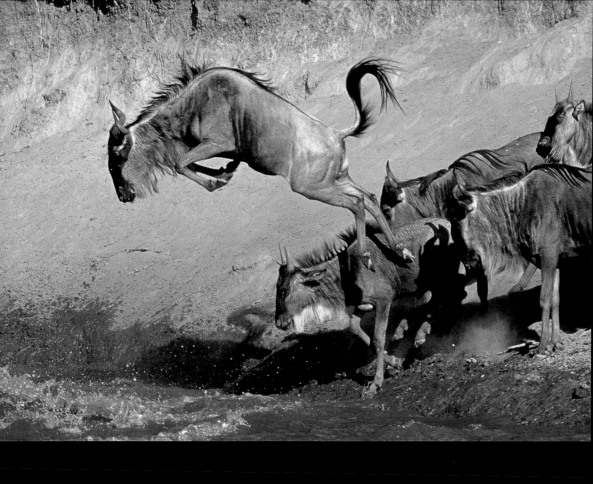

Wildebeest (Connochaetes taurinus) *are at great risk when crossing rivers.
They can drown on the way or be captured by large Nile crocodiles*
(Crocodylus niloticus). *Both photos,* © Anup Shah

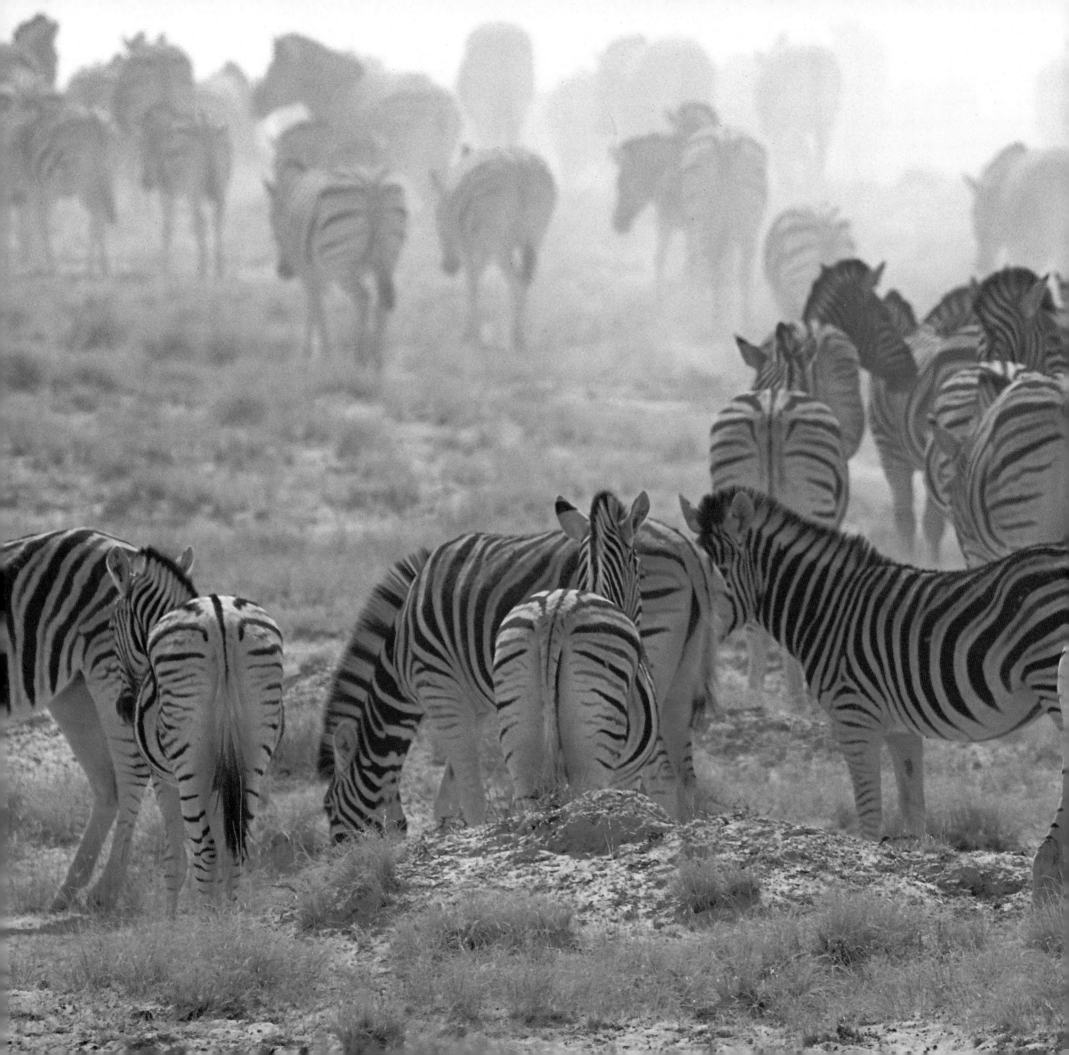

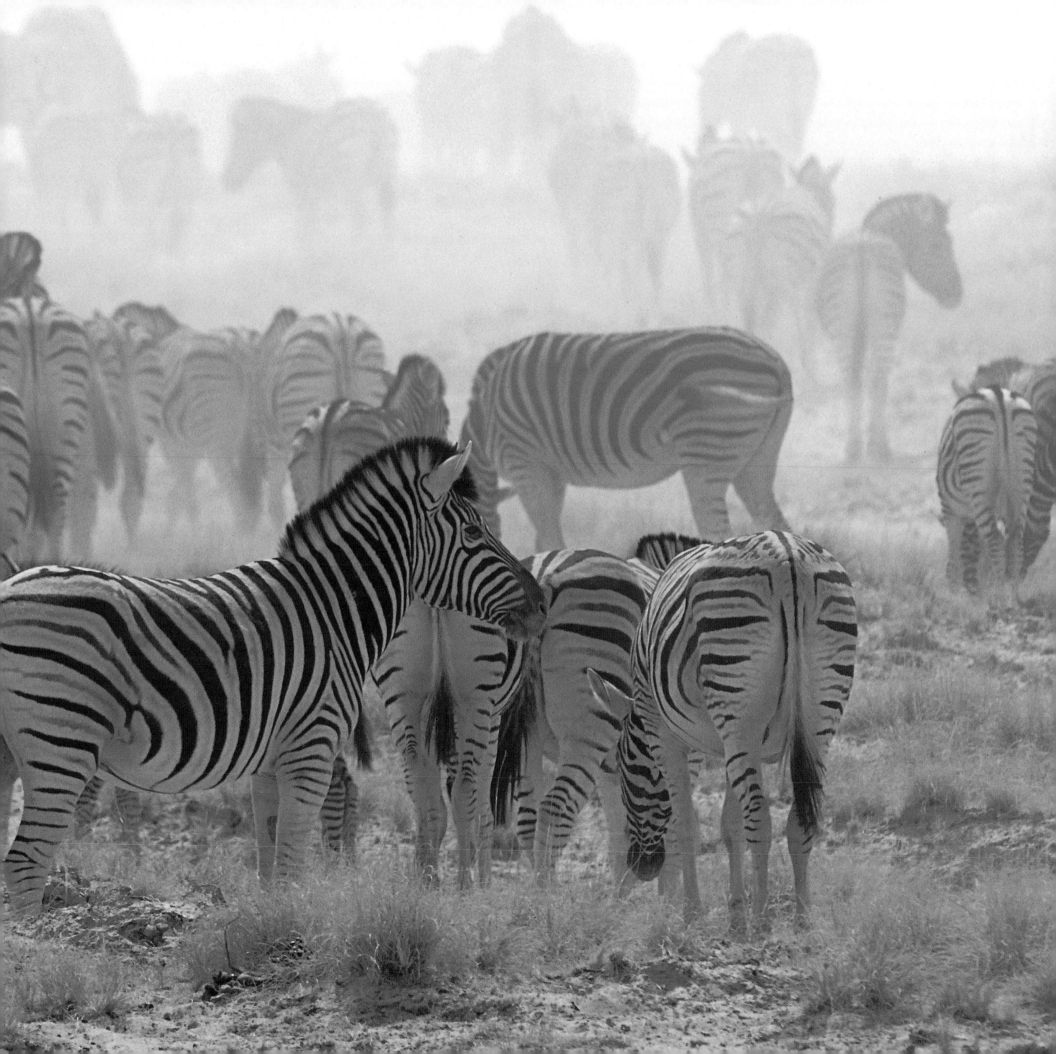

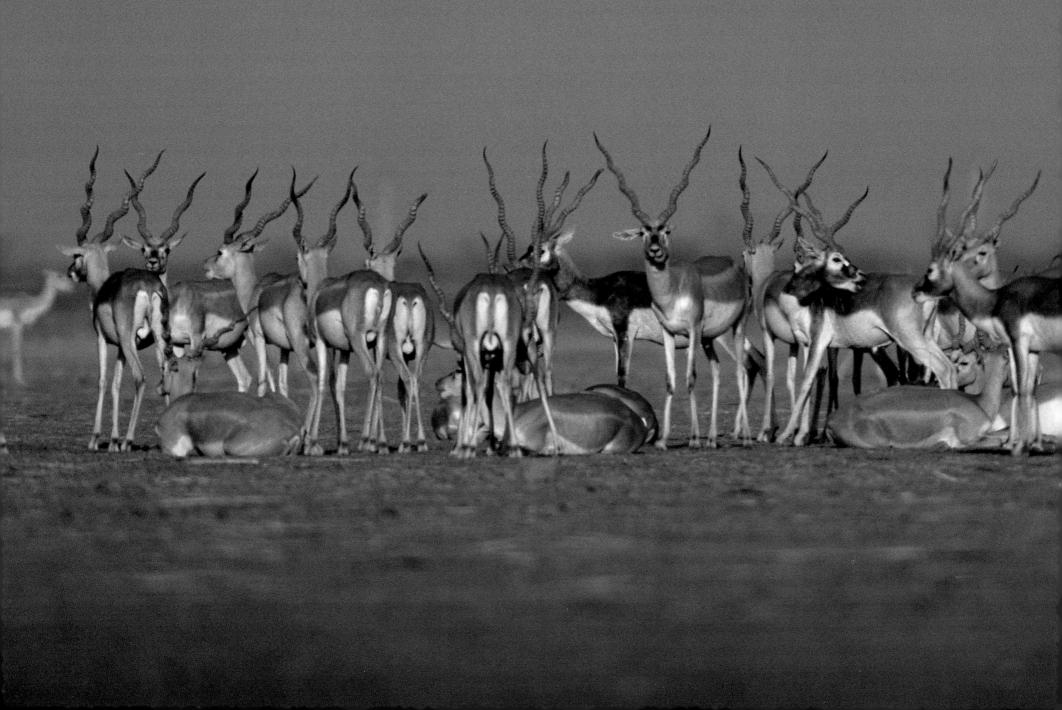

SOUTH ASIAN UNGULATES

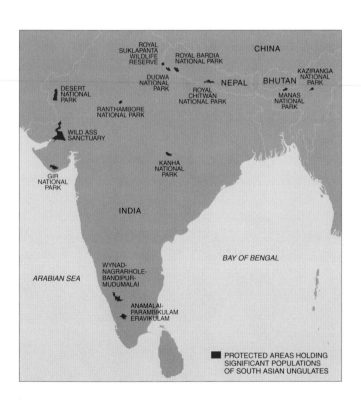

PROTECTED AREAS HOLDING SIGNIFICANT POPULATIONS OF SOUTH ASIAN UNGULATES

We sat clinging to the seats at the back of our open-top jeep as we bounced our way through villages and towns until we emerged into a wide, open area of cotton and millet fields. The early summer sun was just beginning to glow behind the horizon, casting the morning's first rays of light over the green, yellow, and brown fields. Flat agricultural and fallow land seemed to stretch out before us in all directions, the monotony relieved only by the patches of mesquite (*Prosopis juliflora*) (an exotic tree), thorn forests, and an occasional village. Strange as it might seem, we had come to this place in search of one of the most beautiful antelope species in the world, the blackbuck (*Antilope cervicapra*). Some might object and say that the declaration of one particular antelope species as the most beautiful of all is a matter of subjective opinion. To which our response is that anyone who says this, obviously has not seen an adult male blackbuck, with its spectacular, long spiral horns, and striking black-and-white coat, strutting up and down its lek territory displaying proudly to female onlookers.

Where in the world do you have to go to see large concentrations of wild animals outside protected areas, and in agricultural land? The answer: India. This is especially true of the nilgai (*Boselaphus tragocamelus*), a large antelope that can be observed in groups of up to 10 animals in agricultural land over much of the Indian subcontinent. However, the most spectacular examples are the blackbuck and the chinkara (or Indian gazelle) (*Gazella bennettii*). These two species are considered to be sacred by certain religious communities, in particular the Bishnois in Rajasthan and Haryana, and very high densities of both species can be found around their villages.

India must be the least likely of all countries to have wildlife spectacles, due to its very high human population density, many centuries of civilization and, in recent years, rapid economic growth. Thoughts of huge herds of large mammals take most of our minds to the plains of Africa, and for good reason. However, the continent of Asia also has a large variety of spectacular large mammal species. Unfortunately, for the most part, the large mammals of Asia are now very rare, and most are secretive and hard to see in the wild in densely forested habitats. However, it is still possible to see large mammals in abundance in certain parts of lowland India and Nepal, south of the Himalayas.

Many of the large ungulates of India and Nepal are group-living animals, although none form the large migratory herds characteristic of their African counterparts. Blackbuck can be seen frequently in herds of 50 or more, chinkara in smaller herds sometimes of over 20 animals (usually in crop fields), while many of the deer species also form large groups, notably the chital (or spotted deer) (*Axis axis*), of which large aggregations of up

On the opposite page, the blackbuck (Antilope cervicapra) *is one of the world's most beautiful antelope species, and also one of the fastest land mammals. The long, spiraling horns of the males are particularly impressive.*
© Gertrud & Helmut Denzau

Above, a male Nilgiri tahr (Hemitragus hylocrius) *in Eravikulam National Park in India. This species is endemic to the Western Ghats hotspot.*
© Patricio Robles Gil/Sierra Madre

to 500 animals can be seen; the sambar (*Cervus unicolor*), which sometimes occurs in large groups of up to 70 animals outside the rutting season (from November to April); and the barasingha (or swamp deer) (*C. duvauceli*), which sometimes forms groups of up to 50 animals. The total populations of many of these species in India and Nepal are impressive, including some 40 000 blackbuck (mostly in India), more than 150 000 nilgai and 100 000 chinkara, sizeable numbers of chital and sambar (which are common in many protected areas), and about 5 000 barasingha.

The threats to the large mammals of the Indian Subcontinent result mainly from the huge pressures that arise from the high human population density. Demand for land is intense, and in certain areas there are pressures to de-gazette protected areas. In some places, there are severe conflicts between wildlife and human populations. There has been a decrease in the density of several large mammal species outside protected areas, including on government-owned forested land managed for timber production. And there is an ongoing demand for certain high-value wildlife products, and the conservation of particular species remains a major challenge in the face of heavy poaching pressures.

Despite this, the most remarkable fact about conservation in India and Nepal is its relative success. Like many other parts of the tropical world, an extensive network of protected areas has been established; unlike many others, these protected areas are quite effective. One of the most important is Kaziranga National Park in India. This site, in the productive Brahmaputra floodplain, contains nearly 70% of the remaining Indian rhinos in the world (*ca.* 1 500 animals), as well as nearly 1 000 Asian elephants (perhaps 2% of the global total), 500 barasingha (nearly 10% of the global total), some 5 000 hog deer (probably over 25% of the global total), and about 1 500 wild water buffalo (perhaps 50%-75% of the total wild population). Northwest of Kaziranga, lies Manas National Park, which formerly held important populations of hog deer (10 000 animals, the largest population in the world), barasingha, buffalo, gaur, Asian elephant (1 200 animals), and pygmy hog (probably the largest population in the world of this Critically Endangered species). A decade of insurgency has taken a heavy toll on all these species and today Manas National Park is a threatened World Heritage Site.

There are a number of other important protected areas elsewhere in India and Nepal. In the southwest, in the Western Ghats, there are four contiguous national parks and wildlife sanctuaries, Wynad-Nagrahole-Bandipur-Mudumulai, together comprising a minimum area of 5 000 km², the most productive area for large mammals in lowland southern Asia, and home to 4 000-5 000 elephants and 2 000-3 000 gaur. In addition, key protected areas such

as Anamalai and Parambikulam Wildlife Sanctuaries and Eravikulam National Park have about 70% (or 2 000 animals) of the total population of the Endangered Nilgiri tahr. In northwest India, Desert National Park in Rajasthan and surrounding areas in the Thar Desert are home to over 60 000 chinkara, or well over 50% of the global total; the Wild Ass Sanctuary in Gujarat contains most of the surviving population (*ca.* 3 000) of the Indian wild ass (*Equus hemionus khur*); and the Gir National Park, also in Gujarat, and home to the last population of lions in Asia, has important populations of chinkara, four-horned antelope (*Tetracerus quadricornis*) and 30 000-40 000 chital. In central India, in Madhya Pradesh, Kanha National Park —the setting for Rudyard Kipling's *Jungle Book*— is the most important site for large mammals such as chital (30 000) and sambar (2 000-3 000), and is also home to 100% of the hard-ground race of barasingha (*Cervus duvauceli branderi*), where the population has risen under careful management to about 500 animals. Finally, in Nepal, Chitwan National Park is famous for its 500 Indian rhinos (over 20% of the global total), and for being home to over 10% of the global population of hog deer. Suklaphanta Wildlife Reserve has the largest surviving population of barasingha in the world (2 000 animals, close to 40% of the global total).

Aided by this protected areas network, conservation efforts have been successful in halting the decline of many seriously threatened species, and in bringing about their recovery. For the most part, this has been achieved with local expertise on national government budgets with only very limited assistance from the outside world. India and Nepal have an effective conservation infrastructure in place, and the main priority now is to build on this and enhance it. In some places, protected areas need enlarging. Around most protected areas, improved outreach is needed to help support the needs of local communities. Ranthambhore National Park has pioneered the way on this, with the conservation authorities supplying villagers with alternative cooking fuel, in return for their agreeing not to enter the National Park for firewood. In certain places, much more needs to be done to resolve human-wildlife conflicts, and more fencing of protected areas is likely to become a priority.

In addition to enhanced protection of their outstanding national parks, India and Nepal also need to conserve the cultural traditions that preserve large populations of wild animals in agricultural areas. The survival of blackbuck, chinkara, and nilgai around human settlements and in crop fields depends ultimately on local attitudes and, in many ways, it is these attitudes that have enabled India and Nepal to remain home to so many wildlife spectacles.

SIMON N. STUART A.J.T. JOHNSINGH

Above, male sambar (Cervus unicolor) *eating water lilies in Ranthambhore National Park, India.*
© Patricio Robles Gil/Sierra Madre

On the opposite page, most of the remaining wild population of the Indian wild ass (Equus hemionus) *is found in the Wild Ass Sanctuary in Gujarat State, India.*
© Gertrud & Helmut Denzau

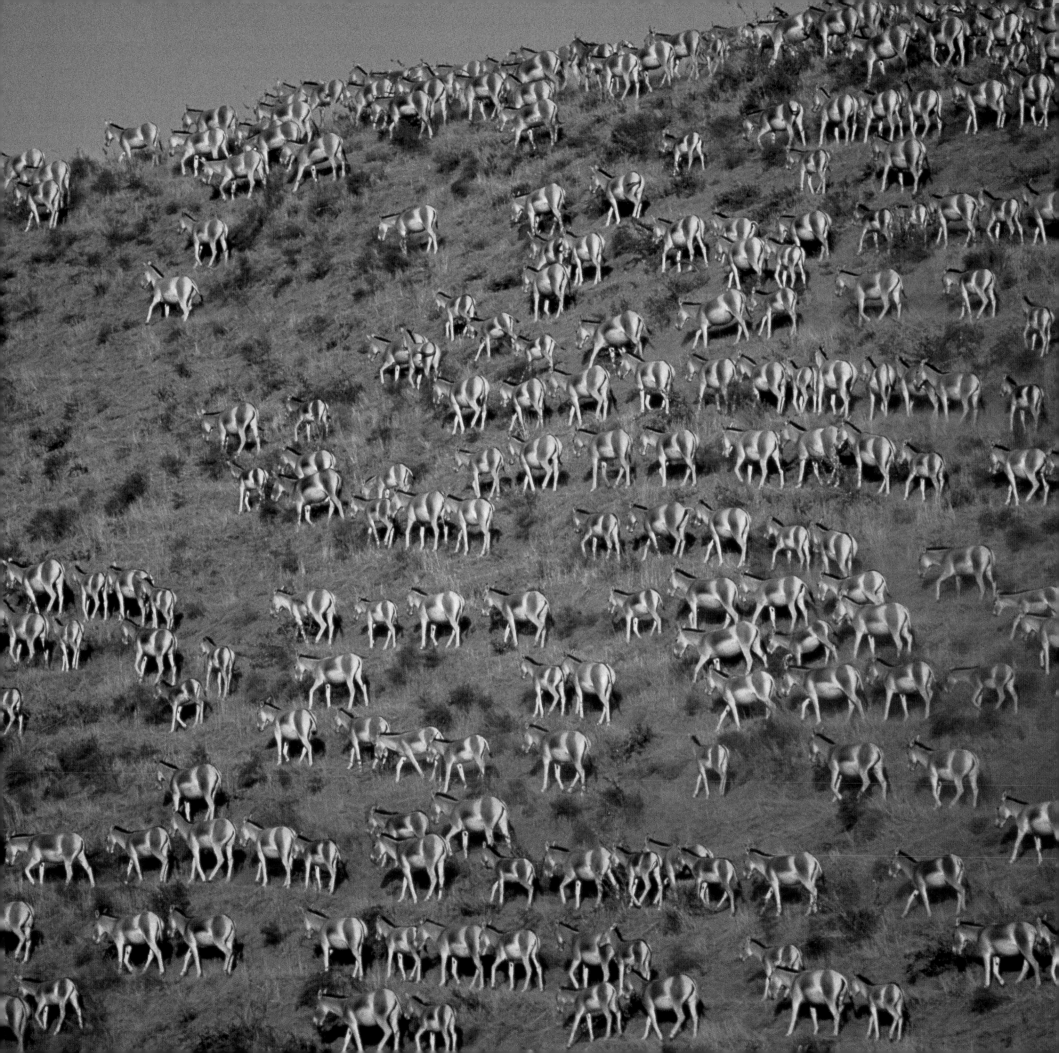

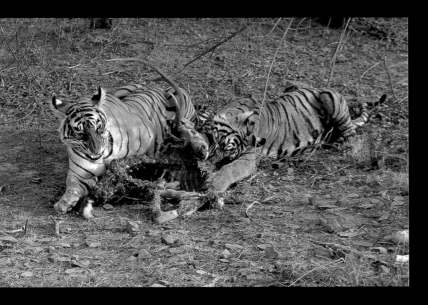

Above, tigress (Panthera tigris) *and daughter feeding on a carcass of a male chital deer* (Axis axis), *Ranthambhore National Park, India.*

On the opposite page, a herd of chital on a prairie close to a water hole in the famous Ranthambhore National Park, India. Here two young males are sparring, preparing themselves for more serious combats to come.
Both photos, © Patricio Robles Gil/Sierra Madre

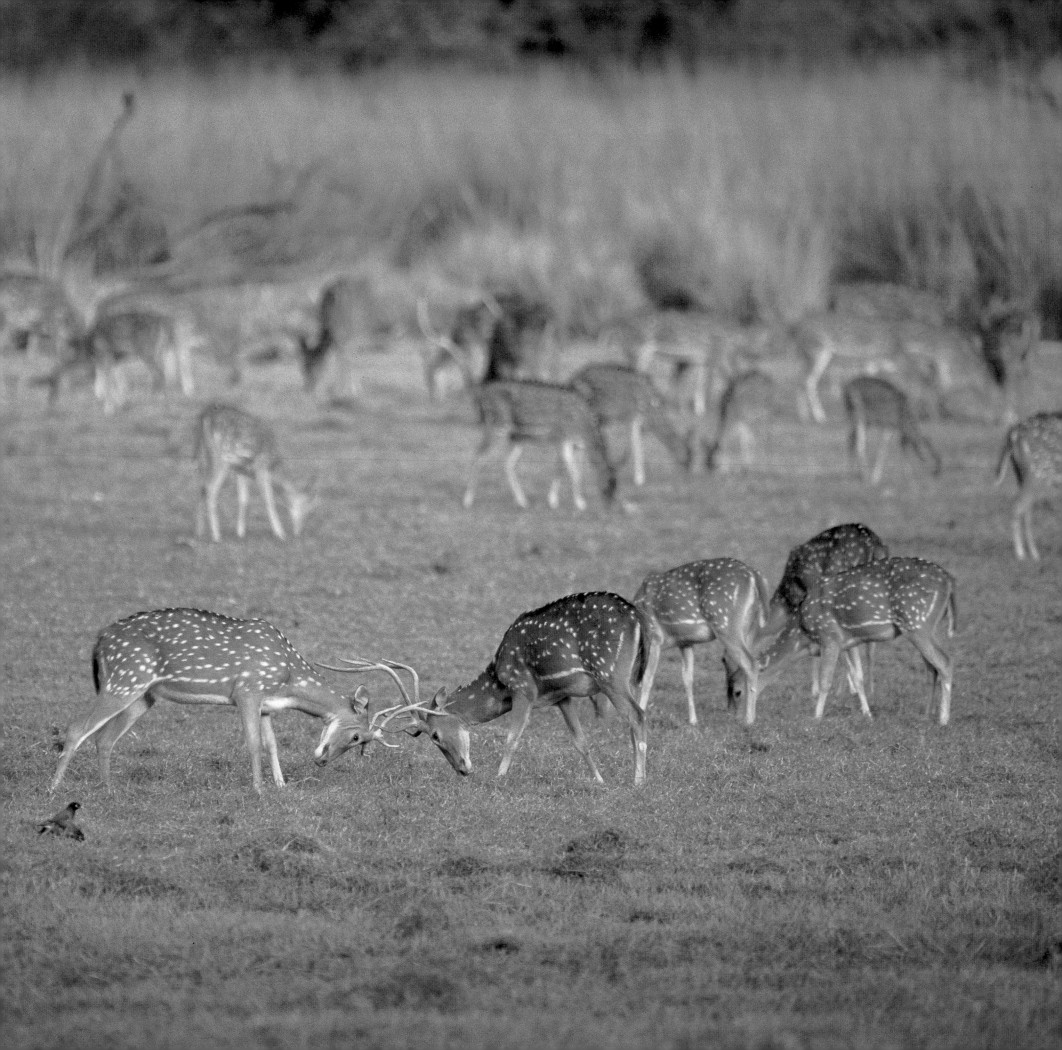

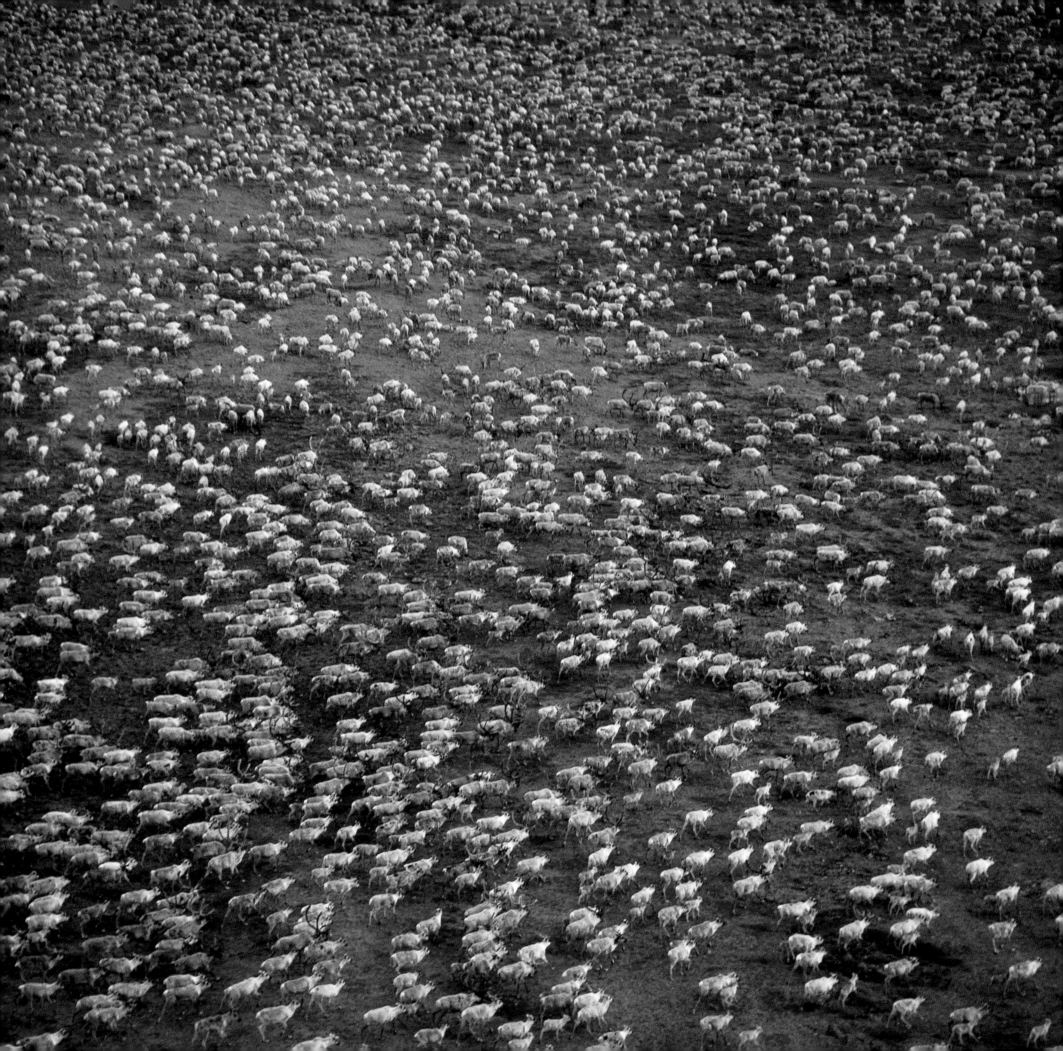

CARIBOU

It was late August and I was camped in the remote barren-grounds of Arctic Canada. Nearby, a spit of treeless tundra penetrated an unnamed lake and provided a narrow water crossing for converging hoards of migrating caribou (*Rangifer tarandus*). Dozens of caribou skulls littered the shoreline. Some were old, gray with time, and encrusted with lichens; others had the bleached appearance of youth. The caribou may have died for many reasons. Some may have drowned or been killed by wolves, grizzlies or human hunters, while others may have simply collapsed, the crossing being the final hardship driving them beyond lethal exhaustion. A web of rutted trails, some etched 20 cm deep into the turf, fanned out from the water's edge —testimony to centuries of use by millions of hooves. From the air, the ancient trails streamed across the tundra like streaks of water on a rain-splattered windshield.

Of the 38 species of deer worldwide, the caribou ranges the farthest north and is the only member in the Family Cervidae to form large aggregations. In Eurasia, the great herds of caribou disappeared centuries ago at the hands of ancient hunters, and today only small populations remain. In contrast, herds of reindeer, the domesticated form of the caribou, are still tended by indigenous northern peoples in Scandinavia, Finland, and Russia. Today, to see great herds of wild caribou one must journey to the hinterlands of Arctic Canada, and some of the greatest herds roam the mythical barren-grounds —that vast wedge of the North American continent lying west of Hudson Bay and north of the wandering treeline. Here, 1.6 million caribou sweep across the tundra in great annual migrations. Biologists subdivide the barren-ground caribou into separate populations, whose members calve, migrate, and overwinter together. These populations are referred to as herds and their names are derived from the locations of their main calving areas. The largest of these herds is the Kaminuriak Herd, occurring in the east, and which pulses with the rhythm of 460 000 pounding hearts. The remaining herds, from east to west, are: the Lorillard Herds (120 000), the Beverly (275 000) and Queen Maud Gulf (200 000) Herds, the Bathurst Herd (350 000), the Bluenose Herd (122 000), and the Porcupine Herd (129 000). When these herds migrate, they do it in a big way!

Caribou, unlike the wildebeest of Africa, don't sweep across the tundra in a vast continuous herd. In autumn, they migrate southward in a steady, leisurely trickle of small bands of ani-

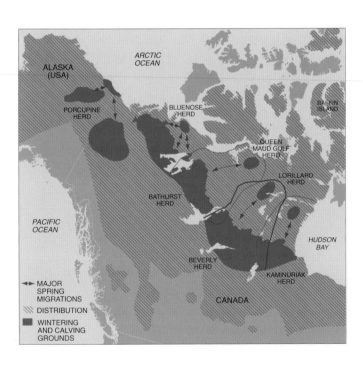

On the opposite page, aerial view of a large herd of caribou (Rangifer tarandus) *migrating north to summer feeding grounds in northern Canada.*
© Fred Bruemmer/DRK PHOTO

Above, grey wolf (Canis lupus) *stalking a caribou. As in Africa and Asia, predators follow the migrating herds of ungulates.*
©Art Wolfe

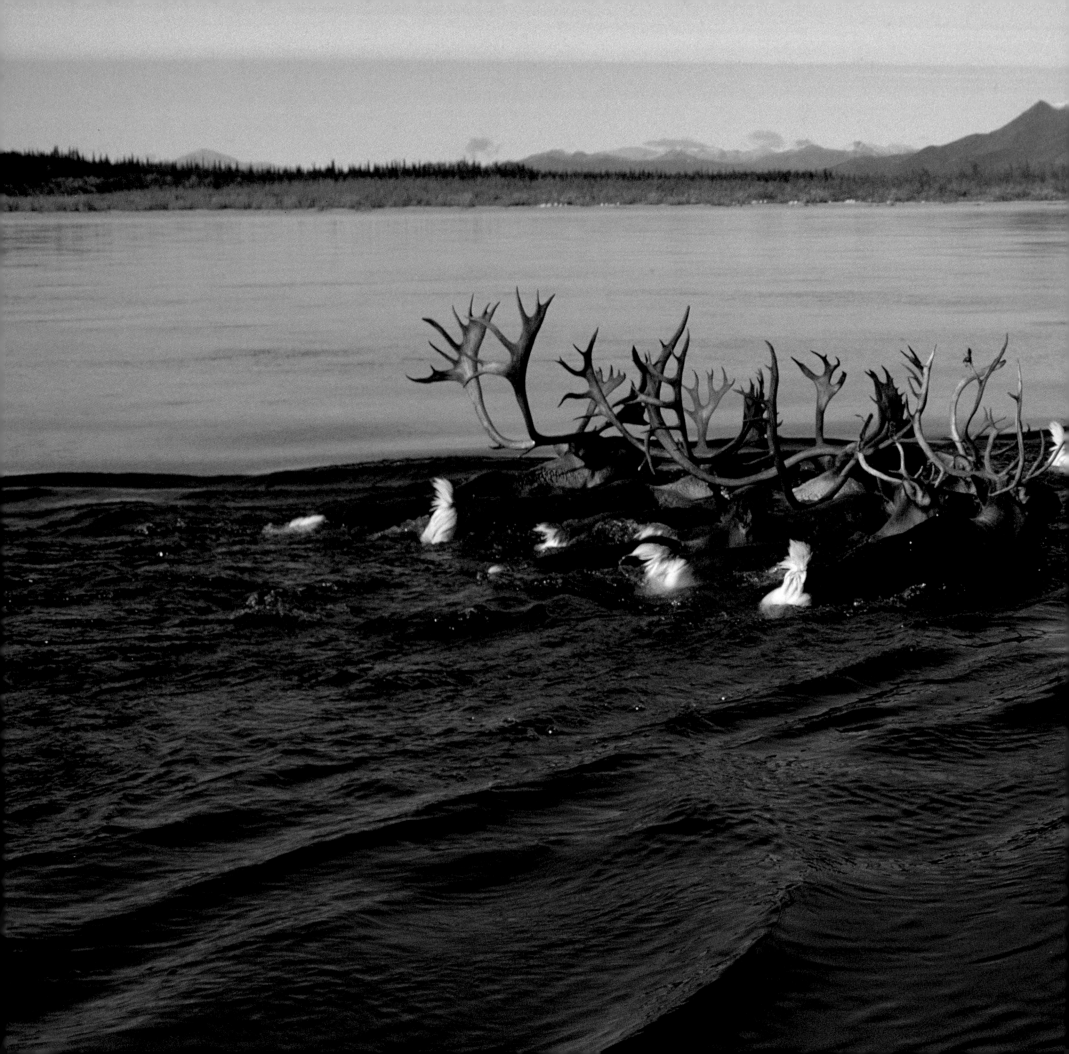

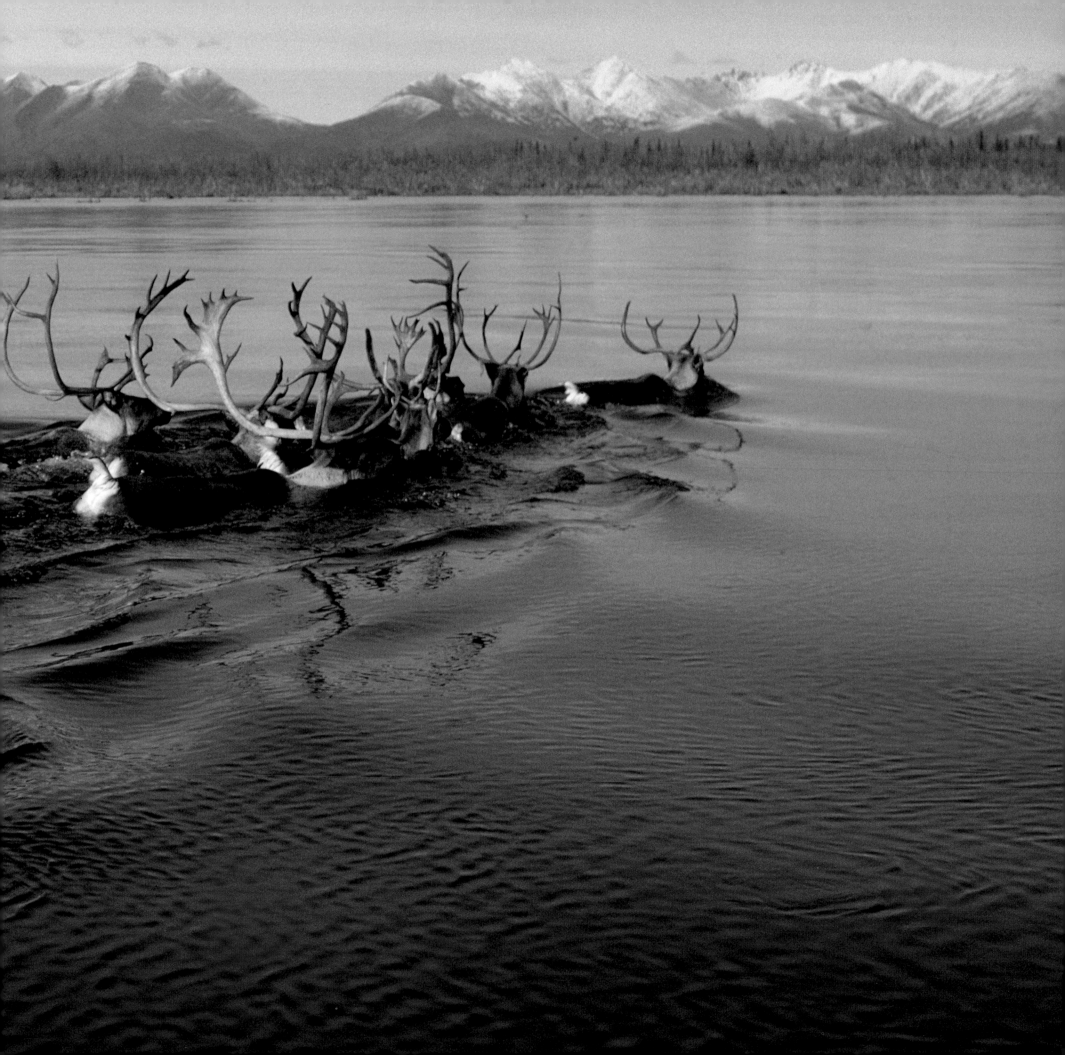

mals; a few in this group, a dozen in that. The year I camped near Damant Lake in the central barren-grounds, I was on the migration path of the Beverly Herd. In seven days there was never a time when caribou could not be seen drifting by, grazing and ruminating here and there, but always moving, slowly moving. The caribou migration in August and September is slow, meandering, and relaxed. The animals are fat and fit, and even though they can cover 56 km in a day, they often travel less. For many, the migration will carry them over 800 km from the northern tundra to the protective fringe of the treeline, where they will overwinter in small groups comprising a dozen or more members. Throughout the winter, the caribou travel and rest on frozen lakes, relying on their sharp eyesight and that of their companions to detect wandering packs of wolves. For caribou, there is safety in numbers. The lengthening days of spring signal the caribou to stream northward again, the pregnant cows leading the way. The vernal migration, unlike the leisurely one in autumn, is an urgent race to reach the calving grounds, and hundreds, sometimes thousands, of expectant mothers trot northward in a steady, excited stream. Now, as in autumn, they travel together to improve their detection of predators and possibly share directions on the route they should follow. After decades of research, scientists still don't know why caribou choose a particular route to follow, and how they navigate over the flat, treeless tundra. Perhaps the Chipewyan people are correct in saying that "no one knows the ways of the wind and the caribou"...

Most of the calving grounds are windy, elevated sites well beyond the treeline. Here, there are fewer wolves, and on the cold windscapes, bloodthirsty mosquitoes erupt a month later than they do on the animals' wintering grounds. The temporary relief from these tormentors gives caribou mothers time to birth, nurse, and bond with their calves before the bloodsucking swarms sweep over the land. On the barren-grounds, mosquitoes often erupt explosively, sometimes billions in a single day. When this happens, the small groups of caribou that were spread out over hundreds of square kilometers suddenly clump together into enormous herds, num bering tens of thousands of animals. These are the legendary post-calving aggregations for which the caribou are unique among deer. The pestered animals snort and toss their heads, shake themselves, and repeatedly flick their ears and tail as they trudge along facing into the wind. Eventually, the humming hordes of biting insects are too much to endure, and a few caribou begin to buck and run. The entire herd may then stampede. At the peak of the mosquito season in July, a herd may stampede a couple of times a day. Some animals are trampled, calves are sometimes separated from their mothers, and many caribou lose weight from the repeated exertion.

Natural threats have always been part of a caribou's life. Starvation may threaten when freezing rain turns snow into concrete and lichens become inaccessible. Drowning can occur when frigid rivers swell and swirl with the raging meltwaters of spring, and when March blizzards bluster for days the winter-weakened may freeze to death. Caribou evolved with such hazards and the persistence of their great numbers attests to their resilience and their capacity to endure the vagaries of nature.

Today, though, human hunters pose the greatest challenge to the caribou's survival. Every winter, when the animals flee south to the northern fringes of the boreal forest, they encounter hungry humans. For centuries, the Loucheux, Hare, Dogrib, Slavey, Yellowknife, and Chipewyan peoples have hunted caribou, and they continue to do so today. This harvest of caribou is carefully managed jointly by government biologists and committees comprised of indigenous peoples. A census is conducted, roughly every four to five years, and depending upon whether the herd size is stable, declining or increasing, a harvest quota is established. The allotted quota typically ranges from three to five per cent of the population. Caribou, like many game animals, are viewed as a renewable resource. When their numbers are managed with science and wisdom, the great herds are guarded for future generations to enjoy, however they choose.

WAYNE LYNCH

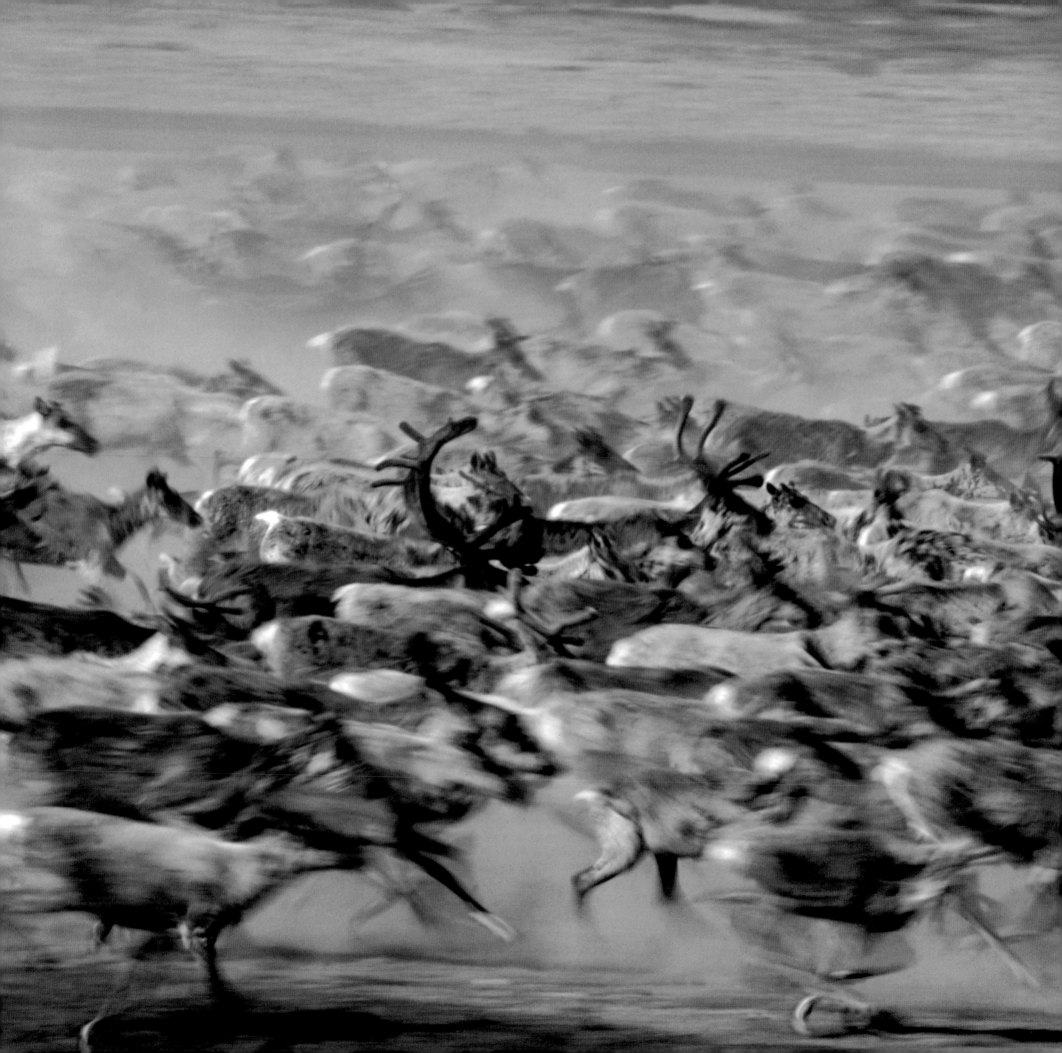

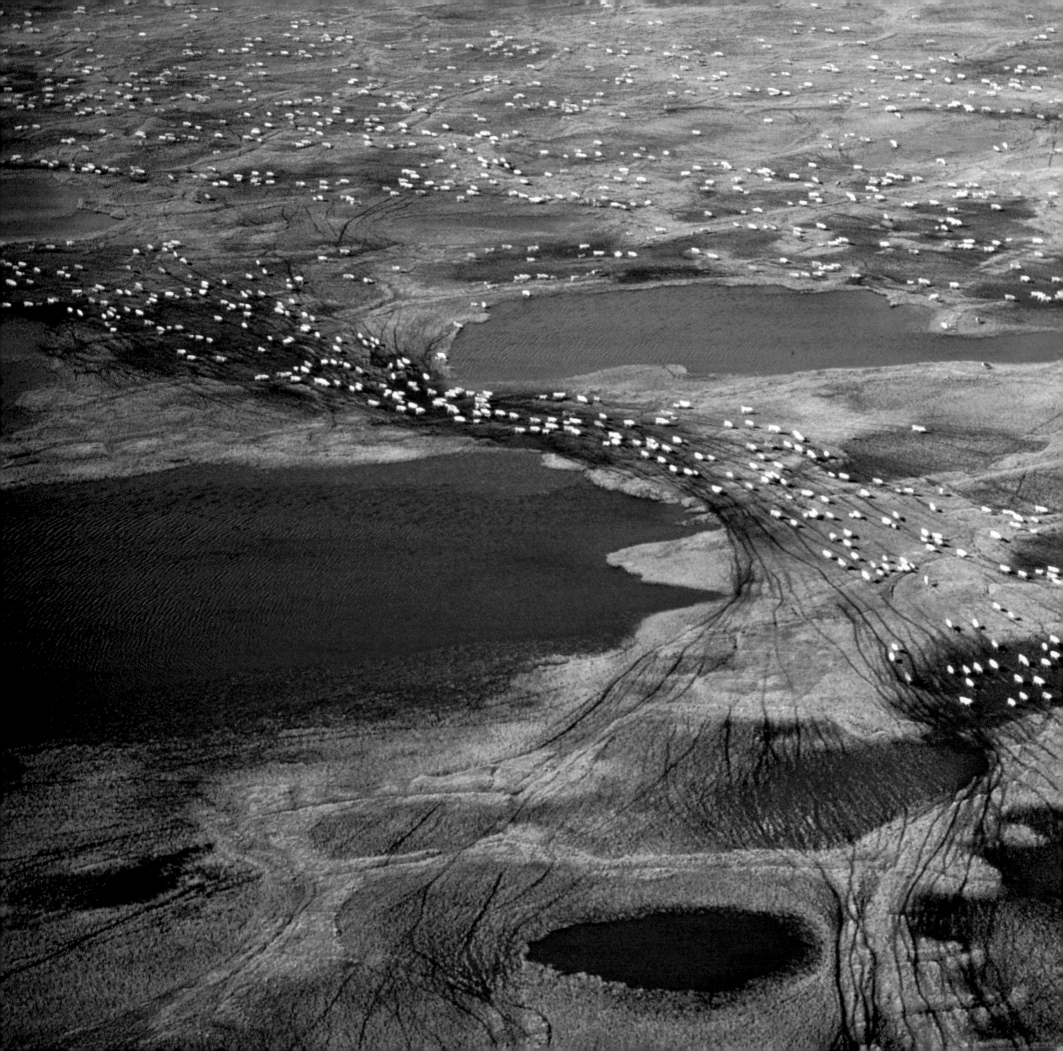

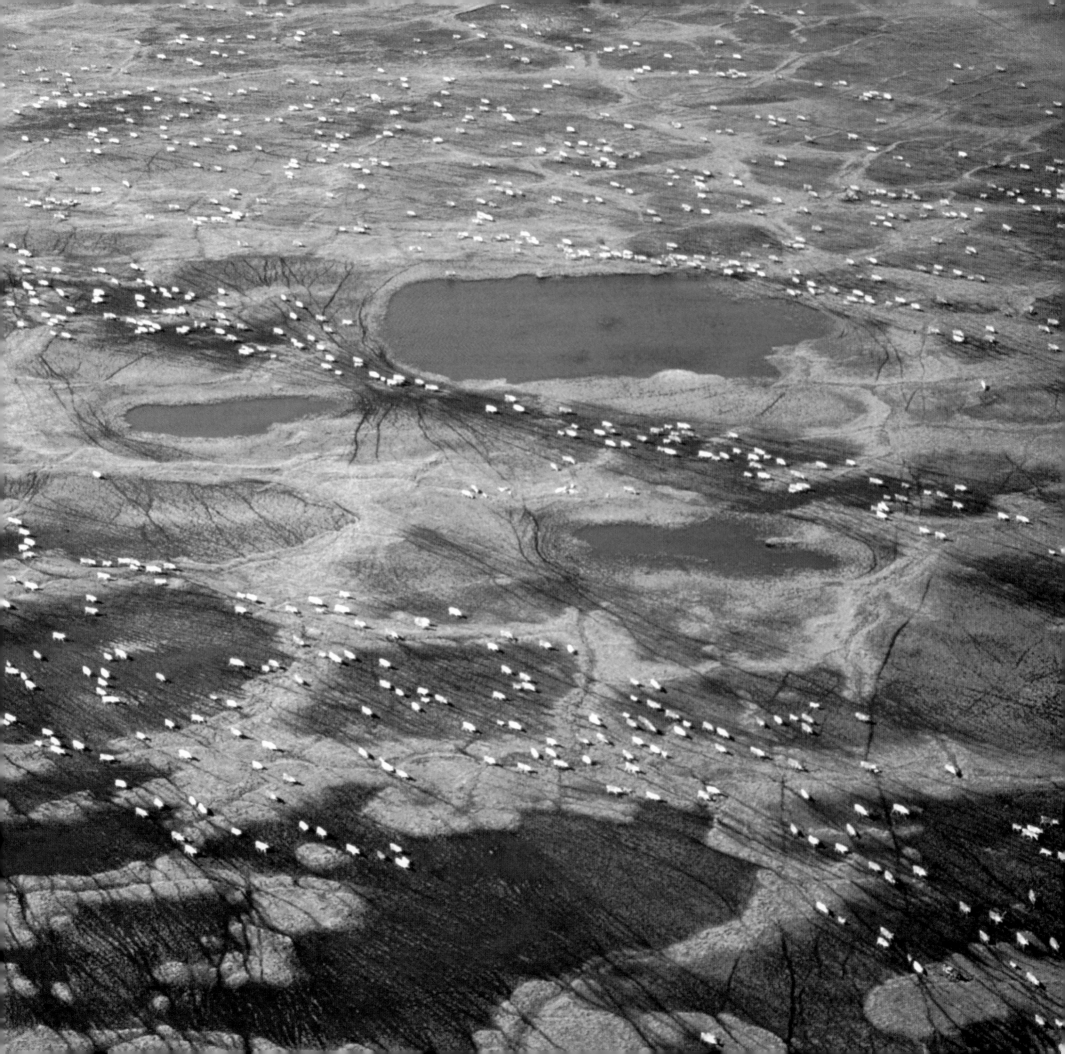

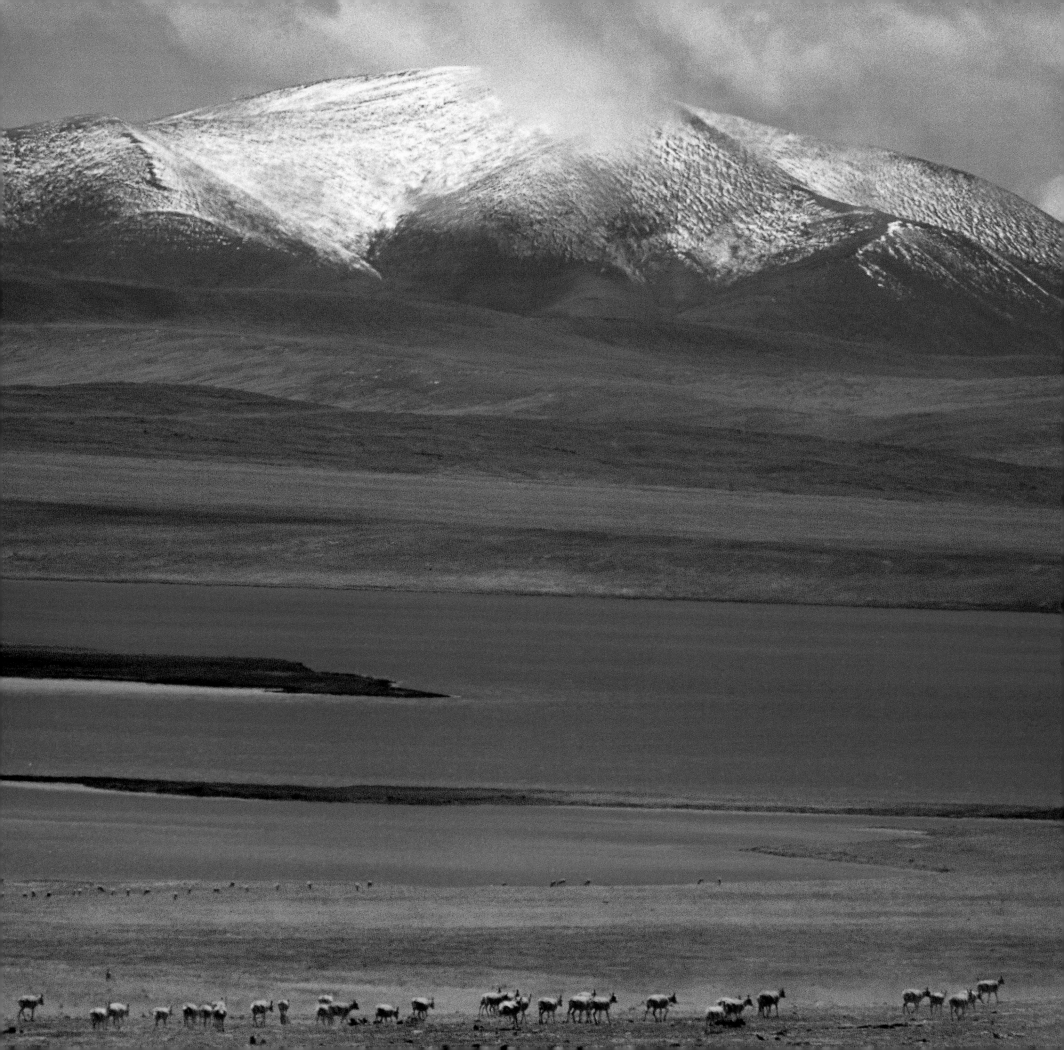

TIBETAN ANTELOPE

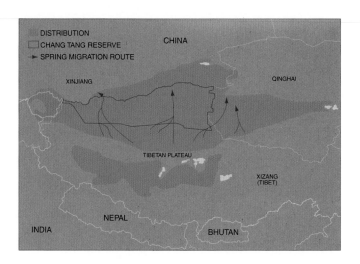

Our team drove across the Chang Tang —Tibetan words meaning northern plain— in search of Tibetan antelope (*Pantholops hodgsonii*) or chiru. Here, at 4 700 m, the land was wild and bleak, a windswept steppe with scattered feather grass, sedge, and various cushion plants stretching to the horizon. Cold stabbed through my down jacket when we stepped from the car even though it was mid-June. Wildlife was scarce but still visible. In a day we could spot an occasional herd of Tibetan wild ass or kiang (*Equus kiang*) and Tibetan gazelle (*Procapra picticaudata*), and rarely a lone wild yak bull (*Bos grunniens*), all members of a unique large mammal community on the high steppes of the Tibetan plateau. Other members are dwarf blue sheep (*Pseudois schaeferi*), Tibetan argali (*Ovis ammon*), and various carnivores, among them Tibetan brown bear (*Ursus arctos*), snow leopard (*Uncia uncia*), lynx (*Lynx lynx*), and wolf (*Canis lupus*). Our car stumbled along a river, when suddenly ahead a slope rippled with tawny animals. Chiru! First there were 200, followed by another 600, hurrying to the north, most of them pregnant females, with some accompanied by their young of the previous year. The wave of animals flowed across the austere expanse like clouds, and disappeared into the valley ahead. Soon they would find their calving grounds somewhere near the crystal peaks of the Kunlun Mountains. Here we were witness to a remnant of one of the last great migrations in Asia. But now these herds were only a reflection of times past. A hundred years earlier the British traveler Captain C.G. Rawling had noted "thousands upon thousands" on the move with sometimes "15 000-20 000 visible at one time."

The chiru is the only species in its genus, which in turn is the only large mammal genus endemic to the Tibetan Plateau. Although the chiru's slender legs, body shape, and the male's lyrate horns render it reminiscent of typical antelopes, DNA analyses have shown that the chiru is actually related to sheep and goats. The current range of the chiru extends over at least 600 000 km² of the northwestern part of the Tibetan Plateau. There, the animals are found in flat to rolling terrain, though they readily ascend hills, usually between 4 300 m and 5 100 m in elevation, but in places as low as 3 250 m or as high as 5 500 m. They prefer alpine steppe or similar treeless arid regions where precipitation is less than 400 mm per year. Except for a few animals that seasonally drift into the Ladakh part of India, the species is found only in China in parts of Qinghai Province and the Tibet and Xinjiang autonomous regions. Given its remote, high, and harsh habitat, much of it away from human habitation, the species has never been the focus of a population-wide census. The whole population probably exceeded one million in the early 1900s, but by the mid-1900s, the second author estimated

On the opposite page and on pp. 138-139, the Tibetan antelope (Pantholops hodgsonii) or chiru is the only large mammal endemic to the Tibetan Plateau, where it ranges over an area of at least 600 000 km² in the northwestern part of the region. There, the animals are found in flat to rolling terrain, usually between 4 300-5 100 m in elevation, but in places as low as 3 250 m or as high as 5 500 m.

Above, baby Tibetan antelope lying motionless to avoid predators.
All three photos, © Xi Zhinong

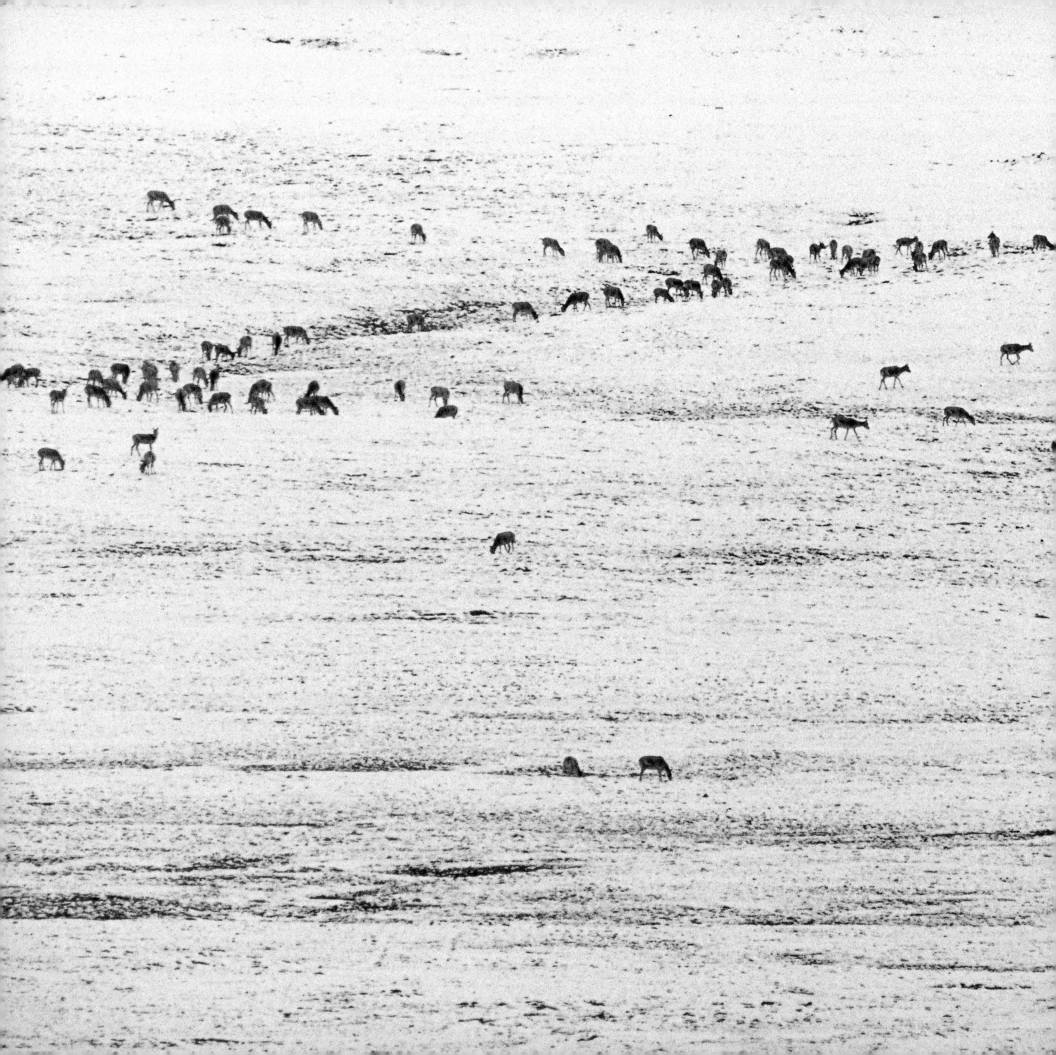

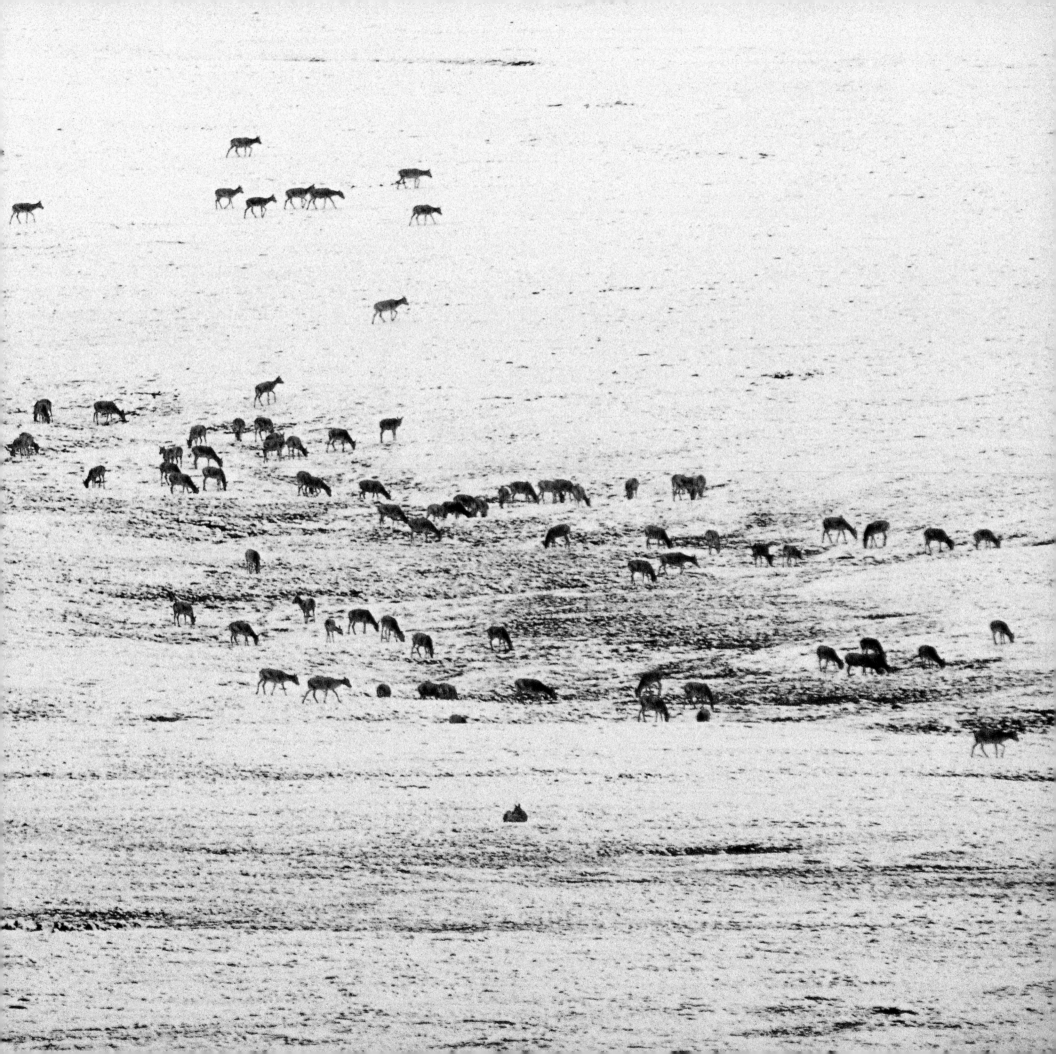

that perhaps no more than 75 000 were left, the decline due largely to excessive hunting.

Some chiru populations are resident, making only local movements, whereas others are migratory. Four major migratory populations are known, each traveling within a certain area of the Chang Tang. The animals are scattered along the southern part of their range, from autumn to spring where *Stipa*, the feather grass and other favored feed is abundant. This area is also home to seminomadic pastoralists, with their herds of sheep, goats, and domestic yaks. In May, the pregnant females and female yearlings gather into herds of up to 500 or more and head north along a traditional narrow route. They travel as much as 300-350 km away from their greening winter range into desolate uplands of 5 000 m or higher where the ground is bare or covered with scarce patches of coarse sedge, and where temperatures fall below freezing. The females drop their single young in late June and early July and, almost immediately, the females and their newborn young turn southward, in large grunting herds that once numbered in the tens of thousands but now are seldom more than a thousand or two. Meanwhile, most males while away the summer, singly and in bachelor groups, ambling a little north or drifting up hillsides, wherever forage is green and nutritious, waiting for the females to return to the golden autumn pastures. Whatever the reasons for this unusual migratory pattern, it probably has persisted at least since the Pleistocene. However, it is now under threat, as is the species as a whole.

Chiru are unfortunate in that they have the finest known wool in the world, gossamer fibers a mere 10-12 microns in diameter. Nomads have shot and trapped chiru in modest numbers for their meat and wool for many years. The wool was exported to Kashmir in India, which is the only place where weavers have the knowledge to weave the short, fine fleece into shawls, known as *shahtoosh*, the king of wool. In the late 1980s the ultra-luxurious and exotic shawls became a trend-setting symbol of style and status, a favorite wrap of the world's wealthy elites. The price of a shawl ranged from $2 000 to $15 000, yet the market became insatiable. A mass slaughter of chiru began. The species has been on Appendix I of CITES since 1979, a Class I protected animal in China since 1988, and is listed as Endangered on the IUCN Red List, but wool is easily smuggled into India, often via Nepal, and shawls readily reach the international market. Kashmiri traders and weavers had guarded the secret source of shahtoosh and made buyers believe that diligent nomads picked shed wool off bushes not from chiru but from wild goat. Meanwhile, motorized poaching gangs roamed the Chang Tang, shooting chiru even on their calving grounds. China estimated that some 20 000 were killed every year (perhaps too modest a figure), providing 2 500 kg of wool —enough to make 6 700 shawls.

In recent years, China has made a major effort to protect chiru and other wildlife in the Chang Tang. Five contiguous protected areas, covering nearly 500 000 km^2, were designated between 1983 and 2001. These protected areas include much of the chiru's range. Major anti-poaching efforts began in the mid-1990s. For example, one patrol in Qinghai in 1999 netted 66 poachers, 18 vehicles, and 1658 chiru hides. By 2001, China's State Forestry Administration had confiscated 20 756 hides and 1 100 kg of wool. An international conference on chiru conservation that invited participants from countries where trade and consumption occur was held by China in 1999. Other countries also made an effort to halt the rampant trade in this endangered species. There were court cases against dealers and boutiques in India, Italy, France, England, the U.S.A., and Hong Kong. And, in 2002, Kashmir finally banned production of shahtoosh.

However, recent reports on law enforcement have shown that the shahtoosh trade is far from being eliminated but becoming more covert. Protecting chiru is a war that demands persistent international cooperation and long-term commitment. In addition to poaching and trade, future threats to the chiru and its habitat include competition with livestock, rangeland fencing, and development such as gold mining and oil drilling. Ignorance, greed, and neglect led to the massacre of a great and beautiful wildlife spectacle in a remote corner of the world to satisfy a fashion craze. With growing awareness and protection by both China and the international community, there is hope that the chiru will continue to roam over unbounded uplands.

LU ZHI
GEORGE SCHALLER

Male Tibetan antelopes are distinguished by their long horns and are able to survive the long winters digging in the snow to locate scarce vegetation. Both photos, © George Schaller

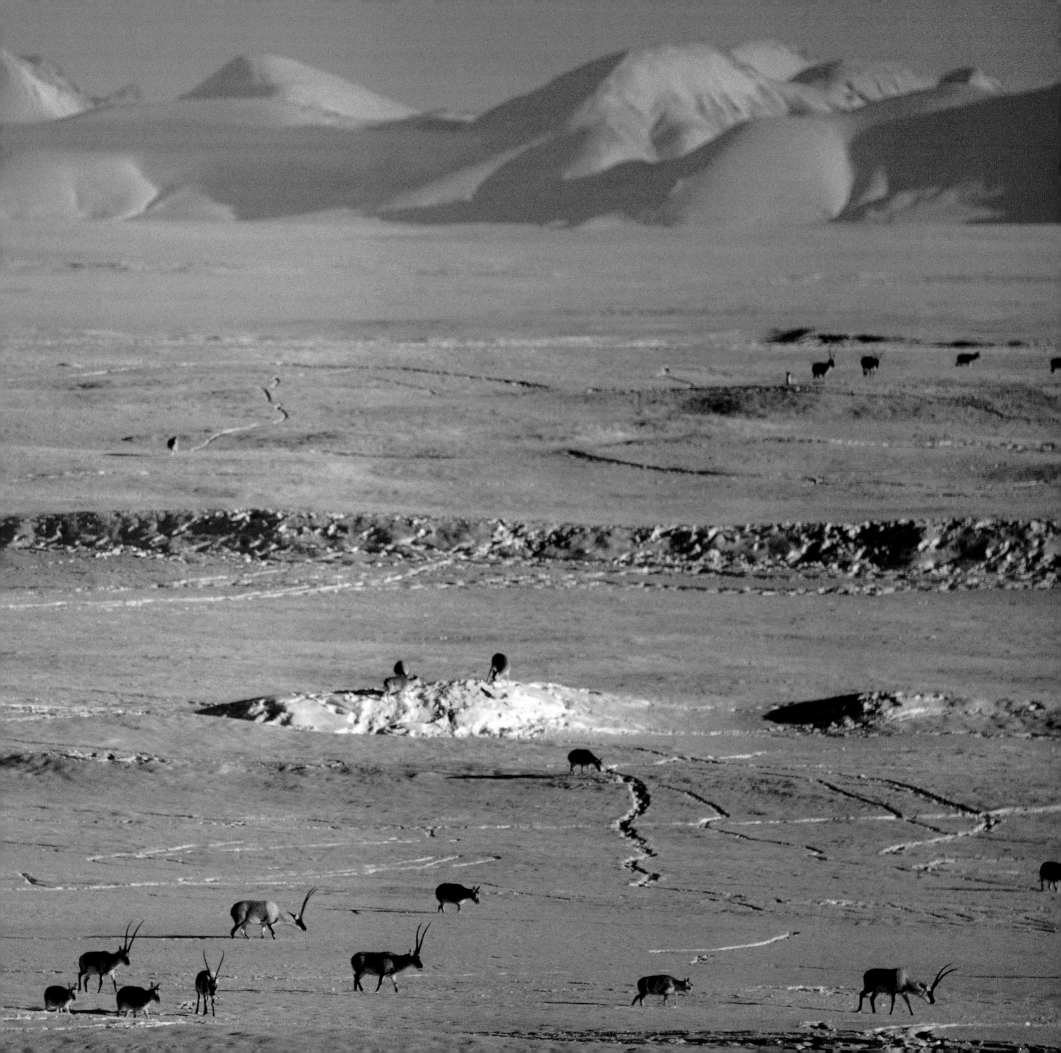

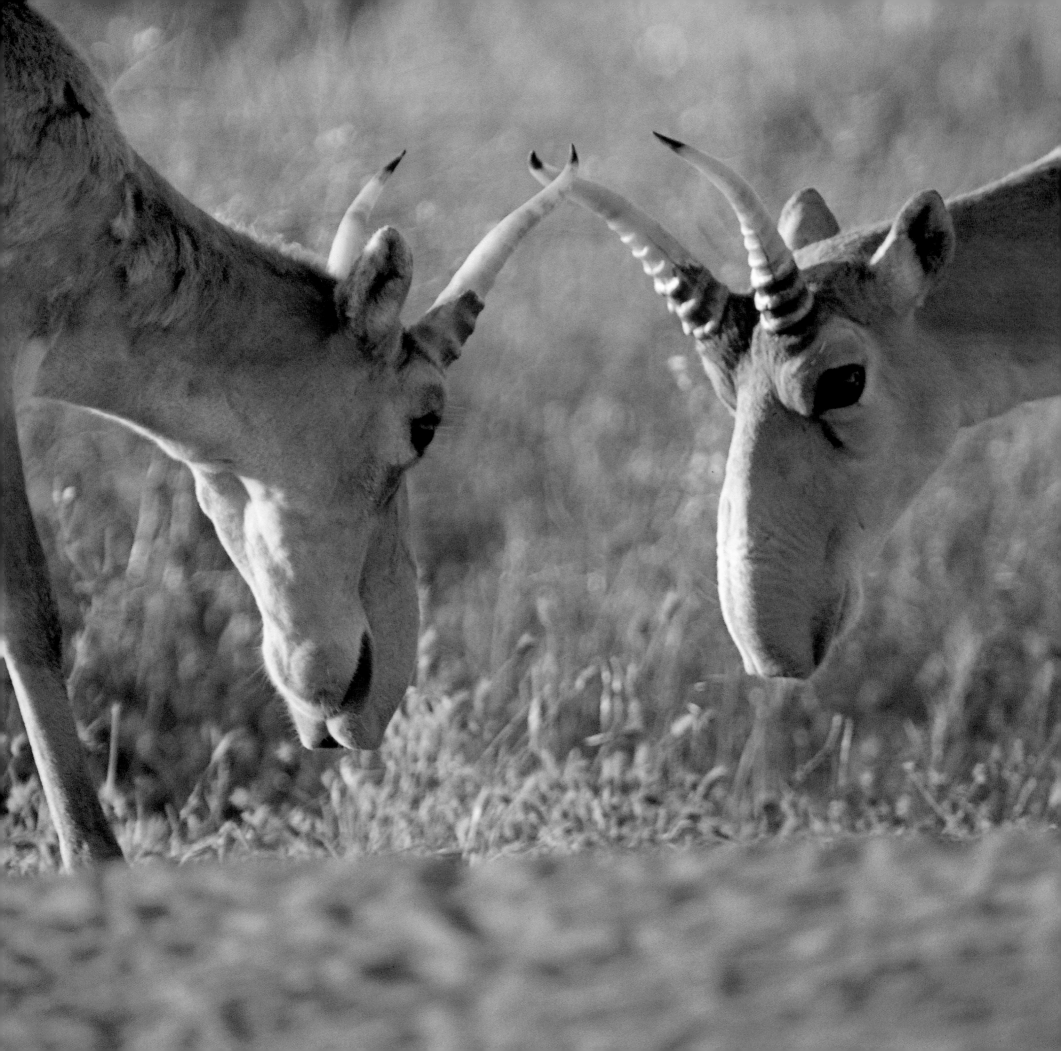

SAIGA

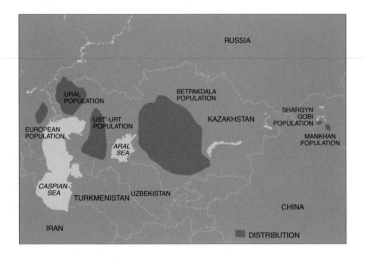

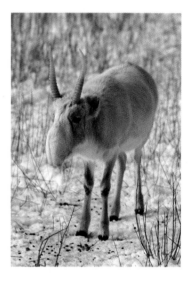

During the Quaternary, when most of the northern hemisphere was covered by tundra, immense herds of the saiga antelope (*Saiga tatarica*) shared the landscape with woolly mammoths across a far more extensive area than its present range. Fossil bones that belong to the modern species have been found in deposits scattered from the British Isles all the way to Alaska and the northwest territories of Canada, extending into the New Siberian Islands to the north and into the Caucasus region to the south.

The saiga is a unique form of nomadic ungulate that regularly migrates throughout North Eurasia across hundreds of kilometers of grassland habitat. The species is very well adapted to the harsh and unpredictable conditions of an extreme environment. Despite its rather sheep-like body shape, the saiga is one of the fastest terrestrial vertebrates, capable of reaching speeds of up to 80 km/hour. The saiga's most peculiar external feature is the presence of a curved, trunk-like nose, apparently an adaptation for filtering air and thermoregulation during hot and dusty summers, and during ice-cold winters. Individuals have a short life span and adults achieve high reproductive rates, adaptations that allow for rapid demographic recovery following particularly severe climatic episodes.

Two subspecies of the saiga are recognized: *Saiga tatarica mongolica*, which inhabits the steppes of Mongolia; and *S. t. tatarica*, which occupies the vast plains of Central Asia and the Pre-Caspian region. Three populations of the latter are known in Central Asia: the Ural, the Ust'-Urt and the Betpakdala populations, in addition to one European population in the Pre-Caspian region. It is possible that some herds from Ust'-Urt, which range mostly through Kazakhstan, can also migrate to Uzbekistan and Turkmenistan. During the period between 1980 and 1994, total saiga numbers fluctuated at around 670 000 to 1 251 000 individuals. During the same period, single population estimates were as follows: European population, 142 000 to 430 000; Ural population, 40 000 to 298 000; Ust'-Urt population, 140 000 to 265 000; and Betpakdala population, 250 000 to 510 000 individuals.

Saiga aggregations vary in size through the year. Large herds are recorded during the reproductive season, but are also observed during other parts of the year. In the winter, larger herds are better able to remove the superficial layer of snow and reach the required foraging resources. During the summer, large herds may offer individuals temporary relief from the massive attacks by mosquitoes. Most importantly, herding behavior offers better protection and an early warning system against predators, particularly wolves that are common throughout the Eurasian steppes.

Unfortunately, wolves and mosquitoes are not the saiga's primary threat. Since the early 1980s, saiga populations have suf-

Male saiga (Saiga tatarica) are crowned with a pair of light yellow, waxy horns, which they use as weapons during the rut. Unfortunately, these horns are also a much desired ingredient in Chinese traditional medicine. Opposite, © Igor Shpilenok; above, © Pavel Sorokin

fered from illegal poaching and trade, habitat degradation, and other forms of environmental disturbance. The demographic effect of periodic summer droughts, occasional severe winters, the spread of recently acquired diseases, and predator pressure, may have been magnified by heavy hunting activity, with dramatic results for most herds. But the decisive factor in the widespread decline experienced by the saiga is definitely hunting, particularly that aimed at obtaining horns for the Chinese traditional medicine market. Only the males are crowned with a pair of light yellow and waxy horns that they wield as effective weapons. The horns are used to prepare medicines that are used as anti-pyretics, to lower blood pressure and as a sedative. Records of exports that passed through the custom's office of Kiakhta (Transbaikalia) indicate that 3.95 million horns were exported to China during the 1800s. By the 1920s, overharvesting had almost completely eliminated the saiga from most of its range.

More recently, in Russia, saigas have been targeted for meat consumption, adding to the overall pressure on wild populations. All four *S. t. tatarica* populations experienced severe declines after 1998. Annual rate of population decline during 1998-1999 was roughly 35%, reaching a dramatic 56% drop during 1999 and 2000. The 2002 census revealed that numbers in the European, Ust'Urt, Ural, and Betpakdala populations had dropped to 19 500, 19 100, 6 900, and 4 000, respectively. Mongolian saigas experienced a slight increase of about 2 000 individuals from their 1980 levels.

Heightened international awareness of the plight of the saiga led, in 1995, to the listing of the species on Appendix II of the CITES Treaty; it is now listed as Critically Endangered on the IUCN Red List. Separate proposals for the listing of the Mongolian subspecies on Appendix I were rejected because of the challenge involved in identifying horns at the subspecies level. The saiga has been listed on Appendix II of the Convention on Migratory Species (CMS) during the Seventh Convention of the Parties in 2002, attending to a proposal submitted by Uzbekistan. Conservation measures must include special protection for areas that are used for lambing and rutting purposes and which are dispersed throughout the entire range of the species. Given that poaching for domestic consumption is now a major threat, anti-poaching measures must be put in place, together with those aimed at curbing the international trade in saiga horns. In addition, captive-breeding programs need to be considered. But what is certain is that without the urgent implementation of this range of conservation tactics, the extinction of both the spectacle and the species is likely in the near future.

The population of saiga fluctuated from 670 000 to 1 251 000 in the period 1980-1984, but began to show a dramatic decline from 1998 onward because of heavy hunting.
© Igor Shpilenok

ANNA A. LUSHCHEKINA VALERY M. NERONOV

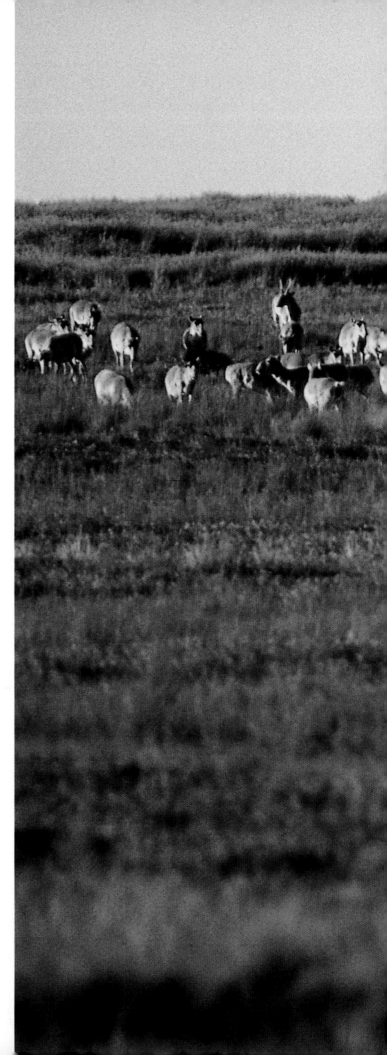

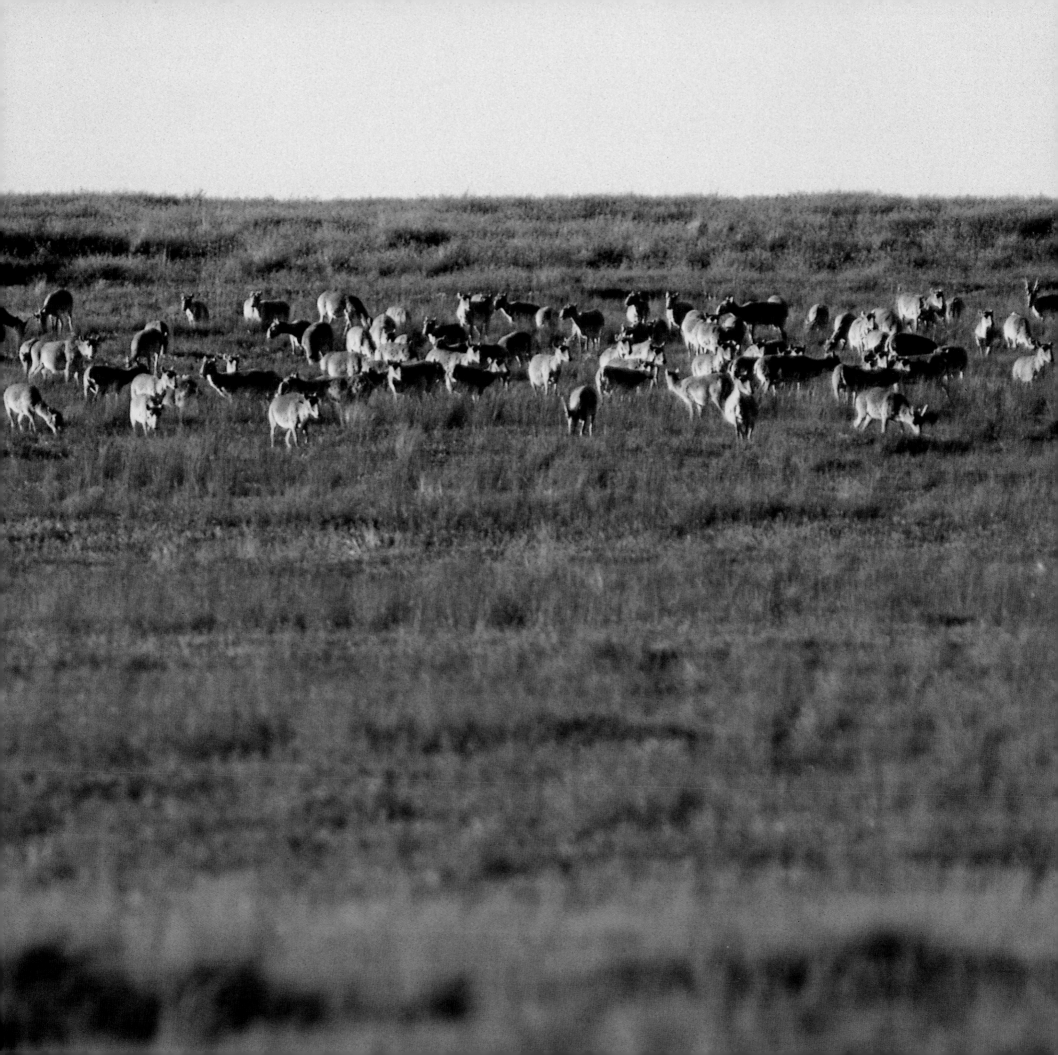

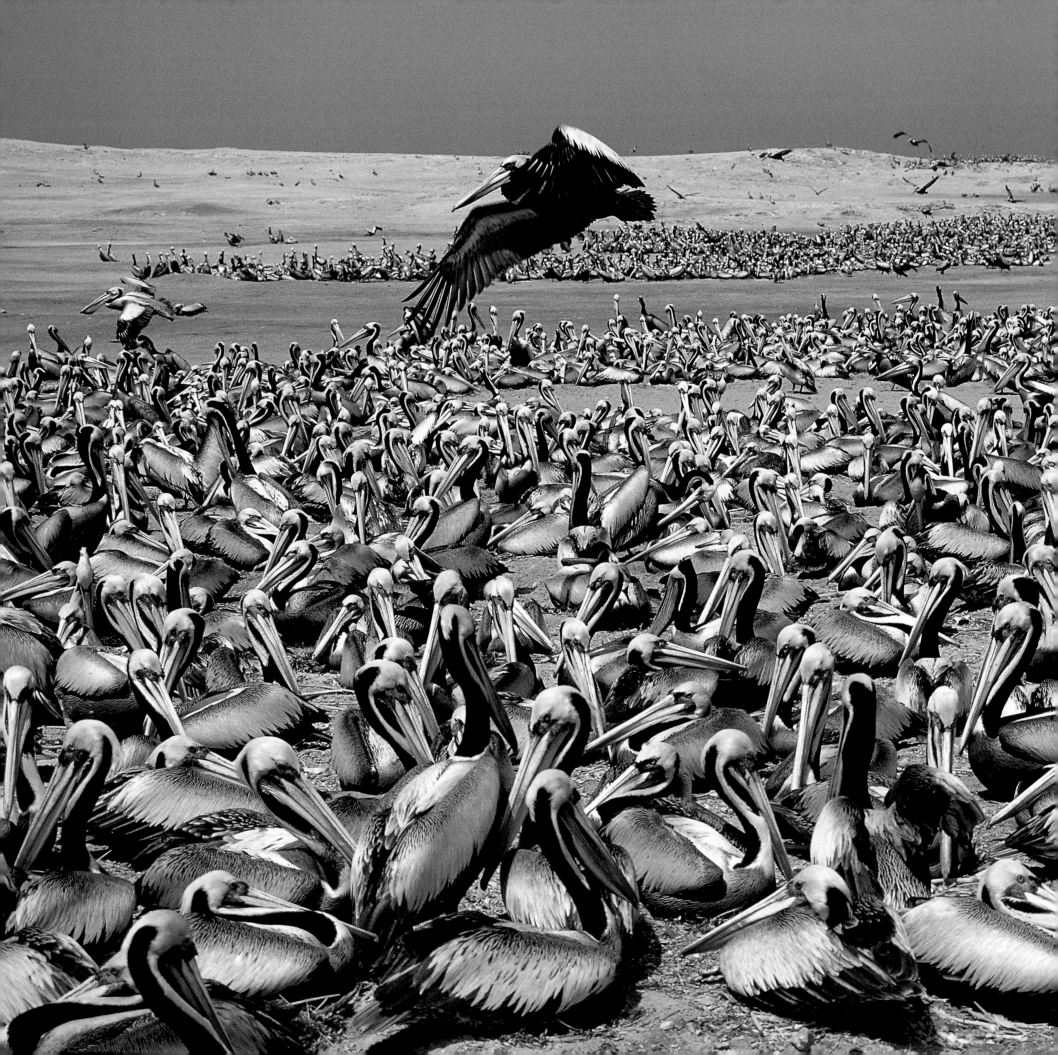

BIRDS

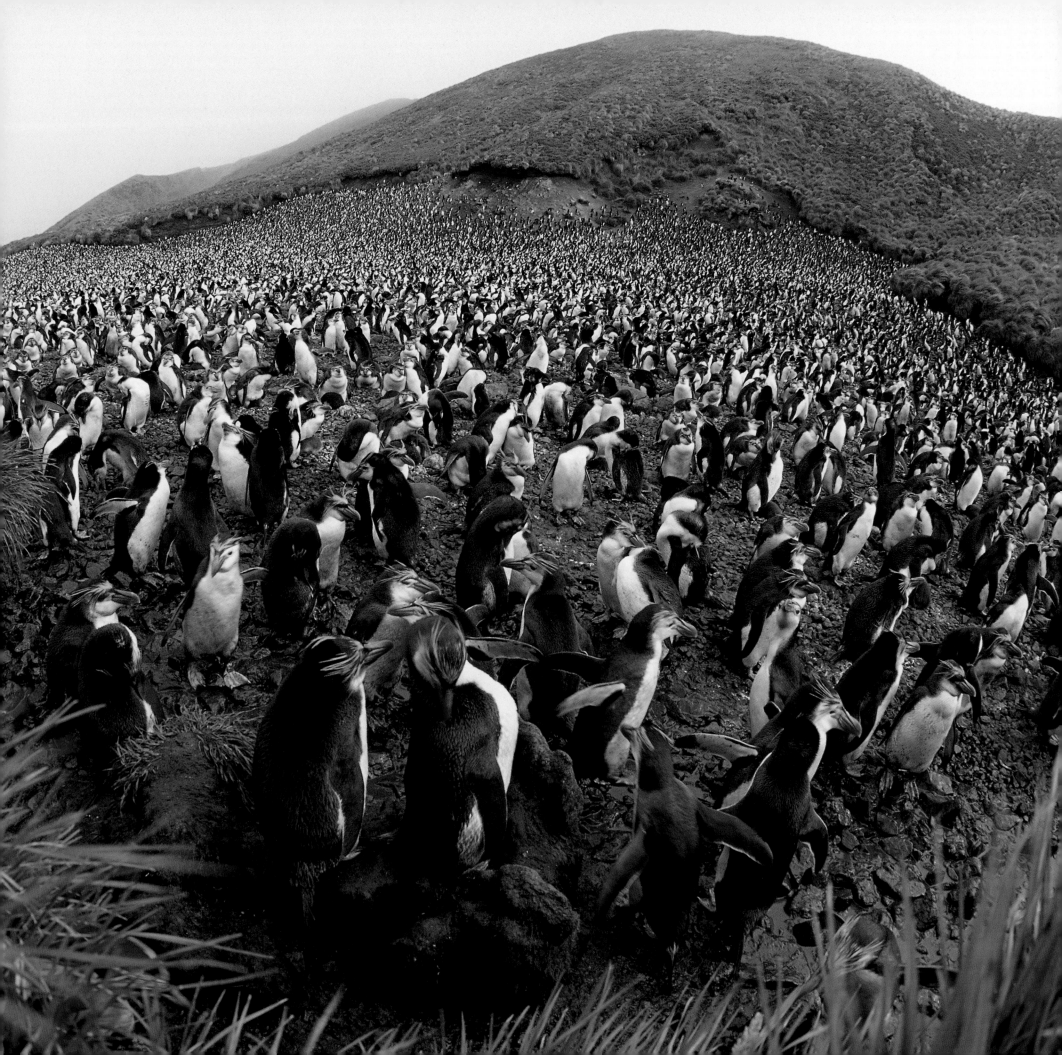

PENGUINS

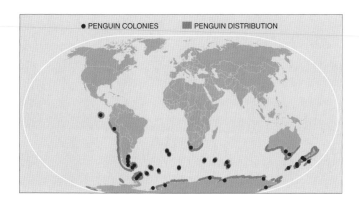

Seeing a penguin colony is an overwhelming and memorable experience. The color, the noise, the smell, and the commotion of thousands and thousands of individuals make penguin colonies interactive spectacles of nature. When we arrived at Punta Tombo in Argentina, and dragged our duffel bags to a waiting trailer where we would be staying, a penguin came out and wandered up over the gravel berm and off to the ocean. Under a bush there was another penguin, several circled each other on the hill, and the incessant peeping of chicks filled the air. It wasn't until we walked to the top of the hill and saw the beaches covered with penguins that we realized this was penguin nirvana. Twenty years later, this is still the largest colony of Magellanic penguins (*Spheniscus magellanicus*) in the world.

Penguins are ancient creatures. The first of their kind evolved in the late Eocene, some 30 million years ago. Thirty-two extinct species are known to science, some of which were over 1.5 m tall and weighed more than 90 kg. By comparison, the 17 (some say 18) species of penguins that exist today are much smaller, and average only about 0.6 m tall. Penguins are long-lived birds, with some individuals living to more than 30 years of age, and populations depend on high adult survival in order to thrive. Throughout history, penguins have always been restricted to the Southern Hemisphere and only the Galápagos penguin (*S. mendiculus*) is found as far north as the equator, where it is largely restricted to the cool waters around the two most western islands in the Galápagos Archipelago. Most penguins are sub-Antarctic or temperate creatures. The three main temperate species —Magellanic, Humboldt (*S. humboldti*), and jackass (*S. demersus*)— can be better labeled by where they occur, namely Patagonia, Peru, and Africa. Only the emperor (*Aptenodytes forsteri*) and Adelie penguin (*Pygoscelis adeliae*) are restricted to the Antarctic. That leaves 12 species, including the macaroni penguin (*Eudyptes chrysolophus*), the royal penguin (*E. schlegeli*), and the most regal, the king penguin (*A. patagonicus*), sprinkled on most of the sub-Antarctic islands, including South Georgia, New Zealand, and Australia.

The distribution and size of penguin colonies depends mainly on whether there is sufficient food nearby and on the availability of suitable nesting sites for breeding purposes. With an

On the opposite page, royal penguins (Eudyptes schlegeli) *are mainly restricted to Macquarie Island in subantarctic Australia, where they breed in immense numbers.*

Above, royal penguin chicks. Both photos, © Konrad Wothe

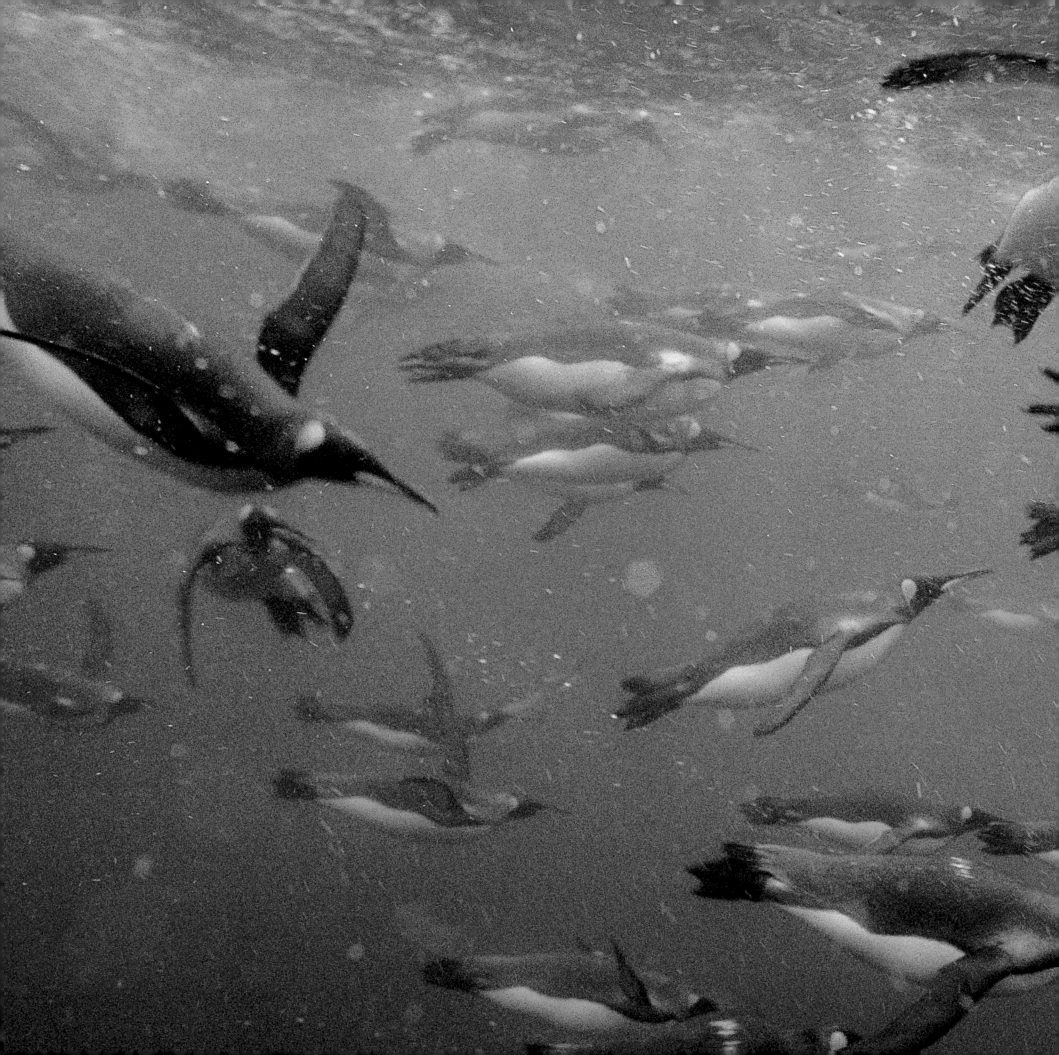

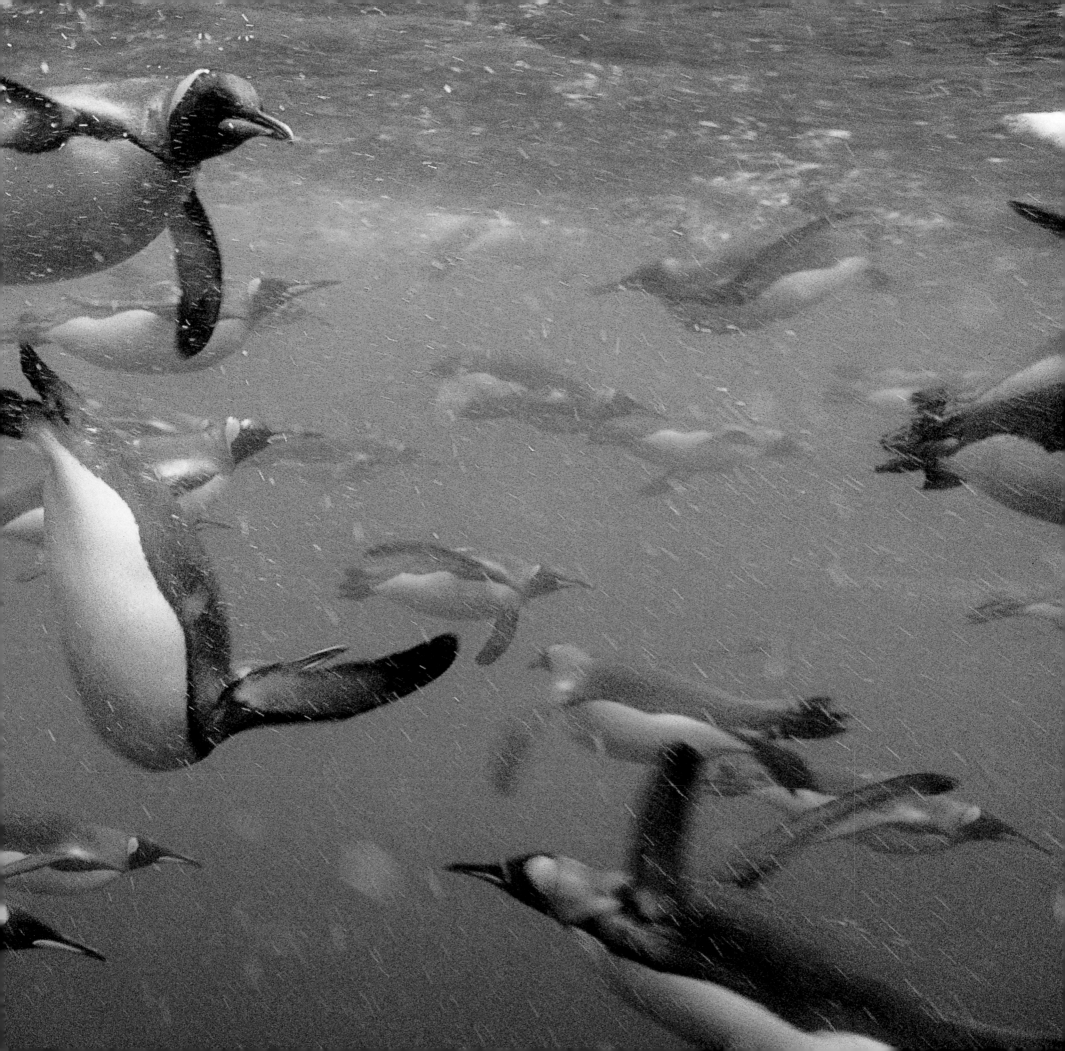

estimated worldwide population of 12 million pairs, the macaroni penguin is perhaps the most abundant penguin species, and on South Georgia roughly five-and-a-half million pairs are distributed among some 60-odd colonies. The only challenger to the macaroni's title is the chinstrap penguin (*P. antarctica*), with the overwhelming majority of the global population of this species occurring in South Sandwich Island (some five million pairs). The colony of magellanic penguins on Punta Tombo numbers some 225 000 breeding pairs, with another 70 000 pairs occurring on Punta Clara. The largest colony of the king penguin occurs on Cochons Island with an estimated 300 000 pairs, and there are an estimated 240 000-280 000 pairs on Kerguelen Island. The largest colony of the Adelie penguin can be found at Cape Adare (282 000 pairs), with another large colony at Cape Crozier (177 000 pairs). Large colonies of rockhopper penguins (*E. chrysocome*) are also known, including some 300 000 pairs on Macquarie Island.

Despite these large numbers, some colonies of various penguin species have suffered dramatic declines in numbers in recent years, such as those of the jackass penguin, the Galápagos penguin, and the fiordland penguin (*E. pachyrhynchus*). In the early 1990s only five species of penguins were considered threatened; a decade later, 10 species are in trouble. Penguins are extremely susceptible to the influences of climate change, and this has been a factor that has led to the extinction of so many species in the past. But two fundamental factors underlie the current plight of penguins: excessive human consumption and increasing human modification of the land and sea. For centuries, penguins have been killed for their meat and oil, and their eggs have been considered an important food source. Penguins were the sustaining food source that allowed many of the early Antarctic explorers to survive through the winter, and pickled penguin eggs could last for a year on old sailing boats. Even today, penguin eggs are still harvested in a few places, such as the Falkland Islands, although egg collecting, where it is still practiced, is generally regulated and sustainable. In addition to the threat of overutilization, pollution (especially oil), the impact of invasive species such as rats and cats that have left young and eggs vulnerable to predation, entanglement in fishing nets, bycatch, and disturbance at colonies (such as low-flying aircraft), have all taken their toll on penguin populations. Penguins evolved so long ago that they have not adapted to rapid changes in the environment caused by humans.

Until recently, conservation of penguins was directly linked to changes in their harvest or utilization. Increasingly, however, conservation efforts are being channeled in new directions. For example, ecotourism is seen as a sustainable, non-consumptive use of penguins and is a rapidly growing industry. At Punta Tombo, Argentina, more than 50 000 tourists visit the penguins every year. Similarly, several million people visit Phillip Island in Australia to see penguins, while 50 000 people visit the Galápagos and more than 15 000 people visit the Antarctic, and penguins are frequently the major attraction. Ocean zoning, as a means of reducing conflicts between people and wildlife, is an additional principal consideration for ensuring the survival of penguins. Penguins depend on a rich, productive ocean system coupled with secure breeding areas. Fortunately, there are many places where both still exist. Most are in Antarctica, which is protected by an international convention which, at a minimum, stipulates that the harvesting of krill or other resources to the detriment of these amazing penguin spectacles is prohibited. However, how well the convention will be enforced remains to be seen. For temperate and sub-Antarctic species of penguins, ocean zoning is probably not sufficient for their long-term conservation, and so our primary challenge remains to develop the means to reduce conflicts between penguins and people.

P. Dee Boersma
Amy N. Van Buren

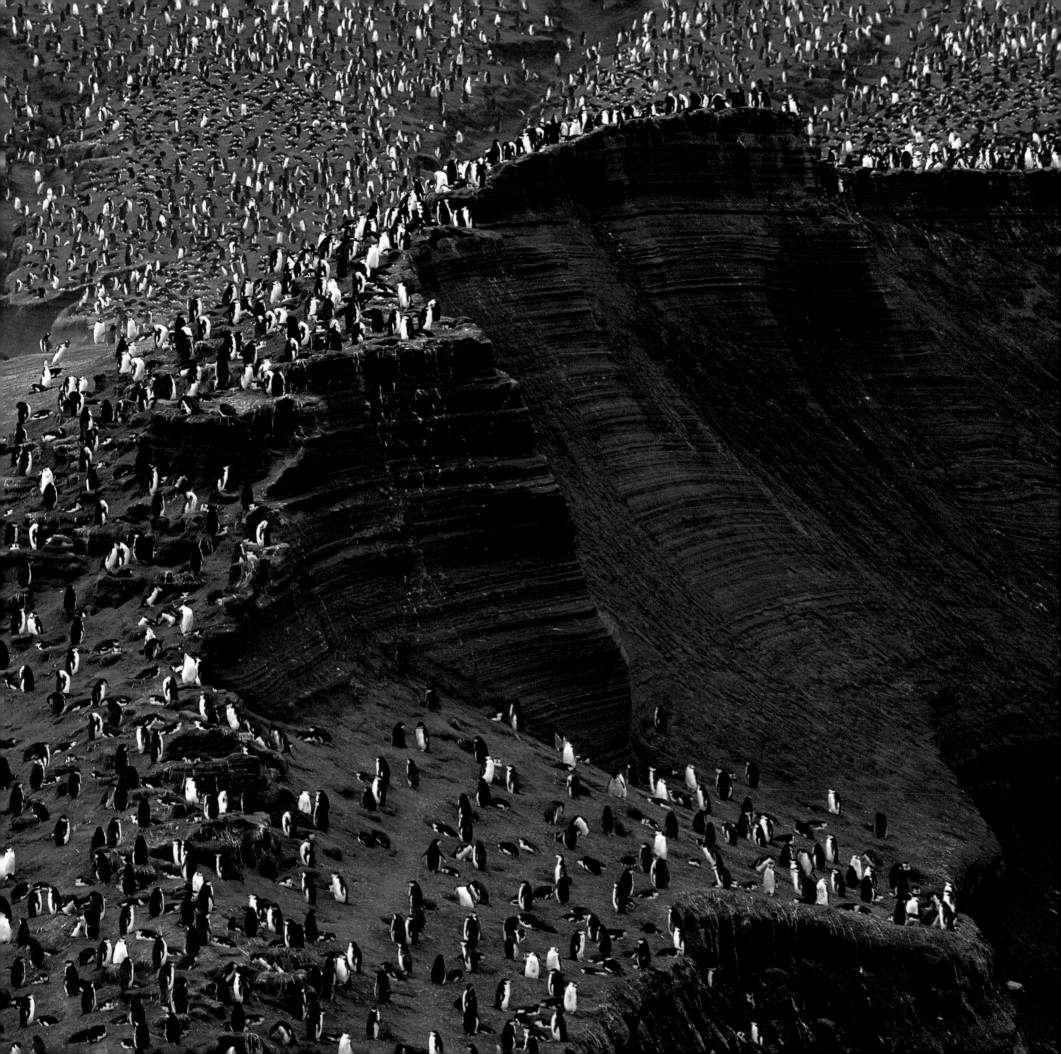

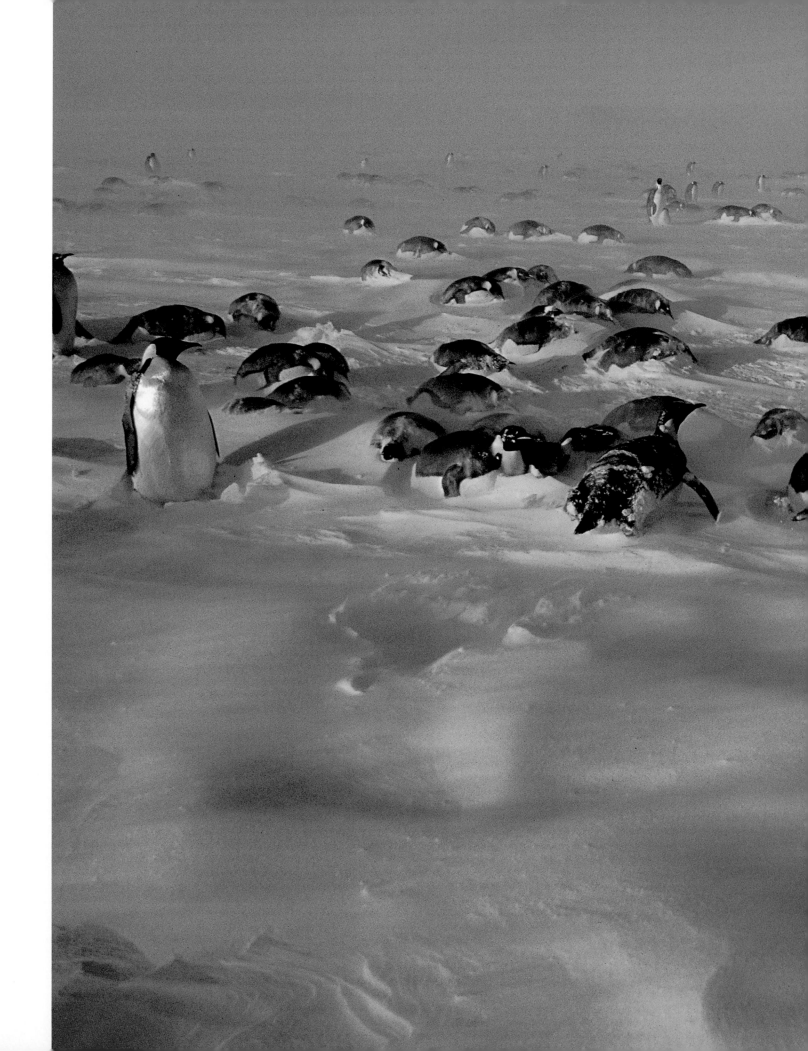

Emperor penguins
(Aptenodytes forsteri) *in
a blizzard on Cape Roget,
Ross Sea, Antarctica.
The emperor penguin
is the only truly Antarctic
penguin, and breeds in
the darkness of the Antarctic
winter on the frozen ice
of the Ross Sea.*
© Graham Robertson/
Auscape

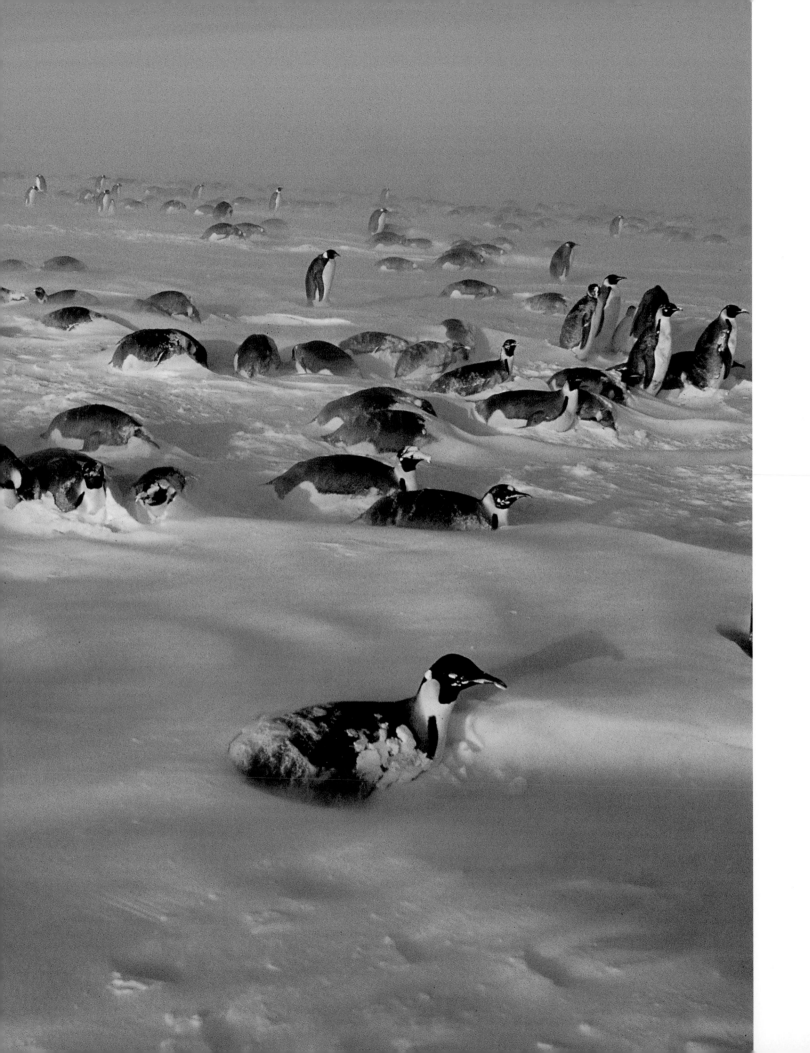

On pp. 156-157,
an immense colony
of Adelie penguins
(Pygoscelis adeliae)
on Paulet Island,
Antarctica. Some
of the greatest
concentrations of Adelie
penguins are found along
the Antarctic Peninsula.
© Fred Bruemmer/
DRK PHOTO

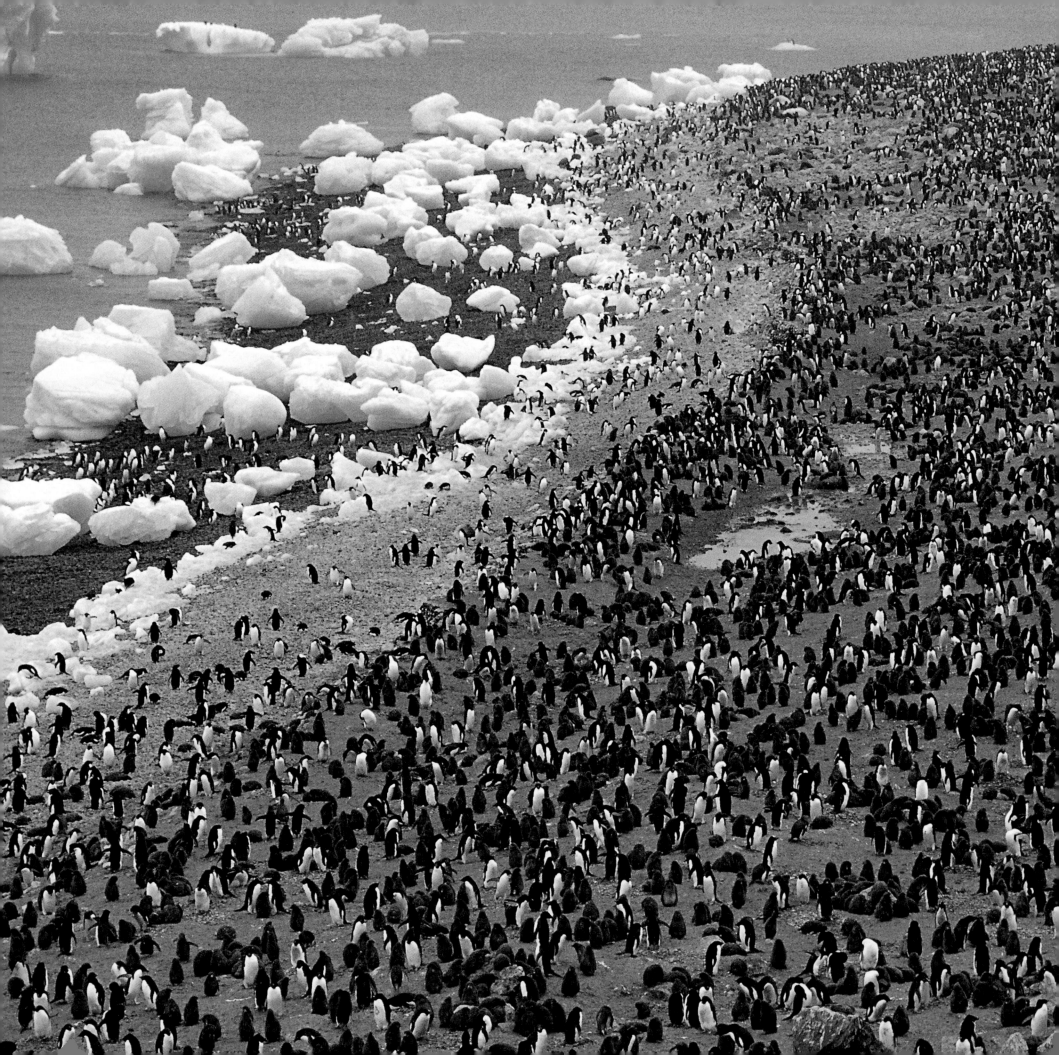

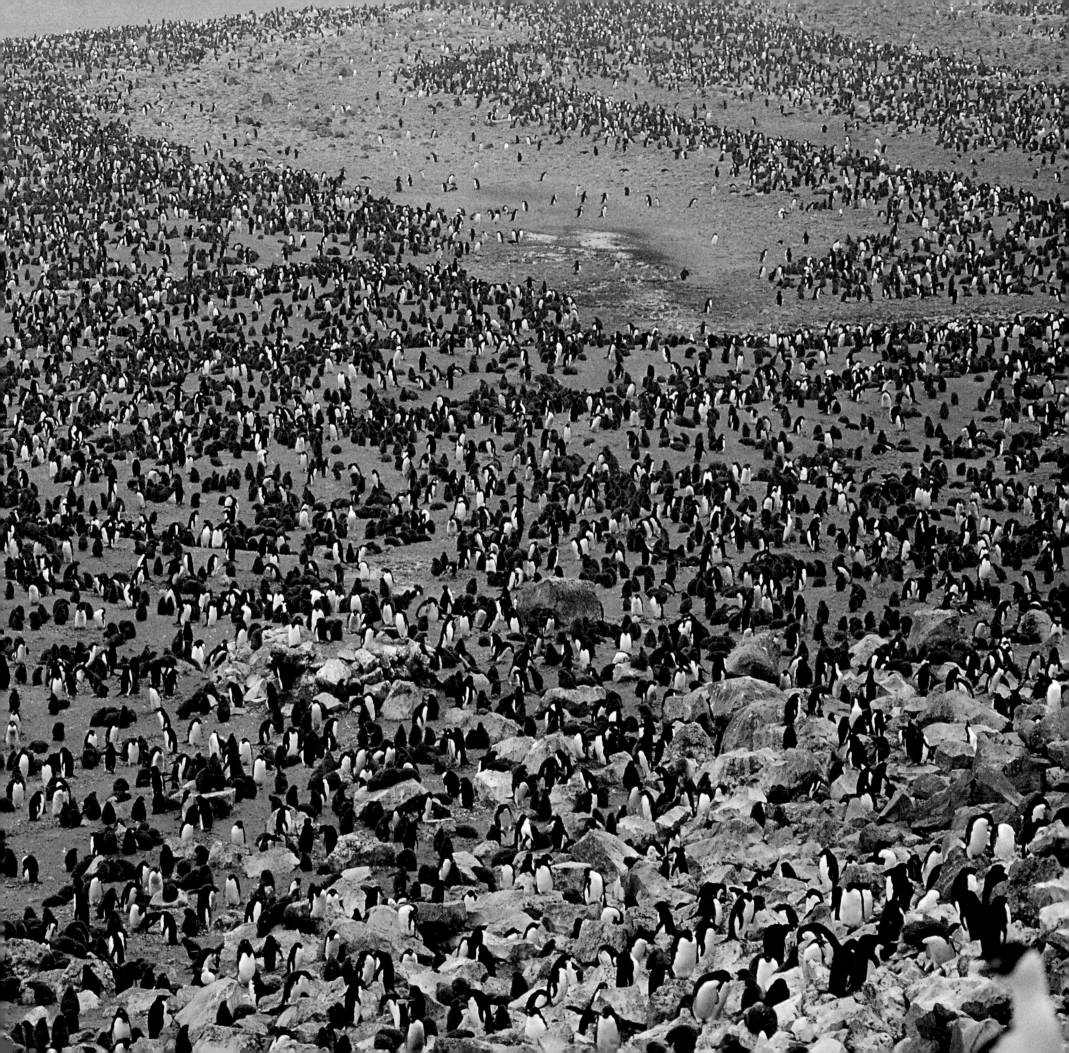

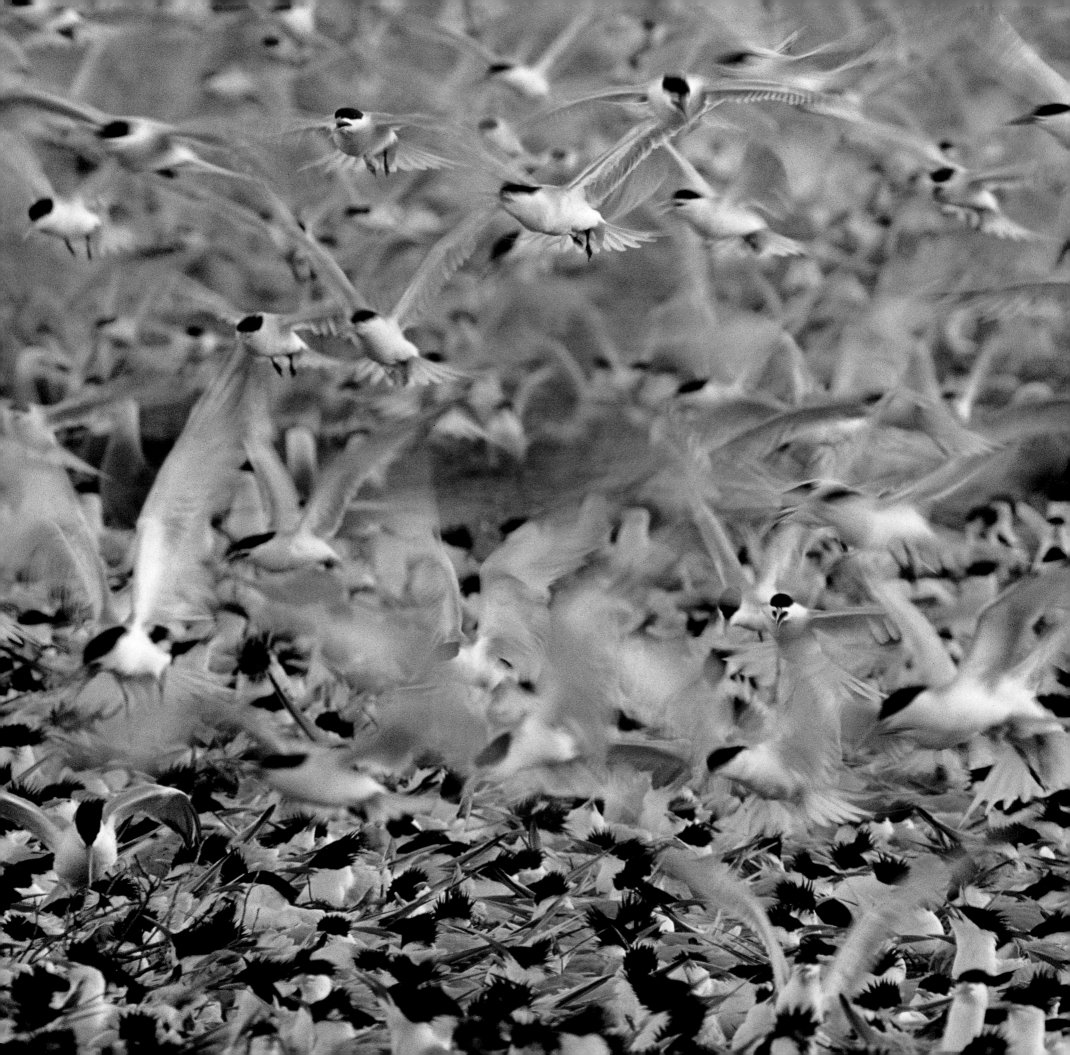

PELAGIC SEABIRDS

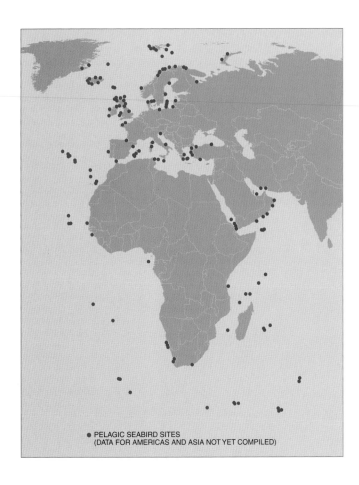

● PELAGIC SEABIRD SITES
(DATA FOR AMERICAS AND ASIA NOT YET COMPILED)

Pelagic seabirds, as epitomized by the albatrosses, are often thought of as the lone wanderers of the oceans, effortlessly moving vast distances over the open seas in search of scraps of food. However, this image was probably popularized by the romantic accounts written during the age of sailboat travel, which was largely confined to the trade-wind areas. Although pelagic seabirds do often travel alone, they also congregate in vast numbers at certain times. In fact, the ratio of the total home range area to congregation area must be amongst the highest for all vertebrates. Albatrosses travel tens of thousands of kilometers from their breeding sites (some even circumnavigating the globe) during the non-breeding season, and yet when breeding are confined to literally just a handful of small oceanic islands.

True pelagic seabirds are dominated by species from the orders Procellariiformes, Pelecaniformes, and Charadriiformes. The order Procellariiformes includes the albatrosses, petrels, shearwaters, and fulmars. Albatrosses generally have relatively small global populations with very restricted breeding ranges, whilst petrels, shearwaters, and fulmars generally have much larger populations and can congregate in the millions on their breeding islands. For example, an estimated 3.4 million pairs of Leach's storm petrels (*Oceanodroma leucorhoa*) breed on the 523-ha Baccalieu Island, Newfoundland. These species tend to congregate only on their breeding islands during the breeding season and roam widely across the oceans when not breeding. Seabirds from the order Pelecaniformes, which includes gannets, boobies, tropicbirds, and frigatebirds, dominate the pelagic seabird community of the tropics, while pelagic seabirds of the order Charadriiformes include species of skuas, gulls, and terns, which generally occur at higher latitudes.

Pelagic seabirds congregate mainly for two reasons, namely to breed and to feed. All pelagic seabirds are colonial breeders. During their breeding season, they congregate in vast numbers on their breeding islands. Prime breeding islands are ones that are free of predators and have a reliable source of food within foraging range. Islands that fulfill these requirements are in short supply and, consequently, large proportions of the global populations of pelagic seabirds breed on a very few islands, mostly oceanic or offshore. Many pelagic seabirds also display very high mate and site fidelity and thus will return to breed with the same mate on the same island (at almost exactly the same nesting site) year after year, making the colonization of new sites a slow process. A perfect example of this is Isla Rasa, a small, volcanic island located in the midriff section of the Gulf of California in Mexico. Every spring, this otherwise unremarkable, flat and arid island —which has been declared a Biosphere Reserve by the Mexican govern-

On the opposite page, elegant tern (Sterna elegans) *colony on Isla Rasa in the Gulf of California, Mexico. More than 90% of the world's population of this species flocks to the shores of this small, volcanic island every spring.*

Above, Heermann's gull (Larus heermanni) *with chick, Isla Rasa, Gulf of California. Some 300 000 gulls, representing almost the entire world population, nest on this small island every year.*
Both photos, © Claudio Contreras

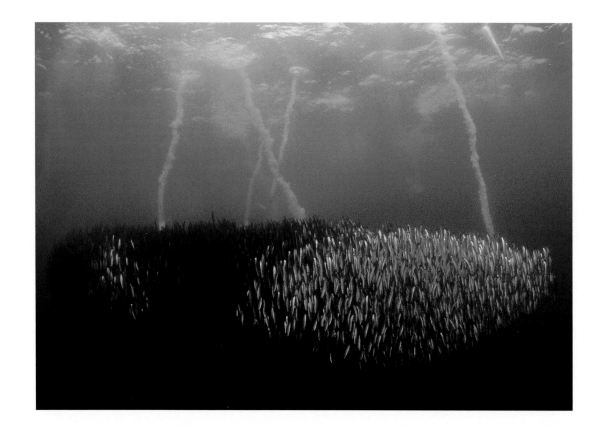

Above, Cape gannets (Morus capensis) *leave "vapor-trails" of air bubbles as they plunge-dive into a baitball of sardines* (Sardinops sagax) *off the coast of South Africa.*
© Doug Perrine/Seapics.com

On the opposite page, a large flock of blue-footed boobies (Sula nebouxii) *in a feeding frenzy following offshore schooling fish near Fernandina in the Galápagos Islands. Blue-footed boobies are highly gregarious in their feeding behavior, sometimes being found in groups of up to 200 birds.*
© Tui De Roy

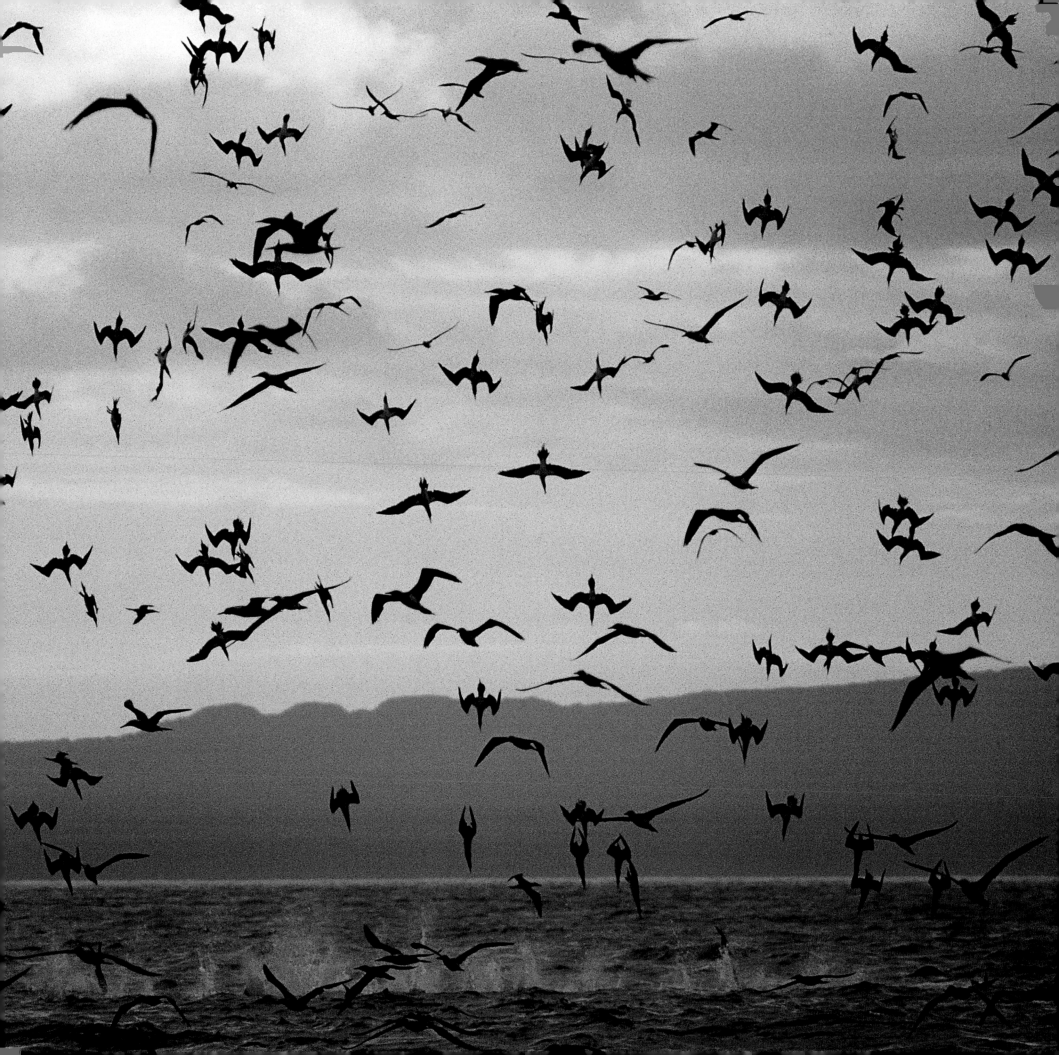

ment— sees some 500 000 birds flock to its shores to nest, including almost the entire global population of Heermann's gulls (*Larus heermanni*) and over 90% of the world's population of elegant terns (*Sterna elegans*).

At sea, pelagic seabirds also congregate in areas where there are high concentrations of food resources. During the breeding season, pelagic seabirds are forced to find food within a confined distance from the breeding island (defined by the commuting capabilities of the species and the interval at which they need to return to their breeding colonies). This drives breeding birds to congregate in large numbers at reliable feeding areas close to their breeding islands. However, even during the non-breeding season, when pelagic seabirds move far away from their breeding islands, they will congregate at the most dependable and productive feeding areas, often located thousands of kilometers from their breeding islands. Feeding congregations are often associated with productive oceanographic features. Many of these features occur predictably both in space (location) and time. For example, an ocean current passing over a mid-ocean ridge could cause an area of high oceanic variability, resulting in the spawning of productive eddies. Seabirds have been shown to target such eddies. Other productive feeding areas may be fixed in space (location), but vary with time. For example, upwelling plumes are known to occur in certain areas but will only occur when local weather conditions are suitable.

Pelagic seabirds are at risk both when congregating on their islands to breed and when feeding at productive areas of the ocean. The fact that many pelagic seabirds only breed on a few select islands —each accommodating high proportions of the global population— makes them very vulnerable at these localities. Disturbance at only one colony can have a disproportionate effect on the global population. The greatest threat to breeding populations of pelagic seabirds is the presence of human-introduced predators. These seabirds have mostly evolved to breed in the absence of mainland predators and the smaller species are particularly poorly equipped to defend themselves. Domestic cats introduced by early human visitors have devastated many populations of smaller petrels, and other introduced predators such as rats, mongooses, stoats, goats, pigs, sheep, and cattle also disturb breeding efforts and transform the breeding habitat. Human disturbance at breeding colonies may pose a further threat to breeding pelagic seabirds, often because breeding birds are scared off their nests, resulting in eggs and small chicks being snatched by roving gulls and skuas. However, the effects of human disturbance are often accumulative over time and thus less apparent to the perpetrators of a single disturbance event. In

other words, repeatedly disturbed colonies may appear to be unaffected by each disturbance event, but then suddenly decide to abandon their breeding attempt when they are pushed past a certain threshold.

At their favored feeding areas, pelagic seabird congregations face further threats, posed mainly through their interaction with fishing vessels. Many of the larger pelagic seabirds (particularly the albatrosses) have become very adept at scavenging offal disposed by these vessels. When these birds attempt to snatch baited hooks being deployed by long-line fishing vessels, they are hooked, dragged beneath the water and drowned. In many cases, long-line fishermen and albatrosses both target the most productive areas of the ocean in search of their prey. This leads to an intense interaction and thousands of seabird deaths. Pelagic seabirds are also killed in some trawl and net fisheries.

The effective conservation of pelagic seabirds requires concerted international efforts to reduce human-related impacts at both their breeding and foraging habitats. In recent years, there have been several very successful programs to eradicate introduced predators on seabird breeding islands. However, despite these efforts many threatened species are still fighting a losing battle against introduced predators. While conservation efforts need to concentrate on ridding these islands of their present suite of introduced problem species, extreme care also needs to be exercised not to make further introductions. In addition, tourists visiting these spectacular breeding islands must be very careful not to disturb breeding seabirds. In the Antarctic, the overriding tourism body (IAATO – International Association for Antarctic Tour Operators) has a strict code of conduct that all operators should adhere to.

Fisheries threats to at-sea congregations of pelagic seabirds have recently been the subject of much global conservation attention. BirdLife International recently launched its *Save the Albatross* Campaign that aims to reduce the bycatch of seabirds in long-line fisheries to a minimum. Of special interest is the initiative by BirdLife International to collate all satellite tracking information on the affected seabirds into a central Geographical Information System (GIS), with the aim of identifying the most important areas of the ocean where these seabirds congregate and, consequently, .where they are at most risk from being killed by long-line and other fishing operations. This GIS database will be a key product influencing the development of special management areas on the high seas.

DEON C. NEL

Above, razorbills (Alca torda) *mating, Shetland Islands, U.K.* © Günter Ziesler

On the opposite page, black-browed albatross (Thalassarche melanophris) *on Steeple Jason Island in the Falklands. The black-browed albatross is probably the most abundant and widespread albatross species, with almost 600 000 breeding pairs. The Falkland Islands alone hold around 400 000 pairs, with the largest colony (166 000 pairs) occurring on Steeple Jason Island.* © Patricio Robles Gil/Sierra Madre

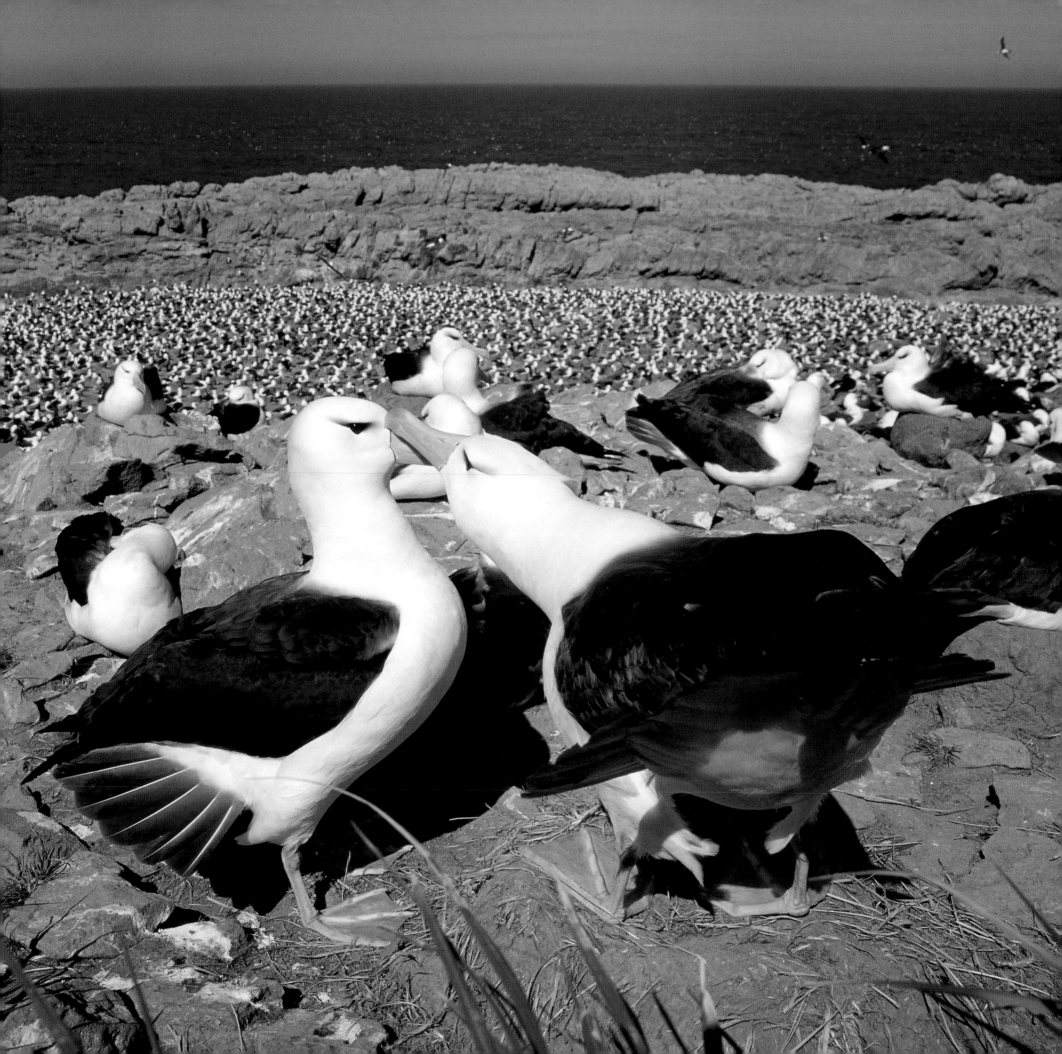

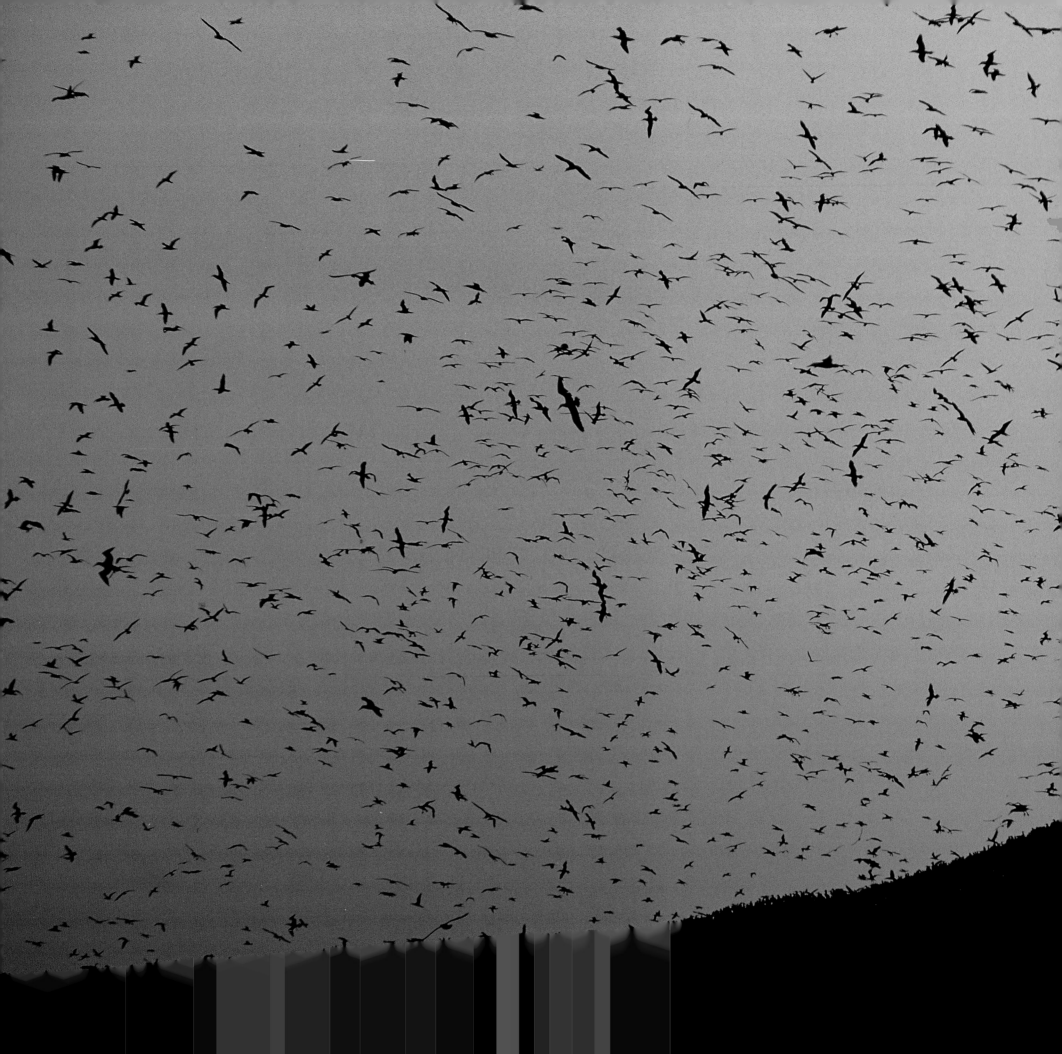

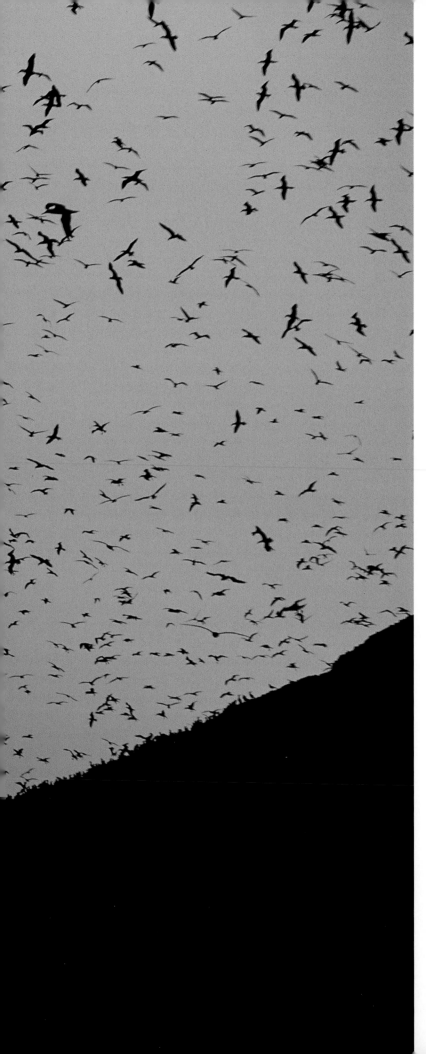

Peruvian boobies (Sula variegata) on an evening flight back to their nesting colony on Guano Island in the Ballestas Islands, Peru. This species, which has its breeding grounds along the coast from northern Peru to central Chile, is greatly affected by El Niño. From 1981-1982 to 1982-1983, the total population fell from almost 2 700 000 birds to a little over 700 000.
© Tui De Roy

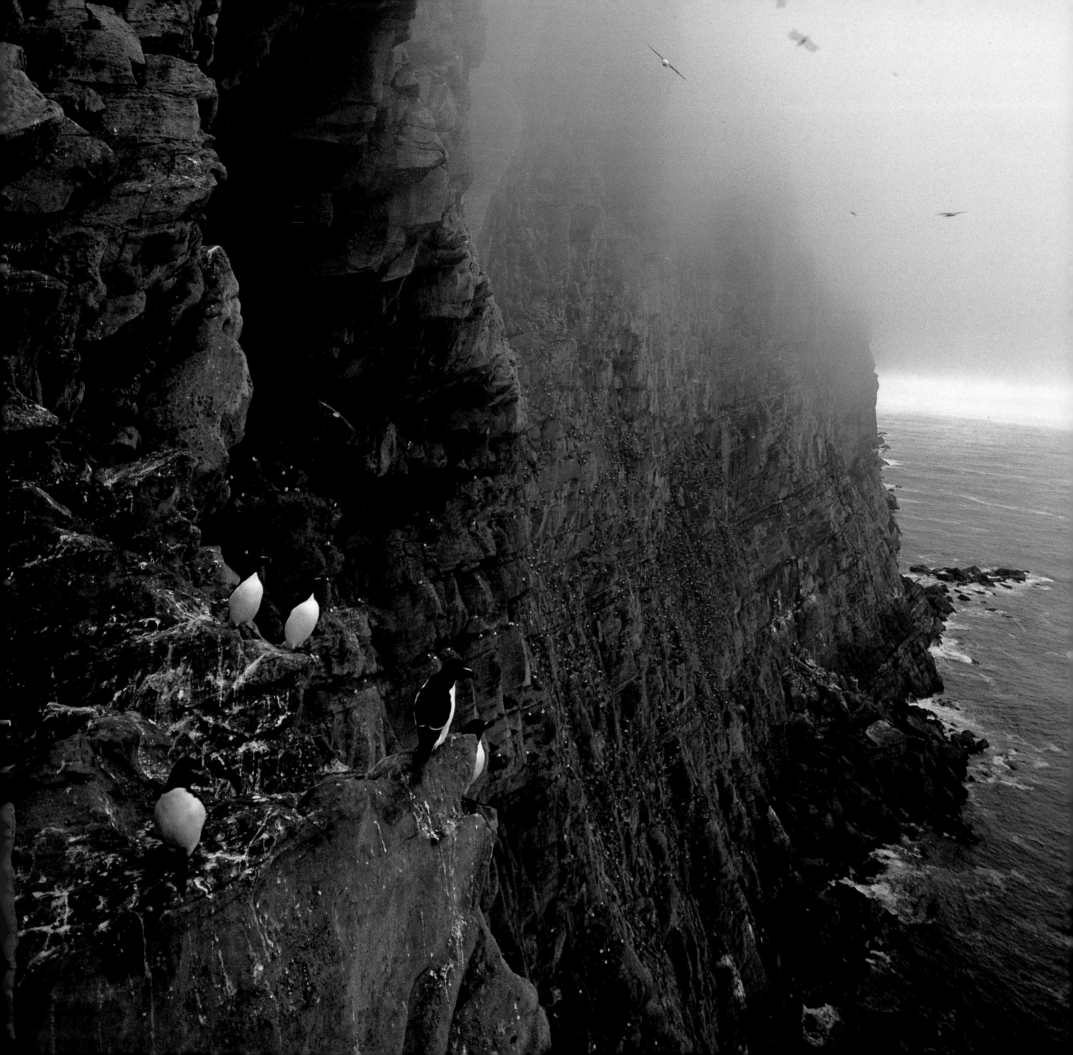

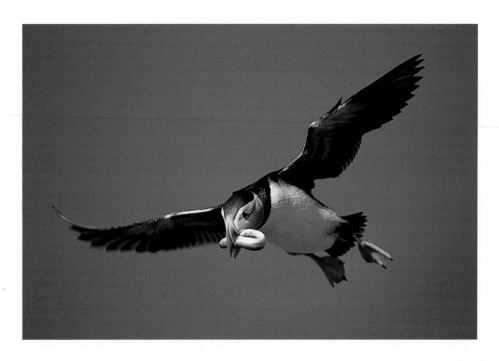

Above, puffin (Fratercula arctica) *with fish arriving at its nest, Iceland.*

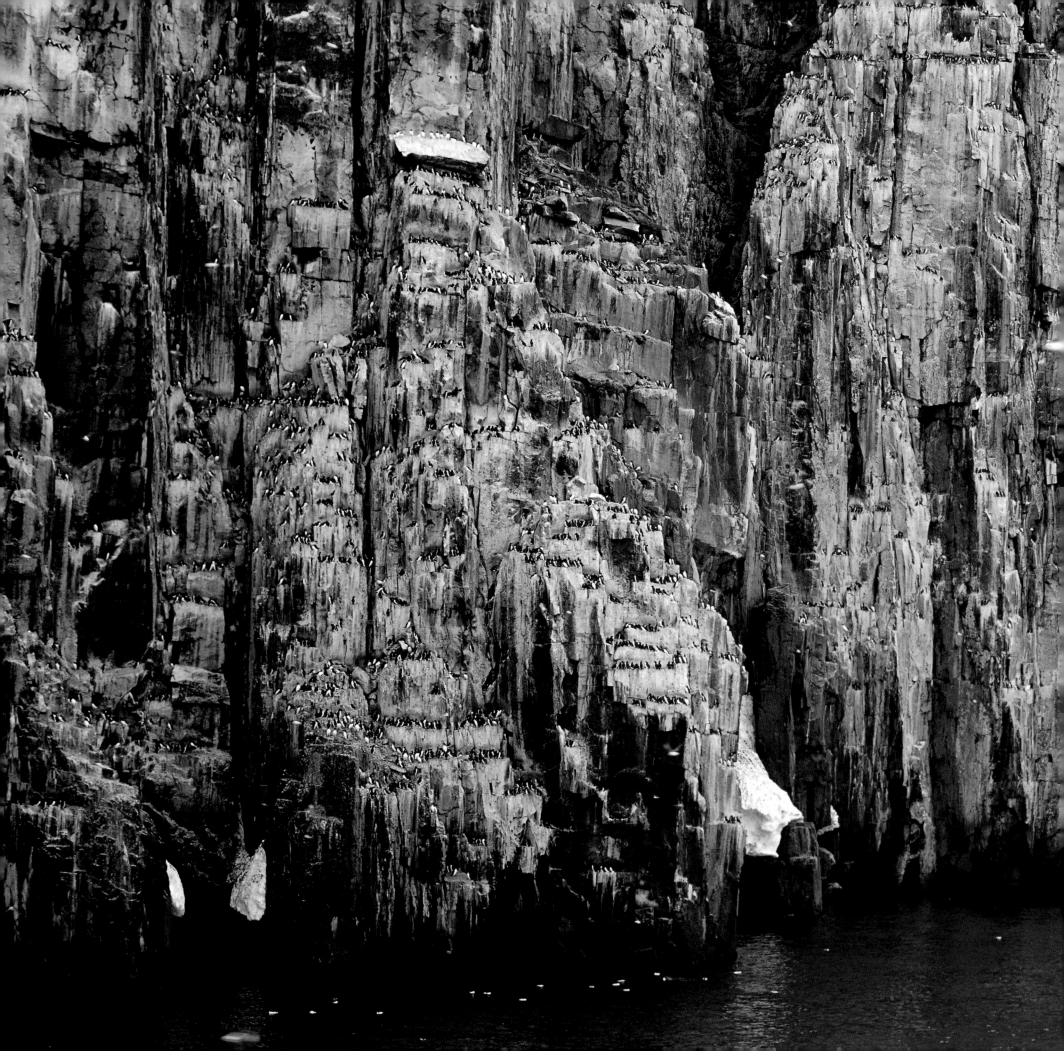

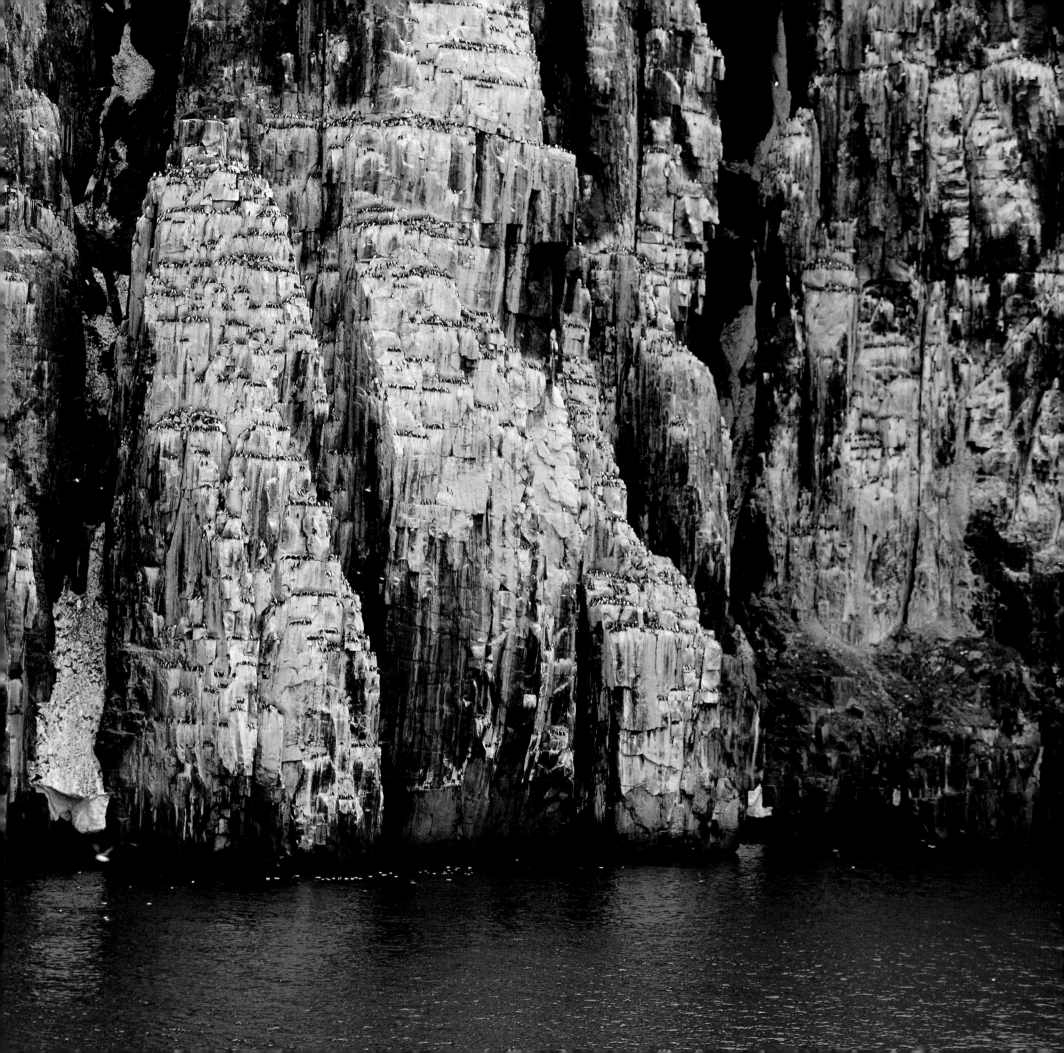

FLAMINGOS

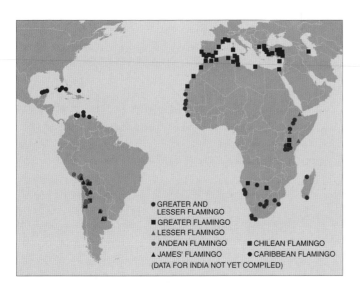

GREATER AND
LESSER FLAMINGO
■ GREATER FLAMINGO
▲ LESSER FLAMINGO
● ANDEAN FLAMINGO ■ CHILEAN FLAMINGO
▲ JAMES' FLAMINGO ● CARIBBEAN FLAMINGO
(DATA FOR INDIA NOT YET COMPILED)

Flamingos may be among the most charismatic of birds. Their pink coloration, sinewy neck, inverted bill, and charm make them immediately recognizable. The nesting colonies and feeding and courting aggregations of wild flamingos are colorful spectacles that attract thousands of visitors to flamingo haunts throughout the globe. Flamingos are quite tough and are adapted to habitats that few other species can tolerate, despite their dainty appearance. Most of the wetlands where flamingos live are highly saline or alkaline, some saturated with soda, sulphates, fluoride, lithium, and other minerals. In some cases, shallow lakes in the tropics reach such high temperatures that flamingos can be seen hopping from one foot to another. At the other extreme, flamingos can also be seen tiptoeing on the surface of frozen lakes during the harsh cold winters in South America. Despite the attention given, many mysteries remain concerning flamingos in the wild, perhaps contributing to their magic.

There are six taxa of flamingo in the world: the Caribbean flamingo (*Phoenicopterus ruber ruber*) inhabits the Caribbean Basin primarily on the islands of the Bahamas, Cuba, Hispaniola, and Bonaire, and along the coast of Venezuela, Colombia, and Yucatán, Mexico. Curiously, there is a small satellite population of Caribbean flamingos of about 500 birds on the Galápagos Islands. South America is home to three species of flamingo: the Chilean (*Phoenicopterus chilensis*), the Andean (*Phoenicopterus andinus*), and the James' or Puna (*Phoenicopterus jamesi*) flamingos. The Andean and James' flamingos are primarily restricted to the shallow lakes of the Central Dry Puna in the high Andes of Peru, Chile, Bolivia, and Argentina, although they have been found in some lower locales as well. The Chilean flamingo is much more widely distributed throughout the southern Andes, sometimes reaching the coastline of Argentina. The greater flamingo (*Phoenicopterus ruber roseus*) has the widest distribution of the six taxa, and can be found from the western Mediterranean and western coast of northern Africa, extending east as far as India and south into southern Africa. The lesser flamingo (*Phoenicopterus minor*) overlaps with the greater flamingo in Africa and Asia.

Obtaining flamingo population numbers can be very hard because they range over wide areas, some of which are very difficult to access. They are notoriously gregarious, with groups numbering in the thousands (sometimes millions!), making accurate counts difficult. An additional complication is that some flamingo species are divided into separate populations, although how rigid these divisions are is unknown. Most population numbers are rough estimations and are usually extrapolations made from counting flamingos at the better-known

On the opposite page, lesser flamingo (Phoenicopterus minor) on Lake Bagoria, Kenya. With an estimated population of 4 million individuals, the lesser flamingo is by far the most flamingo abundant species. It moves between the Rift Valley lakes of East Africa and the saltpans of Botswana and Namibia.
© Ferrero-Labat / Auscape

Above, James flamingo (Phoenicopteus jamesi), Salar de Surire, Chile.
© Günter Ziesler

On pp. 172-173, lesser flamingo on Lake Nakuru, Kenya. In spite of their dainty appearance, flamingos are quite resilient and have adapted to habitats that few other species can tolerate. Most of the wetlands where flamingos live are highly saline or alkaline, some saturated with soda, sulphates, fluoride, lithium, and other minerals.
© Art Wolfe

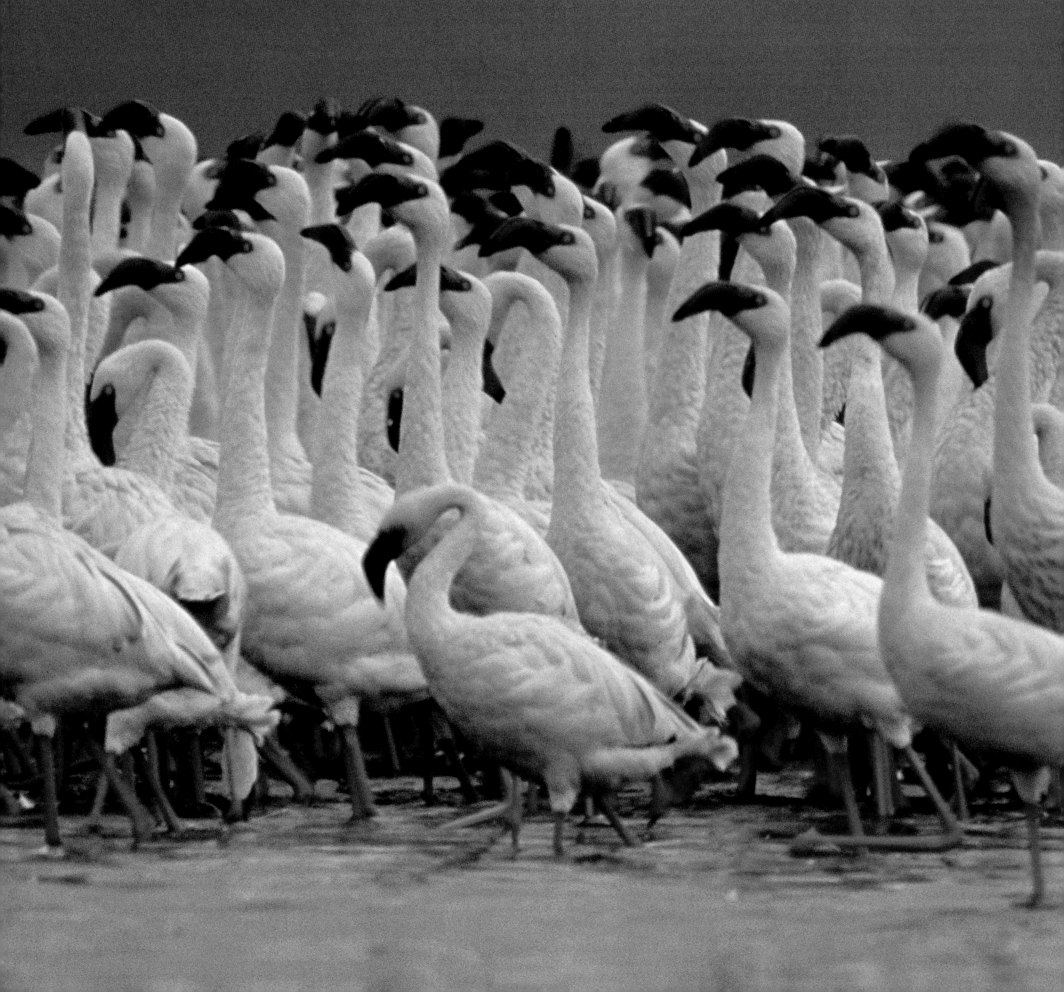

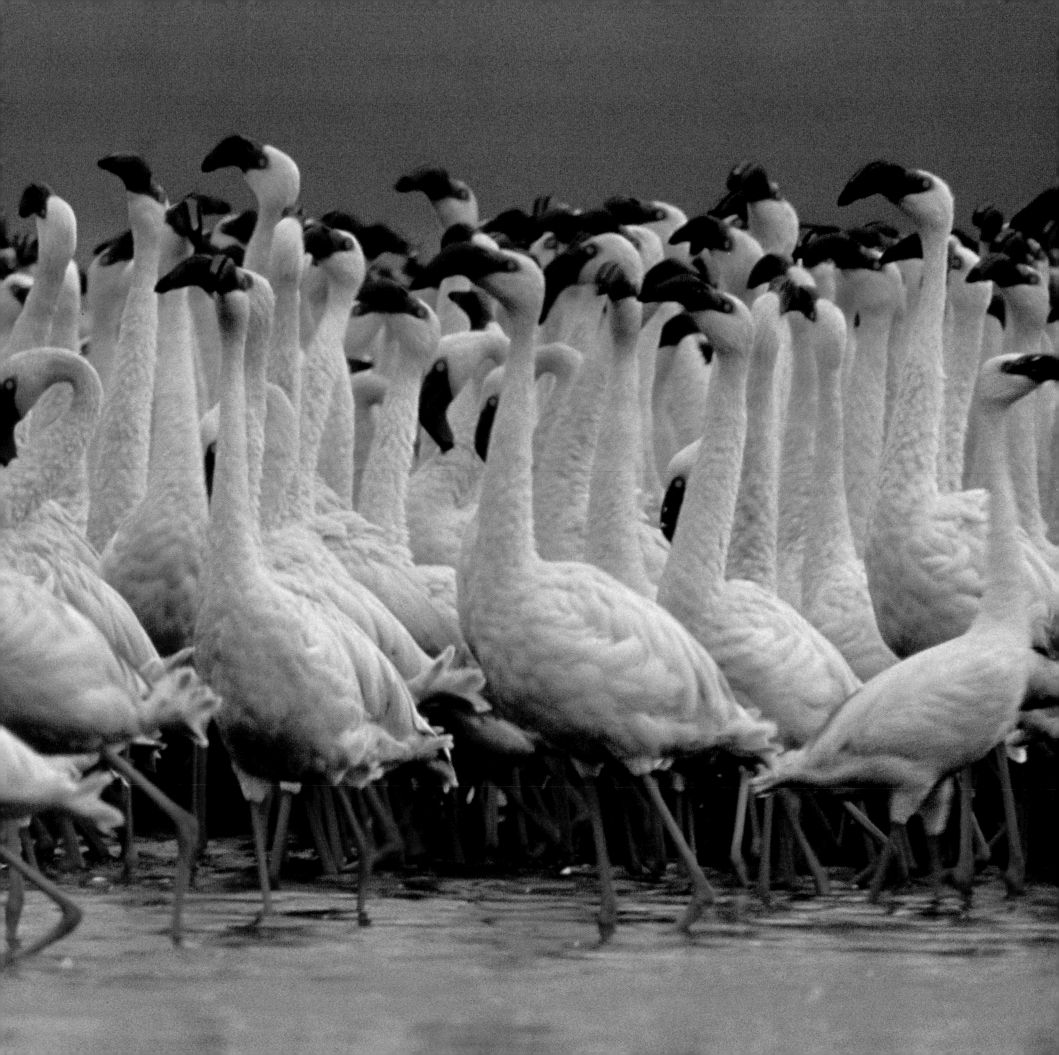

Above, greater flamingo (Phoenicopterus ruber roseus) in the Camargue, France. Their pink coloration, sinewy neck, inverted bill, and overall charm make flamingos immediately recognizable. Nesting colonies and feeding and courting aggregations of wild flamingos are amazing, colorful spectacles that attract thousands of ecotourists every year.
© Thierry Thomas/BIOS

On the opposite page, Caribbean flamingo (Phoenicopterus ruber ruber) on Ría Celestún, Yucatán, Mexico. The Caribbean flamingo population is estimated at around 263 000 individuals, with the largest groups occurring in Cuba (120 000-200 000), the Bahamas (50 000-60 000), and Mexico (30 000).
© Patricio Robles Gil/Sierra Madre

aggregation sites. Reliable flamingo counts involve organizing many observers to cover a large area within a short time frame so as to not recount or miss those birds that are moving from one lake to another. Although more complete and reliable data are becoming available, establishing real population trends can be tricky.

The Caribbean flamingo population is estimated at around 263 000 individuals, with larger groups observed in Cuba (120 000-200 000), the Bahamas (50 000-60 000), and Mexico (30 000). For the South American species, the first reliable population estimates for the Andean and James' flamingos have become available in recent years, as a group of concerned conservationists has engaged in an enormous effort to conduct repeated comprehensive censuses throughout their range. Thanks to these efforts, we know the James' flamingo population is at least around 64 000 and the Andean flamingo, the rarest of all flamingo species, around 34 000 individuals. Because the Chilean flamingo is much more widespread, the population estimate of 500 000 is less reliable. The greater flamingo probably numbers between 500 000 and 700 000, with at least 60 000 observed in the western Mediterranean (France, Spain, and Italy) and 40 000 in West Africa. The lesser flamingo is by far the most abundant species at 4 million individuals, although its numbers have been notoriously hard to estimate, precisely because of the difficulty of assessing the huge aggregations, and because movements between the Rift Valley lakes in East Africa and the saltpans of Botswana and Namibia are difficult to assess. There is strong evidence, however, that there is movement between these important breeding areas.

Animals tend to aggregate either to avoid predators or due to food distribution. Although a flamingo in the middle of a group is safer from a crocodile than a lone one, it is more likely that food drives group formation in flamingos. Flamingos are filter feeders, straining water and mud through the sieve-like lamellae in their curved bills. Each species has slight differences in the size and shape of the lamellae and the bill, so they do not feed on the same foods. Flamingo food is distributed in patches, whether it is the *Spirulina* (blue-green algae) favored by the lesser flamingo or the *Artemia* (brine shrimp) sought after by the Caribbean flamingo. These food patches are very dynamic in space and in time. Within one lake, food can become available in different areas at different times and flamingo groups can be observed following these changes around the lake. Food conditions are also changing over time in the other lakes and when feeding conditions at one lake are not so favorable, flamingos will move on to another lake. At a given point in time, conditions

are ideal for flamingos in some lakes. This changing habitat quality is known as a "shifting mosaic" and for flamingos to be able to survive in such a variable environment, they must be nomadic.

These habitat changes in space and time have major implications for the conservation of flamingos because maintaining their populations depends on making sure that there are many feeding sites available. As food availability fluctuates, some areas will not be actively in use, although they cycle back into use in the near (and sometimes distant) future. Consequently, because flamingos operate over such enormous "ecological neighborhoods," proper management and conservation will require preserving enough wetland habitats over the landscape to secure an adequate sequence of food so that there is some habitat available at any particular point in time. This means that large expanses must be protected, which likely will involve strategies other than protection through parks and reserves.

Today, flamingos are most threatened by changes in their wetland habitats. This means not only a significant direct loss of wetland habitat, but also some severe degradation due to human encroachment and industrial development, especially salt and mineral mining. Human disturbance due to fishing in the lakes, grazing along the shores, or even tourism should not be underestimated. Flamingo colonies are extremely vulnerable. Colonies are lost to people taking eggs either for private consumption or for sale in local markets. In Mexico and Chile, strict protection of colonies has had remarkable results, with noticeable population increases. Localized protection of colonies and feeding areas at key sites can significantly decrease threats to flamingos. The challenge lies in devising a landscape-level approach involving different tools and strategies that will ensure the integrity and dynamic nature of the wetland complex that flamingo populations will depend on into the future.

FELICITY ARENGO

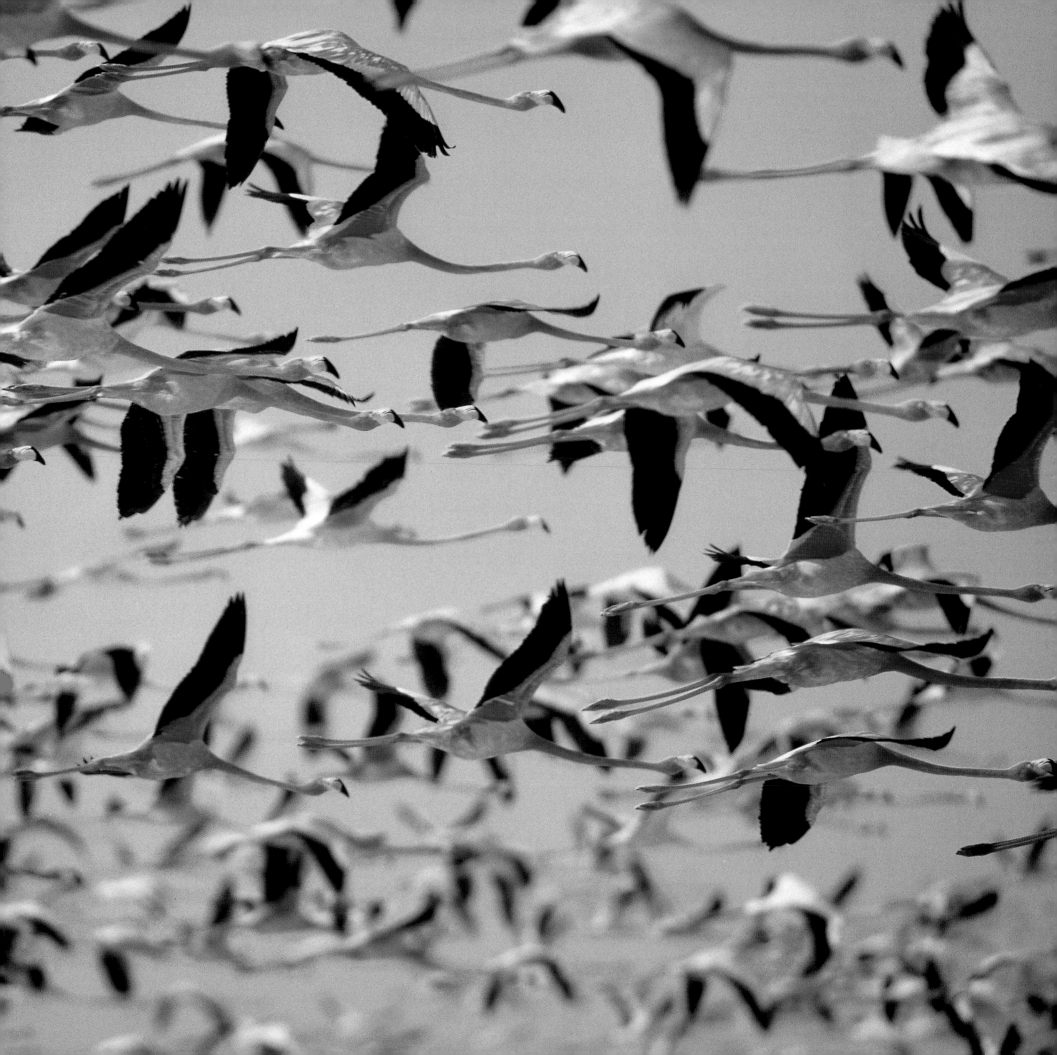

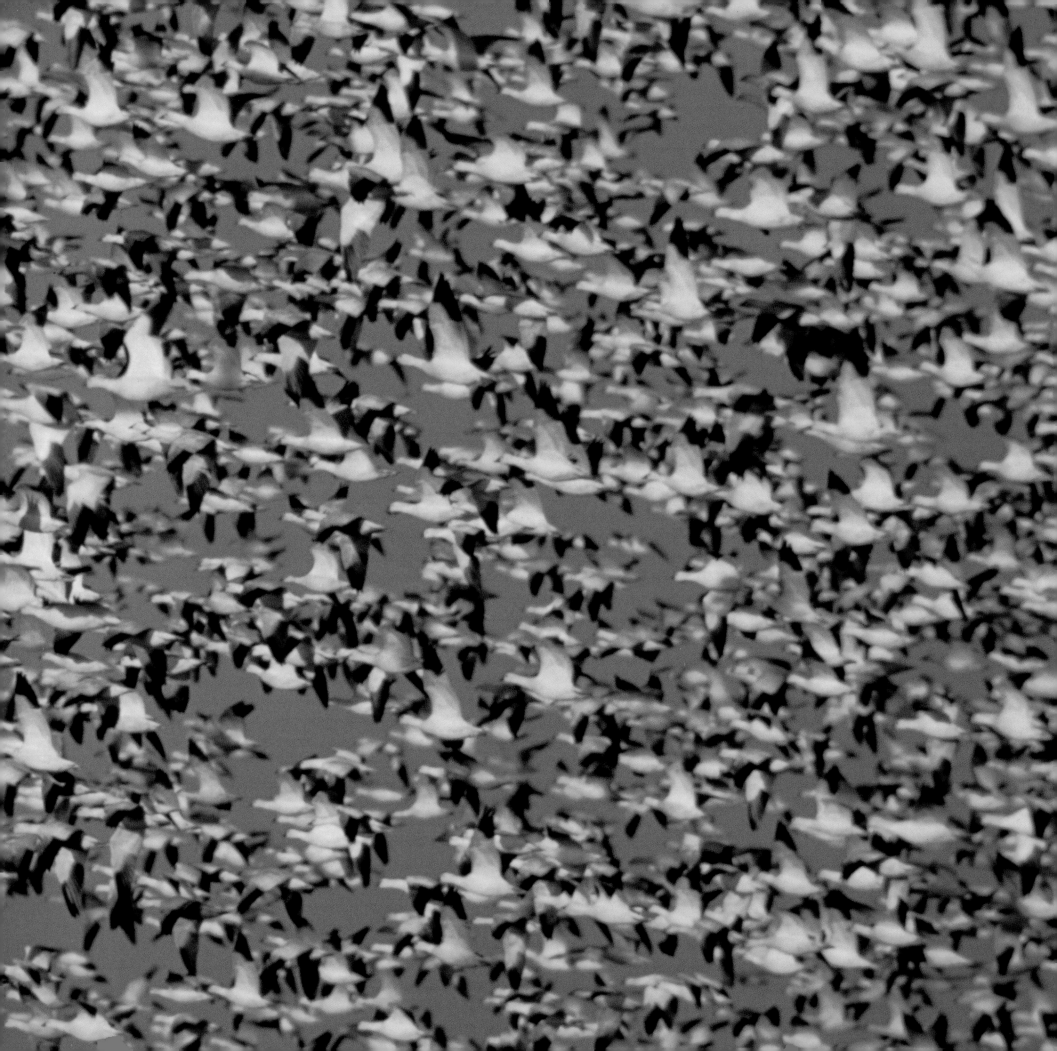

WATERFOWL

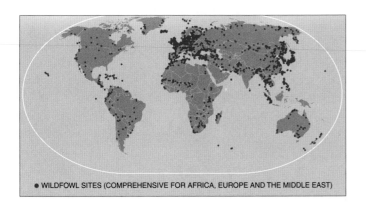

● WILDFOWL SITES (COMPREHENSIVE FOR AFRICA, EUROPE AND THE MIDDLE EAST)

Due to their large size and often approachable nature, waterfowl (ducks, geese, and swans) are among the most conspicuous bird species to form flocks. During the breeding season, some species (mainly geese and swans) nest colonially, but most disperse over wide areas to nest and rear their young. When not breeding, however, almost all waterfowl form flocks at favored passage and wintering sites, the notable exceptions being the few territorial riverine species. Migratory and wintering concentrations of waterfowl can number many thousands, sometimes millions, of individuals.

There are an estimated 140 to 185 million waterfowl in the world, comprising 461 biogeographical populations of 159 species: seven swans, 26 geese, and 126 ducks. Globally, by far the most numerous waterfowl species is the mallard (*Anas platyrhynchos*) (30 million birds). Other numerous species include snow goose (*Anser caerulescens*) (eight million), pintail (*Anas acuta*) (seven million), and long-tailed duck (*Clangula hyemalis*) (seven million). Geese are particularly known for their flocking behavior due to their reliance on a small number of safe night-time roost sites. In the Platte River Valley in central Nebraska, over three million geese (mainly snow geese) congregate each spring. Migrants from Arctic and temperate breeding grounds may form spectacular concentrations in tropical regions, for example garganey (*Anas querquedula*) and pintail form huge flocks with resident white-faced (*Dendrocygna viduata*) and fulvous (*D. bicolor*) whistling ducks in the Sahel region of Africa. By definition, globally threatened species are limited to a restricted number of sites. This is epitomized by the Critically Endangered Campbell Island teal (*Anas nesiotis*): the remaining 25 pairs survive on a single tiny rocky outcrop in the South Pacific.

Waterfowl congregations are found all over the world, but particularly in the northern hemisphere in North America, Central America, Europe, and East and Southeast Asia. Northern hemisphere waterfowl are largely migratory, with those breeding in Arctic and temperate regions migrating along well-established "flyways" to more southerly temperate and tropical non-breeding areas. En route, these birds congregate on relatively few crucial staging sites, where they replenish their energy reserves for migration. Southern hemisphere waterfowl species are largely sedentary or nomadic, their degree of flocking often being determined by the rainfall patterns and the subsequent availability of wetlands. For example, congregations of tens of

On the opposite page, a large flock of thousands of snow geese (Anser caerulescens) *wintering in Sacramento Valley National Wildlife Refuge, California.*
© Kevin Schafer

Above, Canada goose chick (Branta canadensis) *in Churchill, Manitoba. Northern Canada is one of America's most important nesting grounds for waterfowl.*

On pp. 178-179, mallards (Anas platyrhynchos) *and northern pintails* (Anas acuta) *in the Bosque del Apache, New Mexico. The mallard is by far the most numerous wildfowl species with some 30 million individuals, and the northern pintail is also quite widespread and abundant, totaling some seven million birds. Both photos,*
© Arthur Morris/BIRDS AS ART

177

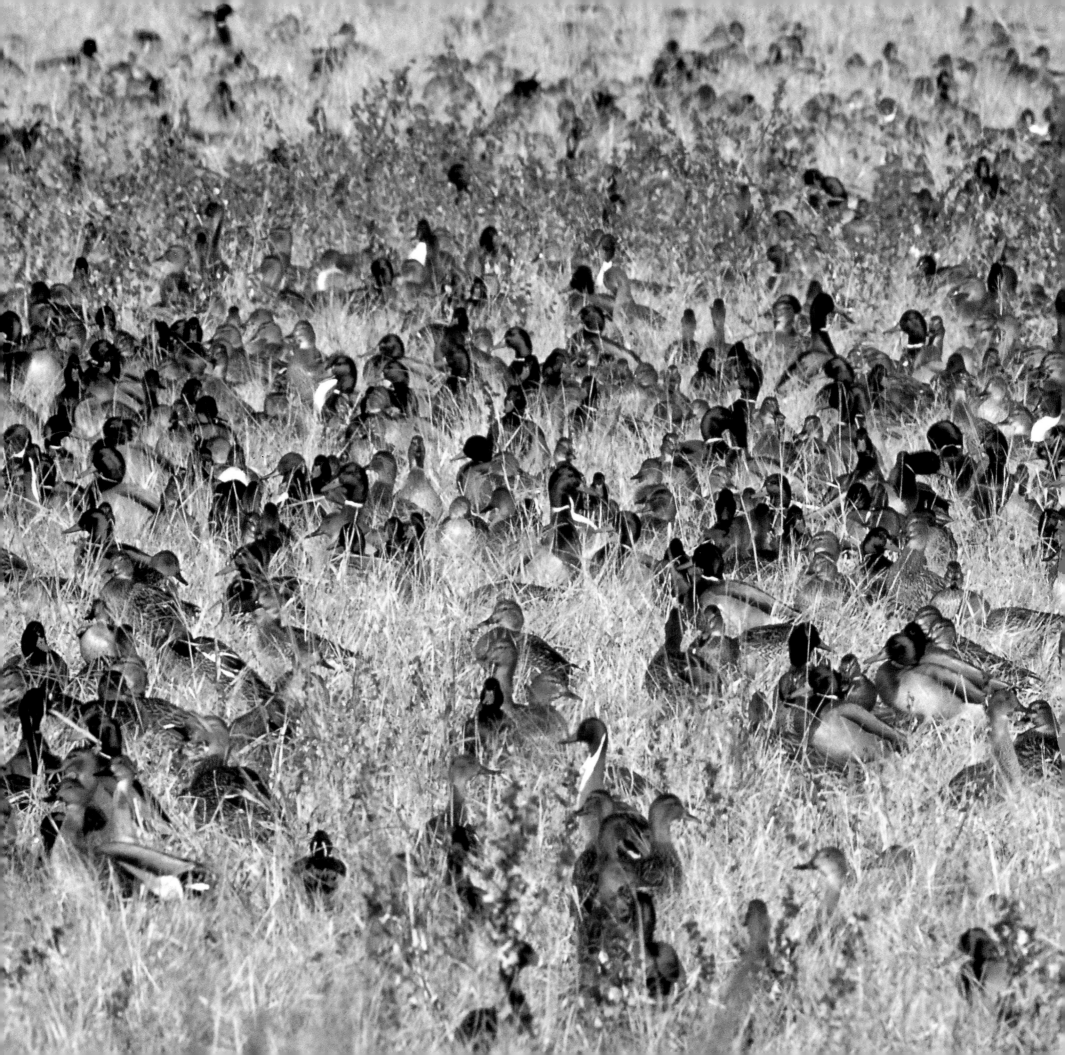

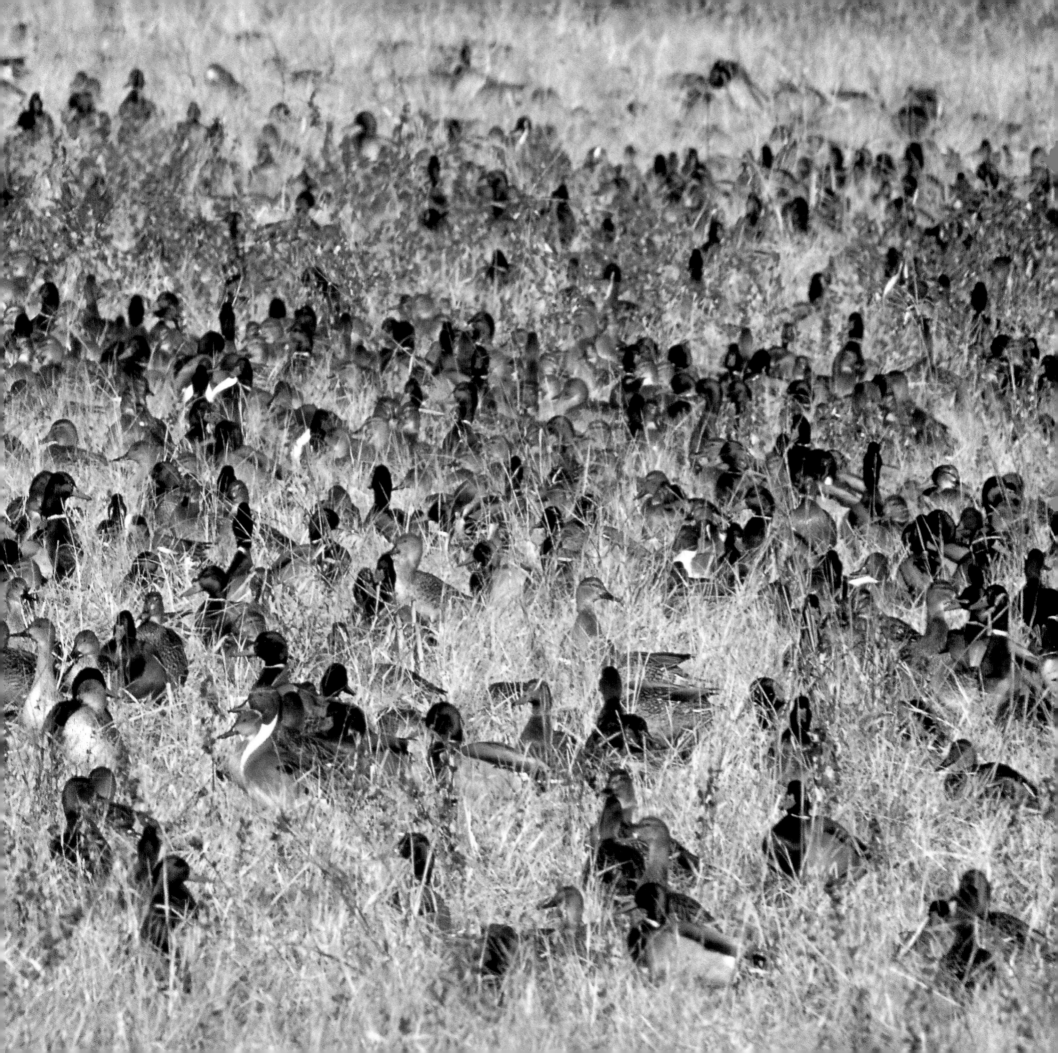

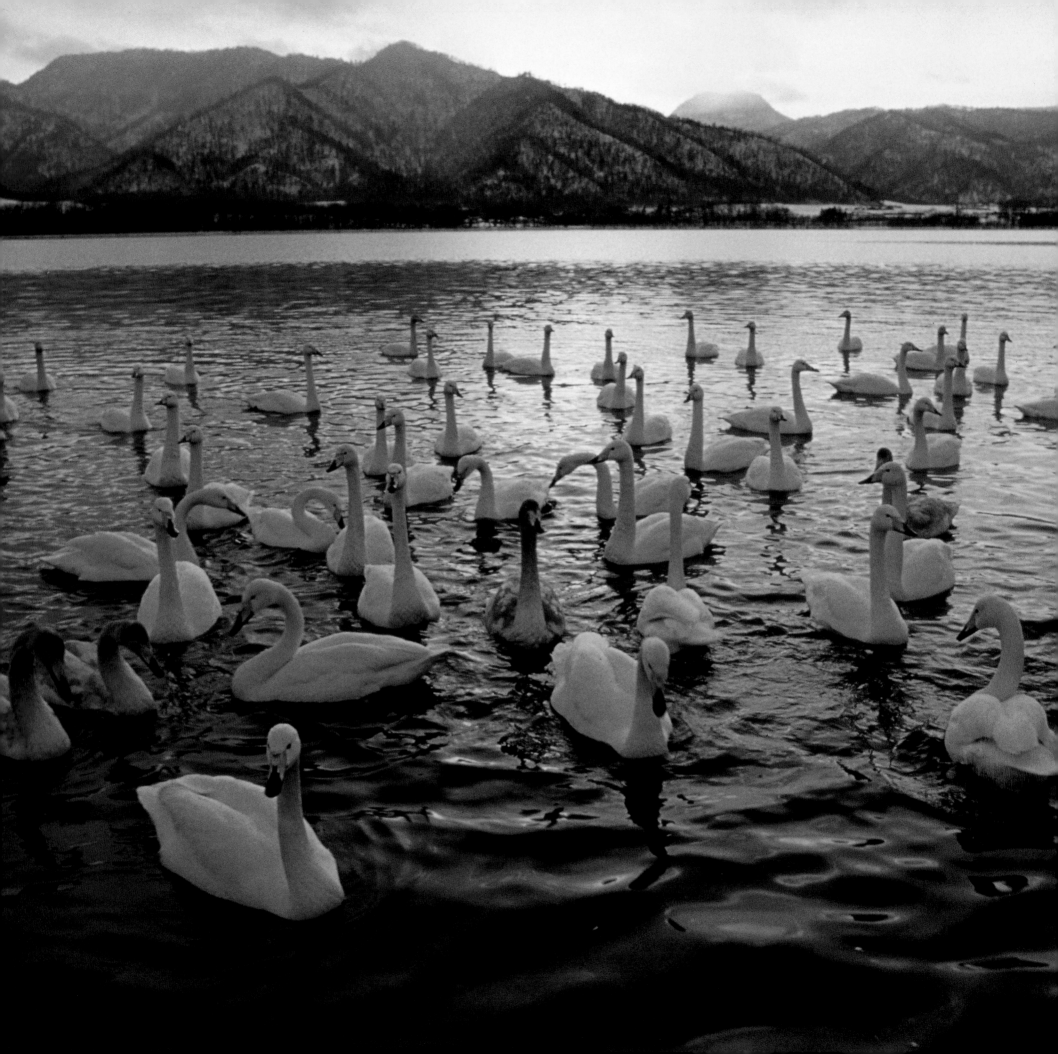

thousands of black swans (*Cygnus atratus*) are found at lakes Cowal, Brewster, and George in Australia. The largest waterfowl congregations are non-breeding flocks on lakes and estuaries, although huge concentrations also occur in marine habitats. Sea ducks are especially known for such large offshore concentrations. For example, in winter 1992, a single flock of common scoters (*Melanitta nigra*) in the Danish Kattegat comprised 600 000 birds. In 1995, approximately 150 000 spectacled eiders (*Somateria fischeri*), virtually the whole known world population, were found in holes in the Bering Sea pack ice, midway between Alaska and Russia.

Waterfowl congregate for many reasons, but mainly as an anti-predator response and because of the concentrated nature of their food resources. Geese flock to the safety of their night-time roosts on lakes and estuaries, at which they arrive in large skeins around dusk. Large waterfowl concentrations also occur at preferred feeding sites. Examples include geese feeding on agricultural areas, and sea ducks congregating over mussel beds. Immediately after breeding, most waterfowl moult and become flightless. Many species of waterfowl, therefore, undergo moult migrations to safe food-rich havens free of predators and people. For example, most of the northwest European population of 300 000 common shelducks (*Tadorna tadorna*) congregate to moult in the vast, inaccessible mudflats of the German Wadden Sea. Congregation may allow waterfowl to exploit better feeding opportunities, either by individuals following each other to the best food resources or through cooperative feeding activities.

The main threats to waterfowl are habitat loss and over-hunting, and the effect of both these factors is exacerbated by their tendency to flock. Waterfowl have long supported subsistence hunting by humans, and still form a vital component of the diet in many cultures. The tendency of the Baikal teal (*Anas formosa*) to form huge flocks makes it extremely susceptible to hunting. Three men operating six throw-nets on a pond in Japan took 50 000 birds over a 20-day period in 1947. Climate change is expected to affect millions of waterfowl by the succession of vegetation from open tundra to unsuitable forest habitats. Oil spills from tankers which have run aground regularly kill tens of thousands of birds, especially sea ducks. Waterfowl concentrations also facilitate the rapid spread of infectious diseases. In North America, more than a million deaths from avian botulism have been reported in a single year, and die-offs of 50 000 birds or more are relatively common. In the U.S., annual losses from lead poisoning from spent shotgun cartridges were estimated at 1.6-2.4 million waterfowl prior to the 1991 ban on lead shot.

Flocking has both costs and benefits in conservation terms. Congregation can be a great threat if site protection is inadequate. Up to 60% of the world's red-breasted goose (*Branta ruficollis*) population roosts on two sites in Bulgaria (Shabla and Durankulak Lakes) which suffer significant, often unregulated, hunting pressure. In recent decades, many waterfowl (especially geese) have concentrated their feeding activities on agricultural crops. Some species, such as mallard and Canada goose (*B. canadensis*), have also increased in areas frequented by humans. Damage by waterfowl to agriculture and amenity land is therefore a worldwide conservation issue. Large waterfowl concentrations can also have a biological effect —sometimes on the waterfowl populations themselves. The lesser snow goose, which numbers some 4-6 million individuals, is now destroying its own breeding grounds through overgrazing. This is a dilemma for conservationists, who now seek to increase hunting bags to halve the population by 2005. In extreme cases, high waterfowl concentrations can cause loss of human life, mainly through collisions with aircraft. There are also huge potential conservation benefits of congregation, though. If the political will to protect key sites exists, then large numbers, often of many species simultaneously, can be protected in a relatively small area. In regions where climate is capricious (such as much of Australia), waterfowl congregations are much less predictable and a far greater network of waterbodies needs protection. For the rest of the world, however, protected site networks now exist along most international waterfowl flyways, much increasing the probability that not just individual waterfowl species but also the phenomenal congregations of individual ducks, geese, and swans will persist into the future.

Baz Hughes
Simon Delany
Carlos Manterola
Martin Sneary
John Woinarski

On the opposite page, whooper swans (Cygnus cygnus) on the island of Hokkaido, Japan. Perhaps 60% of the global population is thought to winter in the western Palearctic, with significant concentrations in Japan, South Korea, and Turkmenistan.
© Art Wolfe

Above, barnacle goose (Branta leucopsis) pairs have from four to five goslings from May to June, Svalbard, Norway.
© Patricio Robles Gil/ Sierra Madre

Magpie geese
(Anseranus semipalmata)
flock to the Alligator River
Floodplains in Kakadu National Park,
Northern Territory, Australia,
at the end of the dry season.
Magpie geese in the wetlands
of Papua on the island
of New Guinea are known
to form concentrations of
up to 10 000 birds.
© Jean-Paul Ferrero/ARDEA LONDON

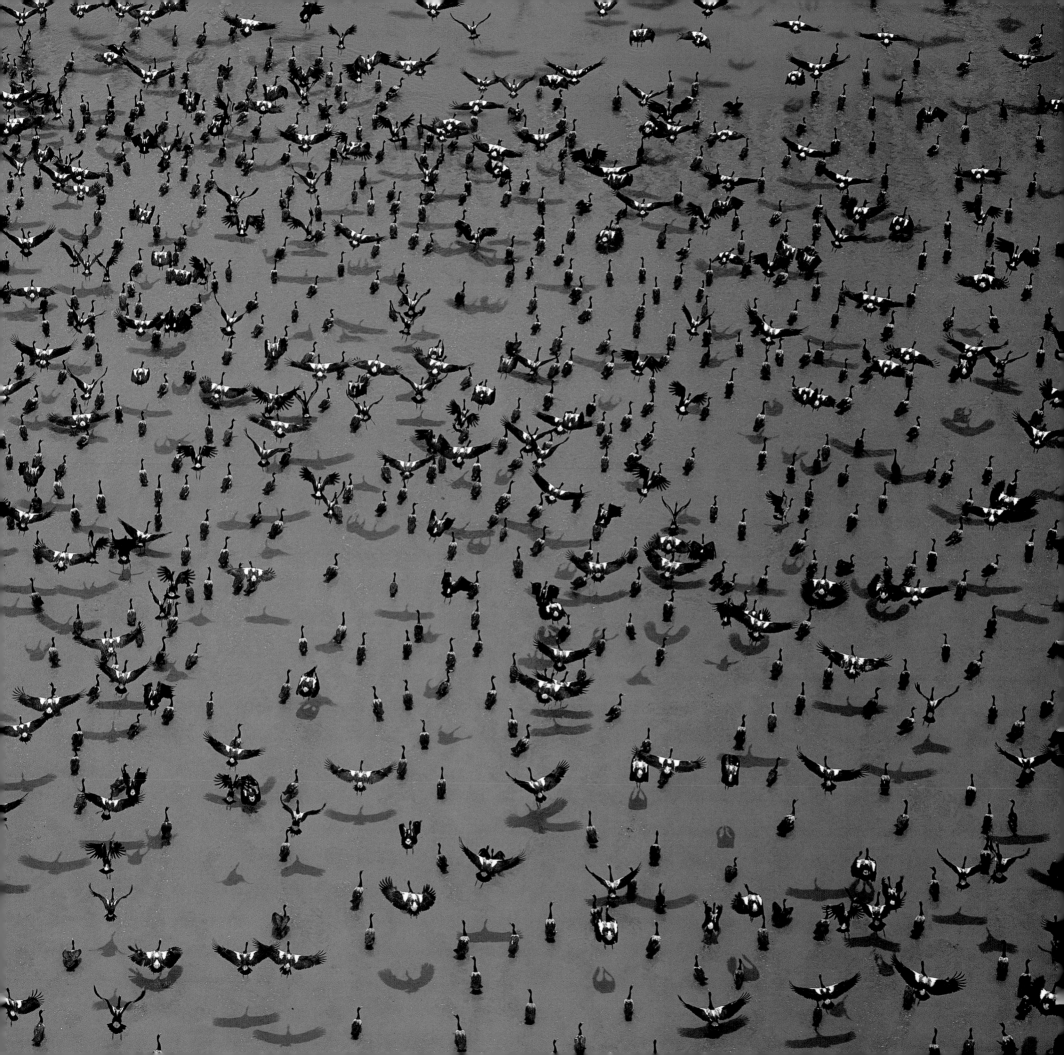

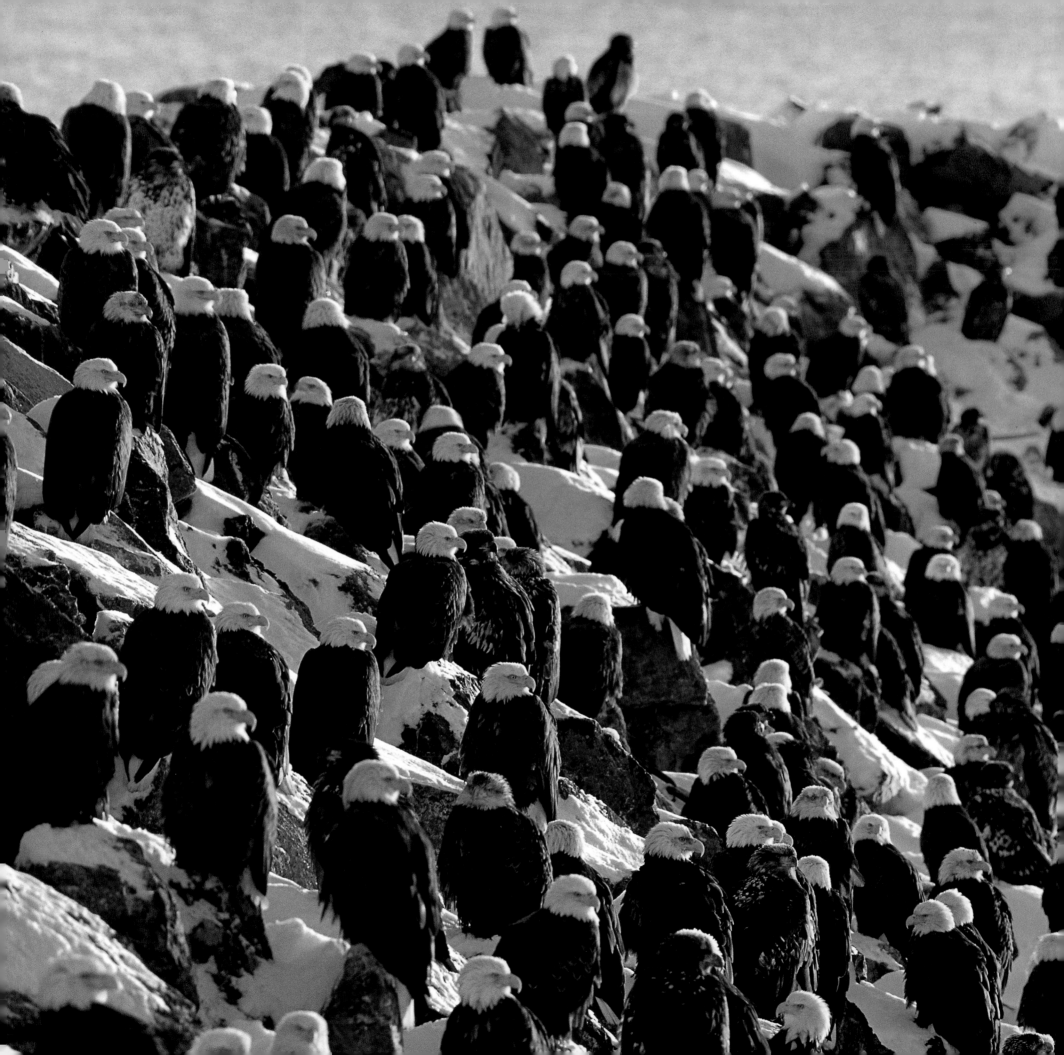

RAPTORS

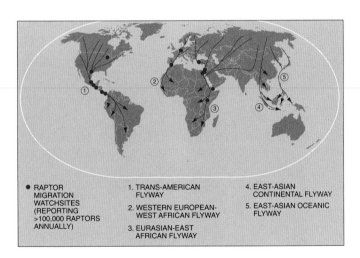

● RAPTOR
MIGRATION
WATCHSITES
(REPORTING
>100,000 RAPTORS
ANNUALLY)

1. TRANS-AMERICAN
FLYWAY

2. WESTERN EUROPEAN-
WEST AFRICAN FLYWAY

3. EURASIAN-EAST
AFRICAN FLYWAY

4. EAST-ASIAN
CONTINENTAL FLYWAY

5. EAST-ASIAN OCEANIC
FLYWAY

Diurnal raptors (Falconiformes), represent a diverse group of 300 species of highly mobile, land-based predators that occur across a range of habitats on six continents and numerous islands. Most exist at the tops of food chains, and their populations are particularly sensitive to changes in ecosystem function, quality, and energy flow. Wide-ranging and secretive, raptors are difficult to survey and monitor. Each year millions of raptors embark upon long-distance, sometimes intercontinental migrations. They do so —as do most birds— to avoid periods of food scarcity and severe weather. Although many travel across broad fronts, others aggregate along established flyways where geography and weather create conditions along so-called "leading lines" that provide updrafts or thermals upon which raptors can soar at low energetic cost. Flocking helps individuals find energy-saving thermals and updrafts more quickly, and enormous aggregations of as many as hundreds of thousands of raptors predictably appear along mountain ridges, coastal plains, isthmuses, and peninsulas. These huge assemblages present conservationists with the opportunity to monitor continental populations of raptors. They also provide enthusiasts with the chance to enjoy the migration spectacle.

Raptors congregate in large numbers for different reasons. Before migration the swallow-tailed kite (*Elanoides forficatus forficatus*) concentrates in large communal roosting sites in the Big Cypress National Preserve in Florida. Rough estimates suggest that 1 800 to 3 100 birds do so annually after breeding. These concentrations, which are thought to be a response to feeding demands prior to migration, probably include only birds from Florida.

Wintering bald eagles (*Haliaeetus leucocephalus*) congregate in different regions of Oregon (the Bear Valley National Wildlife Refuge), Washington (Nooksack River), and Alaska (Alaska Chilkat Bald Eagle Preserve). The last site offers the most impressive concentrations of this species in the world. Each autumn and winter as many as 3 000 eagles gather along in a six-kilometer stretch of the Chilkat River north of Haines, Alaska to feed on a late run of salmon. Bald eagles often roost together in small areas that protect them from cold weather, but these large aggregations also may have a social function in that younger eagles have a chance to observe and emulate the successful foraging strategies of mature eagles.

New World vultures including black (*Coragyps atratus*) and turkey vultures (*Cathartes aura*) regularly concentrate at traditional communal roosts. This behavior serves as a communication center for vultures searching for new sources of carrion, as well as to protect the birds from predators.

Half of the world's raptors migrate regularly. Africa has at least 61 species, Asia 66, Australia 11, Europe 38, Central and

Every fall, up to 3 000 bald eagles
(Haliaeetus leucocephalus)
*congregate on the banks
of the Chilkat River to feed on
spawned-out salmon.
Here, a huge concentration of
eagles at Homer, Alaska.
Both photos,* © Norbert Rosing

South America 33, and the Pacific Islands 29. Thirteen of these species flock by the thousands while migrating. Most super-flocking species are long-distance, trans-equatorial migrants that travel along five global flyways, reaching their greatest concentrations in and around the tropics. Species include turkey vulture (*Cathartes aura*), with a reported maximum flock size of >50 000; Mississippi kite (*Ictinia mississippiensis*) (>1 000); broad-winged hawk (*Buteo platypterus*) (>50 000); Swainson's hawk (*B. swainsoni*) (>50 000); Old World western honey buzzard (*Pernis apivorus*) (>5 000); black kite (*Milvus migrans*) (>1 000); gray-faced buzzard (*Butastur indicus*) (>1 000); Levant sparrowhawk (*Accipiter brevipes*) (>5 000); Chinese goshawk (*A. soloensis*) (>10 000); steppe buzzard (*Buteo vulpinus*) (5 000); lesser kestrel (*Falco naumanni*) (>1 000); Western red-footed falcon (*F. vespertinus*) (>1 000); and eastern red-footed falcon (*F. amurensis*) (>1 000).

More than 100 raptor migration watchsites report movements of >10 000 migrants annually; 18 passage >100 000 migrants; and three counts of >one million. With a springtime average of >half million raptors and an autumn average of >two million, Pronatura-Veracruz River-of-Raptors watchsites in Cardel and Chichicaxtle, Veracruz, Mexico, are the world's most concentrated migration hotspots for raptors. Two thousand kilometers southeast in Caribbean slope Talamanca, Costa Rica, Asociación ANAI's watchsite in the Kéköldi Reserve near Puerto Viejo de Limón, also reports full-season counts of >two million raptors. There also are partial-season counts of >half a million raptors at Ancon Hill, Panama City. All three watchsites are along the Mesoamerican Land Corridor, along which more than five million North American breeding birds of prey migrate between North and South America each spring and autumn. This 32-species flight is dominated by western North American populations of turkey vultures (>1.5 million individuals), and world populations of Mississippi kites (>100 000), broad-winged hawks (>1 million), and Swainson's hawks (>0.5 million).

In the Old World, significant concentration points include the Strait of Gibraltar in Tarifa, Spain (>100 000 individuals representing 17 species annually); the Bosporus at Istanbul, Turkey, in the eastern Mediterranean (>50 000 individuals, 29 species), and Elat, in southernmost Israel (occasionally >1 million northbound migrants) (20 species). Five species —black kite, Western honey buzzard, Levant sparrowhawk, steppe buzzard, and lesser spotted eagle (*Aquila pomarina*)— pass in numbers representing >1% to >>50% of world population migrants at one or more of these sites.

Farther east, more than one million raptors travel along a 7 000-km system of corridors that stretches from eastern Siberia to peninsular Southeast Asia, and beyond to the Indonesian archipelago. The 33-species flight is dominated by crested honey buzzards (*Pernis ptilorhynchus*), grey-faced buzzards, Chinese goshawks, and Japanese sparrowhawks (*Accipiter gularis*). The most important concentration point along the flyway is Tanjung Tuan (Cape Rachado), 80 km south of Kuala Lumpur at the closest point in the Malaysian Peninsula to Sumatra, where thousands of crested honey buzzards (>1% of the world population) are seen each autumn. Farther east still, Beidaihe, on the Bay of Bohai in northeastern China some 280 km east of Beijing, reports >10 000 migrants, representing 21 species, including 6 000 pied harriers (*Circus melanoleucus*), or >5% of the world population.

More than half a million raptors representing 19 species migrate along the mainly over-water East-Asian Oceanic Flyway. The flight is dominated by grey-faced buzzards and Chinese goshawks. Important concentration points include Uchiyama-toge, near Nagasaki Japan, where more than 400 000 Chinese goshawks (>>50% of the world population) were counted in September 1999; and along the southeastern part of the Heng-ch'un Peninsula, in Kenting, southern Taiwan, where 45 000 raptors, including thousands of grey-faced buzzards and tens of thousands of Chinese goshawks, are seen departing for the Philippines each autumn.

Viewed as rapacious and cruel by some and as competitors for game and domestic animals by others, raptors have long been persecuted by people. They also have suffered indirectly from other human actions and the large-scale loss of habitat. Indeed, populations of two-thirds of all species of migratory raptors are threatened, either by habitat loss, environmental contaminants including pesticides, trapping and shooting, or combinations of these. Entire populations of eight species of regular migrants are currently considered globally Threatened by IUCN.

Efforts at well-established migration watchsites indicate that regional and even continental and world populations of raptors can be monitored at these locations. Regionally, watchsites such as these and others along "tributaries" to major migration corridors and flyways can be used to identify critical habitats for migratory species. Locally, watchsites can be used to introduce and build support among local peoples for these charismatic birds, which, in turn, can become flagships for broader conservation issues. The conservation history of the world's oldest continually active watchsite, Hawk Mountain Sanctuary in eastern Pennsylvania, offers one of many examples of how this can happen.

KEITH L. BILDSTEIN
EDUARDO ÍÑIGO-ELÍAS

Above, immature Swainson's hawk (Buteo swainsoni). *This is one of the super-flocking migrant raptor species, with maximum flock sizes of 50 000 individuals.*
© Patricio Robles Gil/Sierra Madre

On the opposite page, swarm of broad-winged hawks (Buteo platypterus), *Ancon Hill, Panama.*
© Neal G. Smith/VIREO

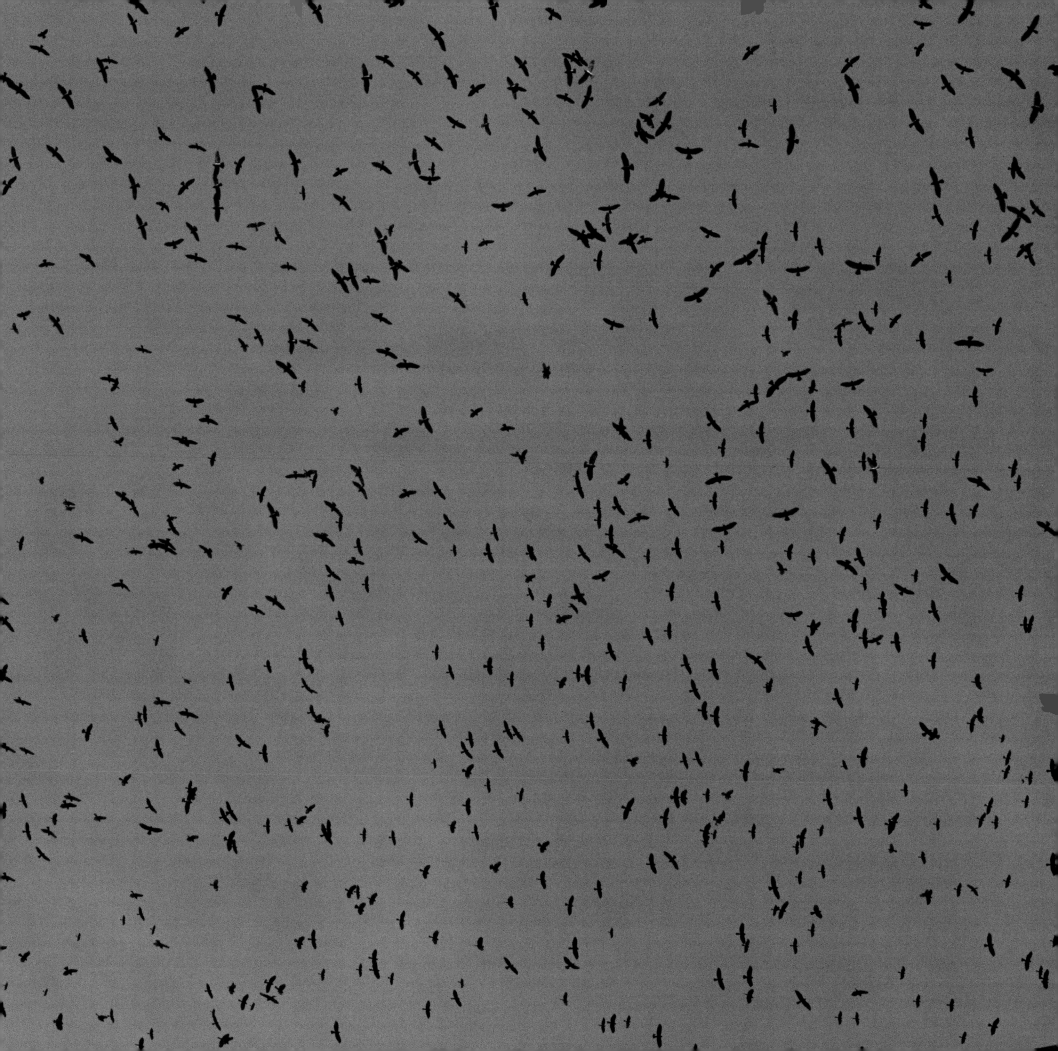

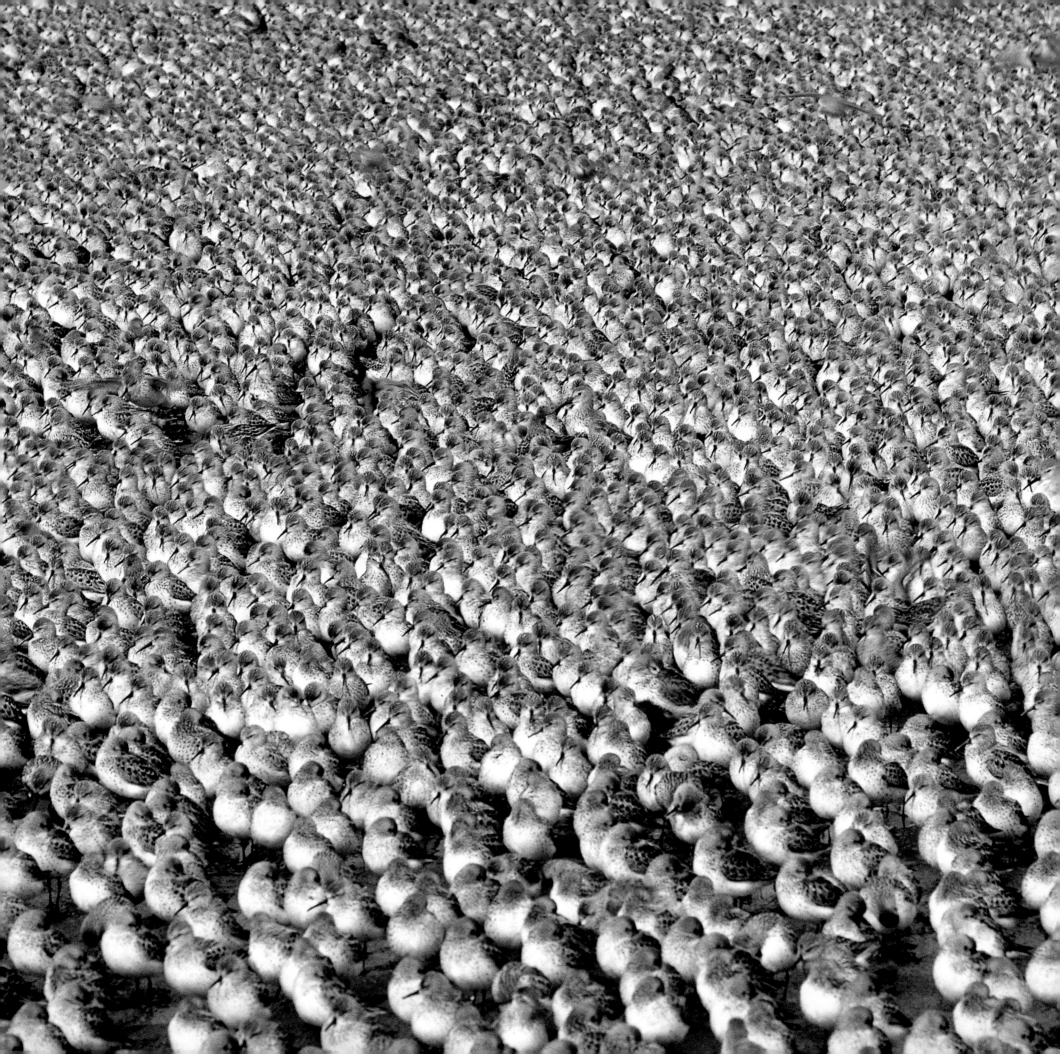

SHOREBIRDS

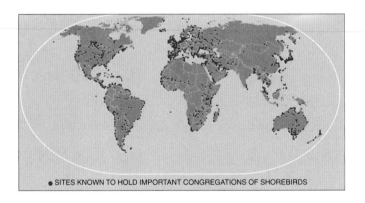

● SITES KNOWN TO HOLD IMPORTANT CONGREGATIONS OF SHOREBIRDS

Shorebirds (or waders) are cosmopolitan species and include some of the most beautiful and spectacular creatures alive. The 215 recent species are subdivided into 12 families. The jacanas (Jacanidae; 8 species) are confined primarily to the tropics and are characterized by greatly elongated toes to spread their weight when walking on floating vegetation (a habit that earns them their popular name "lily-trotters"). The large-eyed, crepuscular painted snipes (Rostratulidae) comprise just two species, one each in the Old and New Worlds. Meanwhile, three species of shorebirds are so distinct that they are placed in families of their own: the peculiar crab plover (Dromadidae) found only on the coasts of the Indian Ocean; the bizarre ibisbill (Ibidorhynchidae) confined to the bleak mountain rivers of Central Asia; and the enigmatic plains-wanderer (Pedionomidae) limited to the lowland grassland of east Australia. Another unusual family is the seedsnipes (Thinocoridae; 4 species), which inhabit grassland, semidesert, and alpine habitats within South America.

The more familiar shorebirds are the oystercatchers (Haematopodidae; 11 species); stilts and avocets (Recurvirostridae; 7 species); thick-knees (Burhinidae; 9 species); coursers and pratincoles (Glareolidae; 17 species); plovers (Charadriidae; 67 species); and sandpipers, snipes and phalaropes (Scolopacidae; 87 species). These shorebirds inhabit every continent, except Antarctica, and include some of the world's greatest migrants. Traveling from the high Arctic to the southern limits of Australasia, Africa, and South America, many cover more than 20 000 km each year. It is these migratory species that tend to congregate in spectacular fashion on their passage and winter quarters, swarming over the beaches, marshes, mudflats, plains, and tundras of the world.

There are eight major "flyways" used by migratory waders across the world. Flyways are the migration routes and areas used by waders in moving between their northern breeding grounds and southern wintering sites. Remarkably, five shorebird species are so widely distributed that they can be seen commuting along any of the eight major flyways: grey plover (*Pluvialis squatarola*), whimbrel (*Numenius phaeopus*), ruddy turnstone (*Arenaria interpres*), sanderling (*Calidris alba*) and dunlin (*C. alpina*). At the other end of the scale, some species can only be seen within single flyways, such as black turnstone (*Arenaria melanocephala*) and surfbird (*Aphriza virgata*) within the Pacific Flyway, and sociable plover (*Vanellus gregarius*), white-tailed plover (*V. leucurus*), and Caspian plover (*Charadrius asiaticus*) along the West Asia/Africa Flyway. The East Asia/Australasia Flyway holds probably the most distinct shore-

Western sandpipers (Calidris mauri) *concentrate in big numbers during their annual migration routes. The world-famous Copper River Delta in Alaska may harbor the entire world population of breeding western sandpipers. Opposite,* © Stuart Westmorland; *above,* © Patricio Robles Gil/ Sierra Madre

bird community, including oriental plover (*C. veredus*), little curlew (*Numenius minutus*), bristle-thighed curlew (*N. tahitiensis*), Far Eastern curlew (*N. madagascariensis*), grey-tailed tattler (*Heteroscelus brevipes*), and sharp-tailed sandpiper (*Calidris acuminata*).

The sites at which shorebirds congregate are concentrated along the coastal regions of temperate and tropical latitudes, though there are also many important sites inland. One of the most spectacular concentrations of shorebirds in the world occurs at Copper River Delta (Alaska, U.S.A.) in spring, where up to five million shorebirds gather together, including 60%-80% of the world population of western sandpiper (*Calidris mauri*) and most of the dunlin (*C. alpina*) within the Pacific Flyway. A lot further south lie the coastal wetlands of Wia-Wia (Surinam) where over two million shorebirds winter, mostly semipalmated sandpiper (*C. pusilla*). The African counterpart of Wia-Wia, 4 000 km across the Atlantic, is Banc d'Arguin National Park (Mauritania), where 2 250 000 shorebirds winter (a staggering 30% of all shorebirds in the East Atlantic Flyway!). While many sites holding large shorebird congregations are apparently concentrated in Western Europe, this is largely an artifact of good data availability; in contrast, the apparent paucity of sites in Central Asia is due to a current lack of site-specific shorebird data.

The largest congregations of shorebirds occur during their non-breeding season on the mudflats of coastal estuaries. These are amongst the most productive habitats on the planet and provide a plentiful supply of invertebrate food. The birds spend about eight or nine months on the mudflats, where they molt their feathers and consume up to one-third of their body weight daily to build fat reserves for northward migration. Upon reaching their northern breeding grounds in the spring, invertebrate food will have begun to emerge, providing another plentiful supply of food for the summer.

The principal threats to shorebirds are conversion and drainage of wetland habitats for agriculture and aquaculture, human disturbance, overhunting and, with particular regard to endemics of islands, invasive alien species. Of the 215 shorebird species known from recent history, three certainly are extinct. The Canarian black oystercatcher (*Haematopus meadewaldoi*) was confined to the Canary Islands, where it seems to have become extinct in the 1940s owing to overharvesting of intertidal invertebrates and disturbance by people. The white-winged sandpiper (*Prosobonia ellisi*) is known only from two paintings, each based on a specimen (now lost) collected from Moorea, in the Society Islands (French Polynesia) during Cook's third voyage in 1777. Likewise, the Tahitian sandpiper (*P. leucoptera*) was endemic to Tahiti, also in the Society Islands. It is known from only one specimen, collected by Forster and painted by his son in 1773. Both these sandpipers probably lived along streams and were driven to exinction by introduced rats in the eighteenth century.

Of the remaining 212 species, 22 are threatened with extinction and a further 19 are near-threatened. In fact, the Eskimo curlew (*Numenius borealis*) and the Javanese lapwing (*Vanellus macropterus*) are both probably extinct already, since there have been no recent confirmed sightings of either despite extensive searches. The Eskimo curlew is known to have been a long-distant migrant, breeding in the Northwest Territories (Canada) and wintering in the southern cone of South America. The main cause of the decline almost certainly was massive habitat loss caused by the near total conversion of North American prairies to agriculture. The Javanese lapwing is known with certainty only from Java (Indonesia), from where the last record was in 1940. Its decline has been attributed to "merciless" hunting and trapping, and conversion of its habitat to aquaculture and agriculture.

The future survival of shorebirds is largely dependent on our ability to conserve the network of critical sites that they use during their annual cycle. To begin with, this requires the identification and documentation of the network, which is still in its infancy in some parts of the world. Subsequently, we need to put in place adequate conservation activities at each site, particularly the development and training of site support groups composed of local people, monitoring of threats and shorebird numbers, and the management and protection of habitat. Such actions are well developed and funded in some regions of our world, while in many other areas they are desperately lacking. Our ability to erase this imbalance will to a large extent determine how stunning future congregations of shorebirds will be.

DES CALLAGHAN

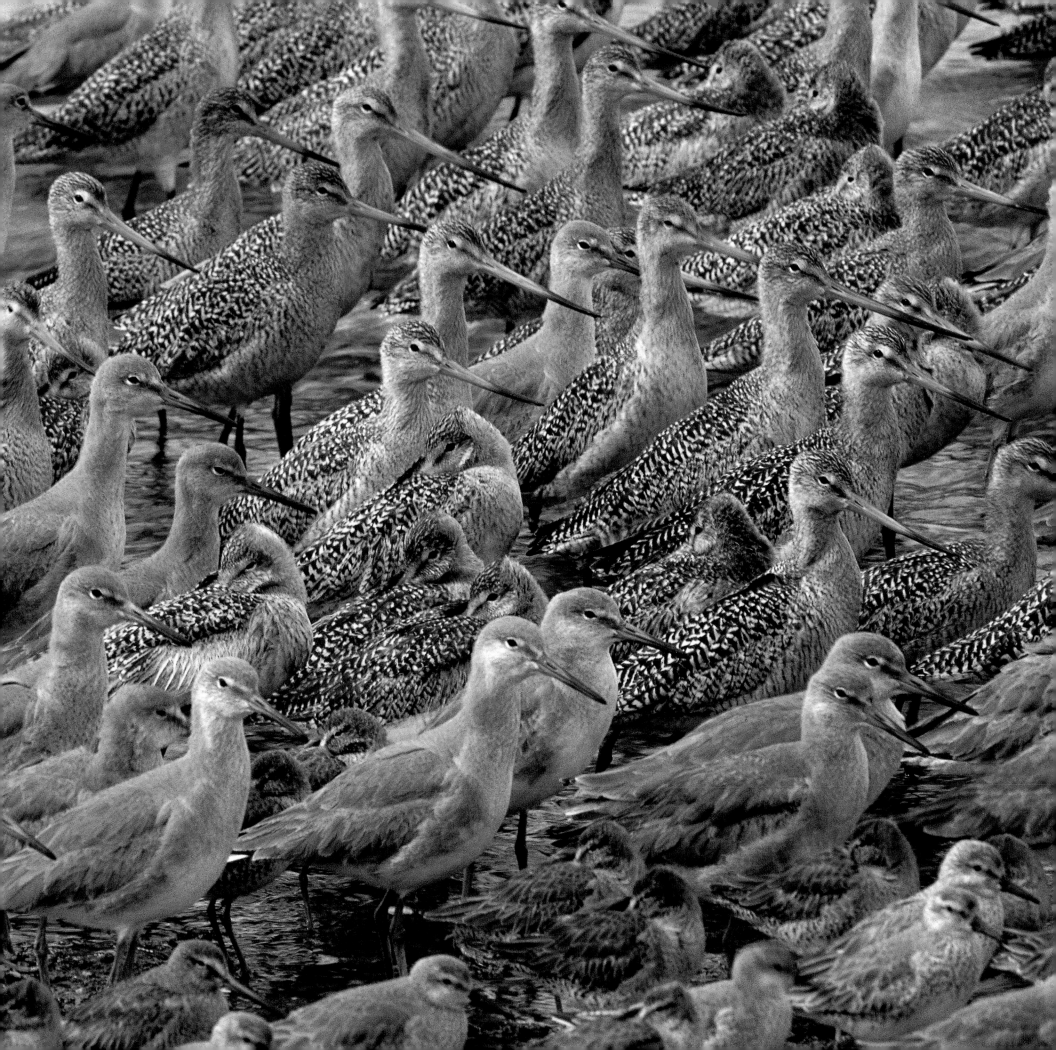

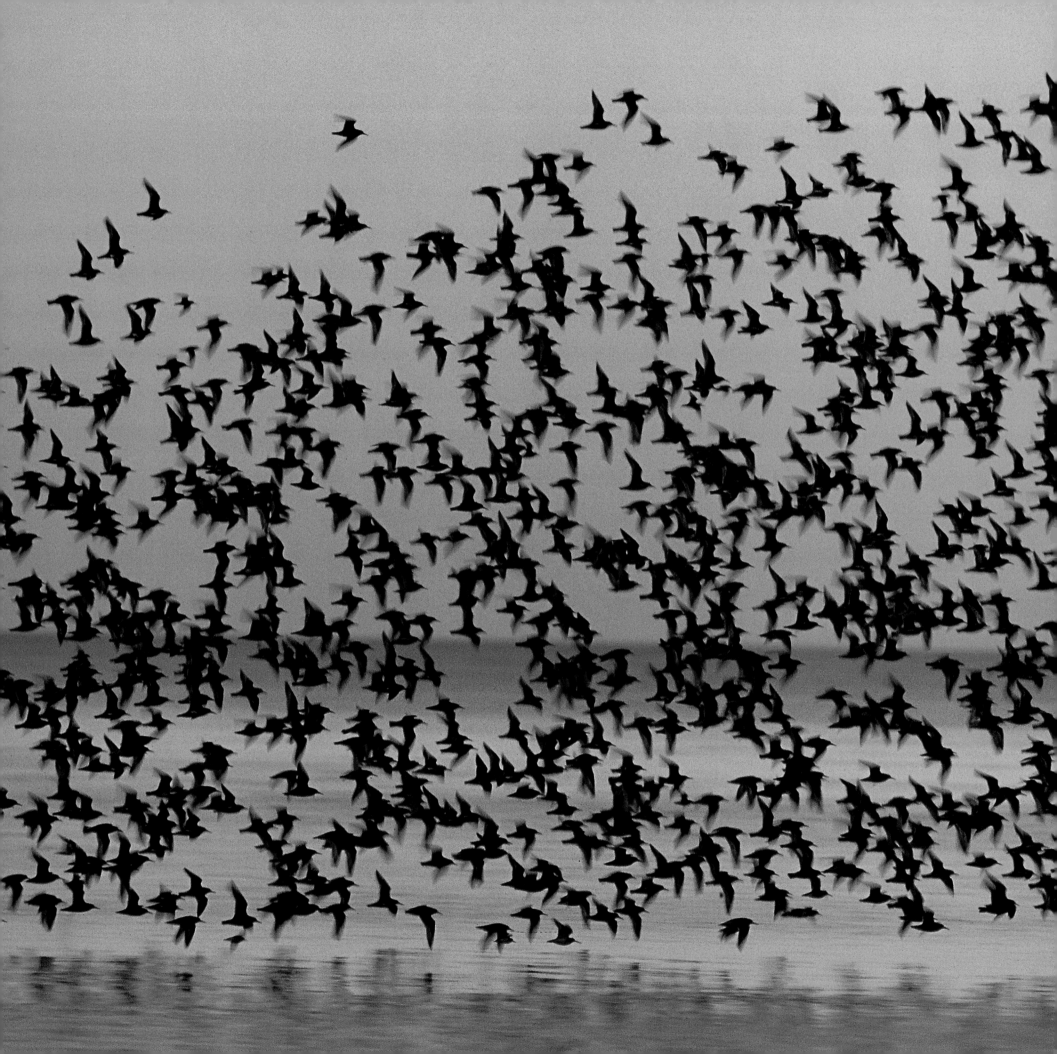

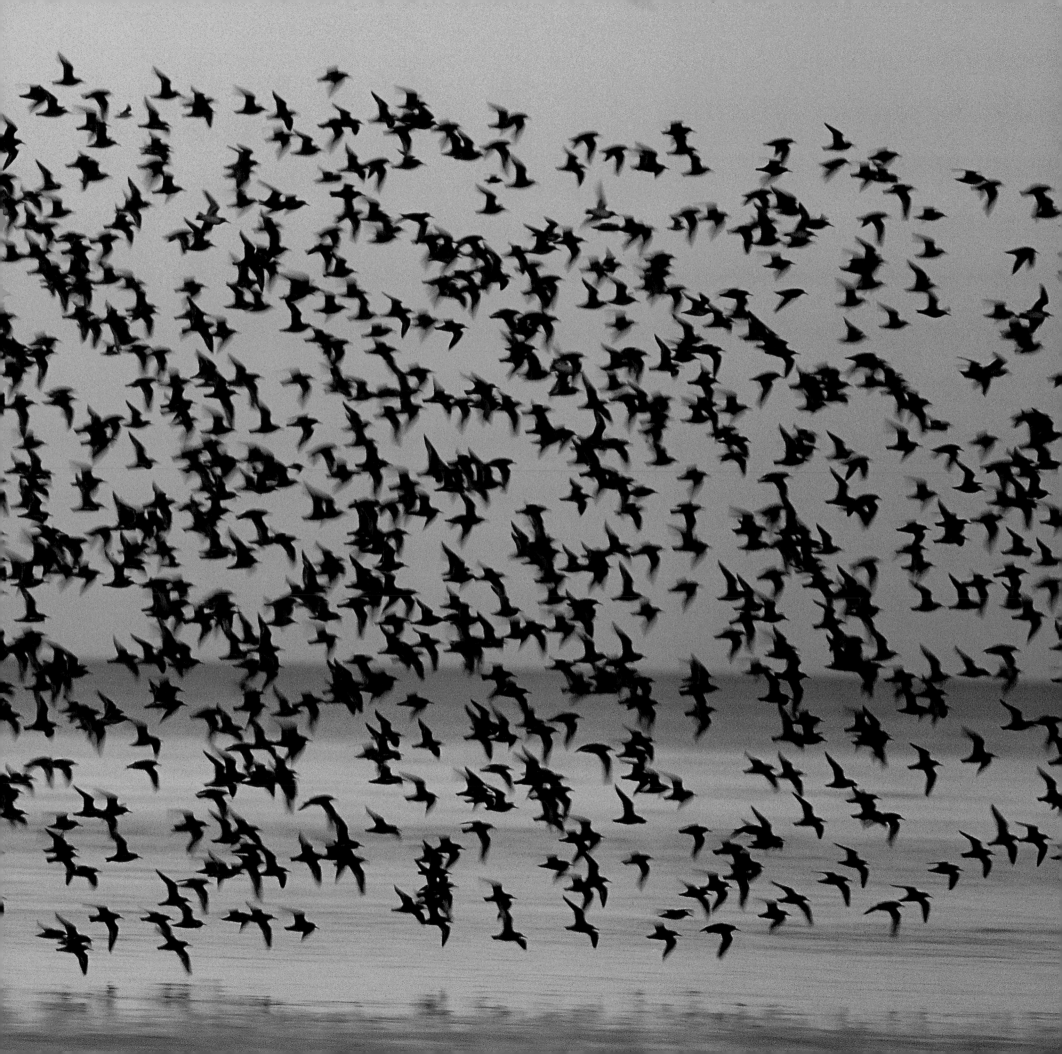

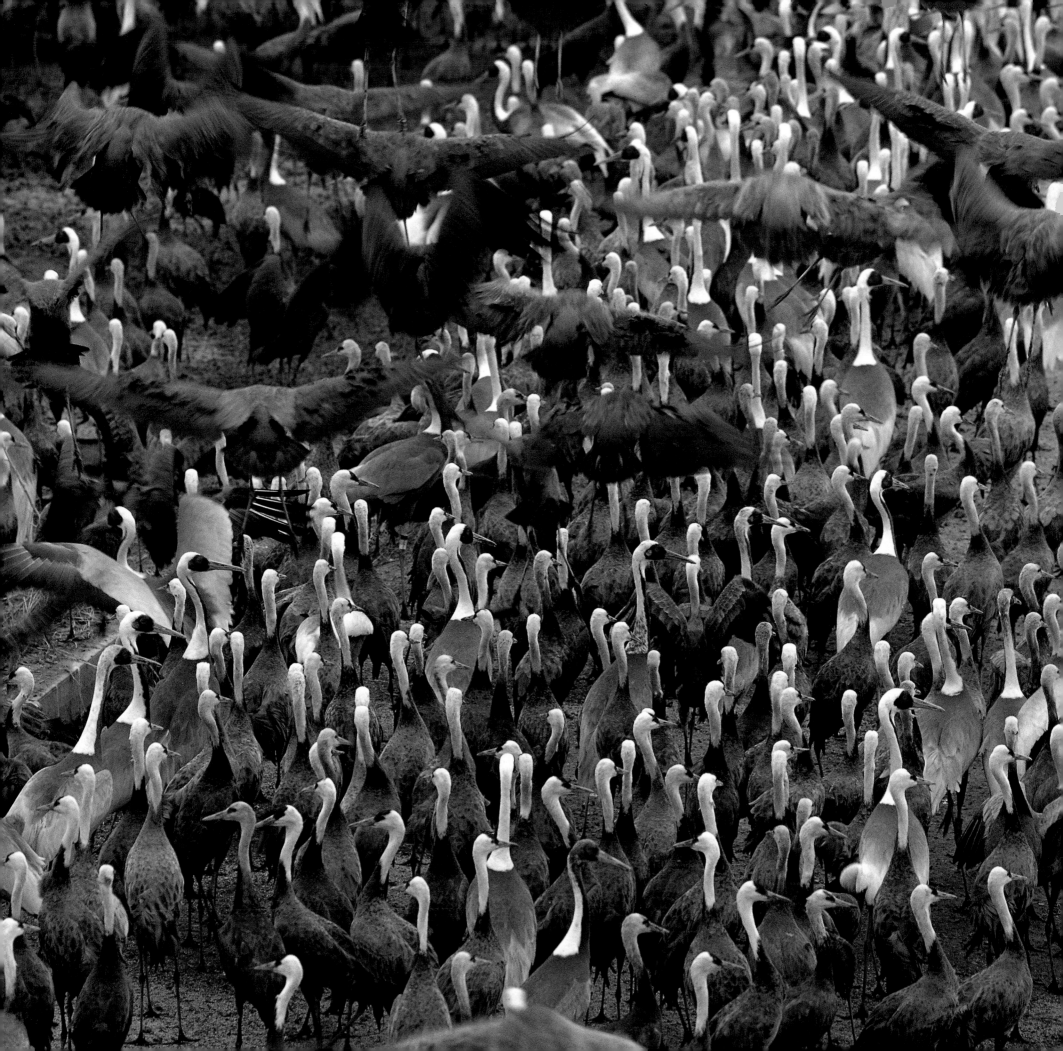

CRANES AND STORKS

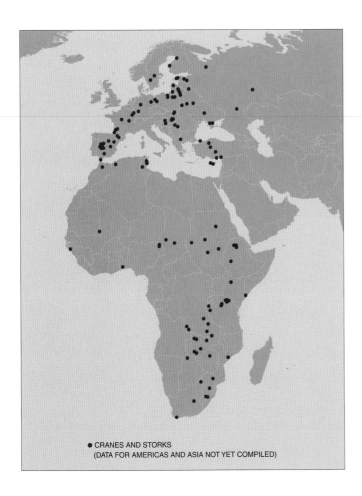

● CRANES AND STORKS
(DATA FOR AMERICAS AND ASIA NOT YET COMPILED)

Despite the similarity in appearance between cranes and storks, and the fact that both usually live in wetlands, the two arose from different ancestors and have quite different physical and behavioral traits. Cranes, of which there are 15 species, belong to the Family Gruidae; they have loud and complex calls, the mated pair remains together for many years, they build platform nests in wetlands, and their young are capable of following their parents soon after hatching. Storks, on the other hand, belong to the Family Ciconiidae, of which there are 19 species; adult storks are voiceless, the male and female storks only associate with one another at the nest, they usually nest in trees, and their young remain in the nest for several months until they are capable of flight.

Both families have near cosmopolitan distributions, although cranes are absent from the Neotropics and storks from most of North America. Both cranes and storks form sizeable colonies in areas of suitable habitat, and exhibit migratory tendencies in large flocks. Flocks of 1 000 or more wood storks (*Mycteria americana*) have been recorded on migration (the largest colony of this species —up to 10 000 pairs— occurs in Usumacinta Delta in southeastern Mexico) and flocks of some 10 000 Abdim's storks (*Ciconia abdimii*) are known to occur in Uganda and elsewhere. A number of sites in Eastern and Southern Europe hold globally significant breeding, passage or wintering congregations of the common crane (*Grus grus*) and white stork (*Ciconia ciconia*).

Both cranes and storks are closely associated with wetland habitats (although storks may occur in areas where water is scarce) and the survival of these long-legged birds, and particularly cranes, depends much on the welfare of wetlands. Two of the world's greatest wetlands, Poyang Lake in China and the Okavango Delta in Botswana, are critical to the welfare of cranes and storks. Poyang Lake lies in a pear-shaped depression that extends south of the middle reaches of the Yangtze River. Five rivers flow into Poyang Lake and in summer, when the Yangtze swells, the flow of water in the narrow neck that links Poyang to the Yangtze reverses direction to fill Poyang Lake to a water depth some 11 m higher than levels during the winter dry season. In autumn, as water levels drop, water again flows from Poyang Lake into the Yangtze. Vast expanses of mudflats appear and among them, shallow "winter" lakes remain. This mosaic of wetland habitats provides excellent winter habitat for about 3 000 Critically Endangered Siberian cranes (*Grus leucogeranus*) (90 per cent of the world population), 3 000 Vulnerable white-

On the opposite page, hooded cranes (Grus monacha) *and white-naped cranes* (Grus vipio) *wintering in the Arasaki Swamps, Kagoshima Prefecture, Kyushu, Japan. Most of the population of the hooded crane (about 8 000 birds) migrates from its breeding range in southeastern Russia and northern China to wintering grounds on Kyushu, where they are joined by some 2 000 migratory white-naped cranes.*
© Jean-Paul Ferrero/
ARDEA LONDON

Above, wood storks (Mycteria americana) *on Marajo Island, at the mouth of the Amazon in Brazil. Flocks of 1 000 or more wood storks have been recorded on migration, and the largest colony of this species —up to 10 000 pairs— occurs in Usumacinta Delta in southeastern Mexico.*
© Luiz Claudio Marigo

Demoiselle cranes (Anthropoides virgo)
on sand dunes in Rajasthan, India.
Although typically found in association
with savanna, steppe and other grassland
types, this species is known to inhabit
semidesert and true desert environments
in places where water is available.
© Bernard Castelein/naturepl.com

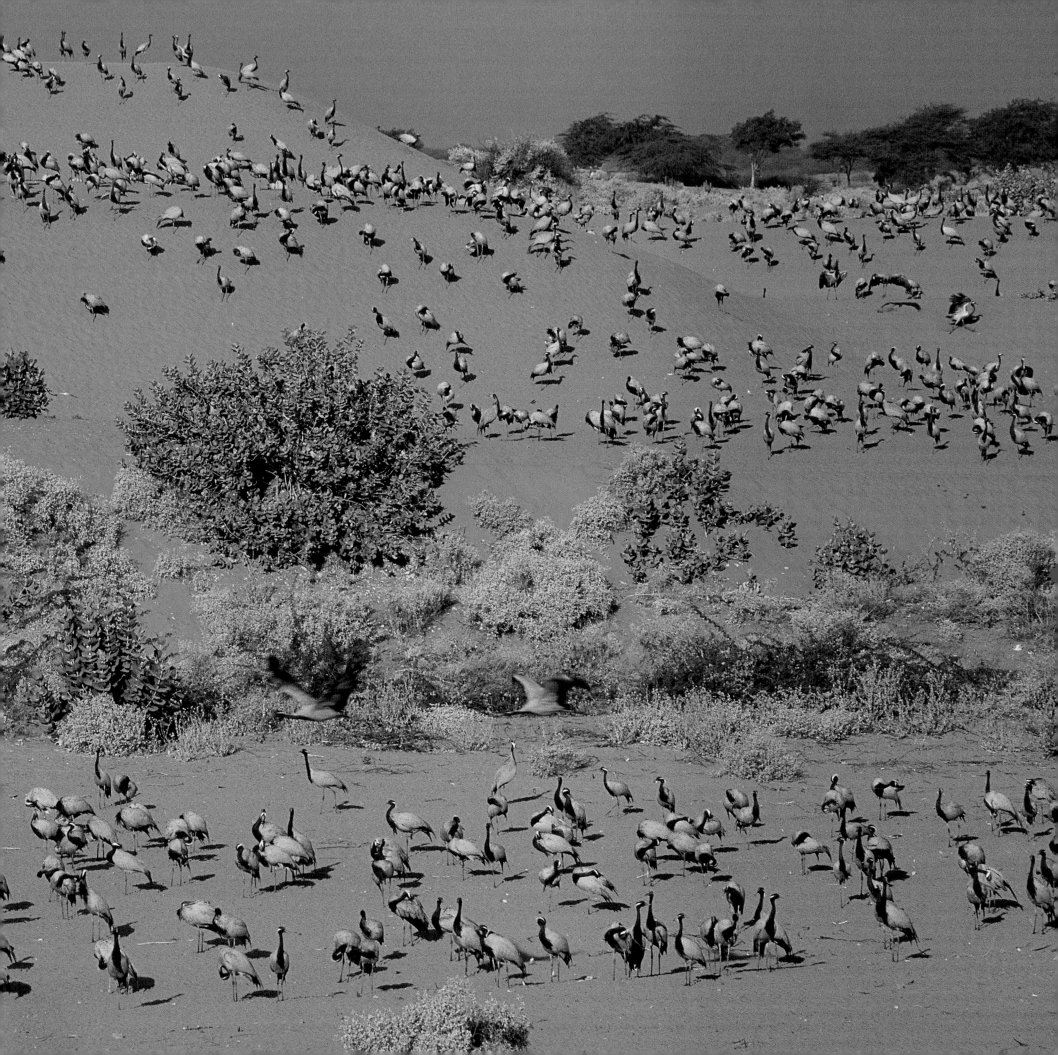

naped cranes (*G. vipio*) (50 per cent of the world population), and about 1 000 Endangered Oriental white storks (*Ciconia boyciana*) (30 per cent of the world population).

An abundance of plant and animal food and the security provided by wide expanses of open habitat, make Poyang Lake a sanctuary for large aquatic and space-demanding birds. In 1981, Poyang Lake was discovered to be the primary wintering area for Siberian cranes in East Asia. At that time, and in preceding years, cranes were hunted for food and feathers. The Chinese government moved quickly in protecting the most important portion of the lake as Poyang Lake Nature Reserve. Hunting has been curtailed and the number of Siberian cranes has increased. Water-diversion projects on the Yangtze River and the five smaller rivers that flow into Poyang Lake now present new challenges in maintaining the fragile annual cycles of water quantity and quality at Poyang Lake. Originally, Poyang Lake was three times its current size. By building massive dikes in winter when water levels are low, land was claimed for agriculture. Partly as a consequence of the dikes, spring and summer water levels have increased in other areas with massive damage to communities. In response to this new crisis, dikes have been opened and agricultural fields flooded to help contain the water. Habitat available to cranes and storks is increasing!

The Siberian crane and white-naped crane prefer to dig in the mud near the water's edge in ankle-deep water for tubers of sedges and for small aquatic animals. Strong winter winds and declining water levels move the location of the shallow water and thereby open new areas for the cranes. Many hundreds of cranes in mixed flocks of both species forage together and roost together at night in the shallows of Poyang Lake. In contrast, the storks feed primarily on fish and are solitary hunters, although they sometimes gather in flocks when resting. In March, the cranes and the storks migrate north to breeding areas in northern Russia (Siberian cranes), northern China, northeastern Mongolia, and southeastern Russia (white-naped cranes), as well as northeastern China and southeastern Russia (Oriental white storks). While they breed in the north, Poyang Lake fills, and the plants and animals on which the cranes forage in winter also reproduce.

The Okavango River has its origin in the highlands of Angola, flows southeast, spreads out into the fan-shaped Okavango Delta and dies in the sands of the Kalahari. Angolan rains in February and March swell the Okavango River. But the movement of water across the wide basin of the Delta is slow.

The peak levels and thus maximum size of the delta is not realized until August, a period that coincides with the peak of the winter dry season in the Kalahari. Great herds of ungulates move from the plains to the waters of the delta. And when the water levels crest, the largest population of Endangered wattled cranes (*Bugeranus carunculatus*) in Africa builds their platform nests and lays their eggs. Conversely, when water levels decline, fish trapped in the shallows make easy prey for Africa's largest and rarest stork, the saddle-billed stork (*Ephippiorhynchus senegalensis*). This abundance of aquatic animal life that concentrates as the delta shrinks, provides optimal conditions for the rearing of both crane and stork chicks.

There are approximately 6 000 wattled cranes in Africa and about 1 200 are residents of the Okavango Delta; the only other two sites seasonally holding more than 1 000 birds are Makgadikgadi in central Botswana and Kafue Flats in adjacent Zambia. Breeding pairs defend a territory of 50-100 ha of wetland against the intrusion of other cranes. Overlapping in habitat with the wattled cranes, but with a completely different niche, are the saddle-billed storks. They are territorial as breeding pairs and, like the wattled cranes, rear their young as the water levels decline. Estimates put the number of saddle-billed storks at more than 100 in the Okavango Delta.

Both Poyang Lake and the Okavango Delta are largely dependent on floodwaters from rivers, water that originates across wide watersheds far from the wetlands used by the rare cranes and storks. Consequently, the conservation of the floodplains is predicated upon the welfare of the watersheds. The Three Gorges Dam across the Yangtze River upstream from Poyang Lake is of major concern to the welfare of downstream wetlands. When political stability returns to Angola, use of the Okavango River's water for energy or irrigation in Angola could seriously impact the Okavango Delta. Let us hope that steps will be taken to assure the welfare of the endangered cranes and storks that are concentrated at two of Earth's greatest treasures.

George Archibald

Above, one of the most elegant cranes is the blue crane (Anthropoides paradisea), *South Africa's national bird. Cranes are always a beautiful sight even in small numbers, like this member of a small population in Etosha National Park, Namibia.*

On the opposite page, sandhill cranes (Grus canadensis) *flying over Babicora Lake, on the high plateau of northern Mexico. With a population estimated at 500 000 birds, sandhill cranes are the most abundant of crane species. Both photos,* © Patricio Robles Gil/Sierra Madre

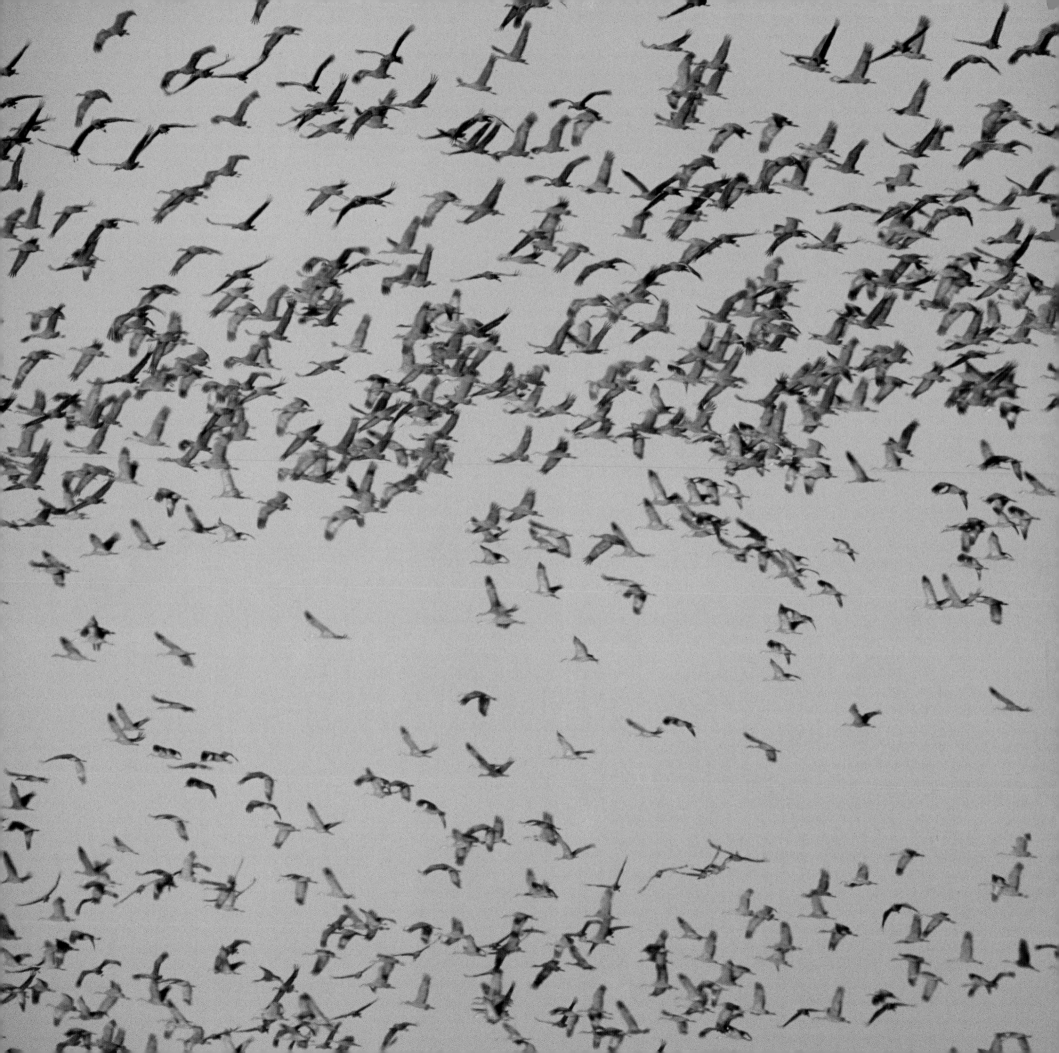

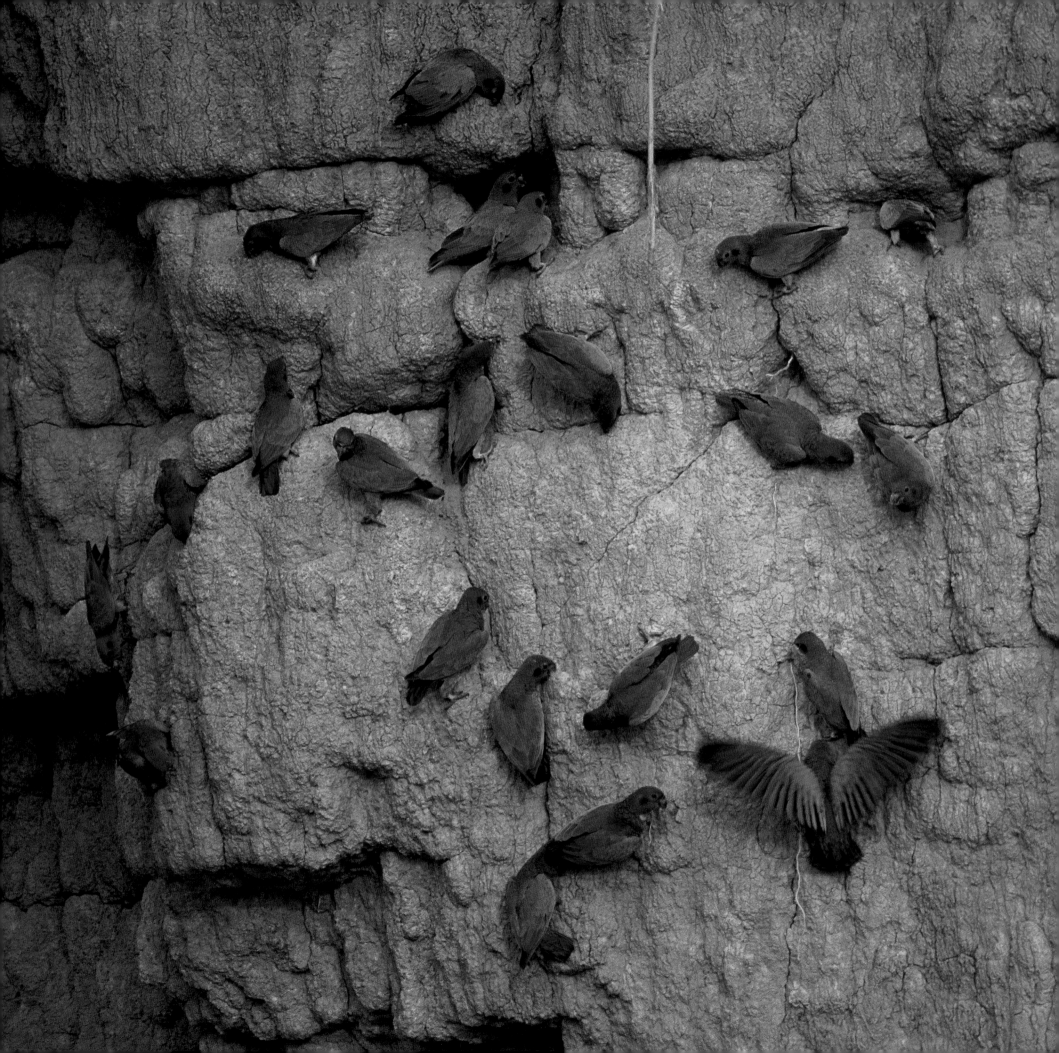

AMAZONIAN PARROTS AND MACAWS

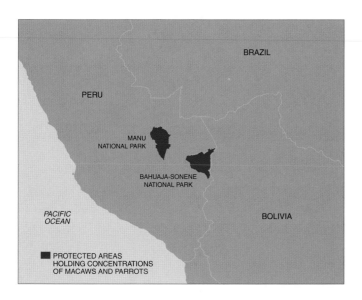

PROTECTED AREAS HOLDING CONCENTRATIONS OF MACAWS AND PARROTS

The parrot clay licks of the Peruvian Amazon are one of the world's best-known wildlife spectacles. They usually consist of exposed clay beds on steep, heavily eroded river banks, and may be attended by several hundred colorful, squawking parrots at a time, providing an awesome spectacle of color, sound, and movement. The parrots gather to ingest clay as a dietary supplement. This process, known as "geophagy," though widely studied, is still not fully understood. Although clay licks have been known for several decades by tropical ecologists and local wildlife guides, the world at large first discovered the wonder of these spectacular phenomena in the early 1990s through the stunning photographs of André Bartschi and Frans Lanting. The fact that licks are known in the ancient Inca language of Quechua as *collpas* indicates that they were probably already well known in the 1400s at the height of the Inca Empire, though they may have been known for many thousands of years before that by indigenous people inhabiting the dense rain forest of southeastern Peru. By 1994, at least 18 clay licks had been discovered by scientists working in the Manú region alone, and many more had been reported by local people. Parrot clay licks have since become an international tourist attraction for birdwatchers and nature enthusiasts from dozens of countries, and they provide one of the most visually appealing and exotic of all the world's avian ecotourism experiences.

Parrot clay licks are found in Africa, New Guinea, and elsewhere in South America, but the largest licks, and the most spectacular congregations, are those in the Manú-Tambopata region of southeastern Peru. The best known and most visited are those at the Tambopata Research Center on the Tambopata River, and close to the Manú Wildlife Center on the Madre de Dios River. The former lies within 300 m of the Tambopata Research Center, which is easily reached by riverboat from the small town of Puerto Maldonado, which in turn is served by regular flights from Lima. The lick is 50 m high, close to 500 m long, and is surrounded by dense rain forest. It is visited by as many as 250 individual parrots each day, and a total of 17 parrot species have been recorded there. Visitors can expect to see as many as 10 or a dozen parrot species during a visit to the Center. The most spectacular users of the lick are the large macaws: green-winged (*Ara chloroptera*), scarlet (*A. macao*), and blue and yellow (*A. ararauna*). At the height of the dry season, during August and September, it is not uncommon for as many as 60 of these impressive birds to gather at the lick each day. Though fewer tend to gather between May and June, macaws may be present at the lick at any time of year.

On the opposite page, blue-headed parrots (Pionus menstruus) in Manú National Park, Peru. Parrot clay licks have been found in Africa, New Guinea, and elsewhere in South America, but the largest and most spectacular congregations discovered thus far are those in the Manú and Tambopata regions of southeastern Amazonian Peru.
© Patricio Robles Gil/Sierra Madre

Above, scarlet macaw (Ara macao) in full flight, Tambopata, Peru.
© Kevin Schafer

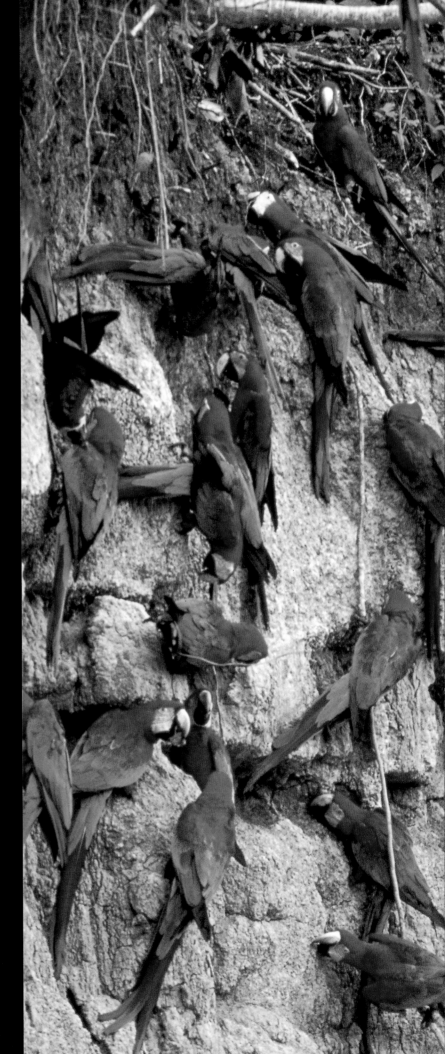

A large gathering of green-winged macaws
(Ara chloroptera) *at a* collpa *or clay lick in Manú National Park,
Peru. These birds are among the most spectacular users of the
Manú* collpa, *with as many as 60 gathering each day at the height
of the dry season in August and September.*
© Frans Lanting

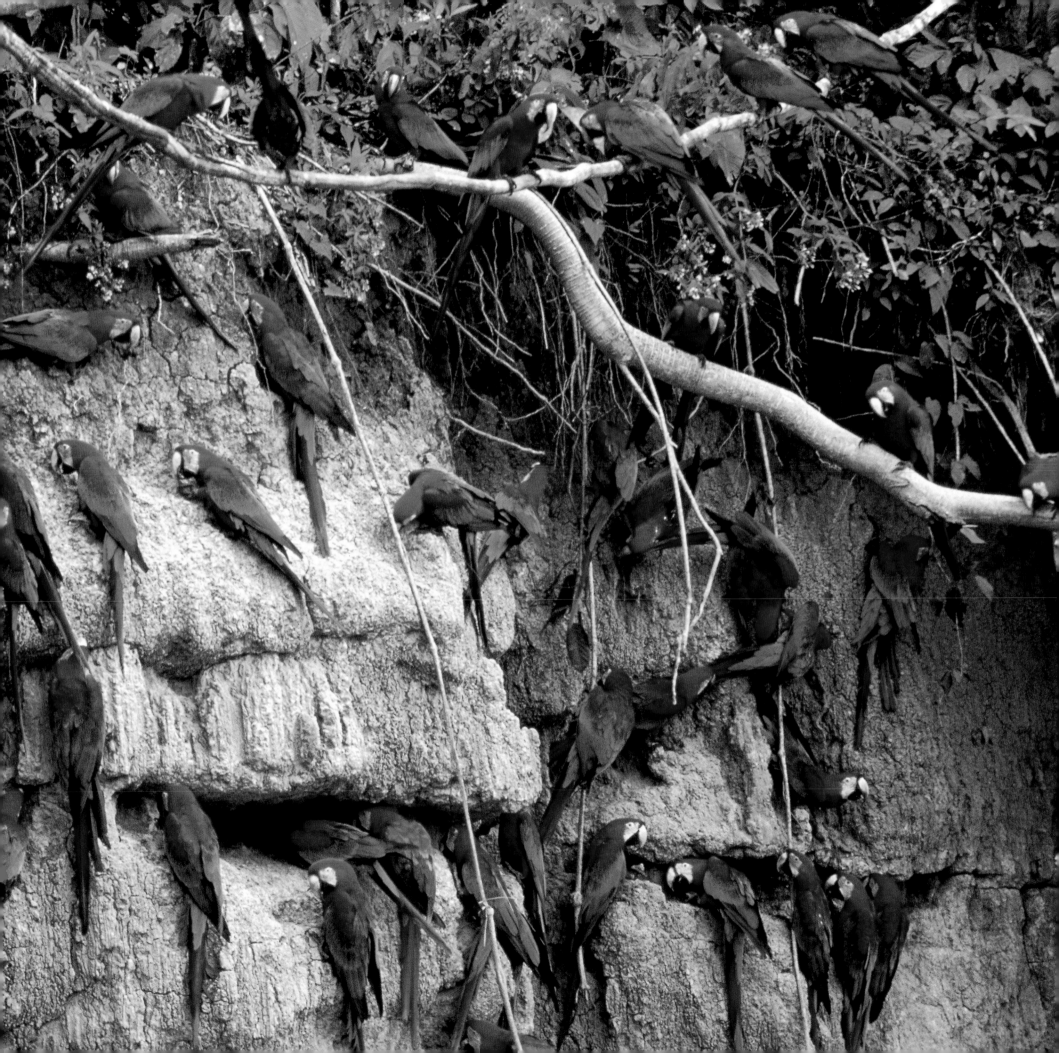

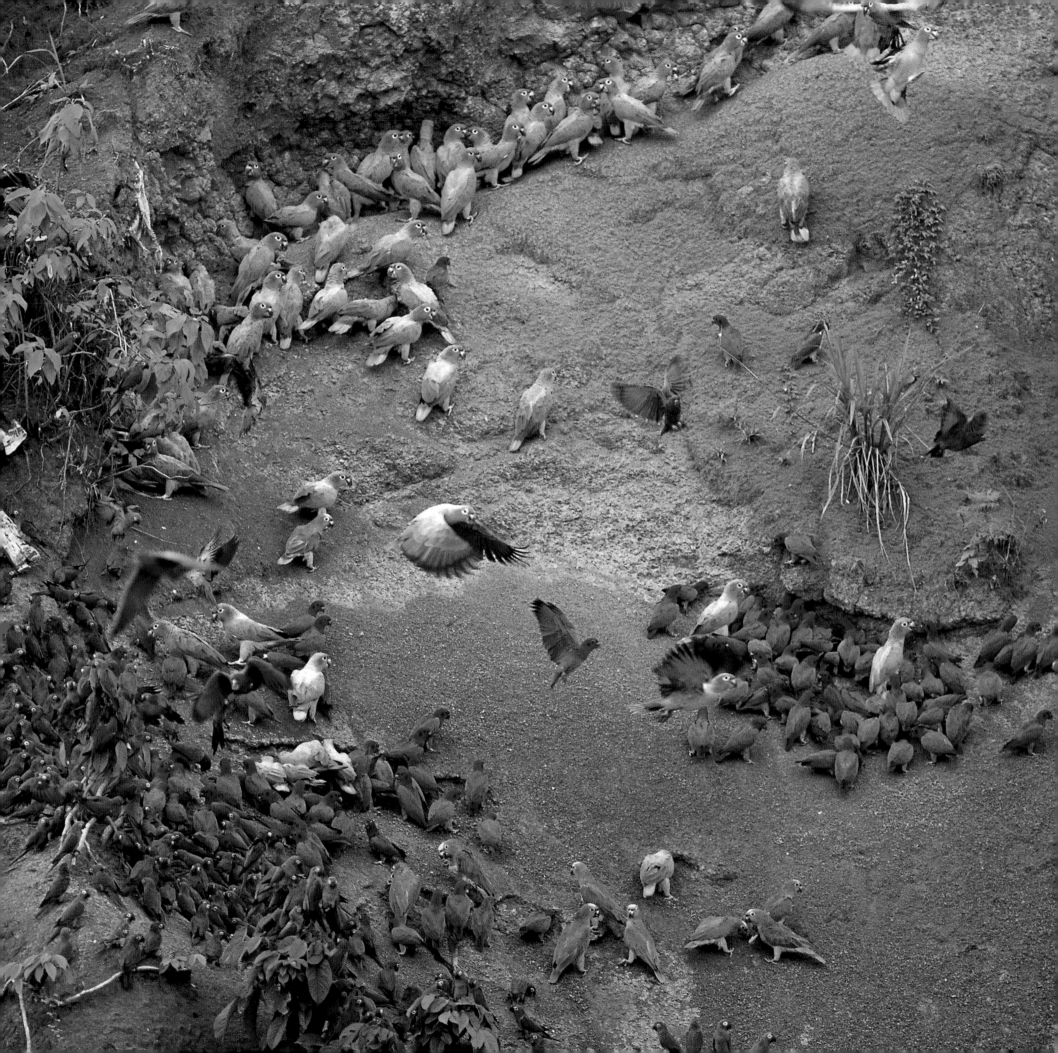

The most numerous parrots at the lick are the noisy green, red, and yellow mealy Amazons (*Amazona farinosa*) with as many as 300 birds attending each day. Other common species include cobalt-winged parakeets (*Brotogeris cyanoptera*), striking blue-headed parrots (*Pionus menstruus*), and slim dusky-headed conures (*Aratinga weddellii*). Two small macaws, the similar-looking chestnut-fronted (*Ara severa*) and red-bellied (*Orthopsittaca manilata*) also occur in good numbers, with 20 or more birds of each species frequently attending the lick daily. These smaller macaws and other small parrots start to gather in trees close to the lick around dawn before alighting to scrape the clay from the cliff with their strong bills, but the large macaws are rarely seen in significant numbers before mid-morning. Clear weather is essential for large parrot gatherings, and days with heavy rain or fog frequently result in the lick being all but deserted. Although different clay licks can attract different parrot species, the reason why species that are present throughout Amazonian Peru ignore certain licks is not known. In addition to those species already mentioned, other parrot species recorded from the Tambopata Research Center lick are: blue-headed macaw (*Propyrrhura couloni*), white-eyed conure (*Aratinga leucopthalmus*), dusky-billed parrotlet (*Forpus sclateri*), Tui parakeet (*Brotogeris sanctithomae*), Amazonian parrotlet (*Nannopsittaca dachilleae*), white-bellied parrot (*Pionites leucogaster*), orange-cheeked parrot (*Pionopsitta barrabandi*), and yellow-crowned Amazon (*Amazona ochrocephala*).

Despite several intensive studies, the reason why parrots ingest clay has still not been proven conclusively. The most likely explanation is that a combination of factors makes the clay attractive to the birds. Studies have shown that parrots favor soil with the highest clay content. Clay is known to contain kaolin, smectite, and other binding agents that can reduce the effect of toxins such as alkaloids and tannic acid that are found in the seeds of some rain-forest trees, protecting the parrot's digestive tract. Soil ingestion, therefore, is likely part of the escalating biological arms race between plants and the animals that consume them. Plants seek to protect their seeds by making their fruits unpalatable before they are ripe to deter seed-dispersing species from consuming fruits too early. They also provide hard seed cases, sometimes laced with toxins, to deter species such as macaws that seek to consume and destroy the seeds themselves. These parrots appear to have discovered a way to counter the plant's biological defense mechanisms so they can exploit a wider range of otherwise less palatable or harmful food plants. This may be especially important for large macaws during times of relative food shortage, which could explain the seasonal fluctuations in lick attendance. Studies have also shown that those clay deposits with higher sodium levels (which tend to be hiarder than those without) are preferentially selected, perhaps also providing a valuable mineral supplement. However, the possibility that they simply taste better has not been ruled out.

The Manú-Tambopata region contains some of the world's largest and most pristine areas of tropical Amazonian rain forest. The region also boasts some of the most significant protected areas for biodiversity conservation anywhere on the planet, including the 1.5 million-ha Manú National Park, the one million-hectare Tambopata Candamo Reserved Zone, the 600 000-ha Bahuaja Sonene National Park, and Peru's first conservation concession, the 140 000-ha Los Amigos concession created in 2001 by the Amazon Conservation Association. Macaws were first traded internationally almost at the same time as the European explorers discovered them in the 1500s. Despite hundreds of years of exploitation by bird traders and hunters (for pets, food, and plumes), none of the parrot species recorded at the Tambopata lick are regarded as being globally threatened, and many are still widespread and abundant where there is sufficient habitat. Peru banned the export of Amazonian wildlife in 1973, and the 1975 Convention on the International Trade in Endangered Species of Wild Fauna and Flora (CITES) restricts the international trade in parrots. The 1992 U.S. Wild Bird Conservation Act also prevents the import of parrots and other wild birds into the U.S. for commercial purposes. Large numbers of macaws and other parrots are also widely bred in captivity, providing an abundant supply for the U.S. and European pet markets. Today, ecotourism operators that have a vested interest in protecting parrots and parrot clay licks are collaborating with local Machiguenga Indians and other indigenous groups to protect these valuable resources. Although subsistence hunting continues, few parrots are targeted, as many local people stand to benefit more from the income generated by tourism than from consumptive use of parrots.

MICHAEL J. PARR

On the opposite page, yellow-crowned Amazons (Amazona ochrocephala), *dusky-headed conures* (Aratinga weddellii), *mealy Amazons* (Amazona farinosa), *and blue-headed parrots* (Pionus menstruus) *at a clay lick in the Ecuadorian Amazon. It is not uncommon to see many different species at a single lick, with the record being 17 parrot species from the clay lick on the Tambopata River.*
© Peter Oxford/DRK PHOTO

Above, the most numerous parrots at the clay lick on the Tambopata River are the noisy green, red, and yellow mealy Amazons (Amazona farinosa). *As many as 300 birds will visit this large lick every day.*
© Art Wolfe

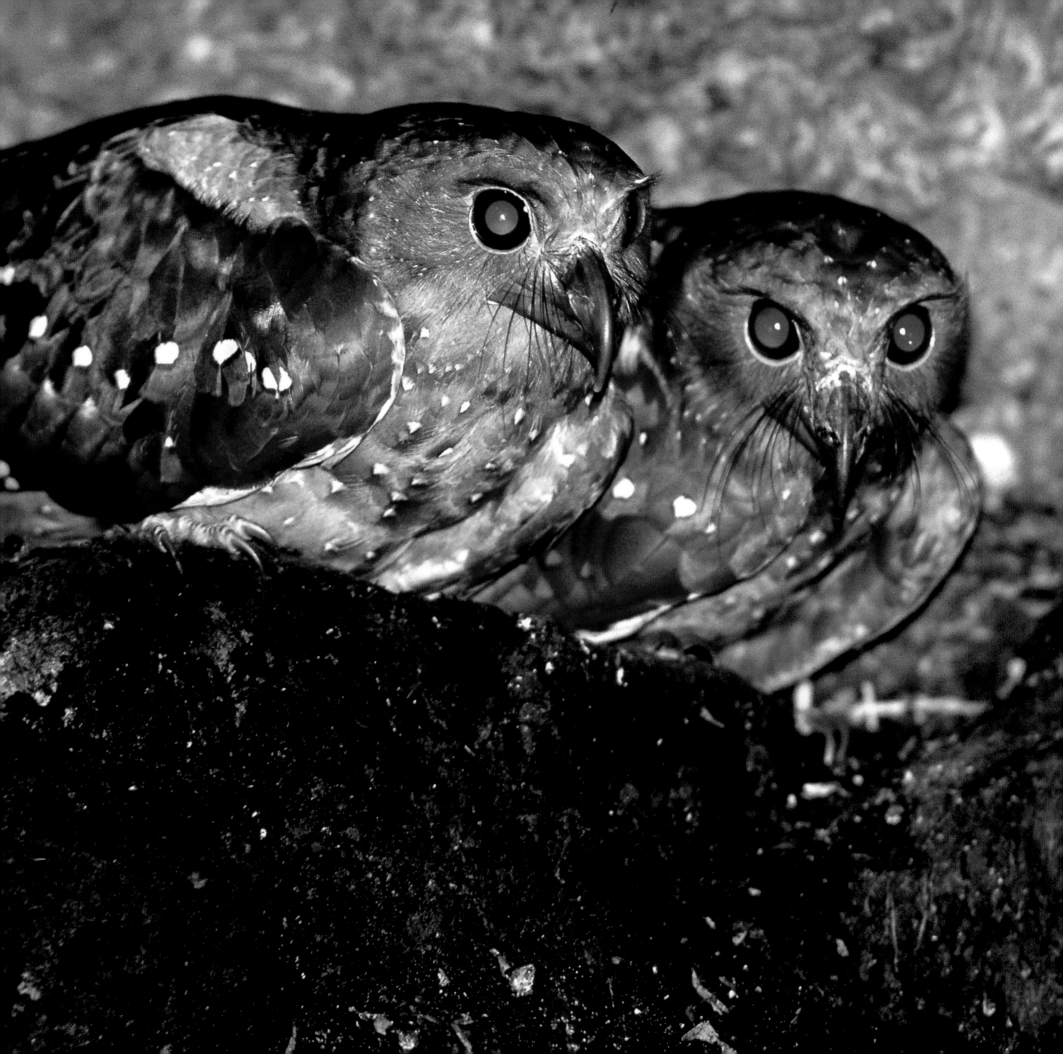

OILBIRDS

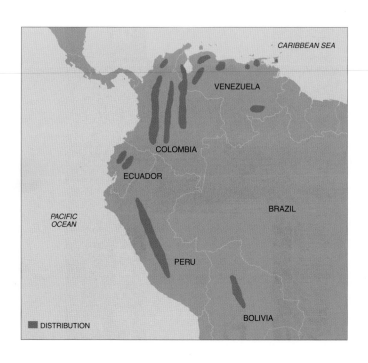

Up in a mountain forest of northeastern Venezuela, dusk settles in, drawing a shadow over the mouth of a great cavern. The darkness arouses something inside, and a commotion of unearthly clicking begins to build. The sound is like that of a mighty chain of metallic particles flowing furiously toward the heavens. In the failing light, human eyes can pick out large birds streaming from the towering vault: at first a few, then in waves they come, their chorus of thousands rising to an overpowering din. For two hours the cave spews its noisy tenants and with rapid wingbeats, they fan out over the moonlit countryside. Every night during the breeding season, from April through August, as many as 10 000 birds leave Guacharo Cave in the Caripe Mountains. By the light of the moon, up to 250 birds a minute exit the cave. The performers of this ornithological spectacle are oilbirds (*Steatornis caripensis*), discovered in this very cave by the German explorer-naturalist Alexander von Humboldt in 1799. Local people call this bird *guácharo*: the one who cries. Others know the bird as a source of tasty flesh and fine oil, hence the English nickname, oilbird.

The guacharo is a large, hawk-like bird of northern South America that, unlike any other bird in the continent, nests and roosts in large, limestone tropical caves. Not surprisingly, its nocturnal and cave-dwelling habits have generated a rich mythology, and many indigenous New World cultures associated the oilbird with omens, evil, and death. While in flight within the cave, oilbirds utter staccato, high-pitched clicks used for echolocation in bat-like fashion (a form of echolocation shared by only one other group of birds, the Asian swiftlets); the sound bouncing off the cave walls enables them to avoid collisions in the pitch black.

Oilbirds possess another quality, one that transcends all myths. By night the guacharos fly out over the mountain forests searching for trees laden with ripe fruits. They stop only at those types of trees bearing fruits with single seeds, hovering gracefully alongside and plucking them with a strong, hooked beak. The fruit is swallowed whole and its pulp digested. The seed, however, invariably is regurgitated and the bird casts the seed while on the wing. This seed dispersal behavior has proven beneficial to the forest, because every night thousands of oilbirds spread tons of seeds —representing at least 40 of the dominant species

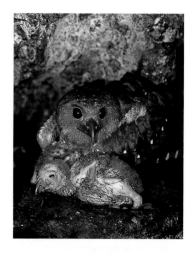

On the opposite page, oilbird (Steatornis caripensis) pair on nest; above, oilbird parent with chicks in the Aripo Caves, Trinidad and Tobago. Both photos, © *Konrad Wothe*

On pp. 208-209, oilbirds in the Humboldt Main Gallery of the famous Cueva de los Guácharos, Caripe, Venezuela. © *Roberto Roca*

207

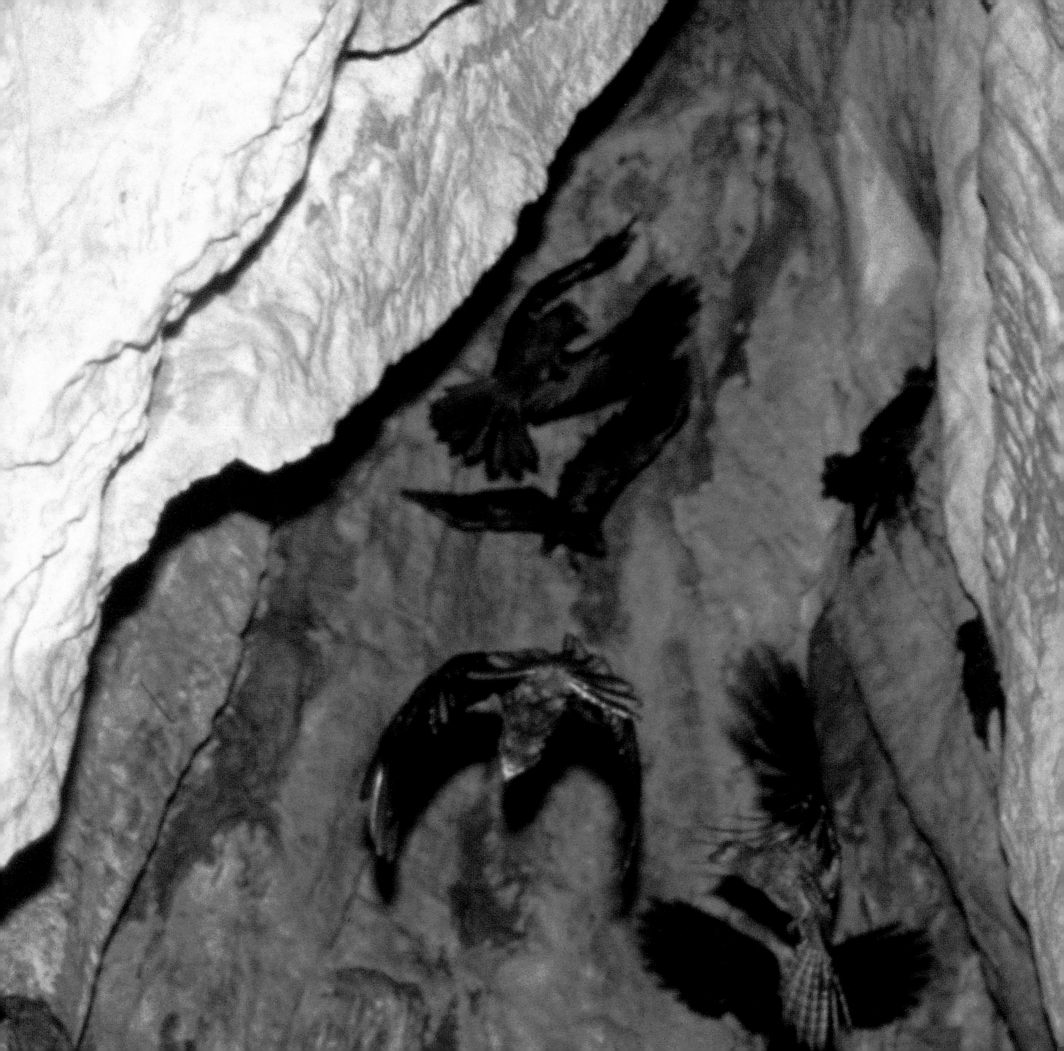

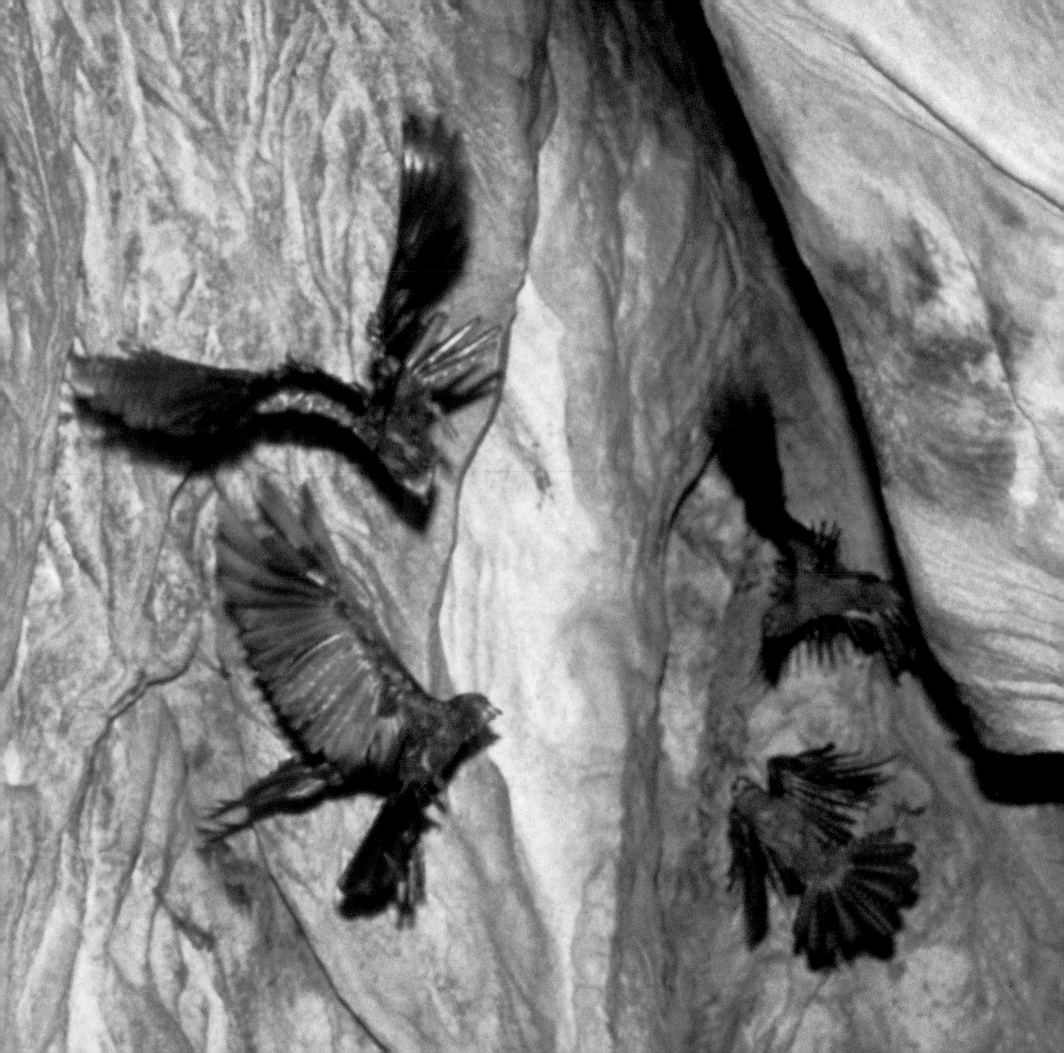

of the forest canopy— along vast areas. An adult oilbird requires about 50 fruits a day to supply all its energy needs, and a colony of 10 000 individuals, such as at the Guacharo Cave, could regurgitate about 21 tons (at least 60% are dispersed on the forest) of seeds per month.

At Guacharo Cave, the birds nest on ledges that soar more than 20 m to the ceiling. Pairs are monogamous and share the duties of nesting. Both parents build a round nest of regurgitated fruit pulp and guano. Females generally lay two to four white chicken-sized eggs. Young remain nest-bound for about 110 days, during which time their parents feed them a diet consisting entirely of fruits. During the first 70 days the young gain a phenomenal amount of weight, increasing from 28 g to as much as 590 g (one and a half times heavier than an adult). Most of the weight is fat, and this has led to their being exploited for oil.

During the breeding season, adult birds from Guacharo Cave limit their foraging to a radius of about 40 km, mostly because they have to return several times a night to feed their nestlings. By the end of the breeding season, with nearby fruits growing scarce, oilbirds show post-breeding dispersal behavior. They relocate to nearby caves and from these new roosting sites the birds travel further, foraging up to 100 km away to the flooded plains of the Orinoco Delta and returning to their caves before dawn. In Trinidad, a less seasonal environment, fruit is produced most of the year and oilbirds stay in their caves year around.

The foraging and cave-roosting behavior of oilbirds is the outcome of ecological and evolutionary pressures acting at different times during their life span. Their behavior tends to minimize predation, optimize foraging costs, and maximize reproductive success within the context of total frugivory. Total frugivory by oilbirds seems to be the result of a relatively predation-free niche that does not constrict the nesting period.

Besides Venezuela, oilbirds are found in Trinidad, Colombia, Panama, Ecuador, Peru, and Bolivia, but the Guacharo Cave of Caripe in Venezuela probably harbors the highest numbers of oilbirds found throughout their range. Sadly, seven out of 54 oilbird colonies in Venezuela have become extinct in the past century. Around Guacharo Cave the hills are being heavily deforested for coffee plantations, orange groves, and subsistence agriculture. In Trinidad, five out of 13 colonies are gone. The current status of colonies in other countries is poorly known, but the species is considered to be threatened everywhere. Colonies have become extinct for two reasons: accelerated deforestation processes associated with human development, and excessive local poaching of the nestlings, whose large deposits of fat and long development time make them attractive prey for local people.

Oilbirds constitute an excellent ally for conservationists in the hard task of preserving wildlife areas. They could be considered as a natural tool for managing watershed areas that require special protection. Through their seed dispersal role, oilbirds contribute to the maintenance of plant diversity of tropical forests. In addition, they constitute a great tourist attraction, particularly in areas that harbor large colonies. The Venezuelan government approved the enlargement of the Guacharo National Park in 1989 by 66 000 ha based on the birds' ecological and conservational importance for watershed management and tourism. However, many other areas in South America where oilbirds occur need much research and improved conservation, including enhancing the protection of their caves and surrounding areas, adequate park design incorporating their home range, and the development and implementation of sound awareness programs and management plans.

ROBERTO ROCA

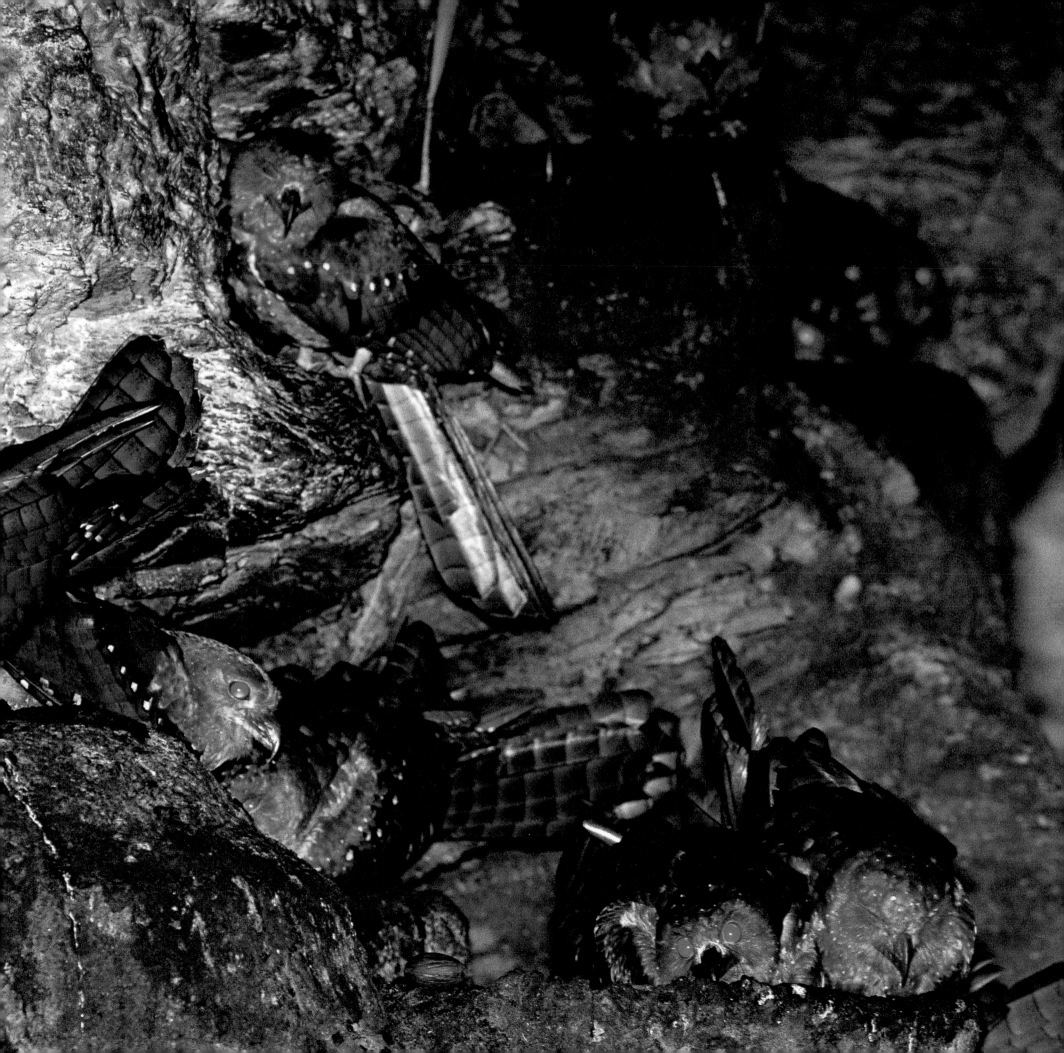

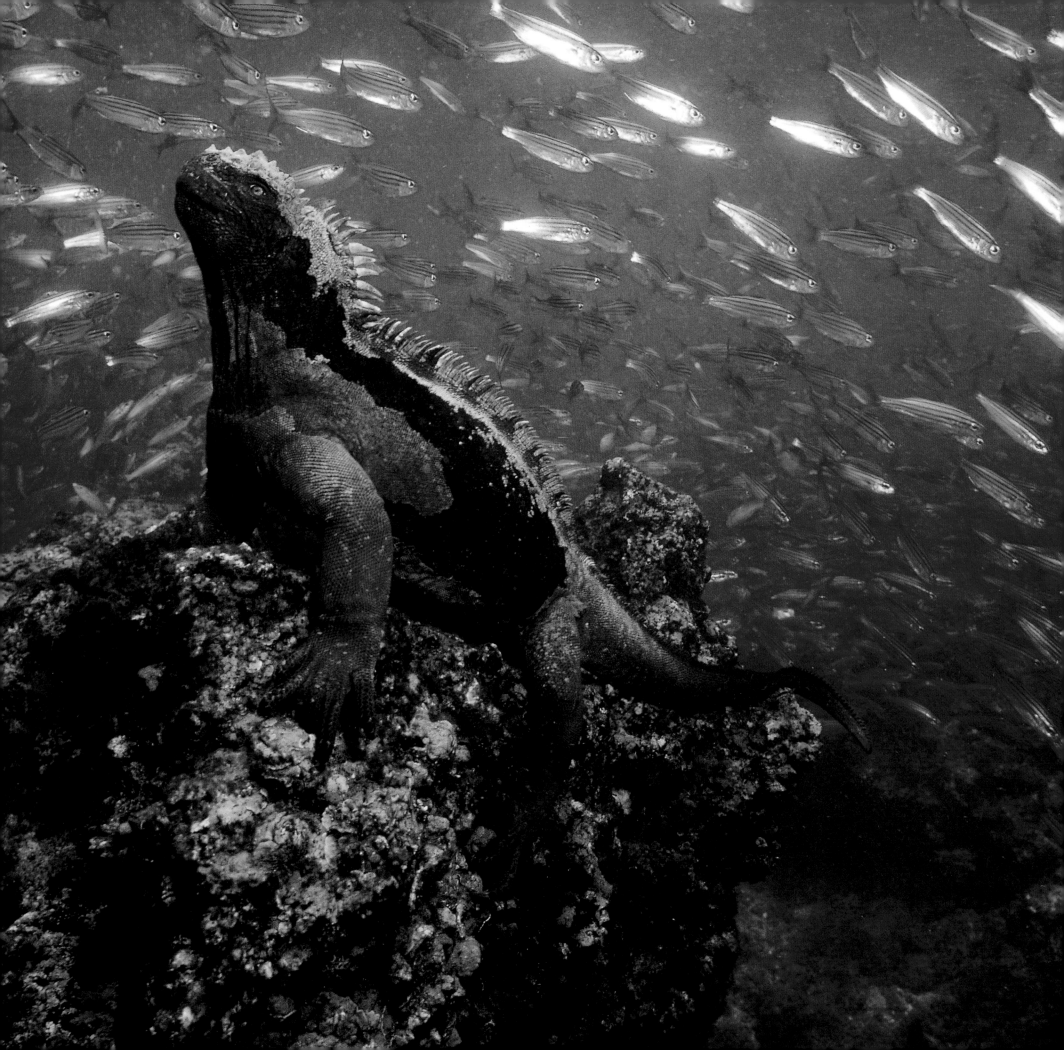

REPTILES, AMPHIBIANS, AND FISHES

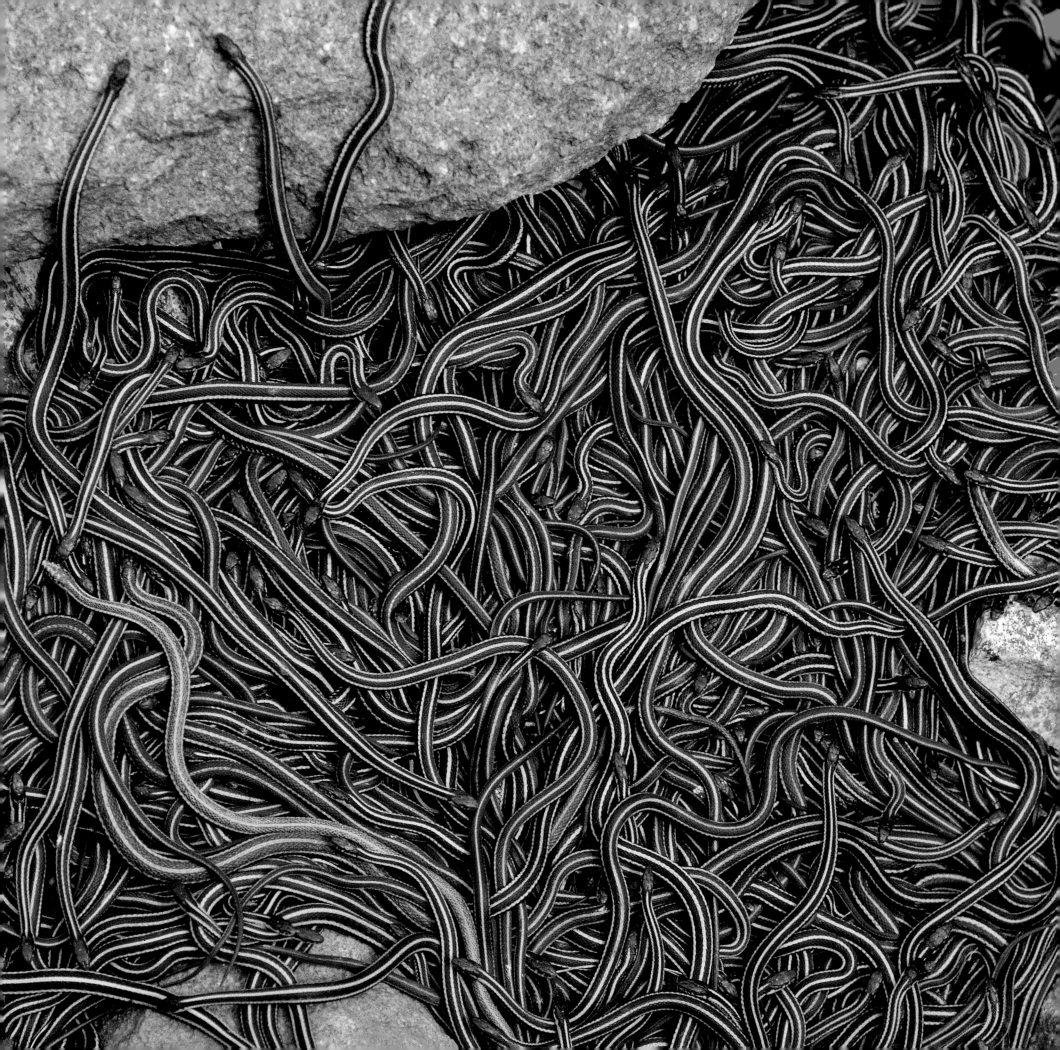

MANITOBA GARTER SNAKES

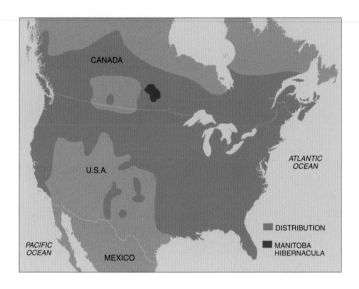

Everywhere I looked inside the pit there were snakes crawling, sliding, searching. They flowed around and over the rocks, under and through patches of dried, golden grass. Some climbed skyward, wrapping the lower branches of leafless bushes like serpentine garlands. Their numbers seeped from the frozen earth in a continuous stream of black sinuous bodies. Many of them moved in animated braids with dozens of excited males entwining the cold sluggish body of a single unmated female. When the females climbed the banks of the pit to escape their determined suitors, the weight was often too great for them, and the tangle of snakes would slide backwards in a heap of writhing coils. And in the aspens overhead, migrating yellow-rumped warblers, white-crowned sparrows, and common crows added their own music to the rhythmic swish of the wind conversing with the treetops. It was the first week of May, and I was in southern Manitoba, Canada to witness the spring emergence of the red-sided garter snake (*Thamnophis sirtalis parietalis*).

Snakes evolved in the tropics, and over the millennia dispersed to colder regions. The harmless red-sided garter snake of North America ranges to 60°N, the farthest north of any serpent on the continent. In the past 30 years, the study of this snake has shed light on how reptiles can adapt to cold environments. Snakes can not withstand prolonged freezing, so in Canada, where winter temperatures commonly plummet to –40°C, they hibernate underground for six to seven months every year. Often, the snakes overwinter in communal dens, or hibernacula, which are cracks and crevices in the bedrock that penetrate below the lethal frost line. In southern Manitoba, the region between Lakes Winnipeg and Manitoba contains roughly 70 such hibernacula. Most of these overwintering sites are limestone sinks, some no larger in area than a household kitchen floor, yet they may shelter more than 10 000 garter snakes in their depths —the largest aggregation of snakes anywhere on the planet. The spring emergence of the red-sided garter snake is a reptilian spectacle like no other.

Throughout winter, the snakes clump in the black depths of their hibernaculum where temperatures hover around the freezing point. The warmth of spring lures them to the surface. Male garter snakes, pencil-thin from months of fasting, are the first to appear, emerging together in great numbers. Hundreds, and even thousands, may surface at once. The females appear soon afterwards but one at a time, or in small numbers, and their emergence is spread over several weeks. As each female appears

Sensing the first warmth of spring, male garter snakes, pencil-thin from months of fasting, begin to emerge together in great numbers —hundreds, even thousands, may surface at once.
Opposite, © Fred Bruemmer/ DRK PHOTO;
above, © François Gohier/ ARDEA LONDON

at the surface, she is mobbed by male suitors. "Mating balls" are formed, consisting of a single female intertwined with as many as 100 males, each intent on copulation. An odor chemical, a pheromone, detectable in the skin of the female's back, advertises her sex and her readiness for mating. The males flick their tongues rapidly over her body sensing the tantalizing taste. Copulation in red-sided garter snakes lasts 15 to 20 minutes, during which the successful male deposits a gelatinous plug in the female's cloaca. Mating secretions produced by the male and/or the female are smeared around her cloacal region leaving a shiny coating. The secretions contain a second pheromone, a sexual repellent that renders mated females unattractive and dissuades courting males. Thus, once females are mated they are spared the continued harassment of amorous males. Most mate within 30 minutes of emergence, and leave the den area soon afterwards.

In recent years, inquisitive researchers have discovered yet another twist to the fascinating physiology of the red-sided garter snake. Surprisingly, some males, when they first emerge, exude the seductive pheromones of a female, and they are vigorously mobbed and courted by regular males. These mixed-up males, called "she-males," still behave like regular males and have a lusty appetite for females; they just smell differently. In fact, a female-hunting she-male may smell so good that he falls in love with himself. If a she-male should accidentally tongue-test his own tail amidst a tangle of tails, he may spend considerable time courting himself! Researchers are uncertain why a small percentage of male garter snakes mimic females. Perhaps it fools rival males and diverts their attention from real females, thus improving the she-male's chances of mating. Whatever the reason, we can expect more surprises from this fascinating reptile.

Clearly, aggregations in red-sided garter snakes are primarily a reproductive strategy. The snakes are starving when they surge to the surface in spring. Most have lost a third of their body weight over the winter, and their energy reserves are critically low. Clumped emergence of the snakes ensures that all the females are mated quickly and expend a minimum amount of energy. Within a day or two, the females disperse to nearby marshes to hunt frogs, tadpoles, leeches, and nestling birds. They will spend only four months away from the den area. Every day is precious if they are to regain the weight they lost in winter, as well as provision and incubate a litter of 15 to 30 live-born young by summer's end.

Animals that aggregate are bound to attract the attention of predators, and red-sided garter snakes are no exception. In southern Manitoba, owls, skunks, and coyotes all have a taste for "serpent au printemps." At one hibernaculum I visited, dozens of dead snakes were scattered about. Most were untouched except for a small hole in their belly through which their liver had been neatly excised. I later learned that crows were responsible for the exacting surgery.

The red-sided garter snake is only one of 11 or 12 subspecies of the common garter snake which ranges from coast to coast, and from the Northwest Territories to Florida, making the common garter snake the most widely distributed snake in North America. Total population numbers are unknown, but researchers estimate that 500 000 to a million red-sided garter snakes may live in Manitoba, where the largest hibernacula occur.

The biggest threat to the garter snakes' survival is nature herself. In the winter of 1998-1999, perhaps 50% of the snakes froze to death in some of the core hibernacula in the Interlake region of Manitoba. However, another threat comes from automobiles. Highways surround most of the large den sites in southern Manitoba, and in the past thousands of snakes were killed every autumn when they massed along the roads on their way back to the dens. By installing culverts under the roads and erecting drift fences to funnel the snakes towards the culverts, biologists have reduced the road mortalities from 25 000 snakes per year to 5 000, an 80% reduction.

Twenty years ago, when I first visited the garter snakes of Manitoba, I saw no one else at the dens. Today, 35 000 ophidiophiles visit annually and, on Mother's Day, the second Sunday in May, the parking lots overflow with families sharing this amazing serpentine spectacle. Perhaps, if garter snakes can arouse such interest in the public there is hope for the planet after all.

WAYNE LYNCH

On the opposite page, the best place to witness the incredible mass emergences of the red-sided garter snake (Thamnophis sirtalis parietalis) *is in southern Manitoba, Canada in the first week of May.*
© François Gohier/
ARDEA LONDON

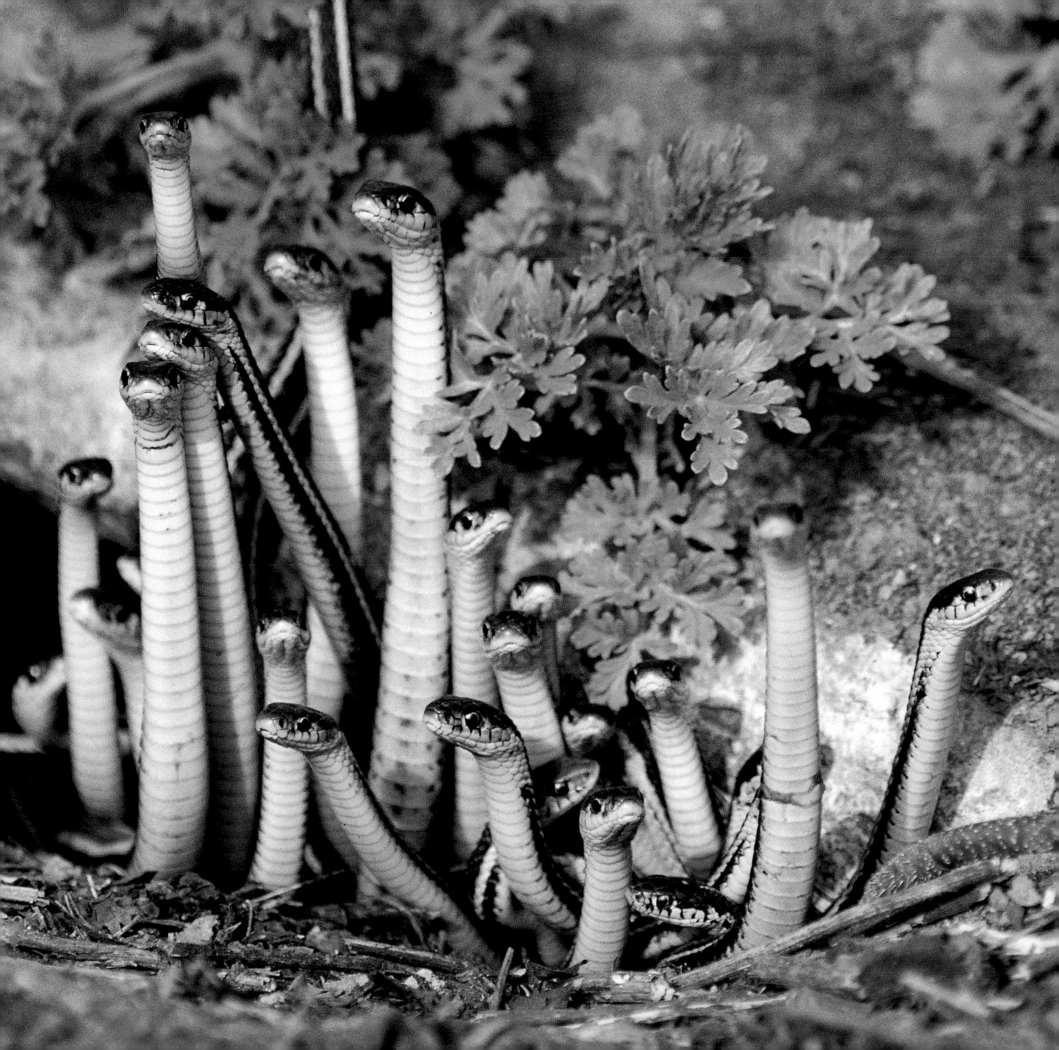

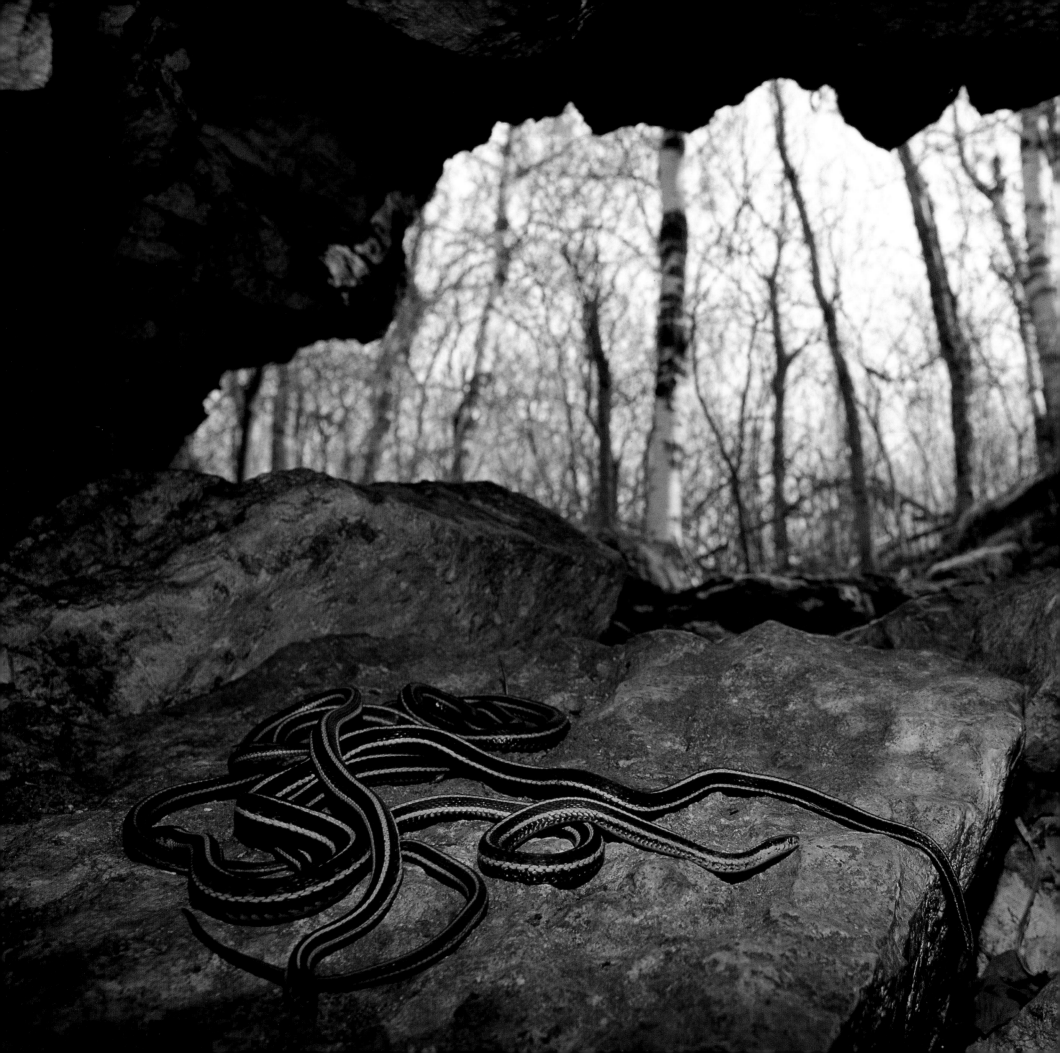

*Red-sided garter snakes hibernate underground for six to seven months
every year in communal dens, or hibernacula. These are cracks and crevices
in the bedrock that penetrate below the lethal frost line.*
© Wayne Lynch

219

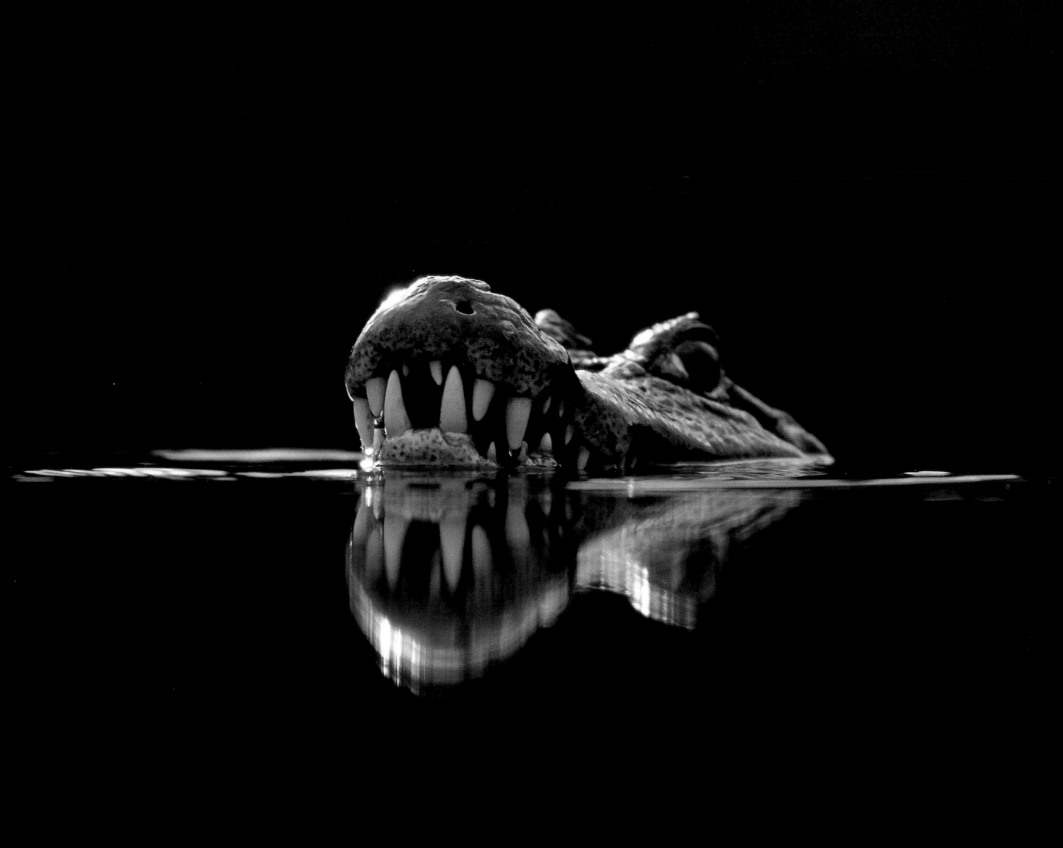

PANTANAL CAIMANS

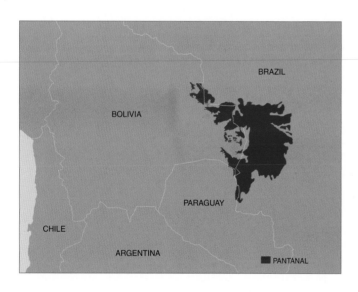

The Pantanal is the world's largest tropical wetland, the core of which extends for 210 000 km² of low-lying areas and is surrounded by 356 000 km² of high plains forming the Upper Paraguay River Basin, one of the most important catchment areas of South America. Most of the Pantanal falls within Brazilian territory, but also extends into Bolivia and Paraguay. As a first-time visitor will describe, one of the most striking and visible features of the Pantanal is the large abundance of caimans (*Caiman yacare*) that are distributed widely throughout the floodplains. Densities in excess of 150 individuals/km² have been recorded, and there are areas of remarkably high densities in virtually all the major rivers draining the area. In fact, caiman populations in the Pantanal exceed those of any crocodilians found anywhere on the planet. One of the most spectacular scenes can be experienced during the dry season, when caimans concentrate in very large numbers around the few remaining water pools and lagoons.

Caimans in the Pantanal experience a highly seasonal environment. There are also marked year-to-year variations in habitat conditions due to climate dynamics. Life-history traits such as foraging, quality of diet, body condition, growth rate, reproductive success and, ultimately, population density, are all closely associated with temporal changes in temperature, rainfall, and flooding levels. All these factors combine to produce four major seasonal conditions that characterize the Pantanal. From January to March, water levels and temperature begin to rise, and caimans find a rich and productive habitat in which to disperse. Water levels peak from April to June, and temperatures start to drop; temperature reaches its lowest mark from August until September. From October to December, the temperature starts to increase, and water levels reach their lowest. As water levels drop, only a few sites remain flooded where large numbers of animals start to converge and congregate. The result is the spectacular concentration of caimans around the few pools that are left in the low-lying areas.

Food availability is particularly critical in the dry season. As water levels decrease and the ground dries off, food supply becomes scarce. Rising energy requirements aggravate conditions. But caimans are able to survive for long periods without feeding. They may also enter into aestivation while keeping their bodies buried under the mud, as has been observed in pronounced dry periods. Such a response may ensure high survival rates even when food availability is low, helping to explain why caimans are able to achieve such high densities in certain areas of the Pantanal.

Congregation events seem to be associated more with reproductive needs than with feeding requirements. The dry period coincides with the phase of rapid gonad development. The onset of gametogenesis occurs in August when females initiate the phase

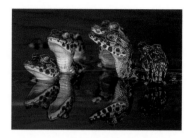

Paraguay or yacare caimans (Caiman yacare) *in the Pantanal region of Brazil. This species reaches the highest densities of any living crocodilian, and Pantanal populations exceed those of any other species.* Opposite: © Konrad Wothe; above: © Theo Allofs

On pp. 222-223, caiman and capybara (Hydrochoerus hydrochaeris) *side by side in the Pantanal. Like the caiman, capybara also exist at high densities in this region.* © Eric A. Soder

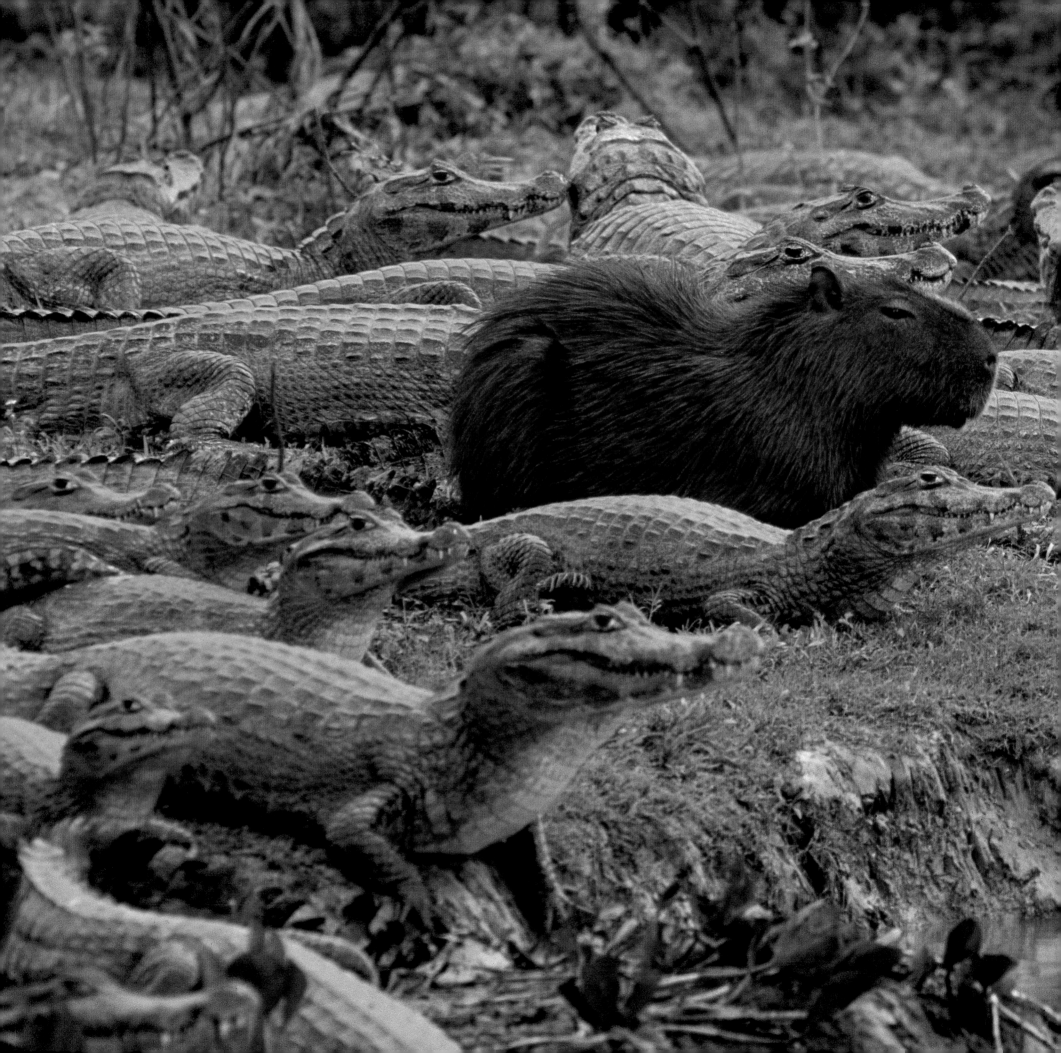

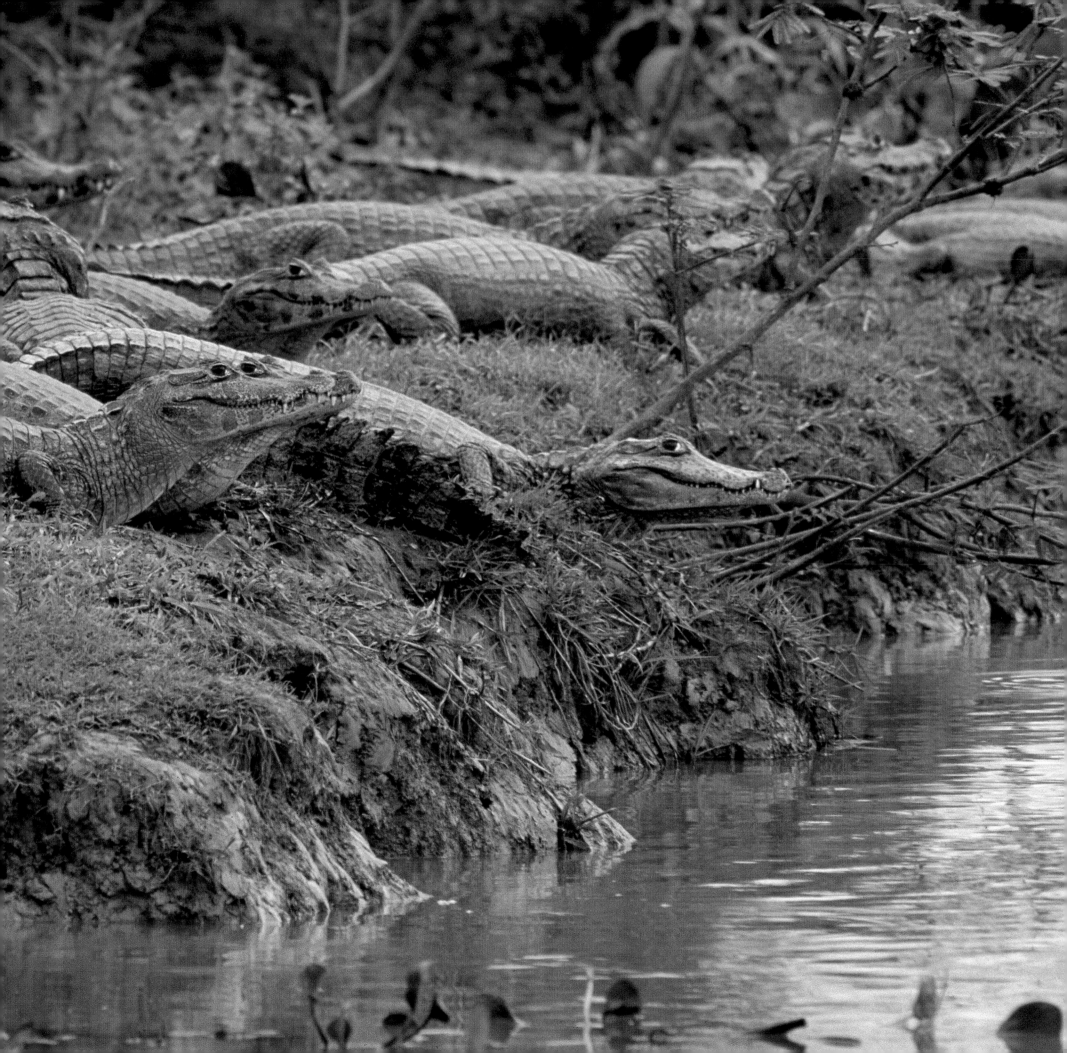

of rapid growth of vitellogenic follicles, and males start to increase in testis mass. The process culminates in December, with the appearance of pre-ovulatory follicles, while males attain full sperm production capacity. A relatively short mating period follows in mid- to late December. Then nests are built and the peak of the egg-laying period extends from mid-January to early February. Water levels start to increase. Hatchlings appear in March, under a wet and warm environment that offers the best conditions for the survival and growth of young caimans. Therefore, caimans time their reproductive efforts to match closely the best environmental conditions that maximize reproductive success.

From 1962 to 1973, the Pantanal experienced a severe drought that lasted for 12 consecutive years. Coupled with this, caiman populations were subjected to intensive hunting that had an immense impact on their numbers. Anecdotal information from the early 1970s suggests that densities dropped to 10-20 individuals/km^2, or 15 times lower than some of the highest densities observed today. Even the Brazilian Federal government promulgated a law in 1967 banning all commercial hunting of wildlife so as to curb further impacts on the severely depleted Pantanal caiman populations. Specialists believed the species was under threat of being completely exterminated from the region. From 1974, the water levels of the Rio Paraguay steadily increased, and caiman numbers began recovering. Despite the commercial hunting ban, as late as the 1980s caimans continued to be subjected to intensive harvest pressure, to the point where the species was reported as one of the most heavily exploited crocodilians in the world. Estimates suggest that perhaps one million caimans were harvested annually in the Pantanal in the 1980s.

Strong enforcement capacity built up over the years in the region, coupled with growing conservation efforts on the part of research institutions like the Brazilian Agricultural Research Corporation (EMBRAPA) and local state universities, and many NGOs. As a result, since the early 1990s, illegal hunting has been all but eliminated from the region. In a harvest-free environment and under a high water-level regime now lasting for close to 30 years, caimans are thriving again under conditions that favor the survival rate of young, accelerate individual growth rates, and maximize overall reproductive success. Today, caiman numbers in the Pantanal exceed a staggering 20 million. But the stability of these population sizes is largely dependent on closely monitored conservation efforts.

Conserving the Pantanal wilderness is an important global priority. As one of the largest wetlands in the world, the Pantanal is an invaluable source of fresh water, and its biodiversity, exuberant flora and fauna, and scenic beauty are also important factors inspiring interest in the conservation of the region. Much of the Pantanal wetland is still pristine. However, the region is undergoing rapid agricultural and urban development, particularly in the high plains, with consequences for the future of the low-lying areas as well.

The relationship between caiman reproductive output and water levels of the Rio Paraguay can not be overemphasized. The fact that we have experienced nearly 30 years of high water levels may lead one to expect years of imminent prolonged drought, which will require more stringent measures to protect Pantanal caiman populations, even in the absence of commercial hunting. Research has shown that the water level measured at the city of Ladário in the southern Pantanal can be used to predict the magnitude of floods throughout the entire wetland. This relationship has far-reaching conservation and management implications. One of the most important is that any human-made disturbance of the dynamics of the Rio Paraguay natural flow will have significant consequences not only for the caimans but also for the overall wealth of vertebrate populations that made the Pantanal Brazil's most famous ecotourism destination. Recently, the region has faced the threat of dredging of major portions of the Rio Paraguay, infamously called the Hydrovia Project. This threat is currently under control, although the political pendulum on the push for infrastructure development swings widely. Fortunately, we have one good tool available, which is keeping track of the water levels of the Rio Paraguay. This is the best and most cost-effective early warning tool we have to predict future population trends and design conservation strategies for caimans and other Pantanal wildlife.

Despite the vital need to preserve the Pantanal, it is unlikely that all of the 210 000 km^2 of wetlands will be left totally untouched, particularly considering growing human populations. Our best bet is to invest in the design of economic incentives that promote benign land uses across the Pantanal, particularly those that benefit from the pristine conditions of the region's ecosystems, such as ecotourism. Proposals have been advanced for allowing controlled commercial harvesting of caimans in private properties using sophisticated population management tools and models that allow for sustainable production at very safe levels for the species. Despite the apparent attractiveness of these proposals, however, we argue that biological and socioeconomic aspects should be evaluated carefully in order to avoid any risk of a return to the era of overexploitation.

MARCOS COUTINHO ZILCA CAMPOS
GUSTAVO A.B. DA FONSECA REINALDO F.F. LOURIVAL
RUSSELL A. MITTERMEIER CRISTINA G. MITTERMEIER

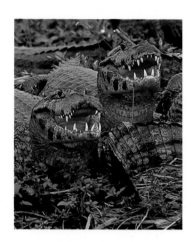

Above, Paraguay caimans basking in the sun. This species has been recorded at densities in excess of 150 individuals/km^2 in the Pantanal, and there are areas of such remarkably high density in virtually all the major rivers draining this region.
© Theo Allofs

On the opposite page, Paraguay caimans concentrated in a dry season pool in the Pantanal. One such pool had some 3 000 adult caimans in an area of 500 m × 20 m.
© Peter Oxford/naturepl.com

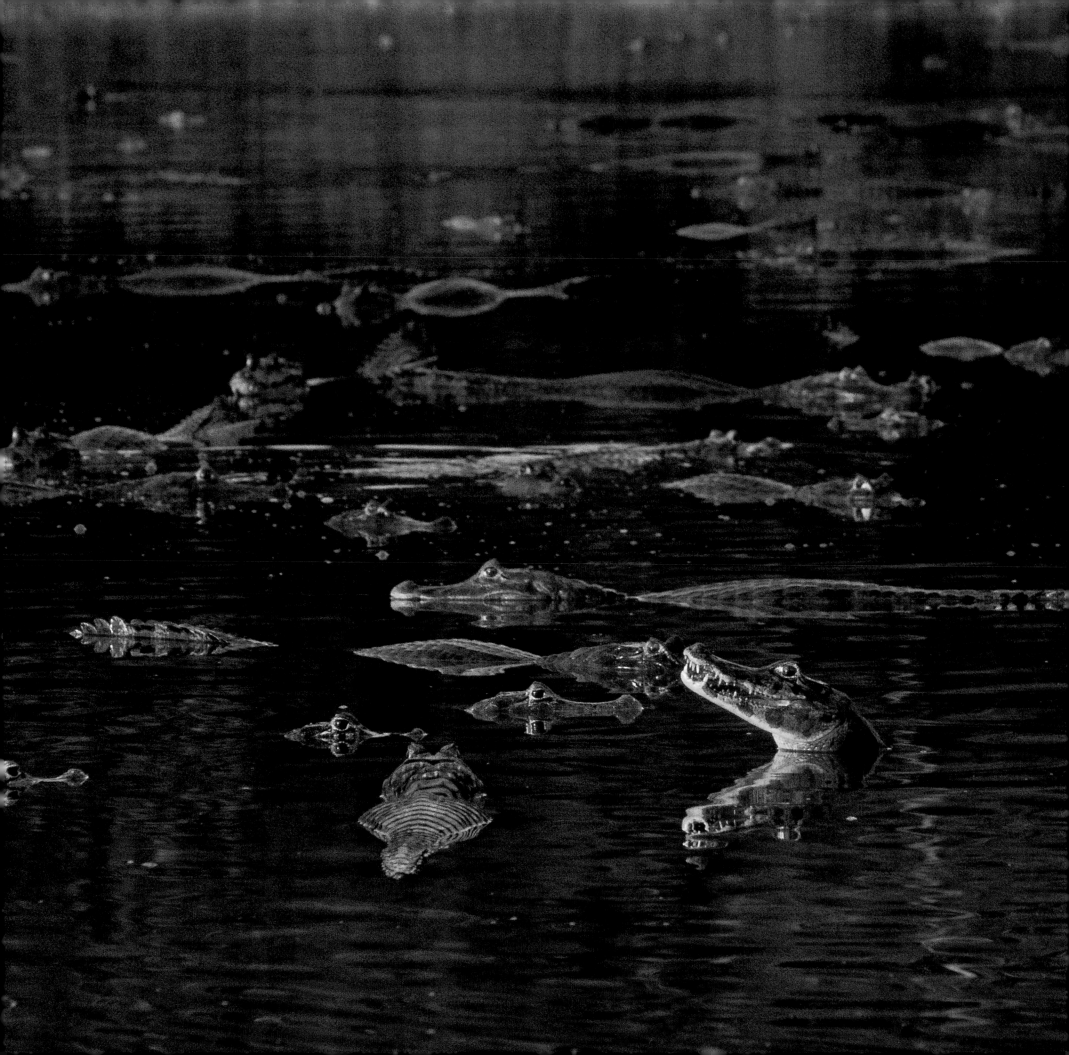

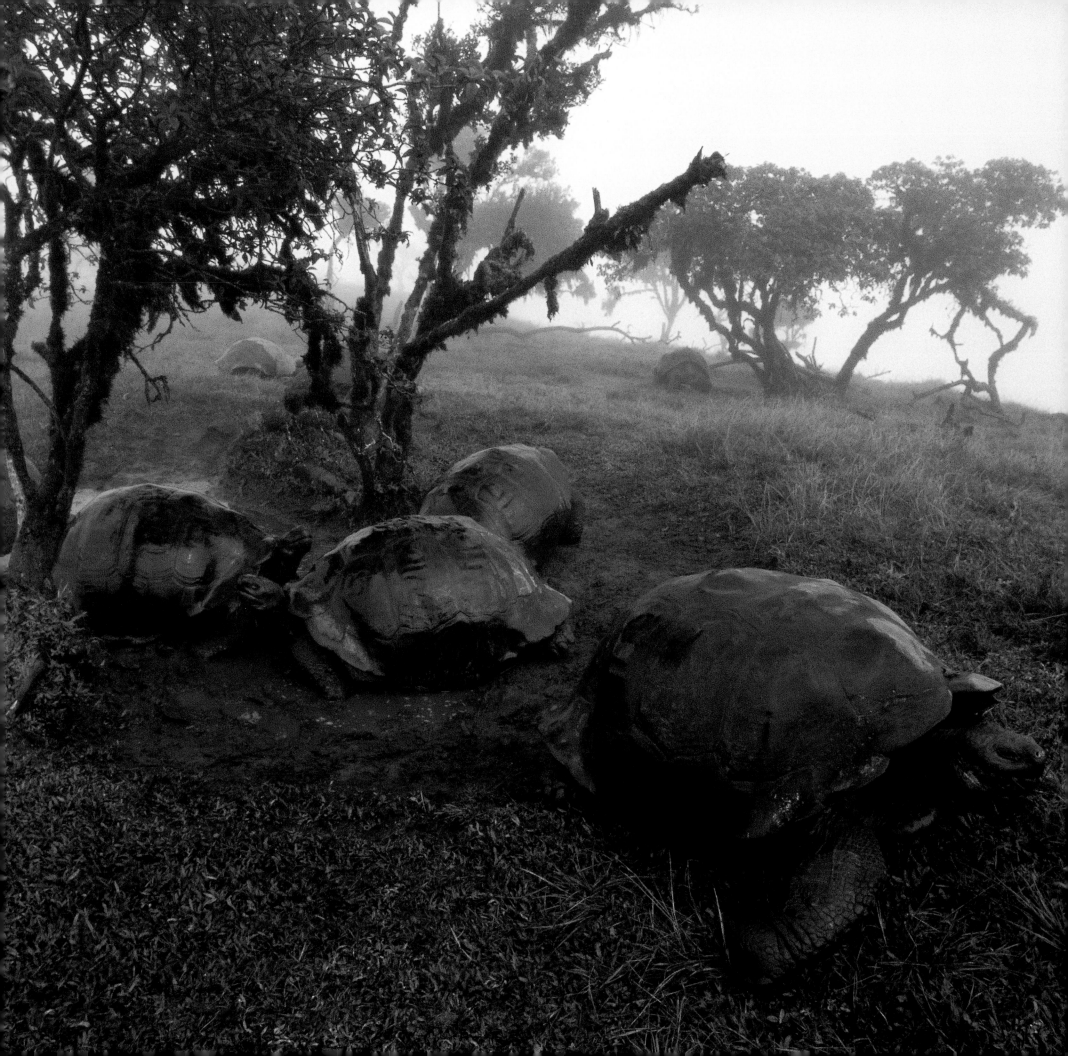

GIANT TORTOISES

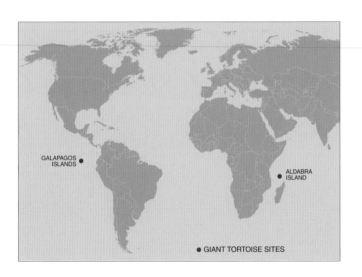

The scene opens on central Isabela Island in the Galápagos, the famous equatorial "tortoise islands" in the eastern Pacific Ocean. The mountain before us, formerly called Cowley and now Alcedo, is, at 1 200 m, the lowest of the five great volcanoes of Isabela, but has the largest population of tortoises in the archipelago. If a recent estimate of up to 10 000 tortoises is correct, Alcedo is home to half the Galápagos tortoises in existence. Near the eastern shore of Alcedo, the strange substrate of feather-light pumice blocks and boulders bears little vegetation, just isolated *palo santo* trees and dwarfish scalesias here and there. Steep-sided ravines, kilometers long, bear witness to rare flash floods that floated the very rocks out to sea. But halfway up the mountain, after two or three hours of hiking, the *palo santos* grow more densely and we find occasional, fist-size, elongate droppings composed entirely of compressed plant fibers, suggesting that, somewhere, there are animals larger than finches or mockingbirds on this mountain...

The terrestrial tortoises belong to the Family Testudinidae and, with some 50-odd species, are the second most numerous in the same order of reptiles that includes the turtles and terrapins. Their members are distributed mainly in the tropical regions of South America, Africa, India, and Southeast Asia, although in times past they also occurred in more temperate regions. Despite their lumbering, languid life-style, tortoises can be heart-stirring spectacles in their own right, not only through sheer beauty, as with the splendid radiated tortoise (*Geochelone radiata*), but by force of great size and numbers. The world's two largest tortoise species are found on opposite sides of the planet, but both species share two things in common: they are both found on islands, and they both can be seen in large aggregations.

Back on Isabela Island, our climb continues. Suddenly, right on the trail, a tortoise is sitting, head raised proudly in the air before it ignominiously withdraws head and limbs under its cupola with a sharp, gusty exhalation. This is the Galápagos tortoise (*Geochelone nigra*), the world's largest species, although this particular animal, while big, is not a giant; perhaps 60 cm long, we estimate 45 kg. We walk on. There are more tortoises, some smaller than basketballs, others bigger than a suitcase. We pass through picturesque, sylvan glades dotted with peaceful tortoises munching on leaves or just resting. We climb further. Abruptly, the trail is steeper, convoluted, almost closed in by bracken

On the opposite page, Galápagos tortoises (Geochelone nigra vandenburghi) *gathering together under a small tree on the rim of Volcán Alcedo, Isla Isabela, Galápagos.*
© Cristina G. Mittermeier

Above, a Duncan Island saddleback tortoise (Geochelone nigra ephippium) *in the Galápagos. Duncan Island was once a regular stop for whalers in the late nineteenth century. They took a fairly large portion of what was always a relatively small population, but the introduction of black rats almost 200 years ago has proven to be the most serious threat. The present population is about 150 adults. Since 1965, eggs of this species have been transported to the Charles Darwin Research Station for hatching and rearing, and so far 182 young tortoises have been returned to the island.*
© Tui De Roy

227

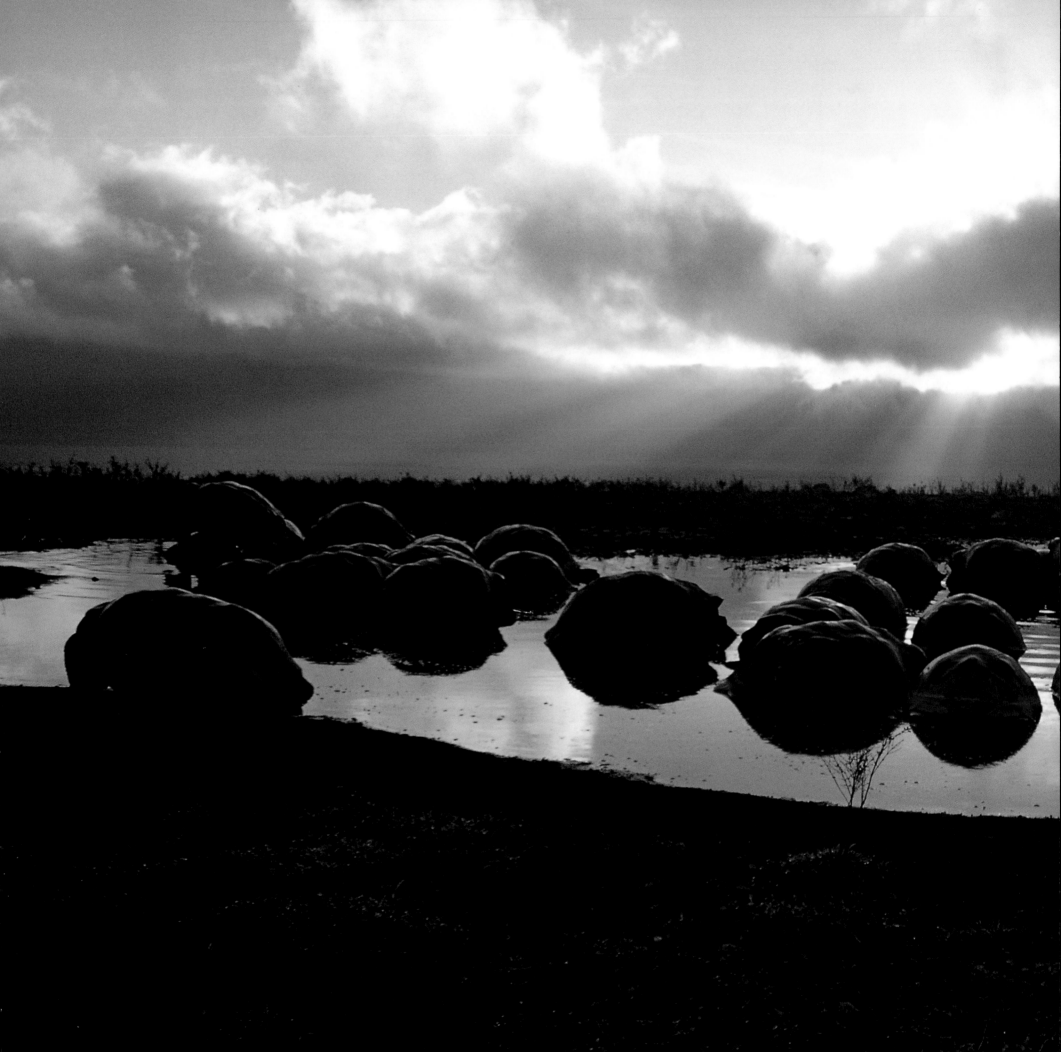

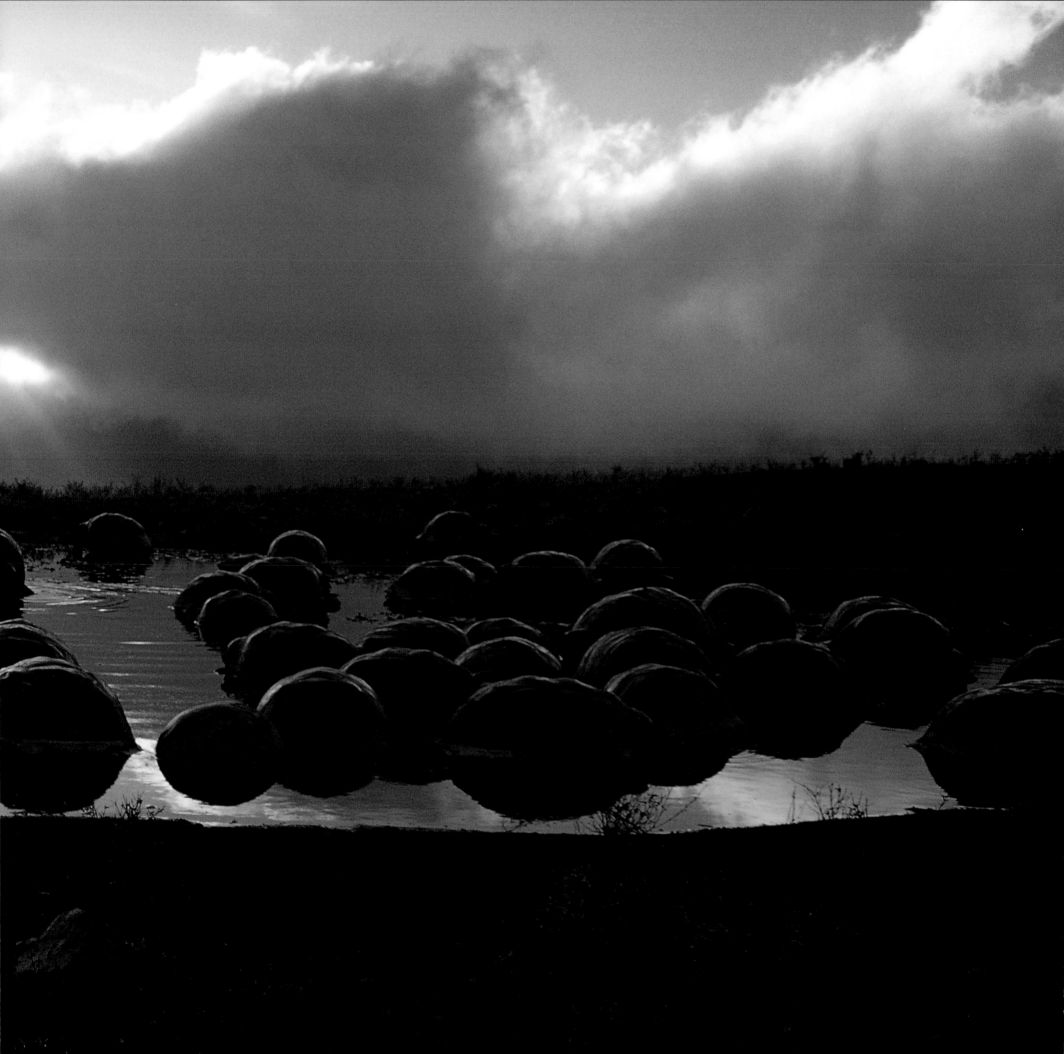

ferns, even tree ferns, giving the scene a montane, cloud-forest touch. Exhausted, we feel the rim will never be reached. But, finally, the latest of dozens of horizons does not give way to a higher one. We have reached the top.

As we sit to catch our breath, the thick clouds lift. Before us spreads an amphitheater of colossal proportions, a perfect caldera 8 km in diameter, its flat bottom, steep sides, and slightly undulating rim a city of tortoises. The encarapaced citizens gather in peaceful groups, patrol their highways and byways, graze on grasses and leaves and, from time to time, chase and mount each other, with otherworldly groans and cries. No other large animal lives here, although the tortoise hunters of the past left their burros behind, and goats are a new threat. The experience is unique. Elsewhere, wild creatures of this size often flee from human intruders, if not attack them, but here they gaze with mild curiosity, and resume the even tenor of their ways. They seem to have found peace, a sustainable life-style without the agonies of violent predation. But it is a fragile peace, perhaps even a doomed one, once its isolation is breached by the depredations of donkeys, goats, and people.

On the other side of the world, on Aldabra Atoll northeast of Madagascar, the world's only other surviving giant tortoise species, the Aldabra tortoise (*Geochelone gigantea*), also has a city of its own. But Aldabra, although once a volcano eons ago, is no longer a magnificent city on a hill like Alcedo. Instead, this sprawling, low-lying atoll, a mere fringe of land around a huge lagoon, is positively jammed with tortoises, passive players in a century-long cycle of boom and bust that may eerily presage our own fate. There may be 100 000 individuals on the island —the largest permanent aggregation of any chelonian anywhere. It is a city of hardship, of beat-up overgrazed landscapes, of poisonous, hot, salty pools of weird colors and strewn with shards and shells of dead tortoises, of old live tortoises too malnourished to grow to proper adult size, too run-down and hungry to breed. Every pothole in the viciously sharp champignon rock (mushroom-shaped outcrops of rock) contains more tortoise bones, animals whose fate was sealed following a single tragic misstep.

Fifty or sixty tortoises may crowd under each decent surviving shade tree in the heat of the day, packed in like cars in a city parking lot, or even stacked two or three deep, like old cars in a junkyard, to escape the fearsome heat. For Aldabra has no hills, no cool uplands. The grass is grazed down to the nub, and the hungry tortoises have to decide how far they dare walk from the shade in their search for food, and how soon they need to return to avoid dying in the sun. Sadly, the island is littered with the sun-bleached shells of those that miscalculated, the soft parts and all the portable bones dragged away by coconut crabs —or by the tortoises' cannibalistic brethren. This is a tortoise city indeed, but a shattered, inner-city neighborhood, a slum of a city, a Calcutta or Cairo perhaps, where life is hard for all, and prospects bleak.

But it is all part of a cycle. Aldabra is composed of a ring of four major islands, all with tortoises, and with only rare accidental exchanges of floating tortoises across the four fast-flowing channels that drain and refill the central lagoon with each tidal cycle. Things are currently tough on Grande Terre, the largest island; but on the others, a different, more gentle world is revealed, of shady groves of Australian pines, where tortoises are scattered but well fed, growing to twice or thrice the size of those on Grande Terre and, like the radiated tortoises in southern Madagascar 1 600 km to the south, their plain, dark shells display their entire history of annual cycles of growth alternating with lean periods of no growth. Even Calcutta and Cairo have their privileged citizens, their rich neighborhoods. And by the time these middle-class Aldabra tortoise populations peak and collapse from overcrowding, the tortoises of Grande Terre may be recovering. Life goes on.

PETER C.H. PRITCHARD

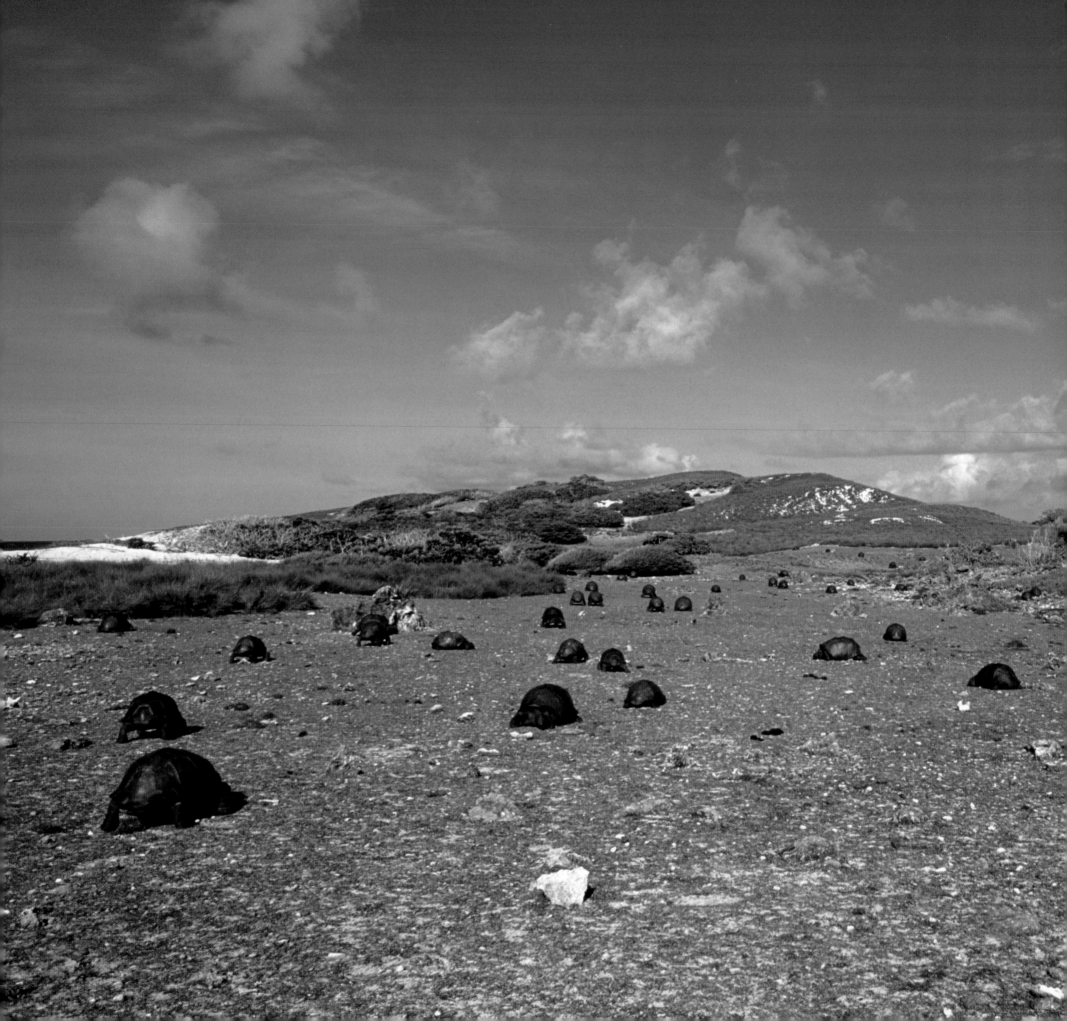

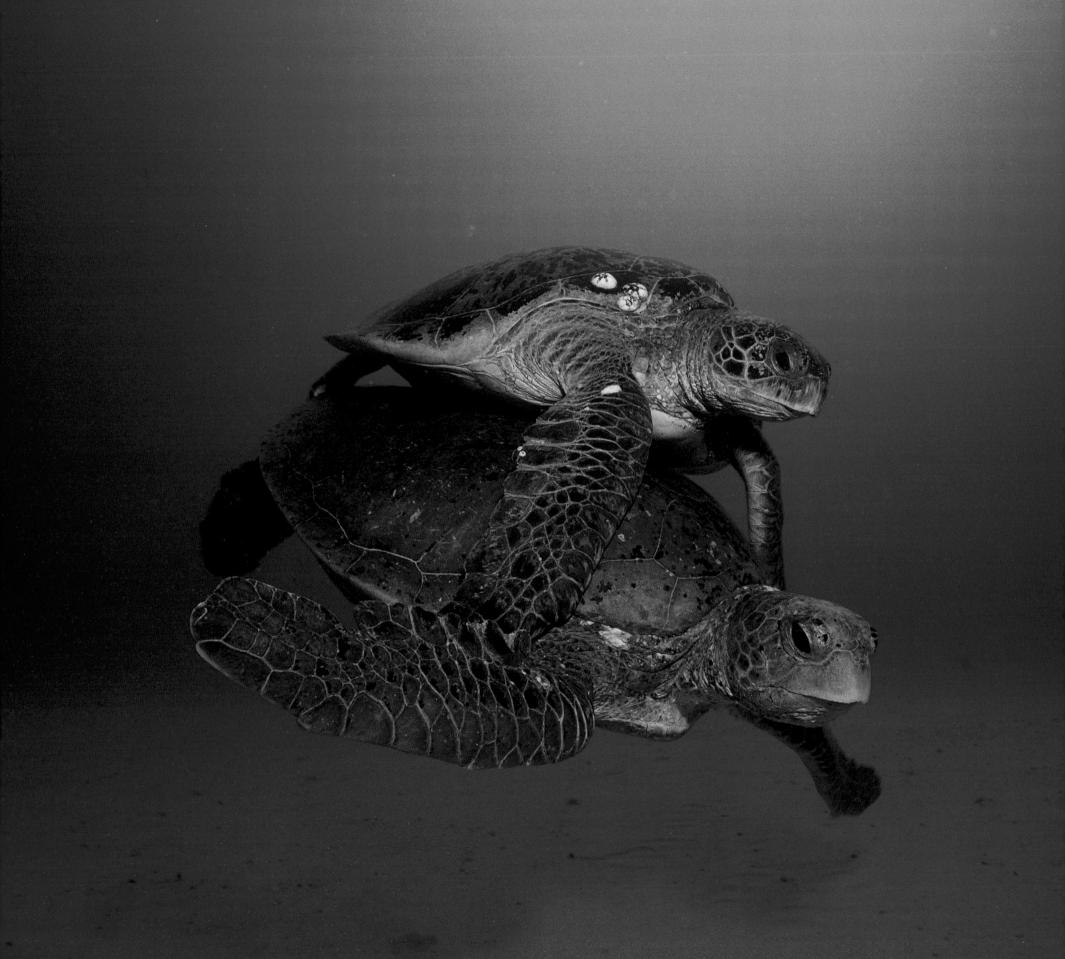

SEA TURTLES

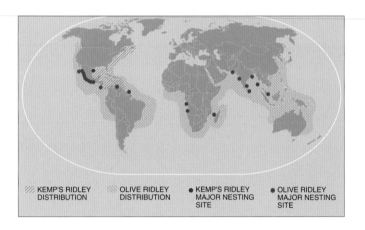

KEMP'S RIDLEY
DISTRIBUTION OLIVE RIDLEY
DISTRIBUTION ● KEMP'S RIDLEY
MAJOR NESTING
SITE ● OLIVE RIDLEY
MAJOR NESTING
SITE

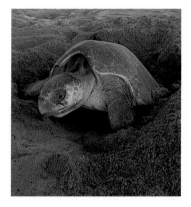

Of all the wildlife spectacles of the planet, one of the most compelling and primeval is that of the synchronous mass nesting of hundreds to thousands of ridley sea turtles (*Lepidochelys* spp.). In an ancient, nocturnal ritual they make their laborious way onto tropical sandy beaches in waves of heaving bodies to deposit their eggs. Such phenomena can still be experienced in a few select and remote corners of the world and serve as a reminder of what life was like in the Age of Reptiles, now long gone in the mists of time. Though greatly reduced from centuries of exploitation, small remnants of previous mass gatherings —called *arribadas*, Spanish for arrivals— are today seen in a few populations of ridley sea turtles.

The olive ridley (*Lepidochelys olivacea*) remains the most abundant of all sea turtle species, although the slaughter of vast numbers over the past 200 years has left even this chelonian classified as Endangered. During most of the year, ridleys range throughout the tropical Pacific, Atlantic, and Indian Oceans. When the time is right, they migrate, often great distances, to amass offshore at their nesting beaches. There they mate, and await that unpredictable moment when the moon, the offshore winds, and the tide precipitate the inception of the *arribada*. Then, the females come ashore, slowly at first, then building to a multitudinous wave, to dig their nests, deposit eggs, and return quickly to the sea. One of the world's principal olive ridley nesting beaches is Ostional in Costa Rica's Nicoya Peninsula, and to experience an *arribada* there is magical.

Gradually, vast numbers emerge along the shoreline. By late evening, countless shield-shaped forms cover the sand as far as the eye can see, gleaming wet in the moonlight, some even shimmering with a pale violet glow from bioluminescent biota on their shells. Intent on their mission, they drag their bodies up the sand beyond the high-tide mark. Sand is tossed in every direction as they excavate their egg chambers using their tactile rear flippers. Some produce a soft thumping as they rock from side-to-side, tamping the sand after laying a clutch of a hundred or more eggs, no larger in size than ping-pong balls.

Sometime after daybreak the last stragglers return to the sea, leaving behind a scene of natural devastation. An occasional turtle may find itself flipped over. The haphazard nesting of the night before has unearthed eggs by the thousands, in all stages of incubation. Flocks of vultures come from afar to enjoy the free dining, ghost crabs (*Ocypode* sp.) drag what hatchlings they can snag down into their burrows, and even the normally shy coatimundis (*Nasua narica*) nose about with impunity in full daylight, unable to resist the feast. Humans, too, harvest the fresh eggs, slinging enormous, white gunnysacks of eggs over the backs of pack burros for transport back to a collection center.

*On the opposite page,
green sea turtles
(Chelonia mydas) mating
on the Great Barrier Reef,
Queensland, Australia.*
© Howard Hall/howardhall.com

*Above, female olive ridley sea
turtle* (Lepidochelys olivacea)
*laying eggs at Escobilla Beach on
the coast of Oaxaca, Mexico.
Mass sea turtle nesting
phenomena called* arribadas,
*have made this beach famous. As
many as 300 000 turtles emerge
at Escobilla in just three nights.*
© Patricio Robles Gil/Sierra Madre

*On pp. 234-235, olive ridley sea
turtles coming to shore in a huge
arribada on a nesting beach
on the Pacific coast of Costa Rica.
The olive ridley is the most
abundant of the world's eight
sea turtle species.*
© Fred Bruemmer/DRK PHOTO

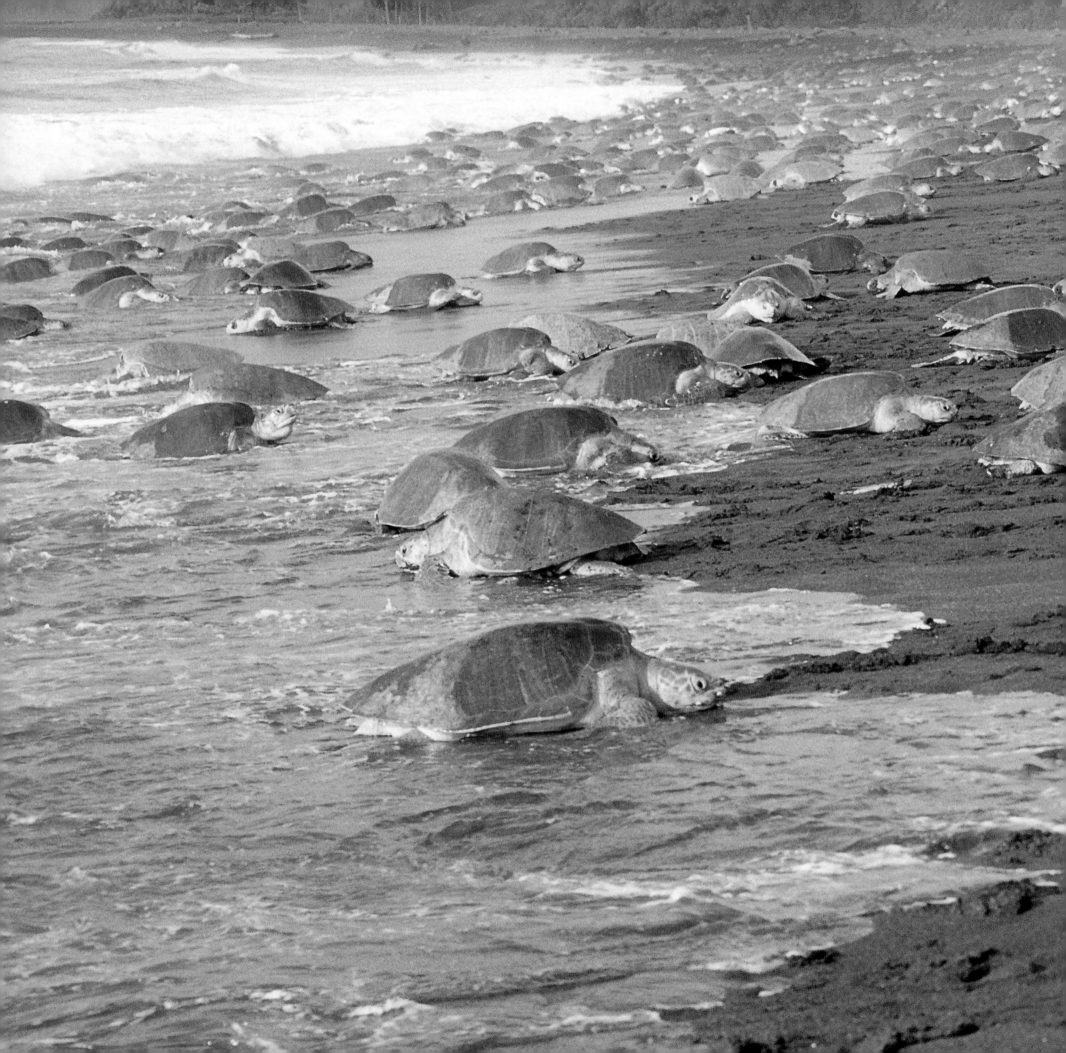

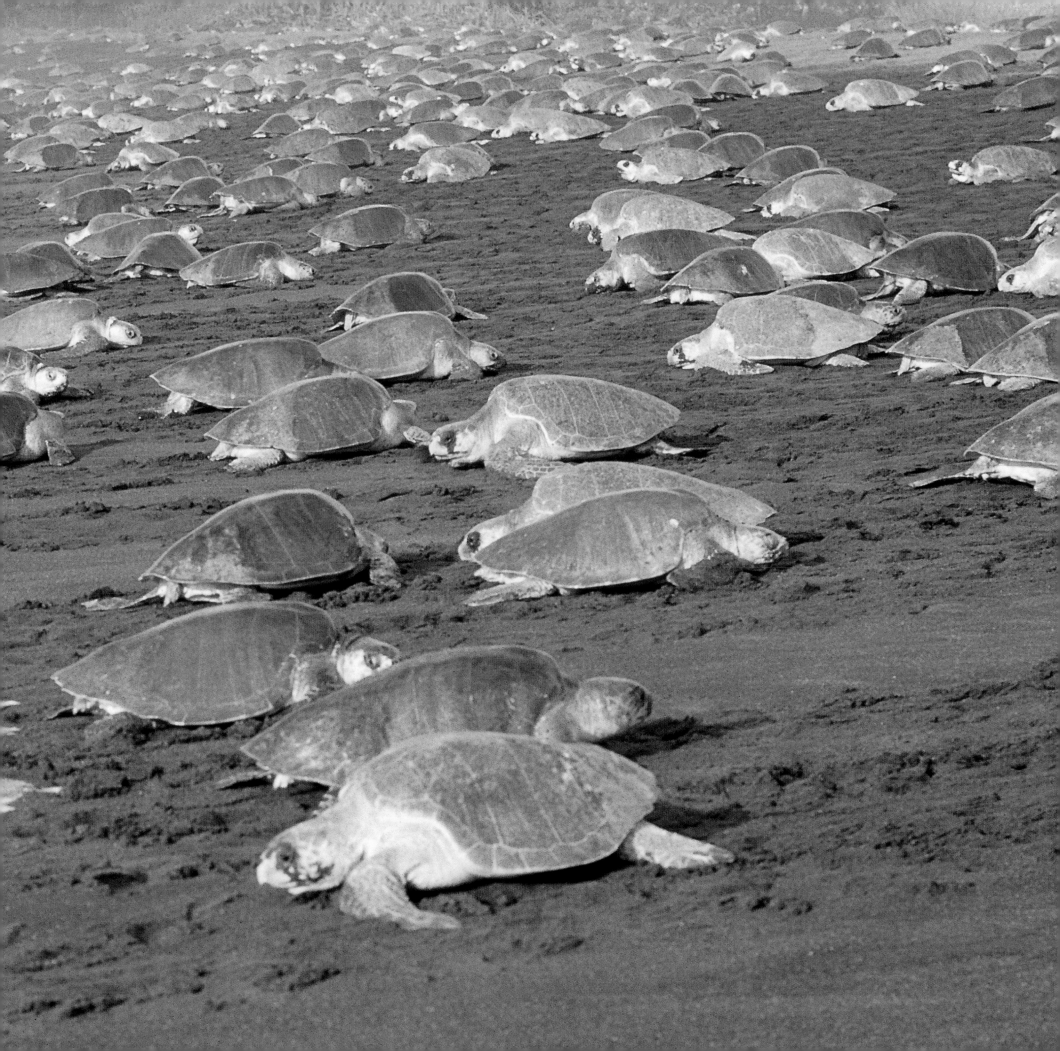

Sea turtle hatchlings confront many dangers, from sand crabs to raccoons, dogs, vultures, herons, and once in the sea, marine predators.
Above, three green sea turtle (Chelonia mydas) *hatchlings rushing to the sea; opposite: ghost crab preying on an olive ridley* (Lepidochelys olivacea) *hatchling. Both photos,* © Patricio Robles Gil/Sierra Madre

Despite the protected status of these turtles elsewhere in the country, the Costa Rican government allows a minimal harvest of turtle eggs from the first night of each 4-5 day *arribada* at Ostional alone, based on the assumption that the vast majority of the first night's eggs will be destroyed by subsequent nesters and may as well be collected to generate income for the local community. Turtle eggs are still considered a delicacy among locals and are used in baking to ensure moist cakes and breads. But they are more commonly served at bars aside a beer or whiskey, where they are eaten raw as a *boca* (snack) for their reputed aphrodisiac and medicinal qualities.

It is estimated that only 5% of the *arribada* eggs actually produce hatchlings at Ostional, given the destruction wrought by predators and the turtles themselves. An even smaller percentage of hatchlings reach the sea, with just the tiniest fraction surviving to adulthood. Yet olive ridley populations remain relatively robust, unlike those of its close relative, Kemp's ridley (*Lepidochelys kempii*). The smallest and the rarest of all sea turtles, Kemp's ridley was originally thought to be a hybrid between other species and was called the "bastard" turtle. The species has a single global nesting site along a small and isolated section of the coast of Tamaulipas in the Gulf of Mexico. When this nesting site was first discovered in the 1940s, the estimated size of a single *arribada* was 40 000 female turtles. By the time the population was first scrutinized by conservationists in the 1960s, it was discovered to be so gravely decimated that the Mexican and U.S. governments launched an immediate effort to save it from imminent extinction. An uncontrolled harvest of both eggs and adults, combined with incidental capture of turtles in shrimp trawlers, had left the numbers of Kemp's severely reduced. Today, the Kemp's total global reproductive effort yields only 500-600 nests, and estimated populations of Kemp's ridleys worldwide do not exceed 3 000 animals, a mere shadow of their former abundance. It is classified as Critically Endangered on the IUCN Red List. Fortunately, recent conservation efforts appear to be showing signs of success, with numbers of nesting females rising slowly over the last decade.

The only fully marine-adapted members of the Order Testudines (turtles, tortoises, and terrapins), there are eight sea turtle species falling into two families: the Cheloniidae (hard-shelled sea turtles) containing seven species in five genera —the green (*Chelonia mydas*), black (*C. agassizii*), flatback (*Natator depressa*), hawksbill (*Eretmochelys imbricata*), Kemp's ridley, olive ridley, and loggerhead (*Caretta caretta*)—; and a monotypic family, Dermochelyidae, the leatherback turtle (*Dermochelys coriacea*), a phenomenon in itself in many ways. The latter species is the most specialized, unique, and formidable of all living reptiles in the world, with the largest specimens having a shell measuring about 1.85 m in length and weighing in at over 900 kg.

The threats to sea turtles worldwide are many and range from habitat alteration and destruction to the more direct impacts of hunting, egg harvesting, and incidental capture. Turtles have long been a source of protein for coastal peoples wherever they occur, and hunting remains a substantial threat to green turtles and black turtles in many areas. Sea turtles have also fed luxury markets, including a former heavy trade in green turtle calipee (fat) for turtle soup in Europe and the U.S.A., a taste that has now mostly disappeared, and trade in tortoiseshell (*bekko*), the product that derives from the scutes of the hawksbill turtle. All species are considered at least threatened on the IUCN Red List. Fortunately, all international trade in sea turtles or their products, including tortoiseshell, is now prohibited under CITES regulations.

Marine pollution and disease pose threats as well, but perhaps the greatest and most insidious danger to sea turtles today are the impacts of commercial fisheries causing incidental mortality, especially as bycatch in shrimp trawlers and long-line and gill-net fisheries. This is the principal cause of what is perhaps the most urgent conservation situation affecting sea turtles today, that of the precipitous decline in leatherback populations worldwide and their near extinction in the Eastern Pacific. The leatherback is considered Critically Endangered, perhaps more so than even Kemp's ridley, as its numbers have dropped over the past decade from tens of thousands to mere dozens of turtles nesting on the beaches from Mexico to Panama.

Numerous conservation agencies, government and private organizations are doing their part to conserve sea turtles, but there is still much progress that must be made. The government of Costa Rica established the Baulas de Guanacaste National Park at Playa Grande as a refuge for the leatherback, and it now stands as one of the last remaining safe areas for their reproduction in the Eastern Pacific. Thanks to the efforts of the Costa Ricans, as well as international conservationists, the park is being expanded through land purchase. Meanwhile, research continues to shed light on new ways to better manage the species. Playa Grande is part of the Galápagos-Cocos Seascape, a newly conceived marine and terrestrial hotspot program designed by Conservation International which was launched at the World Environmental Summit held in Johannesburg in August 2002. Only if such initiatives can be translated into successful conservation action will the spectacular phenomenon of the world's sea turtles survive.

RODERIC B. MAST
ANDERS G.J. RHODIN

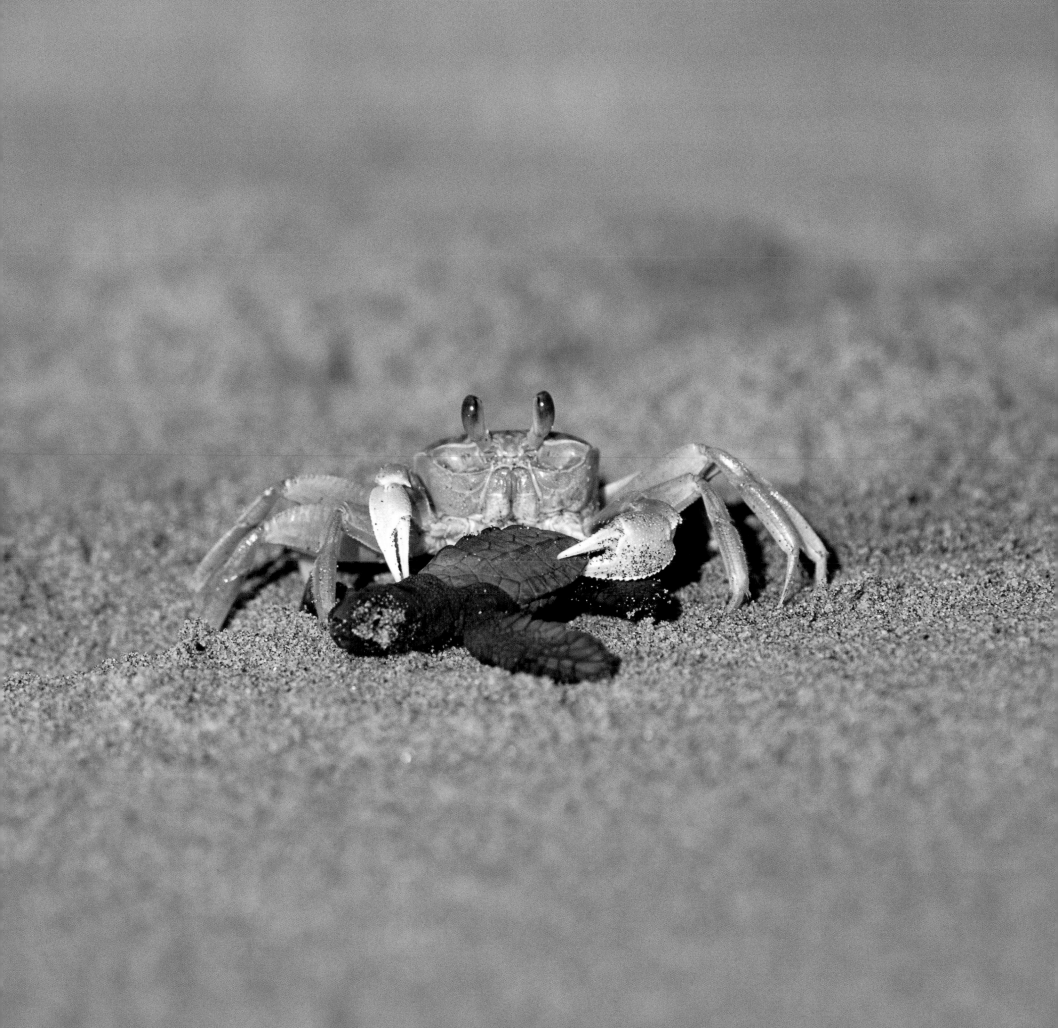

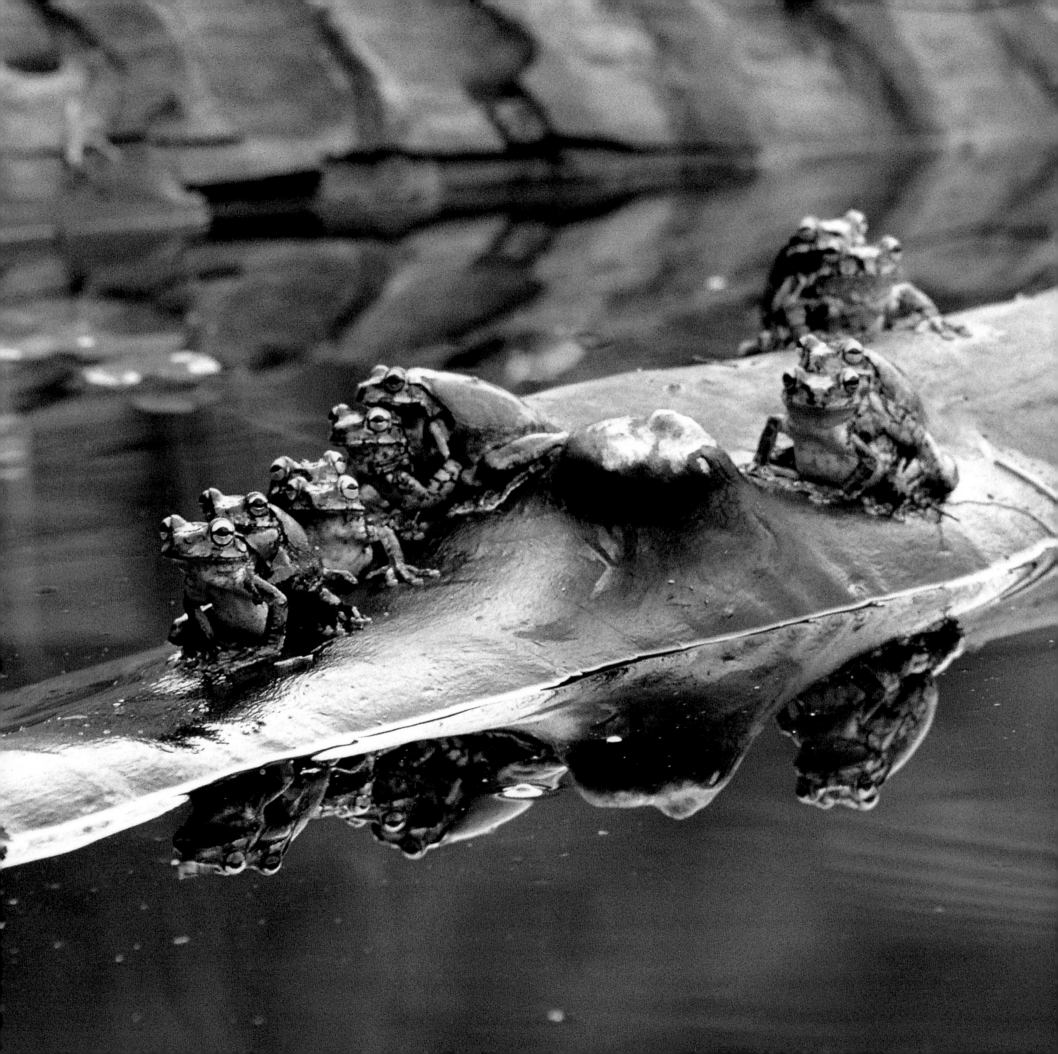

FROGS, TOADS, AND SALAMANDERS

It had been raining solid for days and we were beginning to think that we would need a canoe to get out of what is normally "terra firme" (solid ground) forest. Of course, for a frog lover, this was the deluge of a lifetime. We headed out to the usual upland ponds where, on a good night, anywhere between five and 15 species of tropical rain-forest frogs can be found calling and breeding around a small set of temporary ponds. The ponds were about 1 km from camp and along a trail cutting through a plateau. To our surprise, well before we arrived at the upland pools, we started hearing the long trill call of an elusive micro-hylid, the Guyana humming frog (*Chiasmocleis shudikarensis*). It turned out that a flat area of a few hectares had flooded due to the extraordinary rains of the past two days. The sound was deafening, as there must have been several thousand individuals floating on the surface of the water and singing their hearts out. This was a spectacle to behold, since finding just one individual of this most elusive species already constituted a treat.

Amphibians are excellent examples of animals that come together in large aggregations, mostly for breeding. In fact, a large proportion of the more than 5 500 species worldwide breed in or around aquatic habitats in large groups where males call from a variety of perches to attract females that choose their mate. While some species will breed in large, multi-species aggregations, as in the tropical flooded forests along the Amazon River and its tributaries, for lengthy periods of time during the rainy season, many species remain hidden for most of the year and only appear for a few nights when the conditions are perfect. In these cases, aggregations can be huge, on the order of tens of thousands.

Microhylids, or narrow-mouthed frogs, are notoriously explosive breeders and many of them remain elusive for much of the year, burrowing underground. This behavior is also common in many other species, for example, a number of the widespread dry savanna frogs of Africa including the crowned bullfrog (*Hoplobatrachus occipitalis*), ornate frog (*Hildebrandtia ornata*) and, most especially, the African bullfrogs (*Pyxicephalus* spp.). The latter spend the dry season in underground cocoons, and emerge at the start of the rains to form explosive breeding aggregations in temporary waters, only to vanish again after breeding. The water-holding frogs (*Cyclorana* spp.) of Australia have similar habits, and migrations in the estimated tens of thousands have halted automobile traffic and even the transcontinental railway in central Australia.

Not all explosive breeders disappear from sight outside the breeding season. For example, the African dotted reed frog (*Hyperolius guttulatus*) is distributed patchily in west and central Africa but, where it does occur, it breeds in huge aggregations in large

swamps and permanent pools in secondary habitats in the forest zone. These breeding aggregations have given rise to remarkable adaptations. Males of a closely related reed frog species, the common reed frog (*H. viridiflavus*), can detect the density of males calling in a chorus and, when the competition for mates becomes too great, some males actually change their gender. By turning into females in a male-biased aggregation, these individuals increase their chances of passing on their genes.

Many temperate common species also demonstrate this type of explosive breeding habit. In North America, it is not uncommon to see large aggregations of wood frogs (*Rana sylvatica*), northern chorus frogs (*Pseudacris triseriata*), American toads (*Bufo americana*), and spring peepers (*Hyla crucifer*), bathing and calling in large groups in ponds still partly covered in ice after a long winter. There are similar examples from Europe, with the natterjack toad (*B. calamita*) being particularly well known for its huge breeding aggregations.

In addition to the frogs, several salamander species are explosive breeders. The Siberian newt (*Salamandrella keyserlingii*), the most widely ranging amphibian species on Earth, literally thaws from a deep freeze across northern stretches of Asia to breed in the thousands in pools that form from melting snow and ice. This salamander is remarkably adapted to survive in a frozen state of as low as –40ºC for as much as 75% of the year. Other explosive breeders include the ambystomatid salamanders of North America, which live largely solitary and subterranean lives for most of the year across several terrestrial landscapes ranging from deserts to deciduous forests. During rain events at particular times of the year, these species surface and aggregate to breed in ponds and other quiet waters. On the night of September 5, 1999, the torrential rains of Hurricane Dennis initiated a mass-breeding migration of the marbled salamander (*Ambystoma opacum*) at the base of the Blue Ridge Mountains. On this night, we documented a breeding aggregation of over 5 000 adults in a cluster of three small temporary ponds. These normally hermitic animals aggregate over the course of a few nights to breed terrestrially in and around dry pond beds. Males display dramatic courtship dances with their tails waving high in the air to attract females. The females brood their eggs for weeks to months in simple nests that they construct under logs and leaf litter in the dry pond basins. Mothers remain with their clutches until the ponds begin to fill with water, whereupon gilled larvae hatch from their eggs and the females return to their underground retreats throughout the forest. The breeding event we witnessed gave rise to over 12 000 metamorphic salamanders that emigrated en masse from the ponds in May. Temporary wetlands are among the most produc-

tive environments on Earth. The mass transfer of energy from these ephemeral pools to terrestrial habitats by amphibians is only beginning to be understood and has untold importance to the health of forests and other terrestrial ecosystems worldwide.

Large aggregations that represent highly significant portions of a species' entire population are also common. Perhaps the best-known case of this is that of the golden toad (*Bufo periglenes*) from the cloud forest of Monteverde in Costa Rica. This recently extinct species was restricted to an area of mountaintop of less than 10 km² and bred in groups of several thousands. Competition for females was so fierce that "frog balls" would be common, where many males would try to mate with one female. Such narrow-ranged explosive breeding species also include salamanders such as the Chinhai spiny newt (*Echinotriton chinhaiensis*) and the Anji hynobiid (*Hynobius amjiensis*) from Zhejiang Province, China. The global populations of both species are only about 300 mature individuals, restricted to two and five ponds, respectively.

While there are great amphibian breeding spectacles in nature, this group in general, and frogs in particular, are being severely threatened by a variety of sources. The reasons are complex and include everything from loss of habitat, water pollution from urban and agricultural development, ultraviolet radiation, climate change and, more recently, the appearance of a chytrid fungus that is associated with declines in frog numbers all over the world. It seems likely that those species that form large breeding aggregations are particularly at risk, especially when their breeding sites are lost. One good example of this is a beautiful newt species, the Yunnan lake newt (*Cynops wolterstorffi*), which became extinct when its only known breeding site in a lake in southwestern China became severely polluted.

In this case, complex problems will require complex solutions for the conservation of amphibians and most certainly some emergency rescue operations in the short term. In some regions, the proportion of species that are considered Endangered or Critically Endangered on the IUCN Red List is huge, and if nothing is done, we will be faced with the largest single most important group of extinctions for a vertebrate group. A large-scale, multi-disciplinary approach is needed to address the variety of threats, from site-specific conservation action to research by atmospheric scientists and animal physiologists. Protected areas will be important for long-term conservation and will combat threats of habitat loss and the like; however, as is the case of the golden toad in Costa Rica, many species are disappearing from pristine areas whether they are protected or not.

CLAUDE GASCON SIMON STUART DON CHURCH

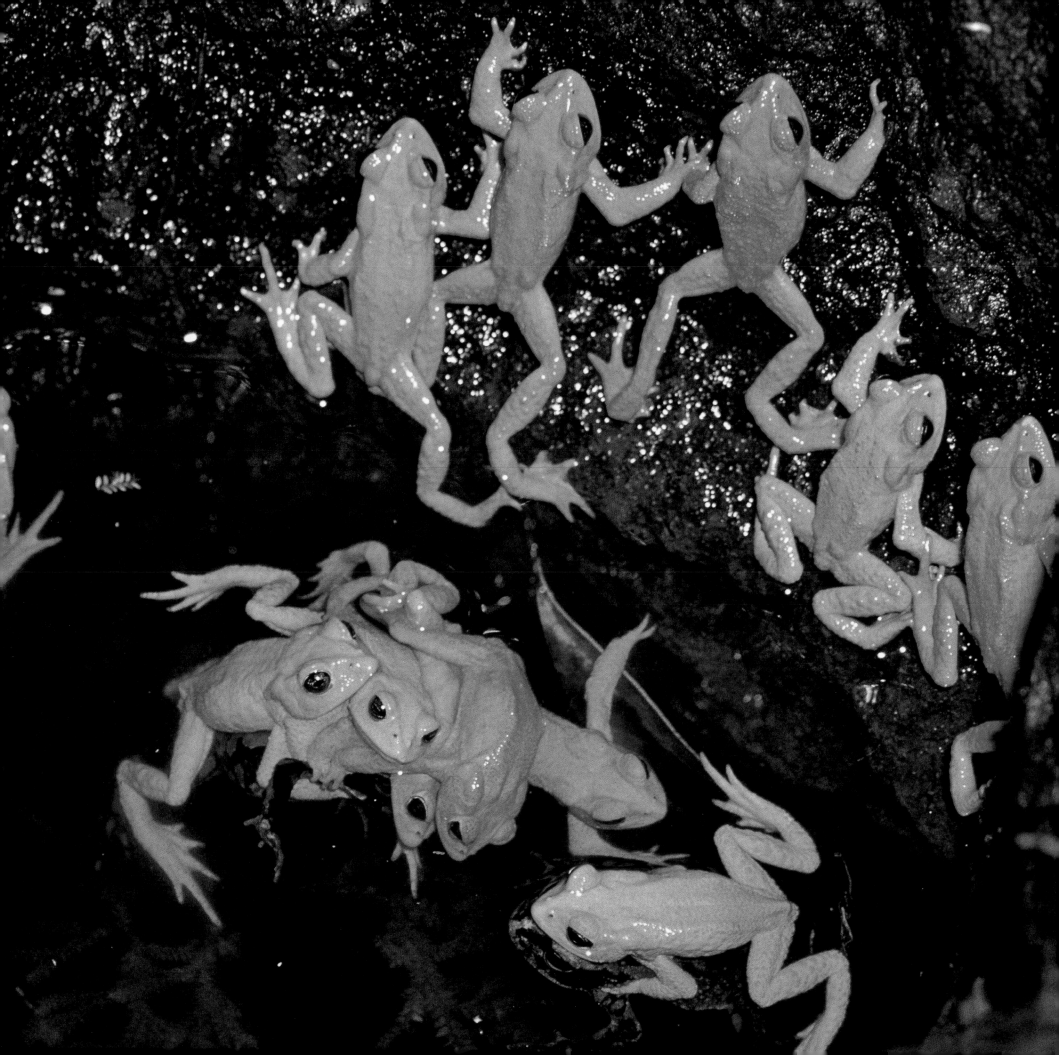

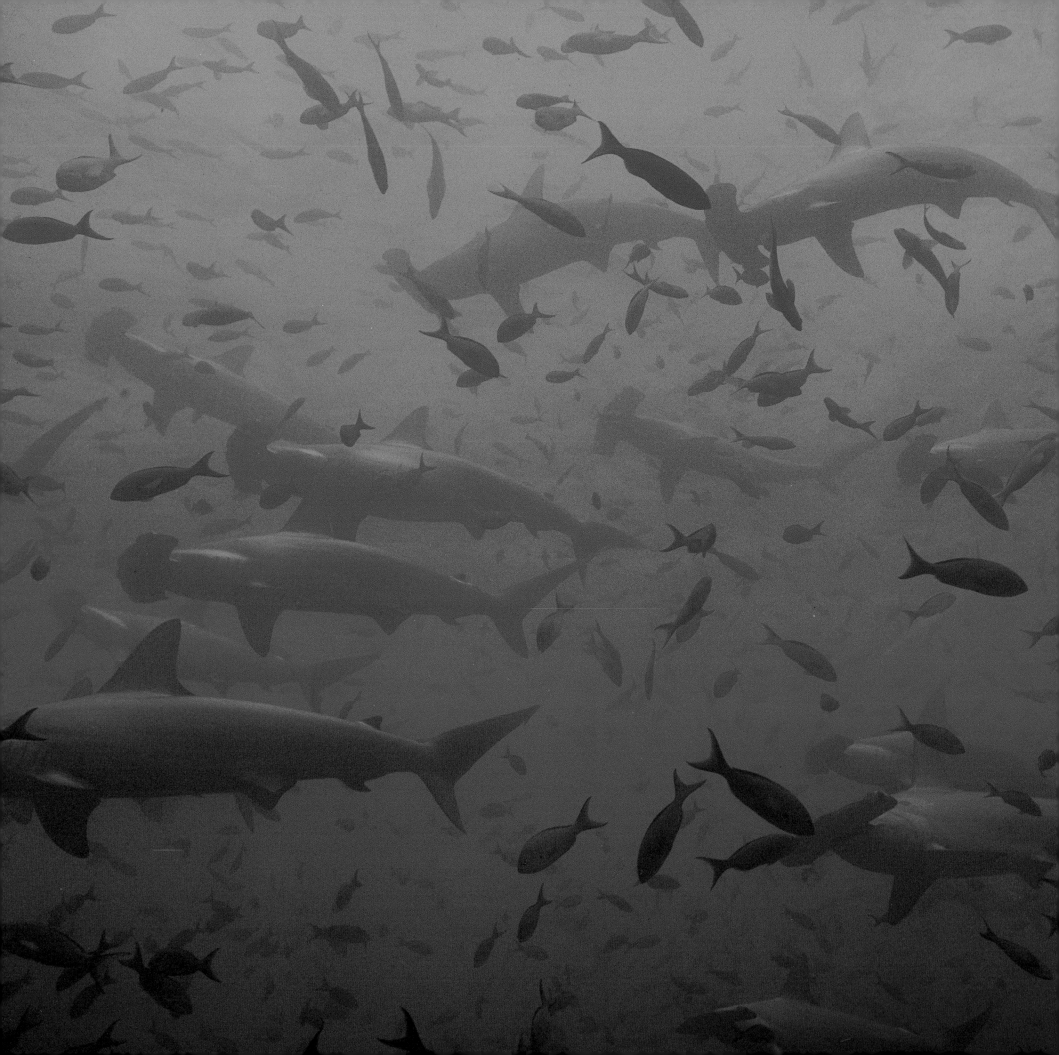

HAMMERHEAD SHARKS

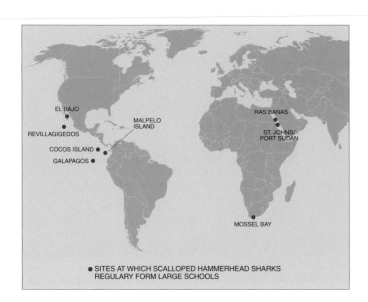

● SITES AT WHICH SCALLOPED HAMMERHEAD SHARKS
REGULARY FORM LARGE SCHOOLS

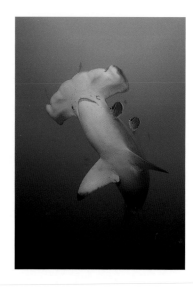

Finding yourself in the midst of a congregation of hammerhead sharks is an exhilarating wildlife experience. There are few more thrilling feelings than jumping into the ocean, only to discover, just a few meters below you, a ghostly parade of two- to three-meter-long hammerheads. Typical emotions range from disbelief, to panic, to awe. It takes but a second to realize that you are also surrounded by thousands of sharp teeth and, although hammerheads rarely pay any attention to divers, they have been classified as one of the ten most dangerous shark species on the planet, even though they feed mostly on bony fishes, various marine invertebrates, and even other elasmobranchs, such as stingrays and smaller sharks.

Hammerheads, or sphyrnid sharks, are one of the most remarkable fish in the oceans. Nine species are currently recognized, and all are characterized by a uniquely characteristic, mallet-shaped head known as a cephalofoil. Scientists believe that this remarkable structure acts as a bow plane providing hydrodynamic lift and increasing maneuvering capabilities. The position of eyes, nostrils, and other sensory organs at the lateral ends of the head also offers potential advantages for electroreception, which may be the key to their migratory behavior. Hammerhead shark species vary widely in coloration, ranging from the bright orange small eye or golden hammerhead (*Sphyrna tudes*) to the more common olive-green/gray smooth hammerhead (*S. zygaena*); they also vary in size, from the tiny bonnethead hammerhead (*S. tiburo*) at just one meter long to the gigantic great hammerhead (*S. mokarran*), which can reach six meters in length. Most remarkable are the variations in the size and shape of the cephalofoil, which can vary from relatively modest in size —less than 30 cm across in the case of the bonnethead— to truly spectacular, as is the case with the winghead shark (*Eusphyra blochii*), which has a head nearly half as wide as the body is long, giving the shark the appearance of a letter "T" when viewed from above.

Hammerhead sharks are found in tropical and subtropical waters of all oceans. Their distribution is confined to coastal and offshore continental and insular waters, from the intertidal zone and the surface down to at least 275 m. Hammerheads are not benthic, they do not range into deep water, and they are not considered truly oceanic, but are highly mobile and migratory. Although several of the species in this group occasionally congregate, it is the scalloped hammerhead (*Sphyrna lewini*) that has

On the opposite page, scalloped hammerhead sharks (Sphyrna lewini) *swimming in a school of creolefish at Deep Wall, Culpepper Island in the Galápagos. Some experts believe that mating, not feeding, may be the principal motive for this kind of grouping behavior.*
© Tui De Roy

Above, hammerhead sharks gather above seamounts to be cleaned by barberfish, Cocos Island, Costa Rica.
© Michele Hall/howardhall.com

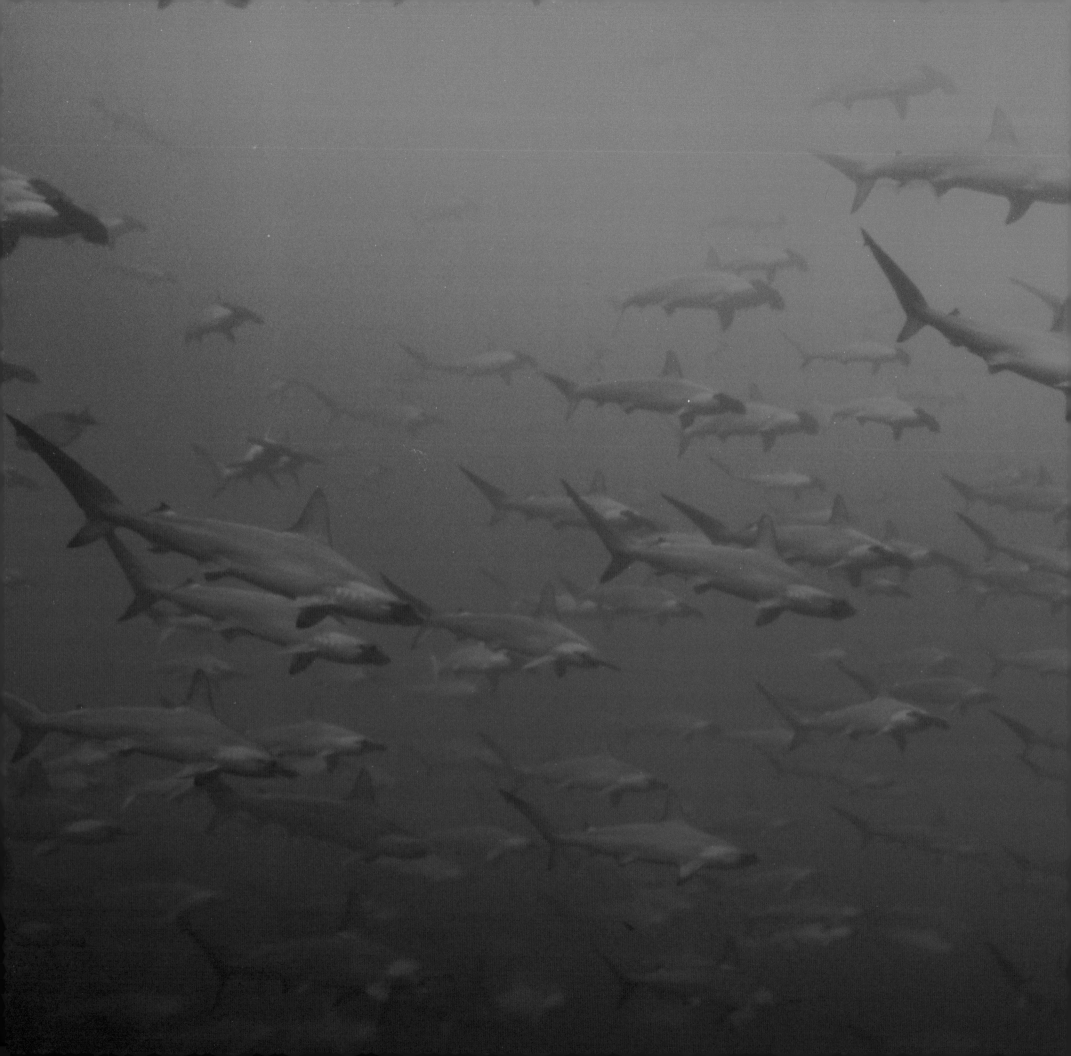

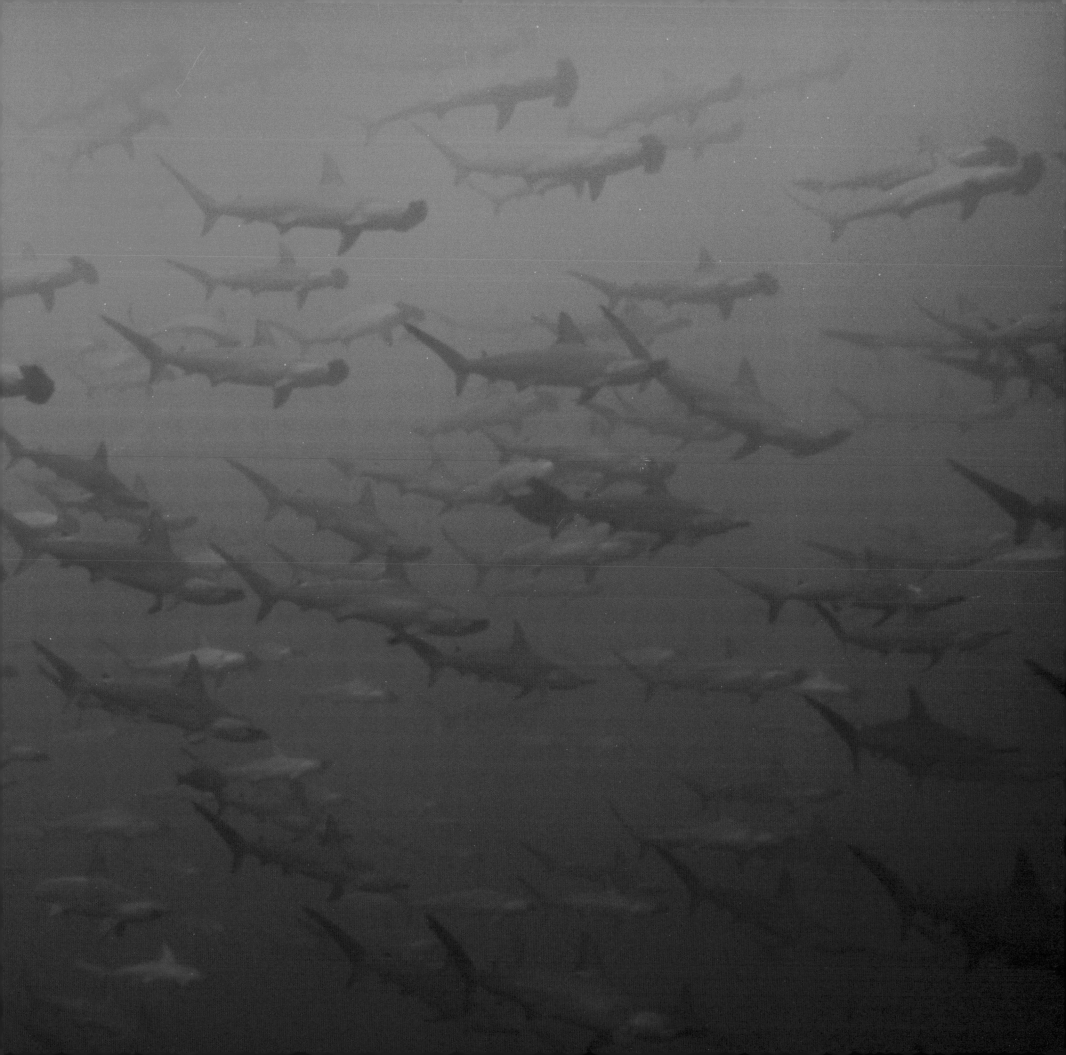

became famous for forming large schools, sometimes up to 500 individuals strong. Such schools have most often been observed in the Gulf of California, the Revillagigedo Islands, and Cocos Island in the Western Hemisphere, but have also been reported from Australia, the southern coast of Africa, and the Sudanese Red Sea, among others.

Adult scalloped hammerheads do not spend their entire lives in these congregations, but segregate during certain phases of their life cycle. Early on it was believed that the sharks were converging around the seamounts because of the abundant sea life found there, but recent research shows that the hammerheads gather at the seamount during the day, but feed elsewhere at night. Mating is a more likely reason for these congregations. Hammerhead schools are primarily formed of females, ranging in size from sub-adult to adult, and there is a dominance hierarchy among them. The largest, fittest, most fecund females occupy the center of the school, and the males wander into the center to find a mate. This behavior helps ensure that these prime females are the ones that procreate.

Many also believe that the gathering of hammerheads around seamounts and the sharks' movements in the waters beyond may be related to their response to magnetic fields, made possible by the presence of electro-receptors at the bottom of the cephalofoil. Telemetric research has shown that after spending the night feeding elsewhere, the sharks return to the seamount in the early morning, consistently following the same paths. They seem to use the seamounts as a kind of magnetic landmark and the geological magnetic bands surrounding these volcanic structures as invisible underwater roads. When the sharks continue their migration and leave their schooling sites near seamounts each year, the animals may follow magnetic "highways" across the ocean floor —swimming from landmark to landmark using the seamounts as "stepping stones."

Although little is known about the migratory behavior of hammerhead sharks, it is clear that, while some populations remain stationary, others migrate in the direction of the poles in summer. Some sexually related migrations, in which females undertake migrations during particular periods of their sexual development, have also been observed.

Being apex predators with relatively few enemies, the largest threat to all species of sharks today is the shark-fin industry. With long lives, low reproduction rates, and a late onset of matu-rity, these animals, which often produce less than ten pups every two years, are a tragic target for large, commercial-scale fishing schemes. According to fishing statistics compiled from the 15 main fin exporters out of a total of 150 countries that trade shark fin (Indonesia, Spain, India, Pakistan, Taiwan, U.S.A., Japan, Mexico, Sri Lanka, Argentina, Malaysia, France, New Zealand, Thailand, and Brazil), some 3 745 tons of dried fins from various shark species —at a price of US$50-150 per 200 g— made their way to Hong Kong, making this the nerve center of the shark-fin market, which has been valued at 953 million Euros per year, and is clearly unsustainable even in the short term.

The IUCN lists the scalloped hammerhead as Near Threatened because this species is often heavily exploited by inshore fisheries and is commonly taken in fisheries, both as a target species and as convenient bycatch. Lack of data on population trends makes it difficult to assess whether the high level of catches of this species at all life stages is having an effect on stocks, but some declines are reported, and those of us who enjoy them more as wildlife than "soup", know that every day many more go missing. In 1994, CITES passed a resolution dealing with "The status of international trade with sharks" and together with the Food and Agricultural Organization and other international organizations responsible for fishery management, has created the FAO International Plan of Action for Sharks, a voluntary mechanism to collect data on the biology and trade of sharks. Clearly, much more needs to be learned about the biology and ecology of hammerhead and all other sharks before any meaningful fishery legislation can be drafted to protect their populations from unsustainable exploitation. But progress is being made. Several countries, including the United States and South Africa, are among the first ones to pass legislation protecting sharks, and the total shark catch for other countries, like Australia and Canada, has at last now dropped below 10 000 tons per year. Although not nearly enough, this is a good start that needs to be followed with more concrete actions that help ensure the continued presence of sharks in our oceans.

CRISTINA G. MITTERMEIER
SYLVIA A. EARLE

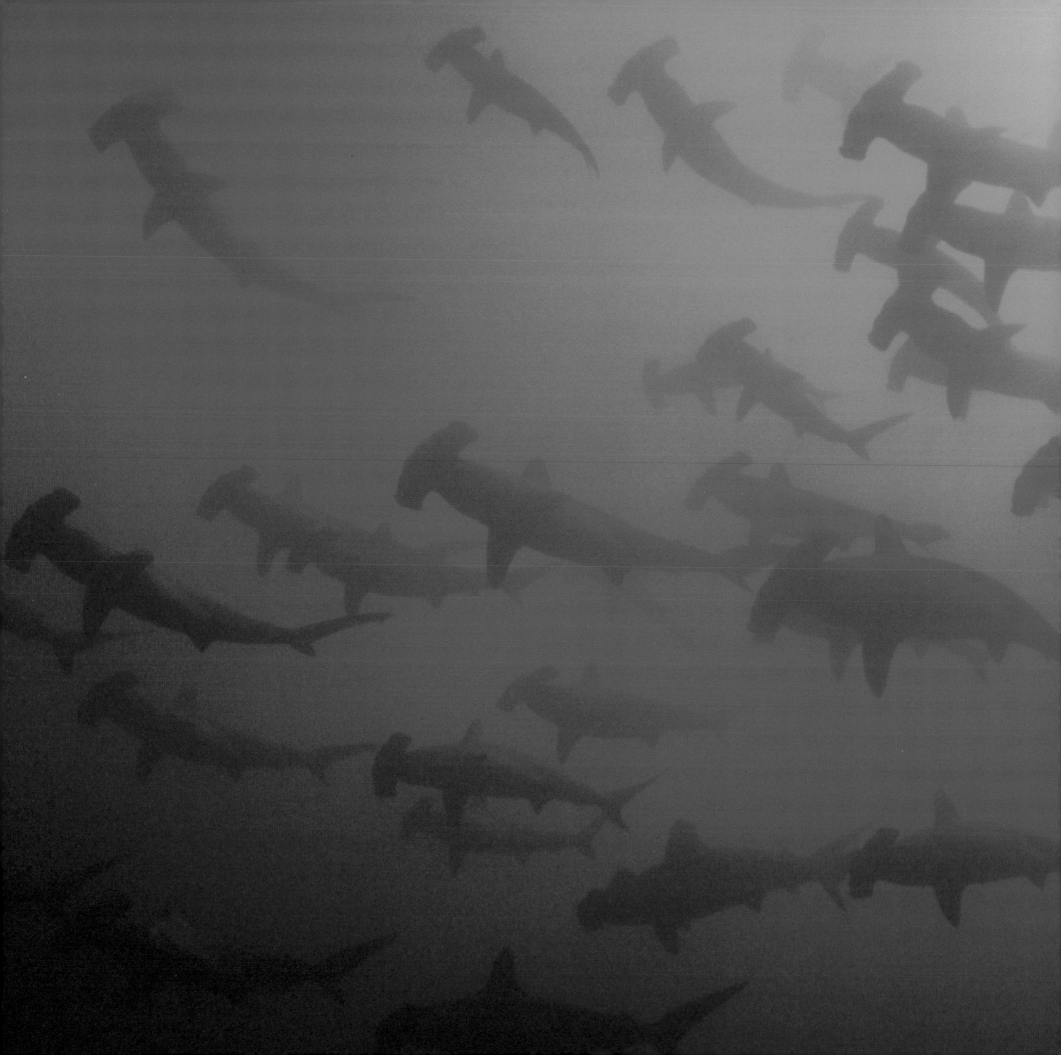

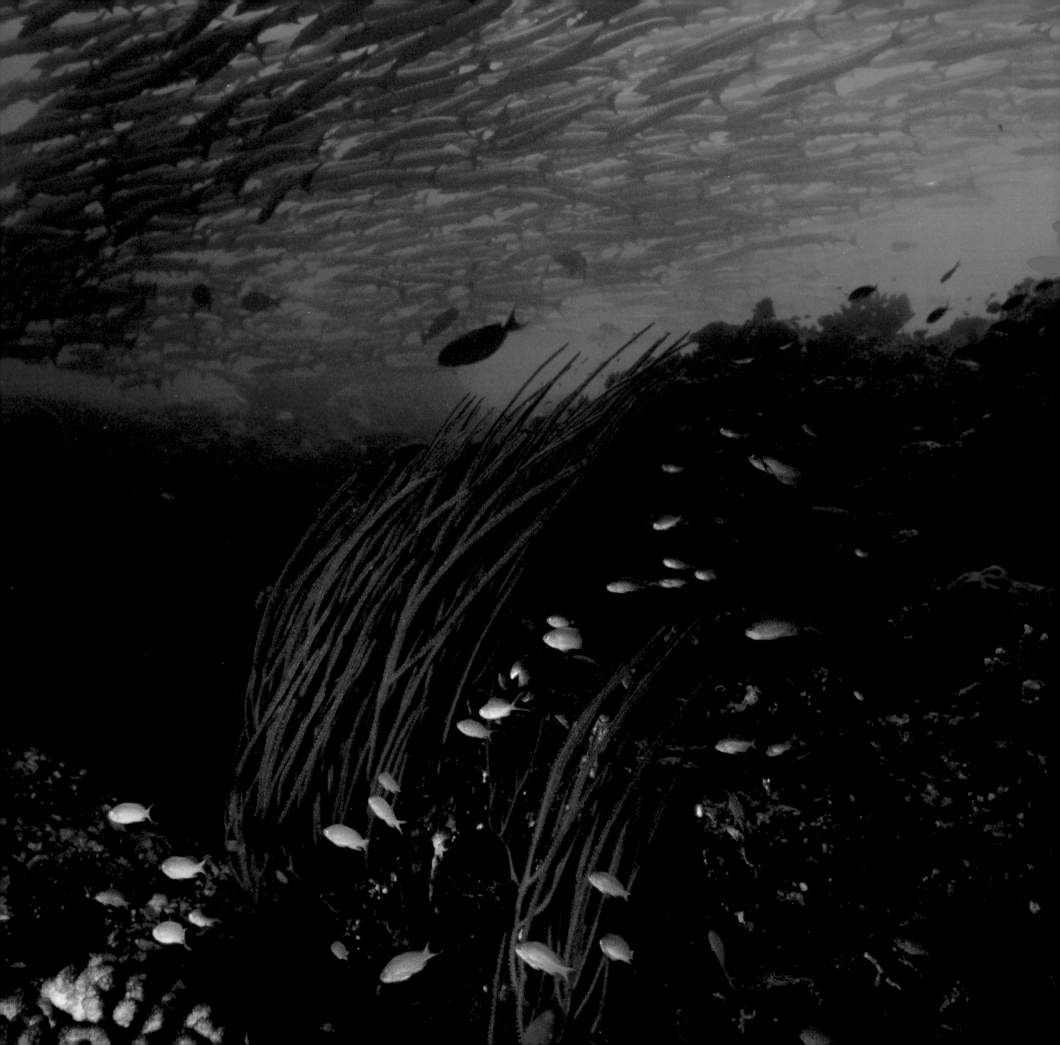

SCHOOLING FISH

The moonless October night in the fishing port of Guaymas, Mexico was shrouded in complete darkness as we took off in a small single-engine plane into a pitch-black sky in search of the common sardine (*Sardinops caeruleus*). The only thing keeping us from plunging into the inky depths of the Sea of Cortés were the cockpit's instruments and the experience of our pilot.

We flew across the entire gulf, and just as we were approaching the Baja California shore, out of the darkness emerged a sudden glow: a school of sardines was moving in the midst of the small microscopic alga (*Noctiluca* sp.) which, when disturbed, gives out a remarkable phosphorescence. It was a liquid dance in which we were able to perfectly see the school of fish as it submerged, elongated, extended, and compacted itself in an exquisite aquatic ballet. The plane called in the precise coordinates of the school of fish to a nearby fishing ship. In no time the chase was on, and although the sardines tried hard to elude the vessel, in a matter of minutes they were enclosed in a purse seine and over one hundred tons of sardines, comprised of millions of individual fish, were dumped into the dark holding tanks of the fishing boat.

We often think of animals in terms of their usefulness to humans. Therefore, it is no wonder that we more often picture schooling fish as a resource, meant to be caught and consumed, and not in terms of their beauty, their ecological role, and their importance in the balance of nature. Actually, few of us have ever had the unbelievable experience of being in the midst of a large school of cruising fish. Being in the water, completely out of one's element, and on a collision course with an enormous mass of fish, is both awesome and thrilling. A school of fish looks and behaves like a single organism, and just when you think this colossal gathering is going to hit you, it miraculously parts, as if cut by an invisible hand, and the fish swim around you, without even brushing you. This is possible thanks to a highly sensitive lateral line that gives fish the remarkable ability to "feel" objects in the water and respond with lightning-speed to their surroundings.

Like other animals, fish can group together in many kinds of aggregations, perhaps attracted by concentrations of food or other limited resources. But a school of fish is not merely an aggregation; it is a unique phenomenon with very special properties. Schools are composed of fish moving in such near synchrony and unified responsiveness that their overall movements seem to be those of a "superorganism." Individuals tend to arrange themselves in certain configurations, maintaining predictable distances and orientation to each other. Schools are possible because many kinds of fish have the ability to detect a form

*On the opposite page,
a huge school of barracudas at
the edge of a reef wall,
Sipadan Island, Borneo.
© 2003 Norbert Wu/
www.norbertwu.com*

*Above, barracuda
(Sphyraena genie) often swim
in large schools that may include
hundreds or even thousands
of young individuals.*
© McChamberlain/DRK PHOTO

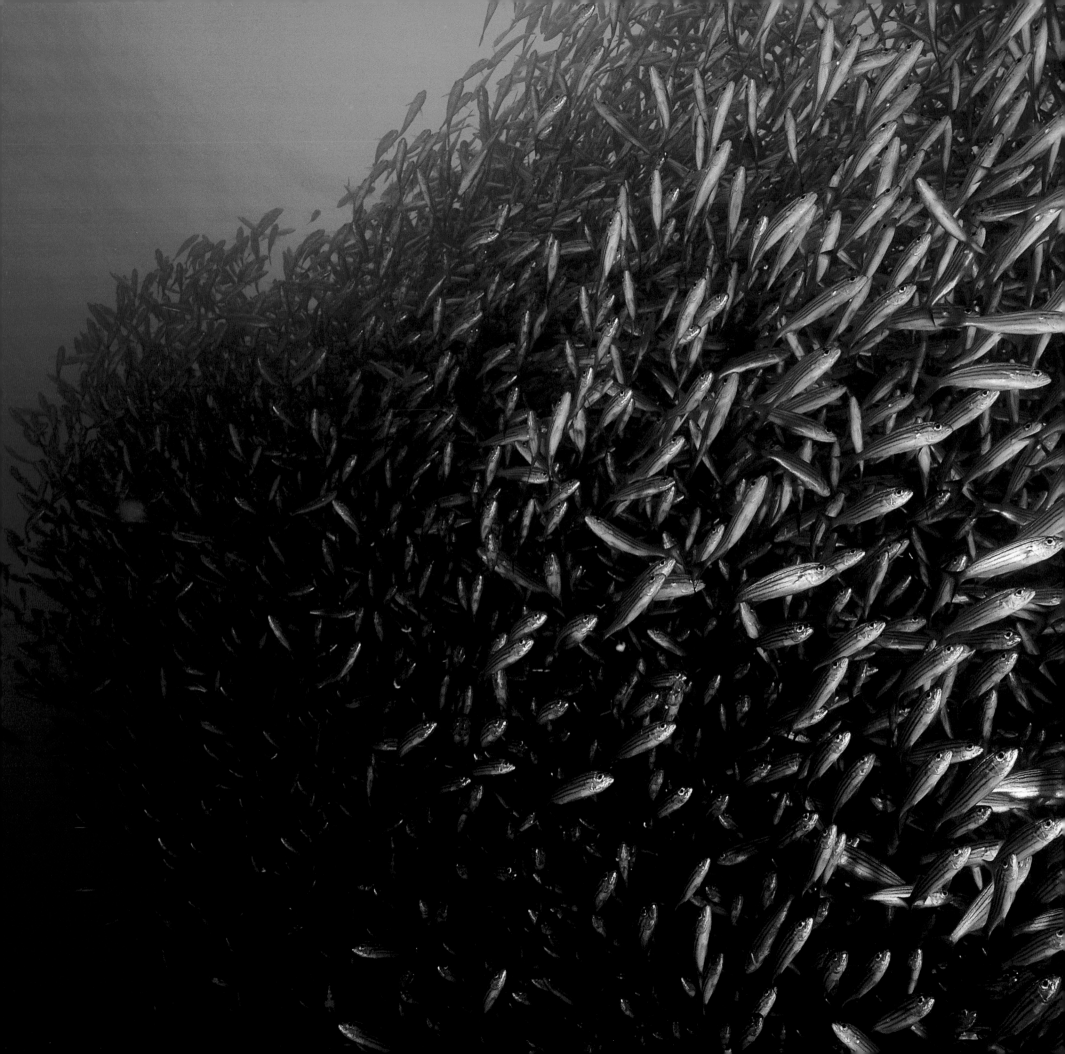

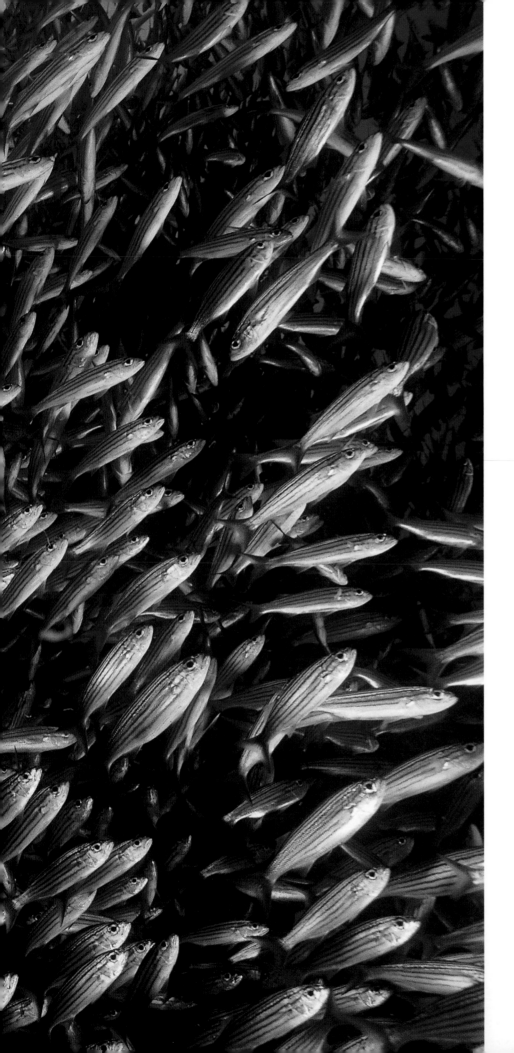

*An enormous school of black-striped salema
(Xenocys jessiae) in the Galápagos. Over half of the world's
24 000 marine and freshwater fish species exhibit some kind
of aggregation behavior at some point in their lives.*
© Steve Wolper/DRK PHOTO

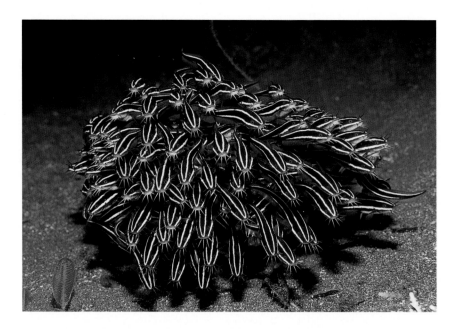

Above, striped catfish on the Great Barrier Reef, Australia.
A fish school looks and behaves like a single super-organism that can split
in a fraction of a second if an obstacle is encountered, as if cut
by an invisible hand. This "fountain effect" is a common reaction
of schooling fish, which possess a remarkable ability to "feel" objects in the water
and to respond with lightning-quick evasive maneuvers.
© G. Allen

On pp. 254-255, reef fish swarms stay near the protection of the coral reef, Fiji.
© Howard Hall/howardhall.com

of energy that lies near the margins of sound, perhaps more like pressure waves than sound waves. This unique sense makes it possible for a fish to feel its neighbors at a distance and to detect their every movement. As a result, movements pass rhythmically through a school. They give rise to an overall harmony of movement, contracting in unison at the approach of danger, or sweeping in unified waves through the water.

Over half of the 24 000 marine fish species on the planet exhibit some kind of aggregation behavior at some point in their lives, but not all kinds of fish show schooling behavior in the true sense. Some actually live alone or in smaller groups. Others, like salmon and cod, form schools at certain times of their life cycle but live alone or in smaller groups at other times. There are, however, those fish for which schooling is an obligate life-style. These include sardines, herrings, anchovies, tuna, mullets, mackerels, pollock, and smelts. Schooling might provide some protection from natural predators, but humans have exploited this behavior to optimize their fishing success. Schooling fish have always been the main targets of the fishing industry.

The phenomenon of schooling is far from being understood. Many reasons are discussed for its function, among them predator confusion, reduced risk to each individual that it will be the one caught, better orientation, and synchronized hunting. The test of whether or not a congregation is a true school is its response to an alarm situation, such as an approaching diver or the discharge of a spear gun into the group. A schooling species will flee in a chorus-line wave of movement, without noticeable variation from any individual in the group. Usually, there is a clearly audible "whooshing" sound as the departing fishes turn on a unified burst of speed. In stark contrast, individual members of a part-time aggregation or shoal will most certainly scatter in all directions.

Schooling doesn't occur in newly hatched fish, but is manifested gradually during a period of social integration. At the early stage, pre-schooling fish often approach each other head-on, or at right angles, but as they mature, head to tail approaches become predominant. Interactions begin by repeatedly approaching each other and then veering sharply away. Finally, fish begin to swim together, at first in pairs and then in large groups, until parallel, synchronized schooling is established. Overall, the normal development of schooling seems to be an ordered, gradual process that is preceded by well-formed, simpler behaviors.

Some species aggregate when they are young, disperse as juveniles or adults, and come back together later in life, when

they are ready to spawn. Foraging aggregations may turn into breeding aggregations as fishes migrate to traditional spawning locations and are joined by members of other aggregations. Within species, schooling tendencies may change with predation intensity. For instance, guppies living in predator-dense habitats form schools throughout their lives, while in other areas where predators are rare, only juveniles school. Thus, European minnows that coexist with predators develop a stronger schooling tendency than do minnows in a predator-free environment.

Schooling fish, such as herrings and sardines, are some of the most important fish groups on the planet. In the northern hemisphere, the Atlantic herring (*Clupea harengus*) is a keystone species, converting the enormous production of zooplankton found in the pelagic ocean into energy, while at the same time becoming the main prey item for higher trophic levels. Herrings are also perhaps the most spectacular schoolers, voyaging ocean-wide in groups of thousands to hundreds of thousands. Within an individual stock, schools generally travel in a triangle between their spawning grounds, feeding grounds and nursery grounds. Such wide triangular journeys are particularly important because herrings feast efficiently on their own offspring.

The strategy of safety in numbers is also operative for numerous small reef fishes including damselfishes, cardinalfishes, and fairy basslets (subfamily Anthiinae) that form dense midwater feeding aggregations. Although tied closely to prominent reef features, such as individual coral heads or larger formations, they regularly venture into the water column in search of current-borne plankton. Consequently, they are fully exposed and most vulnerable to predation from groupers, jacks, and snappers.

A host of mainly nocturnal species such as grunts, goatfishes, snappers, cardinalfishes, bullseyes, soldierfishes, and squirrelfishes, form daytime-resting aggregations. The reason for their aggregating behavior are not so obvious. Perhaps resting groups of these larger fishes are advantageous in allowing individual members to "doze" during daylight, with more security than if they were solitarily dispersed. This behavior may also function in keeping a group of individuals together on a regular basis, a great advantage during reproductive periods.

Many types of surgeonfishes, parrotfishes, and rabbitfishes exhibit schooling behavior associated with feeding. For example, different species of surgeonfishes frequently band together while feeding on algal turf. The only obstacle is territorial herbivorous fishes, usually pugnacious damselfishes or the blue-lined surgeonfish that zealously guard their individual "garden" plots. These solitary bottom dwellers are normally very effective in chasing away individual intruders or even small groups, but are totally overwhelmed when confronted by a relentless onslaught containing hundreds of feeding surgeons.

Schooling occurs in other fishes only during a particular stage of the life cycle. For example, the common reef catfish (*Plotosus anguillaris*), is usually solitary during adulthood, but the young form dense, globular feeding schools that sweep over the reef like an animated vacuum cleaner. They feed mainly on organic detritus and their behavior provides a very effective mechanism for gleaning maximum amounts of nutrients per unit of bottom area.

One of the most important functions of schooling and temporary aggregating is to ensure spawning success. In the case of schooling fishes and species that form more or less constant, unstructured shoals (e.g., damsels, fairly basslets, etc.), suitable mates are generally close at hand, but many other species (e.g., groupers and snappers) depend on seasonal spawning aggregations. Groupers (Serranidae) and snappers (Lutjanidae) form spawning aggregations at predictable places and times, which make them highly vulnerable to fishing pressure. Because these top-end carnivores play such a pivotal role in the overall feeding web, their decline having drastic effects on the entire coral reef ecosystem. Therefore, one of the most important aspects of modern coral reef conservation is the identification and protection of these spawning phenomena. Sadly, it is estimated that only 10 of the known 200 spawning aggregations of Nassau grouper remain in the Caribbean.

Over 2 400 years ago, Aristotle observed and described schooling behavior of fish in his treatise *History of Animals*. Today, mackarel, herring, cod, and tuna are perilously close to being forever lost. Their numbers reduced by 90% in half a century. If these wondrous creatures are to swim in the world's oceans 2 400 years in the future, measures must be taken now to ensure their prosperity.

ALEJANDRO ROBLES
GERALD R. ALLEN
MICHAEL LEONARD SMITH
CRISTINA G. MITTERMEIER
SYLVIA A. EARLE

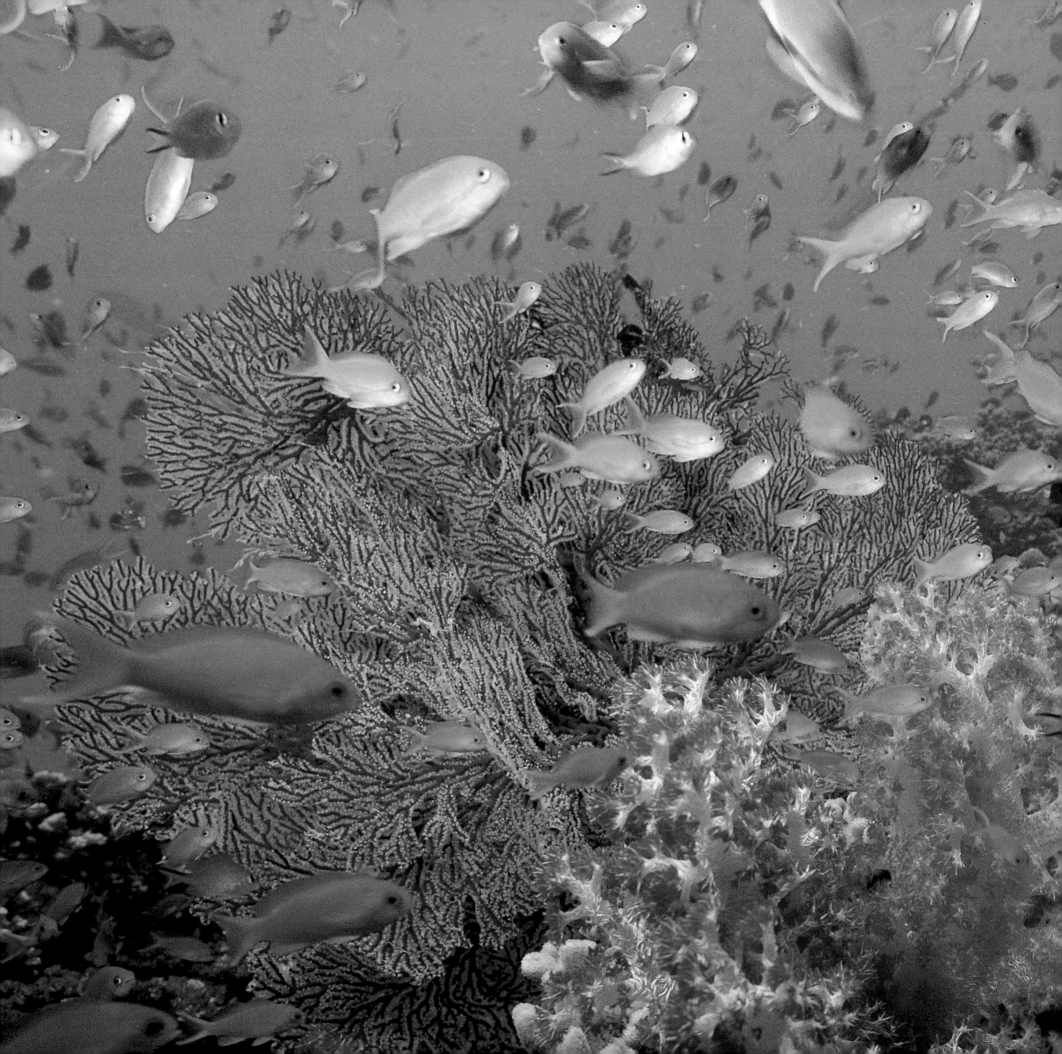

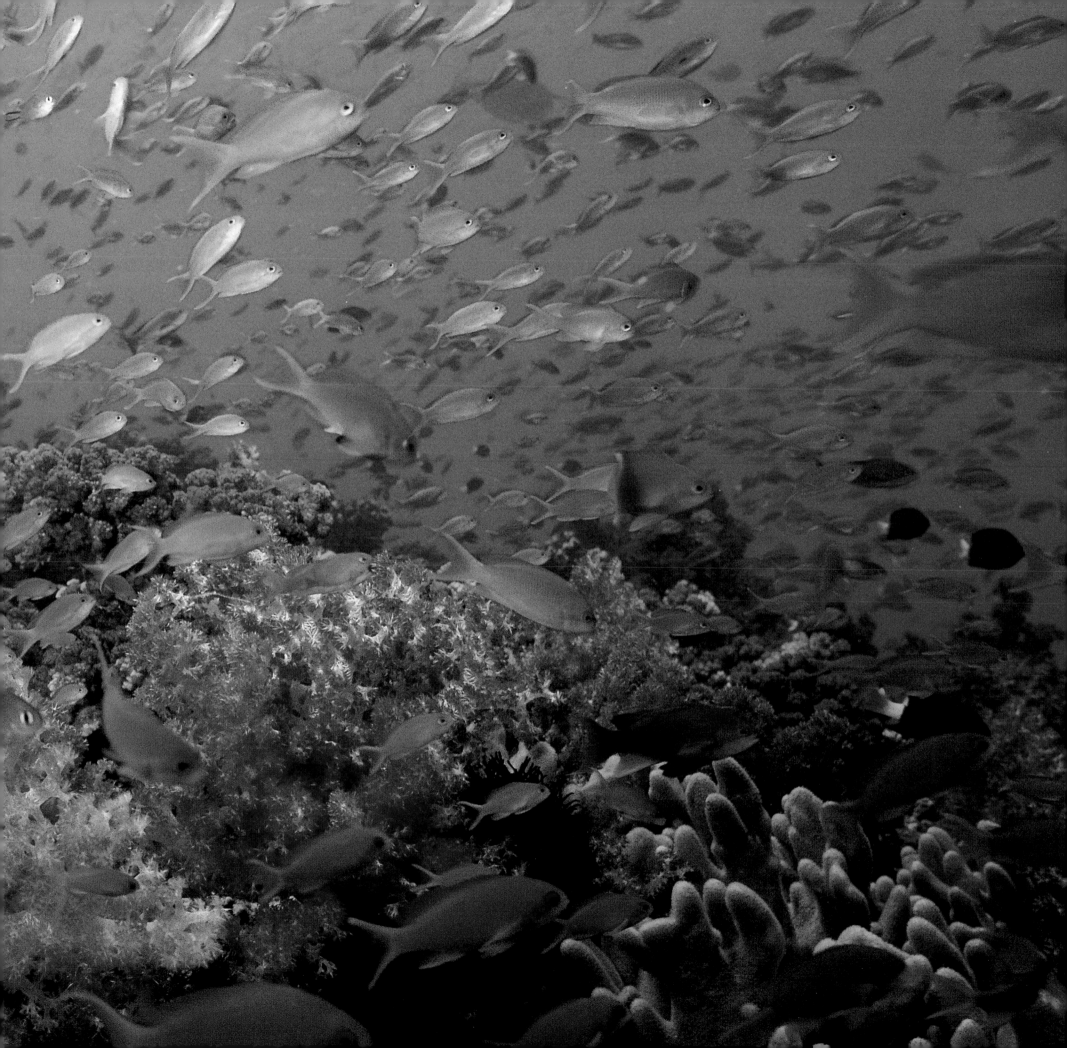

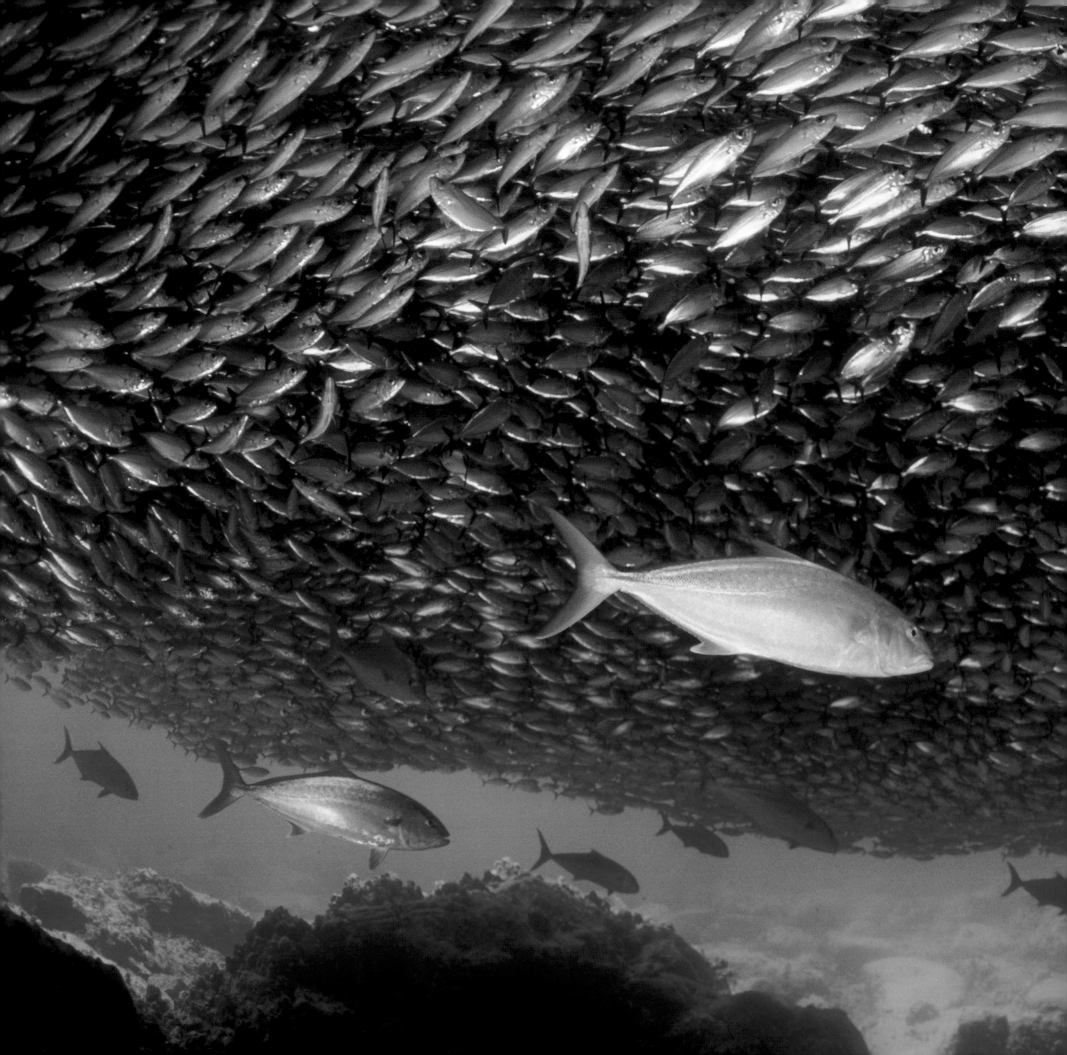

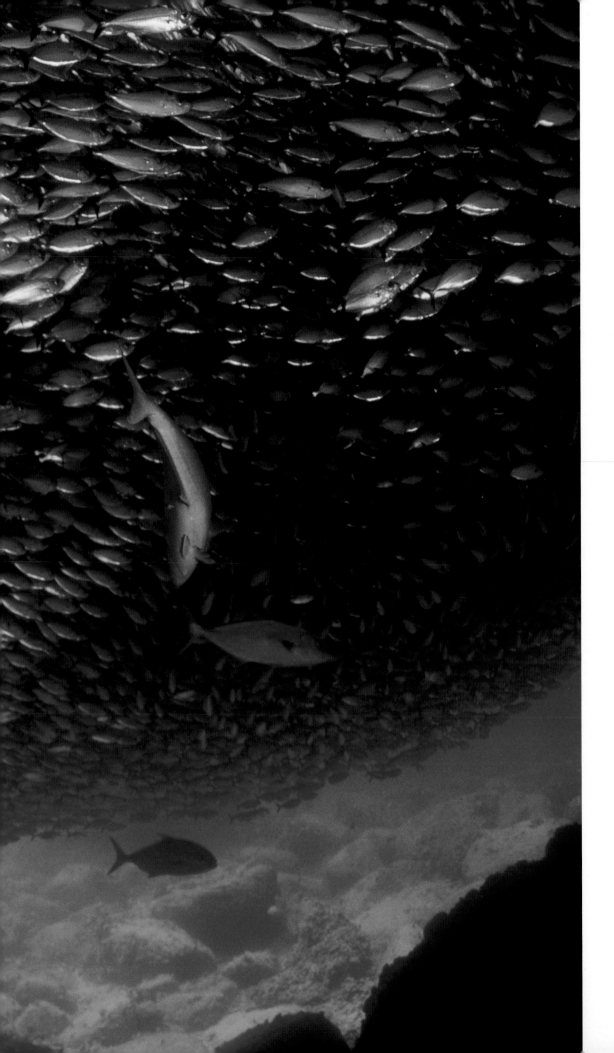

Amberjacks or kahala (Seriola dumerilli)
herding a school of bigeye scad or akule
(Selar crumenophthalmus), *Kona, Hawaii.*
Species like large jacks and groupers are known to hunt
in groups and coordinate their attacks on schools
of yellowtail snapper, scads, herrings, and silversides.
© Doug Perrine/Seapics.com

257

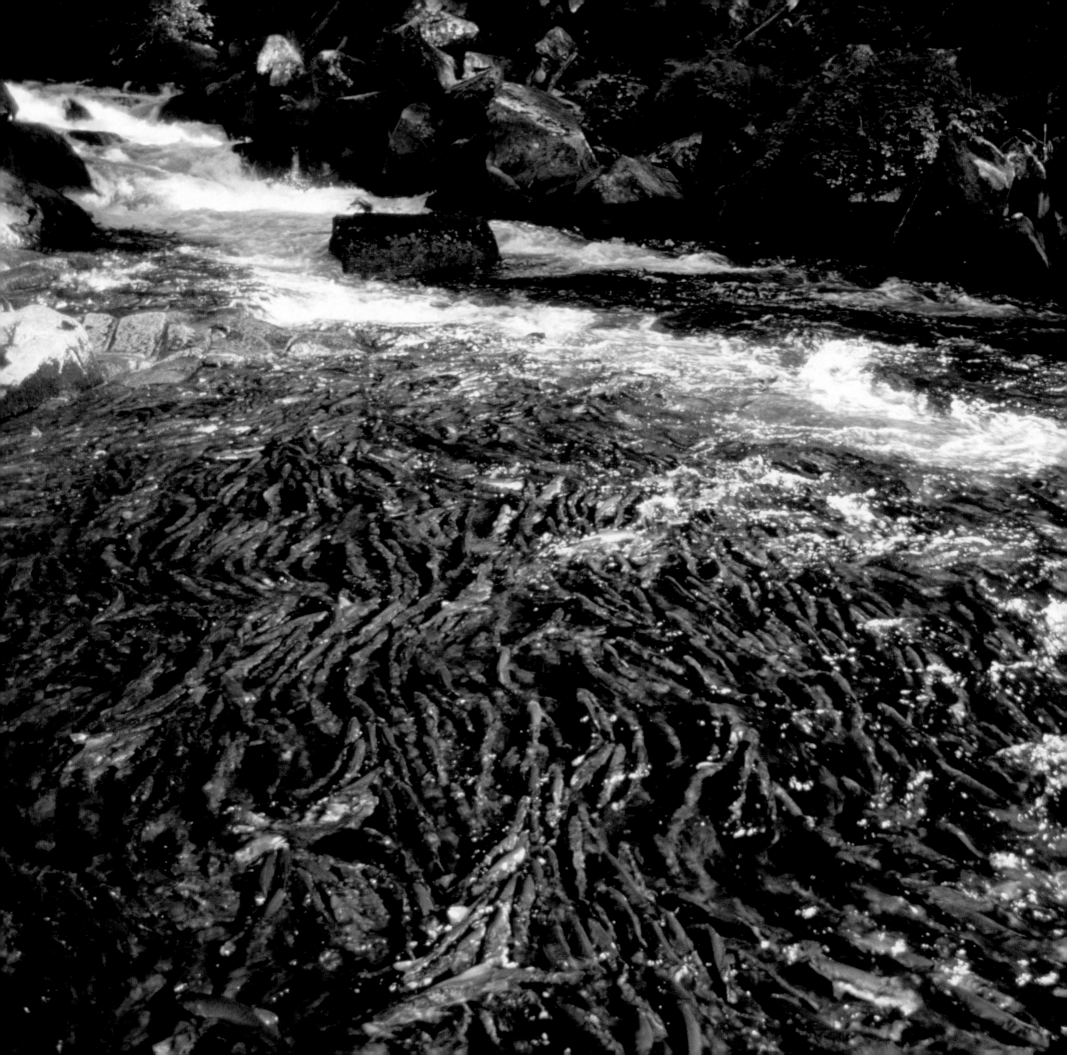

PACIFIC SALMON

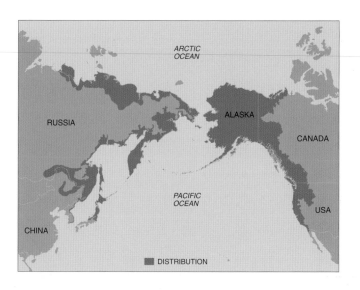

Navigating in the semi-darkness fifty meters below the surface of the northern Pacific Ocean, a chinook salmon begins its migration home, 4 800 km away in the headwaters of the John Day River in the high desert of Central Oregon. In a few weeks, it will find its way through thousands of kilometers of open ocean to the mouth of Columbia River, and swim upstream against heavy spring runoff past three churning hydroelectric dams to find the John Day River. There, the spring-run chinook salmon will climb some 900 m, covering up to 30 km a day to the cool, clear headwaters where it emerged from gravel five years earlier.

Pacific salmon (*Oncorhynchus* spp.) are among the most beautiful creatures on Earth. There are nine species: chinook, coho, chum, pink, sockeye, masu, and amago salmon, and rainbow and cutthroat trout. They spawn and rear in estuaries, rivers, lakes, and wetlands along the northern Pacific Rim, from California north to Alaska and Chukotka and south to Korea. Chinook salmon and rainbow trout (*O. mykiss*) have been introduced to the U.S. Great Lakes, New Zealand, and Chile and Argentina.

All Pacific salmon spawn in fresh water, not far from gravel beds or springs where they were hatched. After spawning, most salmon species die, their carcasses releasing considerable marine derived nutrients. Sockeye salmon (*O. nerka*) runs to rivers and lakes draining into Alaska's Bristol Bay can reach 20 million fish a year and salmon carcasses provide up to 5 million kg of biomass to aquatic and riparian food webs.

While in fresh water, salmon feed on aquatic and terrestrial invertebrates and small fish —often juveniles of other salmon species and the decomposing carcasses of their parents. When the time comes to migrate to the ocean, the spotted, trout-like juvenile salmon transform into sleek, silvery fish called "smolts" and migrate downstream. Once in the ocean, they grow rapidly and migrate great distances in search of zooplankton, squid, herring, and other marine species.

The largest salmon species is the chinook or king salmon (*O. tshawytscha*). They can grow to be almost 45 kg, and migrate thousands of kilometers during the five or more years they spend at sea. Chinook favor the larger river systems. Historically, over two million chinook returned each year to the Columbia River system in the United States Pacific Northwest.

But the massive runs of chinook and other salmon species that native Americans and early settlers witnessed on the Columbia and other rivers such as the Sacramento were not single populations, but hundreds of distinct geographically and temporally isolated populations, or *stocks*. Some are mainstream spawners, others choose the springs at the head of side channels, some rear in lake systems, or navigate waterfalls and spawn in the headwa-

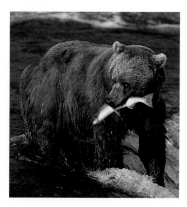

*On the opposite page,
pink salmon*
(Oncorhynchus gorbuscha),
looking like a giant pink and green ribbon, return in massive runs to spawn in the clear rivers from which they originated.
© Michio Hoshino/
Minden Pictures

Above, brown bears
(Ursus arctos) *patrol a river in search for salmon.*
© Robert Valarcher/BIOS

On pp. 260-261, all nine species of Pacific salmon (chinook, coho, chum, pink, sockeye, masu, and amago salmon, and rainbow and cutthroat trout) spawn in fresh water, not far from the gravel beds or springs in which they hatched.
© Richard Herrmann

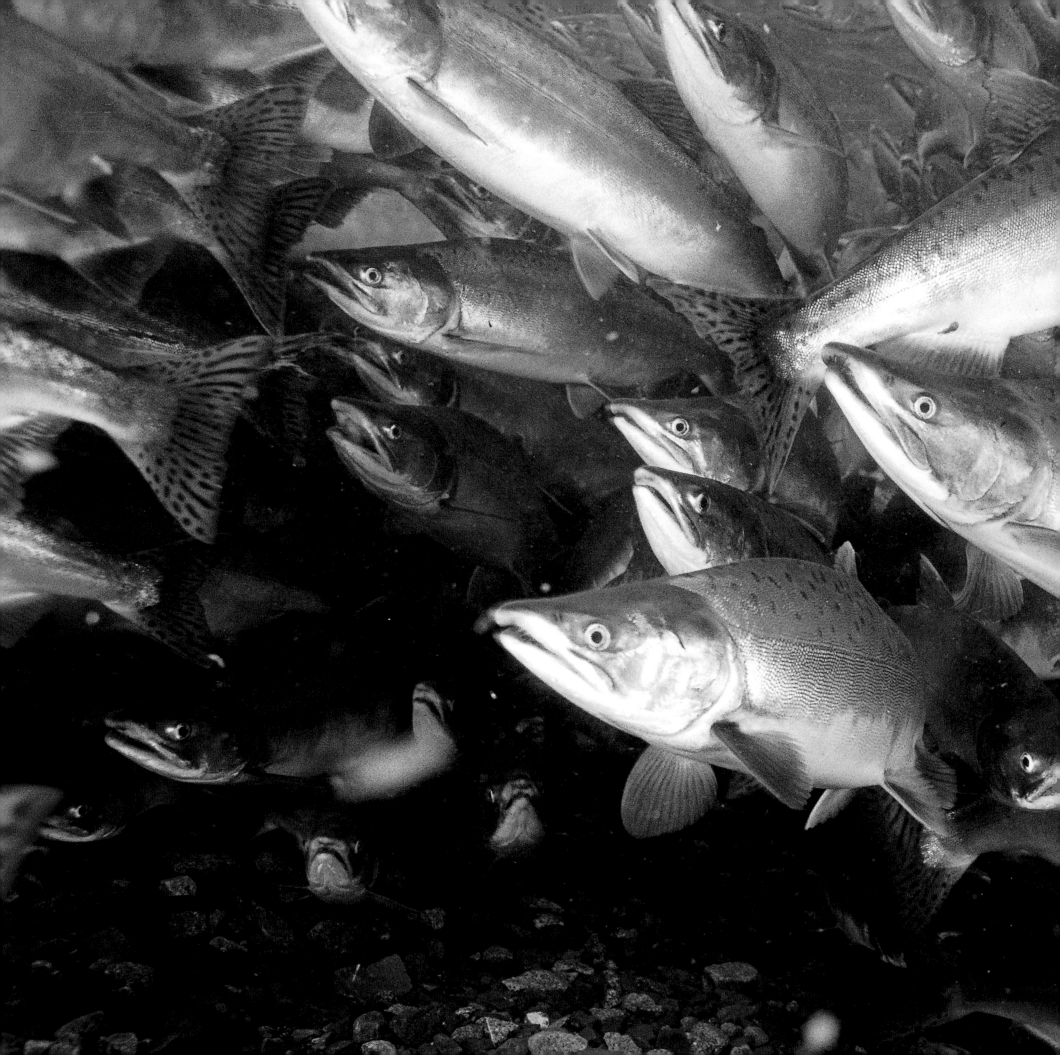

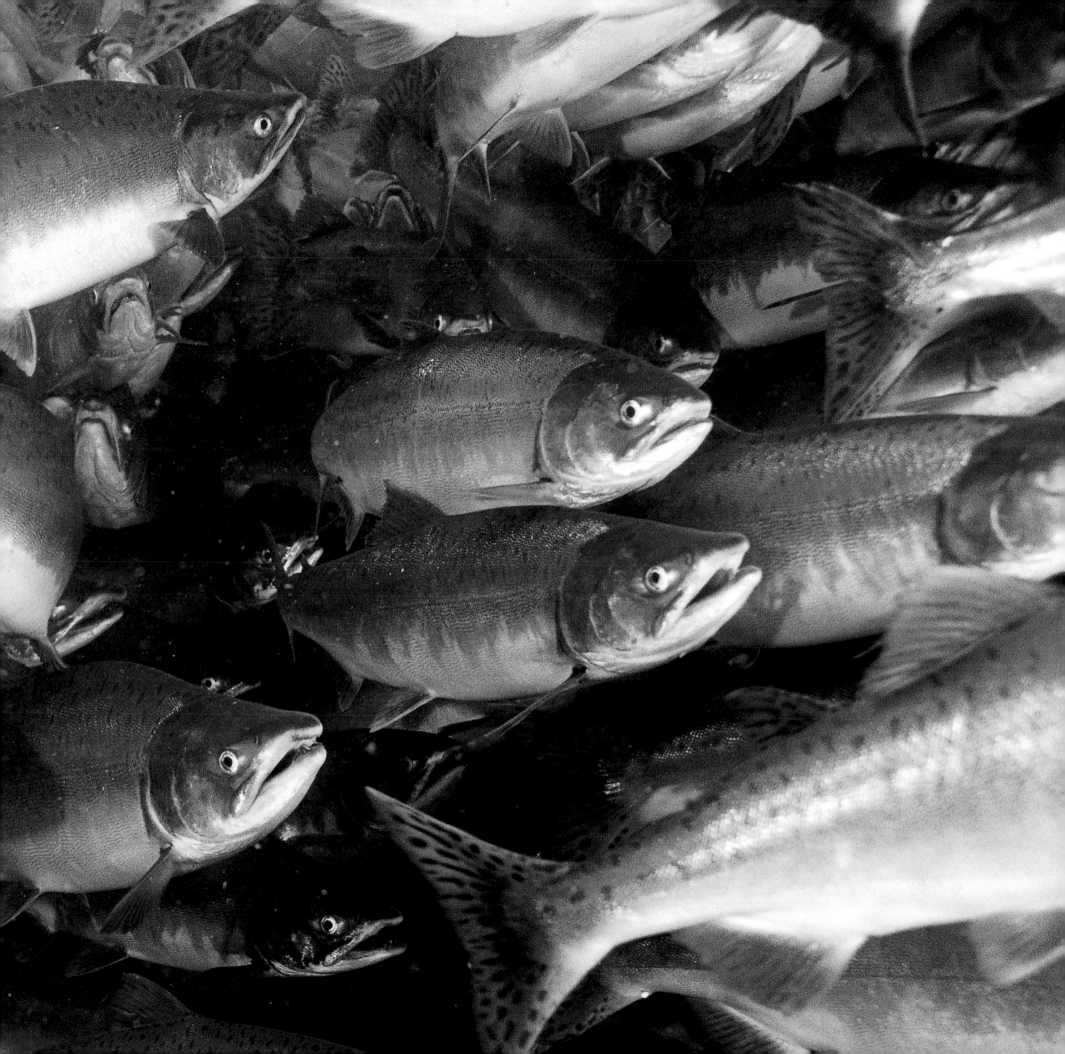

ters. The run timing, behaviors, sand body type of each stock are especially adapted to survival in the network of habitats from their home tributary downstream to the open ocean. Different stock-specific adaptations help juvenile and adult fish migrate at favorable times, provide for a range of tolerances to variation in water temperature, enable returning adults to navigate waterfalls, and may even chart ocean migrations. The key to salmon persistence is the adaptation of many distinct stocks to specific places in the river basins where they spawn and rear.

Some of the largest salmon migrations today are the runs of pink salmon in Alaska, and Kamchatka and Sakhalin Island in the Russian Far East. Pinks migrate to the ocean within days of spawning and return in less than two years. The largest known runs of pink salmon return to the Bolshaya River on Russia's Kamchatka Peninsula. Here the runs can exceed six million fish and in 1996 the Kamchatka Fisheries Science Institute estimated that 30 million pink salmon returned to the Bolshaya —so many fish crowded the river that a large part of the run died from lack of dissolved oxygen.

Salmon are declining along both sides of the Pacific Ocean. The declines are most advanced along the southern and central parts of their range. In the United States Pacific Northwest, native salmon have been extirpated from 40% of their historic range and most salmon species are now listed for protection under the United States Endangered Species Act. There are no healthy native chum (*O. keta*) stocks and only a handful of native masu (*O. masu*) stocks remaining in Japan, and the once legendary runs of upriver chum salmon in the vast Amur Basin are also in decline.

These fish are sensitive to human impacts, especially in the vulnerable first years of life in the freshwater environment. This is because they need cold (less than 12.8°C), well-oxygenated water and healthy aquatic food webs to grow large enough to survive entry into the ocean environment. Mining, forest harvest, and agriculture have inflicted considerable damage to water quality in salmon rivers. In the Pacific Northwestern United States, inland migrating chinook salmon and rainbow trout (steelhead) have been heavily affected by reduced stream flows and high water temperatures resulting from irrigation withdrawals. Irrigation and hydroelectric dams have cut off thousands of kilometers of spawning habitat. Logging in the western United States, Canada, and in the upper Amur River Basin in the Russian Far East has caused dramatic fluctuations in stream flow, the siltation of spawning beds, and a loss of in-stream log jams that are critical for creating spawning, rearing, and holding habitat for salmon. Perhaps the greatest effect of timber harvest is road and culvert construction, increasing the rate of slope failures and creating impassable barriers to juvenile and adult salmon. Across the Russian Far East, the illegal harvest of caviar from spawning adult salmon threatens some of the world's most productive and diverse salmon assemblages.

One of the subtlest yet most insidious threats to the health of salmon stocks is the development of fish hatcheries and salmon aquaculture facilities. In response to the decline of salmon from habitat loss and overharvesting, fish hatcheries were built to rear juveniles in captivity and release them into the wild. The release of millions of juveniles has overwhelmed native stocks, causing overcrowding of streams and has reduced the survival of juvenile wild salmon. The enormous returns of non-native hatchery-bred adults to spawning areas have caused substantial erosion of native, locally adapted pools, thus attacking the very foundation of salmon abundance and resilience.

In the United States Pacific Northwest, 85%-90% of salmon are now produced in fish hatcheries. Japan released approximately 80 million chum salmon smolts a year throughout the 1990s, creating concerns among some scientists that the carrying capacity of the northern Pacific Ocean for chum rearing could be exceeded in low-productivity ocean climate cycles. As if things were not bad already, the recent proliferation of floating salmon farms off the coast of British Columbia is threatening some of the best native salmon rivers. Fish farms pollute the ocean environment and the occasional accident causes the escape of millions of non-native salmon, many of which end up in rivers where they hybridize with native salmon stocks.

There are two approaches to salmon conservation: protection and restoration. Protection is the creation of protected habitats and the restriction of harvest and fish hatchery programs in order to prevent the decline of native salmon stocks. Restoration is the effort to reestablish or recover stocks that have declined to very low levels. By targeting the most viable remaining native stocks and their river ecosystems within each bioregion of the Pacific Rim, we can create reservoirs of locally adapted salmon biodiversity for future restoration efforts. There are still chances to create basin level or sub-basin level salmon protected areas, especially in the Russian Far East, Alaska, British Columbia, and parts of northern California, western Oregon, and Washington State. But with projected increases in human populations and impending economic development of salmon watersheds along the northern Pacific Rim, we must act quickly.

GUIDO RAHR

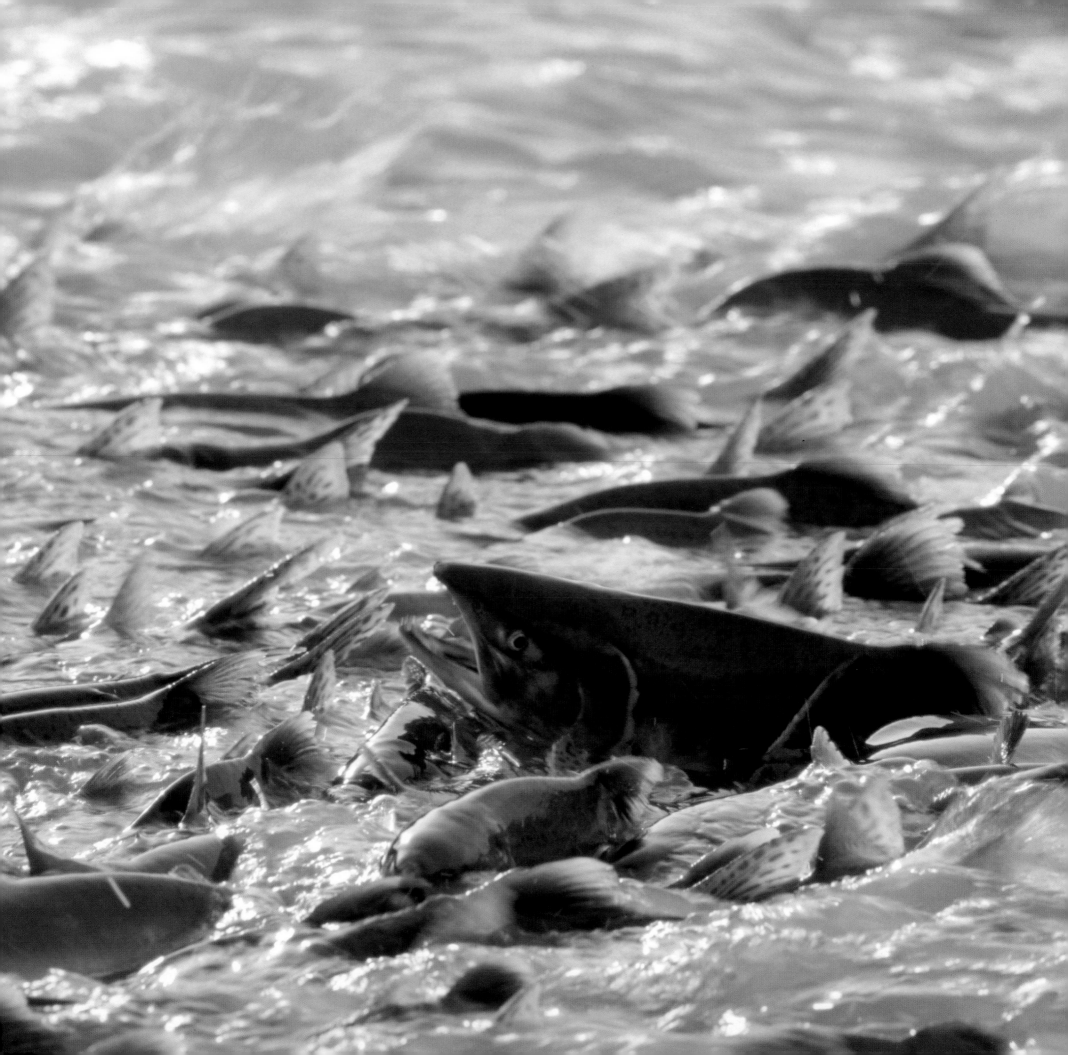

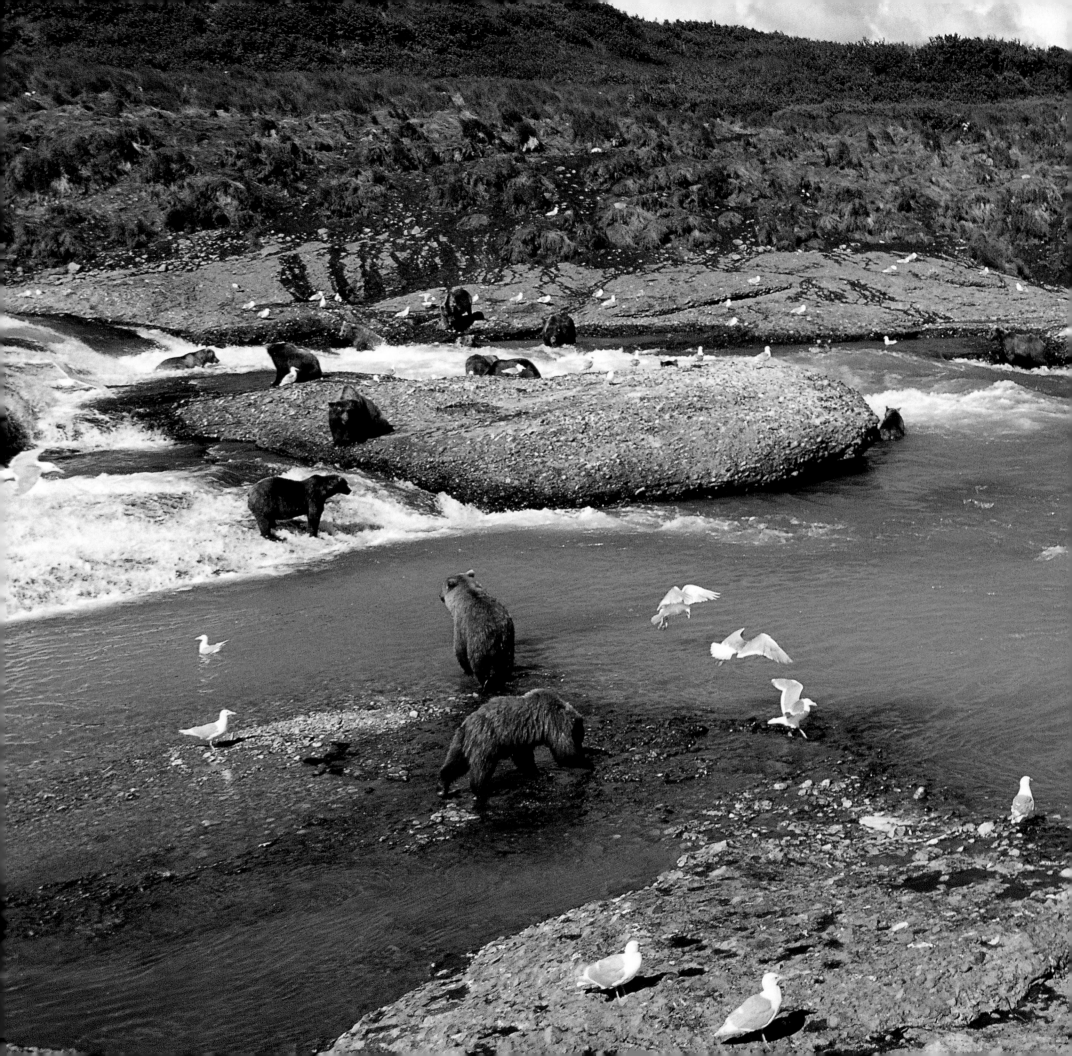

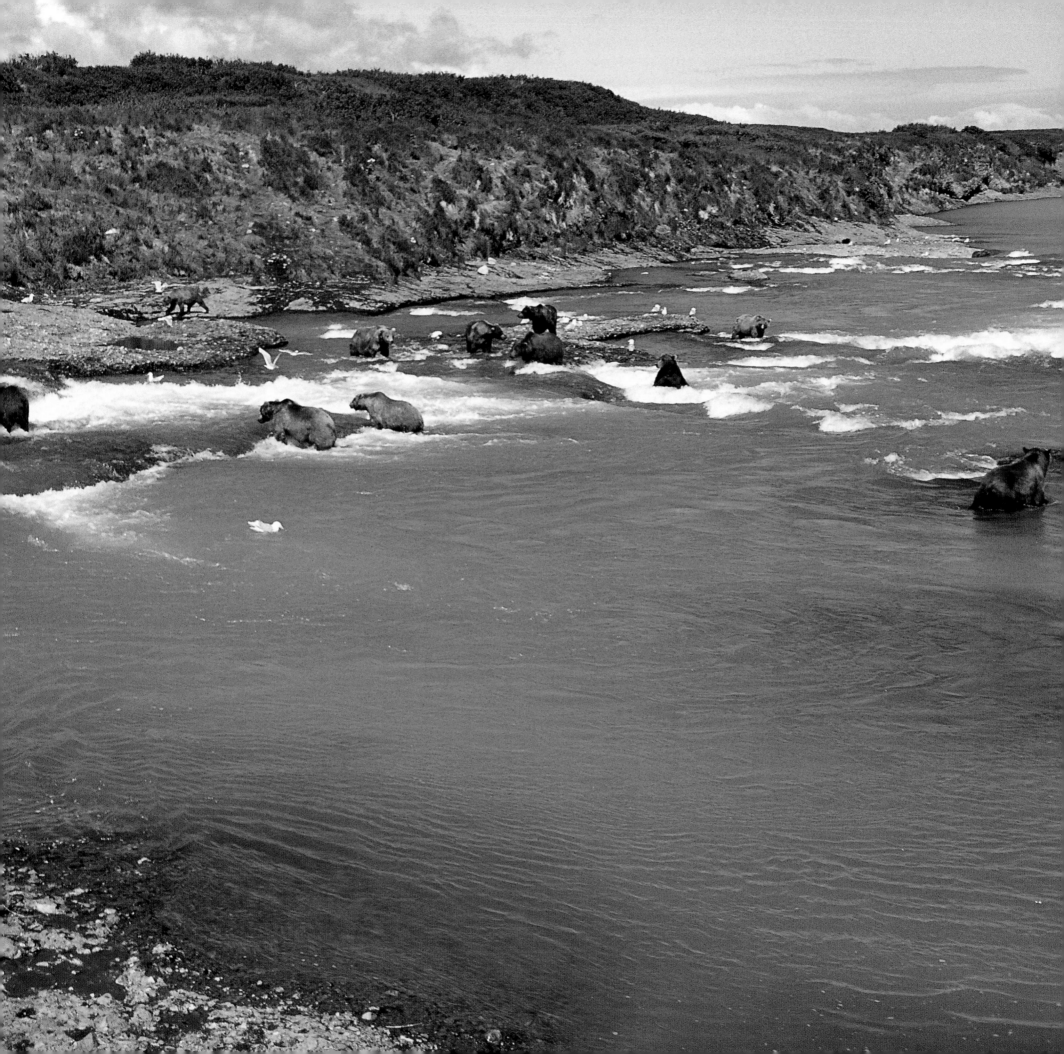

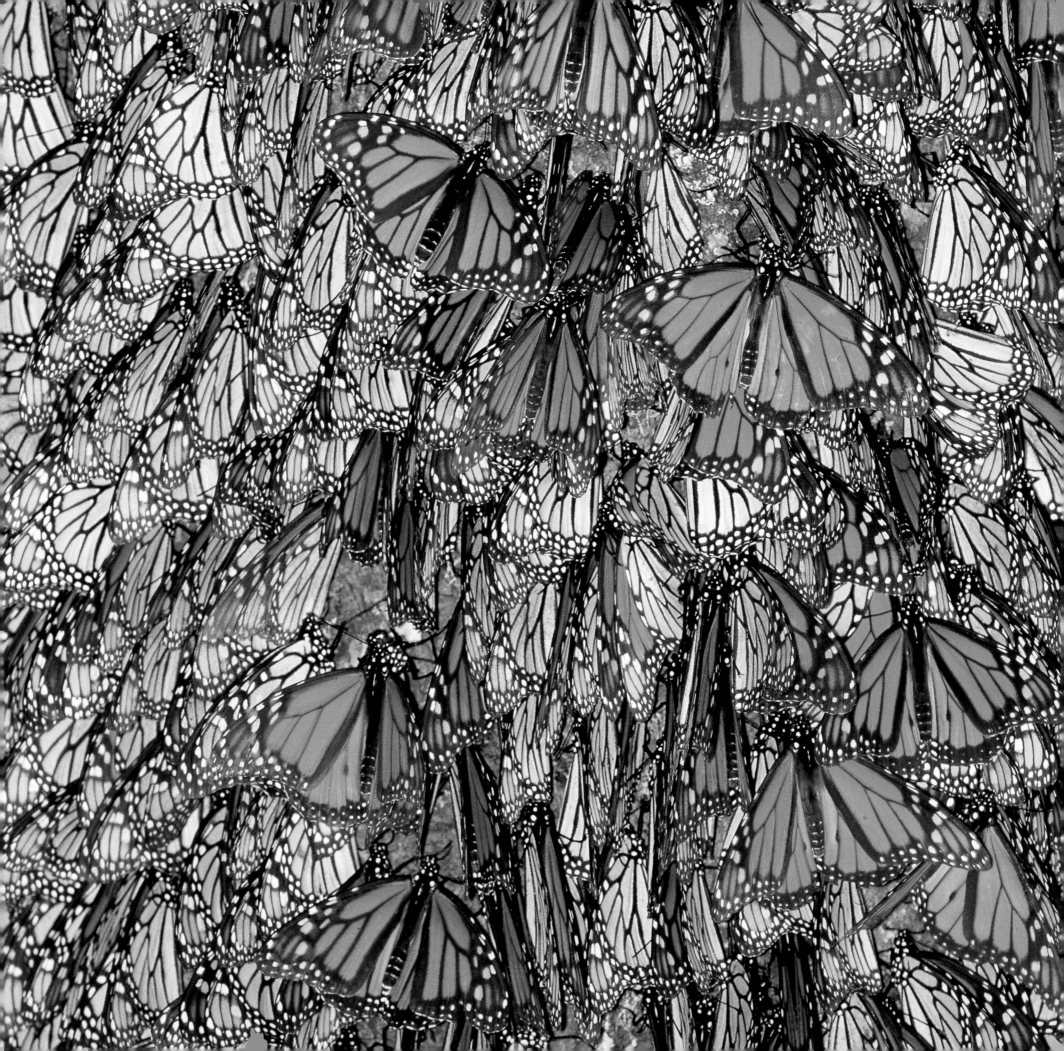

INVERTEBRATES

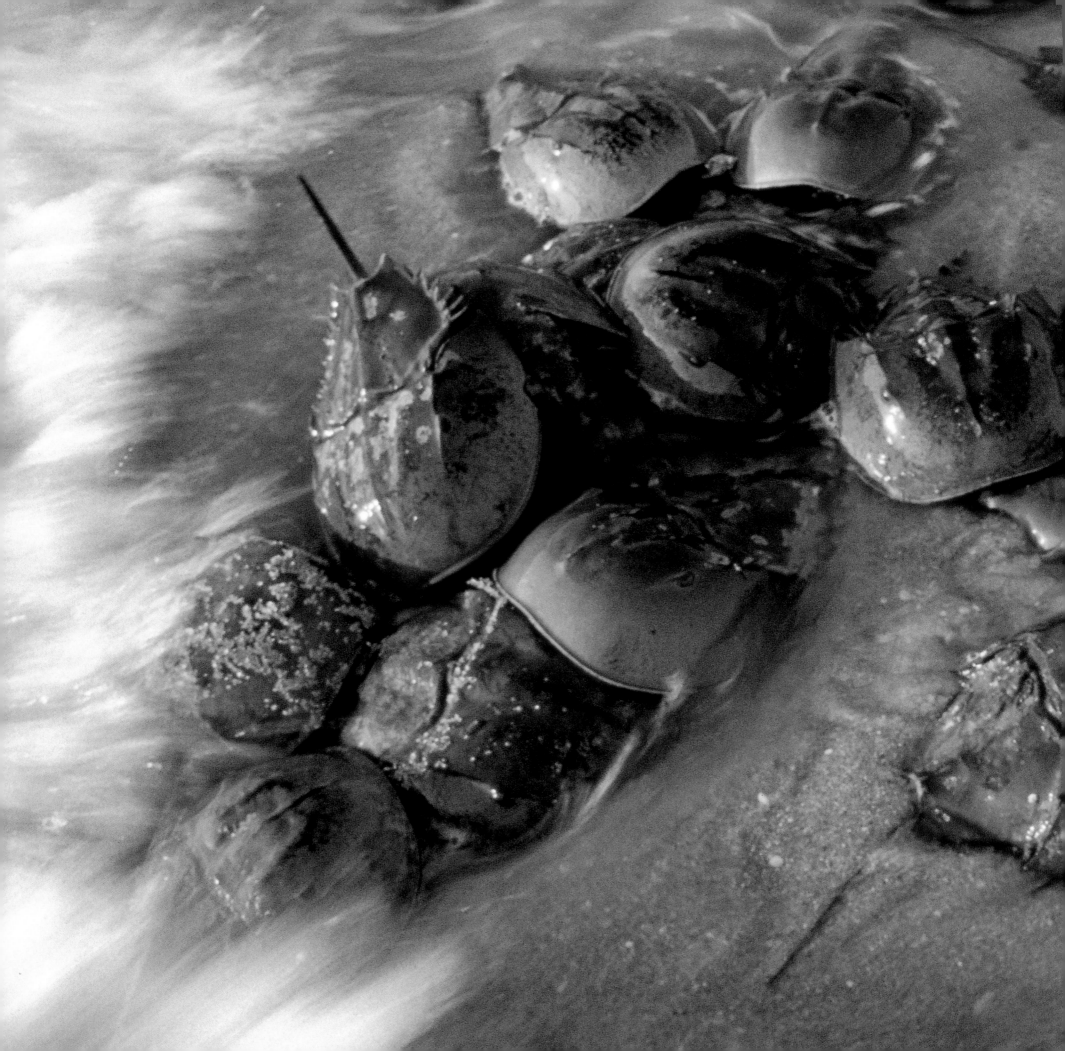

Some of my fondest childhood memories are those of thousands of glossy-brown horseshoe crabs (*Limulus polyphemus*) materializing from the cool, dark water along Delaware Bay —the largest concentration of these creatures in the world. For countless millennia, these beaches have witnessed the astonishing return of the horseshoe crabs to the sandy shores of southern New Jersey, the small but vital fulcrum of a breeding and feeding phenomenon involving millions of crabs and many more millions of migrating seabirds —a long, slender ecosystem of sorts, spanning thousands of kilometers.

Late in the spring and early summer, coincident with the highest full-moon tides, horseshoe crabs crawl out of their deepwater lairs to gather along a band of intertidal sand for mating and spawning. The beaches are stormed by a dark, crawling, brown army of crabs in one of nature's most impressive, and fantastic, spectacles. The female horseshoe crabs, attended by one or more of the smaller males, scramble in tandem to the upper edge of the narrow interface between sand and sea. Heavy with the essence of generations to come, the females lead the way, burrowing 15 or so centimeters down before releasing packets of eggs that are fertilized externally by the males. Birds, such as red knots, ruddy turnstones, sanderlings and dunlins, feast on these newly laid masses of horseshoe crab eggs that become dislodged from their sandy nurseries, a vital source of energy for these avian species to sustain them on their long, often non-stop migrations to their Arctic breeding grounds. Other creatures, too, like loggerhead turtles (*Caretta caretta*) and many juvenile fishes, also consume huge quantities of the eggs but, despite this predation, some of the glistening, jade-green spheres develop into miniature versions of their parents, emerging at first without the spike-like tail. They may remain in this initial "trilobite" stage for several months, gradually maturing over eight or ten years, with the potential for living at least another decade.

For the horseshoe crabs, this phenomenon is an ancient ritual that began more than 400 million years ago, long before there were birds, longer even than the existence of the Atlantic Ocean that now harbors one of the last four species in a distinctive Class of animals, the Merostomata. Their origins are still being debated, but by the late Paleozoic, creatures hauntingly similar to today's horseshoe crabs were already well established.

HORSESHOE CRABS

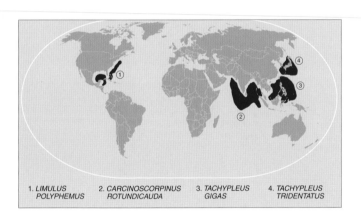

1. *LIMULUS POLYPHEMUS* 2. *CARCINOSCORPINUS ROTUNDICAUDA* 3. *TACHYPLEUS GIGAS* 4. *TACHYPLEUS TRIDENTATUS*

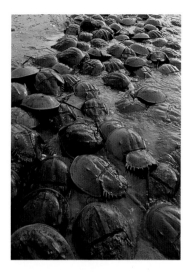

Late in the spring and early summer, coincident with the highest full-moon tides, horseshoe crabs (Limulus polyphemus) crawl out of their deepwater lairs to gather along a band of intertidal sand for mating and spawning. The beaches are stormed by a dark, crawling, brown army of crabs in one of nature's most impressive spectacles.
Opposite, © Stephen J. Krasemann/DRK PHOTO; *above,* © François Gohier/ ARDEA LONDON

Over the ages, they survived waves of extinctions including the Permian Transition, when more than 95 per cent of all animal species were extinguished. They swam in oceans with pleisiosaurs and survived the global upheaval that exterminated the dinosaurs and brought an end to the Cretaceous Era. Season after season, millennium after millennium, horseshoe crabs prospered in their own way, accommodating the arrival of dolphins, whales, birds, flowering plants and, in very recent times, humankind.

Today, arthropods abound, from the tops of mountains to the deepest sea, and among the various classes of these jointed-legged animals with an exoskeleton, the Insecta are the most numerous, with more than half a million species named; the Merostomata, on the other hand, have the fewest. Put simply, each insect species alive today represents 1/500 000 of all the known insect species on the planet. In contrast, each horseshoe crab species represents 1/4 of the distinctive genetic recipe for a creature that is neither an insect nor a crab, but rather a distant relative to the arachnids (spiders, mites, and scorpions). No other creature shares their peculiar anatomy, their distinctive life history, their startling bright blue blood, and their eerie, primitive eyes (prized by humans for biomedical applications). Loss of any of the four species of horseshoe crabs means forever losing 25 per cent of that great reservoir of history now embodied within their craggy shells.

The fossil record indicates that *Limulus'* ancestors, the trilobites, enjoyed a cosmopolitan distribution. Today, however, horseshoe crabs range along the Atlantic coastline of North America from Maine to the Yucatán, from about 19°N to 42°N. Although population surveys of horseshoe crabs have been conducted for several years, no one knows with certainty how many of these animals still exist. We do know that between 80 and 90 per cent of this population is found in Delaware Bay. A conservative estimate of adult horseshoe crabs based on the National Marine Fisheries Service's Northeast Fisheries Center trawl survey data, placed the Atlantic Coast population, between New Jersey and Virginia, at 2.3 to 4.5 million individuals in the early 1980s. Unfortunately, there has been a significant drop in the spawning population, from an estimated 1 200 000 crabs in the Delaware estuary in 1990 to a little more than 200 000 in 2001: a dramatic 85 per cent drop in just five years. As for the other species of Merostomata, there are two Asiatic species with overlapping ranges off Southeast Asia and Indonesia, and a third, the wide-ranging (*Tachypleus tridentatus*) which, while nowhere nearly as abundant, occurs in East Asia north to Japan. Imazu Tideland, located in Fukuoka City, Japan is one of the largest spawning grounds of this latter species.

Sadly, all three Asiatic species are rare and populations of the North American horseshoe crab have declined sharply in the past century. Widespread pollution in the coastal waters favored by all four species may be having an impact on their numbers, coupled with the extensive shoreline development that has destroyed prime horseshoe crab spawning and nursery areas. But most influential in the decline of these ancient creatures is large-scale human predation for various purposes, ranging from fertilizer production and use for road-building materials to the recent taking of the females as bait for eels and whelks. In one year alone in the 1870s, four million specimens were taken from Delaware Bay. While it is difficult to be precise about the number that exist presently, it appears that the Atlantic population may have fallen to less than 25 per cent of its former abundance at the beginning of the twentieth century.

Recently, I returned to the sandy beaches of Delaware Bay and was greeted by windrows of plastic trash, bottles, cans, and other junk that was absent in my childhood —and by something small, round, and alive, glistening in the wet sand. Carefully, I lifted onto the tip of my finger a living treasure, a miniature horseshoe crab still within its protective sphere. That morsel of life was for me a symbol of vulnerability and resilience and, most of all, a reason for hope.

SYLVIA A. EARLE

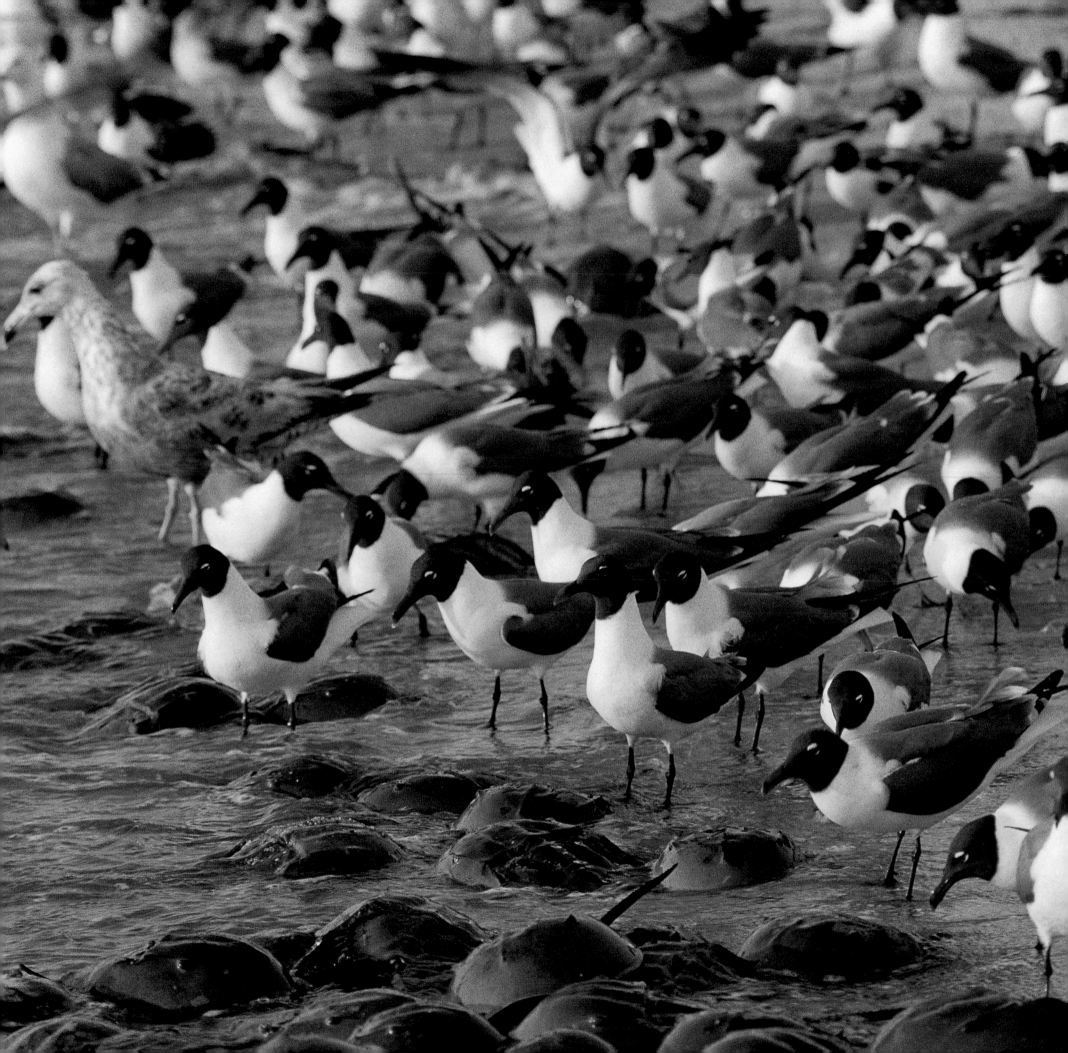

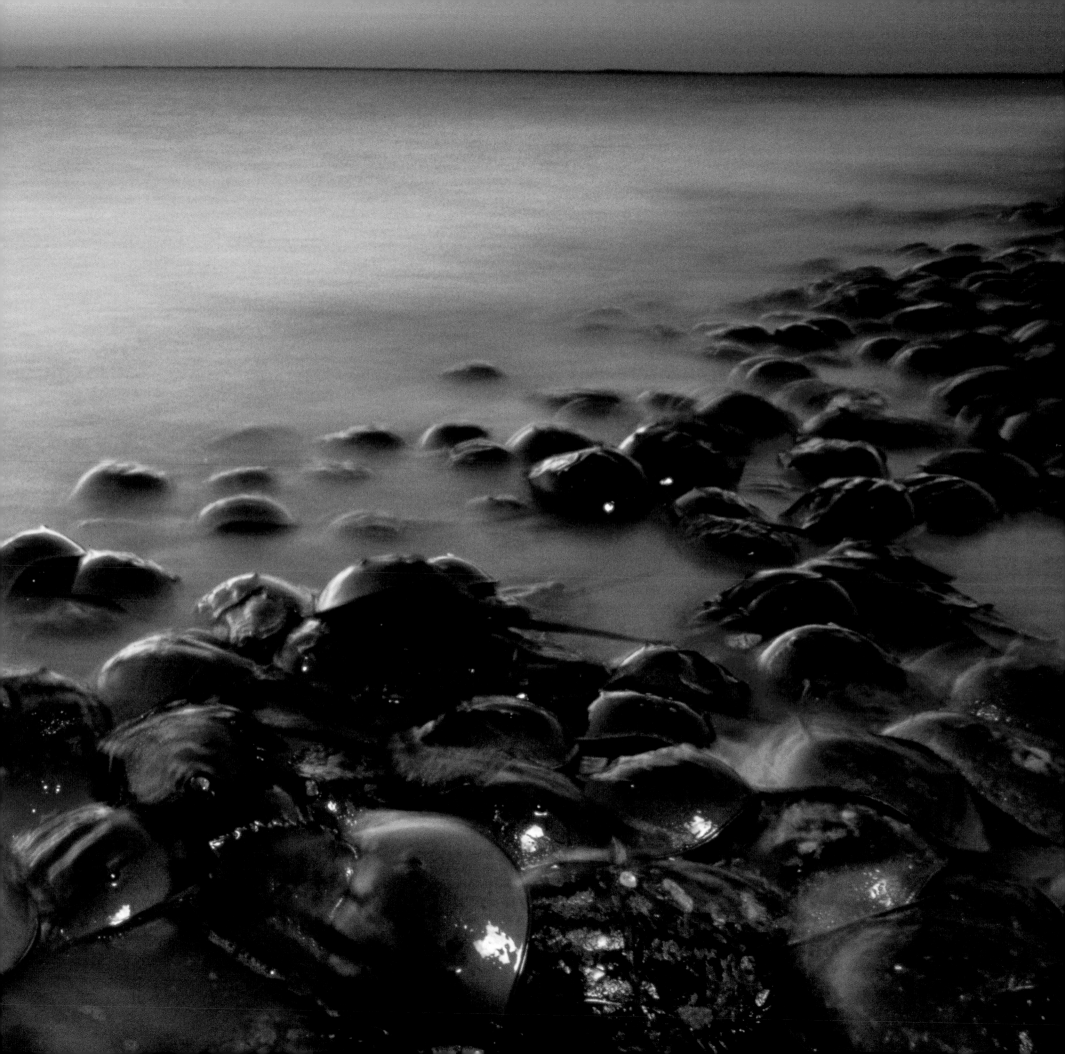

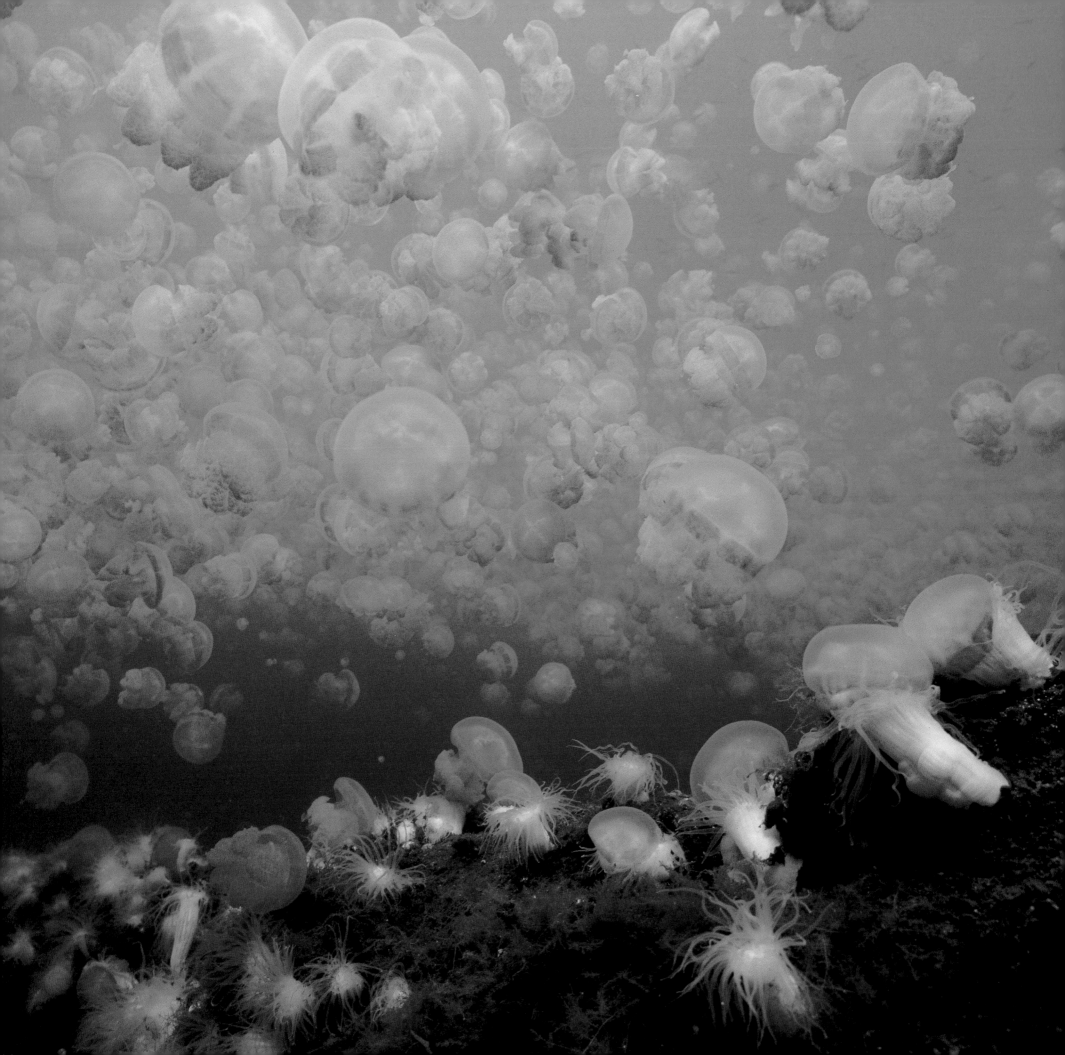

Many marine animals form large congregations, but few are more astonishing and overwhelming than those formed by jellyfish. These delicate beauties sometimes aggregate in massive blooms, which can have enormous economic and ecological impacts well beyond the shores of the ocean. Thinking about the proverbial "primordial soup," one can imagine being part of the plankton community —swayed gently by the waves and carried by the currents. A closer look reveals that here lurk carnivorous creatures as ferocious as any land predator, although many are as luminous and ephemeral as rainbows.

"True" jellyfish (or medusae) include about 2 000 species in several groups within the Phylum Cnidaria, ranging from the small, usually transparent hydromedusae to the large, and often brightly colored scyphomedusae. Many jellyfish have a small, bottom-dwelling stage of their life cycle called a polyp, which may live singly or in colonies, but derives nutrition from a very different part of the oceanic food web than the free-swimming and reproductive jellyfish that are released from these polyps. The astonishing diversity of life cycles and the extreme morphological differences in every stage makes jellyfish taxonomy a complicated task. In addition to the cnidarian jellyfish, there are perhaps another 400 species in the Phylum Ctenophora, which includes sea walnuts and sea gooseberries. Whereas cnidarian jellyfish swim using jet propulsion by softly undulating their bell-like bodies, ctenophores swim using rows of paddles comprising thousands of highly coordinated cilia. Although only very distantly related, both jellyfish and ctenophores have bodies that are mostly water, both are fierce carnivores, and both are capable of rapidly reproducing in nearshore situations and thus sometimes forming blooms that may overwhelm the oceanic ecosystems in which they occur. In the case of jellyfish, many have tentacles armed with stinging cells called nematocysts, and so the presence of large numbers of jellyfish in coastal waters may also have important implications for human health.

Like all planktonic organisms, jellyfishes and ctenophores have very limited abilities to choose their courses in the sea. Most lack well-developed sensory organs, such as eyes, and can only swim up and down, or horizontally in response to movements of the sun, being otherwise largely at the mercy of wind, waves, and currents. Many of the large coastal congregations of these jellies are the result of physical ocean processes that impound these animals in small spaces, rather than just short-term population explosions. Such local aggregations can be highly impressive and may last anywhere from just hours to a few weeks, depending on the situation.

JELLYFISH AND CTENOPHORE BLOOMS

On the opposite page, anemones feeding on jellyfish in Jellyfish Lake, Palau. Swarms of jellyfish are part of ancient rhythms established thousand of millennia before the advent of our own species. However, the recent trend towards huge blooms of a few species populating new parts of the ocean may be indicative of underlying disturbances in marine ecosystems.
© Howard Hall/howardhall.com

Above, the jellyfish Rhizostoma pulmo *from the Mediterranean Sea reaches 80 cm in length, but is harmless to humans.*
© Thomas Heeger

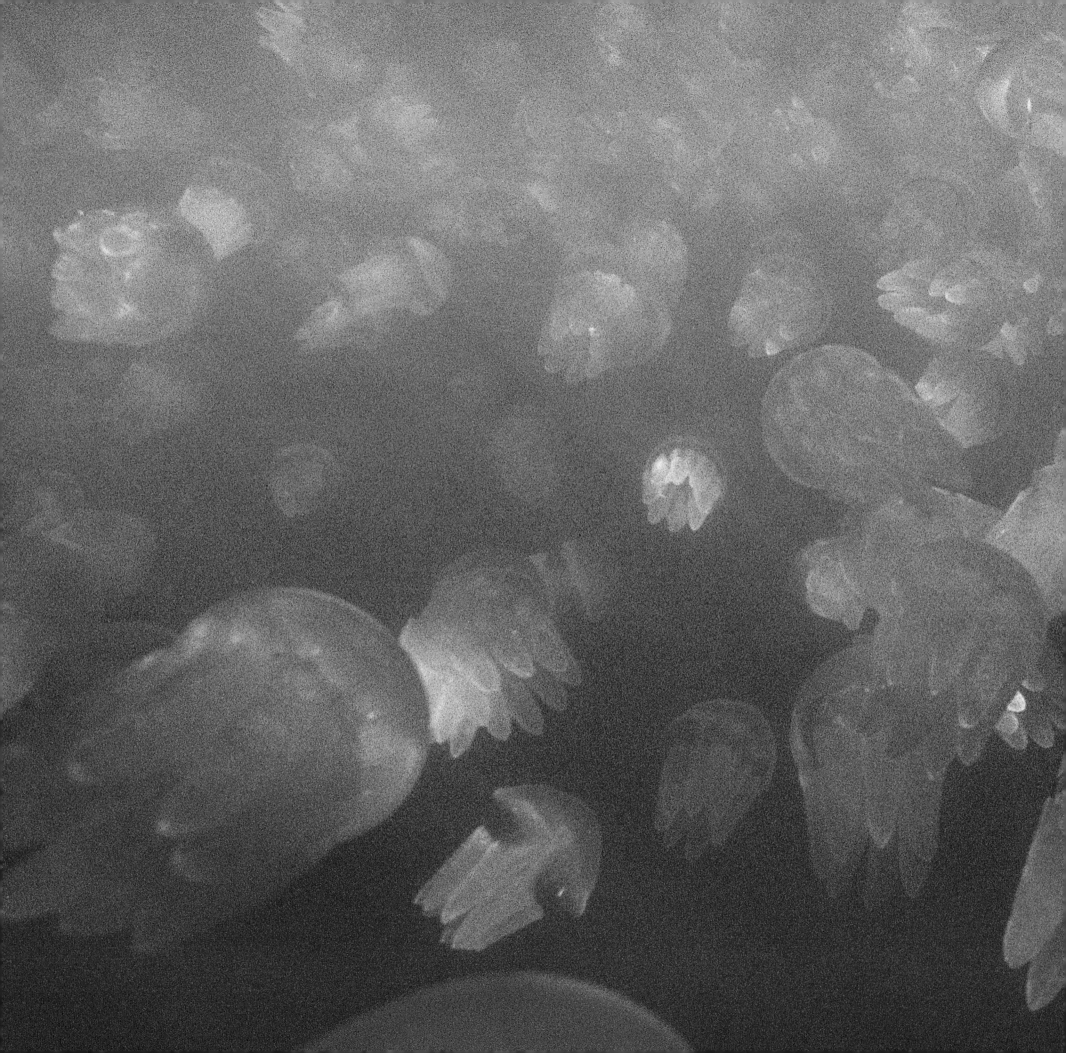

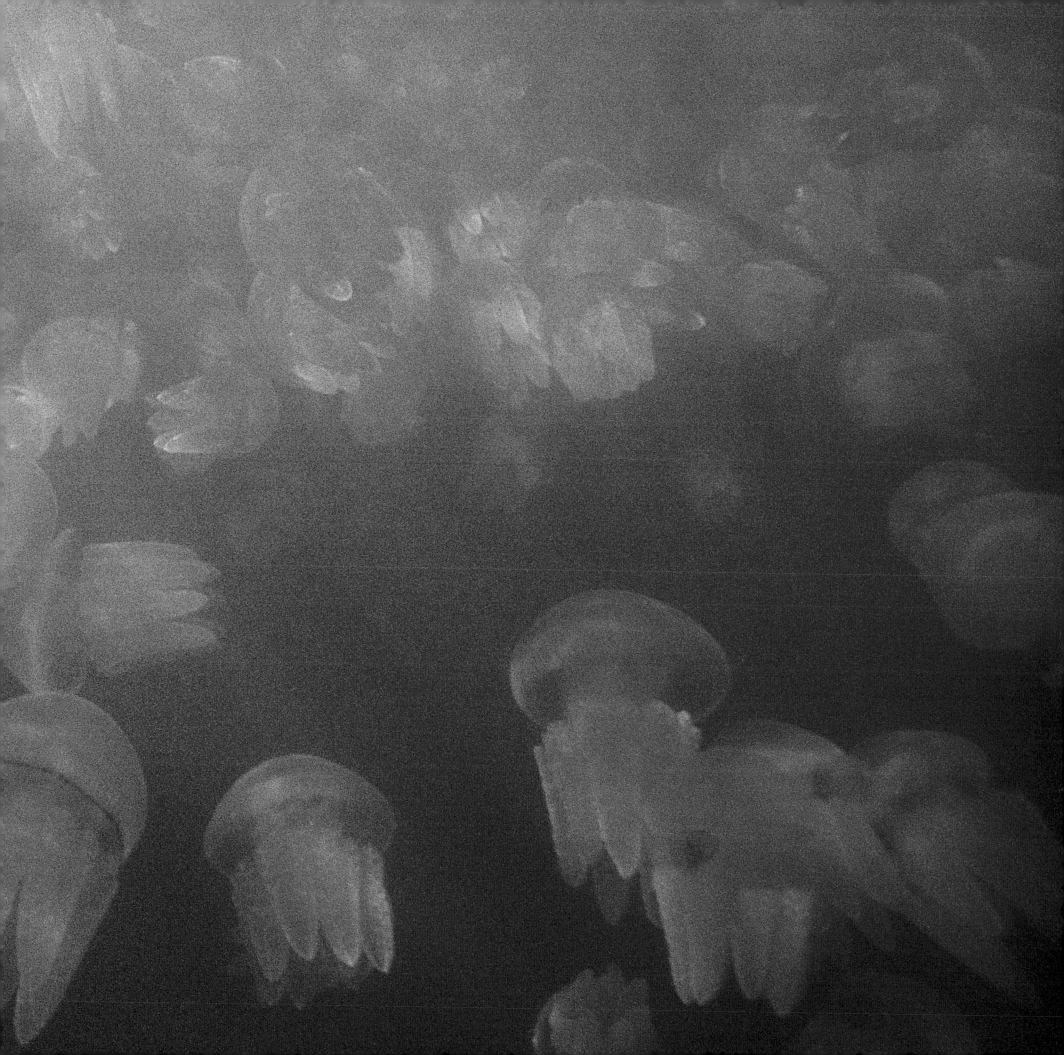

So enslaved by the natural pulses of their life cycles, jellyfish come and go with the seasons. That normal fluctuation, however, may be changing; jellies seem to be increasing in some ecosystems in response to human activities, and in many cases they have become unwanted guests in new ecosystems, where their recent explosions are wreaking havoc. Pollution and environmental degradation, which often result in species loss and eutrophication, may also contribute to the proliferation of some jellyfish species.

One of the most common and perhaps the best-studied members of this group is the moon jellyfish (*Aurelia aurita*). This species has a seemingly cosmopolitan distribution, but modern genetics is proving that many distinct populations exist. Although *Aurelia* arguably had a more restricted range in the past, its affinity for highly eutrophied coastal areas has helped it find its way into every ocean on the planet. In fact, blooms of *Aurelia* can be so dense that an observer would feel he could literally walk on water in their midst. The tight aggregations of *Aurelia* seem to have combined behavioral and hydrodynamic causes, but, whatever their origin, moon jelly blooms are becoming notorious worldwide for interference with, and even periodically shutting down, coastal power plants.

Increasingly, jellyfish blooms are making headlines in the news worldwide. Scientists working in the Bering Sea reported an unprecedented tenfold increase in the biomass of large jellyfish during the 1990s, especially the pizza-size northern sea nettle (*Chrysaora melanaster*) and the Lion's mane (*Cyanea capillata*). Elsewhere in the world, blooms have been reported in the Mediterranean Sea, where the mauve stinger (*Pelagia noctiluca*) and an Indo-Pacific jellyfish (*Rhopilema nomadica*) have been making swimming near some Mediterranean beaches increasingly unpleasant. In September and October of 2002, fishermen off the coast of Japan reported "...more than a thousand jellyfish with bodies the size of washing machines trapped in their nets at a time." The giant jellyfish turned out to be a gigantic red medusa called *Stomolophus nomurai*, a creature that occurs from the surface to 200 m deep, with individuals reaching two meters in diameter and weighing up to 40 kg. Such blooms have occurred off Japan in the 1930s, 1959, 1972, 1995, and 1998 but, with generation-long intervals between blooms until the past decade, the public has been surprised and in awe each time these behemoths appear in great numbers.

In the summer of 2000, ironically only a few months after a meeting in the same location on jellyfish blooms, two large species of jellyfish bloomed sequentially in American coastal waters off the Gulf of Mexico, in sufficient numbers to halt shrimp fishing from Mississippi to Texas simply by the presence of too many jellyfish to haul in the shrimp nets. The jellyfish, which appeared seemingly out of the blue, were spotted jellyfish (*Phyllorhiza punctata*) and then later in the summer the big pink jelly (*Drymonema dalmatinum*) (species of Indo-Pacific and perhaps Mediterranean origin, respectively) and were only vaguely known to have been present in small numbers many years earlier near Puerto Rico. The former reappeared in lesser numbers in 2001, and even fewer in 2002, but it is likely that these jellyfish will linger in the Gulf ecosystem, waning and waxing over the coming years.

The conservation status of most jellyfish and ctenophores is poorly understood. Numbers and diversity of native jellyfishes are known to have dropped substantially in some urbanized coastal areas such as the Adriatic Sea in the Mediterranean and Puget Sound and San Francisco Bay on the west coast of North America, where jellyfishes were studied well enough in the past to recognize such changes now. Although jellyfish have been an important item on the menu in East Asia for generations, a number of new fisheries have been developed recently in Southeast Asia for the global market. In many cases, it is not even known what species are being captured and dried into unrecognizable form, and the consequences for the jellyfish populations or ecosystems are not known.

Aggregations of "jellies" —whether jellyfish or ctenophores— are part of ancient rhythms established thousands of millennia before the advent of humankind and, until recently, their appearance signaled a natural if mystifying phenomenon. However, the recent trend toward huge blooms of a few species populating new parts of the ocean are reflections of underlying disturbances in marine ecosystems. These diaphanous beauties, individually delicate enough to break apart with the slightest nudge, yet durable enough to persist through hundreds of millions of years, are now emerging as harbingers of unprecedented change —oceanic "canaries in the coal mine." The message of the jellies joins other clear signals that we are altering the nature of the sea. Their future —and ours— depends on whether or not we listen.

CLAUDIA E. MILLS
CRISTINA G. MITTERMEIER
SYLVIA A. EARLE

On pp. 276-277, an aggregation of the jellyfish Catostylus mosaicus *off the coast of Brisbane, Australia.*
© Thomas Heeger

On the opposite page, a massive swarm of sea nettles (Chrysaora fuscescens) *in Monterey Bay, California. Near-shore aggregations of this species are most common during the fall and winter months.*
© David Wrobel/Seapics.com

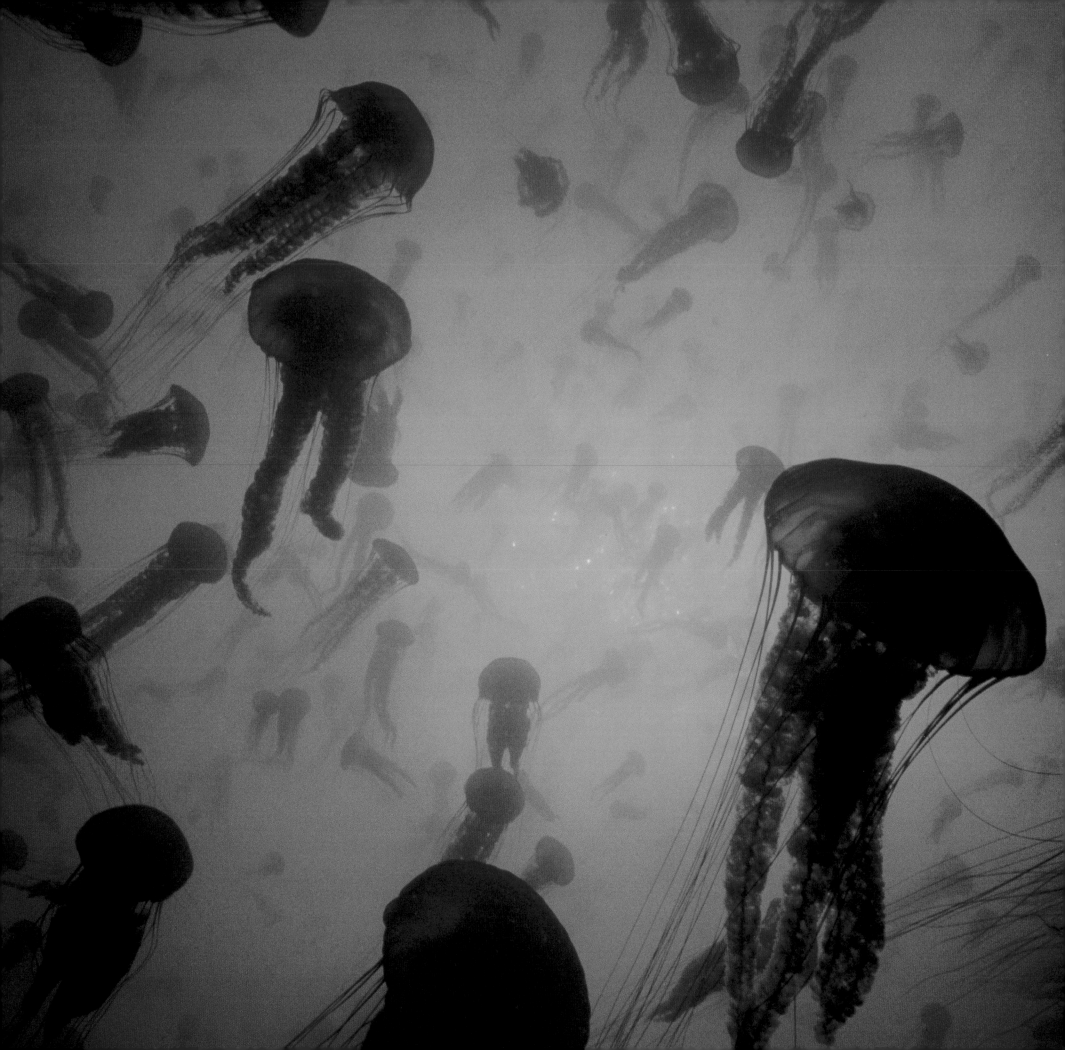

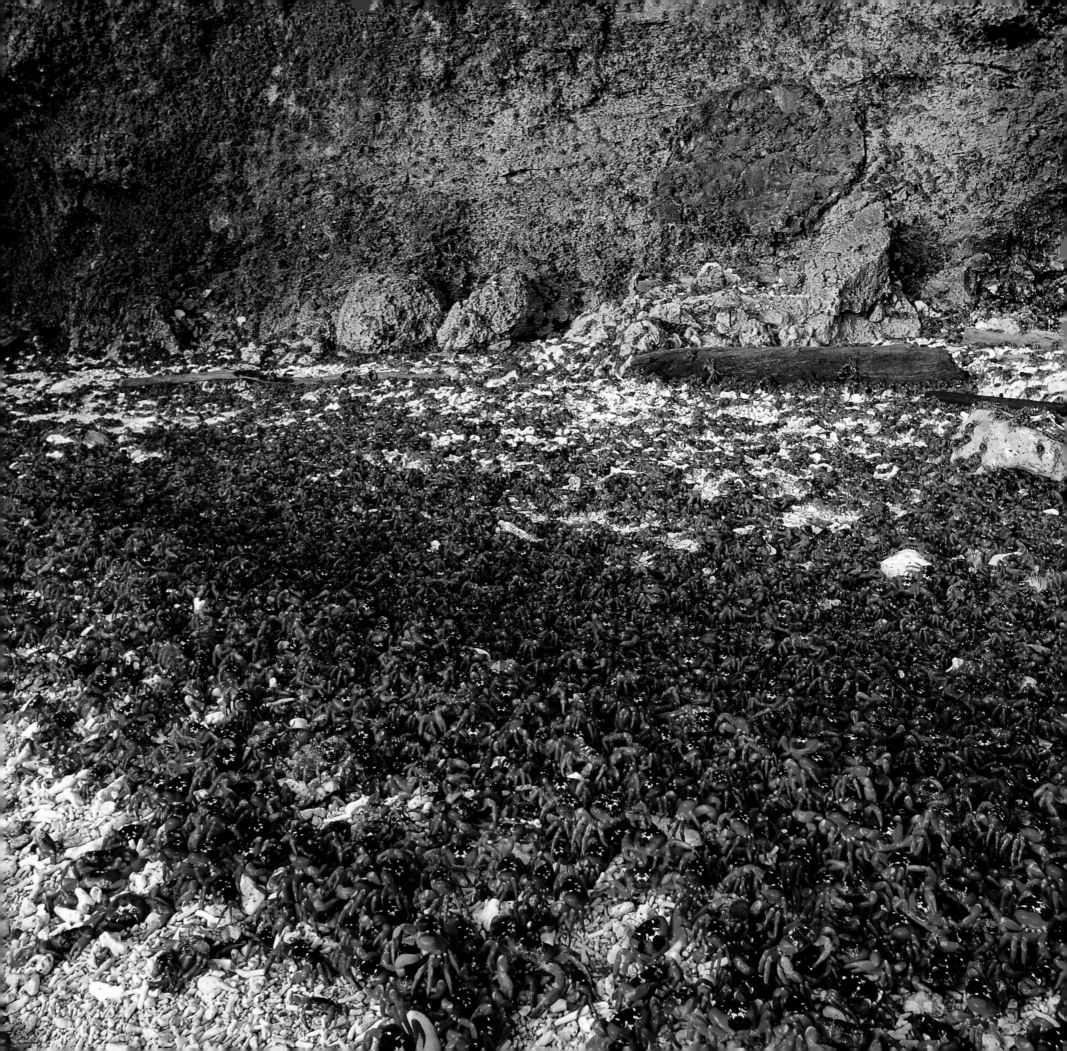

A peak of an ancient volcano rising 5 000 m from the ocean floor some 360 km southwest of the island of Java is home to one of the most dramatic spectacles of animal migration in the world. This peak is known as Christmas Island, a tiny speck of land under Australian jurisdiction. Its volcanic origin is well hidden under a thick layer of coralline limestone and phosphate-rich soil, but in some places the underlying basalt is exposed, allowing the accumulation of surface water. Most of the island is covered by lush tropical forest, supported by over 2 000 mm of annual rainfall and 80%-90% humidity. Under these conditions, a species of a normally aquatic animal flourishes on land in mind-boggling numbers. This animal is the terrestrial red crab (*Gecarcoidea natalis*). With the exception of a small, recently introduced population on the nearby Cocos Islands, red crabs occur nowhere else on Earth.

CHRISTMAS ISLAND RED CRABS

The body of the red crab is one of nature's most successful designs. At an individual weight of up to 500 g, with a rock-hard external skeleton hiding powerful muscles, four pairs of running legs, and a pair of pliers-like pincers, these brightly colored red crabs have few natural enemies. Combine that with the ability to feed on almost any organic matter, climb all obstacles, and excavate deep tunnels, and it is no surprise that the density of these animals can exceed 2.5 individuals/m^2 of the island's 137 km^2 of land. This translates into a biomass of up to 1 454 kg per hectare, or an estimated 100-120 million individuals on the island. These biomass estimates for a single species far exceed those for entire faunas from other tropical forests! No matter how you look at it, Christmas Island belongs to red crabs.

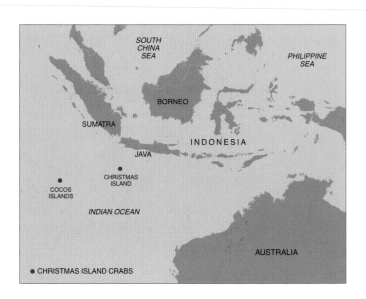

These crustaceans, unlike most other crabs including the few other terrestrial species, are diurnal animals. They forage every day in the understory of the rain forest that covers the island, and their insatiable appetites are responsible for the near complete lack of leaf litter in the forest. In fact, their densities are so high that most fruit and seeds are consumed by the crabs within 12 hours of falling to the ground, resulting in nearly barren forest floor, devoid of any plant matter. Red crabs are more responsible for the current species composition of the island's forests than any other natural force. But while largely herbivorous, red crabs do not shy away from attacking other animals. Their powerful pincers easily crush shells of mollusks, and they have successfully prevented the introduced giant African land snail (*Achatina fulica*) from establishing its destructive presence in the native forests of Christmas Island. At night the crabs hide in their deep burrows, defending their privacy against potential intruders.

Christmas Island,
a tiny speck of land
under Australian jurisdiction,
is home to the terrestrial red crab
(Gecarcoidea natalis)*. With an*
estimated population
of 100-120 million individuals,
these creatures are the dominant
species on this island.
Both photos,
© Jean-Paul Ferrero/Auscape

However, there is no such thing as the perfect design. The red crabs' Achilles' heel is their dependence on water. As the avant-garde of land-invading crustaceans, red crabs still carry the baggage of gills, which while sealed in the sides of their hard thorax need to constantly bathe in moisture. The humidity of the forest's interior is usually high enough to provide the necessary amount of water, but during the dry season, when the leaves fall, exposing and allowing the sun to desiccate the crab's foraging grounds, the animals seal themselves in their burrows for up to three months awaiting the return of wetter conditions. Plugged with a thick wad of leaves, their burrows maintain a humidity level similar to the one during the peak of the rainy season.

But their ties to water go even deeper. Red crabs are direct descendants of marine organisms and their reproductive biology has not yet caught up with the harsh reality of life on land. Each year, at a precise moment dictated by the moon's phases, the entire reproductive population of Christmas Island's red crabs begins a spectacular pilgrimage to the ocean's shore to breed. Red crabs develop slowly and reach sexual maturity at four years of age. Their breeding season, which usually begins in November or December, is an event that affects the entire island. It begins with the males leaving their forest shelters and commencing a trek to the ocean at the onset of the rainy season. Females follow a few days later. The week-long journey envelops the entire island in a moving red carpet of millions upon millions of marching crustaceans. Nothing can stop the moving mass; even human inhabitants have to find ways to accommodate the crabs during their migrations. Most people learn to ignore hordes of red crabs temporarily invading their gardens, golf courses, or even houses. But driving on roads covered with thousands of crushed bodies of crabs killed by vehicles can be very dangerous. The Australian government tries to reduce the threat by building tunnels and walls that funnel the waves of crabs away from busy roads. Regular news bulletins are issued daily, updating the public on the progress of the migration, and traffic is often rerouted around areas of massive crab concentration. Knowing that "...there are still large numbers of females moving to the shoreline across the Resort Road and to Ethel and Lilly Beaches to spawn; they will drop their eggs in the sea over the next couple of mornings" is as important to people on Christmas Island as knowing that a major traffic artery is closed to commuters in Boston or Los Angeles.

After arriving to the shore two weeks before the tide turns during the last quarter of the moon, males quickly dig burrows in the sand and await the arrival of females. Once females reach the shore they mate with the males and begin a two-week long brooding period, during which they produce up to 100 000 small eggs, held in the pouch of their abdomen. Males in the meantime return inland to their old foraging grounds in the forest. When the moon reaches its last quarter, the eggs are ready to be deposited in the sea. At this time there is little difference between the low and high tides, and the females swarm to the shore to dip in the incoming waves and flush out the eggs. Ironically, victims of their own evolutionary advancement, many of them sink and die in the process. Little crab larvae, at this stage known as megalops, hatch almost immediately and swim out into the open sea, only to return a month later as tiny crabs ready to climb ashore. Most of them will die during that time as many filter feeders, such as giant whale sharks and manta rays, make sure they are in the vicinity of Christmas Island during the crab-breeding season. On average, only one or two of the 100 000 tiny larvae each female produces are lucky enough to come back to the island.

While the mortality of adults is much lower, it is still significant. During their migration to the sea, many individuals fall victim to dehydration, and traffic on some roads kills over 15% of crabs in the crosswalk. Then it happens again on their journey back home. Diverting car traffic to roads with fewer crabs and building underpasses helps to lower the mortality but does not eliminate it altogether. Phosphate mining, clearing of forests, and soil removal have been and still are major threats to the population of red crabs. Luckily, 63% of the island is now protected as a national park, including almost the entire western half of the island and a smaller, isolated section on the east coast.

Introduced rats have made a significant dent in the red crab population, but far more serious is the threat caused by a tropical ant (*Anoplolepis gracilipes*) accidentally brought in by humans at the beginning of the twentieth century. These ants are becoming increasingly common in the rain forest favored by the crabs, where they attack and kill them, and then make a nest out of the crab's burrow. Getting rid of the ants is now the priority in conservation efforts to save the crabs and the great wildlife spectacles that they represent.

PIOTR NASKRECKI

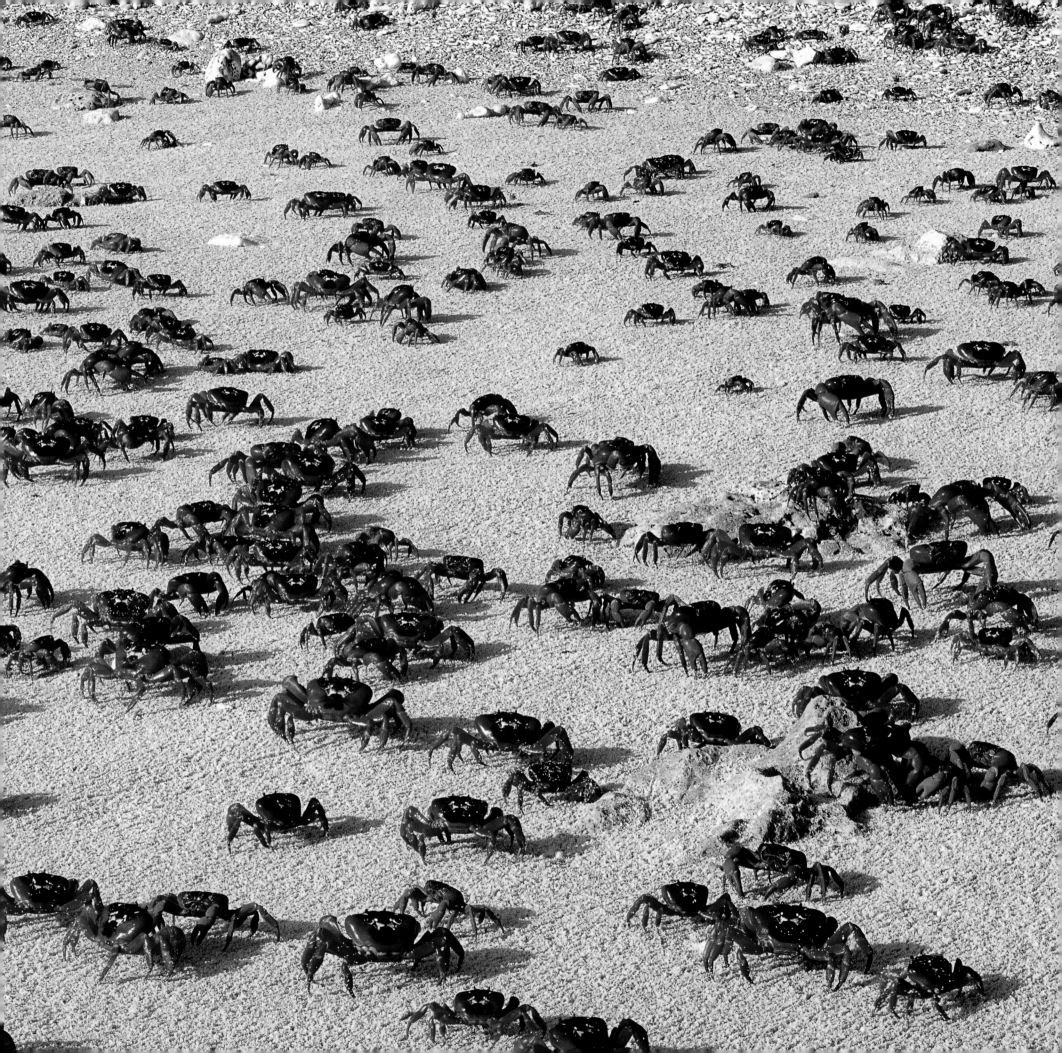

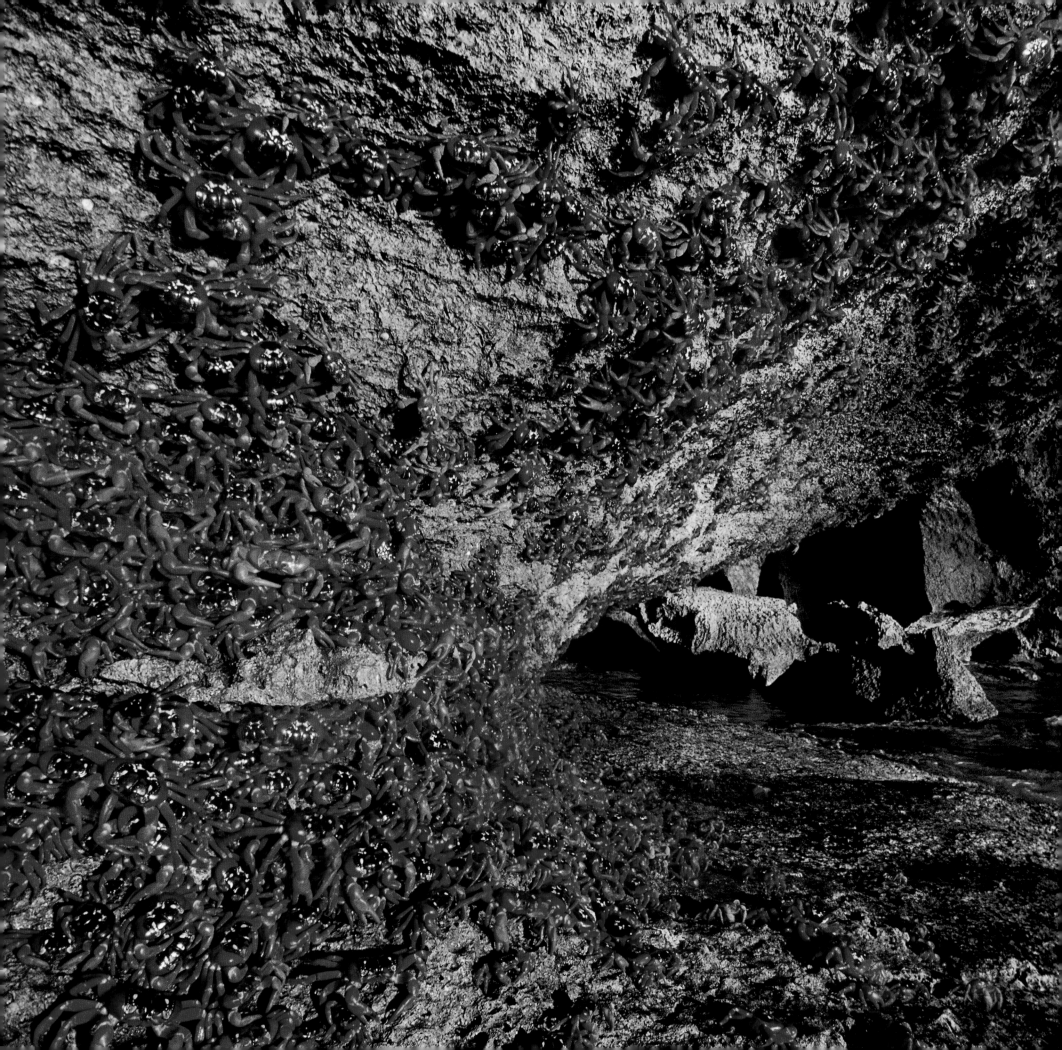

*Although largely herbivorous, red crabs will also
attack other animals. Their powerful pincers easily crush
the shells of mollusks, and they have successfully prevented the
introduced giant African land snail* (Achatina fulica) *from establishing
its destructive presence in the native forests of Christmas Island.
Now, however, their future is threatened by an introduced ant species.*
© Jean-Paul Ferrero/Auscape

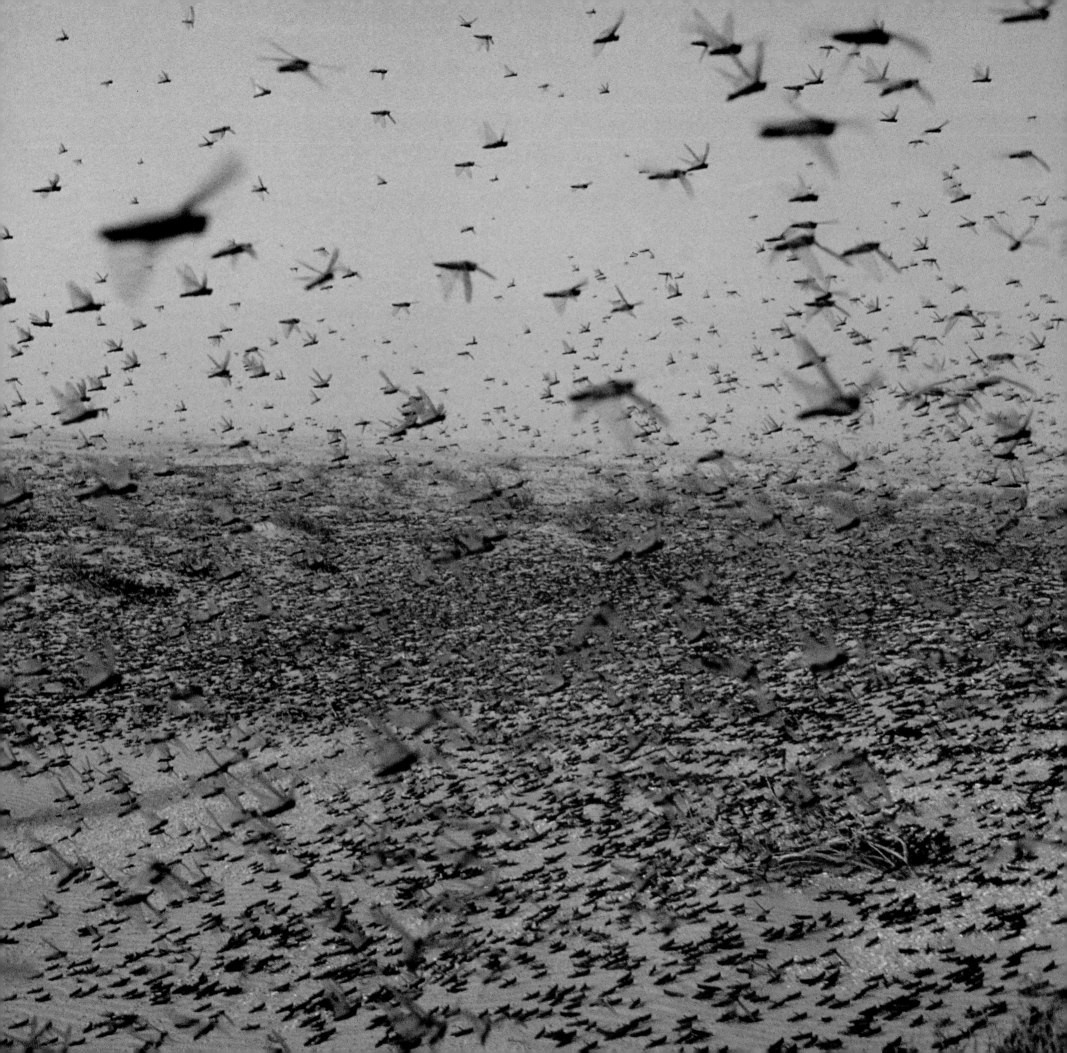

DESERT LOCUSTS

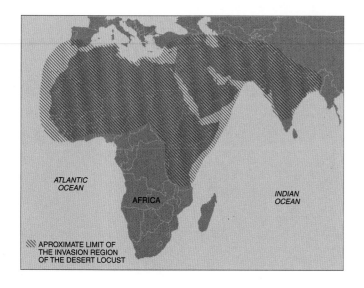

ATLANTIC
OCEAN

AFRICA

INDIAN
OCEAN

▨ APROXIMATE LIMIT OF
THE INVASION REGION
OF THE DESERT LOCUST

A huge, dark cloud looming over the horizon is never a promising sight. Rushing for the shelter of our homes we shudder, thinking of the cold downpour it will bring. But what if instead of fluffy water vapor, the cloud were alive, made of billions of hungry creatures that approach quickly to devour all of the crops you tenderly cared for, bringing famine and devastation? As scary as it sounds, such clouds *do* exist.

It all starts quite innocently in the deserts of North Africa. Inconspicuous, sandy-colored grasshoppers spend their days feeding solitarily on grasses and other vegetation, paying little attention to other members of their own species. At some point females lay eggs in the sand and after a few weeks drab, well-camouflaged nymphs hatch, only to turn into solitary adults a couple of months later; then the cycle continues. But the genetic code of these grasshoppers, known by the name of *Schistocerca gregaria*, the desert locust, harbors the ability to turn those scattered populations of solitary insects into the "Incredible Hulk" of the animal world —a unified, colossal army of powerful destroyers, who abandon their peaceful existence and invade territories hundreds of kilometers away.

The capricious spring rains in the North African desert, though rare, can quickly transform its inhospitable, dry terrain into a green pasture covered with soft, young vegetation. It is a feast for the locusts, which are used to gnawing dried up, dusty stalks and grasses. Females respond with a production of larger than usual eggs, and young nymphs thrive and mature rapidly. As the number of insects in the population grows, so does the chance of physically running into another member of their own species. This casual contact triggers a remarkable transformation. The endocrine system of young locusts starts producing hormones that turn these green, cryptically colored insects a vivid yellow and black. They get bigger and their muscles grow stronger than usual. They no longer shy away from one another; instead they seek each other's company and start forming dense clusters, feeding and marching together. The adults are also different now: from sandy gray they turn bright yellow, their wings become longer, and the body becomes larger and more streamlined. Males start producing pheromones that accelerate the development of other individuals, leading to synchronized maturation across the entire population. At the same time, females' pheromones attract other females, causing them to lay eggs close to each other in dense groups. The entire population grows rapidly and soon the locusts are ready to move on.

The living blizzard
of millions of swarming locusts
is a sight unlike any other
in the natural world.
The speed and direction
of their migrations
is controlled by wind
and other unpredicted weather
conditions, compounding
the problem of locust control.
Both photos,
© Hellio Van Ingen/Auscape

287

From the earliest moments in human history, locusts have terrified and fascinated people. They were seen as a punishment from the gods, a great force of unknown origin that perhaps could be appeased with magic rituals, prayers, or sacrifices. It took us thousands of years to understand that locusts are always around us in dry, warm regions of the world, unnoticed in the normalcy of their solitary phase, mingling with other grasshoppers and not causing any problems. We only start paying attention when a shift into the migratory phase occurs, a change that affects the way locusts look, behave, and reproduce. This ability of certain grasshopper species to alter their behavior and morphology from a solitary to a gregarious phase is what defines the locusts. There are only a handful of species of true locusts, most of them known from the arid regions of Africa, Southeast Asia, and Australia. Populations of other species of grasshoppers on all continents occasionally explode into large swarms and can become serious pests, but they lack the ability to transform into specialized, migratory forms. The grassy plains of Wyoming and Colorado have many such species, yet the only true North American locust, the Rocky Mountain locust (*Melanoplus spretus*), became extinct a century ago for reasons still not entirely clear.

As the population of the desert locusts grows, its members become increasingly restless. Soon after their final molt, the fully winged adults start flying erratically. One group of flying adults stimulates others to take wing, and suddenly an enormous swarm develops and moves off in the direction of the wind. The size of a single swarm can be larger than any other single congregation of organisms on the planet. Desert locust swarms can range in size from 100 000 to 10 000 000 000 insects, making them, in terms of the number of individuals, larger than the entire human population. These giant, live clouds can stretch from a mere 1 km^2 to about 1 000 km^2 and weigh more than 70 000 tons. The amount of food such a mass of insects requires is staggering: in one day, a very large swarm can devour an equivalent of food consumed daily by about 20 million people! In 1794, a particularly large swarm that spread over 5 000 km^2 succumbed to the wind and drowned in the sea off the coast of South Africa. Within days a 1.2-m-deep wall of insect corpses covered 80 km of the shore. Such unimaginable numbers of plant-feeding insects cause similarly unfathomable devastation to crops, and specialized government agencies across the globe are constantly monitoring points of origin and the movement of locust swarms. Unfortunately, once they are airborne, there is

not much that can be done to stop the advancing force. Instead, most of the effort goes towards nipping the problem in the bud by detecting the most likely areas of swarm formation and eradicating young nymphs and eggs. Recently, a promising pathogenic fungus (*Metarhizium anisopliae* var. *acridum*) has provided a viable alternative to harmful and costly pesticide treatments by selectively targeting locusts without any harm to other organisms. Interestingly, few cultures have realized the nutritional value of locusts, which in some cases can counterbalance the complete devastation of the crops. the Jewish *Torah* made an exception to the law forbidding eating any insects by stating "[...] the only flying insects with four walking legs that you may eat are those which have knees extending above their feet, [using these longer legs] to hop on the ground." Some tribes in Southern Africa eat locusts, either boiled or roasted, whereas grilled locusts are often consumed in Cambodia.

Exceeding the carrying capacity of the environment appears to be the principal factor responsible for the swarming behavior of locusts. Massive migrations have evolved in response to diminishing food resources in an attempt to find and colonize new habitats. The strategy turned out to be exceptionally successful, and desert locusts are now widespread over a great area covering most of Africa and a large portion of Southwest Asia. Their ability to stay airborne, carried by winds over huge distances, may also be responsible for the occurrence and subsequent adaptive radiation of the genus *Schistocerca* in the Americas. The migratory locust (*Locusta migratoria*) has a still broader distribution, causing great damage to agriculture in Australia, Asia, Africa, and occasionally even Europe.

In a world where nearly every natural spectacle is threatened by human greed and insensitivity, locust swarms represent a formidable match to our own devastating powers. Like the weather, their occurrence can never be predicted with certainty, and the political instability of the regions most heavily affected by locusts makes any preventive action on the ground exceedingly difficult. This true biblical plague still haunts us, many thousands of years after our ancestors lost their first harvest to a living cloud that came suddenly from a clear, blue sky.

PIOTR NASKRECKI

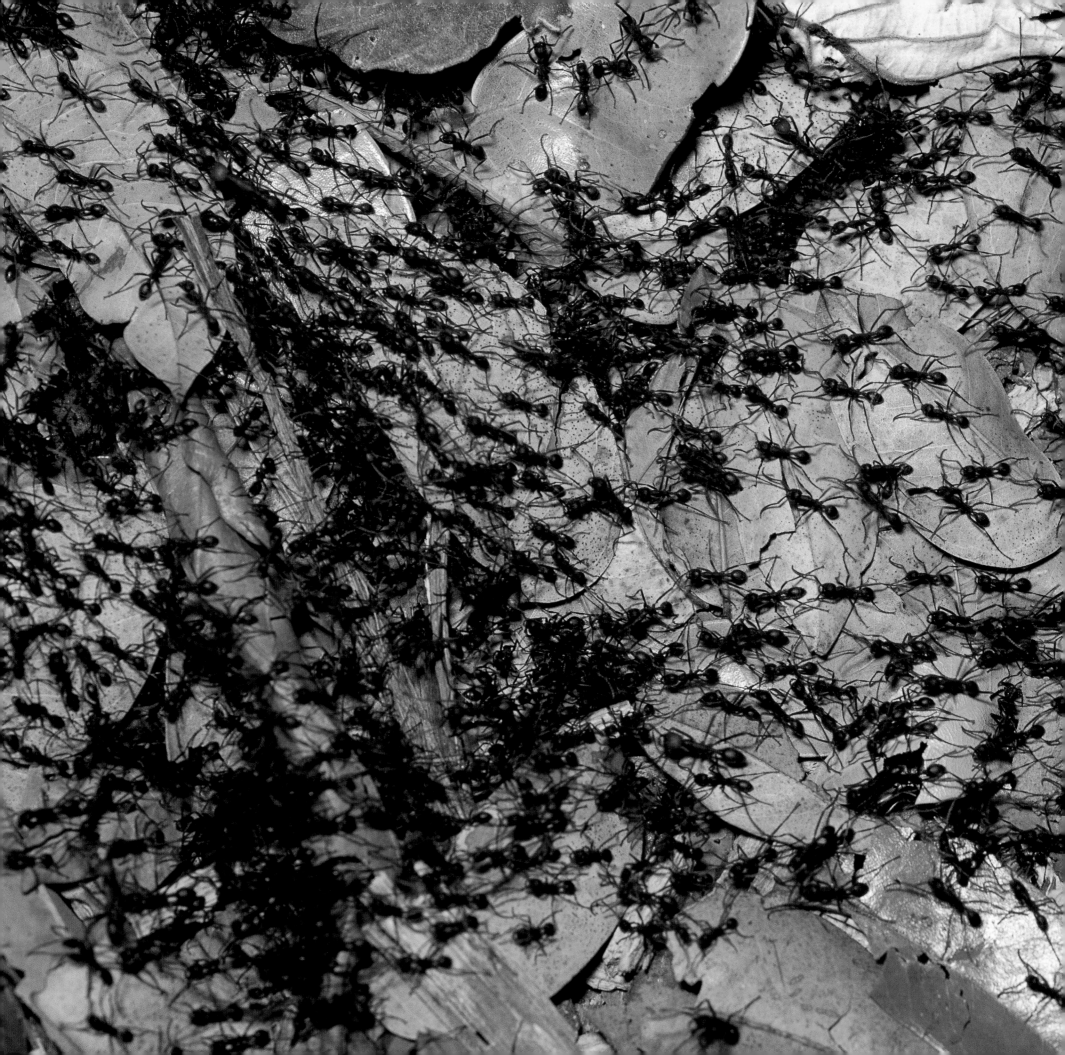

ANTS
AND TERMITES

Insects are among the little things that run the world. Swarming around us in benevolent symbiosis, they keep Earth stable, safe, and fruitful for the rest of life, including our own. Their diversity and numbers are prodigious. More species of insects are known to science —over 800 000 worldwide— than all other kinds of plants, animals, and microorganisms combined. One rough estimate of their global population, meticulously drawn by an ecologist interested in such arcane matters, is a million trillion. Each square meter of English meadow, to take a familiar habitat, contains about a quarter million insects, among which are represented hundreds of species. Including, for example, ants. A good guess of the number of ants in the world is a thousand trillion; because one ant weighs about one-millionth as much as an average human, it follows that the weight of all ants on the planet is very roughly the same as the weight of all humans.

Among the spectacles offered by the insect world, the kind that inspires entomologists and everyone else alike, are colonies of social insects and the nests they build. Higher social life has been attained by some 15 000 species of ants, bees, wasps, and termites, along with a scattering of thrips and aphids. It is marked by the following traits: two or more generations of adults, some of whom are members of non-reproducing worker or soldier castes, live together in colonies and cooperate in the rearing of broods.

If I were a tour guide assigned the spectacular social insects of the world, I would choose five kinds of ants and termites among those that qualify. For sheer visibility and awe-inspiring architectural achievement, there can be no other choice but the mound-building termites of the tropics. Their huge nests, each inhabited by a queen, king, and millions of workers, dot the landscape of savanna and scrub forests of tropics around the world. The most complex among them are domes and spires created by the *Macrotermes* mound-builders of sub-Saharan Africa. The nests rise as much as some 3 m above the ground surface, and extend one or two meters below. At their core lies a labyrinth of cells that serve variously as nurseries for the young and gardens of fungi on which the termites feed. Near the center of the nest is the large royal chamber that houses the queen, her huge sausage-like abdomen filled with developing eggs. By her side lives the king, or reproductive male.

The entire *Macrotermes* mound functions as an air-conditioning system. As air is heated by the bodies of the termites and by their gardens, it rises by convection into a spacious cavern above the living quarters, then flows laterally into flat chambers

On the opposite page, army ants of the Neotropics and driver or safari ants of the Old World are swarm-raiding ants that move in legions that can number in the millions. They move through the forest, flushing and capturing insects and other small prey in one of the great spectacles of nature. In one African species (Dorylus wilverthi), populations grow to as many as 20 million workers, all of them offspring of a single queen.
© Kevin Schafer

Above, social insects, especially ants and termites, are among the most successful animals on Earth, outcompeting solitary insects in most habitats. Worldwide, social insects make up only two percent of the known species of insects, but more than half the total body dry weight. © Konrad Wothe

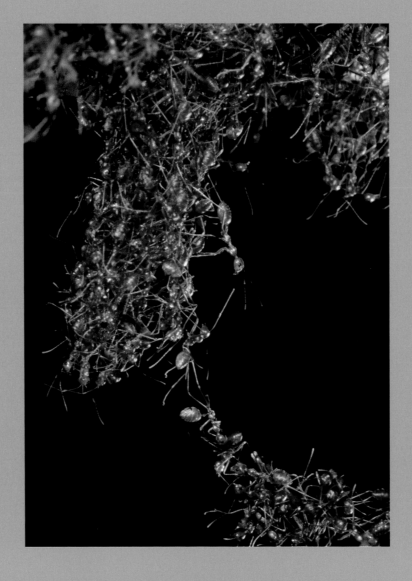

Weaver ants of the genus Oecophylla *are large and ferocious,*
and form colonies of several hundred thousand workers,
each mothered by a single queen, that occupy and completely dominate
the insect life of one or more trees. Their arboreal life-style is made
possible by the construction of football-sized pavilions consisting
of leaves bound together by sheets of silk. To build a pavilion the ants
first form chains of their own bodies, as seen in this photo, pulling leaves
together to form hollow enclosures.
Above, © Mark W. Moffett/Minden Pictures;
opposite, © Günter Ziesler

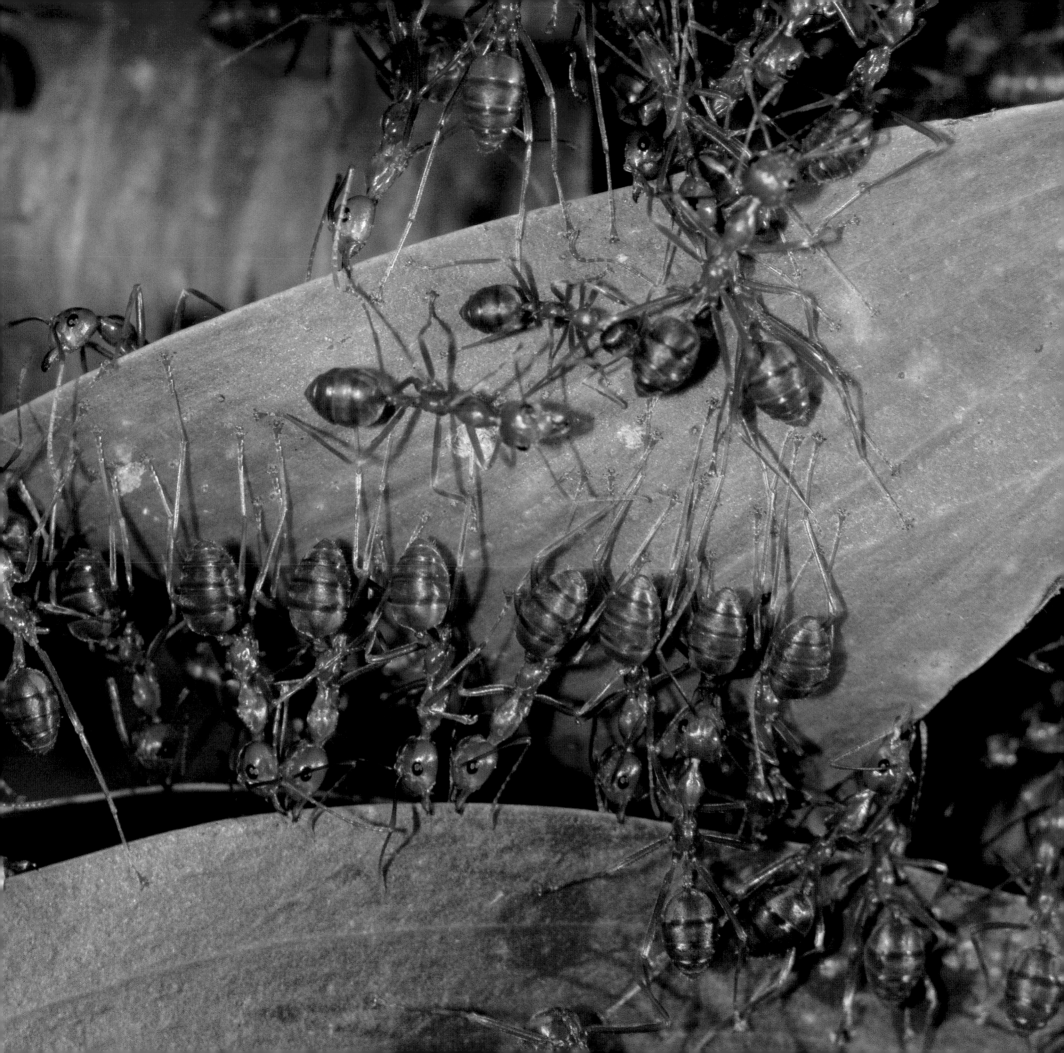

along the side of the nest. There it cools and falls downward to another cavern below the central area, then back up through the living quarters. The flat chambers on the side work like lungs, passing carbon dioxide out and oxygen in by osmosis. Thanks to their instinct-based architecture, the termites live in one of the most secure and climate-controlled environments on Earth.

In the forest canopies of the African tropics and from India to Australia and the Solomon Islands are found architects of a wholly different kind, the weaver ants of the genus *Oecophylla*. Large (for ants) and ferocious, they form colonies of several hundred thousand workers, each mothered by a single queen, that occupy and completely dominate insect life on one to several trees. Their arboreal life-style is made possible by the construction of football-sized pavilions consisting of leaves bound together by sheets of silk. To build a pavilion, the ants first form chains of their own bodies, pulling leaves together to form hollow enclosures. Some then line up in rows to hold the leaves together, gripping one with their legs and the adjacent one with their jaws. With all in place, other workers run into a nearby nursery, pick up grub-like larvae in their jaws, and return to a newly formed seam in the pavilion. It touches the larva's head to a leaf edge at the seam and waves it back and forth, whereupon the larva responds by applying threads of silk to the opposing leaf edges. Countless thousands of such actions hold the pieces of the pavilions together. Additional sheets of silk are laid over the outside and inside of the pavilion walls as a whole.

A way of life radically different from that of weaver ants is followed by the swarm-raiding army ants of the American tropics. The advancing fronts of one colony's legions, composed of tens of thousands to millions of workers flushing and capturing insects and other small prey, is one of the great spectacles of nature. The colonies live in temporary bivouacs rather than well-constructed nests. In the case of the most commonly seen genus, *Eciton*, the shelters are constructed of the workers' own bodies, which they hook together by claws on their feet like circus acrobats.

African driver ants, also often called safari ants, in the genus *Dorylus*, have habits similar to the American army ants. Their legions are among the largest organized societies on Earth. In one species, *Dorylus wilverthi*, populations grow to as many as 20 million workers. All are the offspring of a single mother queen who, at 50 mm is the largest ant known and the most fecund, laying 3 to 4 million eggs a month. On raids the feeder columns, composed of ants running back and forth and on top of one another, resemble black ropes strung along the ground.

The frontal swarm at the end of the main column advances at a rate of 20 m an hour, gathering and killing all insects and other animals unable to get out of its way.

Although not outwardly so awe-inspiring as the swarm-raiding army and driver ants, the most advanced and highly organized colonies of insects anywhere are those of the leafcutter ants in the genera *Atta* and *Acromyrmex*. In forests and grasslands throughout tropical America, columns of their foragers can be seen carrying freshly cut sections of leaves and flowers to their nests. There, in deep underground chambers, operating like an assembly line, specialized workers convert the plant material to pulp and use it to build spongelike beds on which they cultivate a symbiotic fungus, their main source of food. The colonies of some species of *Atta* are immense, comprising a mother queen and several million workers. The galleries and chambers of the nests extend from large mounds of excavated earth to the lowermost penetralia 3 m or more below. It has been estimated that each colony consumes, via its cultivated fungus, as much vegetation as a cow.

The social insects, and especially the ants and termites, are species for species among the most successful animals on Earth. Their colonial life, based upon advanced cooperative techniques in food gathering and defense, allows them to outcompete solitary insects in most habitats. Worldwide, social insects make up only 2% of the known species of insects, but more than half the total body dry weight. In the Amazon forests, ants outweigh all land vertebrates (mammals, birds, reptiles, and amphibians) four times over.

Since the amount of research conducted on social insects has been so limited, at least compared to that devoted to vertebrates and flowering plants, little is known of their conservation status. A few species, such as the primitive Australian "dawn ant" (*Nothomyrmecia macrops*) and Sri Lankan (*Aneuretus simoni*), both important links in evolution, are known to be vulnerable, but the status of the vast majority of other species remains unknown. One thing we do know: most ant species are specialized to live in narrow niches in particular habitats. And of one other thing we can be reasonably sure: the continued destruction of these habitats will eliminate large numbers of social insect species, just as is happening in the better-known organisms.

EDWARD O. WILSON

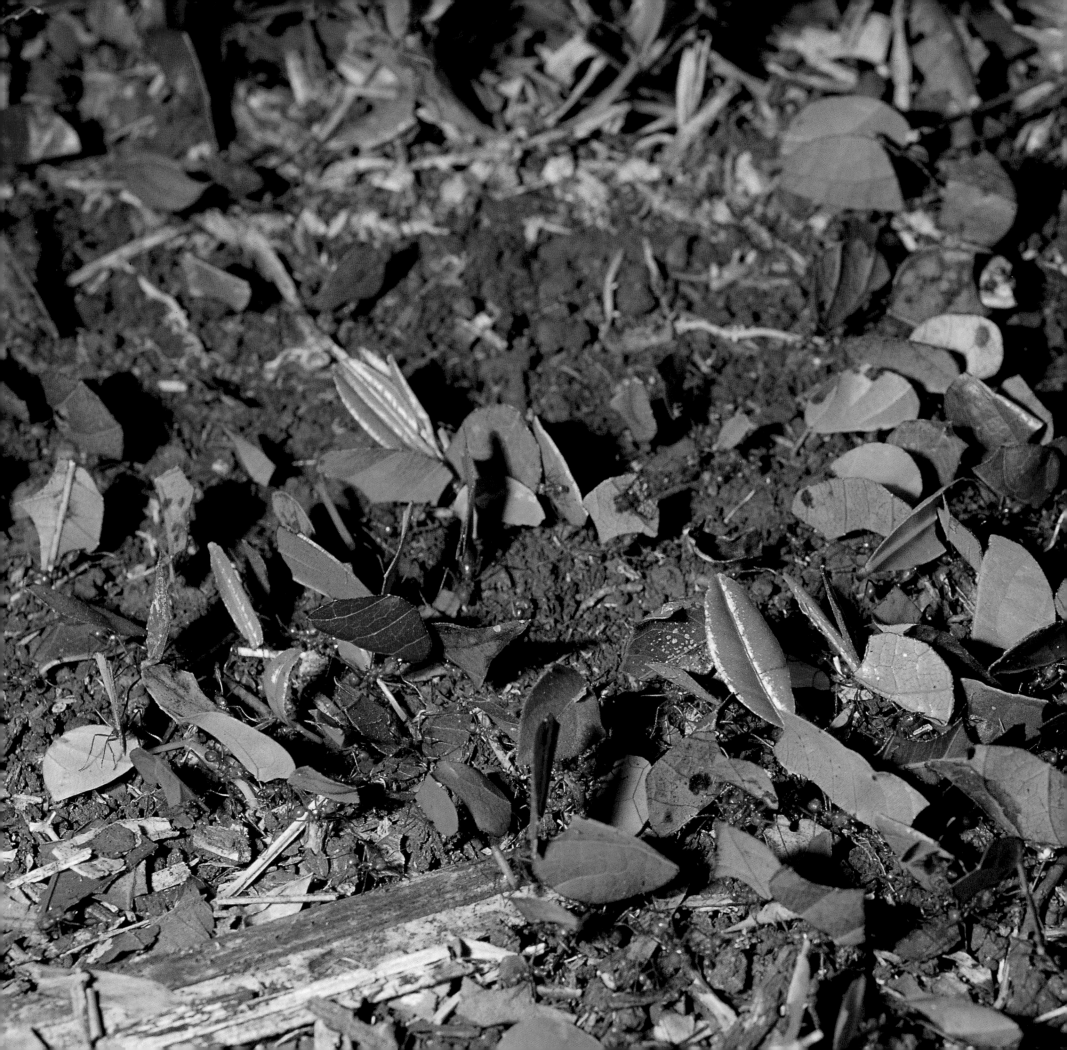

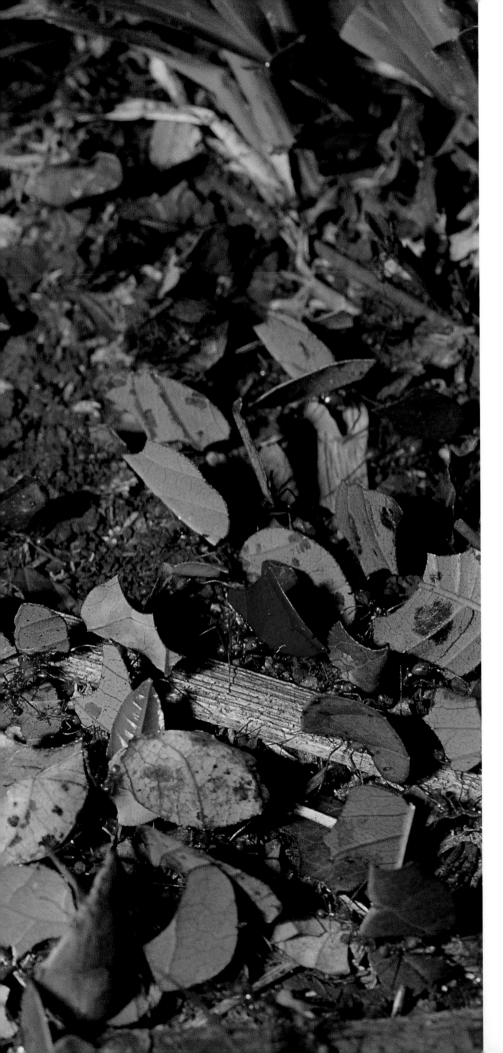

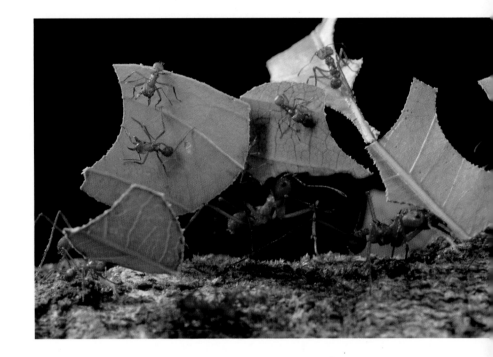

Leafcutter ants (Atta *spp.*) have the most advanced
and highly organized colonies of insects anywhere, and are widespread
and common in the forests and grasslands of tropical America.
Columns of their foragers can be seen carrying freshly cut sections
of leaves and flowers to their nests, where workers convert
the plant material to pulp in deep underground chambers.
This pulp is used to create spongelike beds on which they cultivate a
symbiotic fungus, their main source of food. The colonies of some species of
Atta *are immense, comprising a mother queen and several million workers.*
Opposite, © Stephen J. Krasemann/DRK PHOTO;
above, © Mark W. Moffett/Minden Pictures

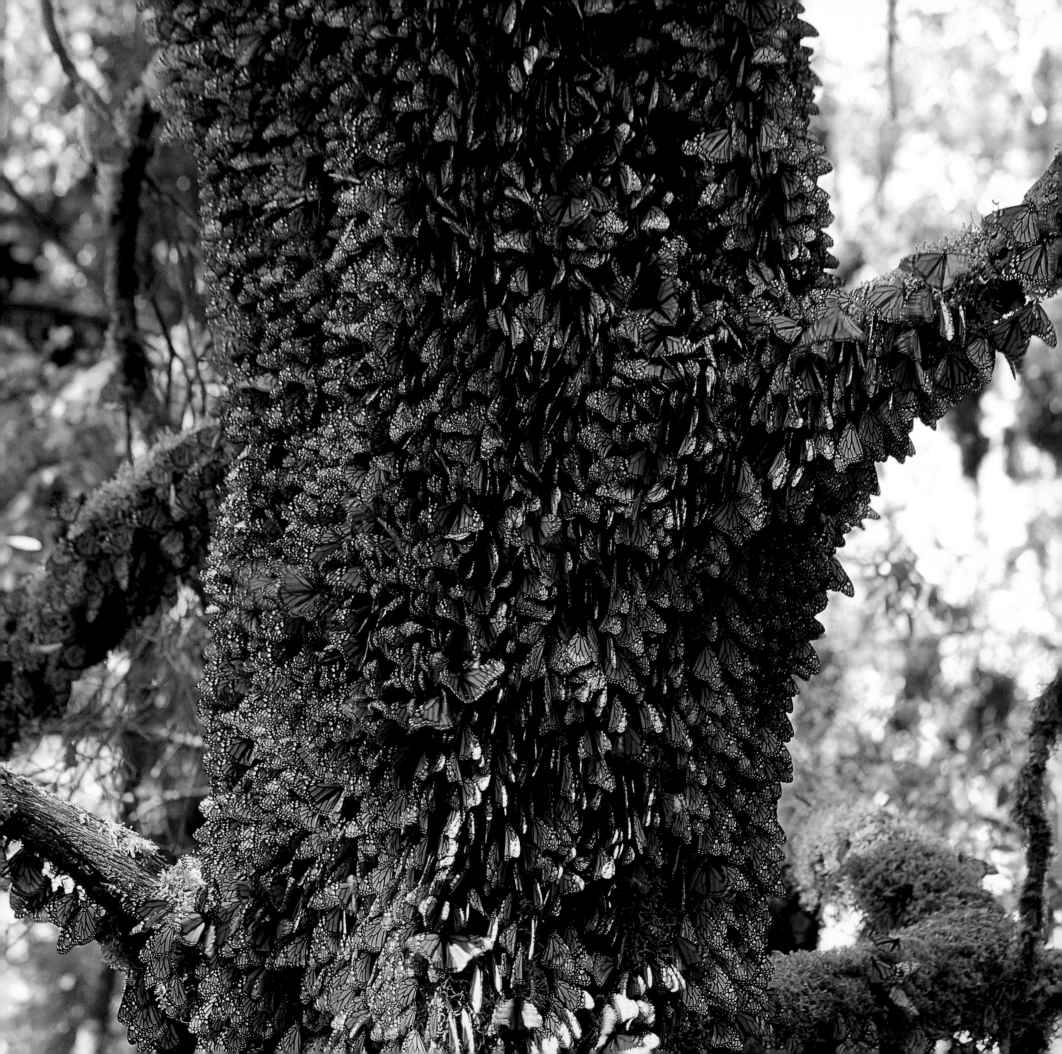

MONARCH
BUTTERFLIES

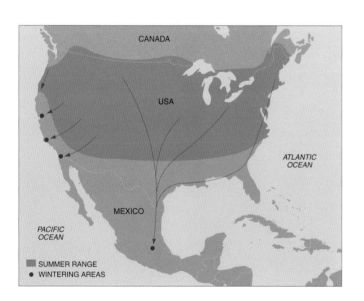

SUMMER RANGE
WINTERING AREAS

There is a sierra in the Mexican Trans-Volcanic Belt where, during the winter months, one can find fragments of forest with trees literally covered with monarch butterflies (*Danaus plexippus*). Such a great number of them come together to winter that the tree trunks are totally covered and the branches droop and sometimes even break off due to the fragile weight of thousands of these lepidopterans. It is like a sleeping forest with a strange, hidden presence that only awakes when bathed by the sunlight. Thus thousands, even millions of monarchs take flight, painting the sky with a visual spectacle unparalleled in the animal kingdom.

This is one of the two migratory populations of monarch butterflies found in North America. In the mid 1970s, Canadian scientist F.A. Urquhart discovered the first overwintering site of the eastern population of monarchs about 120 km west of Mexico City. The second population, which is smaller and ranges west of the rocky mountains, takes refuge in the winter in the eucalypt and Monterey pine forests on the coast of California, where the Pacific marine climate is less extreme; thus, the butterflies avoid the danger of freezing to death.

We now know that each fall an estimated 2 billion monarchs funnel from their northern breeding grounds in Canada and the US into Mexico and form 10 to 20 tightly aggregated colonies that range in size from about 0.1 to 5 hectares, with more than 62 million butterflies per hectare. The combined area they occupy from year to year ranges from about 5 to 20 hectares. To give an idea of the magnitude of butterfly packing in the Mexican aggregations, this combined overwintering area is less than one ten millionth the area of their breeding range. All known overwintering sites occur on only 12 mountain ranges that occupy a 30 by 60 km area. Visiting these sites and seeing the hundreds of tree trunks and thousands of tree boughs festooned with the millions of monarch butterflies is a deeply moving experience.

Monarchs are able to overwinter in these high altitude forests because the firs generate a protective microclimate that is cool enough to preserve the butterflies' lipid reserves and quell their reproductive activities, but not cold enough to freeze them to death, as would happen if they remained in their northern breeding range. As the spring equinox approaches and the weather warms, the overwintering butterflies begin mating and literally flood out of the overwintering forests to migrate back to the Gulf Coast states where they establish the first new spring generation in early April. Perils are ever present, however, and the principal one is variation in the high montane climate of the overwintering area. Because the forest areas occupied by the butterflies occur at more than 3 000 m altitude, northern cold fronts that penetrate across the Tropic of Cancer can bring wind, rain, sleet, snow, and freezing weather.

Monarch butterflies
(Danaus plexippus)
blanketing the trunk and branches of an oak tree in Sierra Chincua. The monarch is a classic example of a seasonal wildlife spectacle, with a combined overwintering area that is less than one-ten-millionth of their overall breeding range.
Both photos,
© Patricio Robles Gil/
Sierra Madre

These aggregations in effect are a seed crop, which must survive the winter in order to continue the annual migratory cycle of the monarch. Realization of their vulnerability in 1983 resulted in the IUCN designating the monarch's migration and overwintering behavior as an *endangered biological phenomenon*. There are two principal reasons for this designation. The first is a long term issue and involves the heavy use of herbicides throughout the spring and summer breeding range in the US and Canada. The repeated use of these agricultural chemicals over millions of hectares of land eliminates milkweeds, the only plants that monarch caterpillars can eat, and also kills the native herbaceous flora from which adults drink nectar, the crucial energy source that fuels their migration and overwintering. The second problem —the immediate Achilles' heel of the overwintering phenomenon— is forest degradation in Mexico. Extensive biological research has shown that an intact forest is crucial for the butterflies because the tree boughs act as an umbrella and blanket protecting the monarchs from wetting and radiational heat loss that can drop their body temperatures well below freezing and kill them. Forest thinning is analogous to cutting holes in the blanket and puncturing the umbrella and greatly exacerbates winter storm mortality in the colonies. Dire predictions of heavy mortality associated with the forest thinning were realized in January 2002 when a widespread rain and snowstorm soaked the entire overwintering region. When it cleared, the wetted and vulnerable monarchs were subjected to extreme radiant heat loss that froze and killed more than a half billion butterflies.

A recent collaborative study involving WWF and scientists from the University of Mexico and Sweet Briar College determined that 44% of the butterfly forests have been degraded and fragmented over the past 28 years and that the rate of degradation is increasing. This study motivated the Mexican government in November 2000 to expand the size of the protected overwintering area from 16 110 ha to 56 259 hectares and also resulted in a private foundation setting up a trust fund to compensate landowners for the loss of income from the taking of their logging rights. Notwithstanding these important conservation advances, commercial wood harvesting, agricultural encroachment and extensive illegal tree poaching in the supposedly protected areas continue. The migratory and overwintering syndrome manifested by the monarch butterfly is too great a cultural and scientific treasure to allow these rampantly destructive processes. Time is rapidly running out.

LINCOLN P. BROWER
GUILLERMO CASTILLEJA
PATRICIO ROBLES GIL

On the opposite page, monarch butterflies (Danaus plexippus) *in the early morning fog, bending the branches of a fir forest by their sheer numbers.*
© Claudio Contreras

On pp. 302-303, monarch butterflies at incredible densities in a forest in Mexico. Every year, an estimated 2 billion monarchs funnel from their northern breeding grounds in Canada and the U.S. into Mexico and form 10 to 20 tightly aggregated colonies that range in size from about 0.1 ha to 5 ha, with more than 60 million butterflies per ha.
© Carlos Gottfried

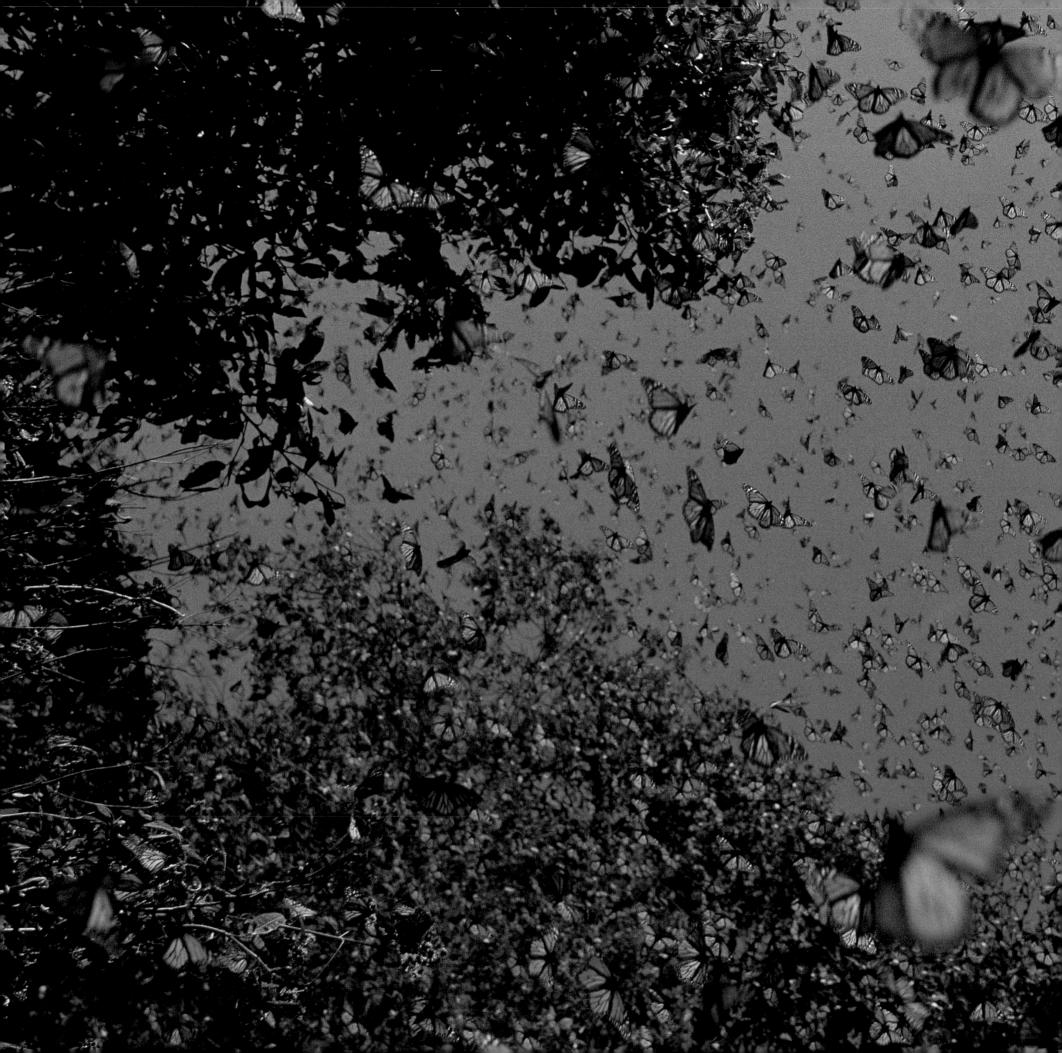

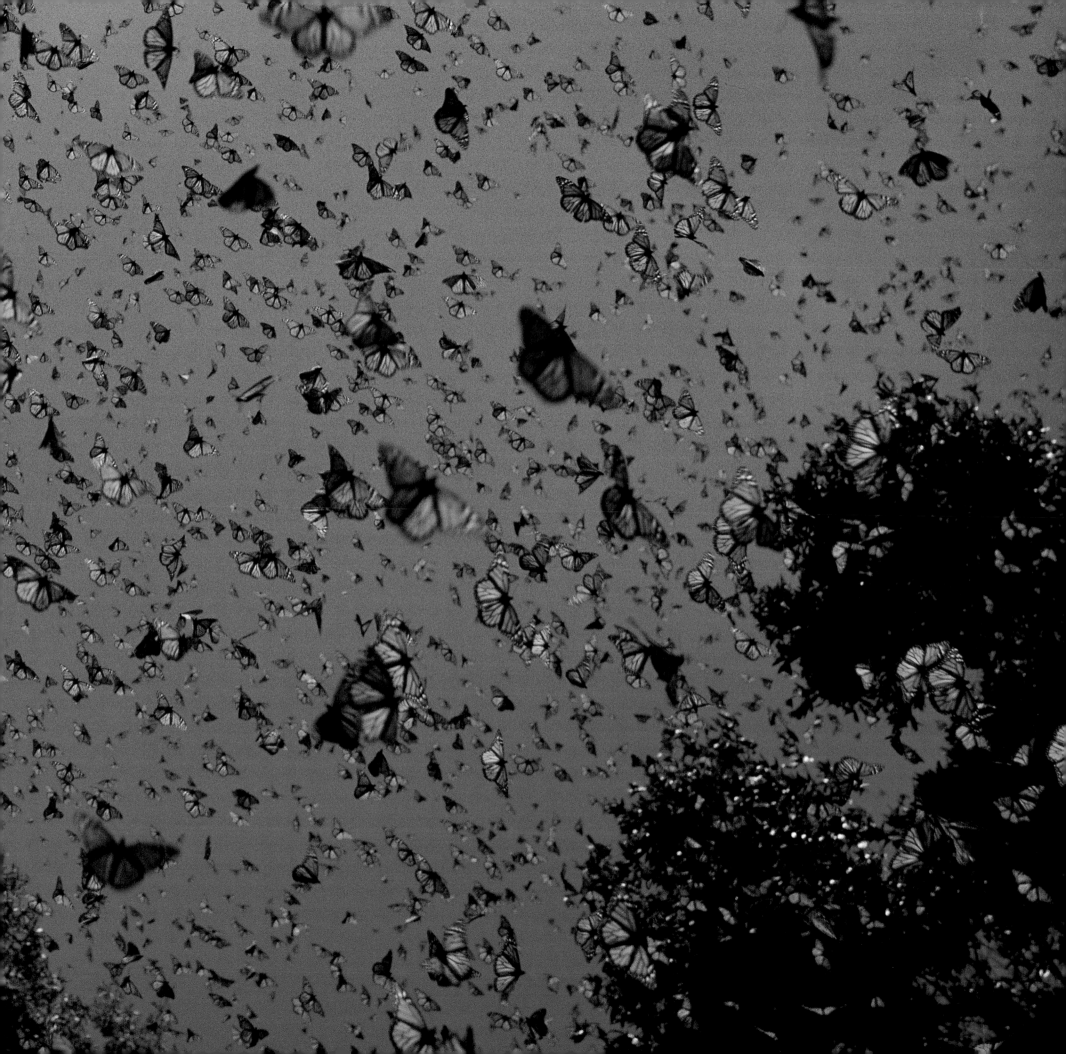

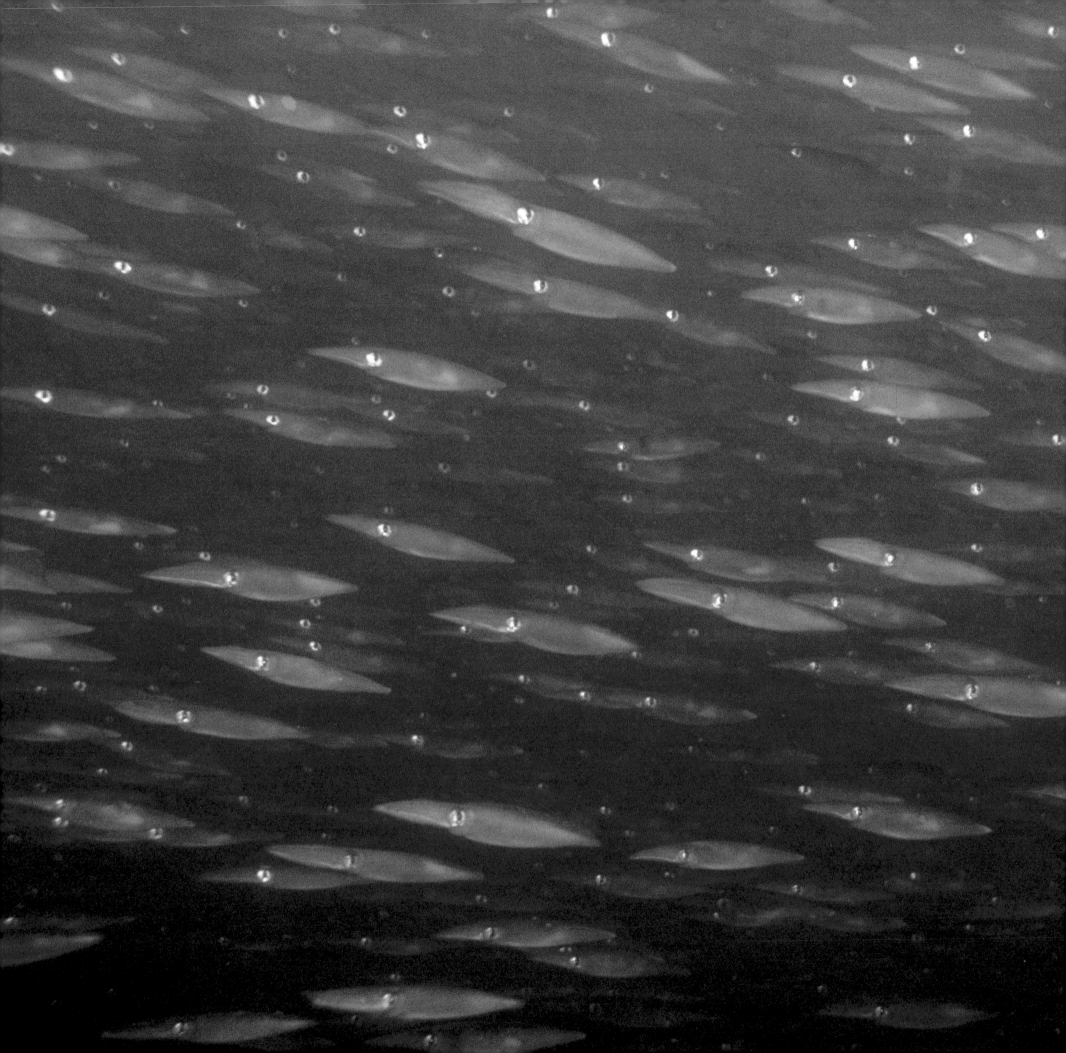

INTRODUCTION

AINLEY, D.G., R.E. LERESCHE, and W.J.L. SLADEN. 1983. *Breeding Biology of the Adélie Penguin*. University of California Press, Berkeley.

BATES, H.W. 1863. *The Naturalist on the River Amazonas*. John Murray, London.

BENNUN, L. and L. FISHPOOL. 2000. The Important Bird Areas Programme in Africa: An outline. *Ostrich* 71:150-153.

BIRDLIFE INTERNATIONAL. 2000. *Threatened Birds of the World*. Lynx Edicions, Barcelona.

BRETT, J.J. 1986. *The Mountain and the Migration*. Cornell University Press, Ithaca, New York.

BUCHER, E.H. 1992. The causes of extinction of the Passenger Pigeon. *Current Ornithology* 9:1-36.

CARAS, R. 1966. *Last Chance on Earth*. Chilton Books, Philadelphia.

CHIPLEY, R.M., G.H. FENWICK, and M.J. PARR. 2003. *The American Bird Conservancy Guide to the Top 500 Bird Sites in the United States: America's Most Valuable Conservation Hotspots*. Random House, New York.

DAVIS, S.D., V.H. HEYWOOD, and A.C. HAMILTON, 1994-1997. *Centers of Plant Diversity. A Guide and Strategy for Their Conservation*. Volumes 1–3. WWF and IUCN, Cambridge, U.K.

DAY, D. 1989. *Vanished Species*. Gallery Books, New York.

EHRLICH, P.R., D.S. DOBKIN, and D. WHEYE. 1992. *Birds in Jeopardy: The Imperiled and Extinct Birds of the United States and Canada*. Stanford University Press, California.

EVANS, M.I. 1994. *Important Bird Areas in the Middle East*. BirdLife Conservation Series No. 2. BirdLife International, Cambridge, U.K.

FISHER, Jr., A.C. 1972. African wildlife: Man's threatened legacy. *National Geographic* 141(2):147-187.

FISHPOOL, L.D.C. and M.I. EVANS. 2001. *Important Bird Areas in Africa and Associated Islands. Priority Sites for Conservation*. BirdLife Conservation Series No. 11. BirdLife International, Cambridge, U.K.

FREEMAN, D. 1980. *Elephants: The Vanishing Giants*. Gallery Books, New York.

FULLER, E. 1999. *The Great Auk*. Harry N. Abrams, New York.

GÓMEZ DE SILVA GARZA, H. 1996. The conservation importance of semiendemic species. *Conservation Biology* 10:674-675.

GREENWAY, Jr., J.C. 1958. *Extinct and Vanishing Birds of the World*. Special Publication No. 13, American Committee for International Wild Life Protection, New York.

HAINES, F. 1970. *The Buffalo*. Thomas Y. Crowell Company, New York.

HEATH, M.F. and M.I. EVANS. 2000. *Important Bird Areas in Europe. Priority Sites for Conservation*. BirdLife Conservation Series No. 8. BirdLife International, Cambridge, U.K.

HILTON-TAYLOR, C. 2002. *2000 IUCN Red List of Threatened Species*. IUCN, Gland, Switzerland.

HORNADAY, W.T. 1887. *The Extermination of the American Bison*. Report of the National Museum, Washington, D.C.

JACKSON, J.B.C., M.X. KIRBY, W.H. BERGER, K.A. BJORNDAL, L.W. BOTSFORD, B.J. BOURQUE, R.H. BRADBURY, R. COOKE, J. ERLANDSON, J.A. ESTES, T.P. HUGHES, S. KIDWELL, C.B. LANGE, H.S. LENIHAN, J.M. PANDOLFI, C.H. PETERSON, R.S. STENECK, M.J. TEGNER, and R.R. WARNER. 2001. Historical overfishing and the recent collapse of coastal ecosystems. *Science* 293:629-638.

KEAR, J. and N. DUPLAIX-HALL (eds.). 1975. *Flamingos*. T. and AD Poyser, Berkhamsted, England.

LEAKEY, L.S.B. 1969. *Animals of East Africa*. National Geographic Society, Washington, D.C.

LOTT, D.F. 2002. *American Bison – A Natural History*. University of California Press, Berkeley.

MACPHEE, R.D.E. 1999. *Extinctions in Near Time*. Kluwer Academic, New York.

MITTERMEIER, R.A., C.G. MITTERMEIER, and P. ROBLES GIL. 1997. *Megadiversity. Earth's Biologically Wealthiest Nations*. CEMEX, Mexico City.

MITTERMEIER, R.A., N. MYERS, P. ROBLES GIL, and C.G. MITTERMEIER. 1999. *Hotspots. Earth's Biologically Richest and Most Endangered Terrestrial Ecoregions*. CEMEX, Mexico City.

MITTERMEIER, R.A., C.G. MITTERMEIER, P. ROBLES GIL, J. PILGRIM, G. FONSECA, T. BROOKS, and W.R. KONSTANT. 2002. *Wilderness: Earth's Last Wild Places*. CEMEX, Mexico City.

MYERS, N. 1972. *The Long African Day*. The Macmillan Company, New York.

NERONOV, V. and A. LUSHCHEKINA. 2002. Extinction crisis for the saiga antelope. *Species, Newsletter of the Species Survival Commission* 38:4-5.

NOWAK, R.M. 1991. *Walker's Mammals of the World : Volume II*. Fifth edition. The Johns Hopkins University Press, Baltimore.

OLSON, D.M., and E. DINERSTEIN. 1998. The Global 200: A representation approach to conserving the Earth's most biologically valuable ecoregions. *Conservation Biology* 12:502–515.

ORENSTEIN, R. (ed.). 1991. *Elephants: The Deciding Decade*. Sierra Club Books, San Francisco.

ORR, R.T. 1970. *Animals in Migration*. The Macmillan Company, London.

O'TOOLE, C. 1995. *Alien Empire: An Exploration of the Lives of Insects*. HarperCollins Publishers, London.

PRITCHARD, P.C.H. 1979. *Encyclopedia of Turtles*. T.F.H. Publications, Neptune.

PRITCHARD, P.C.H. 1996. *The Galapagos Tortoises: Nomenclatural and Survival Status*. Chelonian Research Monographs, Number 1. Chelonian Research Foundation, Lunenberg, Massachusetts.

RIEDMAN, M. 1990. *The Pinnipeds: Seals, Sea Lions and Walruses*. University of California Press, Berkeley.

RUDLOE, A. and J. RUDLOE. 1981. The changeless horseshoe crab. *National Geographic* 159(4):562-572.

SAFINA, C. 1997. *Song for a Blue Ocean*. Owl Books, New York.

SCHORGER, A.W. 1955. *The Passenger Pigeon: Its Natural History and Extinction*. University of Oklahoma Press, Norman.

SCHWEITZER, A. 1956. *On the Edge of the Primeval Forest*. The Macmillan Company, New York.

SEABORN, C. 1996. *Underwater Wilderness: Life in America's National Marine Sanctuaries and Reserves*. Roberts Rhinehart Publishers, Boulder, Colorado and Monterey Bay Aquarium.

STATTERSFIELD, A.J., M.J. CROSBY, A.J. LONG, and D.C. WEGE. 1998. *Endemic Bird Areas of the World: Priorities for Biodiversity Conservation*. BirdLife Conservation Series, BirdLife International, Cambridge, U.K.

SWAN, L.A. 1964. *Beneficial Insects*. Harper and Row, Publishers, New York.

SWINGLAND, I.R. and M.W. KLEMENS. 1989. *The Conservation Biology of Tortoises. Occasional Papers of the IUCN Species Survival Commission (SSC), No. 5*. IUCN – The World Conservation Union and the Durrell Institute of Conservation and Ecology, Gland, Switzerland.

TEALE, E.W. 1966. *Grassroot Jungles*. Dodd, Mead and Company, New York.

MAMMALS

Bats

HALL, L.S. 1994. The magic of Mulu. *Bats* 12(4):8-12.

HUTSON, A.M., S.P. MICKLEBURGH, and P.A. RACEY. 2001. *Microchiropteran Bats: Global Status Survey and Conservation Action Plan*. IUCN, Gland, Switzerland.

KUNZ, T.H., J.O. WHITAKER, and M.D. WADANOLI. 1995. Dietary energetics of the insectivorous Mexican free-tailed bat (*Tadarida brasiliensis*) during pregnancy and lactation. *Oecologia* 101:407-415.

MCCRACKEN, G.F. and M.K. GUSTIN. 1991. Nursing behavior in Mexican free-tailed bat maternity colonies. *Ethology* 89:305-321.

MICKLEBURGH, S., A.M. HUTSON, and P.A. RACEY. 1992. *Old World Fruit Bats. An Action Plan for Their Conservation*. IUCN, Gland, Switzerland.

SORENSEN, U.G. and K. HALBERG. 2001. Mammoth roost of nonbreeding straw-coloured fruit bat *Eidolon helvum* (Kerr, 1792) in Zambia. *African Journal of Ecology* 39:213-215.

WILSON, D. and M.D. TUTTLE. 1997. *Bats in Question: The Smithsonian Answer Book*. Smithsonian Institution Press, Washington, D.C.

On the opposite page, market squid (Loligo opalescens) schooling in large numbers during a mating episode, La Jolla Marine Reserve, La Jolla, California. © Richard Herrmann/ Seapics.com

Primates

BENNETT, E.L. and F. GOMBEK. 1993. *Proboscis Monkeys of Borneo.* Natural History Publications (Borneo) SDN. BHD, Sabah, Malaysia.

DUNBAR R.I.M. 1993. Conservation status of the gelada. In N.G. JABLONSKI (ed.), Theropithecus: *The Rise And Fall of a Primate Genus.* Cambridge University Press, Cambridge, pp. 527-531.

DUNBAR, R.I.M. and E.P. DUNBAR. 1974. Ecological relations and niche separation between sympatric terrestrial primates in Ethiopia. *Folia Primatologica* 21:36-60.

GARTLAN, J.S. and T.T. STRUHSAKER. 1972. Polyspecific associations and niche separation of rain-forest anthropoids in Cameroon, West Africa. *Journal of Zoology, London* 168:221-266.

GAUTIER-HION, A. 1988. Polyspecific associations among forest guenons: Ecological, behavioural and evolutionary aspects. In A. GAUTIER-HION, F. BOURLIERE, J.-P. GAUTIER, and J. KINGDON, *A Primate Radiation: Evolutionary Biology of the African Guenons.* Cambridge University Press, Cambridge, pp. 452-476.

GAUTIER-HION, A., M. COLYN, and J.-P. GAUTIER. 2001. *Histoire Naturelle des Primates d'Afrique Centrale.* ECOFAC, Libreville.

KIRKPATRICK, R.C. 1998. Ecology and behavior in snub-nosed and douc langurs. In N.G. JABLONSKI (ed.), *The Natural History of the Doucs and Snub-nosed Monkeys.* World Scientific Publishing, Singapore, pp. 155-190.

KUMMER, H. 1968. *Social Organization of the Hamadryas Baboons: A Field Study.* University of Chicago Press, Chicago.

LONG, Y.C. and R.C. KIRKPATRICK. 1991. A preliminary report on the Yunnan snub-nosed monkey (*Rhinopithecus bieti*). *Asian Primates* 1(3):1-3.

SANDERSON, I. 1957. *The Monkey Kingdom.* Hanover House, Garden City, New York.

STRUHSAKER, T.T. 1969. Correlates of ecology and social organization among African cercopithecines. *Folia Primatologica* 11:80-118.

WASER, P.M. 1987. Interactions among primate species. In D.L. CHENEY, R.M. SEYFARTH, R.W. WRANGHAM, and T.T. STRUHSAKER, *Primate Societies.* The University of Chicago Press, Chicago, pp. 210-226.

Seals, sea lions, and walruses

BONNER, W.N. 1989. *The Natural History of Seals.* Christopher Helm Publishers, London.

KING, J.E. 1983. *Seals of the World.* Oxford University Press, Oxford.

PERRIN W.F., B. WURSIG, and J.G.M. THEWISSEN. 2002. *Encyclopedia of Marine Mammals.* Academic Press, San Diego.

REEVES, R.R., B.S. STEWART, and S. LEATHERWOOD. 1992. *The Sierra Club Handbook of Seals and Sirenians.* Sierra Club Books, San Francisco.

RIEDMAN, M. 1990. *The Pinnipeds: Seals, Sea Lions, and Walruses.* University of California Press, Berkeley.

TWISS, J., R.R. REEVES, and S. MONTGOMERY. 1999. *Conservation and Management of Marine Mammals.* Smithsonian Institution Press, Washington, D.C.

Whales, dolphins, and porpoises

American Cetacean Society. 2003. Gray Whale (*Eschrichtius robustus*) Fact Sheet. Online: http://www.acsonline.org/factpack/graywhl.htm

CLAPHAM, P.J. and J.G. MEAD. 1999. *Megaptera novaeangliae. Mammalian Species* 604:1-9.

EVANS W.E. 1994. Common dolphin, White-bellied porpoise – *Delphinus delphis* Linnaeus, 1758. In S.H. RIDGWAY and S.R. HARRISON (eds.), *Handbook of Marine Mammals.* Vol. 5: The first book of dolphins. Academic Press, London, pp. 191-224.

FISHERIES AND MARINE INSTITUTE of Memorial University of Newfoundland, Canada. 2003. Offshore/Inshore Fisheries Development. Online http://www.mi.mun.ca/mi-net/fishdeve/cetace14.htm

HEWITT, R.P. and J.D. LIPSKY. 2002. Krill. In W.F. PERRIN, B. WÜRSIG, and J.G.M. THEWISSEN (eds.), *Encyclopedia of Marine Mammals*, Academic Press, San Diego, pp. 676-684.

JONES, M.L. and S.L. SWARTZ. 2002. Gray whale *Eschrichtius robustus.* In W.F. PERRIN, B. WÜRSIG, and J.G.M. THEWISSEN (eds.), *Encyclopedia of Marine Mammals*, Academic Press, San Diego, pp. 524-526.

KLEINENBERG, S.E. et al. 1969. Beluga (*Delphinapterus leucas*): Investigation of the Species. Translated by O. Theodor. National Science Foundation. (Available from the National Technical Information Service, Springfield, VA 22161. Stock No. TT-67-51345.).

African plains game

BALMFORD, A. 1992. Social dispersion and lekking in Uganda kob. *Behaviour* 120:177-191.

EAST, R. 1999. *African Antelope Database 1998.* IUCN, Gland, Switzerland.

GRZIMEK, B. and M. GRZIMEK. 1960. *Serengeti Shall Not Die.* Hamish Hamilton, London.

HANKS, J. 2000. The role of Transfrontier Conservation Areas in southern Africa in the conservation of mammalian biodiversity. In A. ENTWHISTLE, and N. DUNSTONE (eds.) *Priorities for the Conservation of Mammalian Diversity.* Cambridge University Press, Cambridge, U.K., pp. 239-256.

KINGDON, J. 1997. *The Kingdon Field Guide to African Mammals.* Academic Press, London and New York.

LEUTHOLD, W. 1977. *African Ungulates. A Comparative Review of Their Ethology and Behavioral Ecology.* Springer-Verlag, Berlin, Heidelberg, New York.

MILLS, G. and L. HES. 1997. *The Complete Book of Southern African Mammals.* Struik, Cape Town.

South Asian ungulates

MISHRA, C. and A.J.T. JOHNSINGH. 1998. Population and conservation of the Nilgiri tahr *Hemitragus hylocrius* in Anamalai Hills, South India. *Biological Conservation* 86:199-206.

RAHMANI, A.R. 1990. Distribution of the Indian Gazelle or Chinkara *Gazella bennettii* (Sykes) in India. *Mammalia* 54:605-619.

RAHMANI, A.R. 1991. Present distribution of the blackbuck (*Antilope cervicapra* Linn.) in India, with special emphasis on the lesser known populations. *Journal of Bombay Natural History Society* 88:35-46.

RODGERS, W.A. 1988. The wild grazing ungulates of India: An ecological review. In P. SINGH, and P.S. PATHAK (eds.), *Rangeland Symposium.* Rangeland Management Society of India, IGFRI, Jhansi, Nov. 9-12, 1987, pp. 404-419.

SHAH, N. 1999. Mammals. In H.S. SINGH, B.H. PATEL, R. PARVEZ, V.C. SONI, N.V. SHAH, K. TATU, and D. PATEL (eds.), *Ecological Study of Wild Ass Sanctuary Little Rann of Kutc.* GEER Foundation, Gandhinagar, Gujarat, pp. 109-150.

Caribou

CALEF, G. 1981 (Rev. ed. 1995). *Caribou and the Barren-lands.* Firefly Books, Willlowdale, Ontario.

GEIST, V. 1998. *Deer of the World: Their Evolution, Behaviour, and Ecology.* Stackpole Books, Mechanicsburg, Pennsylvania.

HALL, E. (ed.) 1989. *People and Caribou in the Northwest Territories.* NWT Department of Renewable Resources. Yellowknife, NWT.

KELSALL, J.P. 1968. *The Migratory Barren-ground Caribou in Canada.* Queen's Printer, Ottawa.

Tibetan antelope

GOLDSTEIN, H. and C. BEALL. 1990. *Nomads of Western Tibet.* University of California Press, Berkeley.

MALLON, D.P. and S.C. KINGSWOOD. 2001. *Antelopes. Global Survey and Regional*

Action Plans. Part 4. North Africa, the Middle East, and Asia. IUCN, Gland, Switzerland.

RAWLING, C. 1905. *The Great Plateau.* Edward Arnold, London.

SCHALLER, G. 1997. *Tibet's Hidden Wilderness.* Abrams, New York.

SCHALLER, G. 1998. *Wildlife of the Tibetan Steppe.* University of Chicago Press, Chicago.

WRIGHT, B. and A. KUMAR. 1998. *Fashioned for Extinction: An Exposé of the Shahtoosh Trade.* Wildlife Protection Society of India, New Delhi.

Saiga

BANNIKOV, A.G., L.V. ZHIRNOV, L.S. LEBEDEVA, and A.A. FANDEEV. 1961. *Biologiya saigaka* [Biology of the Saiga Antelope]. Moscow.

BEKENOV, A.B., YU. A. GRACHEV, and E.J. MILNER-GULLAND. 1998. The ecology and management of the saiga antelope in Kazakhstan. *Mammal Review* 28:1-52.

CHAN, S., A.V. MAKSIMUK, L.V. ZHIRNOV, and S.V. NASH. 1995. *From Steppe to Store: The Trade in Saiga Antelope Horn.* TRAFFIC International, Cambridge, U.K.

LUSHCHEKINA, A.A., S. DULAMTSEREN, L. AMGALAN, and V.M. NERONOV. 1999. The status and prospects for conservation of the Mongolian saiga *Saiga tatarica mongolica. Oryx* 33:21-30.

MILNER-GULLAND, E.J., A.B. BEKENOV, and YU. A. GRACHEV. 1995. The real threat to the saiga antelope. *Nature* 377:488-489.

MILNER-GULLAND, E.J., M.V. KHOLODOVA, A. BEKENOV, O.M. BUKREEVA, YU. A. GRACHEV, L. AMGALAN, and A.A. LUSHCHEKINA. 2001. Dramatic decline in saiga populations. *Oryx* 35:340-345.

SOKOLOV, V.E. and L.V. ZHIRNOV (eds.). 1998. *Saigak: filogeniya, sistematika, ekologiya, okhrana i ispol'zovanie* [The Saiga Antelope: Phylogeny, Systematics, Ecology, Conservation, and Use]. Russian Academy of Sciences, Moscow.

BIRDS

Penguins

BOERSMA, P.D. 1986. Patagonia's penguin megalopolis. *Animal Kingdom* 89:29-39.

BOERSMA, P.D. 1998. Plight of the penguins. *Wildlife Conservation* 101(1):20-27.

BOSWALL, P.D. and R.J. PRYTERCH. 1972. Some notes on the birds of Punta Tombo, Argentina. *Bulletin of the British Ornithological Club* 92:118-129.

DANN, P., I. NORMAN, and P. REILLY. 1995. *The Penguins: Ecology and Management.* Surrey Beatty & Sons, Chipping Norton, Australia.

DAVIS, L.S. 2001. *The Plight of the Penguin.* Longacre Press, Dunedin, New Zealand.

ELLIS, S., J.P. CROXALL, and J. COOPER. 1998. *Penguin Conservation Assessment and Management Plan.* IUCN/SSC Conservation Breeding Specialist Group, Apple Valley, Minnesota.

HARRISON, P. 1983. *Seabirds, an Identification Guide.* Houghton Mifflin, Boston.

MARTINEZ, I. 1992. Order Sphenisciformes. In: J. DEL HOYO, A. ELLIOTT, and J. SARGATAL (eds). *Handbook of the Birds of the World,* Vol. 1, Lynx Edicions, Barcelona, pp. 140-160.

SIMPSON, G.G. 1976. *Penguins: Past and Present, Here and There.* Yale University Press, New Haven.

STONEHOUSE, B. 1975. *The Biology of Penguins.* Macmillan, London.

WILLIAMS, D.T. 1995. *The Penguins: Spheniscidae.* Bird Families of the World Series. Oxford University Press, Oxford.

Pelagic seabirds

BROTHERS N. 1991. Albatross mortality and associated bait loss in the Japanese longline fishery in the Southern Ocean. *Biological Conservation* 55:255-268.

HUNT G.L., F. MEHLUM, R.W. RUSSEL, D. IRONS, M.B. DECKER, and P. BECKER. 1998. Physical processes, prey abundance and foraging ecology of seabirds. In N.J. ADAMS and R.H. SLOTOW (eds.), Proc. 22 Int. Ornithol. Congr., Durban. *Ostrich* 69:106.

MOORS P.J. and I.A.E. ATKINSON. 1984. Predation on seabirds by introduced mammals and factors affecting its severity. In J.P. CROXALL, P.G.H. EVANS, and R.W. SCHREIBER R.W. (eds.), International Council for Bird Preservation Technical Publication No. 2, Cambridge, pp. 667-690.

NEL D.C., J.R.E. LUTJEHARMS, E.A. PAKHOMOV, I.J. ANSORGE, P.G. RYAN, and N.T.W. KLAGES. 2001. Exploitation of mesoscale oceanographic features by grey-headed albatross *Thalassarche chrysostoma* in the southern Indian Ocean. *Marine Ecology Progress Series* 217:15-26.

NORMAN F.I. 1970. The effects of sheep on the breeding success and habitat of the short-tailed shearwater *Puffinus tenuirostris* (Temminck). *Australian Journal of Zoology* 18:215-229.

SKEPKOVYCH B.O. and W.A. MONTEVECCHI. 1989. The world's largest known nesting colony of Leach's Storm Petrel on Baccalieu Island, Newfoundland. *American Birds* 43:38-42.

Flamingos

ALLEN, R.P. 1956. *The Flamingos: Their Life History and Survival.* National Audubon Society Research Report 5.

BALDASSARRE, G.A., F. ARENGO, and K.L. BILDSTEIN. 2000. Conservation biology of flamingos. *Waterbirds* 23 (Special Publication 1).

GRUPO PARA LA CONSERVACIÓN DE FLAMENCOS ALTOANDINOS. 2001. Priority actions for the conservation of high-Andes flamingos. Final Report to the Convention on Migratory Species.

KEAR, J. and H. DUPLAIX-HALL. 1975. *Flamingos.* T. and A.D. Poyser. Berkhamsted, United Kingdom.

OGILVIE, M. and C. OGILVIE. 1986. *Flamingos.* Alan Sutton, Gloucester, U.K..

Waterfowl

BIRDLIFE INTERNATIONAL. 2000. *Threatened Birds of the World.* Lynx Edicions, Barcelona.

DEL HOYO, J., A. ELLIOTT, and J. SARGATAL. 1992. *Handbook of the Birds of the World.* Volume 1. Lynx Edicions, Barcelona.

FRIEND, M. and J.C. FRANSON. 1999. *Field Manual of Wildlife Diseases, General Field Procedures and Diseases of Birds.* U.S. Geological Survey, Madison, Wisconsin.

TODD, F. 1996. *Natural History of the Waterfowl.* San Diego Natural History Museum and Ibis Publishing Co.,Vista, California.

WETLANDS INTERNATIONAL. 2002. *Waterbird Population Estimates* – Third Edition. Wetlands International Global Series No. 12. Wageningen, The Netherlands.

Raptors

ADAMS A.A.Y., S.K. SKAGEN, and R.L. KNIGHT 2000. Functions of perch relocations in a communal night roost of wintering bald eagles. Canadian Journal of Zoology 78(5):809-816.

ALASKA DEPARTMENT OF NATURAL RESOURCES (ADNR). 2002. Chilkat Bald Eagle Preserve Management Plan. Public Review Draft. April 2002. Alaska Dept. of Natural Resources.

BILDSTEIN, K.L. 1999. Racing with the sun: The forced migration of the Broad-winged Hawk. In K.P. ABLE (ed.). *Gatherings of Angels: Migrating Birds and Their Ecology.* Cornell University Press, Ithaca, New York, pp. 79-102.

BIRDLIFE INTERNATIONAL. 2000. *Threatened Birds of the World.* Lynx Edicions, Barcelona.

BUCKLEY, N.J. 1999. Black Vultures (*Coragyps atratus*). In A. POOLE and F. GILL (eds.), *The Birds of North America,* No. 411. The Academy of Natural Sciences, Philadelphia and the American Ornithologists' Union. Washington, D.C.

On pp. 308-309, on slightly cloudy days, hundreds of thousands of monarch butterflies (Danaus plexippus) perched on tree trunks take flight when they are hit by sudden sunlight.
© Patricio Robles Gil/Sierra Madre

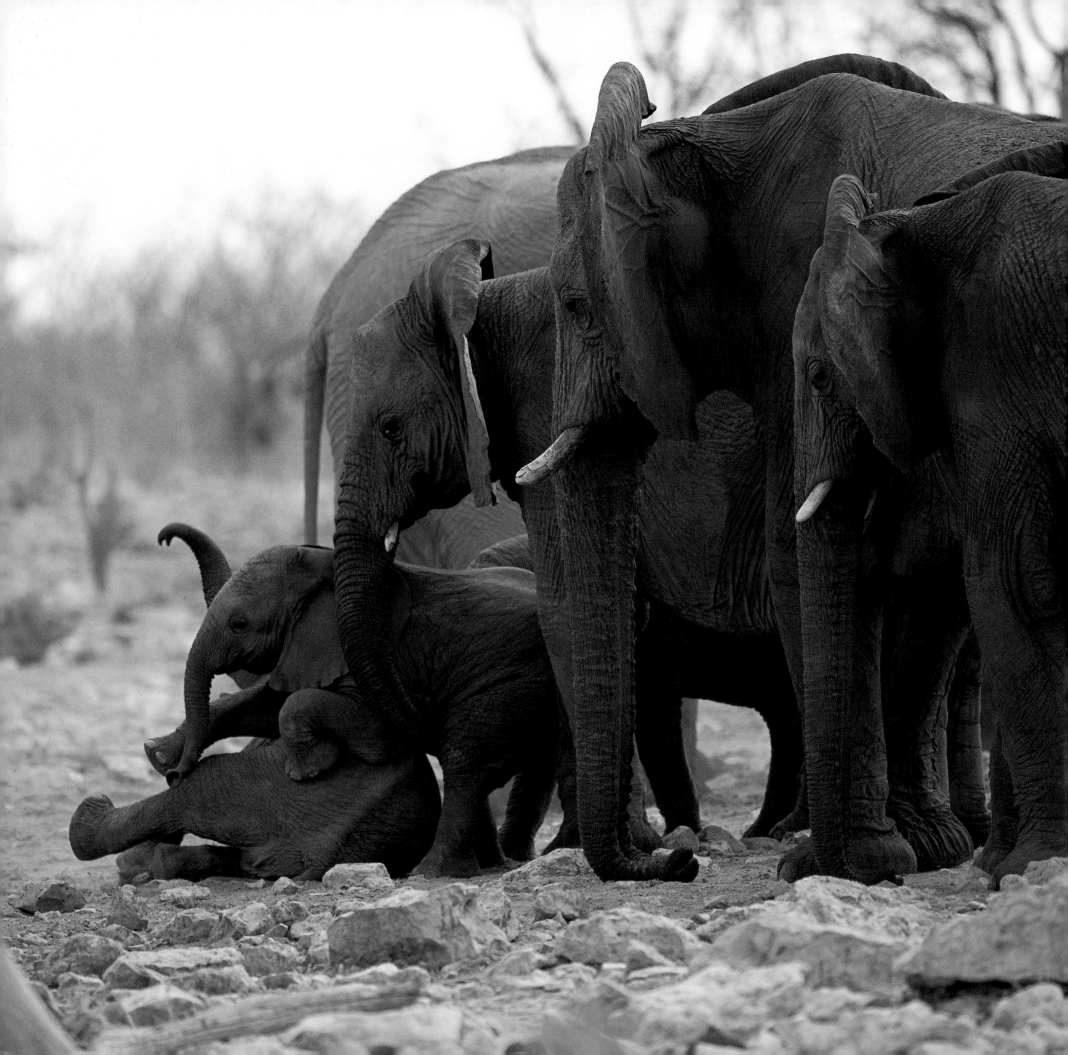

BUEHLER, D.A. 2000. Bald Eagle (*Haliaeetus leucocephalus*). In A. POOLE and F. GILL (eds.), *The Birds of North America*, No. 506. The Academy of Natural Sciences, Philadelphia and the American Ornithologists' Union. Washington, D.C.

FERGUSON-LEES, J. and D.A. CHRISTIE. 2001. *Raptors of the World*. Houghton Mifflin, Boston, Massachusetts.

ÍÑIGO-ELÍAS, E.E. 1987. Feeding habits and ingestion of synthetic products in a Black Vulture population from Chiapas, Mexico. Acta Zoológica Mexicana No. 22:1-15.

KERLINGER, P. 1989. Flight strategies of migrating hawks. University of Chicago Press, Chicago, Illinois.

MEYER, K.D. 1995. Swallow-tailed Kite. (*Elanoides forficatus*). In A. POOLE and F. GILL (eds.), *The Birds of North America*, No. 138. The Academy of Natural Sciences, Philadelphia and the American Ornithologists' Union. Washington, D.C.

MEYER, K.D. 1996. Communal roosts of the American swallow-tailed kite in Florida: Habitat associations, critical sites, and a technique for monitoring population status. Final Rep. Florida Game and Fresh Water Fish Commission, Tallahassee.

STALMASTER, MARK V. 1987. *The Bald Eagle*. University Books, New York.

ZALLES, J.I. and K.L. BILDSTEIN. 2000. Raptor watch: A global directory of raptor migration sites. BirdLife International, Cambridge, U.K.; and Hawk Mountain Sanctuary, Kempton, Pennsylvania.

Shorebirds

BARTER, M. 2002. *Shorebirds of the Yellow Sea. Importance, Threats, and Conservation Status*. Wetlands International Global Series 9, International Wader Studies 12, Canberra.

BIRDLIFE INTERNATIONAL. 2000. *Threatened Birds of the World*. Lynx Edicions, Barcelona.

CHIPLEY, R.M., G.H. FENWICK, and M.J. PARR. 2003. *The American Bird Conservancy Guide to the Top 500 Bird Sites in the United States: America's Most Valuable Conservation Hotspots*. Random House, New York.

DEL HOYO, J., A. ELLIOTT, and J. SARGATAL. 1996. *Handbook of the Birds of the World. Volume 3. Hoatzin to Auks*. Lynx Edicions, Barcelona.

FISHPOOL, L.D.C. and M.I. EVANS. 2001. *Important Bird Areas in Africa and Associated Islands*. BirdLife Conservation Series No. 11. BirdLife International, Cambridge, U.K.

HAYMAN, P., J. MARCHANT, and T. PRATER. 1986. *Shorebirds: An Identification Guide*. Houghton Mifflin, Boston.

HEATH, M.F. and M.I. EVANS. 2000. *Important Bird Areas in Europe. Volumes 1-2*. BirdLife Conservation Series No. 11. BirdLife International, Cambridge, U.K.

HICKLIN, P. (ed.). 1996. Shorebird ecology and conservation in the Western Hemisphere. International Wader Studies 8. International Wader Group, Thetford, U.K.

HÖTKER, H., E. LEBEDEVA, P.S. TOMKOVICH, J. GROMADZKA, N.C. DAVIDSON, J. EVANS, D.A. STROUD, and R.B. WEST (eds.). 1998. Migration and international conservation of waders. International Wader Studies 10. International Wader Study Group, Thetford, U.K.

REED, J.M., N. WARNOCK, and L.W. ORING (eds.). 1997. Conservation and management of shorebirds in the Western Great Basin of North America. International Wader Studies 9. International Wader Study Group, Thetford, U.K.

STRAW, P. (ed.). 1997. Shorebird conservation in the Asia-Pacific region. Australasian Wader Studies Group, Victoria, Australia.

Cranes and storks

BIRDLIFE INTERNATIONAL. 2000. *Threatened Birds of the World*. Lynx Edicions, Barcelona.

FISHPOOL, L.D.C. and M.I. EVANS. 2001. *Important Bird Areas in Africa and Related Islands*. BirdLife Conservation Series No. 11. BirdLife International, Cambridge, U.K.

HEATH, M.F. and M.I. EVANS. 2000. *Important Bird Areas in Europe*. Volumes 1 and 2. BirdLife Conservation Series No. 8. BirdLife International, Cambridge, U.K.

MEINE, C.D. and G.W. ARCHIBALD. 1996. *The Cranes: Status Survey and Conservation Action Plan*. IUCN, Gland, Switzerland.
http://www.npwrc.usgs.gov/resource/distr/birds/cranes/cranes.htm

URBAN, E.K., C.H. FRY, and S. KEITH. 1986. *The Birds of Africa*. Volume II. Academic Press, London.

Amazonian parrots and macaws

BRIGHTSMITH, D.J. and K. VAN HOUTAN. undated. *Clay Lick Use by Macaws and Parrots in Madre de Dios, Peru*.
http://www.duke.edu/~djb4/Colpa%20to%20Parrot%20Biology%20no%20figures.htm

BRIGHTSMITH, D.J. and R.A. MUÑOZ-NAJAR. 2002. *Why Do Parrots Eat Dirt? A Study of Avian Geophagy in Peru*. Paper presented at the 3rd North American Ornithological Conference, September 24-28, 2002. New Orleans, Louisiana.
http://www.duke.edu/~djb4/Abstract%20Geophagy.htm

DIAMOND, J., K.D. BISHOP, and J.D. GILARDI. 1999. Geophagy in New Guinea birds. *Ibis* 141:181-193.

GILARDI, J.D., S.S. DUFFEY, C.A. MUNN, and L.A. TELL. 1999. Biochemical functions of geophagy in parrots: Detoxification of dietary toxins and cytoprotective effects. *Journal of Chemical Ecology* 25 (4):897-922.

JUNIPER, A. and M. PARR. 1998. *Parrots: A Guide to the Parrots of the World*. Yale University Press, Princeton.

MUNN, C.A. 1994. *Macaws*. National Geographic 185 (1):118-140.

Oilbirds

ROCA, R. 1992. Oilbirds of Venezuela: Ecology and conservation. *Publications of the Nuttall Ornithologists' Club. Museum of Comparative Zoology. Harvard University* 24:1-83.

ROCA, R. and P. GUTIERREZ. 1991. Fine feathered foresters. *Wildlife Conservation* 94(5):78-87.

SNOW, D.W. 1962. The natural history of the oilbird, *Steatornis caripensis*, in Trinidad, W.I. Part 2. Population, breeding ecology and food. *Zoologica* 47:199-221.

REPTILES, AMPHIBIANS, AND FISHES

Manitoba garter snakes

CHURCHILL, T.A. and K.B. STOREY. 1992. Freezing survival of the garter snake *Thamnophis sirtalis parietalis. Canadian Journal of Zoology* 70:99-105.

GARSTKA, W.R., B. CAMAZINE, and D. CREWS. 1982. Interactions of behavior and physiology during the annual reproductive cycle of the red-sided garter snake (*Thamnophis sirtalis sirtalis*). *Herpetologica* 38:104-123.

JOY, J.E. and D. CREWS. 1987. Hibernation in garter snakes (*Thamnophis sirtalis parietalis*): Seasonal cycles of cold tolerance. *Comparative Biochemistry and Physiology*. 87A (4):1097-1101.

MASON, R.T. and D. CREWS. 1985. Female mimicry in garter snakes. *Nature* 316:59-60.

MASON, R.T., H.M. FALES, T.H. JONES, L.K. PANNELL, J.W. CHINN, and D. CREWS. 1989. Sex pheromones in snakes. *Science* 245:290-293.

SHINE, R. and R. MASON. 2001. Serpentine cross-dressers. *Natural History*, February:56-61.

On the opposite page, young African elephants (Loxodonta africana) play with each other. In big herds of elephants it's always a thrill to observe the behavior of young animals. Etosha National Park, Namibia.
© Patricio Robles Gil/Sierra Madre

Pantanal caimans

BRAZAITS, P., E. WATANABE, and G. AMATO. 1998. The caiman trade. *Scientific American* 3:70-76.

CAMPOS, Z., G. MOURÃO, M. COUTINHO, and C. ABERCROMBIE. 1994. Night-light counts, size structures, and sex ratios in wild populations of yacare caiman (*Caiman crocodilus yacare*) in the Brazilian Pantanal. *Vida Sivestre Neotropical* 4:46-50.

COUTINHO, M. and Z. CAMPOS. 1996. Effect of habitat and seasonality on the densities of caiman in southern Pantanal, Brazil. *Journal of Tropical Ecology* 12:741-747.

COUTINHO, M., Z. CAMPOS, F. CARDOSO, P. MARTINELLI, and A. CASTRO. 2001. Reproductive biology and its implication for management of caiman (*Caiman yacare*) in the Pantanal wetland, Brazil. In G. GRIGG, F. SEEBACHER, C. FRANKLIN (eds.): *Biology and Evolution of Crocodilians*. Surrey Beaty & Sons, Brisbane, Australia.

GRIGG, G., P. HALE, and D. LUNNEY. 1995. *Conservation Through Sustainable Use of Wildlife*. Centre for Conservation Biology. The University of Queensland, Brisbane, Australia.

HAMILTON, S., S. SIPPEL, and J. MELACK. 1996. Inundation pattern in the Pantanal wetland of South America determined from passive microwave remote sensing. *Archives of Hydrobiology*, 137:1-23.

SCHALLER, G. and P. CRAWSHAW. 1982. Fishing behaviour of Paraguayan caiman (*Caiman crocodilus*). Copeia 1:66-72.

Giant tortoises

BOUR, R. 1984. Les tortues terrestres geantes des Iles de l'Ocean Indien occidental: donnees geographiques, taxinomiques et phylogenetiques. *Studia Geologica Salamanticensia – Studia Palaeocheloniologica* 1:17-76.

ERNST, C.H. and R.W. BARBOUR. 1989. *Turtles of the World*. Smithsonian Institution Press, Washington, D.C.

GERLACH, Justin. 1998. *Famous Tortoises*. J. Gerlach, Publ.

HNATIUK, R.J., S.R.J. WOODELL, and D.M. BOURN. 1976. Giant tortoise and vegetation interactions on Aldabra Atoll. Part 2: Coastal. *Biological Conservation* 9:305-316.

PRITCHARD, P.C.H. 1979. *Encyclopedia of Turtles*. T.F.H. Publications, Neptune, New Jersey.

PRITCHARD, P.C.H. 1996. The Galápagos tortoises, nomenclatural and survival status. *Chelonian Research Monographs* 1.

VAN DENBURGH, J. 1914 (Reprint SSAR 1998, with Foreword by Peter C.H. Pritchard). The gigantic land tortoises of the Galápagos Archipelago. *Proceedings of the California Academy of Sciences*, II (I):203-374, plates 12-124.

Sea turtles

BJORNDAL, K.A. (ed.). 1982. *Biology and Conservation of Sea Turtles*. Smithsonian Institution Press, Washington, D.C.

CARR, A. 1986. *The Sea Turtle: So Excellent A Fish*. University of Texas Press.

ERNST, C.H. and R.W. BARBOUR. 1989. *Turtles of the World*. Smithsonian Institution Press, Washington, D.C.

LUTZ, P.L. and J.A. MUSICK. 1997. *The Biology of Sea Turtles*. CRC Press, Boca Raton.

SPOTILA, J.R., A.E. DUNHAM, A.J. LESLIE, A.C. STEYERMARK, P.T. PLOTKIN, and F.V. PALADINO. 1996. Worldwide population decline of *Dermochelys coriacea*: are leatherback turtles going extinct? *Chelonian Conservation Biology* 2:209-222.

SPOTILA, J.R., R.D. REINA, A.C. STEYERMARK, P.T. PLOTKIN, and F.V. PALADINO. 2000. Pacific leatherback turtles face extinction. *Nature* 405:529-530.

Frogs, toads, and salamanders

DUELLMAN, W.E. 1999. *Patterns of Distribution of Amphibians*. Johns Hopkins University Press, Baltimore.

PETRANKA, J.W. 1999. *Salamanders of the United States and Canada*. Smithsonian Books, Washington, D.C.

POUNDS, J.A., M.P.L. FOGDEN, J.M. SAVAGE, and G.C. GORMAN. 1997. Tests of null models for amphibian declines on a tropical mountain. *Conservation Biology* 11:1307-1322.

RÖDEL, M.-O. 2000. *Amphibians of the West African Savanna*. Chimaira, Germany.

SCHIØTZ, A. 1999. *Treefrogs of Africa*. Chimaira, Germany.

ZIMMERMAN, B.L. and M.T. RODRIGUES. 1990. Frogs, snakes, and lizards of the INPA-WWF reserves near Manus, Brazil. In A.H. GENTRY (ed.), *Four Neotropical Rainforests*. Yale University Press, New Haven, pp. 426-454.

Hammerhead sharks

DE STEFANO, D. 2001. The biogeography of the smooth hammerhead shark (*Sphyrna zygaena*). San Francisco State University, Department of Geography.
http://bss.sfsu.edu/geog/bholzman/courses/Fall01%20projects/hammerhead%20web%20page.htm

FAO Fishstat. FAO Fishery Department statistical databases and software. Total Production 1950-2000.
http://www.fao.org/fi/statist/FISOFT/FISHPLUS.asp

HANDWERK, B. 2002. Do hammerheads follow magnetic highways in migration? *National Geographic News* June 6, 2002.

KAJIURA, S.M. 2001. Head morphology and electrosensory pore distribution of carcharinid and sphyrnid sharks. *Environmental Biology of Fishes* 61:125-133.

KLIMLEY, A.P. 1993. Highly directional swimming by scalloped hammerhead sharks, *Sphyrna lewini*, and subsurface irradiance, temperature, bathymetry, and geomagnetic field. *Marine Biology* 117:1-22.

RITTER, E. 2002. Scalloped hammerhead fact sheet.
http://www.sharkinfo.ch/SI2_00e/slewini.html

Schooling fish

GULF AND CARIBBEAN FISHERIES INSTITUTE. 2002. Policy recommendation statement: Spawning aggregation site protection in the wider Caribbean.
http://www.gcfi.org

MARSHALL, N.B. 1966. *The Life of Fishes*. The World Publishing Company, Cleveland.

PAXTON, J.E. and W.N. ESCHMEYER (eds.). 1994. *Encyclopaedia of fishes*. Weldon Owen, Sydney.

STOUT, P.K. 2003. Fish Schooling. Rhode Island Sea Grant Fact Sheet.
Online: http://seagrant.gso.uri.edu/factsheets/schooling.html

Pacific salmon

GENDE, S.M., R.T. EDWARDS et al. 2002. Pacific salmon in aquatic and terrestrial ecosystems. *BioScience* 52(10):917-928.

HEARD, W.R. 1998. Do hatchery salmon affect the North Pacific Ocean ecosystem? *North Pacific Anadromous Fishery Commission Bulletin* 1:405-411.

KAERIYAMA, M. 1999. Hatchery programmes and stock management of salmonid populations in Japan. In B.R. HOWELL, E. MOCKSNESS, and T. SVASAND (eds.), *Stock Enhancement and Sea Ranching*, Blackwell Science, Ltd., pp. 153-167.

KAERIYAMA, M. and H. MAYAMA. 1996. Rehabilitation of wild chum salmon population in Japan. *Technical Rep. Hokkaido Salmon Hatchery* 165:41-52.

LICHATOWICH, J.A. 1999. *Salmon without Rivers: A History of the Pacific Salmon Crisis*. Washington, D.C., Island Press.

NORTHWEST POWER PLANNING COUNCIL. 2001. Inaugural Annual Report of the Columbia Basin Fish and Wildlife Program, 1978-1999. Portland, Oregon, Northwest Power Planning Council.

PEARCY, W.G. 1992. *Ocean Ecology of North Pacific Salmonids*. Seattle, Washington Sea Grant Program.

SINIAKOV, S.A., N.B. MARKEVICH, et al. 2000. Site selection and analysis of river systems. Petropavlovsk-Kamchatskii, United Nations Development Programme GEF project Conservation of Salmonid Biodiversity and Their Sustainable Use: 42.

VOLPE, J. 2001. Super Un-natural: Atlantic salmon in BC waters. Vancouver, B.C., David Suzuki Foundation: 32.

INVERTEBRATES

Horseshoe crabs

BOTTON, M.L. and J.W. ROPES. 1987. Populations of horseshoe crabs, *Limulus polyphemus*, on the northwestern Atlantic continental shelf. *Fishery Bulletin* 85(4):805-812.

HAWES, A. 1999. Crabs in the Crossfire. *ZooGoer* 28(3). Friends of the National Zoo. http://nationalzoo.si.edu/Publications/ZooGoer/1999/3/crabsincrossfire.cfm

SHUSTER, C.N., Jr. 1982a. A pictorial review of the natural history and ecology of the horseshoe crab, *Limulus polyphemus*, with reference to other limulidae. In: J. BONAVENTURA, C. BONAVENTURA, and S. TESH (eds.). *Physiology and biology of horseshoe crabs: Studies on normal and environmentally stressed animals*. Alan R. Liss, Inc., New York, pp. 1-52.

SHUSTER, C.N., Jr. 1982b. Xiphosurida. In: *Encyclopedia of Science and Technology*. McGraw-Hill, New York, pp. 766-770.

SWAN, B.L., W.R. HALL, Jr., and C.N. SHUSTER, Jr. 2001. Delaware Bay Horseshoe Crab Millennium Survey.

http://www.ocean.udel.edu/mas/bhall/hsccensus/Milleniumsurvey.html

Jellyfish and ctenophore blooms

BENOVI, A., D. JUSTI, and A. BENDER. 1987. Enigmatic changes in the hydromedusan fauna of the northern Adriatic Sea. *Nature* 326:597–600.

BRODEUR, R.D., C.E. MILLS, J.E. OVERLAND, G.E. WALTERS, and J.D. SCHUMACHER. 1999. Evidence for a substantial increase in gelatinous zooplankton in the Bering Sea, with possible links to climate change. *Fisheries Oceanography* 8:296-306.

GRAHAM, W.M., D.L. MARTIN, D.L. FELDER, V.L. ASPER, and H.M. PERRY. 2003. Ecological and economic implications of the tropical jellyfish invader, *Phyllorhiza punctata* von Lendenfeld, in the northern Gulf of Mexico. *Biological Invasions* 5: in press.

GRAHAM, W.M., F. PAGÈS, and W.M. HAMNER. 2001. A physical context for gelatinous zooplankton aggregations: A review. *Hydrobiologia* 451:199-212.

HEEGER, T. 1998. Quallen – Gefährliche Schönheiten. Wissenschaftliche Verlagsgesellschaft mbH Stuttgart.

KIDEYS, A.E. 2002. Fall and rise of the Black Sea ecosystem. *Science* 297:1482-1484.

LUCAS, C.H. 2001. Reproduction and life history strategies of the common jellyfish, *Aurelia aurita*, in relation to its ambient environment. *Hydrobiologia* 451:229-246.

MILLS, C.E. 2001. Jellyfish blooms: Are populations increasing globally in response to changing ocean conditions? *Hydrobiologia* 451:55-68.

OMORI, M. and E. NAKANO. 2001. Jellyfish fisheries in southeast Asia. *Hydrobiologia* 451:19-26.

SHIGANOVA, T.A. 1998. Invasion of the Black Sea by the ctenophore *Mnemiopsis leidyi* and recent changes in pelagic community structure. *Fisheries Oceanography* 7:305-310.

Christmas Island red crabs

DU PUY, D.J., 1993. Christmas Island. In: A.S. GEORGE et al. (eds.), *Flora of Australia*, Vol. 50: Oceanic Islands 2. Australian Government Publishing Service, Canberra, pp. 1-30.

GREEN, P.T., 1997. Red crabs in rain forest on Christmas Island, Indian Ocean: Activity patterns, density and biomass. *Journal of Tropical Ecology* 13:17-38.

MALE, T. 2001. Terrestrial Ecoregions – Christmas and Cocos Islands tropical forests (IM0110). Available online:
http://www.worldwildlife.org/wildworld/profiles/terrestrial/im/im0110_full.html

O'DOWD, D.J. and P.S. LAKE, 1991. Red crabs in rain forest, Christmas Island: Removal and fate of fruits and seeds. *Journal of Tropical Ecology* 7:113-122.

Desert locusts

FAO, 2003. FAO: Frequently Asked Questions (FAQs) about Desert Locusts. Available online:
http://www.fao.org/news/global/LOCUSTS/LOCFAQ.htm

UVAROV, B.P. 1966. *Grasshoppers and Locusts*, Vol. 1. Cambridge, published for Anti-Locust Research Centre, London.

UVAROV, B.P. 1977. *Grasshoppers and Locusts*, Vol. 2. Centre for Overseas Pest Research, London, 613 pp.

Ants and termites

HÖLLDOBLER, B. and E.O. WILSON. 1990. *The Ants*. Belknap Press of Harvard University Press, Cambridge, Massachusetts.

HÖLLDOBLER, B. and E.O. WILSON. 1994. *Journey to the Ants*. Harvard University Press, Cambridge, Massachusetts.

WILSON, E.O. 1971. *The Insect Societies*, Belknap Press of Harvard University Press, Cambridge, Massachusetts.

Monarch butterflies

BOJÓRQUEZ, L.A., L.P. BROWER, G. CASTILLEJA, S. SÁNCHEZ-COLÓN, M. HERNÁNDEZ, W.H. CALVERT, S. DÍAZ, P. GÓMEZ-PRIEGO, G. ALCANTAR, E.D. MELGAREJO, M.J. SOLARES, L. GUTIÉRREZ, and M.D.L. JUÁREZ. 2003. Mapping expert knowledge: redesigning the monarch butterfly biosphere reserve. *Conservation Biology* 17:367-379.

BROWER, L.P. 1995. Understanding and misunderstanding the migration of the monarch butterfly (Nymphalidae) in North America: 1857-1995. *Journal of the Lepidopterists' Society* 49:304-385.

BROWER, L.P. 1999. Biological necessities for monarch butterfly overwintering in relation to the Oyamel forest ecosystem in Mexico. In J. HOTH, L. MERINO, K. OBERHAUSER, I. PISANTY, S. PRICE, and T. WILKINSON (eds.), *Paper presentations: 1997 North American Conference on the Monarch Butterfly* (Morelia, Mexico.). The Commission for Environmental Cooperation, Montreal, Canada, pp. 11-28.

BROWER, L.P., G. CASTILLEJA, A. PERALTA, J. LÓPEZ-GARCÍA, L. BOJÓRQUEZ-TAPIA, S. DÍAZ, D. MELGAREJO, and M. MISSRIE. 2002. Quantitative changes in forest quality in a principal overwintering area of the monarch butterfly in Mexico: 1971 to 1999. *Conservation Biology* 16:346-359.

BROWER, L.P., D.R. KUST, E. RENDÓN-SALINAS, E.G. SERRANO, K.R. KUST, J. MILLER, C. FERNÁNDEZ DEL REY, and K. PAPE. (In press 2003). Catastrophic winter storm mortality of monarch butterflies in Mexico during January 2002. In K.M. OBERHAUSER and M. SOLENSKY (eds.). *Conservation Biology of the Monarch Butterfly*, Cornell University Press, Ithaca.

A large school of yellowfin goatfish
(Mulloidichthys vanicolensis), *Great Barrier Reef,
Australia. A school of fish is not merely
an aggregation; it is a phenomenon with very special
properties in which all members move in synchrony
and with such unified responsiveness
that at times their behavior seems
to be that of a single super-organism and
not just a group of individual animals.*
© Gary Bell/Seapics.com

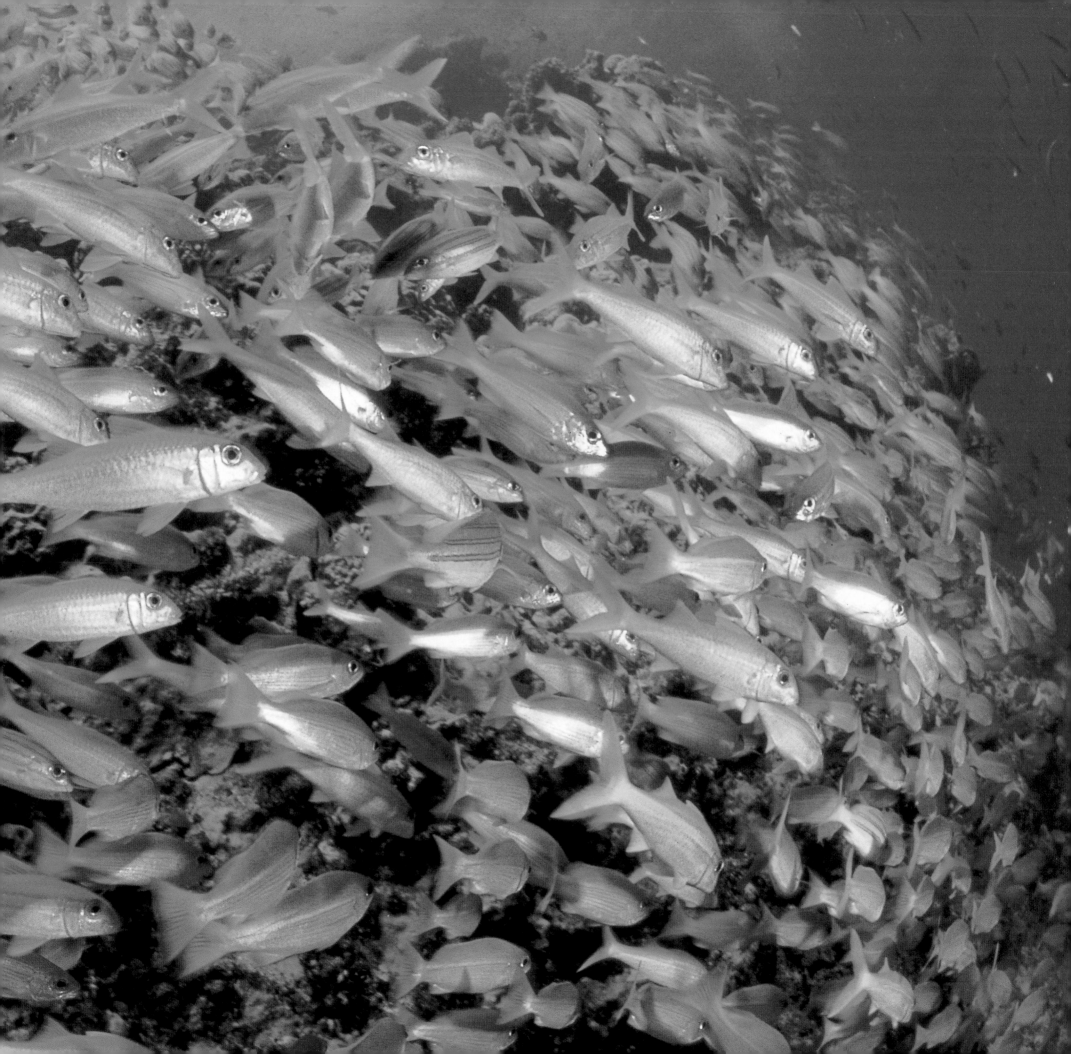

GERALD R. ALLEN / Conservation International
1 Dreyer Road, Roleystone, WA Australia, 6111
tropical_reef@bigpond.com

GEORGE ARCHIBALD / International Crane Foundation
E-11376 Shady Lane Road, PO Box 447, Baraboo, WI 54913-0047, U.S.A.
george@savingcranes.org

FELICITY ARENGO / Wildlife Conservation Society
2300 Southern Boulevard, Bronx, NY 10460, U.S.A.
farengo@wcs.org

KEITH L. BILDSTEIN / Hawk Mountain Sanctuary
410 Summer Valley Road, Orwigsburg, PA 17961, U.S.A.
bildstein@hawkmtn.org

P. DEE BOERSMA / University of Washington
Dept. of Zoology, Box 351800, Seattle, WA 98195-1800, U.S.A.
boersma@u.washington.edu

THOMAS BROOKS / Conservation International
1919 M St. NW Suite 600, Washington, DC 20036, U.S.A.
t.brooks@conservation.org

LINCOLN P. BROWER / Sweet Briar College
Sweet Briar, VA 24595, U.S.A.
brower@sbc.edu

THOMAS BUTYNSKI / Conservation International
1919 M St. NW Suite 600, Washington, DC 20036, U.S.A.
t.butynski@conservation.org

DES CALLAGHAN / BirdLife International
Vicente Cárdenas E5 75, Casilla 17-17-717, Quito, Ecuador
Des@Birdlife.org.ec

ZILCA CAMPOS / EMBRAPA
Rua 21 de setembro, 1880, Nossa Sra. de Fátima, Corumbá - MS, 79320-030 Brazil
zilca@cpap.embrapa.br

GUILLERMO CASTILLEJA / World Wildlife Fund
1250 Twenty-Fourth Street, N.W.
Washington, DC 20090-7180, U.S.A.
guillermo.castilleja@WWFUS.ORG

SHANNON CHARLTON / Conservation International
PostNet Suite 292, Private Bag X15, Somerset West 7129, South Africa
charlton@nbict.nbi.ac.za

DON CHURCH / University of Virginia, Department of Biology
P.O. Box 400328, Charlottesville, VA 22904-4328, U.S.A.
drc9a@virginia.edu

WILLIAM G. CONWAY/Wildlife Conservation Society
2300 Southern Boulevard, Bronx, NY 10460, U.S.A.
wconway@wcs.org

MARCOS COUTINHO
Rua Junkuilhos 544, Cidade Jardim 79040-721, Campo Grande, MS Brazil
coutinho@ipaam.br

SIMON DELANY / Wetlands International
P.O. Box 471, 6700 AL Wageningen, The Netherlands
simon.delany@Wetlands.org

SYLVIA A. EARLE / Conservation International
1919 M St. NW Suite 600, Washington, DC 20036, U.S.A.
s.earle@conservation.org

LINCOLN FISHPOOL / BirdLife International
Wellbrook Court, Girton Road, Cambridge CB3 0NA, U.K.
lincoln.fishpool@birdlife.org.uk

GUSTAVO A.B. DA FONSECA / Conservation International and
 Federal University of Minas Gerais
1919 M St. NW Suite 600, Washington, DC 20036, U.S.A.
 and Avenida Antonio Carlos 6627, Belo Horizonte, Brazil
g.fonseca@conservation.org

MATT FOSTER / Conservation International
1919 M St. NW Suite 600, Washington, DC 20036, U.S.A.
m.foster@conservation.org

CLAUDE GASCON / Conservation International
1919 M St. NW Suite 600, Washington, DC 20036, U.S.A.
c.gascon@conservation.org

JOHN HANKS / Conservation International
Kirstenbosch National Botanical Garden, Private Bag X7, Claremont 7735,
 South Africa
hanksppt@iafrica.com

MICHAEL HOFFMANN / Conservation International
1919 M St. NW Suite 600, Washington, DC 20036, U.S.A.
m.hoffmann@conservation.org

BAZ HUGHES
WWT, Slimbridge, Glos. GL2 7BT, UK
Baz.Hughes@wwt.org.uk

EDUARDO ÍÑIGO-ELÍAS / Cornell University
159 Sapsucker Woods, Ithaca, NY 14850, U.S.A.
eei2@cornell.edu

ASIR J.T. JOHNSINGH / Wildlife Institute of India
Chandrabani, Post Box 18, Dehradun, Uttaranchal 248001, India
ajtjohnsingh@wii.gov.in

WILLIAM R. KONSTANT / Conservation International
1919 M St. NW Suite 600, Washington, DC 20036, U.S.A.
b.konstant@conservation.org

PENNY LANGHAMMER / Conservation International
1919 M St. NW Suite 600, Washington, DC 20036, U.S.A.
p.langhammer@conservation.org

REINALDO F.F. LOURIVAL / Conservation International
Rua Eduardo Santos Pereira, 1550 - Sala 16, 79020-170 Campo Grande, MS, Brazil
r.lourival@conservation.org

ANNA A. LUSHCHEKINA / Russian MAB Committee
13 Fersman Street, Moscow, 119312, Russia
mab.ru@relcom.ru

WAYNE LYNCH
3779 Springbank Drive S.W., Calgary, Alberta, T3H 4J8, Canada
lynchandlang@shaw.ca

PATRICIA MAJLUF
Av. Pezet 1970, Magdalena del Mar, Lima 17, Peru
pmajluf@spondylus.org

CARLOS MANTEROLA / Unidos para la Conservación
Primero de Mayo 249, San Pedro de los Pinos, 03800 México, D.F., Mexico
uni2@infosel.net.mx

RODERIC B. MAST / Conservation International
1919 M St. NW Suite 600, Washington, DC 20036, U.S.A.
r.mast@conservation.org

SHEILA A. MCKENNA / Conservation International
1919 M St. NW Suite 600, Washington, DC 20036, U.S.A.
s.mckenna@conservation.org

RODRIGO A. MEDELLÍN / Center for Environmental Research and Conservation
Columbia University, 1200 Amsterdam Avenue, New York, NY 10027, U.S.A.
medellin@miranda.ecologia.unam.mx

CLAUDIA E. MILLS / University of Washington
620 University Road, Friday Harbor, WA 98250, U.S.A.
cemills@u.washington.edu

CRISTINA G. MITTERMEIER / Conservation International
432 Walker Rd, Great Falls, VA 22066, U.S.A.
cgmittermeier@conservation.org

RUSSELL A. MITTERMEIER / Conservation International
1919 M St. NW Suite 600, Washington, DC 20036, U.S.A.
r.mittermeier@conservation.org

PIOTR NASKRECKI / Conservation International / Museum of Comparative
 Zoology, Harvard University
26 Oxford Street, Cambridge, MA 02138
p.naskrecki@conservation.org

DEON C. NEL / BirdLife International-South Africa
P.O. Box 1586, Stellenbosch 7599, South Africa
dnel@savethealbatross.org.za

VALERY M. NERONOV / Russian MAB Committee
13 Fersman Street, Moscow, 119312, Russia
mab.ru@relcom.ru

MICHAEL J. PARR / American Bird Conservancy
1834 Jefferson Place, NW Washington, DC 20036, U.S.A.
mparr@abcbirds.org

JOHN PILGRIM / Conservation International
1919 M St. NW Suite 600, Washington, DC 20036, U.S.A.
j.pilgrim@conservation.org

PETER C.H. PRITCHARD / Chelonian Research Institute
402 South Central Avenue, Oviedo, FL 32765, U.S.A.
ChelonianRI@aol.com

GUIDO RAHR / The Wild Salmon Center
721 NW 9th Avenue, Suite 290, Portland, OR 97209, U.S.A.
grahr@wildsalmoncenter.org

ANDERS G.J. RHODIN / Chelonian Research Foundation
168 Goodrich Street, Lunenburg, MA 01462, U.S.A.
RhodinCRF@aol.com

ALEJANDRO ROBLES / Conservation International
1919 M St. NW Suite 600, Washington, DC 20036, U.S.A.
a.robles@conservation.org

PATRICIO ROBLES GIL / Agrupación Sierra Madre
Primero de Mayo 249, San Pedro de los Pinos, 03800 México, D.F., Mexico
patricio@terra.com.mx

ROBERTO ROCA / Conservation International
1919 M St. NW Suite 600, Washington, DC 20036, U.S.A.
r.roca@conservation.org

LORENZO ROJAS BRACHO / Instituto Nacional de Ecología/CICESE
Km. 107 Carretera Ensenada-Tijuana, A.P. 2732, 22860 Ensenada, BC, Mexico
lrojas@cicese.mx

ANTHONY B. RYLANDS / Conservation International
1919 M St. NW Suite 600, Washington, DC 20036, U.S.A.
a.rylands@conservation.org

GEORGE SCHALLER / Wildlife Conservation Society
2300 Southern Boulevard, Bronx, NY 10046, U.S.A.
asiaprogram@wcs.org

PETER A. SELIGMANN / Conservation International
1919 M St. NW Suite 600, Washington, DC 20036, U.S.A.
P.Seligmann@conservation.org

MICHAEL L. SMITH / Conservation International
1919 M St. NW Suite 600, Washington, DC 20036, U.S.A.
m.smith@conservation.org

MARTIN SNEARY / BirdLife International
Wellbrook Court, Girton Road, Cambridge, CB3 0NA, U.K.
Martin.Sneary@birdlife.org.uk

SIMON N. STUART / Conservation International
1919 M St. NW Suite 600, Washington, DC 20036, U.S.A.
s.stuart@conservation.org

MERLIN D. TUTTLE / Bat Conservation International
500 N. Capital of Texas Hwy. Bldg. 1, Suite 200,
 P.O. Box 162603, Austin, TX 78746, U.S.A.
batinfo@batcon.org

AMY N. VAN BUREN / University of Washington
Dept. of Zoology, Box 351800, Seattle, WA 98195-1800, U.S.A.
anvb@u.washington.edu

CARLY VYNNE / Conservation International
1919 M St. NW Suite 600, Washington, DC 20036, U.S.A.
C.Vynn@conservation.org

EDWARD O. WILSON / Harvard University, Museum of Comparative Zoology
26 Oxford St., Cambridge, MA 02136, U.S.A.
ewilson@oeb.harvard.edu

JOHN WOINARSKI / Biodiversity Section, Natural Systems, Department of
 Infrastructure, Planning and Environment
P.O. Box 496, Palmerston, NT, Australia, 0831
john.woinarski@nt.gov.au

LU ZHI / Conservation International-China
Conservation Biology Building, College of Life Sciences, Peking University,
 Beijing 100871, P.R. China
z.lu@conservation.org

We would like to express our sincere thanks to the following people for their help and assistance in various aspects relating to the production of this book: Exequiel Ezcurra (Instituto Nacional de Ecología), Jorge Soberón (CONABIO), Gerardo Ceballos (UNAM), and Humberto Berlanga (NABCI) for their advice in the planning stage of this work and for proposing chapter authors; Cliff Jolly (New York University), and Andrew Plumptre and Amy Vedder (Wildlife Conservation Society) for providing data for the primates chapter; Wes Sechrest (University of Virginia) for providing maps for use in the caribou, primates, and bats chapters; Tim Werner (Conservation International) and Randall Reeves (IUCN Cetacean Specialist Group) for help with the whales and dolphins chapter; Leon Bennun (BirdLife International) for help with the bird chapters; John Shaw, who provided us with information on Iceland; Mauricio Ruiz Galindo and Norma Ferriz (Proyecto Río Rapaces of Pronatura), John Nuhn (National Wildlife Magazine/The National Wildlife Federation), and Fulvio Eccardi for help in looking for photographs; Javier Vasconcelos and Martha Harfus (Centro Mexicano de la Tortuga), and Víctor Sánchez (Reserva de El Vizcaíno) for their support in photographic documentation; Chip Chipley and Gavin Shire (American Bird Conservancy) for providing draft U.S. Important Bird Area site accounts; Enriqueta Velarde (UNAM) for providing Mexican data for the seabirds chapter; Thomas Madsen for providing data on Australian pythons; Sarah Fowler (Nature Conservation Bureau) for help with the sharks chapter, Erich F. Horgan (Department of Biology, Woods Hole) for his assistance with the ctenophore species numbers for the jellyfish chapter, and to Janice Long for her help in proofreading drafts. We owe a huge amount of thanks to the staff of the GIS Lab at Conservation International, in particular Rob Waller for his tireless and patient GIS help with producing maps, and Mark Denil and John Musinsky for their guidance and technical input. Special thanks also to Shawn Concannon for providing support for some of the research that went into this book. Finally, we would like to thank Jill Lucena, from the President's office at CI for all her assistance; Oriana Castelló, Martín Jon García-Urtiaga, Doris Osuna del Villar, and Guillermo Osuna, for their support and friendship; Raúl Pérez Madero for having been our first liaison with CEMEX, and Patricia Rojo for her participation in many aspects of the book, especially planning trips for taking photographs.

*On the opposite page,
a flock of wood pigeons
(Columba palumbus). Outside
their breeding season, they are
usually found in flocks,
sometimes of enormous size.
Badajoz, Extremadura, Spain.
© Francisco Márquez*

On p. 1, Galápagos penguins (Spheniscus mendiculus) *fish for anchovy in the Galápagos Islands. This species is endemic to the Galápagos and ranges further north than any other penguin.* © D. Parer & E. Parer-Cook/Auscape; *on p. 2, lesser flamingo* (Phoenicopterus minor) *at the hot springs at Lake Bogoria, Rift Valley, Kenya.* © Ferrero-Labat/Auscape; *on pp. 4-5, a group of some 20 humpback whales* (Megaptera novaeangliae) *feeding on herring in Southeastern Alaska.* © Brandon Cole; *on pp. 6-7, a huge colony of Cape gannet* (Morus capensis) *at Lambert's Bay, South Africa.* © Peter Oxford/DRK PHOTO; *on pp. 8-9, enormous herds of wildebeest* (Connochaetes taurinus) *coming to drink in the Serengeti, Tanzania.* © Anup Shah/DRK PHOTO; *on p. 10, king penguin* (Aptenodytes patagonicus) *adults incubating and older chicks, St. Andrews Bay, South Georgia.* © Jean-Paul Ferrero/Auscape; *on pp. 12-13, long-beaked common dolphins* (Delphinus capensis) *attacking a large baitball of sardines* (Sardinops sagax) *during the annual sardine run off South Africa's Wild Coast.* © Doug Perrine/Seapics.com; *on p. 14, brown bear* (Ursus arctos) *catching salmon at Katmai National Park, Alaska.* © Stuart Westmorland; *on pp. 16-17, the gelada* (Theropithecus gelada) *is endemic to Ethiopia and feeds mainly on seeds in high-altitude grasslands up to 4 400 m. Here, a group in Ethiopia's Simien National Park.* © Michael K. Nichols/National Geographic Image Collection; *on p. 18, Atlantic puffin* (Fratercula arctica), *Iceland.* © Patricio Robles Gil/Sierra Madre; *on p. 21, sambar* (Cervus unicolor), *chital* (Axis axis), *and some peafowl* (Pavo muticus). *Many of the large ungulates of India and Nepal can often be seen in herds of 50 or more, while some, like the chital, can form aggregations of up to 500 animals.* © Patricio Robles Gil/Sierra Madre; *on p. 22-23, a school of glassfish and soft coral, Phuket, Thailand. A number of small reef fish species, including damselfishes, cardinalfishes, and fairy basslets form dense, mid-water feeding aggregations. Although tied closely to prominent reef features, such as individual coral heads, they regularly venture forth into the water column in search of current-borne plankton. At these times, they are vulnerable to predation from larger species like groupers, jacks, and snappers.* © Doug Perrine/Seapics.com; *on p. 24, Magellanic penguin* (Spheniscus magellanicus), *Punta Tombo, Argentina.* © Günter Ziesler; *on p. 27, Andean flamingos* (Phoenicopterus andinus) *in "alert posture" in the Salar de Atacama, Chile.* © Günter Ziesler; *on pp. 28-29, female olive ridley sea turtles* (Lepidochelys olivacea) *come ashore at sunset to nest during* arribada *(mass nesting), Ostional, Costa Rica.* © Doug Perrine/Seapics.com; *on pp. 76, zebra* (Equus burchellii) *and wildebeest* (Connochaetes taurinus) *grazing during their yearly migration in Kenya.* © Frans Lanting/Minden Pictures; *on p. 146, Peruvian brown pelican* (Pelecanus thagus) *nesting colony on the Guano Islands off the Peruvian coast.* © Tui De Roy; *on pp. 212, a school of fish and Galápagos marine iguanas* (Amblyrhynchus cristatus). © Howard Hall/howardhall.com; *on p. 266, monarch butterflies* (Danaus plexippus). © Patricio Robles Gil/Sierra Madre; *on p. 320, scarlet ibises* (Eudocimus ruber) *flying over a mangrove in Canelas Island, coast of the State of Pará, Brazil.* © Luiz Claudio Marigo; *on pp. 322-323, migrating herd of bison* (Bison bison). *Although this species narrowly escaped extinction, it will never again be seen in the spectacular numbers that once existed in nineteenth-century America.* © Jim Brandenburg/Minden Pictures; *on p. 324, snow geese* (Anser caerulescens), *Bosque del Apache, New Mexico.* © Arthur Morris/BIRDS AS ART

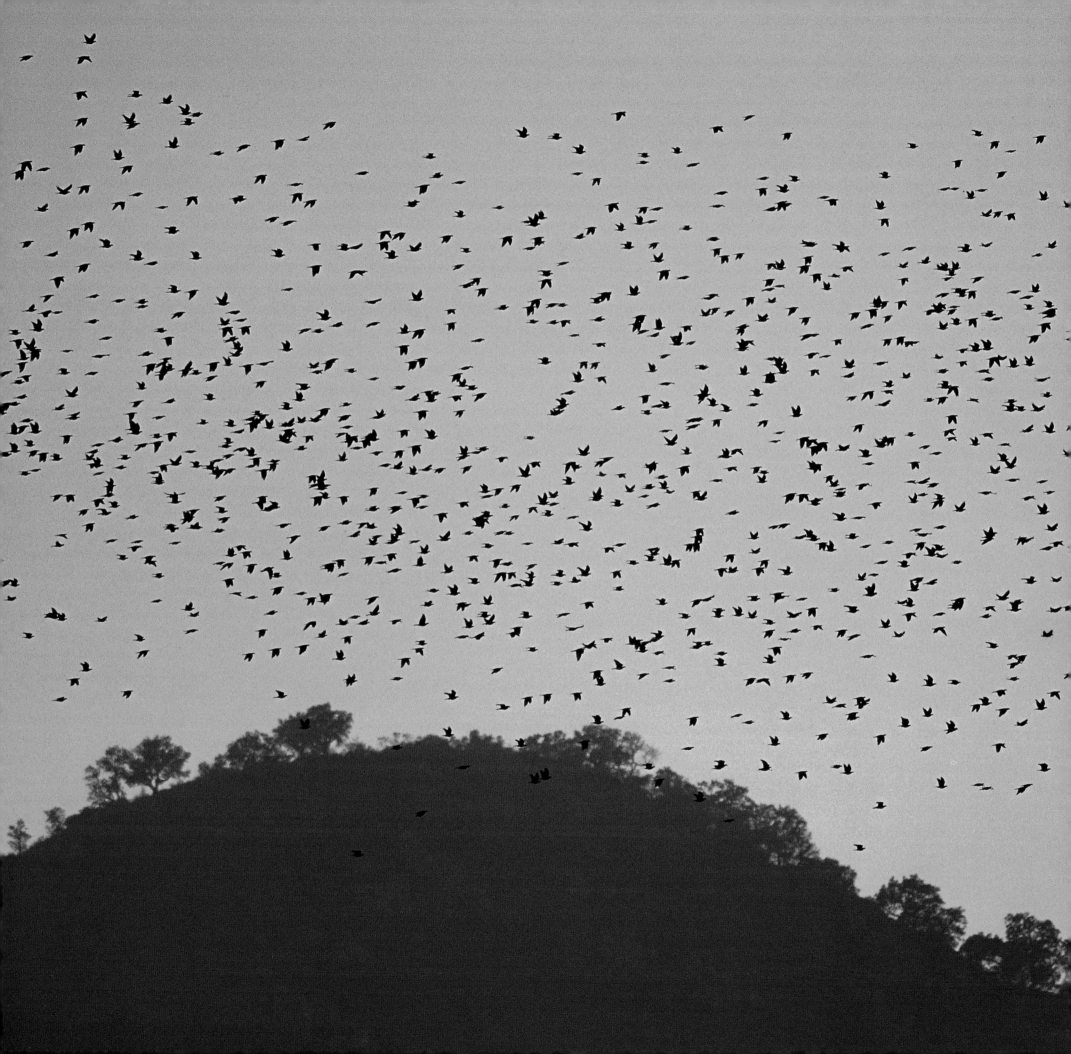

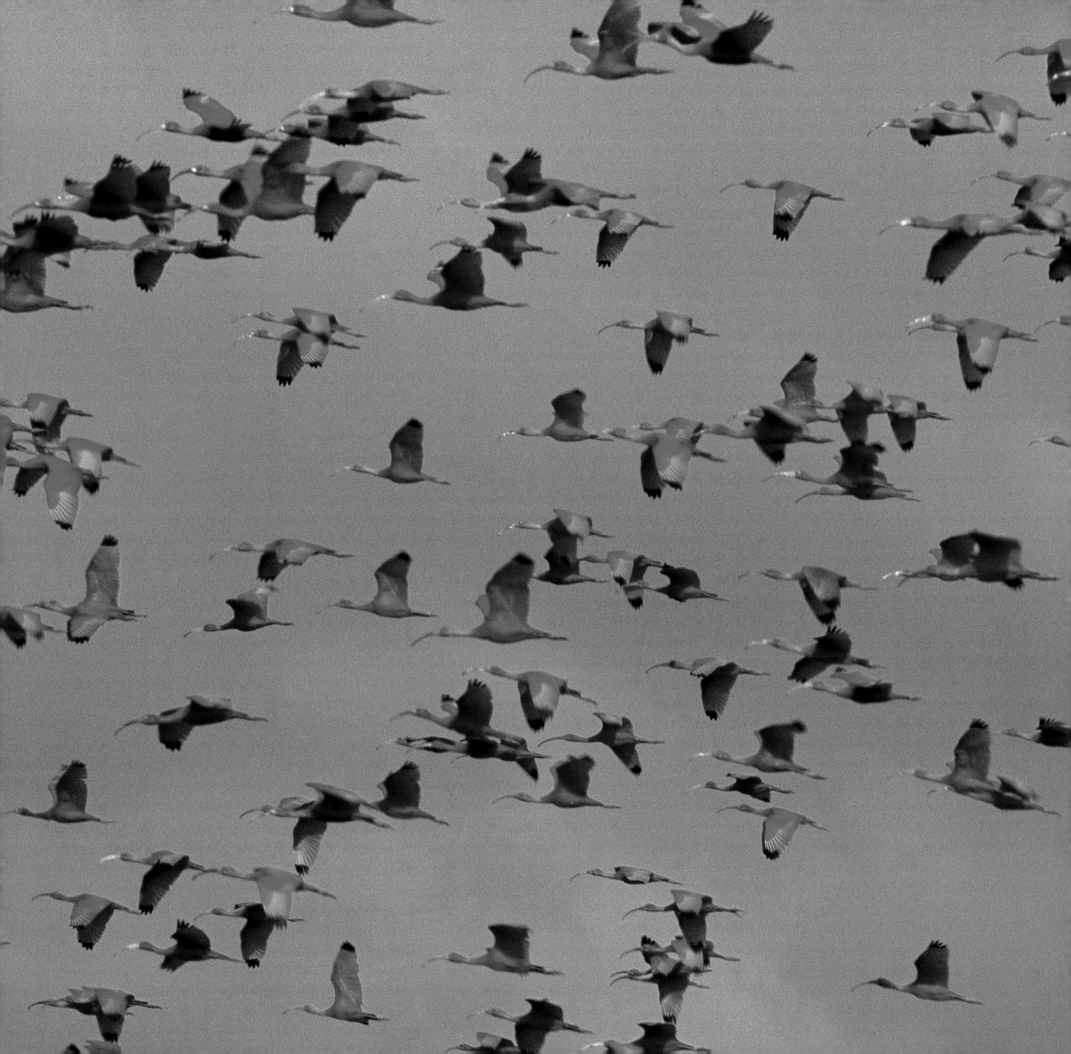

PRODUCTION
Agrupación Sierra Madre, S.C.
Redacta, S.A. de C.V.

EDITORIAL DIRECTION
Antonio Bolívar

EDITORIAL REVISION AND CORRECTION
Susan Beth Kapilian

GRAPHIC DESIGN
Juan Carlos Burgoa

COORDINATION OF PRODUCTION
Eugenia Pallares Elena León

COORDINATION OF PHOTOGRAPHS
AND EDITORIAL ASSISTANCE
Roxana Vega

TYPESETTING
Socorro Gutiérrez Rosalía Luna

MAPS PROVIDED BY CONSERVATION INTERNATIONAL
Design: Álvaro Couttolenc

ISBN 968-6397-72-8

Printed in Japan by Toppan Printing Co., on acid-free paper

Suggested citation for this book:
Mittermeier, R.A., P. Robles Gil, C.G. Mittermeier, T. Brooks, M. Hoffmann, W.R. Konstant, G.A.B. da Fonseca, and R.B. Mast. 2003.
Wildlife Spectacles. CEMEX–Agrupación Sierra Madre–Conservation International, Mexico, 324 pp.

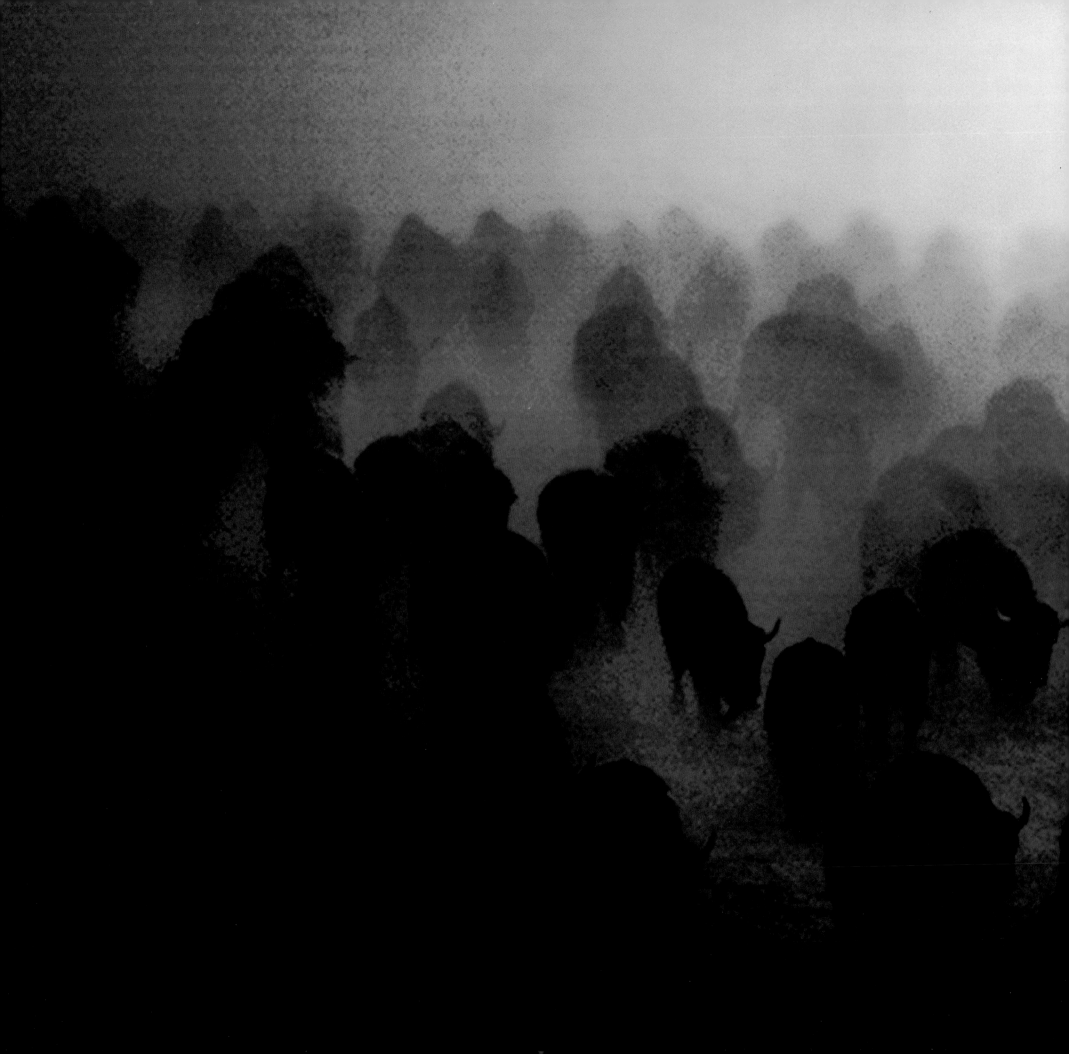

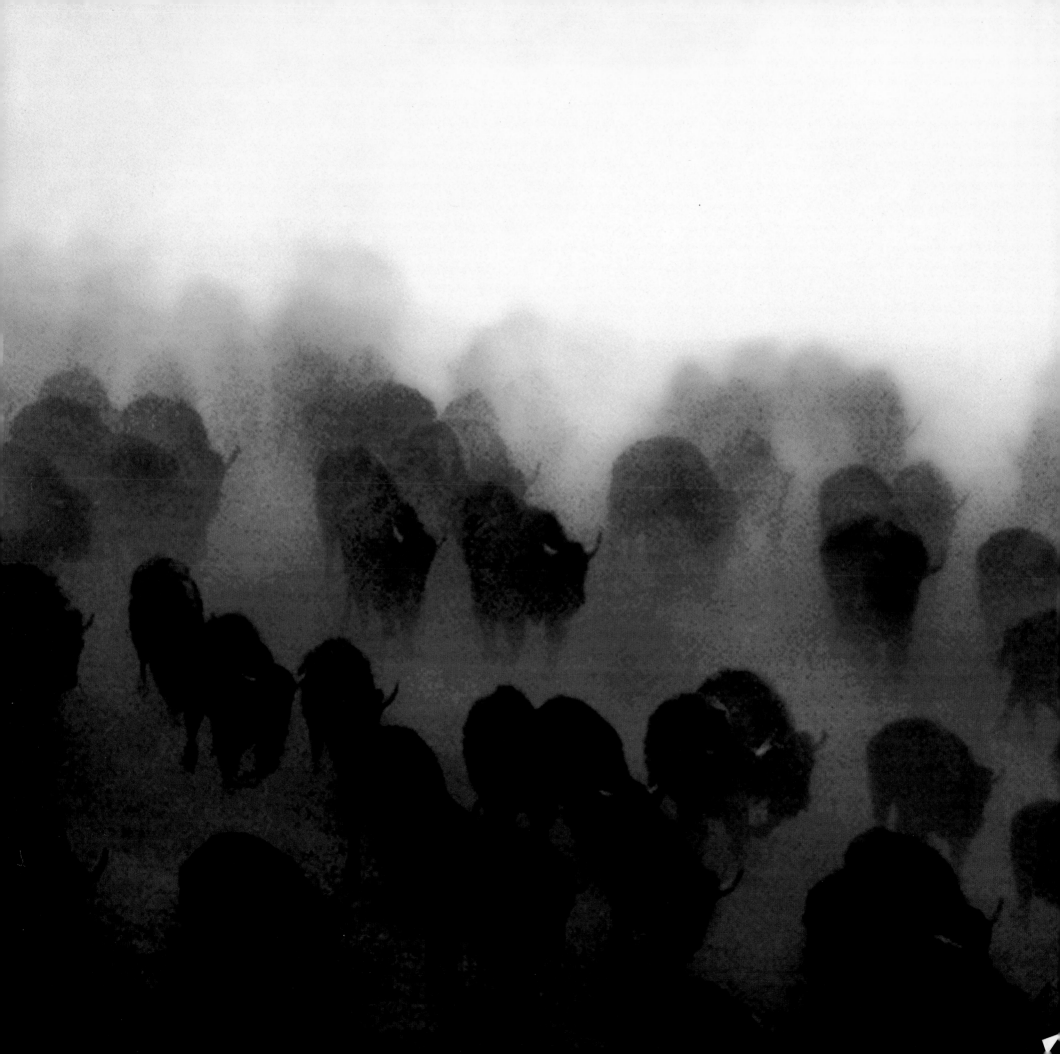

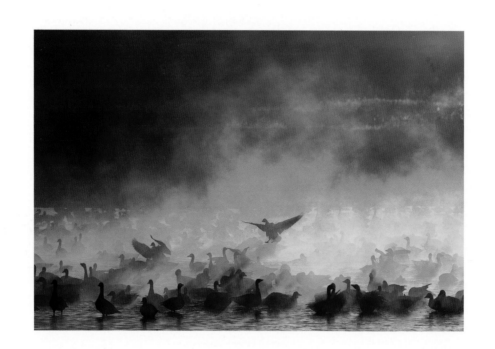